Reframing I

Mediated Cities

ISSN 2058-9409

Series Editor: Dr. Graham Cairns, Architecture_Media_Politics_
Society (AMPS) Director

Please send all series enquiries and proposals to Jelena.

The *Mediated Cities* series explores the contemporary city as a
hybrid phenomenon of digital technologies, new media, digital art
practices and physical infrastructure. It is an inherently interdisci-
plinary series around intersecting issues related to the city of today
and tomorrow.

As Marshall McLuhan identified in 1964, today's global village is
a place of simultaneous experience; a site for overlapping material
and electronic effects; a place not so much altered by the content
of a medium, but rather, a space transformed by the very nature of
medias themselves. For some, this is little more than the inevitable
evolution of urban space in the digital age. For others, it represents
the city's liberation from the condition of stasis. For scaremongers,
it's a nightmare scenario in which the difference between the virtual
and the real, the electronic and the material, the recorded and the
lived, becomes impossible to identify.

Reframing Berlin

Architecture, Memory-Making and Film Locations

Christopher S. Wilson and Gül Kaçmaz Erk

Bristol, UK / Chicago, USA

First published in the UK in 2023 by
Intellect, The Mill, Parnall Road, Fishponds, Bristol, BS16 3JG, UK

First published in the USA in 2023 by
Intellect, The University of Chicago Press, 1427 E. 60th Street,
Chicago, IL 60637, USA

A catalogue record for this book is available from
the British Library.

Copy editor: MPS Limited
Cover designer: Aleksandra Szumlas
Cover image: Film still from *B-Movie: Lust & Sound in West-Berlin 1979–
1989* (2015), used with permission from DEF Media GmbH.
Production manager: Laura Christopher
Typesetter: MPS Limited

Hardback ISBN 978-1-78938-687-5
Paperback ISBN 978-1-78938-964-7
ePDF ISBN 978-1-78938-688-2
ePUB ISBN 978-1-78938-689-9

This is part of the Mediated Cities series.
ISSN: 2058-9409
Series editor: Graham Cairns, AMPS

To find out about all our publications, please visit our website.
There you can subscribe to our e-newsletter, browse or download our current
catalogue and buy any titles that are in print.

www.intellectbooks.com

This is a peer-reviewed publication.

To the memory of filmmaker Paddy Cahill
21 April 1977–9 April 2021

Contents

Foreword

Kathleen James-Chakraborty

Berlin is an exception among European capitals. Unlike London, Paris, Rome or Vienna, it was founded in the Middle Ages rather than by the Romans and became a major metropolis only in the nineteenth century. Moreover, its rapid growth was related as much to the industries that clustered there as the rising importance of the Prussian state, of which it was the capital before Germany was united under the leadership of the local Hohenzollern dynasty in 1871. It is, quite fittingly, the European city that, even before it became the site of a murderous regime, was largely destroyed by aerial bombardment and invasion, divided between the victorious powers, and became ground zero for the Cold War, became a particularly attractive subject for two specifically modern media, photography and then film. Where Paris is inseparable from the painting of the nineteenth-century European urban life, filmic depictions of twentieth and twenty-first century Berlin are central, as this book demonstrates, to both the history of the medium and of the city.

Berlin is not famous for being beautiful, although in the right light and at the right season in front of the right building or landscape it can be. Instead, it is important as the site where many of the multiple modernities of the twentieth and early twenty-first century found their most urgent expression. This included already before the First World War the emergence of such major industries as locomotive production (Borsig) and electricity (AEG), as well as consumerism (Wertheim) and entertainment (Café des Westens). Germany lost the First World War; in defeat substantial chunks of territory to the east, north and west were sheared off and awarded to Poland, Denmark and France. But Berlin continued to flourish; during the Golden Twenties, it also became the world's most innovative center of film production. The Babelsberg studios drew as well upon experimental theatre for the masses conceptualized already before the war by Max Reinhardt, the city's leading theater director. Already in the 1920s, the city became not just the backdrop but a filmed actor with whom audiences forged the same eerie sense of familiarity as they did with the faces and gestures of Gustav Fröhlich and Marlene Dietrich.

The excitement buzzing through Wilhelmine (1888–1918) and Weimar (1919–33) Berlin was largely the product of private initiative. Few twentieth-century

political regimes, however, have taken the representation of their cultural authority as seriously than the three that governed the city between 1933 and 1989. The National Socialists, and the governments of West Berlin and the German Democratic Republic, of which East Berlin served as the capital, all staged their regimes in ways that were designed to entice the camera. These proved as seductive in many cases to their opponents, even generations later, as to their own supporters. The challenge of tying the city back together following German reunification in 1990 was also extremely imageable, although by the twenty-first century the internet was as important as film to its global dissemination. But Berlin in the past 30 years has not just been about remembering horrific pasts. The parties, including Christopher Street Day, the Love Parade and the rest of the techno scene, much of it made possible by deindustrialization and cheap flights, have become legendary, too. And since the 1980s Kreuzberg's counterculture and Turkish communities have put up principled, if not always successful resistance to the gentrification that has more recently transformed Prenzlauerberg into a haven for young Americans and Israelis dissatisfied with regimes at home.

Considering the way in which Berlin has been filmed is, of course, not new. But this collection is unique in the way in which its analysis of the built environment is organized. In place of a chronological narrative or indeed a tour of the city that follows a cartographic path, the authors analyze pairs of buildings in terms of their fate over time or, in one final and particularly meaningful coupling, their purpose. While scholarly analyses of Berlin have for 30 years been dominated by the theme of memory, Wilson and Kaçmaz Erk's typological focus on fate of buildings generates fresh pairings and perspectives that provoke us to think in new ways about how the life cycles of buildings affect our experience of the cities they shape. The transformation of their appearances, purposes and meanings across time are presented here in ways that challenge us to think anew about the multiple ways in which specific sites contribute to shaping our experience and understanding of the city as a whole.

In assembling a list of more than a thousand films that feature Berlin – and that a list this long is not comprehensive says a great deal about the city's unique role in the history of the medium – Wilson and Kacmaz Erk provide a guide to future scholars, film buffs and Berlin fans. Meanwhile, their collages of the way similar views out over the city or of places within it have been captured or recreated across time reminds us that, despite the enormous changes in the appearance of the city that these films chronicle, there is also often startling spatial continuity across contradictory political regimes and that films not just reinforce but also invent a sense of this.

Film has, of course, also played a prominent role in establishing the now platitudinous idea that Berlin is a city haunted by its complex past. Wim Wenders's

iconic *Wings of Desire* (1987) provided the point of departure for the way in which many of its viewers experienced the city's frayed edges once the champagne corks stopped popping after the exuberant celebrations that marked the fall of the Berlin Wall. And film itself, as anyone who has glimpsed fragments of the equally celebrated Walter Ruttmann's *Berlin: Symphony of a Metropolis* (1927) in the corners of museum exhibitions knows, can preserve artistically staged representations of a long-vanished present as apparent facts about the past. This book returns again and again to the ways in which attitudes towards a particular structure can shift over time. I remember being enraged upon my first visit to the city in the summer of 1985 by how the Kaiser Wilhelm Memorial Church was presented to tourists as a monument to peace without any acknowledgement of its frankly militaristic origins. I missed the wrapping of the Reichstag in 1995, and the subsequent sense that it had thus been cleansed of its inadequacies as an institution as well as a building. But my attitude towards the Victory Column in the Tiergarten was entirely transformed by its role in Wenders's film. Viewing it from Hans Scharoun's State Library, another forceful presence in the movie, it was in the late 1980s and across the 1990s no longer a troubling reminder of German unification's violent origins but seemed instead to be an angelic presence watching beneficently over my struggles to reconstruct the career of an architect – Erich Mendelsohn – who had undoubtedly failed to appreciate either its form or its function.

Generations of twentieth-century intellectuals from Argentina to at least Vietnam, if not necessarily Zaire and Zimbabwe, grasped something of the flavor of the nineteenth century Paris from listening to La Bohème or looking at slides or photographs of Manet's Bar at the Folies-Begère and believed that what had happened there mattered to them in some way. Today their counterparts are more likely to be haunted by the sparer, more fractured images and sounds of Berlin. This is true whether or not they have ever traversed Unter den Linden or the Ku'damm, or lingered in a café on Oranienburger Strasse or a bookshop in Charlottenburg. The many films staged in Berlin or simulacra of it have made the city an effective stand-ins for other, often specifically personal, experiences of collective trauma and individual loss, as well as a poignant backdrop of inclusive, if typically wry celebrations in which misfits can aspire to their own particular glamour, dancing to the rhythms of twenties jazz, seventies Bowie or nineties techno. And at least something of Berlin, this constantly shifting city, these filmic images and snatches of soundtrack suggest will nonetheless continue to bear witness long after we ourselves are gone.

Under the Bridges (1945)

Introduction

Berlin: The remembered city

This is Berlin, a pounding heart beat, grown out of a divided nation.
People come to Berlin to dream, to dance, and to fall in love.
And some of them, to fly away.

<div align="right">Sara in Berlin, I Love You (2019)</div>

The Bunker, a 1981 French-American production directed by George Schaefer, begins with an uncanny scene in which the audience is taken down into Adolf Hitler's ruined *Führerbunker* in June 1945, two months after his suicide in this basement. As narrator James O'Donnell descends the stairs down into dark and flooded concrete rooms, he utters: 'I cannot guarantee what you are about to see is historical truth. Memory always distorts'. Referring to the recollections of those who worked in this bunker under the New Reich Chancellery during the final days of the Second World War, O'Donnell continues: 'But I do believe their stories present a psychological truth and are perhaps as close as we can come'. He then begins to tell the tale of two men, Hitler and his architect Albert Speer, going back and forth in time. The viewer sees Speer's short-lived Chancellery in its glorious pre-war days and in its final days as a ruin. This book, like the scene described, is about the intersection of architecture and memory, the connection between the built environment and the passing of time. It is also about how this connection is made visible via film locations and their cinematic representations.

This book is unique on multiple levels. First, it is about how architecture and the built environment can reveal the memory of a city, an urban memory, through its transformation and consistency over time by means of 'urban strategies', a term proposed by the authors. Strategies, which will be discussed in detail, have developed throughout history as cities have adjusted to numerous political, religious, economic and societal changes. Urban strategies have mostly been carried out by those in (political and financial) power as they made decisions about the nature

and future of particular buildings, streets and districts. In a few situations, private initiatives and marginal groups have also taken action and carried out a strategy.

Second, the book uniquely links these urban strategies to the process of memory-making. The authors have catalogued and organized the strategies, which range from on the one hand, demolition, an action that attempts to evoke forgetting by eliminating a physical source of urban memory, to, on the other hand, memorialization, a process that attempts to evoke remembrance by constructing a physical source of urban memory. Depending on how they transform the use, form or meaning of a structure or place,[1] strategies between demolition and memorialization embrace a degree of forgetting or recalling. Therefore, the strategies are organized on a 'memory spectrum' to proceed from forgetting through absence (demolition) to remembering through presence (memorialization) with varying levels of forgetting and remembering in-between.

Third, unlike similar publications that concentrate on a particular time period, this book covers the history of Berlin since the beginning of cinema. This is the time when Berlin began to fully embrace the revolutionary industrial developments of the time, although somewhat later than London and Paris. The book focuses on the transformations of the urban memory of Berlin between 1895 and 2022, as shaped or influenced by the identified strategies. Although the text may periodically refer to buildings from earlier times, the discussion is limited to the transformation of these structures after 1895. The case study buildings and places have been chosen on the basis of whether or not they serve the analysis of an urban strategy of memory-making during these years. Utilizing case studies drawn from the built environment from the perspective of the 2020s (a pivotal time in itself), the study details how Berlin has adjusted to its traumatic twentieth-century history through architectural transformations. Two dissimilar case studies frame each strategy, indicating that an urban strategy which works for one building may or may not be sufficient for another, and a strategy is neither good nor bad by nature; its implementation makes its effort worthwhile or otherwise.

Finally, the cinematic representations of Berlin's cityscape are a tool, an audio-visual archive, to reveal the memory of the city. The book utilizes film locations to provide a deeper analysis of the issues brought up by particular urban strategies and case studies in relation to memory-making. Having said that, if the reader is solely interested in film analysis, this is not the book for them because the focus of this study is the agency and power of architecture in the process of memory-making. Cinema, particularly film locations, is employed to present and justify the role of architecture in urban memory-making.

This book is therefore about the architecture and urbanism of the city of Berlin. These are the disciplines that are studied in close relation to memory, particularly urban memory, throughout the book, and the discussion is enriched with films

made in/about Berlin. The authors have purposefully chosen widely known films that represent the built environment in Berlin so that the argument is clear but have also utilized lesser-known outputs of German cinema that portray the buildings highlighted. This will hopefully encourage the reader to seek out films they may have not watched before. For this purpose, over a thousand Berlin films are listed in the Filmography. This methodology is also valid for the chosen case studies: alongside well-known buildings that have created high-profile controversies, other highly relevant but less discussed structures have been selected.

Accordingly, the book intends to reveal the intricate relationship between urban transformation and its influence on memory-making in the context of Berlin, with the help of film locations. In this context, the study presents urban strategies that shape memories in/of any city. It also narrates the story of every case study to reveal the workings of each particular urban strategy on memory-making. Finally, it uses representations of film locations from different decades to evidence the relationship between urban strategies and the process of memory-making. The links between space and time, architectural change and time, and memory and time are emphasized throughout the book.

This is an architectural manuscript written entirely from an architectural point of view; architecture is the ingredient binding memory, urban development and film together with the city of Berlin. The book introduces a structure to the urban strategies that often have no formal organization and are carried out for purposes other than memory-making. It brings together buildings and structures that readers might be familiar with, but the way they are assembled, studied and connected – via the urban strategies – is particularly unique. Accordingly, the book proposes a new methodology, a megastructure, to review the urban memories of Berlin through its architectural transformations. Finally, the insights that the book produces are relevant not just to Berlin but also to other cities undergoing urban transformation such as Belfast, Damascus, Sarajevo or Shenzhen, thereby making it a valuable publication outside the realm of the literature on the German capital.

Because the book connects the areas of architecture, memory and film to the context of Berlin, it is indebted to previous works on the topic of urban memory, although not necessarily oriented towards this particular city. James E. Young's *The Texture of Memory: Holocaust Memorials and Meaning* (1994) is a noteworthy introduction to memorials and the issues surrounding them. Its first chapter is dedicated to German examples, including what Young calls 'the counter monument', and a discussion of the area in Berlin that would eventually become the Topography of Terror. However, Young's book is specifically focused on Holocaust memorials, whereas that topic is only one of twenty-four case studies investigated in this book. Similarly, M. Christine Boyer's *The City of Collective Memory: Its Historical Imagery and Architectural Entertainments* is a valuable introduction

to the concept of urban memory, noting that 'different layers of historical time superimposed on each other or different architectural strata (touching but not necessarily informing each other) no longer generate a structural form to the city but merely culminate in an experience of diversity' (1996: 19). Robert Bevan's *The Destruction of Memory: Architecture at War* (2007) is also related to this area of study, covering major topics like the Berlin Wall, Daniel Libeskind's Jewish Museum and the Church of Reconciliation on Bernauer Strasse.

In the field of memory studies, Berlin has been well-covered, especially after the fall of the Berlin Wall in 1989 and the reunification of Germany the following year. Brian Ladd's *The Ghosts of Berlin: Confronting History in the Urban Landscape* identifies how certain Berlin buildings 'are the symbols and repositories of memory' (1998: 4), focusing on the role of the city's past in (re-)making its present society. It approaches the urban memories of Berlin solely from an architectural perspective whereas this book additionally incorporates cinematic representations of the city. Ladd's commonly-cited book was written in the 1990s. That is, this topic has continued to develop in Berlin more than twenty years after Ladd's book. Additionally, Ladd's research is organized chronologically, unlike this book, which is thematically structured. Michael Z. Wise's *Capital Dilemma: Germany's Search for a New Architecture of Democracy* (1998) was also written when the reunification was in its infancy and does not incorporate film into its architectural analyses. What may seem like the norm in 2020 will alter in 2030. Viewpoints advocated in the 1990s have evolved in the 2000s and 2010s and are continuing to develop. In other words, because memory is fluid and changes with time, the discourse around Berlin's urbanism and memory also grows over time.

Many studies of Berlin and its urban memory focus on a particular time period of the city's history – an understandable decision given the fact that its tumultuous twentieth century can be broken up into five different phases: empire, republic, dictatorship, division and reunification. Janet Ward's *Weimar Surfaces: Urban Visual Culture in 1920s Germany* (2001) is an in-depth analysis of art and architectural culture in that particular decade. Karen E. Till's *The New Berlin: Memory, Politics, Place* (2005) focuses on issues involving the reunification years, as does Jennifer A. Jordan's *Structures of Memory: Understanding Urban Change in Berlin and Beyond* (2006). Jordan's study is more specialized, solely limited to the urban redevelopments that occurred on Berlin sites connected to the Nazi era.

Andrew J. Webber's *Berlin in the Twentieth Century: A Cultural Topography* (2008) tackles the entire period covered in this book, but from a literary, rather than architectural point of view. Emily Pugh's *Architecture, Politics, and Identity in Divided Berlin* (2014), as its title suggests, examines the circumstances between 1949 and 1989, with an emphasis on former East German structures. Simon Ward's *Urban Memory and Visual Culture in Berlin: Framing the Asynchronous*

City, 1957–2012 comes the closest to matching this book, focusing 'not on what happened "here" in the past, but what happened *to* the site' (2016: 13, original emphasis), revealing the memory of places in Berlin benefiting from photographic exhibitions and films. However, this comprehensive study is limited to a shorter time period, 1957–2012, organized chronologically and written from the perspective of visual arts and culture. Stephen Barber similarly approaches Berlin's urbanism from the perspective of the visual arts, especially cinema, in, for instance, *The Walls of Berlin: Urban Surfaces, Art, Film* (2010), focusing solely on the vertical surfaces of the city.

Janet Ward's *Sites of Holocaust Memory* (2016), like Young's *The Texture of Memory*, examines how Holocaust memorials have developed into sacred sites of experience, additionally placing emphasis on objects as well as spaces. Kathleen James-Chakraborty's *Modernism as Memory: Building Identity in the Federal Republic of Germany* (2018) includes not just Berlin but also other cities in the former West Germany, focusing on the division years. Hope M. Harrison's *After the Berlin Wall: Memory and the Making of the New Germany, 1989 to the Present* (2019), while beneficial for the post-Wall period, does not utilize film locations in its analysis.

Several edited books on the topic of Berlin and memory have been published over the years. While individual chapters of these compilations adeptly address some of the case studies in this book, they are always isolated analyses, as expected from an edited volume. Such publications include chapters from the 'Physical space' and 'Experiential space' sections of *Berlin – The Symphony Continues: Orchestrating Architectural, Social and Artistic Change in Germany's New Capital* (2004), edited by Carol Anne Costabile-Heming, Rachel J. Halverson and Kristie A. Foell; *After the Berlin Wall: Germany and Beyond* (2011), edited by Katharina Gerstenberger and Jana Evans Braziel; the 'Border buildings' section of *The Design of Frontier Spaces* (2015), edited by Carolyn Loeb and Andreas Luescher; and the 'Spaces, Monuments and the Appropriation of History' section of *Cultural Topographies of the New Berlin* (2017), edited by Karin Bauer and Jennifer Ruth Hosek. This book, as its title suggests, aims to reframe all of these previous studies on Berlin's built environment around the topics of architectural change, urban strategies, memory-making and film locations.

Urban memory

Memory is very important, you hear? Very important, memory …
Dementia-sufferer Andrés in *Off Course* (2015)

Understanding the intersection of architecture and memory as visualized through film first requires an awareness of 'urban memory'. The concept of memory is generally defined as the product of a lived experience that is constructed in people's minds. It is the mental faculty of retaining and recalling past experience(s). As a result, memory is a process whereby a subject endlessly recollects personal reminiscences in order to provide a representation of past events. Psychologist Frederic Bartlett (1932: 213) defines memory as an internal constructive act that occurs inside people's minds: 'Remembering is not the re-excitation of innumerable, fixed, lifeless and fragmentary traces. It is an imaginative reconstruction, or construction, built out of the relation of our attitude towards a whole active mass of organized past reactions or experiences.'

Except for the remote corners of the world without even the most basic of human-made structures, architecture and the built environment are all around us, playing a significant role in our lives, even if just as a backdrop to it. A childhood home is often the first architectural space that makes people aware of this fact and is the location of many (positive and negative) memories. The various spaces in a house such as kitchen, living room, bedroom, basement and attic usually have their own personality, resulting in their own memory-making patterns. Other people's homes, schools, libraries, office buildings, train stations, airports, museums, cafes and shops soon join the childhood home in providing other locations for memory-making and expand one's understanding of just how much they are reliant upon architecture to create, retain and represent their memories. These include both voluntary and involuntary memories, as author and critic Marcel Proust calls them in *Remembrance of Things Past* (2006: 61–64), which are generated with or without the person noticing:

> Mémoire involontaire, a term coined by Proust, refers to the memories that we accumulate in a state of distraction. In contrast to experiences committed to memory (mémoire volontaire), half-noticed sensations and repetitive activities find their way into the less-accessible reaches of the mémoire involontaire.
>
> (Chaikin 2010: 15)

On an urban level, buildings, streets and other public spaces may have been planned for functional reasons such as providing shelter, enabling travel between two places, and allowing large numbers of people to gather, but by their very existence, they also allow for impressions, representations and connotations to become repositories of memory for a city. Architect and writer Juhani Pallasmaa portrays this situation as: 'Buildings and towns enable us to structure, understand and remember the shapeless flow of reality and, ultimately, to recognize and remember who we are' (1996: 71).

Despite 'the necessarily selective and incomplete foundations of memory' (Jordan 2005: 61), it is through memory that we are able to conceptualize the past – all of it, not just selected parts – while still being in the present. As stated by sociologist Barry Schwartz (1982: 374), 'To remember is to place a part of the past in the service of conceptions and needs of the present'. Social anthropologist Paul Connerton (1989: 2), agreeing with Schwartz, adds: 'our experience of the present very largely depends upon our knowledge of the past.' Historian John Gillis (1994: 3) explains the situation in simpler terms: 'Memories help us make sense of the world we live in', combining the past and the present. Memory, therefore, is not solely about the past; it is a faculty that we use to make sense out of the present and to shape the future, the result of which can be explained as a triptych in our minds composed of where we came from, where we are and where we may be going.

The research area of memory studies began to develop in earnest in the early twentieth century and was mostly concerned with the study of an individual's memory, how memories are made and how they are recalled. This soon expanded into examining the memories of groups of people, broadly conceived as 'collective memory', the phenomenon whereby groups of people remember the same and/or similar events. This concept was first theorized by sociologist Maurice Halbwachs who argued that individuals are only able to acquire, localize and recall memories through membership in social groups, particularly those based on family, religion and social class ([1925] 1992: 84). Collective memory, then, can be described as a jointly shared notion of how a group conceptualizes their past – a communal construction created to place an individual within 'a shared image of the past and the reflection of the social identity of the group that framed it, view[ing] events from a single committed perspective and thus ensur[ing] solidarity and continuity' in the words of sociologist Barbara Misztal (2003: 52).

Collective memory is not only defined by what is remembered but also by equally what is forgotten. That is, memory seems to be a selective process of what the rememberer wants to remember, and yet, something always seems to be forgotten at the same time. As summarized by playwright Harold Pinter, 'Memory is what you remember, imagine what you remember, convince yourself you remember or pretend to remember' (Adler 1974: 462). Extending Pinter's concept from the individual to the group, the process of collective memory construction is primarily an attempt by a society to define an identity for itself – to define who they are and who they are not.

Although Halbwachs' conceptualization of collective memory was formulated in the 1920s, his ideas were not translated into English until the 1990s, after which Connerton developed Halbwachs' concept into 'social memory' (1992: 2), additionally spatializing it as 'conserving our recollections by referring them to

the material milieu that surrounds us' (1992: 37). Art historian Aby Warburg also utilized the term 'social memory', referring to artworks as repositories of history (Olick and Robbins 1998: 106), whereas subsequent scholars labelled this phenomenon as 'cultural memory' (Assman 1995), 'shared memory' (Margalit 2002) and 'collective subconscious' (Frankel 1987 in Gedi and Elam 1996). Although author Hugo von Hofmannsthal is generally credited with the first use of the term 'collective memory' in 1902 (Klein 2000: 127), it is Halbwachs who theorized the concept in detail as 'shared social frameworks of individual recollections' in 1925 (Misztal 2003: 2).

While there are subtle differences between Halbwachs' conception of collective memory and the variations of social memory, cultural memory, shared memory and the collective subconscious, these differences are not the subject matter here. What concerns this study is the next step in the discourse whereby the built environment is understood to influence the shaping, maintaining and/or erasing of collective memories. Halbwachs ([1950] 1980: 134) himself hints at the role of architectural space in this process:

> The group not only transforms the space into which it has been inserted, but also yields and adapts to its physical surroundings. It becomes enclosed within the framework it has built. The group's image of its external milieu and its stable relationships with this environment becomes paramount in the idea it forms of itself.

In *The Legendary Topography of the Gospels in the Holy Land* from 1941, Halbwachs more explicitly makes the connection between memory and the built environment when he concludes that the Christian community in Palestine created a collective memory based on shrines there that do not date back to the time of Jesus Christ. In the words of architect Can Bilsel, that community's memory was 'fixed in architecture' rather than in historical accuracy (2017: 5). Halbwachs calls this phenomenon of attributing meaning to the built environment 'place memory', and asserts that a city can be decoded for such meanings ([1950] 1980: 143–44):

> [T]he forms of surrounding objects certainly possess such a significance; [...] every collective memory unfolds within a spatial framework. Now space is a reality that endures: since our impressions rush by, one after another, and leave nothing behind in the mind, we can understand how we recapture the past only by understanding how it is, in effect, preserved by our physical surroundings.

These 'forms of surrounding objects' are the buildings that make up the city. Urban theorist Marcel Poëte writes about the necessity, in his mind, to 'gather and store all the memory tokens from bygone times, so that in our present time we can

arrive at an equilibrium between the urban being and its material environment';
he continues stating 'they are the artifacts that give meaning to and constitute our
memory of a city' (Boyer 1996: 17). Buildings and urban spaces are not merely
containers for events; they are the physical embodiment and, when they persist,
remnants of past lives and experiences. They are the tangible accumulation of
the past that, along with smaller artifacts such as furniture, artwork and printed
matter, can offer an insight – but not a definitive answer – into life in former times.

Highly influenced by the writings of Halbwachs, architect and theorist Aldo
Rossi declares in *The Architecture of the City* that 'the city is the locus of the
collective memory' ([1966] 1982: 130). For Rossi, just like Poëte, it is the urban
artifacts of cities – buildings, streets and squares – that reveal a consciousness, or
an urban memory:

> Ultimately, the proof that the city has primarily itself as an end emerges in the arti-
> facts themselves, in the slow unfolding of a certain idea of the city, intentionally.
> [...] Memory, within this structure, is the consciousness of the city; it is a rational
> operation whose development demonstrates with maximum clarity, economy and
> harmony that which has already come to be accepted.
>
> (Rossi 1982: 131)

This interpretation of memory as urban consciousness has the ability to generate
rich discussions about the ability of the built environment to represent a particu-
lar point of view, especially with regards to monuments, memorials, statues,
street names, public spaces and even urban layouts. Architects, urban planners,
historians and historic preservationists are generally well aware of this power
of the built environment, but the general public is usually not concerned about
it. This book is a call-to-action that the city should not be taken for granted
because it is a generator and storehouse of memories and should be investigated
as such. Keeping in mind that memory-making is a process, the built environ-
ment then is a tangible product of that process, which in turn cycles back to
influence intangible memories.

Historian Pierre Nora has more concretely defined Rossi's concept of urban
artifacts with a term that combines architecture and memory: *lieux de mémoire*
(sites of memory), which are 'any significant entity, whether material or non-mate-
rial in nature, which by dint of human will or the work of time become a symbolic
element of the memorial heritage of any community' (1989: xvii). Nora delineates
his term, sites of memory, into either material or non-material. Material sites of
memory are elements of the built environment such as the Eiffel Tower, French
Museum of National Antiquities and Place de la Concorde. Non-material sites
of memory are not part of the built environment: artworks such as Leonardo da

Vinci's *Mona Lisa*, historical persons like Joan of Arc and philosophical texts like Rene Descartes's *Discours de la Méthod*. Nora (1989: 8) argues:

> Memory is life. [...] It remains in permanent evolution, open to the dialectic of remembering and forgetting, unconscious of its successive deformations, vulnerable to manipulation and appropriation, susceptible to being long dormant and periodically revived. History, on the other hand, is the reconstruction, always problematic and incomplete, of what is no longer.

That is, memory and history are in contrast to each other. Memory is generally more of an oral tradition than history that is mostly written. Memory is also carried out by everyone, not just those in power. Lastly, memory accepts and even thrives on change(s) over time, whereas history attempts to conceal change when it happens; 'historical representations are negotiated, selective, present-oriented and relative' (Kansteiner 2002: 195). All these factors combine to make history incomplete shortly after its creation, whereas memory constantly adapts, attempting to be current and complete.

Urban memory stands between the two extremes of collective memory and urban history. Whereas collective memory, as defined earlier, is a jointly shared notion of how a community conceptualizes their past, urban history is neither jointly shared by a community nor created by one. Urban history is what historians, who are usually singular entities speaking for (and in favour of) a collective elite, write in order to make selective stories more permanent. Film theorist Simon Ward links his definition of urban memory to Halbwachs' concept of 'place memory' and the two ways that it can be generated:

> [F]irst, how the repair of urban environments has sought to revive processes that connect social life to locality; and second, how the encounter with material remnants left behind by successive reconstructions of the urban environment [...] have been subject to technologies of urban memory production.
>
> (2016: 15)

Urban memory shares with collective memory the aspect of being socially constructed. And, like collective memory, urban memory is a process that involves many players, both those in power, such as politicians, planners, urban policy makers, developers and investors, and those not in power in the minority. Urban memory is different from collective memory in the way it manifests itself as Nora's 'sites of memory' – physical locations of collective remembrance. Urban memory shares with urban history an awareness of what has come before. However, urban memory is a longer process that takes time to develop and is concerned as much

with future expectations as it is with past accomplishments. Urban history, when concerned with the coming times, is more about the manipulation or propagandization of the future. Indeed, geographer–ethnographer Karen Till (2005: 5) identifies places of memory as 'landscape markers from the past' as well as 'traces of the future'.

While Nora's emphasis is on the intersection of memory, history and nationhood, he nonetheless manages to spatialize the concept of collective memory by literally assigning it a place – a site – that is capable of calling up 'memory images' (Erll 2011: 23). In the words of psychologist Alan Radley, 'Artefacts and the fabricated environment are also there as a tangible expression of the basis from which one remembers, the material aspect of the setting which justifies the memories so constructed' (1990: 49). This distinction between non-material 'sites of memory' and the materiality of the built environment is particularly relevant because we are constantly surrounded by architecture within the urban landscape. Not only are buildings physically larger than us but they also frequently outlive us, which is one way – amongst many – that they help to create and sustain a city's 'urban memory'. As highlighted by urban theorist Lewis Mumford, 'buildings and monuments and public ways, more often than the written record [...] leave an imprint upon the minds of even the ignorant or the indifferent' (1938: 4).

'Since the most ancient times', says Umberto Eco, 'space and memory have been very closely linked. [...] Remembering is like constructing and then travelling again through a space. [...] Memories are built as a city is built' (1986: 89). That is, the architecture of the built environment is a tool for generating collective memory through its representational qualities, the way that buildings can 'stand in for' something intangible. Architectural historian Winfried Nerdinger succinctly summarizes this as: 'Architecture gives memory to a place and thus anchors it more than writing or words in the memory of individuals and peoples' (Handa 2021: 5). Urban theorist Christine Boyer, concerned with those physical traces of memory that become removed from public view, furthers this discussion by examining the 'representational images and architectural entertainments of present-day cities' (1996: 19), placing emphasis on the layers of a city:

> [D]ifferent layers of historical time superimposed on each other or different architectural strata (touching but not necessarily informing each other) no longer generate a structural form to the city but merely culminate in an experience of diversity. Especially in the last few decades, these architectural residues from earlier times have become important sites of pleasure.

It is these 'layers of the city' that most effectively reveal the past to those in the present. To do so in a meaningful way, architectural theorist Rumiko Handa (2021:

11

80–81) has identified four 'distinct mechanisms' at work in this process: the formal characteristics of a building (style), physical traces of the past still extant in the present (scars), a building's designation as a commemorative object (memorialization), and simply the fact that a significant past event took place there (memento). At times, the case studies in this book focus on one of Handa's mechanisms, while at other times multiple mechanisms are at work.

Urban memory can be created through all of the objects mentioned above: architectural styles, urban artifacts, layers of the cityscape, architectural residues, traces of the past, sites of pleasure, memory tokens, mementos, commemorative designations and spatial frameworks. These elements are not merely static objects sitting within the urban landscape. As Rossi (1982: 21) explains,

> With time, the city grows upon itself; it acquires a consciousness and memory. In the course of its construction, its original themes persist, but at the same time it modifies and renders these themes of its own development more specific.

Urban sites and elements are subject to processes like gathering, storing, superimposition, repair, revival, justification, spatialization, unfolding, translation, imprinting and preservation – what the authors of this book are labelling as urban strategies.

Urban strategies

Because in this city you only get what you take.
Opening line of *Berlin for Heroes* (2012)

While it is not possible to quantitatively measure to what extent the built environment affects a city's urban memory, it is possible to catalogue the physical changes that have occurred throughout time. In a city, buildings are constructed, demolished, renovated, altered and added onto. Streets are laid out, paved, redirected and renamed. Entire neighbourhoods are listed for preservation, neglected or gentrified. Public parks are created, enhanced, abandoned and even turned over for urban development, whether private or public. Halbwachs elaborates on this as early as the 1920s:

> Cities are indeed transformed in the course of history. Entire districts may be left in ruins following siege, occupation, and sacking by an invading army. Great fires lay waste whole areas. Old homes deteriorate. Streets once inhabited by the rich change appearance as they are taken over by the poor. Public works and new roads require

much demolition and construction as one plan is superimposed on another. Suburbs growing on the outskirts are annexed. The centre of the city shifts.

([1925] 1992: 87)

These actions and practices are what the authors are calling urban strategies. They are usually carried out for pragmatic purposes such as providing shelter, accommodating institutional structures or allowing for easy transit from one part of the city to another, and (in a capitalist economy) for economic purposes, mainly to obtain financial gain. However, just like with any construction, these actions also come with the less pragmatic dimension of meaning. That is, whether performed consciously or not, urban strategies denote intentions beyond the physicality of the objects they affect; they alter memories. In *The Practice of Everyday Life*, historian and philosopher Michel de Certeau (1984: xix–xx) characterizes strategies as:

> the calculus of force-relationships which becomes possible when a subject of will and power (a proprietor, an enterprise, a city, a scientific institution) can be isolated from an 'environment'. [They] conceal beneath objective calculations their connection with the power that sustains them from within the stronghold of its own 'proper' place or institution.

Therefore, for de Certeau, a strategy is the manifestation of a power relationship hidden within the built environment. In his discussion of everyday practices, he refers to strategies as actions that 'elaborate theoretical places [...] capable of articulating an ensemble of physical places in which forces are distributed' acknowledging that strategies 'privilege spatial relationships' (de Certeau 1984: 38). This strong link between strategy as a generator of change in time and space-making as well as place-making is further established by de Certeau as: 'strategies pin their hopes on the resistance that the establishment of a place offers to the erosion of time' (1984: 38).

For de Certeau (1984: 53–54), strategies are spatial operations by nature and rely on the principles and rules of society, be they political, scientific, military or economical. They are the physical result of a conflict between the rulers and the ruled. For the authors, this physical result manifests itself in the built environment. Strategies are actions, or policies put in practice, which are designed to achieve a major or overall aim. Planning and policy discussions and decisions about the built environment often influence memory-making as well as enable the changing nature of urban memory. Urban transformations based on political, economic or other decisions have an influence on the built environment and consequently contribute to what to remember or forget, shaping a city's urban memory in the process. De Certeau agrees, stating that memory 'is mobilised relative to what happens. [It]

derives its interventionary force from its very capacity to be altered – unmoored, mobile, lacking any fixed position [...] Memory is in decay when it is no longer capable of this alteration' (1984: 86–87). Therefore, memory cannot exist in the absence of 'manipulations of space' or 'spatial transformations' brought about through urban strategies (1984: 85, 87).

This book proposes urban strategies as a framework to explore the phenomenon of urban memory, in this context Berlin's urban memory, in the last 125 years. Twelve urban strategies of urban memory-making have been identified by the authors and are arranged on a 'memory spectrum' from forgetting to remembering: Demolition, Temporary Installation, New Construction, Disneyfication, Mutation, Supplementation, Suspension, Relocation, Adaptation, Appropriation, Preservation and Memorialization.[2] These urban strategies are placed in order in the book from forgetting to remembering. The chapters are organized around these strategies, presenting case studies of buildings, streets, neighbourhoods or other urban constructions that exemplify that particular urban strategy. The meaning and potential of each urban strategy is revealed to the reader via two dissimilar case studies.

Each case study is further uncovered through its appearance in films, either shot in Berlin or set in the city. Some films utilized in the book are set in their time

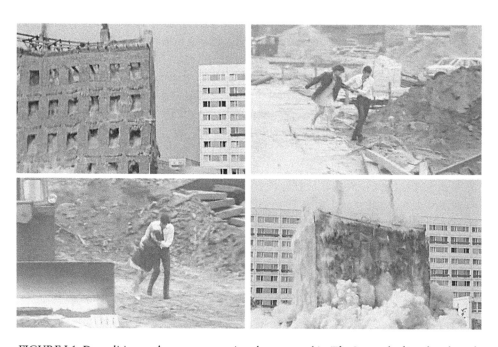

FIGURE I.1: Demolition and new construction documented in *The Legend of Paul and Paula* (1973). (All illustrations are film stills captured by the authors.)

14

of production, whereas others are period films shot much later than the time they represent. Some films are documentaries, but the majority are non-period fictional narratives that employ Berlin as their stage. Both types of films, documentary and narrative, serve as archival chronicles representing the perspective of their time of making. All of the films referenced in the book exemplify a particular way of seeing that adds to the understanding of how each case study embodies its particular urban strategy and how each strategy affects and unfolds urban memory. In *The Legend of Paul and Paula* (1973), for example, Heiner Carow repeatedly visualizes acts of demolition and new construction, revealing the changing nature of East Berlin's urban environment in the 1970s.

Because of the book's organization, the chapters can be approached as separate entities and can be read independently of each other. Each chapter stands on its own for those who are interested in a particular urban strategy. Similarly, if a reader is interested in a specific structure, for instance the Reichstag Dome or the Berlin Wall, they can solely focus on its case study, which is clearly identified in the text. Alternatively, reading the book cover-to-cover would give the reader a more comprehensive understanding of the link between the city and its memory-making processes because the urban strategies discussed provide an overall megastructure to untangle this relationship collectively.

Memory in Berlin

> Forgetting is a two-way street: there are things that *you* want to forget and things that *we* want to forget.
> Congressman Breimer in *The Good German* (2006, original emphasis)

Commenting in the 1930s on the rapidly changing built environment of Berlin 'so promptly shaking off what has just occurred', film theorist Siegfried Kracauer characterized the city as a 'place in which one quickly forgets; indeed, it appears as if this city has control of the magical means of eradicating all memories. [...] Only in Berlin are the transformations of the past so radically stripped from memory' (1932). While Berlin has transformed tremendously since the 1930s and appears to do so more frequently and radically than other capital cities, the loss of past memories in the city can be debated. As Berlin goes through dramatic changes, its memory too reshapes, which does not mean that the past is lost. Memories in Berlin, rather, are layered; they accumulate, since memory is flexible. As Carol Anne Costabile-Heming, a German studies scholar, asserts, 'The very essence of Berlin seems to emerge from the remnants of the past that surreptitiously come into view from various corners' (2011: 232). Its changing and layered nature

15

makes Berlin a fitting context to explore the concept of urban strategy in relation to urban memory. This unique city helps the authors decipher which layers to unfold, as Till suggests:

> In Berlin, it was precisely the question of what ghosts should be invoked, what pasts should be remembered and forgotten, and through what forms that led to heated public debates over what and where these places of memory should be.
>
> (2005: 5)

Keeping in mind Boyer's argument that 'architectural residues from earlier times have become important sites of pleasure' (1996: 19), Berlin has capitalized on the multitude of changes that the city experienced since the end of the nineteenth century. 'As the capital of five different historical Germanys, Berlin', writes Till, 'is the city where, more than any other city, German nationalism and modernity have been staged and restaged, represented and contested' (2005: 5). Mostly due to its connection with Nazi Germany and the Cold War, Berlin has become a tourist destination with a dark past, an exotic attraction with 'authentic sites' to visit and experience safely.

Since Germany's reunification, a marketization of an authentic past has emerged in the city, commodifying memory through products such as guidebooks, tours and festivals. This 'memory industry' (Klein 2000: 127), usually focusing on a dark past, corresponds with what social historian John Bodnar classifies as the three primary forces that shape public memory: elite manipulation, symbolic interaction of people with commemoration and contested discourse generated because of the tension between official and people's memory. Bodnar refers to leaders' use of 'the past to foster patriotism and civic duty' and how that is altered (accepted, reformulated or ignored) and replaced with a 'deep emotional response' towards monuments by the locals (1991: 20). In the case of Berlin, these forces correspond to: the Federal Republic of Germany and its major industrialists (elites); Berliners' reactions to ruins, memorials and tours (symbolic interaction), and the legacy of the Nazi Regime and German Democratic Republic, especially with regards to the Holocaust and the Berlin Wall (contested discourse).

Urban historian Brian Ladd (1998) aptly calls Berlin's *lieux de mémoire* as 'the ghosts of Berlin', and asserts that the collective identity of Germany's capital city, and possibly also Germany, has been forged by this very struggle between the built environment and its meaning(s). While Ladd's extension of this dynamic to the whole of Germany can be debated, it is most certainly the case that Berlin's identity and urban memory have been influenced – if not shaped – by the authentic sites of the city such as the TV Tower, Brandenburg Gate, Topography of Terror and all the other case studies that form this book. Referring to the growing interest in

authentic sites in Berlin, urban sociologist Jennifer Jordan (2005: 38) focuses on the ever-changing memorial culture in the city: 'No concentrated site of collective memory happens of its own accord. Every plaque, every engraved stone, and certainly every interpretive exhibit bears the traces of years of activity'. On the topic of authentic sites, media scholar Mattias Ekman (2009: 2–3) states 'we lend these historic sites the capacity to make the past tangible'. Similarly, memory scholar Aleida Assmann declares, 'The site is all that what one seeks in it, what one knows of it, and what one relates to it' (Ekman 2009: 3). Authentication – as the official acknowledgment and validation of the originality of a site of memory – is added to a city's repertoire as 'a predominant category of memorialization' over time (Jordan 2005: 47). Berlin today is officially an authentic Second World War and Cold War city.

Historian Alexandra Richie (1998: xvii–xviii) describes Berlin as 'a place whose identity is based not on stability but on change, [...] a city which has never been at ease with itself'. Change has been the major driving force of politics, culture and urbanism in Berlin since the publicization of cinema in 1895. A memorable phrase supposedly by former French Culture Minister Jack Lang (2001), quoted without reference in many Berlin travel guides, summarizes this situation: 'Paris is always Paris, but Berlin is never Berlin.' This book attempts to tell the story of the ever-changing city of Berlin and its urban memory since the invention of cinema by reframing it from the architectural and cinematic perspectives of the 2020s. These 125 years of Berlin's memory are arguably the most critical years within the history of this cinematic city, as explained by literary theorist Martin Jesinghausen (2000: 116):

> Berlin became what it is today in the course of little more than a hundred years. Whereas Paris was fully developed as a metropolis by the end of the 19th century, Berlin's growth only took off after Paris had arrived. [...] Paradoxically, Berlin's historical belatedness is also the reason for an acceleration of the speed of its historical development. Within decades rather than centuries, Berlin developed from being a provincial German town into a major centre of German nationalism and a cosmopolitan metropolis.

Films shot or set in Berlin chronicle these vast changes and contribute to the documentation of the city's urban memory. While Berlin can be seen as a rich source of inspiration for untangling the relationship between urban transformations and urban memory, it can be argued that cinema is a rich archive (or *dispositif* in philosopher Michel Foucault's words) to (re)frame this complicated relationship. The fake façades in Dani Levy's fiction film *My Fürher – The Really Truest Truth about Adolf Hitler* (2007), in this

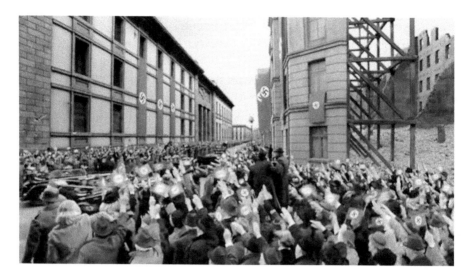

FIGURE I.2: The fake façades of *My Führer – The Really Truest Truth about Adolf Hitler* (2007).

context, illustrates this link between memory and urbanism. The narrative of the film justifies the construction of a dozen film-set-like façades between the New Reich Chancellery and the Lustgarten as a device to maintain Hitler's memories of pre-war Berlin, tricking him into thinking that there has been little or no damage to the city. Hitler's Berlin turns into a film set – fake but effective. In this context, the authors have montaged several film stills into one larger image, creating filmic collages that represent the same case study from diverse perspectives at different times in history. In doing so, film aids the unfolding of the complex layers of urban memory in Berlin.

Filmstadt *Berlin*

> Blixa Bargeld: Do you have any particular reason to film what Berlin is?
> Muriel Gray: No, just my interest.
> Blixa Bargeld: I don't think that it is possible to film Berlin.
> *B-Movie: Lust and Sound in West-Berlin 1979–89* (2015)

The invention of photography altered the meaning of temporary presence indefinitely. A photograph capturing a particular moment freezes that moment in time for all to see, anywhere and at any time in the future. The cinematic experience, being both temporal and spatial, enhances the capturing of what will soon be the

past by keeping its mediated memory alive in the present. Or, in the words of media studies scholar José van Dijk, 'Mediated memories involve individuals carving out their place in history, defining personal remembrance in the face of larger cultural frameworks' (2008: 77). Events and places that are recollected in people's memories can be framed and stored in the form of film. As an art form more directly linked to its subject matter than, for instance, literature and painting, cinema not only keeps memories safe but is also capable of recalling them to a greater degree of accuracy than the other art forms. Therefore, the moving pictures hold an undeniable role in the representation and documentation of urban memory.[3]

'Seeing comes before words' says art critic and theorist John Berger (1972: 33). In *Ways of Seeing* (1972), he emphasizes the significance of images like paintings and photographs in one's process of making sense of the world. Berger's appreciation of the work of philosopher Walter Benjamin, especially *The Work of Art in the Age of Mechanical Reproduction*, and his vision regarding perception and new ways of seeing can be captured in his own words (1972: 9–10, emphasis added):

> An image is a sight which has been recreated or reproduced, it is an appearance, or a set of *appearances,* which *has been detached* from *the* place and time in which it first made its appearance and preserved – for a few moments or a few centuries. Every image embodies a way of seeing. Even a photograph. For photographs are not, as is often assumed, a mechanical record.

Berger proposes a new way of seeing art, particularly the visual arts. The viewer shares the artist's unique way of seeing an object, person or space at a certain time through the artwork. This process combines the artistic and representational qualities of the work. Film is no exception. The film camera frames and captures the unique perspective of the filmmaker via this dynamic audio-visual and temporal medium. The point of view of the director may be acknowledged by the viewers in many ways since, 'although every image embodies a way of seeing, our perception or appreciation of an image depends also upon our own way of seeing' (Berger 1972: 10). The interpretation of an artwork may change from person to person, and from time to time. Past comes across differently at different times in history: 'Today we see the art of the past as nobody saw it before. We actually perceive it in a different way' (Berger 1972: 16). Berger continues: 'The past is never there waiting to be discovered, to be recognized for exactly what it is' (1972: 11). For that reason, city films made, or set, in the past and studied from a contemporary point of view can be a selective archive and valuable tool to support the understanding of the memory of a city. Even in a film like Robert Schwentke's *Flightplan* (2005), whose story only takes place in Berlin during its first five minutes, the city acts as a background upon which life or, in this film's case, death plays out.

FIGURE I.3: Contemplating life and death while waiting for the U-Bahn in *Flightplan* (2015).

Architectural historian Shelley Hornstein claims 'visual images of sites can generate constructed images that in turn can create a memory of a place' (2011: 3). Location films take the audience to a past version of a place allowing them to mentally (or later physically) compare 'as was' with 'as is'. In this sense, cinema can be about remembering *and* not forgetting. Sites of memory live on in their filmic representations. Moving images freeze certain moments in time, so they document places. Architectural historian Paul Goldberger comments, 'Buildings enter our memories as characters in film' (2009: 17), and the opposite is also true: buildings in film enter our memories as characters. Films represent and record sites, and therefore are able to manipulate, master and enhance urban memory, however that is not the focus of this book. Cinema and urban memory are similar in the sense that they both montage pieces of the past. As architecture-film scholar François Penz states, 'learning from the filmic spaces of the past may offer a more holistic approach to the understanding of cities in order to better anticipate the present, but also the future' (Penz and Lu 2011: 8).

It is also the case that what an audience sees frozen in a film changes according to *when* it is screened. Walter Ruttman's *Berlin: Symphony of a Great City* (1927), for example, has been received differently by audiences over the decades, not only because of its ground-breaking cinematic techniques but also because it is a silent film in black and white that documented many places destroyed in the Second World War. This changeable perspective turns film into a dynamic memory reservoir, available to be tapped as desired. Film historian Thomas Elsaesser (2013: 18) also emphasizes the temporality of memory and the process of keeping the memory of the past active in the public sphere and the arts, including cinema. The authors of this study view films as the evidence of certain moments in history. Urban traces

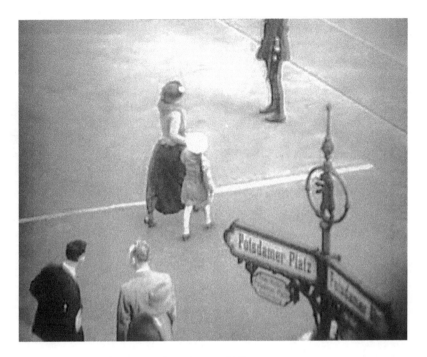

FIGURE I.4: Potsdamer Platz in *Tugboat M17* (1933).

that can be followed in films are also seen in contemporary Berlin to link them to the memory of the city. In cultural theorist Stephen Barber's words 'above all other cities, the film and art images of Berlin always collided and intersected with the contemporary city, and [...] they determined its perception, from the first-ever film images' (2010: 8). The non-perspectival view of Potsdamer Platz filmed in the Weimar Republic as part of Heinrich George and Werner Hochbaum's *Tugboat M17* (1933), for instance, captures the essence of this dynamic five-partite intersection that is evident even today.

It is almost impossible to study location films without the cities in which they are shot. As elaborated by film scholar Alan Marcus and architectural historian Dietrich Neumann (2007: 14): 'The urban rhythm and the geographic narrative of cinema are joined in a cumulative assemblage.' Urban spaces framed in films are spatio-temporal documents. The subjective perspective of the filmmaker, be it fiction or documentary, can be considered as an illustration of a city.[4] For this reason, cinematic cities benefit from a significant amount of filmic representations that complement their urban history as well as their urban memory. In the twentieth century, large cities and metropolises underwent constant evolution alongside (and because of) the film industry, particularly in France, Germany, Russia and the

FIGURE I.5: Film sets simulating Berlin in *Dr. Mabuse, the Gambler* (1922), *The Last Laugh* (1924), *I am a Camera* (1955 – set in the 1930s) and *The Good German* (2006 – set in 1945).

United States. 'Cinema's emergence as a quintessentially *urban* set of practices has ensured that the city and the moving image have, from the very outset, remained inseparable constituents of the modern urban imaginary' (Koeck and Roberts 2010: 1). This feature is particularly visible in cinematic cities such as Berlin that pioneered the film industry, as exemplified in a UFA set of a Berlin site created for F. W. Murnau's *The Last Laugh* (1924) or the recreation of 1945 Berlin in ruins for period films shot many years after the rubble has been cleared away.

Pallasmaa (2007: 13) emphasizes the link between cinema and the city as documentations of culture: 'In the same way that buildings and cities create and preserve images of culture and a particular way of life, cinema illuminates the cultural archaeology of both the time of its making and the era that it depicts'. In this context, a cinematic city can be defined as a city that is framed in films so that the audience has a familiarity with its urban context without even ever visiting that place. A cinematic city is the illusion of this urban environment created through filmic imagery. Geographer and historian David Clarke points out that the

conception of the cinematic city generates complex and valuable insights into both cities and film (1997: 13). Emphasizing the historical affectivity of cinema within urban space, film scholar James Hay (1997: 224) similarly argues 'if cinema can only be understood through particular sites, then we also need to think about how a cinematic connection to certain places transforms those places, their relations, and social subjects' relation to them'. Clarke concludes saying, 'The "cinematic city", understood this way, is a strategic articulation' (1997: 222).

Filmstadt Berlin is arguably *the* cinematic city of Germany. The 'Hollywood of Germany' was founded in Berlin for that reason. Fritz Lang, and others, filmed some of their uncanny stories in reconstructed urban settings there. The true-life child-murder storyline of *M* (1931) originally occurred in Düsseldorf, yet Lang chose to set his film in the Berlin neighbourhood of Friedrichsfelde, a testimony to the city's 'cinematicity'.[5] Berlin is a place where movies happen, even when they are not actually filmed there, like Tony Scott's *Spy Game* (2001), in which Budapest stands in for Berlin, as well as war-time films such as Raoul Walsh's *Desperate Journey* (1942) and John Farron's *The Hitler Gang* (1944) in which it was not physically possible for such Hollywood productions to be filmed in Berlin at the time.[6]

Berlin is also a place where strange and unusual things happen – at least according to non-German directors. Both Michael Bartlett's *The Berlin Bride* (2019), set in the 1980s, and Cate Shortland's *Berlin Syndrome* (2017) seem to contain the name of the city for this very reason. These films could have been entitled *The Bride* or *The Syndrome*, but it seems as if the addition of 'Berlin' to the title works with their strange stories of agalmatophilia and sexual slavery, respectively.[7] Berlin also seems to be a fitting place as a setting for fantastic stories, as seen in James McTeigue's martial arts film *Ninja Assassin* (2009), Dennis Gansel's vampire film *We are the Night* (2010) and Marvin Kren's zombie film *Rammbock: Berlin Undead* (2010).

FIGURE I.6: The rooftops of Budapest standing in for Berlin in *Spy Game* (2001).

Recently, Berlin has joined London, New York and Paris as locations – albeit briefly – where blockbuster action takes place. Paul Greengrass' *The Bourne Supremacy* (2004), the Wachowskis' *Speed Racer* (2008), Anthony and Joe Russo's *Captain America: Civil War* (2016), Jon Watts' *Spider-Man: Homecoming* (2017) and *Spider-Man: Far from Home* (2019) as well as Elizabeth Banks' *Charlie's Angels* (2019) all contain at least one scene where the characters are in Berlin, usually passing a landmark like Sony Center, Victory Column or the Reichstag.

When asked why he chose Berlin to be the location for his film about a man who needs to complete a mission in 90 minutes, *The Berlin Project* (2011) director Ivo Trajkov replied: 'I was thinking about a city in Europe which could fulfil having locations that are wonderful, fitting to the story, nice and filmic/cinematic [...] and only Berlin came to my mind.'[8] Because of other directors' similar feelings, actual streets and buildings in Berlin have become the setting of many German and international films over the decades. The urban image of this *Filmstadt* has been created from various aspects, one of which are the framed and montaged views and experiences found in films such as Ruttmann's *Berlin: Symphony of a Great City* and 60 years later *Wings of Desire* (Wim Wenders, 1987) situated in or about a particular site. In his mission 'to recover the heart and soul of the then divided city of Berlin' (Bordo 2008: 86), Wenders poetically writes (1991: 74–76):

My story isn't about Berlin because it is set there,
but because it couldn't be set anywhere else. [...]
As if every last particle of Berlin hadn't been tapped, taped, typed.

The first 75 minutes of Ken Duken's *Berlin Falling* (2017) is spent driving to Berlin and when the characters finally arrive, the audience is introduced to the city via its main icons, in rapid order, gradually increasing in fame: the Kaiser Wilhelm Memorial Church, Victory Column, Brandenburg Gate and finally the Reichstag with its new glass dome. Similarly, to introduce the audience to the city, the opening credits of Franziska Meyer Price's *Berlin, Berlin: Lolle on the Run* (2020), animated in the style of the main character's artwork, superimposes actors' names over Berlin landmarks such as the World Clock on Alexanderplatz, the Brandenburg Gate and Potsdamer Platz. The difference here with *Berlin Falling* is that the actual action of *Berlin, Berlin* does not contain any of these landmarks and takes place in locations that could be in any German city – old warehouses turned into lofts, local cafes, corner pubs, etc.

Other contributors to the formation of Berlin's and other cities' images include paintings, maps, postcards, guidebooks, newspapers, television broadcasts, novels, poems and especially the buildings that make up the city itself. As a medium that utilizes all of the above in various degrees, film can be considered as a contemporary Wagnerian *Gesamtkunstwerk*, a total work of art with a potential for including

FIGURE I.7: The animated credits of *Berlin, Berlin: Lolle on the Run* (2020) taking the audience on a tour of the city.

all art forms. This power comes from the way cinema stitches various times and spaces together via montage. Berlin films like *Run Lola Run* (Tom Tywker, 1998) use this fragmented nature of film as a deriving force:

> Just as the narrative and its protagonists build up their own impossible fragmented and repeated stories, so too does the city. Directly paralleling the film's narrative, it rejects its real topography and becomes a 'filmic simultaneous city' in which time and space implode into a geographical urban montage. *Run Lola Run* […] reworks the city through the formal possibilities of the cinematic medium. In this regard, it engages with a long architectural-cinematic tradition, the City Symphony.
>
> (Cairns 2013: 66–67)

In this study, to explore the urban memory of Berlin from an architectural point of view, several well-known and marginal fiction films and documentaries are examined. The process of memory-making in the city is explored by following the footsteps of a film's protagonist in or through streets, buildings and spaces.[9] Concluding that film-making and memory-making both make use of similar processes (the editing of fragmented pieces of so-called reality to create its own reality), the book is an attempt to discover the reframed and remembered Berlin from a perspective based in the early

twenty-first century. Berlin is arguably the most exciting and thought-provoking European city in the history of the twentieth century. It is also an attractive, contemporary and creative city (Lange et al. 2008). As the authors have stated elsewhere:

> Berlin, Germany's political and economic capital, and one of the most vibrant cities in Europe, has been a 'cinematic city' – a city familiar through film – since the very invention of cinema. It has had a central role in films not simply as a backdrop to action, but as a character in its own right.
>
> (Kaçmaz Erk and Wilson 2018: 244)

As an audio-visual medium, film can be a useful document to study urban memory-making because it can take the audience back to the time when it was made. Not only places and spaces but also many urban activities are documented in films that may seem perfectly normal at the time but disappear over time. One example of this is queues of people during times of shortages or other hardships. Reflecting the post-war reality, such scenes were normal in the Berlin films of the late 1940s, but due to Germany's post-war economic ascension are hardly seen after that.

Film is the only twentieth-century medium that brings sound, image and movement of a past time into one object. In the words of German historian Todd Herzog, 'Perhaps more than any other city in the world, Berlin is haunted by the ghosts of its history' (Ingram 2012: 116). *Five Fingers* (Joseph L. Mankiewicz, 1952), a film looking back to its immediate past, for instance, portrays an imagined collage of 1944 Berlin, capturing a ghost of the city during the Second World War from the perspective of the early years of the Cold War. This book looks at how historical clues and audio-visual evidence from Berlin films related to architecture and urbanism reveal the urban memory of this city. This is achieved by studying moving images as representations of either an urban strategy (a significant transformation in the city), or the state of a building or urban space before or after that transformation (that is caused by the urban strategy).

In *The Walls of Berlin*, Barber (2010: 9) claims 'Berlin is a city that generates itself through its projections, pre-eminently those held by its film and art images, and through the intersection of those projections with its urban surfaces'. He utilizes the terms 'city film' (urban film) and 'film city' (cinematic city) in his research (Barber 2002: 13–60). It is no coincidence that the Skladanowsky Brothers, the pioneers of German cinema, and the first German film studios – Babelsberg founded in 1912 and Universum-Film AG (UFA) founded in 1917 – are based in Berlin.[10] The establishment of the Berlinale film festival followed in West Berlin in 1951. Film scholar Colin McArthur states 'cities in discourse have no absolute and fixed meaning, only a temporary, positional one' (Clarke 1997: 20). As the city regenerated itself under extreme conditions, the story of Berlin cinema has

shifted since the first public screening with the Skladanowskys' *Bioskop* in the Wintergarten in November 1895.

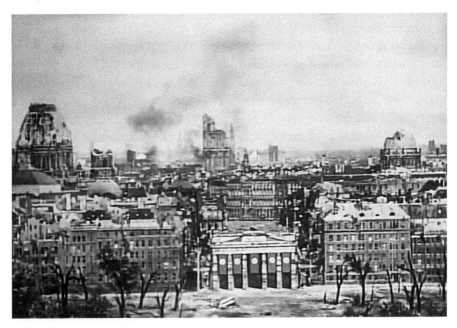

FIGURE I.8: The imagined and collaged Berlin of *Five Fingers* (1952).

In the words of architecture-film scholar Richard Koeck, 'We live in an age in which film has become the frame of reference for our urban existence, and our activities and thoughts are intertwined with screen-based realities' (2013: 6). Though cinema has that power, this book does not focus on the aspect of film that generates or contributes to the generation of individual or collective memories. Rather, the book benefits from cinema by using the medium to mediate and highlight the role of architecture and urbanism in the memory-making process. In this book, cinema acts as a vehicle, an 'apparatus' in Foucauldian terms, to visualize the urban strategies that influence, shape and generate urban memory by framing identified case studies. As such, urban development in Berlin is studied through the spatio-temporal medium of cinema in relation to history, memory, architecture and the city. As Ladd (1998: 1) notes, 'Memories often cleave to the physical settings of events. That is why buildings and places have so many stories to tell. They give form to a city's history and identity.'

Based on film historian Sabine Hake's categorization of German cinema in *German National Cinema* ([2002] 2008), Berlin films can be classified into the following categories: Berlin's Wilhelmine Films (1895–1919),[11] Berlin's Weimar

Films (1919–33),[12] Berlin's Third Reich Films (1933–45),[13] Berlin's Pre-Wall Films (1945–61),[14] East Berlin Films (1961–90)[15] and simultaneously West Berlin Films, aka New German Cinema (1961–90),[16] and finally Berlin's Post-reunification Films including the Berlin School (1990 onwards[17]).[18] Although this classification may be beneficial at times, it should be noted that this study has no intention to cover film history, chronologically or otherwise, and even specifically refer to these categories. In this book, Berlin films are pragmatically selected – by the architectural-scholar authors – for a specific purpose, which is to evidence what the book attempts to bring forth about the relationship of a certain building and an urban strategy. In *Memory and Architecture*, architectural historian Eleni Bastea (2004: 9) mentions:

> We have learned from psychology that we perceive and remember visual designs and spatial locations by employing the right side of the brain. We remember verbal information with the left side of our brain. The right side of the brain 'sees' space and images, while the left 'narrates'.

It only makes sense to enrich the discussion on the link between urban and architectural spaces and urban memory with another visual and spatial art form: cinema. For understanding collective actions and their results that took place in the twentieth century, films are ideal outputs – the closest (framed) experience of a lived urban situation one can encounter.

Conclusion

> Jane's mother: 'I know what you are doing here is very noble, but it is an escape.'
> Jane: 'It is not an escape. This is Berlin. This is what life is right now.'
> *Berlin, I Love You* (2019)

As demonstrated in this introduction, the book constructs an overall structure (a megastructure in architectural terms) for the types of urban transformation that Berlin has gone through mainly in the twentieth century, and have affected its memory. 'Someone has to make a decision to either leave [a building damaged in the Second World War] a ruin, tear it down completely, or reconstruct it based on what is salvageable' writes Jordan (2005: 42), referring to several urban strategies in one sentence including suspension, demolition and preservation, and yet there is no formulated structure to understand these urban strategies, and their relation to urban memory. This book explores such urban strategies from an architectural perspective in the early 2020s through a comparative analysis of two significant case studies placed on a memory spectrum. Using historical research, fieldwork

and audio-visual analysis, the research proposes a new methodology – the megas-tructure – to study cities in relation to memory.

This book attempts to untangle a complex symbiosis of architecture, urbanism, history, politics, memory studies and cinema. One may argue that it leaves out some issues related to, for example, identity, film theory and/or multimedia, however, acknowledging the expansive nature of this project, the authors have only chosen to tackle specific questions relevant to the understanding of architecture's role in the making of a city's memory throughout time. Exclusions have naturally occurred in order to maintain the actual focus on architectural change, urban memory and film locations.

In the upcoming chapters, the authors will open up various discussions in rela-tion to architecture, urbanism and memory that will lead to some refined outcomes, which can be summarized as follows: first, making more layers of a city's history visible for later generations results in a more robust, healthier and non-repressed urban memory. Second, demolition and new construction seem to be the most favoured strategies, yet as memory activists (and the authors) demonstrate, there is a wide spectrum of urban strategies that can be utilized as a city develops and urban living evolves in it. Lastly, like all representations, film frames a particular view that the director wants the audience to consider. Like memories, this refram-ing of the city cuts off and excludes as much as it highlights and includes.

NOTES

1. For instance, Disneyfication or adaptation transforms use, temporary installation or supple-mentation transforms form, and suspension or appropriation transforms meaning in the urban landscape.

2. It should be noted that this list does not include every urban strategy that exists. More can be added to Berlin's memory spectrum and others can be highlighted for a different city.

3. 'For centuries only poets and painters have taken up this gigantic work of memory. Then photographers made a valuable contribution, then cinema people' (Wenders 1991: 87).

4. This book mainly makes use of fiction films and some documentaries that open up a discus-sion around the case studies and urban strategies that have affected Berlin's urban memory. Television series, shorts and animated films have largely been excluded.

5. Further proof of this is the fact that Lang did not film *M* in Friedrichsfelde but in the western suburb of Staaken: the film was seen to be occurring in Friedrichsfelde, Berlin, regardless of the actual filming location.

6. Similarly, Liliana Cavani's *The Berlin Affair* (1985) is set in Berlin but shot in Vienna (as can be seen from a meeting at the Theseus Temple in the *Volkspark*) and Geoffrey Sax's *Christopher and His Kind* (2011), which was shot in Belfast (the intersection of Donegall and Waring Streets being the most obvious). Period films, such as Tinto Brass's *Salon Kitty* (1976), set in the 1940s, must usually create their own versions of Berlin in the studio.

29

7. There are also films with Berlin in the title, but they do not actually take place there: *This Is not Berlin* (Hari Sama, 2019), *An Autumn without Berlin* (Lara Izagurre, 2015) and *On the Road to Berlin* (Sergei Popov, 2015).

8. http://www.freshmilk.tv/videos/premiere-90minutes (last accessed 26 August 2021).

9. A valuable source for the curious reader is a website that provides the digital mapping of more than five thousand Berlin films made since the Skladanowsky brothers, along with their filming locations: Shot in Berlin: *Eine Internet-Seite über Berliner Filme und deren Drehorte* (https://www.shotinberlin.de, last accessed 30 August 2021).

10. Babelsberg was the first large-scale film studio in the world. In fact, Berlin was the only major European city with an established film industry to compete with Hollywood in the early decades of cinema.

11. Black-and-white silent films of this early era, starting with the ones made with the Skladanowskys' *Bioskop*, paved the way to German Expressionism.

12. The film industry was thriving during the Weimer period with 230 German film companies.

13. Third Reich films were made during the time when the Reich Chamber of Film (*Reichsfilmkammer*) controlled the German film industry as part of the Ministry of Propaganda, despite the immigration of 1500 film professionals to France and other countries, but mainly to Hollywood. The second part of this period includes Second World War films.

14. This period between the war and the Wall that Hake (2008: 2) calls 'the divided, but still unified cinema of the postwar period' mainly includes rubble films (*Trümmerfilm*, 1946–50) in the context of Berlin. Much-popular homeland films (*Heimatfilm*, 1950–70) were usually rural and not set in Berlin.

15. Though the German Democratic Republic (GDR) inherited UFA, turned it into DEFA and from 1946 onwards produced about 700 films, East German cinema was less known in West Europe. It was part of the East European socialist film culture. DEFA (*Deutsche Film-Aktiengesellschaft*) was the GDR's state-owned film studio, founded in 1946 during the Soviet Occupation and closed in 1992 following German reunification.

16. Beginning with the Oberhausen Manifesto of Young German Cinema (1962), this is arguably the most internationally recognized period in German cinema, particularly the 1970s.

17. Tourist films were also made in this period, for branding the city rather than for propaganda. Farhan Akhtar's Bollywood production *Don – The King Is Back* (2011), Alex Holdridge and Linnea Saasen's *Meet Me in Montenegro* (2014) and the stories in *Berlin, I Love You* (2019), for instance, represent a touristic Berlin via stereotypical locations and buildings explored usually by foreigners. In his Ph.D. thesis, Luke Vincent Postlethwaite (2015) focuses on this cinematic branding of Berlin.

18. It should be noted that not solely German and German-speaking films but also Hollywood and other foreign productions including Italy, Russia, India, South Korea and New Zealand are utilized throughout the book.

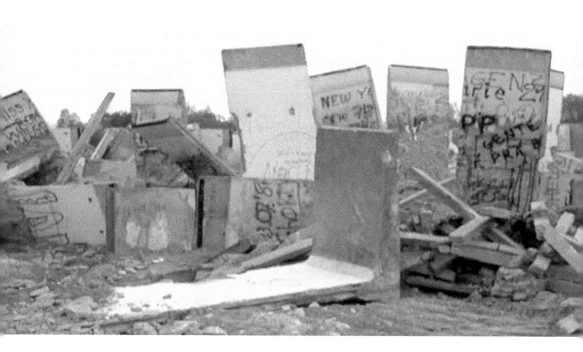

Rabbit à la Berlin (2009)

1

Out of Sight, Out of Mind: Demolition

How on earth did you ever get into this demolition business?
British Major Haven to German architect and bomb-diffuser.
Eric Körtner in *Ten Seconds to Hell* (1959)

This first chapter of urban strategies discusses the most frequent tactic employed in Berlin in the process of urban memory-making, demolition, which is the wholesale destruction and erasure of buildings from the urban landscape. As a process of creating absence, the demolition of buildings is frequently carried out in order to suppress and/or forget any urban memories that may have been associated with those particular buildings.

'Berlin holds a vanished, silent city within itself: that of East Berlin, erased from one moment to the next', writes Barber (2010: 7). The act of demolition, however, is not unique to Berlin, east or west, nor to the twentieth century. The destruction of buildings has been around just as long as the act of construction. War, urban development, fashionability as well as considerations for the health and safety of the society have all been used to justify the eradication of human-made structures worldwide at different times in history. Though an understanding of 'heritage' started to emerge amongst both conservative and progressive circles in the nineteenth century (Harvey 2008: 27), Modernist architecture and planning in the twentieth century, rather than working with the many layers readily available in a city, preferred clean sites and 'blank slates'. This tendency towards *tabula rasa* resulted in massive demolition projects in order to provide the open space needed for new, modern structures. Currently, climate awareness is forcing stakeholders to change their strategy from demolition to adaptation, supplementation, appropriation, etc.

In turn-of-the-twentieth-century Berlin, observers lamented the extraordinary amount of demolition being carried out in the name of development (Paeslack 2013: 34), but the city's most famous destruction occurred during the

mid-twentieth century. Following the bombing of the city in the Second World War,[1] Hitler did not surrender to the invading Soviet forces, resulting in even more destruction by turning the streets of Berlin into a battlefield. The 'Battle of Berlin' that put an end to the war was one of the longest city battles in Europe in the twentieth century, and Berlin was one of the most bombed and ruined cities of the Second World War in terms of number of buildings destroyed.[2] Historian Alexandra Richie (1998: 607) describes the scene following the city's eventual capitulation:

> The city centre was almost totally destroyed – a ghostly sculpture of shards of buildings – burning wood, twisted metal and broken glass. The roads, canals, and sewers were clogged with debris. Bodies lay everywhere and thousands of corpses had been left to rot under the immense piles of brick and stone.

Following the war, there was an estimated 60–70 million m³ of rubble in Berlin.[3] Once the rubble was cleared, many vacant sites appeared, especially in the central districts of the city.

In both Berlin and Germany, the quickest way to erase the memory of a Nazi building without actually demolishing it was to eliminate any swastika (*Hakenkreuz*) decorations from it.[4] Poignant scenes of workmen chipping away at swastikas can be seen in post-war documentaries as well as period films, such as István Szabó's *Taking Sides* (2001), Steven Soderbergh's *The Good German* (2006) and Max Färberböck's *A Woman in Berlin* (2008). To this day, that symbol – when used to promote Nazi ideology – is still illegal to use in public in Germany, an issue which period filmmakers need to negotiate with local authorities when shooting outside on location with Nazi banners, uniforms and other paraphernalia.

The German Democratic Republic (GDR) also undertook demolition projects in Berlin, especially during the construction and upgrading of the Berlin Wall in the 1960s and 1970s, when significant swaths of land were cleared to make a no man's land or 'death strip' between the wall facing West Berlin and a second wall facing East Germany. This involved, for instance, the GDR's complete demolition of the nineteenth-century Church of the Reconciliation (*Versöhnungskirche*) on Bernauer Strasse in 1985, decades after the division of the city, despite the fact that it was neither majorly war-damaged nor poorly maintained.

Reunified Germany has equally been responsible for demolition, mainly for political purposes in Berlin. The East German Ministry of Foreign Affairs (*Ministerium für Auswärtige Angelegenheiten*), built on the former site of Karl Friedrich Schinkel's Building Academy (*Berlin Bauakademie*) in 1964–67, was demolished shortly after German reunification. This 145 m-long ten-storey

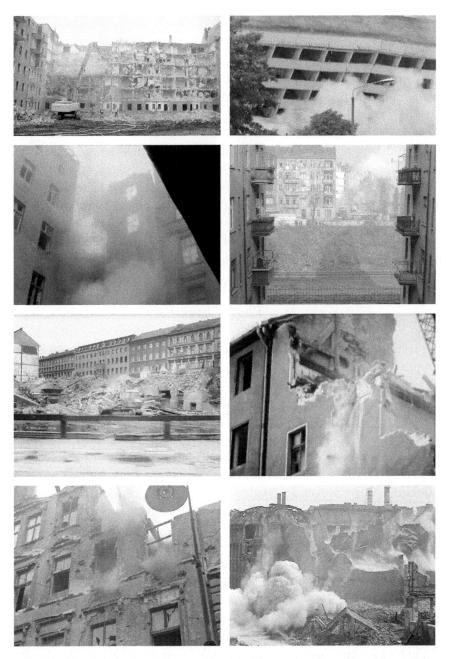

FIGURE 1.1: Cinematic representations of Berlin's different demolition eras: Post-reunification (*Berlin Stories*, 2015 and *Berlin Babylon*, 2001), the Division Years (*Attempt at Living*, 1983; *Solo Sunny*, 1980; *Redupers*, 1978; and B-Movie, 2015 with 1970s footage) and post-Second World War (*A Berlin Romance*, 1956 and *Irregular Train Service*, 1951). (All illustrations are film stills captured by the authors.)

Modernist building, designed by architects Josef Kaiser, Heinz Aust, Gerhard Lehmann and Lothar Kwasnitza, featured vertical façade elements on its large horizontal block and was prominently located on the Spree River at the eastern end of Unter den Linden. Its demolition in 1995–96 was the first physical act of attempting to erase the memory of the socialist past of the city. Wise (1998: 113) writes that 'the government took care to use a bizarre linguistic contortion, "Rückbau" (a newspeak term meaning "reverse building") rather than "Abriss" (demolition) to refer to the Foreign Ministry's removal. The task was completed with scant protest or regret'.

Demolition is a strategy primarily about forgetting. The goal of most demolitions – the erasure of an existing physical space – is to omit to remember what had been and to make room for what will be. Unless kept alive by memory activists or others, the urban strategy of demolition usually achieves its goal; the memory of the demolished structure is lost.

New Reich Chancellery

> Berlin: capital of a world that was supposed to revolve around the building called the Reichs Chancellery, around a leader who stood on a balcony and explained how it would last for a thousand years.
>
> American Robert Lindley in *Berlin Express* (1948)

Perhaps the most exemplary act of demolishing a Berlin building in the twentieth century as an attempt to the erasure of memory is the fate of the New Reich Chancellery (*Neue Reichskanzlei*) following the defeat of Nazi Germany. Designed by architect Albert Speer as a headquarters for the Nazi government, it did not last 1000 years as advertised – although it did linger as a ruin, both visible and buried, for about half a century.

The construction of the New Chancellery located on Vossstrasse, south of the Old Chancellery on Wilhelm Strasse, was completed in January 1939. Its main purpose was to impress foreign dignitaries with the tremendous power of Hitler's regime. According to the architect, Hitler was delighted at the design, exclaiming: 'On the long walk from the entrance to the reception hall they'll get a taste of the power and grandeur of the German Reich!' (Speer [1969] 1970: 103). In his memoirs, *Inside the Third Reich*, Speer proudly describes this extravagant journey:

> From Wilhelmsplatz an arriving diplomat drove through great gates into a court of honour. By way of an outside staircase he first entered a medium-sized reception room

from which double doors almost seventeen feet [5 m] high opened into a large hall clad in mosaic. He then ascended several steps, passed through a round room with domed ceiling, and saw before him a gallery four hundred eighty feet [146 m] long. [...] As a whole, then, it was to be a series of rooms done in a rich variety of materials and color combinations, in all some seven hundred twenty-five feet [221 m] long. Only then came Hitler's reception hall. To be sure, it was architecture that reveled in ostentation and aimed at startling effects.

(1970: 103)

As attested by the lengthy gallery and over-sized doors mentioned by Speer, these spaces were of monumental proportions. According to the floor plans published in Rudolf Wolters and Heinrich Wolff's contemporaneous book *Die Neue Reich-skanzlei*,[5] the court of honour measured 25 m by 70 m, the 'medium-sized' reception room 10 m by 15 m, the mosaic-clad large hall 20 m by 35 m, the round room 15 m in diameter, the gallery 12 m wide, and the reception room at the end of this series of spaces was 17 m by 25 m.

The style of the New Reich Chancellery has been labelled as 'stripped-down Classicism'. Such architecture utilizes design principles from Ancient Greek and Roman architecture such as axiality, symmetry, monumentality and a proportion system based on the golden mean, which was revived in nineteenth-century movements like Neoclassicism and the *École des Beaux Arts*. Although the style continued to favour the use of natural stone as a finishing material, it did not utilize the decorational and detailing programmes of classical architecture.[6] Speer described this style as 'austere and severe, but never monotonous. Simple and clear, and without false ornamentation. Sparing in its decoration, but with each decorative motif placed in such a way that it could never be thought superfluous' (Whyte 1998: 4). Due to its monumentality, most prominent buildings representative of the Nazi state, as well as buildings by other fascist or dictatorial regimes of the time, were built in the style of stripped-down classicism, although it can also be found in democratic societies as an attempt to link forward-thinking modern architecture with history.

The New Reich Chancellery features in three architectural short films of the time period: *The Buildings of Adolf Hitler* (*Die Bauten Adolf Hitler*, Walter Hege, 1938), *Buildings in the New Germany* (*Bauten im neuen Deutschland*, Curt Engel, 1939) and *Word Made of Stone* (*Das Wort aus Stein*, Kurt Rupli, 1939), the latter title of which referring to Hitler's famed definition of architecture.[7] Speer's New Reich Chancellery, with construction crane in the background, appears at the end of *Word Made of Stone* and is in fact the only actual built work shown during the film – all the others were scale models filmed with figurines and toy cars against a painted sky background.[8]

These three Nazi propaganda films – shown to the public before commercial screenings – presented the (perceived) greatness of this architecture as a statement about German racial superiority. Indeed, no expense was spared in the design and construction of the New Reich Chancellery: materials, furnishings and artwork were all of the highest quality. Wood and marble were brought in from every corner of the country to make the building truly representative of the Reich. Bronze sculptures of 4 m tall by artist Arno Breker could be found flanking the entrance in the Court of Honour ('Armed Forces' and 'The Party') and the Round Room ('Daring' and 'Caring'). Gilded reliefs designed by Speer, entitled 'Wisdom', 'Prudence', 'Fortitude' and 'Justice', hung over four entrances to Hitler's study (Speer [1969] 1970: 114).

Hitler's study, which was an imposing 14.5 m by 27 m, contained a map table designed by Speer that was a 1.5 m by 5 m marble slab, complemented with a 1.5 m diameter globe. In a Soviet documentary about the Battle of Berlin, entitled *Fall of Berlin* (1945), this grand room is portrayed in a ruined state, representing the defeat of Hitler and the victory of the USSR.

Albert Speer's New Reich Chancellery, therefore, was one of the major architectural symbols of the Nazi Regime.[9] It was where the ageing president of Czechoslovakia, Emil Hacha, overwhelmed by Hitler's insistence and, some say, affected by the overbearingness of the architecture (Whyte 1998: 3), surrendered his nation to 'Greater Germany' on 9 March 1939, paving the way towards the beginning of the Second World War. Hitler and his generals led this deadly war inside this building. On 30 April 1945, in his bunker 10 m below the chancellery, encased in 3 m of concrete (Richie 1998: 567), a defeated Hitler committed suicide, paving the way towards the ending of the Second World War.

Beginning in January 1945, the Soviets started to surround Berlin and prepare for its seizure. When that finally happened on 2 May 1945, they took full control and Berlin was defeated. As an architectural symbol of the Nazi regime and the centre of governmental control, the New Reich Chancellery had been heavily bombed since 1943, especially in the fight for Berlin. Soviet Foreign Minister Andrei Gromyko surveyed the site soon after its capture and described the scene:

> [The Chancellery] was riddled by countless shrapnel, yawning by big shot-holes from shells. Ceilings survived only partly. [...] Doors, windows and chandeliers testified on them [the] imprint of battle, most of them being broken. [...] The lowest floors of the Chancellery represented chaos. [...] All around lie heaps of crossbeams and overhead covers, both metal and wood and huge pieces of ferro-concrete. [...] All this produced a grim and distressing impression.
>
> (Ostrovsky 2007: 145)

FIGURE 1.2: Albert Speer's short-lived New Reich Chancellery in *Berlin Capital of the Reich 1936* (1939), *Fall of Berlin* (1945), *Germany Year Zero* (1948, middle left stills) and *Berlin Express* (1948), and its visualization in *Downfall* (2004), *The Hitler Gang* (1944) and *The Great Dictator* (1940).

The ruined New Reich Chancellery, nowhere to be found today, took a prominent role in many Berlin 'rubble films' (*Trümmerfilme*) that were made after the war.[10] Rubble films of Berlin are excellent examples in determining the significance of cinema for urban memory since no photograph or writing is as powerful as these films made right after the war in order to show the generations to come what the ruined city was like in the 1940s. In Jacques Tourneur's *Berlin Express* (1948), the ruined Chancellery introduces the city to the audience and epitomizes it, along with the main character's quote at the beginning of this case study and the monologue that follows: 'Berlin, the focal point of the rise and fall of a dictator, is today a monument in ruins. Other cities [destroyed in the Second World War], like Hiroshima, have been obliterated, but no other city so mighty as Berlin has fallen so low.'

Released in the same year, Roberto Rossellini's *Germany, Year Zero* (1948) is the finale of his neorealist War Trilogy, following *Rome Open City* (1945) and *Paisan* (1946). It is interesting that the director chose to finalize his trilogy in Berlin, rather than his native Italy, acknowledging that the story of the Second World War cannot be told without Germany, and Berlin in particular. *Germany, Year Zero* narrates the survival story of a young boy named Edmund and his hopeless family immediately after the fall of Berlin. Strolling the miserable streets full of rubble, the boy desperately looks for work, food and supplies. In hope of selling a record player on the black market, Edmund plays a record of a Hitler speech to Allied soldiers; the Fuhrer's victorious voice echoes within the Chancellery's empty walls. *Germany, Year Zero* and *Berlin Express* are arguably the best films that represent the New Reichs Chancellery, albeit in its ruined state, bringing back the memory of post-war Berlin onto the big screen.

Speer's Chancellery was partially demolished in 1947 by the occupying Soviet powers. The GDR blew up any remaining parts between 1949 and 1952 to prevent the glorification of Hitler and/or Nazism. By 1956, all rubble from the site was removed. It has been argued that some parts of the building, especially the red marble covering the long gallery on the way to Hitler's study, may have been reused in other constructions around Berlin and Germany, but scientific evidence has yet to confirm this claim.[11] Commenting on the relationship between this red marble and the workings of memory, art historian Hans Mittig (2005: 184) poses:

> demolition may banish the ghosts of the past, but it can certainly enliven them. As an imaginary dream object, the marble of the Reich Chancellery not only remains in the memory of individuals, but is also more permanently stored in the media.

Even though the surface had been wiped clean, Hitler's bunker under the New Chancellery was still buried below. With the creation of the Berlin Wall in 1961,

the area was off-limits and left empty. In 1987, during excavations needed to build apartment blocks on the site, Hitler's bunker, consisting of about two dozen interconnected rooms, was uncovered, partially demolished further, filled with rubble and then covered over to make a carpark. In the 1990s, the site was further developed following the reunification of Germany and the vast amount of urban growth that occurred in Berlin at that time. During this construction, remnants of Hitler's bunker again surfaced and were again further demolished and buried (Bennett 2019: 74–76).

Despite this concern around the transformation of Adolf Hitler's death location into a possible place of Nazi worship and/or pilgrimage, his bunker in the basement of the Reich Chancellery became the main location for three period films from three different countries over three different decades: Ennio De Concini's *Hitler: The Last Ten Days* (1973), George Schaefer's *The Bunker* (1981) and Oliver Hirschbiegel's *Der Untergang* (*Downfall*, 2004).[12] Each of these films tells the story of Hitler's final days inside his bunker in April 1945. Since the original building had long been demolished, they all represented the building via a film set, attempting to recreate the memory of the New Reich Chancellery.

The New Reich Chancellery is a textbook example on the subject of demolition for the purposes of erasing memory, or what journalist Christopher Reynolds (2002) describes as 'erase-acture'. Since Nazism was organized around a 'cult of Hitler' (Zeman 1964: 35), the Soviets and the GDR removed the building and any trace of Hitler's body, which had been burnt in a shallow ditch in the garden, for the purpose of cleansing the site from its Nazi past. Later, when Hitler's bunker began to surface, again and again, the act of demolition was chosen, again and again, even after the reunification to erase his memory. Those carrying out the demolition, whether they were the Soviets, the GDR or reunified Germany, were all worried of creating a pilgrimage site to Hitler and the Nazis, so as a result wiped the site clean of any trace of them.[13] In the words of Jordan (2006: 188), the demolishers all shared the conviction of 'the power of authentic location and the moral content of this physical place, implying a belief in a kind of material transmission of evil'.

Mittig (2005: 176) has succinctly described the situation as: 'There is nothing to "look at" on the spot, because the building has been radically removed and made invisible.' He clearly disagrees with this course of action taken here and at other authentic Nazi sites, instead preferring to privilege physical sites over photographs (Mittig 2005: 175):

> This [demolition of Nazi buildings] is to be regretted. [...] They are evidence of history, as three-dimensional vividly as no photographic or electronic medium can

FIGURE 1.3: The New Reich Chancellery site today in *Look Who's Back* (2015) and *Berlin Now & Then* (2018).

simulate. Remembrance of the Nazi era, always called for again, would remain blind without such sources, lack of pictures makes you forgetful, even a flood of pictures can be deceptive. That is why realities are needed on which the images of memory can be measured – and on which the materials with which the architects and other artists of the Nazi regime worked, remain accessible.

Jeroen Ruiter's *Berlin Now & Then: The Reichshauptstadt of Adolf Hitler* (2019), part of an extensive series overlaying immediate post-Second World War images with current conditions at locations in Germany, Austria and Norway, is a highly effective documentary and memory project that, at a single glance, reveals the layers of urban memory that have disappeared, almost bringing them back to life.[14] Most of the vintage imagery of this series consists of either swastika-decorated buildings or ruined structures which are then contrasted with contemporary views showing no swastikas and renovated buildings. The scene of Speer's New Reich Chancellery in *Berlin Now & Then* is different, and more poignant since the hulking ruin of the building that is shown in the vintage shot is completely absent in the contemporary view, showing only the GDR-era apartment buildings, also seen in David Wnendt's *Look Who's Back* (2015).

The repeated demolitions of the New Reich Chancellery as an architectural symbol of the Nazi Regime were continual attempts, again and again, to erase any memory of the National Socialists, no matter if it was carried out by the Soviet Union, East Germany or the post-Wall post-unification Germany. This attitude towards the remnants of a Nazi past is in contrast to the attitude of mediation seen in the Topography of Terror. In fact, Berlin has recently started to embrace the 'dark side' of its past, especially because that is now considered as an asset for international tourism. Memories of old wounds are now being reframed for economic profit more than the good of the society.

Palace of the Republic

Frau Schäfer: Maybe I'll see your mother on TV.
Alex: In the Palace? You'll have to look for her with a magnifying glass.
Alex's Mother: I don't really know if I'll go. All of the party's bigwigs will be there.
<div align="right">Good Bye Lenin! (2003)</div>

Many people, especially those from the former east, were against the reunification of East and West Germany. Before and immediately after the fall of the Berlin Wall, author and Nobel Prize recipient Günter Grass argued strictly against unification (1990: 74) explaining it as a simplification from two states into one (1990: 2) and favouring instead 'an independent togetherness' via a confederation (1990: 5). In his 1990 book, *2 States – 1 Nation? A Case against German Reunification*, Grass states:

> A confederation of the two states that make up the German cultural nation would provide an example for the solution of different yet comparable conflicts through-out the world, whether in Korea, Ireland, Cyprus, or the Middle East – wherever one political entity has aggressively established borders or seeks to extend them at the expense of another. A German confederation could become a model to emulate.
>
> <div align="right">(1990: 5)</div>

Regardless, the reunification went through, although it was less of a unification and more of West Germany taking over and standardizing the east.[15]

Many buildings in Berlin were purposefully demolished both before and after reunification, including the eighteenth-century Berlin City Palace (*Berliner Schloss*) and the twentieth-century Palace of the Republic (*Palast der Republik*) that replaced it. Between September and December 1950, the GDR dynamited the heavily bombed and partially ruined City Palace. This was done in an attempt to erase the memory of this lavish building by Andreas Schlüter and Johann Friedrich Eosander von Göthe, which represented the German Empire and its associated militarism. It was, after all, the official residence of the Hohenzollern dynasty for over two centuries between 1701 and 1918.[16] At the time, no one knew that the new *Palast* would have a similar fate.

The resulting empty space left from the *Schloss* was a massive four-hectare area on the *Museumsinsel*, right in the middle of central Berlin, which was now the capital city of the new East Germany. To the north was, and still is, the Pleasure Garden (*Lustgarten*) defined by the nearby 116 m tall Berlin Cathedral (*Berliner Dom*), Schinkel's Old Museum (*Altes Museum*), opened as the Royal Museum (*Königliches Museum*) in 1830, and the river Spree. To the south was the State

Council Building (*Staatsratsgebäude*, 1964), a modern construction for the GDR government that incorporated the actual balcony from the City Palace from which Karl Liebknecht declared the Free Socialist Republic of Germany in 1918. Also in honour of Liebknecht, the eastern extension of Unter den Linden was changed from *Kaiser Wilhelm Strasse* to *Karl Liebknecht Strasse*.[17] Contemporary Berlin in this area is carefully framed in Maria Schrader's unusual romantic comedy *I'm Your Man* (*Ich bin dein Mensch*, 2021), as Alma the scientist, who is experimentally partnered with a robot, works and lives around the Museum Island.

After being used as a carpark and parade ground in the 1950s and 1960s, the steel and concrete construction of the Palace of the Republic began on the site in 1973 and finished in 1976. The city's governmental construction agency BMK-IHB[18] implemented the design of architect Heinz Graffunder. The building was programmatically quite varied. On the one hand, it was the location of the People's Chamber (*Volkskammer*), the official legislature of the GDR, with 540 seats for delegates, 240 seats for spectators and six conference rooms for the working groups of the legislature. The building also contained leisure spaces, such as an impressive 5,000-seat auditorium with adjustable hydraulic seating making various combinations, a 200-seat theatre, an art gallery, the 600-seat *Palastrestaurant*, the *Spreerestaurant* overlooking the river, the *Lindenrestaurant* with a view towards Unter den Linden, five different bars (milk, espresso, mocha, wine and beer), a discotheque and even a bowling alley. Services such as a post office, news stand, souvenir shop, first aid station, cloakroom, information booth, telephones and public toilets could also be found. The complex, therefore, was not solely for the government but also for the regular use of the people for cultural events, recreational activities and everyday functions. The building was the centrepiece of East Berlin, a landmark that represented the socialist city, as seen in Sebastian Peterson's *Heroes Like Us* (*Helden wie wir*, 1999).

The *Palast der Republik* was noticeably very modern, especially compared to its nineteenth-century neighbours. The structure took up a volume of 180 m long, 85 m wide and 32 m high, and was composed of white marble rectangular prisms connected with golden brown curtain walls made of reflective glass. Together with the new GDR Ministry of Foreign Affairs and State Council Building, this monumental structure defined a large square in front, called Marx-Engels-Platz, across from the public space defined by Schinkel's museum, *Berliner Dom* and the river. The resulting monumentality and the piazza-like square in front gave the building a nickname, 'Palazzo Prozzo', a play on *protzen*, the German for 'boast'. The *Palast der Republik* gained another nickname, 'Erich's Lamp Shop' (*Erichs Lampenladen*), from the name of the GDR head of state, Erich Honecker, and the hundreds of minimalist sculptural light fixtures in the building, especially in the generous entrance lobby. Peter Rockel designed the basis of these fixtures,

which is called the Module Lamp in 1975 using aluminium, chrome-plated steel and spherical blown glass (Hartung 2001: 3).

This iconic building was used regularly and loved by the people of East Berlin and East Germany. As Ward (2016: 119) asserts, 'site-specificity has more to do with the modes of encounter embedded in a site, rather than any history of the location'. It is estimated that, on average, 15,000 people visited the Palace of the Republic each day (Misselwitz and Oswalt 2004: 6). East Berliners enjoyed using the building for its recreational and cultural activities. They could visit the venue to attend a rock concert or go bowling. They could arrange a meal with friends or post a letter. It is not an exaggeration to say that there was not another building like it in the country, as described by urban planner William J. V. Neill (1997: 184):

> East Berliners and East Germans could forget plastic imitations and bask in the comfort of real leather chairs, surrounded by real wood and lighting fixtures which were unavailable to buy in their own shops; [...] people held weddings, birthday parties and other celebrations in the Palast. [It] was, therefore, not simply the home of a rubber-stamp parliament and symbol of a regime from which ordinary East Berliners felt isolated.

The GDR governing body met in the *Palast der Republik* between 1976 and 1990. In 1989, during the celebration of the 40th anniversary of the East German state, the building hosted a state gala at which Soviet leader Mikhail Gorbachev was present. In *Good Bye Lenin!* (2003), this historical moment not only triggers what is about to come for East Germany but also for the main character. These celebrations and the street protests of young East Berliners shape the lives of Alex's family. This film, just like Winfried Bonengel's *Führer Ex* (2002), visualizes the meaning of the demolition of the Wall for common people – on the East side. Just a few years before the historical collapse of socialism in Germany, Wieland Speck's hidden Super 8 camera framed East Berlin from a youthful perspective of a West Berliner in love with an East Berliner in *Westler: East of the Wall* (1985). As the protagonists of the film wander around 'downtown' Berlin, the director captures iconic structures, including the *Neue Wache*, Palace of the Republic and TV Tower, in a way never to be perceived the same way after the 1980s.

Following the reunification of East and West Germany in 1990, the Palace of the Republic was closed down, despite the fact that its leisure elements were far greater and more in number than its governmental functions. In their 1991 documentary film *The Caretaker and His Palace*, Arpad Bondy and Margit Knapp Cazzola follow the caretaker of the iconic building behind closed doors. As his days go by in the ghostly rooms of the abandoned palace, he talks about his memories of the building, with his words accompanied by archival footage

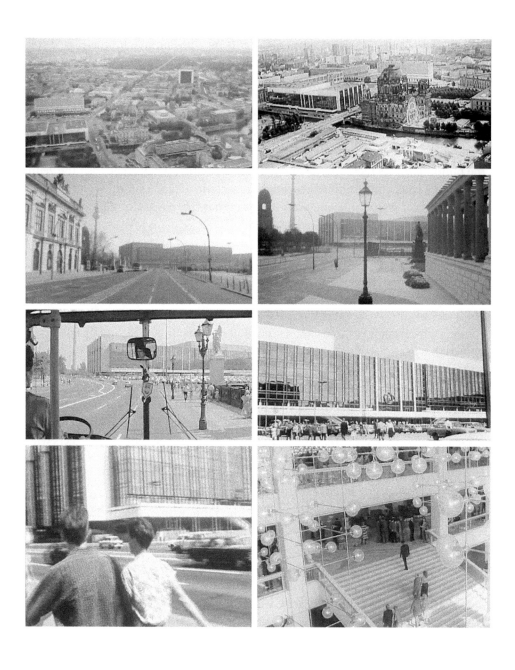

FIGURE 1.4: The Palast der Republik in *Berlin in Berlin* (1993), *Führer Ex* (2002 – set in the 1980s), *Berlin Babylon* (2001), *Learning to Lie* (2003 – set in 1982), *Heroes Like Us* (1999 – set in the 1980s), *Westler: East of the Wall* (1985) and *Palace of the Republic: House of the People* (1976).

of those events. He also considers what might happen to the building in reunified Germany, bringing the past, present and future together. This was a building to be remembered.

During those years, skateboarders populated the cantilevered terraces around the building, and an amusement park was temporarily installed on Marx-Engels-Platz (Wise 1998: 114). In 1993, the *Palast* was condemned to demolition by 'a joint Berlin-Bonn committee' (Neill 1997: 187) that was set up to oversee the move of the federal government from Bonn back to Berlin. That same year, the federal government held a competition to redesign the area around Marx-Engels-Platz. Calling for the entire restructuring of the area following the demolition of the Palace of the Republic and GDR Foreign Ministry building, the competition results were seen by many as part of a governmental plan to eradicate all traces of the GDR. The president of the Berlin Chamber of Architects, Cornelius Hertling, summarized this position succinctly by stating 'We find it unacceptable that buildings that have become a part of urban history are being erased from memory precisely because they are historically burdened. [...] History and identity are thereby being eradicated' (Wise 1998: 111).

After a further outcry from both former East and West Berliners, the decision to demolish the *Palast* was overturned in 1995. It sat empty and unused until a process of asbestos removal began in 1997.[19] Reunified Germany spent 78 million euros to remove the asbestos, which was completed in 2002 (Kil 2006: 155). In July 2002, the German *Bundestag* officially voted to demolish the building and then in November 2003 voted to construct a replica of the eighteenth-century Berlin City Palace in the exact location of where it used to be: the combined site of the *Palast* and Marx-Engels-Platz.

The Palace of the Republic has been filmed several times for documentation and/or propaganda purposes. Hubertus Siegert's camera in *Berlin Babylon* (2001), a documentary film about the explosion of development in the city following the reunification, for instance, drives by the *Palast* in 1998 while still in limbo. Approaching the building on Unter den Linden from the west highlights the view that demolition proponents say did not urbanistically work as well as a reconstructed *Berliner Stadtschloss*.

A Palace and Its Republic (*Ein Palast und seine Republic*, 2004), also filmed in the 2000s, shows the building in its glorious days during the last quarter of the twentieth century. Well-dressed East Berliners, young and old, fill the grandiose main entrance lobby with its polished white marble flooring reflecting the numerous Module Lamps. Happy children perform on the large hexagonal stage of the auditorium. Berliners visit the espresso bar for a light bite or one of the restaurants for a full meal while groups of youths occupy the discotheque dance floor. There are people's representatives getting work done, attending ceremonies and giving

a tour of their modern building to world leaders. A floor plan and section of the building as well as technical blueprints appear on the screen. Directors Julia M. Novak and Thomas Beutelschmidt represent the building as a high-tech total work of art (*Gesamtkunstwerk*) with mobile partitions, multi-purpose spaces, high-quality finishes and well-designed furniture, cutlery, artwork, souvenir and stamps specially designed for the *Palast*. The film is not only about the old days, rather, it starts with the removal of the building's asbestos. This is an intense process, similar to lifting someone's skin and ripping all the muscle off on their bones. After this procedure, the building looks naked. Towards the end of the film, the audience sees art performances and fairs taking place inside.[20] This documentary is a pertinent reminder of both the good and bad days of the GDR palace, which is shown at the end of the film as being deconstructed for 'organ donation'. British artist Tacita Dean's ten-minute *Palast,* also from 2004, differs from the holistic approach of Novak and Beutelschmidt, creating a fading image of a building edited from its fragments, like a broken vase glued together with missing pieces.

Those who argued for the demolition of the Palace of the Republic did so based mostly on the fact that it should have never been there in the first place. That is, the building was only able to be there because the GDR demolished the *Berliner Schloss* after the Second World War. Another claim was that the building did not fit in with its context in two different ways. Firstly, the Modernist style of the *Palast* did not match the historical architecture around it: 'only the imperial building, by its volume and external appearance, can unite the eclectic styles [of the surrounding buildings] harmoniously' (Ekici 2007: 28). Despite the fact that the mirrored glass reflected images of these historical buildings and therefore could possibly be seen as fitting in Staiger (2009: 314), this was a strong argument that most pro-demolition factions supported. The second aspect of 'not fitting in' was that the Palace of the Republic, with its vast empty space in front, did not urbanistically work as well as the Berlin City Palace in terminating the axis of Unter den Linden, which bends slightly at this point, making whatever is there a focal point when approaching the site from the west. Fred Scott writes (2008: 1):

> All buildings, once handed over by the builders to the client, have three possible fates, namely to remain unchanged, to be altered or to be demolished. The price for remaining unchanged is eventual loss of occupation, the threat of alteration is the entropic skid, the promise of demolition is of a new building.

Those arguing for the demolition of the *Palast der Republik* were not directly doing that. Their main argument was really for rebuilding the *Schloss*, which they almost presented as a historical inevitability. German writer and publisher Wolf Jobst Siedler summarized this position: 'There is no other way to save the city as a

city' (Weiss-Sussex 2011: 157). In contrast, those who argued against demolition did so without discussing the rebuilding of the *Schloss*, with reasons ranging from the *Palast* being part of a shared heritage (not just East German) to the fact that it was still relatively young and still had some use to it, to the high costs involved in the demolition, not to mention the money already spent on clearing the asbestos. In a short documentary, *Brokedown Palace* (Ole Tangen Jr. 2006), a former East Berliner, Karen Baumert, gave a perspective perhaps lost on some West Berliners: 'There was a lot about the GDR that we were not proud of, but the *Palast* was somewhere we could feel good.' Burton Bollag (1999: B2) agrees:

> 'My children celebrated Christmas there', says Dorit Aue, a retired office worker from the former East Berlin. 'They went to the disco there. There was no entrance fee – it was for everybody. A symbol of totalitarianism? No, absolutely not.' [...] 'The Palace of the Republic has great memories for many people', [Laurenz Demps, a professor of history at Humboldt University] says. 'It was very insensitive of West German politicians not to take that into consideration.'

Street protests broke out against the decision to demolish the *Palast*, and there was political opposition from the Left Party and the Greens. A grassroots organization called the Alliance for the Palace (*Bündnis für den Palast*) set up camp in front of the building and in 2005 produced a pamphlet outlining their platform, '12 good reasons against demolition: New facts for the Palace of the Republic'. In addition to the reasons listed above (shared heritage, high costs, etc.), the Alliance argued that historical experts, architectural professionals and a majority of Berliners were against the demolition, the building had been 'cleaned of the East' as well as of asbestos, and that demolition did not match Berlin's upcoming status as a 'World City of Creativity' in 2006.

Despite these attempts, the demolition of the *Palast der Republik* was executed between 2006 and 2008 by the Schrott-Wetzel Company, at a cost of 32 million Euros. Before the demolition, the empty shell of the building, now free of asbestos, was used as a temporary art venue. Following a feasibility study by the Urban Catalyst Research Project of the Technical University of Berlin in 2002, private interests financed a simple refurbishment of the building to make it safe for the public and the city of Berlin financed a two-part cultural activities programme: 'Between Palace Use' (*Zwischen Palast Nutzung*, 2002–04) and 'People's Palace' (*Volkspalast*, 2004–06). During these years, more than 900 art events took place with an estimate of 650,000 visitors.[21] Between January and May 2005, Norwegian artist Lars Ramberg's temporary installation of the word *ZWEIFEL* ('DOUBT') glowed on the outside of the building in 6 m high letters, a fitting ending to the structure whose demolition began on 6 February 2006.

Addressing a large amount of opposition to the building's demolition, during the process, the Berlin Senate Department for Urban Development and Housing (*Senatsverwaltung für Stadtentwicklung und Wohnen*) attempted to paint it as positive and peaceful by using slogans such as: 'Dismantling not demolishing: good for the environment' (Ekici 2007: 26). In this way, the demolition was presented as being sensitive to the dense conditions of its city centre location, creating little noise and dust pollution, as well as recycling as many materials as possible.

The Palace of the Republic may have been demolished, but it lives on in smaller pieces around Berlin, Germany and the world. The concrete recovered from the building was used for road construction, and the steel was recycled in the construction of SOM's 828 m tall *Burj Khalifa* tower (2004–10) in Dubai (Sandler 2016: 214). Pieces of the characteristic brown-tinted glazing were sent to museums and universities for reuse. Artists also reclaimed the building's glass.[22] Paintings and furniture from the *Palast* are now on display in the German History Museum, located not far away, down Unter den Linden in the restored *Zeughaus*. Other parts of the building can be found in the former barracks in Berlin-Spandau and in Bonn. Memorabilia smaller in size such as dinnerware and cutlery, as well as Rockel's lamps, are for sale in Berlin antique shops, online and, ironically, in the Humboldt Forum gift shop. Film scholar Jennifer Kapczynski calls this memorabilia-philia, such as the postcards of the former capital in *Good Bye Lenin!*, as 'the kitschification of East German history: the images are obviously "collectible," just as so many other relics of GDR life that have disappeared from production only to return to circulation as representations' (2007: 87).

Thirty years after the fall of the Berlin Wall and more than a decade after the fall of the *Palast*, Elke Neumann curated an exhibition about the building in the Rostock Art Museum (*Kunsthalle Rostock*): 'Palace of the Republic: Utopia, Inspiration, Politics.'[23] In this 2019 exhibition, about 40 artists, in more than 200 pieces, interpreted the building as a historical artefact, in order to cast light on the political and cultural heritage of the GDR *and* reunified Germany. During this exhibition, the construction of the replica *Berliner Schloss* that started in 2013 was ongoing.

Although its fragments and furnishings can be found almost anywhere, the *Palast der Republik* has disappeared from Berlin. The fact that the official publications released by the group funding and directing the *Schloss* reconstruction, Friends of the Berlin Palace (*Förderverein Berliner Schloss*),[24] never mention what was standing on this site between 1950 and 2008 raises the question: Were they trying to erase the memory of the Palace of the Republic, a symbol of the GDR, for good? The sole purpose of this organization is to raise money for the replica of the *Schloss*, so remembering the iconic Palace of the People that was standing there beforehand may not be ideal. This, moreover, might be an attempt to

physically erase East Germany from the cityscape and to let it slip 'out of sight, out of mind', which is certainly the implication of the graffiti 'The GDR Never Existed' (*Die DDR hat's nie gegeben*) that appeared on the *Palast*'s demolition site in 2008 (Bartmanski and Fuller 2018: 211–12). The only information in English on the official website of Berlin about this GDR building provides only this cursory summary:

> On April 23 [1976], the Palace of the Republic (*Palast der Republik*) is opened on the grounds of the former City Palace in East Berlin's Mitte borough. Starting in 1990, the building remains empty for years until the work of demolishing it begins in 2006. It is making way for the construction of a building that will be a replica of the City Palace torn down in 1950.[25]

This brief description lacks to mention that the building was the parliament of a state that now ceases to exist. A very small black and white photograph in which the *Palast der Republik* is cropped and seen from a distance accompanies this unexciting text.

As humanity absorbs the lessons of Berlin's 'demolition stories', there is always room to learn from the accounts of historical buildings that were at one time considered for demolition but, following heated debates, passed the judgement of future generations and survived. In central Berlin, the Nazi Ministry of Aviation (Ernst Sagebiel, 1935–36) on Wilhelmstrasse and the Ministry of Public Enlightenment and Propaganda (Karl Reichle, 1934–38) on Mauerstrasse both survived the Second World War intact and are being used as ministry buildings by the reunited Germany: Ministry of Finance and Ministry of Labour and Social Affairs, respectively. From GDR times, the House of Statistics (1968–70) on Alexanderplatz and State Council Building (1962–64) on Schlossplatz have both survived, however, whereas the latter now houses a private non-profit business school (European School of Management and Technology), the exact fate of the former, with the efforts of a group of activist artists, is still to be determined.

Different periods of the history of Berlin since 1895 have clearly manifested that authorities believing in diverse ideologies may associate urban memory with architecture. They assert that the established physicality of architecture may evoke a memory, and, if within their power, they often do not hesitate to choose the option to erase a memory arisen by a building by completely destroying it from roof to foundation. In this way, the Berliners who experienced those times fail to take advantage of a physical manifestation of a certain time period. Moreover, the new generations do not get to experience a part of that past as in a (hypothetical) Greek capital without an Acropolis or an American metropolis without a skyscraper. Berlin may be the most bombed city in Europe, but that

does not mean Berliners and the rest of the world cannot benefit from what is left in the city.

NOTES

1. Fest (2005: 88) estimates that over 100,000 tonnes of explosives were dropped on Berlin: The Allied forces used about 60,000 tonnes over the course of the war, and it is estimated that the Soviets used 40,000 between January and May 1945.

2. Other German cities, like Dresden, Cologne and Hamburg, were destroyed 90–95 per cent, but they were smaller cities.

3. Some estimate this number to be 75 million m³ (Francisco and Merritt 1986: 153), while others claim it is 55 million (Jordan 2005: 42).

4. The authors are aware of the difference(s) between a swastika and the Nazi *Hakenkreuz*, but choose to use 'swastika' throughout this book because it is the common standard English translation of that German term.

5. The full title of this highly detailed publication is *The New Reich Chancellery: On the Construction of the New Reich Chancellery of Adolf Hitler* (*Die Neue Reichskanzlei: Über den Bau der Neuen Reichskanzlei von Adolf Hitler*). It was published by Franz Ehrer Press in Munich in 1940. The publication contains high-quality black and white as well as colour photographs, scale drawings and essays by architect Albert Speer, architect Hermann Giesler, art publisher Wilhelm Lotz, book editor Rudolph Wolters, sculptor Arno Breker and artist Hermann Kaspar. This publication is conventionally listed in bibliographies with Albert Speer as the author, when in fact on page 112 it clearly states: 'Compilation of the book: Rudolf Wolters and Heinrich Wolff' ('Zusammenstellung des Buches: Rudolf Wolters und Heinrich Wolff').

6. The architectural style of 'Stripped-down Classicism' was the norm in Nazi Germany because of its monumentality. Richard Ermisch's main hall of the Berlin Fair (*Messe Berlin,* 1936–37) in Charlottenburg, for instance, is plain and functional, but highly impressive with its symmetrical monumentality, as seen in the period film *Valkyrie* (2008). As preferred in Nazi Architecture, its structure hides behind natural stone, and high pillars and large vertical windows define the *Messe*'s central 35 m tall entrance volume, contrasted with its horizontal exhibition wings on either side.

7. On the occasion of the First Architecture and Crafts Exhibition in Munich (1937), Hitler stated: 'When peoples experience great times internally, they also shape these times externally. Your word is then more convincing than the spoken one: it is the word made of stone' (Domarus 1962: 778).

8. The other structures shown in *Word Made of Stone* were the redesign of the Munich's *Königsplatz* into a *Gauforum* (with a *Führerbau* and two Temples of Honour), the New Odeon and Great Opera (both also in Munich), a *Gauforum* in Augsburg, a Round Plaza with Army High Command Building in Berlin, and an elite Nazi Party High School in Chiemsee.

9. In 1939, addressing the many workers who contributed to the construction of the New Reich Chancellery, Hitler exclaimed that the building was the first Nazi building (Speer [1969] 1970: 114). Tempelhof Airport might have qualified for that title since its construction began in 1936, but it was not completed until 1941. The Olympic Stadium (1934–36), however, actually predates the Chancellery.

10. German studies scholar Eric Rentschler (2010: 10) defines rubble film as follows: 'Strictly speaking not a genre, *Trümmerfilme* are a series of feature films produced in Germany between 1946 and 1949 that confront postwar realities. [...] *Trümmerfilme* took stock of a shattered nation and registered a state of physical and psychological ruin: Half of the forty-seven German features that premiered between 1946 and 1948 are set in the shattered streets of a contemporary big city – more often than not, Berlin.'

11. The walls of the Mohrenstrasse (formerly Ernst Thälmann Platz) U-Bahn station as well as the Soviet Memorial in Treptow have been suggested as reusing some New Reich Chancellery red marble, but art historian Hans-Ernst Mittig (2005: 184–85) has convincingly disproven these claims.

12. It can be argued that Swiss actor Bruno Ganz is best known as an angel. Ten years after shooting *The American Friend* (1977) in Hamburg with Wim Wenders, he appeared as Damiel the angel in the director's Berlin films *Wings of Desire* (1987) and its sequel *Faraway, So Close!* (1993). In his long career, Ganz has portrayed historical figures such as Sigmund Freud in Nikolaus Leytner's film adaptation *The Tobacconist* (2018) based in Nazi-occupied Vienna, and Dr Heinrich Faust on stage in Peter Stein's interpretation of Johann Wolfgang von Goethe's eighteenth-century play (2000). However, Ganz is internationally known for his performance of Adolf Hitler in the Oscar-nominated *Downfall*. For this part, Ganz studied voice recordings of Hitler's speeches and in particular a conversation with Finnish military leader Carl Gustaf Emil Mannerheim in 1942 as Hitler, unaware of the recording, abandoned his official tone. Ganz's version of Hitler's manner of speaking and body language, unlike the Nazi leader's own performance in front of the cameras, represent him as an ordinary man.

13. In 2006, an information board was installed at the corner of *In den Ministergärten* and *Gertrud-Kolmar-Strasse* to mark the location of Hitler's bunker. The board, entitled 'Myth and Historical Testimony of the Führer Bunker' ('Mythos und Geschichte Zeugnis Führerbunker'), contains a schematic diagram of the bunker and provides information about the former use of the site.

14. *Berlin Now & Then* can be seen at https://vimeo.com/348918250. The entire series can be accessed at https://vimeo.com/ruiterproductions (both last accessed 30 August 2021).

15. 'German reunification has been characterized as a unilateral process of assimilation during which the GDR, an entire state with its institutions, cultural values, and individual hierarchies was swept away' (Brunk et al. 2018: 1329).

16. In truth, the GDR were merely echoing the same sentiment about the militaristic and imperial symbolism of the Berlin City Palace that was expressed by Karl Liebknecht in 1918.

17. At the very beginning of Robert A. Stemmle's *The Berliner* (1948), the imperial/military nature of Berlin street and park names, many of which would later change just as Kaiser-Wilhelm-Strasse, is highlighted in an ingenuous succession of street signs (Bismarck-Allee, Königsallee, Gardeschützenweg, Grenadierstrasse, etc.).

18. BMK-IHB stands for *Bau- und Montagekombinat Ingenieurhochbau Berlin* or 'Building, Assembly and Civil Engineering Construction [Authority] Berlin'. The main architects from the BMK-IHB who assisted Graffunder were Heinz Aust (restaurants), Dieter Bankert (façades), Wolf-Rüdiger Eisentraut (entrance foyer) and Günter Kunert, Manfred Prasser and Karl-Ernst Swora (People's Chamber) (Hartung 2001: 4–8).

19. During the construction of the building in the 1970s, an immense amount of asbestos was installed behind most surfaces for fireproofing. At the time, this was standard construction practice since the material's carcinogenic properties had not yet been readily shared with the public. This was not a matter of poor East German standards as some critics have argued: the asbestos used in the Palace of the Republic was in fact supplied by West Germany (Ledanff 2003: 46).

20. An energetic future Chancellor Angela Merkel can be seen visiting one of the fairs.

21. Some of these events included: the World Breakdance Championship, a concert by Berlin rock band *Einstürzende Neubauten* (fittingly, meaning 'collapsing new buildings'), a 44 m multi-faceted installation of metal and plastic triangles called *The Mountain* (*Der Berg*), and an installation that flooded the interior of the building so that visitors could navigate in small inflatables around a fake metropolis, called *Façade Republic* (*Fassadenrepublik*).

22. See, for instance, Benjamin Bergmann's work entitled *The Dream of Something Big* (*Der Traum von einer grossen Sache*, 2008), https://www.uncubemagazine.com/blog/10642637 (last accessed 8 June 2020).

23. Rostock, in North Germany, was the location of the only art museum built by the GDR during its 41-year history.

24. Many of the Friends of the Berlin Palace were West Germans who were nostalgic for the monarchy and in some cases tied to some of the other former royal and grand ducal families of the German Empire.

25. https://www.berlin.de/berlin-im-ueberblick/en/history/the-fall-of-the-wall-and-reunification (last accessed 8 June 2020). The use of the present tense in these sentences is a German convention for doing so when discussing past events.

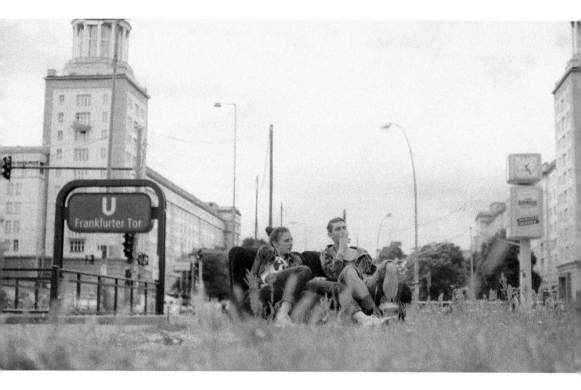

Fucking Berlin (2016)

2

Here Today, Gone Tomorrow: Temporary Installation

I can't believe how much Berlin has changed.
Tracy in *Assignment Berlin* (1998)

Temporary installations are urban interventions that only exist for a specific, limited period of time, changing current conditions into something new. Such constructions are designed to be impermanent additions to the city and represent a particular point in time. Therefore, they supply added layers to what Huyssen (2003: 7) calls the urban palimpsest, attempting 'to understand the fundamental temporality of even those human endeavours that pretend to transcend time through their material reality and relative durability'. A construction that is temporary, be it one for a street market or festival, a circus tent, disaster response unit or refugee camp, is created with the intention of not being enduring. As new insertions to the built environment, they contribute to contemporary urban memory.

Being a large cultural capital city, Berlin has had its share of art installations. One of the first was 'Proun Room' (*Prounenraum*) created for the Berlin Great Art Exhibition in 1923 by Constructivist artist El Lissitzky who was the Soviet Cultural Ambassador to Germany at the time. In the 1960s, temporary installations became a vehicle to achieve the goal of taking art out of the museum and gallery context and bringing it onto the street for the public to experience it. The painting of the Berlin Wall – on its west side – provided such temporary public art experiences, for the professional artist as well as the amateur. Two high-profile artists who used the Wall as a canvas for their art were Gordon Matta-Clark and Keith Haring. In 1976, Matta-Clark pasted real billboard advertisements for German consumer products such as chocolate, beer and cheese and above these wrote 'FROM USSR MIT LOVE'. Below he spray-painted a stencilled 'MADE IN AMERICA' with a hybrid flag containing both stars and hammer and sickle on a red background. With this temporary installation, Matta-Clark was

blaming the urban destruction brought on by the Wall on both the Soviet Union and the United States. A decade later, by invitation from the director of the *Haus am Checkpoint Charlie*, Keith Haring painted a temporary mural nearby. On a yellow background, Haring depicted his trademark stylized humanoids standing on top of each other, alternating between black and red over the course of 300 m, struggling to stay 'up'. Haring's installation, as opposed to Matta-Clark's, was aesthetically polished and became an instant postcard image, although other artists soon painted over it.

One month after the fall of the Berlin Wall, artist Hubert von der Goltz positioned two witty installations, both of which consisted of silhouettes of a man seeming to walk a tightrope. Installed on top of the still-existing Wall at both Potsdamer Platz and the Brandenburg Gate, the two sculptures subtly expressed the tenuous feeling of the interim period before reunification.[1] Despite eventually gaining official permission for these installations from the East German government, each one lasted for about two weeks at its location. On a more official level, in 2009, artist Kalliopi Lemos created a temporary installation entitled 'A Crossroads' in front of the Brandenburg Gate. Consisting of actual boats used by immigrants to cross the Mediterranean Sea into Europe, the installation was the third in a series after similar works in Greece and Turkey, attempting to highlight the often deadly plight of such immigrants.

These installations were all artworks meant to be sought out and contemplated. When Berlin experienced its construction boom in the 1990s, another type of temporary installation could be seen all around the city which was not intended to be artistic. Pink and blue pipes wound their way up in the air, above streets, on medians and along curbs. At one time, these pipes were almost everywhere in the city centre and also in some outlying areas. They were necessary for construction sites because Berlin was founded on a swampy area around the Spree River and, as a result, has a high water level. These pipes were used to constantly pump the groundwater away from construction sites, usually to the river or a canal. During the development of Potsdamer Platz, where the groundwater level was only at three metre and some of the excavations went down to twenty metre, a very complicated system of pipes, drainage, pumps and viaducts was developed to handle an estimated 14 million m^3 of water over the course of the construction project (Maier 1997: 235). The temporary piping system for Potsdamer Platz resembled a city-wide installation highlighting the urban infrastructure needed in large cities, but in reality was purely a logistical solution to the area's high groundwater level. In *Run Lola Run* (1998), Tom Tykwer frames the eponymous character with such pink pipes, most notably in the scene where she races with a cyclist. Blue pipes framing the street in the Russos' *Captain America: Civil War* (2016) are no different.

FIGURE 2.1: Berlin's pipes that come and go in *Run Lola Run* (1998) and *Captain America: Civil War* (2016). (All illustrations are film stills captured by the authors.)

Escape tunnels

If you really want to go across, I'll give you a little advice:
You don't go over the wall, and you don't go through the wall – you go this way: under.
<div align="right">Kurt in <i>Escape from East Berlin</i> (1962)</div>

According to the 2014 'Risking Freedom' exhibition prepared by the Berlin Wall Foundation (*Stiftung Berliner Mauer*), it is estimated that around 75 escape tunnels were dug under the East Berlin–West Berlin border following the construction of the Berlin Wall, eighteen of which were successful in allowing people to escape.[2] These tunnels were dug from both directions, although digging from west to east was more prevalent as it was less dangerous (NARA 2013: 21). Digging tunnels required much time and effort, as well as a way to hide the fact that an illegal border crossing between two countries was being created: somewhere to dispose of the excavated soil, a method of disguising digging sounds, a means of concealing the entrances, and a system of support to prevent collapse. Berlin's escape tunnels were truly temporary installations meant to serve the sole purpose of moving people from one side to the other, especially considering the fact that they were abandoned after use or if discovered by the authorities.

Starting in the early morning hours of 13 August 1961, the physical connection between East and West Germany was cut off by the German Democratic Republic (GDR) by means of the construction now known as the Berlin Wall. While it would eventually turn out that the Wall itself was a temporary installation, between 1961 and 1989 it was a real, tangible and deadly obstacle. Its first incarnation was merely rolls of barbed wire strewn to demarcate the border of the GDR (the former Soviet Sector) to block passage into and, most importantly, out of it. Within a week (13–18 August), it is estimated that 800 people still managed to flee from the east to the west

despite these fortifications (Richie 1998: 720). Such attempts were usually desperate measures, such as 'making a run for it', which is what the 19-year-old East German border guard Hans Konrad Schumann did on 15 August, throwing away his rifle and jumping over the barbed wire at Ruppiner and Bernauer Strasse.[3]

When it became clear that the East German border guards would actually carry out their shoot-to-kill orders,[4] other methods were devised to illegally cross the border. Fake passports, fast cars, false panels in vehicles and flying contraptions were all attempted at some point to safely pass through checkpoints or even forcefully go over or through the Wall.[5] Sneaking under the border was also an option because below ground the two halves of Berlin were still connected via sewer and metro tunnels (Pike 2010: 84). Once the eastern authorities blocked such underground connections, a more elaborate method of escaping under the Wall began to develop: digging tunnels.

Most Berlin Wall escape tunnels were constructed in the early years of the Wall's existence, between 1961 and 1964. The first documented tunnel was completed in October 1961 leading from Kleinmachnov in the east to Zehlendorf in the west (Dietmar and Kellerhoff 2008: 279), which was unusual because, as mentioned, most tunnels were dug from the west. Soon after the Wall was erected, western 'escape helpers' began to assist easterners wishing to flee, not for financial gain but out of societal concern. One of the well-known western escape helpers was a group of law students from the Free University of West Berlin, informally referred to as 'The Girrmann Group', who coordinated an operation that utilized a combination of fake passports, the sewer system and underground tunnels to move an estimated 5000 people from east to west (Taylor 2006: 305).[6] Harry Seidel, a former East German cyclist who had left for the west before 1961, was also involved in digging five escape tunnels before being caught.[7]

One unusual tunnel was dug by a group of elderly East Germans, giving it the nickname 'Pensioners Tunnel' (*Rentner Tunnel*). This 32 m underground passage went from Glienicke/Nordbahn in the east to Frohnau in the west. Twelve senior citizens walked through the 1.75 m tall tunnel in May 1962. The initiator of the project, 81-year-old Max Thomas, explained: 'We dug it deep so that our wives would not have to crawl. We wanted them to walk to freedom' (USIS 1963: 5).

Two tunnels, in particular, Tunnel 29 and Tunnel 57, eventually became very famous.[8] Tunnel 29 began in a ruined factory at Bernauer Strasse 78 in the West and ended in the basement of Schönholzer Strasse 7 in the East (Berlin Wall Foundation 2015d). Forty-one people, mostly university students, helped to dig this tunnel, which was about 135 m long and allowed the escape of 29 people in September 1962. Oddly, an American television network helped to fund this tunnel, in exchange for exclusive rights to film the exiting escapees.[9] Using this

footage, NBC released an 80-minute documentary entitled *The Tunnel,* winning three Emmys in 1963.

Even earlier than *The Tunnel,* Robert Siodmak released *Escape from East Berlin* in 1962.[10] This film, distributed by Metro-Goldwyn-Mayer, was highly successful at the American box office, suggesting that financial gain perhaps was a reason why NBC was willing to fund the construction of Tunnel 29. Siodmak had emigrated from Berlin to Paris in 1933 and then to Hollywood in 1939, returning to Germany in 1955.[11] In Hollywood, Siodmak's speciality was *film noir*. In this context, *Escape from East Berlin* combined Siodmak's interest in realism and crime drama, depicting 'the tunnel as an extension of the lived space of the Schröder family and their neighbors' (Pike 2010: 83), as well as the frantic race to complete the tunnel before the authorities discover it. The tunnel in the film is portrayed as a mechanism of transitioning from the socialist East to the capitalist West. Once that goal is achieved, the tunnel, befitting a temporary installation, is abandoned. The Baron in Peter Tewksbury's Disney re-make of *Emil and the Detectives* (1964) insinuates this when stating: 'Look at all the people who have dug out from behind the Wall [...] How would you like to go back and use the tunnels they left behind?'

Roland Suso Richter's *Der Tunnel* (2001) is loosely based on the story of Tunnel 29. Using parts of grainy NBC black-and-white footage in contrast to the slick colour production of the rest of the film, the story continues beyond 1964 to provide a post-1989 update about most of the participants. The result 'suggests that the Cold War was merely a bump when freedom temporarily sought shelter underground' (Pike 2010: 90).[12]

Tunnel 57 began at Bernauer Strasse 97 in the west and went 12 m underground (Novikov 2009: 24) for about 150 m to a disused latrine in the courtyard of Strelitzer Strasse 55 in the east (Berlin Wall Foundation 2015b). Over the course of two nights in October 1964, this escape route was used to smuggle out 57 people. On the third night, when the escape helpers emerged to take more people, there was a group of armed East German Border Police (*Grenzpolizei*) waiting. One of the tunnelers had a weapon and fired some shots as cover to allow retreat, and the police fired back. The tunnelers made it back to the west alive, but on the eastern side a soldier, Sergeant Egon Schultz, was shot, according to a GDR announcement, by the tunnellers.[13] As a result, western support for tunnelling efforts, both financially and psychologically, waned after that incident and other methods became more prevalent.

Berlin Tunnel 21 (1981), a made-for-television American film by Richard Michaels, was shot to coincide with the twentieth anniversary of the Wall. It was based on Donald Lindquist's 1978 novel with the same title. This film stars an American soldier who collects an assortment of characters (male model, university

student, ageing artist and distrustful engineer) to dig a tunnel to help free his East German girlfriend. In exchange for their hard work, fellow tunnellers got to free their relatives in the East. The story gathers bits and pieces of real Berlin Wall tunnel stories with real footage of Berlin and stitches them together to make the American character into a hero because he dies inside the collapsing tunnel, allowing everyone else to escape. In Lindquist's book, the main character survives, underscoring the ideological underpinnings of this late Cold War production. The escape tunnel in this film, again, serves as a temporary installation that is abandoned after its successful use. Reframed via Michaels' camera, it marks a lost layer of urban memory in Berlin.

After the fall of the Berlin Wall, the metaphor of illicitly travelling under the border continued to be a cinematic trope. John Schlesinger's *The Innocent* (1993) depicts Allied Powers in 1954 tunnelling into the Soviet Zone in order to tap telephone lines, a story based on an actual situation.[14] Margarethe von Trotta's *The Promise* (1995) uses both the Berlin sewer system with its associated excrement as well as a hand-dug escape tunnel with its own type of refuse, to conclude that these spatial constructions were merely transient installations when compared to the 28 years of the Berlin Wall, which in the long run itself turned out to be temporary.

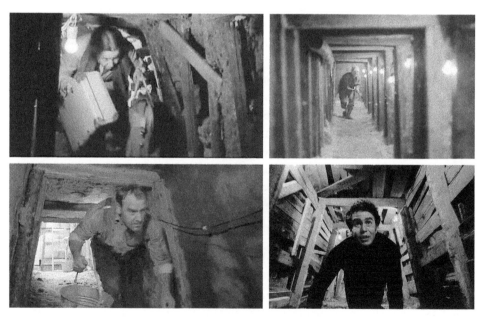

FIGURE 2.2: The cinematic tunnels of *Escape from East Berlin* (1962), *Berlin Tunnel 21* (1981), *Der Tunnel* (2001) and *Confessions of a Dangerous Mind* (2002).

Lastly, George Clooney's *Confessions of a Dangerous Mind* (2002) visualizes an exquisitely built tunnel connecting the two halves of Berlin underground, but used by the main character to sneak into, not escape from, East Berlin.

Keeping in mind that everyday people, not official organizations like the GDR or Federal Republic of Germany (FRG), created Berlin's escape tunnels, they were never meant to be more than just a utilitarian way of escaping East Germany. However, the heroics and ingenuity that were involved make them candidates for memorialization, which is exactly what has happened at the Berlin Wall Memorial (*Gedenkstätte Berliner Mauer*) on Bernauer Strasse. Constructed by the FRG and maintained by the Federal State of Berlin, this complex originally consisted of three parts opened between 1998 and 2000: Monument, Documentation Centre and Chapel.[15] In 2006, the entire south side of Bernauer Strasse between Gartenstrasse and Schwedter Strasse, 1.3 km long and 4.4 hectares in area, containing a 60 m original piece of the wall, was 'established as the central site of commemoration for the victims of the Berlin Wall'.[16] In terms of the memorialization of the illegal and highly dangerous escapes, all known tunnel paths are traced on the ground using bronze plaques that, although visitors are unable to see the actual tunnels, now permanently mark them in the city.

This monument was further added onto with the construction of a Visitor Centre (2009) at the corner of Bernauer Strasse and Gartenstrasse as well as a memorial entitled the 'Window of Remembrance' (2010). In 2014, a permanent exhibition opened in the Documentation Centre entitled '1961 | 1989 Berlin Wall', solidifying the role of the institution in the shaping of urban memory concerning the Wall and its escape tunnels.

Another escape memorialization in the vicinity of the Bernauer Strasse Berlin Wall Memorial is the 'Wall Jumper' (*Mauerspringer*) sculpture that realistically re-creates Hans Konrad Schumann jumping over the barbed wire in 1961.[17] A memorial plaque for slain East German soldier Egon Schultz, installed as a joint initiative of former escape helpers and border guards, can be found on Strelitzer Strasse 55. Lastly, while in the area of Bernauer Strasse, visitors are also able to experience 'Under the Berlin Wall', one of the many tours that private company Berlin Underworlds (*Berliner Unterwelten*) offers. In the cellars of the former Oswald-Berliner Brewery at Brunnenstrasse 141–43, scale replicas of successful and unsuccessful tunnel projects can be viewed. In 2019, the company completed their project of constructing a 30 m passage to an original escape tunnel from 1970, accessible from these cellars 8 m below the ground. In this way, tourists are able to experience an intact, authentic and preserved Berlin Wall escape tunnel.

All of these urban artefacts – tunnel paths, sculpture, plaque, scale replicas and museum-tunnel – work to make the temporary and fleeting constructions and actions of tunnel building, wire jumping and tragic shootings more permanent in

the twenty-first century. In this way, they do not disappear forever and remain part of Berlin's urban memory.

Wrapped Reichstag

An artist can do things that last.
It won't stay; that's what bothers me most.

<div align="right">Steel worker in To the German People (1996)</div>

Environmental artist-duo Christo and Jeanne-Claude's[18] *Wrapped Reichstag* instal-lation, realized in 1995, became a symbolic cleansing and restoration of the Reich-stag building into its intended function as a parliament building for the elected members of the people.[19] The wrapping mentioned in the title of the artwork is not a metaphorical expression. The artists literally wrapped the 47 m tall structure with fabric from head to toe. This project created a rupture in the perception of the nineteenth-century building and a shift in the collective memory of Berliners, the influence of which still lasts, by modifying the perception of the Reichstag from imperial pompousness to democratic representation. This process could be said to have its roots in the Peter Behrens-designed inscription of *Dem Deutschen Volke* ('To the German People') above the main façade of the building 22 years after its 1894 construction. In addition, the wrapping evoked unpleasant memo-ries of the Nazi regime that not only abused the institution of the parliament but also the building itself by leaving it as a ruin after a suspicious 1933 fire, which 'came to symbolise the death of parliamentary democracy in Germany' (Deutscher Bundestag 2018b: 52).

Because the renovation of the Reichstag building officially began immediately after the building was 'unwrapped', Christo and Jeanne-Claude's strictly tempo-rary installation acted like a metaphorical cleansing of the building, although it was not initially intended as such. The unwrapping rendered the Reichstag neutral and unsoiled, ready for a new beginning. As Ladd (1998: 84) states, 'Christo [and Jeanne-Claude]'s "wrapping" was a peculiarly appropriate homage to the Reichstag, celebrating a conventional symbol of national dignity in an unconven-tional way'. Referring to politician Wolfgang Schuble's objections to the project, Ladd continues:

What exactly was the reason for wrapping the Reichstag in 1995? Was it another attempt to come to terms with the Nazi past? Or a dramatic gesture in the shadow of the Berlin Wall? Or the inauguration of a new unity of East and West? Or just art for art's sake? Indeed the project was (or had been) about all of these things.

No grand gesture in the center of Berlin could be unambiguous, just as none could be uncontroversial.

With over five-million visitors in fourteen days, the *Wrapped Reichstag* might be Christo and Jeanne-Claude's most prominent and political urban project, but it certainly is not the only one. The couple is well-known for their large fabric installations that temporarily cover buildings, statues and bridges in cities around the world. Their installations are so sizable (large curtains, gates, fences, umbrellas, etc.) that the artists in fact prefer landscapes to cityscapes. They build in nature, choosing valleys, islands, parks and cliffs as their sites. Because Christo and Jeanne-Claude's work occupy and manipulate large urban and rural areas, not confined interiors, their artwork is not designed for museums, galleries or art collectors. They explain: 'No one can keep it. [Our work] cannot remain or become someone else's property, [...] possession is equal to permanence' (Christo and Jeanne-Claude in *To the German People*, 1996). In order to finance these expensive installations, they frame and sell Christo's representations of each project (sketches, maps, text and sometimes photographs), along with process drawings and physical models. These artistic representations may end up in collections and museums, but they themselves are not the actual artwork.

Christo Vladimirov Javacheff and Jeanne-Claude Denat de Guillebon were both born on 13 June 1935 at different peripheries of continental Europe: Gabrovo, Bulgaria and Casablanca, Morocco, respectively. They met in Jeanne-Claude's home in Paris in 1958 when Christo was hired as a portrait artist, and they mostly lived in New York after that. Christo's interest in Berlin first materialized in a public installation in 1962 in Paris. As an artist who grew up in socialist Bulgaria under Soviet influence, Christo felt strongly about the 1961 construction of the Berlin Wall and protested it with an installation, entitled *Iron Curtain: Wall of Oil Drums*, made out of 240 stacked oil barrels that created a physical barrier blocking the Rue Visconti.[20]

A wrapping project in Berlin similar to the Wrapped Reichstag took place adjacent to the Palace of the Republic in 1994 with dissimilar intentions and results. French artist Catherine Feff installed a massive one-to-one representation of the façade of the *Berliner Stadtschloss* at the exact location where the imperial building had stood before its demolition in 1950. Accompanied by a nostalgic privately funded exhibition, Feff's mockup managed to cause Berliners to re-remember the imperial palace for nearly a year and to almost forget the GDR building that stood in the same location and was still functional only a few years previously (Wise 1998: 115). Since the Modernist palace was partially built on the site of the old palace, the installation, perpendicular to the elevation of the *Palast*, ended on its glazed façade that reflected the ghost of the *Schloss* at a strategic perspective seen as one approached this authentic

site from the west. Therefore, Feff's fake palace veiled the existing real palace, reminding Berliners of a nostalgic past long before the GDR.

Unlike Christo and Jeanne-Claude's temporary *Wrapped Reichstag* that gave value to the building it shrouded, like a window framing the landscape, Feff's installation was an invasive attempt to make the building it veiled disappear, like a coin that a magician hides in their hand. The Reichstag installation was about the authenticity of the architecture and what it represented, whereas the *Schloss* installation was about the authenticity of the site. Political journalist-author Michael Wise (1998: 116) states: 'For Berliners, the fleeting experience of the original palace's massing via the mockup underscored the importance of the site and its role in determining the city's identity and historical self-understanding.' Christo and Jeanne-Claude's 1995 *Wrapped Reichstag* installation was about washing off negative memories associated with the Reichstag, while Feff's 1994 fake *Berliner Stadtschloss* façade was about forgetting the *Palast der Republik* and its memories altogether.

Although dated later than Feff's project, Christo had planned to wrap the Reichstag as early as 1971, when Berlin was still a divided city. However, the artist had to wait a quarter of a century to realize this, in his words, 'absolutely irrational' project.[21] Despite intensive lobbying efforts by Christo and Jeanne-Claude, it was not possible to convince anyone to carry out the project until 25 February 1994. On that day, following three refusals in 1977, 1981 and 1987 by the FRG, the reunified German government, meeting in Bonn, voted 292 to 223 in favour, that the project proceed.

For the *Wrapped Reichstag*, Christo and Jeanne-Claude chose a thick-woven white polypropylene fabric with an aluminized surface that gave the textile a silvery finish. They contrasted this fabric with blue polypropylene rope 3.2 cm in diameter. Folds, pleats and drapes gave a short-lived imperfect form to what laid under. The 100,000 m² fabric and 15.6 km of rope used were to be industrially recycled after the dismantling of the installation. For this large-scale project, the artists teamed up with many experts, including historian Michael S. Cullen,[22] developer Roland Specker, and photographers Wolfgang and Sylvia Volz as well as 120 installation workers and 90 professional climbers.

This team completed the wrapping of the Reichstag building on 24 June 1995, covering its surfaces with a total of 70 fabric pieces starting with the roof, then the four facades, and finally the most tricky part, the towers at the corners, because the sandstone sculptures on the facades had to be first covered with steel structures to protect them. Extremely large panels of semi-glossy white fabric flowed down from the roof with the help of the climbers who, from far, looked like scale humans on an architectural model. The entire process of covering and then wrapping that took 9 days was quite dramatic, almost as dramatic as the

finished piece.[23] The wrapped building shone like a jewel and sat quietly beside the Tiergarten like a cocoon waiting for its contents to break out. On their website, the artists proclaim:

> Fabric, like clothing or skin, is fragile; it translates the unique quality of impermanence. For a period of two weeks, the richness of the silvery fabric, shaped by the blue ropes, created a sumptuous flow of vertical folds highlighting the features and proportions of the imposing structure, revealing the essence of the Reichstag.[24]

This robust silvery fabric looked almost like the shiny metal spaceship surfaces in early science fiction films. It had structure and texture, and appeared bright white under direct sunlight, while the parts in shade were grey as if there was more than one material. Its 'back' facing the Reichstag, on the other hand, was more porous, permeable and transparent like a lace curtain, mainly to let light into the building.

Concurrent with this unusual and brave project, Wolfram and Jörg Daniel Hissen created a 98-minute documentary film entitled *To the German People – Wrapped Reichstag 1971–1995* (1996).[25] Between 1989 and 1995, the brothers followed the artist couple in New York and Germany, and documented the realization of the installation from the negotiations with politicians, to the production and testing of the materials in factories, to the act of wrapping the building and experiencing the installation. Film, in this context, is a fitting medium to witness how Berliners, Germans and tourists received this urban art piece and its making: Some just sat there with friends as if this was a meeting point or the best tree to sit under, others went for the artistic vibe and played guitars, sang and danced, while others joined in just 'to see and to be seen'.[26] On the opening day of the installation, as filmed by the Hissen brothers, the crowd's first instinct was to move towards the building and touch the fabric. They then looked up to see its effect close up. Thirdly, people either took photographs or had their photographs taken. Now that they had experienced the temporary installation, they wanted to record that memory. 'In the *Wrapped Reichstag*, each German will mirror themselves', said West German Chancellor Willy Brandt (repeated by Jeanne-Claude in *To the German People*, 1996).

After all, this was a temporary installation, and they were at the right place at the right time. This memory was also materialized with small square pieces of the original fabric that the artists shared with the public as a reminder of this temporary and historical event. One million such free souvenirs were distributed on the site during its two-week installation. Referring to the hidden potential that was hinted at by *Wrapped Reichstag*, Francesca Rogier (1996: 66) mentions:

The project not only effected a kind of purification rite for the home of the new Parliament, but its two-week life span forced Berliners, who struggle and fail to be spontaneous, to take part in the here and now, to sit, eat, sleep, dance, listen to drums around the clock. More importantly, it triggered an enthusiasm untrammeled by pessimism: as much a response to the wrapping as to the possibilities it created, themselves a key part of the 'art' whose meaning critics pondered. The Reichstag project captured the imagination and may have even signaled a turning point in the city's attitude, a positive outlook that might be taken up by its new planners: for the first time since 1989, Berliners could let go, could experience, even enjoy, one another, could occupy a space they barely knew night and day – a moment whose memory left them wanting more.

The Hissen's film does not solely record the finale of the wrapping process. It starts on a snowy Berlin day in 1980 as the artists pay a visit to the site and explore the Reichstag and its surroundings, including the Brandenburg Gate that was still behind the Berlin Wall. Most of the film documents the many years of the design process in the artists' studio in New York, negotiations in Bonn and the making, testing and installation of the silvery fabric, blue rope and steel under-structure in various factories and on site in Berlin. As Christo states in the film (1996), the seed of the project is a 1961 collage entitled

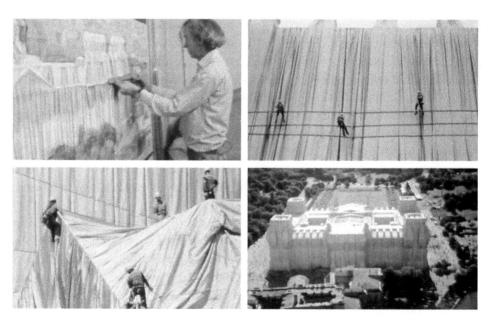

FIGURE 2.3: Various stages of wrapping the Reichstag in *To the German People* (1996).

'Proposal for a Wrapped Public Building', exhibited in Cologne, which he imagined to be either a parliament or a prison.

Christo's first Berlin visit would not take place until 1976 and a tour of the building was not until 1984. He made large-scale drawings of the proposal as well as multiple scale models to share with the Germans and to test ideas. The first physical model was made in 1977 in a hotel room in Bonn. Following the long approval and installation process of the project, the Hissen's camera finally wanders around like one of Wim Wenders' angels and documents the wrapped building and its audience. There is also music. The sound of many creates a festive atmosphere, even at night when only the walls were lit with deep dark shadows and the roof was in complete darkness. The film ends with poetic shots of the 'jewel' in context and with an aerial view, showing that Christo and Jeanne-Claude even wrapped the courtyards of the Reichstag, despite the fact that no one would have known otherwise had they not done so.

The day after the unwrapping of the silvery fabric, demolition work at the Reichstag began. In a farewell article to Jeanne-Claude about her 'environmental canvas', *New York Times* journalist William Grimes wrote (2009), 'Whether executed in oil drum or brightly colored fabric, the art of her and her husband, Jeanne-Claude said, expressed "the quality of love and tenderness that we human beings have for what does not last"'. Temporariness can be visually captured through, for instance, family photographs, or in exhibitions such as *Christo and Jeanne-Claude: Wrapped Reichstag, Berlin, 1971–95. A Documentation Exhibition*, appropriately displayed in the renovated Reichstag in 2015. Temporary art lasts and lives on with the help of visual media such as photography and film, which freeze temporary installations in time, making the impermanent permanent. Ephemeral urban art like the *Wrapped Reichstag* is framed to remind societies of their history and urban memories at that time.

Temporary installations represent momentary but crucial urban interventions; they reveal a hidden meaning connected to urban memory, especially in the case of Berlin. Their creators bring this meaning to the surface, but they may not dwell on the temporary and negotiable character of that meaning. For example, it is not possible to fully understand the Berlin Wall's relationship to memory without comprehending the escape tunnels that were dug underneath it in the early 1960s. Nor can one appreciate the new meaning of the Reichstag for the city without understanding how the ritual of its wrapping silenced or soothed the many voices of memory that linked the building to its restless history. As artistic and/or political amendments to the city, the effects of temporary installations, such as the Berlin Wall escape tunnels or Christo and Jeanne-Claude's *Wrapped Reichstag*, on urban memory are felt long after these momentary but memorable constructions are gone.[27]

Urban strategies identified in this book tend to aim for permanence. An architect designs a new building, preserves a historical structure or suspends a ruin in perpetuity – as a reminder of their time and their past. Even when existing buildings are demolished, they are expected to stay that way – erased from urban memory. Some strategies though, like mutation, which by definition incorporates urban change in its DNA, are not meant to last. Temporary installation is another such example, arguably the least permanent urban strategy of all. Installations have an in-between existence: they mark a pause in the urban memory, concluding the existence and meaning of a site, building, era or ideology, and clearing the air for new beginnings. The *Küchenmonument*, an inflatable space that stood in front of Tempelhof Airport for three days in 2016 for a workshop for refugees and young Berliners, for instance, marked such a disruption in the history of this turbulent ex-Nazi building.[28] Such pop-up structures are temporal, transitory and experimental by definition. After this temporary state – the short lifespan of a temporary installation – anything is possible; there is room for the creation of fresh memories to allow multiple voices of memory, old and new.

NOTES

1. Von der Goltz's installation at Potsdamer Platz was entitled, *The Political Situation at Potsdamer Platz*. The installation at the Brandenburg Gate was entitled, *Balance – Path through Germany*.
2. See https://www.risking-freedom.de/tour.html?tour=1#1. Sixty tunnels, some with links to maps and a history of the dig, are listed at http://www.tunnelfluchten.de/liste.html (both last accessed 30 April 2020).
3. Peter Lieging's momentary photograph of Schumann jumping over the barbed wire was published as 'The Leap into Freedom' in the western press.
4. The first recorded victim shot while attempting to flee to the West was 24-year-old Günter Litfin who tried to swim across the Spree River near Humboldthaven eleven days after the Wall went up. The first documented victim of the Berlin Wall was 58-year-old Ida Siekmann, who died the day before Litfin after jumping from her apartment window on Bernauer Strasse 48 (Hertle 2007: 104).
5. Many original gadgets used for successful escapes are (dispersedly) exhibited in the Wall Museum, which was founded by Dr Hildebrandt near Checkpoint Charlie in 1962. This museum is less about the Berlin Wall and more about the Cold War period in Germany and elsewhere, and the fact that it is not advertised that way causes confusion among visitors (see for instance Google reviews).
6. This name is derived from Detlef Girrmann, one of the main leaders. They formally called themselves 'Operation Travel Agency' (*Unternehmen Reisebüro*).

7. Seidel is credited with digging four tunnels from Neukölln to Treptow and another from Zehlendorf to Kleinmachnow. http://www.tunnelfluchten.de/liste.html (last accessed 12 October 2020).

8. Tunnel names are derived from the number of people who managed to escape through them.

9. NBC paid the equivalent of $12,500 in Deutsche Marks (Taylor 2006: 322), equivalent to approximately $100,000 today.

10. Because this film was based on a 27 m tunnel from Oranienburger Chaussee 13 used on 25 January 1962 to free 28 people, an alternative title, released in the UK, was *Tunnel 28*.

11. Before his emigration, with a young team including Billy Wilder, Siodmak had directed the last German silent film, *People on Sunday* (1930), which was a milestone that depicted leisurely life during the Weimar Republic framed in a realist manner similar to *Berlin: Symphony of a Great City*.

12. Pike (2010: 89) links Richter's *Der Tunnel* to Tunnel 57, but because of the details to which he refers, especially the connection with NBC, the film he is describing is based on Tunnel 29.

13. After the opening up of East German archives following German reunification, Schultz' death turned out to have been caused by a fellow soldier.

14. Operation Gold (known as Operation Stopwatch to the British) was a joint assignment conducted by the American CIA and the British MI6 in the 1950s to tap into Soviet landline communications in Berlin using a tunnel into the Soviet-occupied zone. *The Innocent* was based on Ian McEwan's 1990 novel with the same title.

15. The Berlin Wall Monument was opened on 13 August 1998, exactly 37 years after the initial construction of the Wall. The Documentation Centre opened on 9 November 1999. Rudolf Reitermann and Peter Sassenroth designed the Chapel of Reconciliation dedicated on 9 November 2000.

16. 'History of the Memorial', https://www.berliner-mauer-gedenkstaette.de/en/history-of-the-memorial-211.html (last accessed 28 April 2020).

17. Artists Florian Brauer, Michael Brauer and Edward Anders' sculpture was originally installed near the intersection where Schumann's jump occurred, but has since relocated one block away to Brunnenstrasse.

18. In the first years of their collaboration, only Christo was named as the artist of their works despite Jeanne-Claude's involvement in the development of ideas every step of the way. This changed in 1994 when they started branding their artistic practice as Christo and Jeanne-Claude (https://christojeanneclaude.net, last accessed 1 September 2021). Since 2009 when Jeanne-Claude passed away, Christo has pursued their work in progress, such as *the Mastaba* (1977 onwards) in Abu Dhabi, a contemporary pyramid-like permanent structure that will be world's largest sculpture (truncated pyramid), and *L'Arc de Triomphe, Wrapped* (1962 onwards) in Paris, constructed from 18 September to 3 October 2021. Sadly, a decade after

Jeanne-Claude, Christo passed away in 2020 before completing this Paris project. The wrapping of the 50 m arch (1806) by their team was live-streamed on their official website: https://christojeanneclaude.net/timeline (last accessed 1 September 2021).

19. Although this is how the project became to be perceived after reunification, a symbolic cleansing was not part of Christo's concept in the first version of the proposal.

20. Stacked oil barrels and the Berlin Wall came up more than once in their work after the 1960s.

21. In a Gallery of Lost Art interview, Christo continues: 'They cannot be bought, nobody can charge tickets, nobody can own it, nobody can use them. All that is the power of this project.' https://www.youtube.com/watch?v=4zYKa6xmbjQ (last accessed 31 January 2021).

22. It was Cullen who initiated the idea of wrapping the building by sending Christo a postcard (a black and white photograph of the Reichstag) in September 1971 (*To the German People*, 1996).

23. A five-minute time lapse video of the covering process can be seen at: https://www.youtube.com/watch?v=esiErDm62E4 (last accessed 28 May 2021).

24. https://christojeanneclaude.net/projects/wrapped-reichstag?view=info (last accessed 1 September 2021).

25. Although this book mainly covers full-length fiction films, this documentary is essential to understand *Wrapped Reichstag* as it is arguably the best representation of both the process and experience of the artwork.

26. About the visitors to the project, Christo states: 'That participatory public is unique. Actually, people created that energy anticipation that was impossible to orchestrate or invent. Everything that is inherent to that space became part of the work of art.' https://www.youtube.com/watch?v=4zYKa6xmbjQ (last accessed 31 January 2021).

27. The same is valid for the temporary existence of artists on Earth; their presence and influence will be felt long after they are gone.

28. https://raumlabor.net/tempelhof-workshop and https://raumlabor.net/kuchenmonument (last accessed 19 March 2021).

Stories of that Night: The Test (1967)

3

From Scratch:
New Construction

*Building is political. We project power. Each building reflects status,
like it or not. Prosperity or austerity. Dreams or despair. Economics
and technology.*

Prof. Vesely in *The Architects* (1990)

Architects and other professionals involved with the built environment are most
familiar with the term new construction, which for them means projects in their
offices. The authors, however, define the urban strategy of new construction as the
design and erection of buildings and spaces that have no link to those that were
previously there. In this way, such constructions function to suppress any memo-
ries associated with a site by proposing a new and 'history-less' environment.
The followers of the modern movement, by the nature of their forward-looking
ideology, very frequently practised the strategy of new construction, most famously
seen in the construction of brand-new twentieth-century capital cities like Brasilia
(Niemeyer et al. 1956), Canberra (Griffin and Mahony 1913) and Abuja (Wallace
et al. 1979) that treated their sites as *tabula rasa*.

New construction can occur after the total destruction and devastation of an
urban area. In Berlin, Nollendorfplatz was so completely rebuilt and reorgan-
ized after the Second World War that the address of the protagonist in Roberto
Rossellini's *Germany Year Zero*, Nollendorfplatz 19, does not exist today. Two
1930s films have scenes filmed in a theatre in Nollendorfplatz between the wars:
Carl Froelich's drama *Fire in the Opera House* (1930) and Fred Sauer's comedy
The Dancing Hussar (1931). These films help Berliners remember the area as it was
before the war. Geoffrey Sax, with the same purpose, recreates the 1930s Cafe am
Nollendorfplatz that British author Christopher Isherwood favoured in *Christopher
and His Kind* (2001).

Because of Berlin's changing nature throughout the twentieth century, new
construction is a general theme of Berlin cinema, especially after the war. During the

75

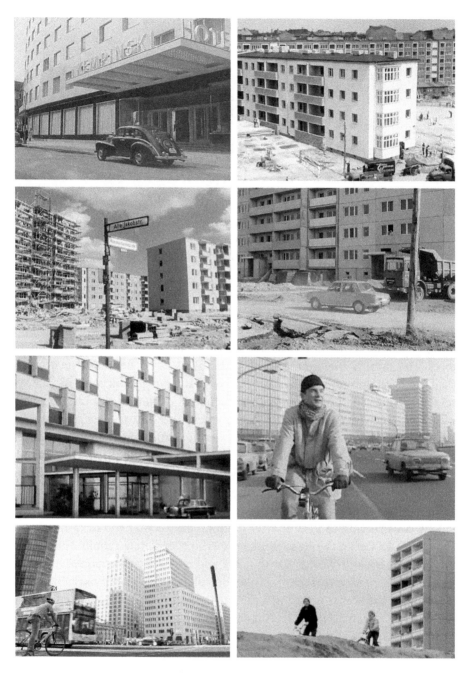

FIGURE 3.1: Cinematic new construction in both West Berlin (left column: *Adventure in Berlin*, 1952; *Ten Seconds to Hell*, 1959; *My Bed Is Not for Sleeping*, 1968; and *Single by Contract*, 2010) and East Berlin (right column: *Story of a Young Couple*, 1952; *Solo Sunny*, 1980; *Coming Out*, 1989; and *The Architects*, 1990). (All illustrations are film stills captured by the authors.)

division years, a layer of meaning is added to the appearance of new construction in a film. Kurt Maetzig's *Story of a Young Couple* (1952) climaxes in a performance by the actress-wife at the then-under-construction Stalin Allee, giving the audience the message that her western husband finally sees the true meaning of his eastern wife's values. Robert Aldrich's *Ten Seconds to Hell* (1959), after showing multiple acts of destruction and demolition, ends with optimistic scenes of new construction, hinting at a bright future. Klaus Lemke's *My Bed Is Not for Sleeping* (1968) has the glamorous tourist staying in a brand new hotel in West Berlin, and the main character in Wolf and Kohlhaase's *Solo Sunny* (1980) visits her friend moving into a new *Plattenbau* satellite town while still under construction, uncharacteristically (for a German Democratic Republic (GDR) film) questioning the new urban environment.

Immediately following Germany's reunification, when Berlin was nicknamed 'Europe's largest construction site', construction cranes, concrete mixers and ubiquitous drainage pipes can be seen in many films of the 1990s, even providing a title for Wolfgang Becker's *Das Leben ist eine Baustelle*[1] (1997) where the life of the main character in his twenties, just like Berlin, is still under construction. The most notable new construction documentary made in Berlin is arguably *Berlin Babylon* (2001), in which Hubertus Siegert's camera follows politicians, developers, planners and architects on construction sites talking about the projects, or making small talk.[2] Throughout the film, stakeholders talk; construction workers build.

Sony Center

Bruce: For an American, a city represents the future. They thrive on growth.
Felix: For Europeans, a city represents the past.

Westler: East of the Wall (1985)

The Sony Center on Potsdamer Platz, built at the end of the millennium, is a colossal international business and leisure complex that has no relationship in footprint, massing or appearance to the buildings that were on that site before the Second World War. This is also valid for several high-rise buildings that were constructed on and around Potsdamer Platz in the last three decades. *The Legend of Rita* (2000), Volker Schlöndorff's film released in the same year the centre opened, represents buildings and streets of Berlin that could have been in any western or eastern metropolis, just like Baran bo Odar's hacker mystery *Who Am I* (2014), but unlike Florian Henckel von Donnersmarck's *The Lives of Others* (2006) that explicitly represents East Berlin of the 1980s.

Potsdamer Platz, partly due to its central location, has historical significance for both Berlin and Germany. Once the busiest crossroads in Europe, the area suffered damage from Second World War bombing and neglect from being located immediately next to the Berlin Wall and its wide deathstrip. By the late 1980s, the area was a surreal wasteland at the edge of both Berlins, as seen in *Wings of Desire* (1987) where Wenders' aged poet Homer wanders, unable to find the Potsdamer Platz of his memories. In the 1990s, Potsdamer Platz was a busy out-of-scale construction site, a gold mine for developers and contractors when the now-established Sony Center was built.

Following a 1991 competition, architects Hilmer-Sattler carried out the master planning of the area. They divided the district into four large plots, each developed by a different company – Sony, Daimler, Beisheim and Park Kollonnaden – that attempted to prepare Potsdamer Platz for the economic possibilities of the new millennium. 'The new Potsdamer Platz is in this sense an engineered centre for the New Berlin – a Sony Center perhaps – that trades on the city as another marketplace for globalised capital in a transnational, telecommunicating, inter-city age' (Webber 2008: 14). Siegert's timely documentary *Berlin Babylon* (2001), as previously mentioned, narrates a bittersweet story of deconstruction and reconstruction of Berlin. The altered Potsdamer Platz, in this process, significantly changed the surrounding historical urban landscape.

The Sony Center was designed by Chicago-based German-American architect Helmut Jahn of Murphy-Jahn Architects and was constructed between 1996 and 2000 for the European headquarters of Japanese technology company Sony. Jahn is known for his glass architecture in which structure defines space.[3] As described on his practice's website, Jahn 'is committed to design excellence and the improvement of the urban environment. He believes the continuous innovation of architecture has to do more with *the elimination of the inessential*, than inventing something new'.[4] One can see this vision in the Sony Center in terms of how Jahn 'improved' the site by demolishing or moving around the remains of the past, and by designing a complex that has no natural connections to a historical or existing Berlin. It seems like Jahn includes the past into his designs only if he must after eliminating the 'inessentials'.

Three streets define the challenging triangular project site of the Sony Center: *Ben-Gurion-Strasse* to the west, *Bellevuestrasse* to the northeast and the new *Potsdamer Strasse* to the south, whose median contains a 2010 installation glamorously called *Boulevard of the Stars*, which consists of polished bronze stars dedicated to the celebrities of German-speaking film like Marlene Dietrich, Bruno Ganz, Wim Wenders and Billy Wilder, embedded in a red-carpet-like asphalt. Basically, following the example of the Los Angeles *Walk of Fame*, also part of this artwork are 'cameras' utilizing the Pepper's Ghost phenomenon to make the celebrity's

semi-transparent freestanding image hover above their star. This memorial, facing the German Cinema Library and Museum for Film and Television (*Deutsche Kinemathek – Museum für Film und Fernsehen*, 1963) inside the Sony Center, is one of the few in the city that does not refer to a dark side of Berlin's past, despite the fact that Dietrich and Wilder fled the Nazis for Hollywood. This installation is one of the highlights of the Berlin Biennale film festival.

The footprint of the Sony Center is the size of four football fields and the complex itself is composed of a total of 132,500 m² of floor space. Its modern steel and glass architecture contrasts with the historical context of central Berlin that mainly consists of stone buildings. However, since Potsdamer Platz was built 'from scratch' following reunification, its immediate surroundings with 'designer buildings' (Akcan 2018: 340) is not that different from the building itself. In fact, the prevalence of glass skyscrapers in the area makes this part of the city 'the least Berlin-looking' and has been used in films as locations of modern international institutions and companies. A scene in the Russos' *Captain America: Civil War* (2016) in which the Sokovia Accords are discussed at the United Nations in Vienna is actually filmed in Berlin at the fully-glazed Sony Center. Brian de Palma's *Passion* (2012) depicts the complex as an office building for a global advertising company, with the executive being dropped off in front by her chauffeur every morning.

The Sony Center's sculpturesque suspended tent structure on the roof of its semi-enclosed column-free atrium is its most prominent feature and has turned the complex into a modern landmark in Berlin's skyline, in line with the civic intention of the *Kulturforum*. The triangulated elliptical ring beam of this 67 m-high roof spans 102 m by 78 m and covers 5250 m². The alternating glass and white teflon-coated canvas of the structure resembles the skirt of a caba-ret dancer opening as she moves with the music on stage, especially at night, when coloured artificial lights ever-changingly alternate to artist Yann Kersale's design.[5] The compression ring in the centre, in that sense, is the dancer's waist. The unusual structure is composed of steel, PTFE-coated aluminium, steel cable and self-cleaning breathable fabric, as well as laminated glass towards the top. This complex geometry weighs 920 tonnes, but because it is vertically supported at the top of the buildings of the complex (at seven points), it actually conveys a light feeling.[6]

The central courtyard under this extra-large roof is surrounded by seven build-ings and is an in-between space that is neither public nor private. Six of these buildings are 8–10 floors, while the much-taller Bahntower at the eastern corner of the site is 103 m high. This slim semi-circular glass skyscraper marks the entrance to the complex at urban scale (in aerial view, for instance) but fails to do the same at human scale for pedestrians, mainly because of the ever-transparent shiny material

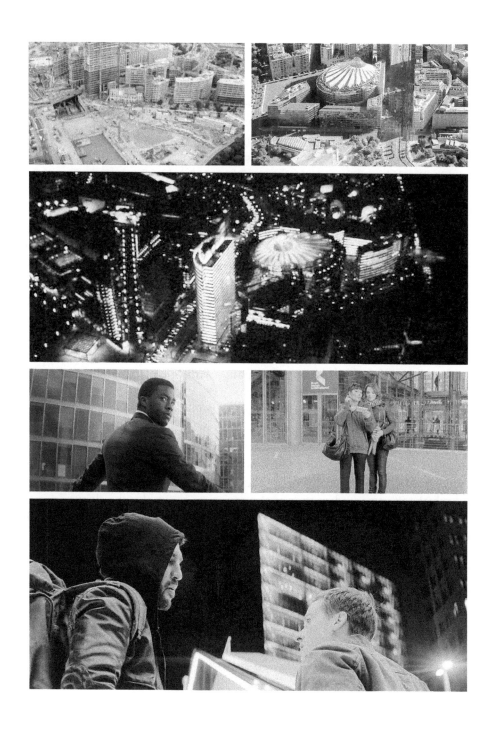

FIGURE 3.2: The Sony Center in *Berlin Babylon* (2001), *Off Course* (2015), *Bourne Supremacy* (2004), *Captain America: Civil War* (2016), *Passion* (2012) and *Who Am I* (2014).

choice of the complex. A pre-war S-bahn sign for Potsdamer Platz is incorporated into the Sony Center's tower. Another sharp-angled building on the western side of the site contains Sony's own offices.[7]

In addition to the office space needed for Sony headquarters and many other companies, the centre provides a highly consumerist understanding of leisure and culture in the area. As early as 1999, sociologist Hartmut Häussermann called it 'a new urban entertainment center [...] being built by Sony Enterprises as a European pilot project' (1999: 181). Locals and tourists alike go there to dine, drink, meet friends, have a coffee, catch a 3D movie or a Berlinale film, visit the *Deutsche Kinemathek* or purchase a book from the museum's gift shop. Jahn aimed to create a forum in this historical hub of the city, and although the complex does emulate the busy life of 1920s Potsdamer Platz, in the end, it is private property and not public space. The Sony Center 'resembles an American-style mall and entertainment center' (Ladd 2000: 9), a sign of the triumph of the global American/capitalist mode and actually a memory-erasure of the previous century.

As in similar mix-use building complexes, the lower floors of the Sony Center are designed for semi-public commercial functions such as restaurants and shops, whereas the upper semi-private/private floors are for offices and apartments. Residential accommodation was a requirement of Potsdamer Platz's master plan. The housing block on *Bellevuestrasse*, named 'Esplanade Residences', is suspended on a steel bridge above the original remains of the Hotel Esplanade (1908) and contains 134 condominium apartments and 60 rental units entered via a lobby that used to be the entrance of the historical building.

The Esplanade Hotel was part of Berlin's social life in the early twentieth century, and its importance comes from the fact that it was one of the few surviving structures in Potsdamer Platz following the Second World War. After the fall of the Berlin Wall and before the planning of Potsdamer Platz, the ruined building was listed as a historical monument (1990), a fact not taken too seriously in Jahn's initial design for the Sony Center. The architect intended to keep the hotel's main façade on *Bellevuestrasse* solely as a decor for the apartment building, therefore demolishing all the other hotel spaces that survived. Sony's contract with the state clearly stated the preservation and integration of the historical building into the new scheme (1992). There were also protests against the demolition of the Esplanade. At that point, Jahn started to search for and implement innovative ways to keep 'some more' of the remains without altering his design too much. In 1996, the Emperor's Hall (*Kaisersaal*) was relocated by moving the whole building almost 75 m in one piece. (This was also necessary for the road construction: part of the *Kaisersaal* was in the way.[8]) The Breakfast Room of the hotel was deconstructed, relocated and reconstructed as part of one of the restaurants in the atrium. Two of its decorated walls were not relocated

and are displayed separately behind clear glass like expensive antiques on sale in a shop window, adding to the staging of the Hotel Esplanade within the new centre. Ward agrees: 'the form of the frame, which at Potsdamer Platz includes the use of display glass and signage, gives the objects the particular status of the antique' (2016: 146).

It seems like Helmut Jahn 'eliminates the inessentials' and includes the past into his designs only if he must. Bits and pieces of a listed hotel stand in rather unfortunate means within the premises of the Sony Center only after being shuffled to fit his new picture, as in the case of the highly decorated *Kaisersaal*. The architectural attention paid to the Sony Center during its construction almost suddenly disappeared following its completion. Since the 2000s, it has not been a place that Berliners regularly visit. One wonders which version holds a stronger urban memory in Berliners' minds: Jahn's atrium or Wenders' wasteland.

Spreebogen

I think that you should quit [the bomb disposal unit]and start designing the newer, the greater, and grander Germany.

Karl in *Ten Seconds to Hell* (1959)

With the 20 June 1991 decision to make Berlin the capital city of reunited Germany, a need arose for locations to accommodate most of the existing ministries and governmental offices that would be moving from the provisional West German capital of Bonn.[9] In the autumn of 1991, the Berlin Senate carried out a preparatory investigation resulting in the identification of three potential locations for the development of a new government district in Berlin: the area northwest of the Reichstag (Parliament) building, the *Wilhelmstrasse* corridor and a section of *Leipziger Strasse* with the southern *Spreeinsel* (Spree Island). In the end, all three areas were chosen to be developed. Due to the Second World War destruction and a lack of development following the construction of the Berlin Wall, the Reichstag location, known as the *Spreebogen*, was relatively empty.[10] For this reason, it was chosen over the other two locations to be the site of new buildings, whereas a policy of 'adapting to the inventory' was pursued along *Wilhelmstrasse*, *Leipziger Strasse* and the *Spreeinsel*.[11]

Already on the *Spreebogen* site was the Reichstag building, designed by Paul Wallot and completed in 1894. Throughout the twentieth century, this area had already been subject to many design analyses. In 1908, the city of Berlin held an architectural competition to find 'a unified, generous solution for the transportation requirements [of the city] and also for beauty, public health and economic efficiency' (Sonne 2004: 285). While the first place winner Hermann Jansen proposed

to represent Berlin as a uniform and democratic metropolis, similar to Daniel Burnham's 1909 Plan for Chicago, other entrants, such as fourth place winner Bruno Möhring, unequivocally stated their imperialist intentions with a 'Forum of the Empire', suggestively counter-balancing the Reichstag with a proposed War Ministry, Imperial Naval Office and Imperial Colonial Office. None of the 27 submissions to this competition were ever carried out.

By the time of the Weimar Republic, ministry buildings had already been constructed along the Wilhelmstrasse corridor, southeast of the *Spreebogen*, which only supplemented the distribution of governmental functions throughout the city rather than concentrating them. Believing that the centre of Berlin should lie solely on the *Spreebogen*, architects at this time advocated proposals such as gathering ministries on a north-south axis (Martin Mächler) or a centralized cluster of ministries around the Reichstag (Otto Kohtz). In 1926, the name of the square in front of the Reichstag was changed from *Königsplatz* ('King's Square') to a more egalitarian *Platz der Republik* or Republic Square. One year later, at the Great Art Exhibition of Berlin, several architects of the avant-garde *Der Ring* group presented *Spreebogen* schemes to reflect this change in name. Hugo Häring proposed a governmental district with high-rise slabs, turning the area in front of the Reichstag into a 'Forum of the German Republic' surrounded with grandstands to hold throngs of viewers for public events. Hans Poelzig suggested low-rise uniform blocks that turned the *Platz der Republik* into a well-defined open urban space. None of these ideas ever came to fruition.

A 1929 competition for an addition to the Reichstag that also asked entrants to take the *Platz der Republik* into consideration was launched, with city planner Martin Wagner explicitly stating the competition's goals: 'The new democracy still needs to develop its own design consciousness' (Sonne 2004: 289). Hans Poelzig again proposed identical cubic blocks, but in a more radical manner than his 1927 proposal because the Alsen neighbourhood to the north was to be demolished, opening up the square to the Spree River. Hugo Häring did not officially submit an entry to this competition but did produce a re-working of his 1927 proposal to orient the grandstands towards the Reichstag building, symbolically making 'the people' oversee the parliament. The financial situation of the Weimar Republic could never allow any of these plans to materialize.

During the National Socialist years, governmental buildings were still concentrated on the north-south *Wilhelmstrasse* corridor, with the Nazi Party constructing more ministries, adding onto existing ones and also erecting new buildings. The *Spreebogen* area was planned to be the focus of a monumental 120 m-wide and 5 km-long north-south axis, similar to Martin Mächler's proposal of 1920. The northern terminus of this axis, called Avenue of the

Splendours, was to be a massive People's Hall six times larger than the *Reichstag* building.[12] In his memoires, Hitler's architect Albert Speer ([1969] 1970: 74) described it this way:

> On the northern side, near the Reichstag, [Hitler] wanted a huge meeting hall, a domed structure into which St. Peter's Cathedral in Rome would have fitted several times over. The diameter of the dome was to be eight hundred twenty-five feet [250 m]. Beneath it, in an area of approximately four hundred and ten thousand square feet [38,000 m²], there would be room for more than a hundred and fifty thousand persons to assemble standing.

The Victory Column, Hohenzollern sculptures and the other memorials in front of the Reichstag were all to be relocated to allow for a Grand Plaza at the foot of the People's Hall. Framed by a Leader's Palace and Army High Command Headquarters, this public space would have been large enough to hold 1 million people (Schäche 1995: 583). Between the People's Hall and the river to the north, buildings for the German Navy, Berlin City Council and a Police Headquarters were also planned, underlining the theme of state and civic control through urban planning. The Avenue of the Splendours would contain a 100-m triumphal arch in the middle and terminate on its southern end with a new central train station. 'The idea was that as soon as [state visitors], as well as ordinary travelers, stepped out of the station they would be overwhelmed, or rather stunned, by the urban scene and thus the power of the Reich' (Speer [1969] 1970: 134–35).

These redevelopment plans, which Hitler named 'Germania', would have shifted the symbol of power away from *Wilhelmstrasse*, but not surprisingly, most of them did not materialize except the relocation of the Victory Column and memorials, leaving a re-named *Königsplatz* in front of the Reichstag building largely empty.[13] Together with the decaying Reichstag, which, after a fire, had been purposely left as a ruin by the Nazis during their reign, the area was a virtual wasteland following the Second World War. In 1949, with the division of the country into East Germany and West Germany and the construction of the Berlin Wall immediately to the east of the Reichstag building in 1961, the *Spreebogen* area of Berlin was largely ignored.

A 1957 architectural competition entitled 'Capital City Berlin' did in fact suggest to entrants that a governmental district be established in the *Spreebogen* area, which was reflected in a 1965 West Berlin zoning plan that proposed Republic Square for this purpose, but given the precarious and divisive political situation at the time, this idea was quite unrealistic – until the reunification of Germany. In 1992, the Berlin Senate Department for Urban Development and Housing

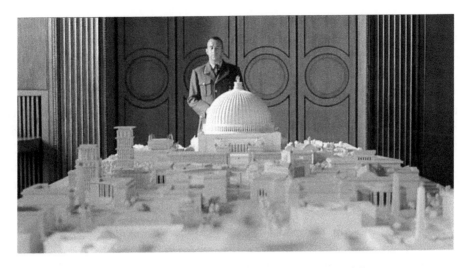

FIGURE 3.3: Albert Speer surveying his model of Germania in *Downfall* (2004).

announced the Spreebogen International Urban Planning Ideas Competition, to which 835 entries were submitted.[14]

While in theory, entrants to the 1992 competition were designing for a site that was physically devoid of any structures, the site was not without a symbolic history and memory, as can be seen from the proposals of 1908, 1920, 1927, 1929, the 1930s Nazi era, 1957 and 1965. There were imperial connotations that rendered the area subordinate to the power represented by the Berlin City Palace further east (demolished in 1950). There were Nazi vestiges like the ruined *Reichstag* (which would be soon renovated) and Speer's design for Germania, featuring a prominent north-south axis. Lastly, the scar left by the Berlin Wall was a reminder of the 1949–89 division and the Cold War.

Berlin architects Axel Schultes and Charlotte Frank won the 1992 competition, proposing an east-west axis that they called *Band des Bundes* ('Federal Ribbon or Federal Belt'). The original name of Schultes and Frank's proposal, *Spur des Bandes* ('Federal Trace'), was perhaps changed because it acknowledged the memory of the past on the site. Their design, consisting of a linear series of buildings, stretched from the opposite side of the Spree river in Moabit in the west, through the *Spreebogen* area, and then across the river again, as far east as the Friedrichstrasse Train Station. Since the former east-west border in this location was also the Spree River, Schultes and Frank were literally tying together the two former halves of the city, like 'a gigantic girder or truss repairing the fissures of a metropolis torn asunder by decades of East-West conflict' (Wise 1998: 62) as they 'let the chain of federal buildings benefit from the meander of this spacious town-landscape'.[15]

In Siegert's *Berlin Babylon*, the Berlin Senate Director of Building Barbara Jakubeit claims that Schultes and Frank's scheme 'was the only design that broke with the historical pattern to create an architectural bridging effect' (2001). According to journalist Michael Wise (1998: 61), although several entries did stray away from creating an east-west axis,[16] 'Speer's ghost haunted the jury deliberations, so only schemes with an east-west axis were seriously considered by German members of the jury'. Indeed, Schultes has unequivocally described their *Band des Bundes* proposal as cutting through the axial planning of Speer, with a 'built-up' stroke.[17]

The other ghost haunting these new *Spreebogen* buildings was Speer's New Reich Chancellery. In complete opposition to the way that building made

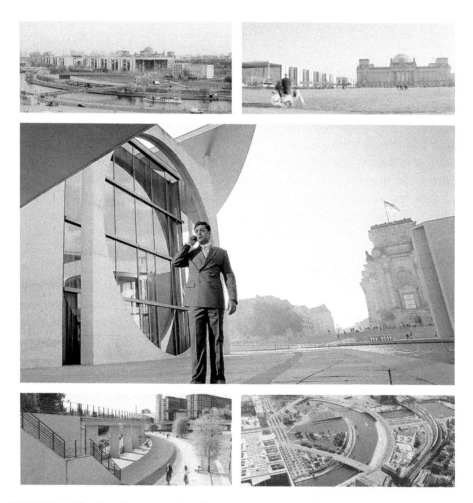

FIGURE 3.4: The *Spreebogen* area in *Off Course* (2015), *Charlie's Angels* (2019), *Don 2 – The Chase Continues* (2011), *Ninja Assassin* (2009) and *The Berlin File* (2013).

visitors seem uncomfortable and almost humiliated, Schultes and Frank's building attempts to be inclusive and democratic by way of its literal transparency. However, in the end, since the *Spreebogen* buildings are governmental properties, they are still well-guarded and fortress-like, regardless of all their glass.[18]

Within the spectrum of urban strategies, Schultes and Frank's *Spreebogen* scheme was new construction. The design was oblivious to the previous footprint of the historical *Königplatz/Platz der Republik* in front of the Reichstag building as well as the former Alsen neighbourhood to the north, as can be seen in an aerial shot of a train arriving to Berlin's new Hauptbahnhof in Seung-wan Ryoo's *The Berlin File* (2013). The scheme, however, was not oblivious to the heritage of previous plans on the site, both large and small, which proposed a north-south axis. The design set out to build something new for the new country, albeit weighed-down with old hang-ups.

Schultes and Franke's scheme has allowed for the rewriting of the memory of the area. Seen in Farhan Akhtar's Bollywood action-thriller *Don 2 – The Chase Continues* (2011), the *Spreebogen* buildings are grand gestures opposite the Reichstag framing the intriguing espionage plotline of the film. In *Captain America: Civil War* (2016), a more fortified version of the *Spreebogen* buildings is used to represent a menacing high-security prison. Conversely, in both James McTeigue's *Ninja Assassin* (2009) and Christian Petzold's *Undine* (2020), the new construction of the *Spreebogen* acts as anonymous background architecture rather than mega-starchitecture. The Interpol officers of *Ninja Assassin*, fearing for their lives because of their current investigation, choose to meet at the *Spreebogen* riverside park in order to appear as a casual coincidence outside of the office, and the lovers of *Undine* stroll around the complex arm-in-arm, more concerned with their budding relationship than the urban history of the area, despite of (or because of?) one of them being a historian specializing in Berlin.

In Berlin, the reunification of the two Germanys in 1990 has been interpreted as the beginning of an era of reconstruction. The merge of the two halves of Berlin, for instance along the threshold defined by the former Wall, has been used as an excuse to treat empty sites, plots and districts as blank canvases to re-plan, re-divide and build from scratch for monetary, capital or political gain, often without considering the implications on urban history and memory. This ignorant attitude has caused more damage and scarring in Berlin in the post-Wall period. Small gestures like keeping bits and pieces of the Hotel Esplanade, having a plaque here and there and bringing back GDR traffic lights nowhere near balance out the damage new construction have caused to the urban memory of Berlin. The sensitivity shown to design the already vacant site of the government district differently from the unrealized previous plans, especially Nazi plans,

did not exist for Potsdamer Platz and many other areas including *Kreuzberg*, the *Hansaviertel* and *Nollendorfplatz*. As a result, inconsiderate new construction with its generic glazed facades that could be anywhere in the world has aided the erasure of urban memory, at times at a higher level than demolition. The appearance of Critical Reconstruction was a direct reaction to the prevalence of these glass buildings.

Berlin's temporary installations naturally do not exist today, unless they have popped up recently. They have served their purpose to clear the way for new memories when needed. Similarly, what stood on certain sites in Berlin in the past before any new construction is unknown to a young Berliner or a newcomer to the city. These structures disconnect Berlin from its former recollections in an attempt to create a *tabula rasa* later filled with new, brighter and modern memories. History is included in this high-tech painting only if compulsory – if the building is historically listed – and after being shuffled to fit the new picture. Paradoxically, temporary installations support the growth of urban memory while new construction may suppress, hinder or disable it. It goes without saying that cities, by all means, need to change and evolve. As they adjust to new situations, careful consideration of the long-term influence of the modifications needs to be assessed from a cultural perspective, not just a financial one, since, as a social species, humans exist and survive with their aged stories that are enhanced with physical reminders.

NOTES

1. This means 'life is a construction site' but the film was released as *Life Is All You Get*.
2. *Berlin Babylon* should not be confused with *Babylon Berlin* (2017–present), a TV series created by Henk Handloegten, Tom Tykwer and Achim von Borries, which is set in the 'Golden Twenties' between the world wars.
3. Regardless of its dynamic and varied forms and high-tech architecture, the choice of materials for the Sony Center is rather ordinary, mainly steel and glass, as in many Jahn buildings. The complex is fairly fragmented with many buildings and numerous transparent surfaces that reflect light. They have a shiny look, and despite being much smaller than the slender Bahntower, for someone standing close to the site, the buildings seem fairly high. This is also true with the large atrium in the middle. It is tall, airy, colourful, and shiny day and night whereas the introverted complex with its multiple pedestrian-only passages into the atrium feels porous and permeable. These passages and the atrium are crowded and busy resembling the hustle and bustle of Potsdamer Platz between the two wars. Jahn favoured and managed to create an outdoor experience.
4. Italics by the authors, https://www.jahn-us.com/helmut-jahn (last accessed 11 May 2020).

5. 'Kersale's vision was to have clear glass and translucent fabric reflecting the daylight as well as the moonlight in a very extraordinary way. In his concept the transparent structure of the roof serves as a projection surface for the changing light. The colors alternate from cyan to magenta, in order to represent the sunset. [...] A sequence of this streaming play of colors lasts about 21 seconds and repeats itself without interruption until late at night' (https://www.sonycenter.de, last accessed 11 May 2020).

6. More information about the structure of the roof by Arup is available at https://www.arup.com/projects/sony-centre (last accessed 19 March 2021).

7. The initial plan was for Sony to occupy the tower but then it was leased to Deutsche Bahn AG, Germany's railway company.

8. https://www.stadtentwicklung.berlin.de/planen/staedtebau-projekte/leipziger_platz/pix/planungen/koordinierungsbebauungsplan_600px.jpg (last accessed 4 July 2020).

9. From the perspective of 30 years later, it is interesting that the move from Bonn to Berlin almost did not happen: the vote was 338 'for' and 320 'against'. This was yet another turning point in the complicated history of Berlin.

10. The German *Spreebogen* can be translated variously as 'Spree Bow', 'Spree Arc' or 'Spree Bend', none of which work well in English. For this reason, the authors use the term *Spreebogen* when referring to this area.

11. https://www.stadtentwicklung.berlin.de/planen/hauptstadt/dokumentation/en/herausforderung/neuanfang.shtml (last accessed 14 December 2020). Despite the stated policy of 'adapting to the inventory', this webpage does reluctantly acknowledge 'Several prominent buildings from the GDR's legacy nonetheless remained on the list of buildings to be torn down: the Palast der Republik and the Foreign Ministry'.

12. The People's Hall was also called the Great Hall and Hall of Glory. The dome of the People's Hall was to be 290 m high, as compared with the *Reichstag* height of 47 m.

13. In 1941, Speer erected a 12,000-metric ton structure to test the marshy ground at the proposed location for Germania's triumphal arch. This 'heavy load-bearing body' (*Schwerbelastungskörper)* still exists today at General-Pape-Straße 100 and has been a historically listed structure since 1995. It can be toured and is 'primarily a source of information which aims to encourage critical engagement with National Socialism', https://www.visit-berlin.de/en/schwerbelastungskorper-heavy-load-bearing-body (last accessed 28 March 2021). See also: https://www.schwerbelastungskoerper.de (last accessed 28 March 2021).

14. There were other competitions held for the landscaping of the *Spreebogen* area, the Lehrter Bahnhof/Hauptbahnhof Quarter buildings and landscaping (north, across the Spree River), the train station's forecourt and a temporary public space for the *Stadtschloss* area required after the demolition of the Palace of the Republic.

15. https://www.schultesfrank.de/en/portfolio_page/spreebogen-concept (last accessed 15 December 2020).

16. Most notably Dagmar Richter, Morphosis, Smith-Miller+Hawkinson, Andrew Zago, Daniel Libeskind, and Mark Angelli and Sarah Graham. See Richter (1996) for more information.

17. http://www.stadtentwicklung.berlin.de/planen/hauptstadt/dokumentation/en/wettbewerbe/ spreebogen_staedtebau.shtml (last accessed 14 December 2020).

18. Despite its favourable reception, Schultes and Frank's *Band des Bundes* proposal was not fully realized. The completed eastern section does not reach *Friedrichstrasse* as planned, the centrally located Civic Forum was never built, and the architects themselves were only assigned one of the three buildings in the complex – the Federal Chancellery (*Bundeskanzleramt*). Architect Stephan Braunfels was commissioned to design the other two.

Hanna (2011)

4

Business or Pleasure?: Disneyfication

I want to live in the West [...] it's more interesting, more opportunities. Everything is more modern, like in the advertisements.
Uschi in *A Berlin Romance* (1956)

'Sometimes the things we feel most attracted to are those we once aspired to and never had, architecture that exists, you might say, in the memory of dreams. On this notion Walt Disney invented Disneyland and built an empire' (Goldberger, 2009: 141–42). The term Disneyfication is derived from the theming practices perfected by the Disney Corporation during the second half of the twentieth century, but can also be applied to experiences outside of Disney theme parks, hotels, cruise lines and other such themed environments.[1] Disneyfication is the process of presenting or staging an experience or urban condition through simulation, thereby imitating reality without the audience knowing or sometimes even caring. This urban strategy legitimately functions in the process of memory-making by creating authentic memories from simulated environments. The 'cleaning up' and transformation of New York's Times Square in the 1980s, for instance, has been described as a process of Disneyfication which made theatre, bright lights and urban hustle and bustle a theme for the area.

Disneyfication arises specifically to cater for visitors to the city, but not necessarily for its residents. It influences the branding of the city, and therefore how it is to be remembered, in the highly competitive international context of urban tourism. Disneyfication is a conscious effort to attract guests to a city by presenting an image that they seek. Disneyfication deceives – the appearance of what it offers does not match with its substance. That is, with Disneyfication, you leave the world of reality for the world of fantasy. Because it can happen anywhere, it is not bound to an actual, physical location – Disneyfication is rootless.

In divided Berlin, East Germany created its own attempt at Disneyfication with the establishment of the *Kulturpark* amusement park in the Berlin district of Treptow-Köpenick in 1969. Containing fairground rides imported from non-socialist countries, 'Failed Architecture' blogger Jens Peter Kutz (2014) claims that the park was an integral part of East Germans' recreational activities for generations and 'deeply rooted in the collective consciousness of GDR citizens'. In 1991, the park was de-nationalized and a private entity called Spreepark was awarded a lease to run it. Following mismanagement and bankruptcy, this closed in 2002 and has been a wonderland of abandoned rides, fantasy sculptures, weeds and stagnant water, featured prominently in many films in the 2010s. In reunified Berlin, German scholar Professor Susanne Ledanff (2003: 36) describes the urban policy of Critical Reconstruction as Disneyfication and 'historicizing urbanity as an object of consumption'. In front of the graffiti-covered pieces of the Berlin Wall at the Potsdamer Platz metro entrance in the early 2010s, 'soldiers' stamped East German visas into passports – for a fee. This simulated action does not compare to the tension felt when the protagonist must cross the Wall in Guy Hamilton's *Funeral in Berlin* (1966). But it did not seem to matter to the tourists that Potsdamer Platz was never a crossing point between East and West Berlin. The free-standing pieces of the Wall seem to somehow justify and validate the scene, despite the fact that they are spaced apart from each other like stelae, rather than actually making a non-permeable barrier. Themed touristic activities such as this are Disneyfication acts based on entertainment experiences unbound to authentic locations.

Checkpoint Charlie

Stasi Agent: You are constantly trying to cross the border, either from East to West or from West to East. Where do you really want to be?
Arnulf: On the other side.

The Man on the Wall (1982)

A contemporary visit to the authentic site of Checkpoint Charlie, at a busy crossroads in the heart of contemporary Berlin, says little about what the border crossing point for foreigners between the American and Soviet sectors of the city was physically and mentally like during the Cold War.[2] Anything that was there – the Wall, the deathstrip, the watchtower and other barriers – is long gone and a guardhouse (supposedly for American soldiers who left three decades ago taking their original guardhouse with them) sits in the middle of the busy inner-city street on Friedrichstrasse between Peter Eisenman's IBA 87 Housing with the Wall Museum (1985–86) and OMA's IBA 87 Housing at Checkpoint Charlie (1987–89).[3] In the background are souvenir shops

marketing the Wall, fast food chains like McDonald's and KFC, sightseeing buses and numerous tourists in a carnival-like setting taking pictures with 'the soldiers' in front of *a* guardhouse. Elevated and lit-up, back-to-back photographs of a young Russian soldier facing West and an American soldier facing East, both larger than lifesize, is a 1998 artwork by Frank Thiel entitled, 'Without Title (Light Boxes)'. A replica of one of Berlin's most celebrated post-war signs, reading 'You are leaving the American Sector', completes Checkpoint Charlie's theme park.

The Woman from Checkpoint Charlie (2007) tells a different story. Miguel Alexandre's two-partite film represents the crossing point in the 1980s as a highly enclosed and dangerous territory (via a film set that is conceptually, rather than physically, authentic). Much of the 'other' side is blocked by the Wall and a watchtower that housed GDR soldiers following every move. The film tells the true story of Jutta Gallus, who attempted to flee East Berlin with her daughters in 1982, was caught and imprisoned for two years and then sent to West Berlin without her children. In the film, she tries to get the attention of the authorities and the international press by regularly demonstrating at Checkpoint Charlie throughout the late 1980s with a sign hanging around her neck stating 'Give me my children back!'. Although the physical resemblance to the real Checkpoint Charlie at that time can be questioned, the feelings that are revealed to the audience are to the point: the pain of separation, hopelessness, longing and desperation, especially one night when she goes there and crosses the line into the deathstrip risking to be shot. On a personal level, Checkpoint Charlie in this film represents such feelings for Alexandre's audience.

On a much larger scale, the situation was no different. The strong polarization of the Cold War worldwide, with the NATO Alliance on one side and the Warsaw Pact on the other, materialized in divided Berlin ever since the late 1940s. The two treaties were side by side but physically separated by the Wall, and the pressure point where a flow of diplomats and international visitors occurred was Checkpoint Charlie.[4] Despite its relatively small size, the American guardhouse at this legendary crossing location represented this dark past loaded with political and military tension and, in the words of political scientist Maja Zehfuss (2007: 76), the 'wounds of memory'.

With the construction of the Berlin Wall, the checkpoints between the Soviet sector and British, French and American sectors immediately changed from the result of an informal agreement between the occupying forces to being a highly structured and regimented process. The locations of these checkpoints were street intersections, not chosen for their facilities, which had to be constructed later, but for their position (access to a particular area and/or spaced apart from one another). With the building of the Berlin Wall, these checkpoints symbolically represented the fundamental clash of the Cold War: Capitalism versus Marxism and/or democracy versus socialism.

This was specifically true at Checkpoint Charlie. Located at Friedrichstrasse and Zimmerstrasse in central Berlin, this intersection was the site of much tension,

especially on 25–28 October 1961 when American and Soviet tanks confronted each other on either side of the border. This 'tank duel' brought international geopolitics close to the threat of a nuclear war. From that moment on, Checkpoint Charlie had been appropriated as a symbol of the Cold War conflict and its stalemate (Garthoff 1991: 149).

As a symbol of the Cold War, Checkpoint Charlie is often featured in spy movies from the era, for instance, Martin Ritt's *The Spy Who Came in from the Cold* (1965), based on John le Carré's 1963 bestseller novel with the same title, and John Glen's James Bond movie *Octopussy* (1983). Ritt's film opens and closes with dark and intensified scenes of the Berlin Wall at night, the former being at Checkpoint Charlie.

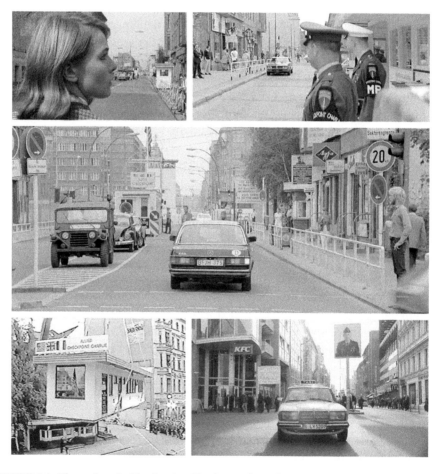

FIGURE 4.1: The authentic Checkpoint Charlie in *Playgirl* (1966), *A Dandy in Aspic* (1968), *Octopussy* (1983), *Checkpoint Charlie Closure* (1990) and *Berlin, I Love You* (2019). (All illustrations are film stills captured by the authors.)

The carefully composed black-and-white frames of the US guardhouse, Soviet watch-tower and the deathstrip with curved light posts that illuminate the wet cobblestones are accompanied by introductory dialogue and classical music. The slow pace of a long and quiet wait dramatized in this studio-shot opening scene contrasts with the intensity of action and sirens at the end of it. This film, after all, is shot a few years after the Wall's construction and the start of the Cold War standoff right at that spot. Glen's film, on the other hand, treats Checkpoint Charlie as one of many border crossings. It is a prominent inner-city checkpoint that is shown in broad daylight as an almost-normal construct of urban living. If the audience does not know where the Wall is, they would not notice it. Due to its status as a tourist destination, non-spy movies set in Berlin between 1961 and 1989, such as Will Tremper's *Playgirl* (1966), also go out of their way to show Checkpoint Charlie, in this way making the site represent-ative of the city, similar to the Kaiser Wilhelm Memorial Church, Victory Column, Brandenburg Gate and the Reichstag.[5]

After almost three decades of non-stop 'service', the United States, United King-dom, France, Russia and Germany officially closed Checkpoint Charlie follow-ing the fall of the Berlin Wall, with a festive ceremony on 22 June 1990. The big gesture of the public event was the removal of the guardhouse like an oversized coffin floating in the air, as the band played Paul Lincke's 'Berlin Air' (*Berliner Luft*), the unofficial anthem of the city.[6] The temporary structure, first moved to McNair Barracks, now resides in the Allied Museum (*Alliierten Museum*) in Berlin. 'To the Berliners, this small piece of real estate was now part of the city's heritage' (MacGregor 2019). Referring to Checkpoint Charlie as the embodiment of the Cold War, US Secretary of State James Baker stated in the ceremony:

> 29 years after this barrier was built, we meet here today to dismantle it, and to bury the conflict that created it. And in its place, together, we pledge to build a bridge between East and West, a bridge not of cement and steel but a bridge of peace and a bridge of freedom.[7]

Surrounded today by private initiatives such as Wall Museum: House at Check-point Charlie (*Mauermuseum: Haus am Checkpoint Charlie*, 1962),[8] Asisi Berlin Panorama (2012),[9] BlackBox (2013)[10] and the VR tour of TimeRide Berlin (2019), this authentic site of memory remained empty after the removal of the Allied guard-house and open to interpretation and recreation 'in a state of becoming' (Bach 2017: 154).[11] 'Checkpoint Charlie is organized around [...] the interval between the erasure of the original space and its repurposing; [...] it becomes a space of anticipation, always waiting for something to happen' (Bach 2017: 154).

In 1998, the *Mauermuseum* installed a '(true to the original) copy of the sector sign "You are leaving the American sector" at its historical location' as the 'first

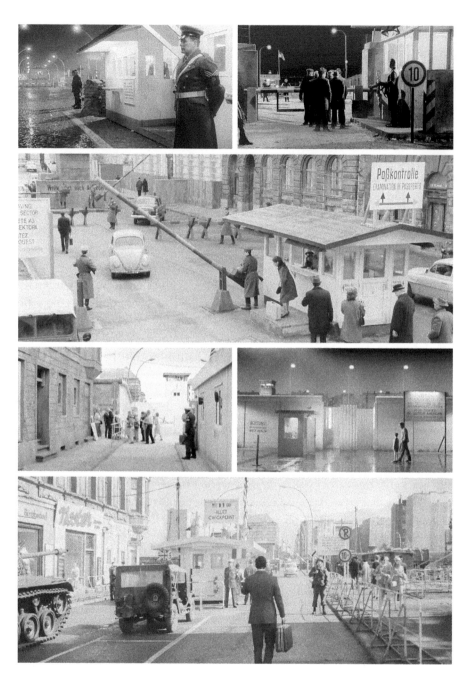

FIGURE 4.2: Simulated Checkpoint Charlies in *The Spy Who Came in from the Cold* (1965), *Confessions of a Dangerous Mind* (2002 – set in the 1960s), *The Debt* (2010 – set in 1965), *The Woman from Checkpoint Charlie* (2007 – set in the 1980s), *Sources of Life* (2013 – set in the 1980s) and *The Man from U.N.C.L.E.* (2015 – set in the 1980s).

step toward giving Checkpoint Charlie a face again', as the museum website claims.[12] Ten years after the celebratory removal of the legendary guardhouse and its original sign, the museum commissioned a replica of the first guardhouse made and installed at its prospective location in 2000. Till refers to American tourists who 'make the pilgrimage to Checkpoint Charlie' (2005: 26), which is treated like a Disney theme park rather than a memorial. Unbeknownst to most visitors that the guardhouse and sign are replicas,[13] tourists also pose for photographs with so-called soldiers in military uniforms located on the site, although this has been officially banned since 2019.[14] 'Checkpoint Charlie connects to the global experience economy, linking consumption to experience and turning the memory of the experience into the product' (Bach 2017: 168). In this way, both Checkpoint Charlie and its memory are transformed and Disneyfied. Surrounded by touristy consumption of food and sale of souvenirs, not much is authentic in this context. A Big Mac and a piece of the Wall are purchased and consumed in the same way:

> Most everything else is 'false': the iconic U.S. guardhouse, complete with sandbags, and the 'Leaving the American Sector' sign are replicas, the huge pop art paintings across the street are recent creations by international artists on wall segments from other parts of the wall, and the military regalia and ubiquitous small wall pieces sold as souvenirs are untraceable and widely considered fake. The American and Soviet soldiers in front of the guardhouse replica are, of course, actors (often students and, famously, at one point, strippers), who pose for photos for money.
>
> (Bach 2017: 155)

The time between the original guardhouse's removal (1990) and the fake guardhouse's installation (2000) was a lost opportunity for the urban memory of Berlin. This time could have been used to 'imagine' a reminder of peace that was in the future, rather than war that was in the past. Even before the fall of the Wall, Berlin-based artist Emanuel Dion proposed an 8 m tall sculpture for this purpose with two interlocking bridges representing the intention to meet and balance. Entitled 'Bridges of Life' (*Brücken des Lebens*, 1979–83), similar to James Baker's referral to building bridges, this Berlin memorial for political and social balance to be achieved via 'the destruction and reconstruction of the center of Berlin' was designed for Checkpoint Charlie (Dion 1991: 512–13, based on a report he wrote in 1987):

> Checkpoint Charlie [is] in the midst of the historical capital Berlin, the point of intersection between East and West as well as North and South, of Berlin, of Germany and of Europe – a crossroads of worlds. [...] Although I doubt that this site could become an exterritorial or neutral area, it [...] could be a meeting place for people of the divided town and divided nation. [...] For the first time in history a fully

functioning military facility with the highest standards of military technology could be exchanged for an artwork, a work embodying the idea of a balance between East and West and therefore the idea of peace.

An art installation did take place at Checkpoint Charlie in 2004. However, rather than proposing an original, connective and progressive piece like Emanuel Dion's sculpture, it followed the attitude of using replicas, and in this case, a fake graveyard beside a fake Berlin Wall in the wrong location. Privately sponsored by the *Mauermuseum*, Alexandra Hildebrandt's political piece consisted of 1065 wooden crosses painted black, bearing the names of the victims of the GDR border regime, on white gravel bordered with randomly collected pieces of the Berlin Wall with mismatched graffiti on adjacent vacant sites at the intersection of *Friedrichstrasse* and *Zimmerstrasse*.[15] Hildebrandt leased the privately owned sites from BAG banking group for three months and built a wall using 120 relocated pieces, but plastered and painted them white, and improperly positioned them not on the original location of the Wall. The installation, despite having honourable intentions and welcomed by passers-by and tourists (Liebhart 2007: 267), was an oversimplified, inaccurately treated freestanding wall without the rest of the wall system (deathstrip, watchtowers, etc.). Therefore, it provided a dramatic almost Expressionist, look, but a mystified and distorted memory. Though some GDR victims and tourism professionals guarded the installation, it was generally criticized for its lack of authenticity and historical accuracy of location, materiality and commemoration (Schlör 2006: 88). While the numerous tall crosses planted in the ground were artistically admirable, the fabricated wall was criticized as 'Wall-Disney', or 'a "Disneyland version" of a murderous barrier' (McStotts 2006: 40, 46). The final mayor of West Berlin, Walter Momper stated, 'The wall was an instrument of murder, not a tourist attraction. There are a few places in Berlin where the wall is still standing. They are authentic – everything else is Disneyland' (Paterson 2004). After eight months, the art installation was removed in 2005 by court order because its lease had expired. It failed to be a convincing commemoration 'because it "falsified reality" and in doing so failed to emphasize the most appropriate cultural resource values inherent in the site' (McStotts 2006: 45).

Checkpoint Charlie did eventually turn into a neutral area, a meeting point like Emanuel Dion envisioned but did not bring East and West Germans together. Instead, it has attracted international tourists through the Disneyfication of its dark past. 'Empirical questions about memory and materiality are embedded in ques-tions about the relation of space and time: to be made visible as a symbol of time past, a site requires emplacement in a spatiotemporal relationship to the present' (Bach 2017: 137). In this context, both the dematerialization of the Checkpoint Charlie guardhouse and its rematerialization supported the preservation of the site of memory. But asking 'what' to do there was not enough; the next question

could have been 'how' to do it. The reaction to this second question needed to be a new cultural response looking forward with the memories of the past at hand, rather than a fake military response looking back to the mistakes of humankind.

In the case of Checkpoint Charlie, Disneyfication is about the consumption of historical, cultural and touristic services and products. The popular environment of Charlie's theme park is nourished with the history and memory of the Second World War, the Cold War, divided Berlin and the Berlin Wall. Cultural tourism, such as visiting an exhibition and taking a virtual reality tour, is interlinked with buying Berlin souvenirs or ordering a favourite burger menu combination. The Wall Museum shop, and other souvenir shops, provide copyrighted merchandise such as certified 'original' vintage wall pieces (chipped off last year, not in 1989/90) with 'fake' new paint.[16] Finally, costumed Berliners pretending to be American MPs from the 1970s or 1980s salute smartphones and perform their best smiles in front of the made-up guardhouse for a tip. The Disneyfied Checkpoint Charlie, unregulated by authorities, offers the full package of experiential consumption and touristic extravaganza.

Berliner Stadtschloss

In the centre of Berlin now stands a museum built in the twenty-first century in the form of an eighteenth-century ruler's palace. The deceptive part lies in the hypothesis that this makes no real difference, which is the same as claiming that progress is impossible.

Historian Undine Wibeau in *Undine* (2020)

A curious temporary exhibition filled the parking lot in front of the then still-standing Palace of the Republic in 1993. Plastic sheeting was installed over metal scaffolding supplied by steel producer Thyssen. French artist Catherine Feff, known for her large-scale *trompe l'oeil* installations, painted the façade of the Berlin City Palace (*Berliner Stadtschloss* or *Schloss*, 1689–1845) onto this sheeting, according to a design by historian Goerd Peschken and architect Frank Augustin. Since the installation was located exactly where the *Schloss* walls used to be, it effectively simulated the massing of the former imperial palace, which had not existed on that site since its demolition by the GDR authorities in 1950.

The proposed reconstruction of the Berlin City Palace was closely intertwined with the debate on the demolition of the Palace of the Republic. Those in favour of the *Schloss* reconstruction were also frequently in favour of the *Palast* demolition. The public discussion about these two topics dragged on for over twenty years, between the first proposal for a replica *Schloss* by *Frankfurter Allgemeine Zeitung* culture editor Joachim Fest in November 1990 and the eventual demolition of the *Palast* in 2008, to the new *Schloss* ground-breaking ceremony in June

2012. As summarized by Ladd, 'A look at the arguments [for Schloss reconstruction] reveals several issues at stake, but these issues – architectural aesthetics, urban form, civic and national identity, historical preservation, historical justice – were hopelessly intertwined with one another' (1998: 60).

The intricate details of the *Schloss* controversy have been very well documented in many publications.[17] The intention of this case study is to address the issues of (1) the argument that the palace was a historically and architecturally significant building and therefore worth reconstructing, (2) replicating only the exterior facades of the building, (3) using the reconstruction as an excuse to demolish another significant piece of architecture (as an attempt to erase GDR memories), (4) using the reconstruction to Disneyfy the Humboldt-Forum, and by doing so (5) creating false memories.

Proponents of a *Schloss* reconstruction framed the situation as filling in a gap or healing a wound in the city, a problem that would not have existed if 'Ulbricht's Crime' (Ledanff 2003: 45) had not occurred following the Second World War. Reunified Germany at this time was searching for architectural materializations of power, at the expense of erasing opposing materializations. To its proponents, a reconstructed *Schloss* seemed to provide this via a 'restorative nostalgia' that would 'rebuild a lost home and patch up memory gaps' (Boym 2001: 41). Opponents of the reconstruction of this imperial symbol countered most of their arguments in terms of the authenticity of a *Schloss* reconstruction, decrying such a project as 'absurd', 'irresponsible', 'an embarrassment', 'a clone', 'a patina of history', 'an empty invocation', 'an illusion of continuity', 'a phantom palace', 'a historico-political investment', 'a magically theatrical act' and a 'fake'.[18]

Returning to the 'Scaffold-Schloss' installation, it was only meant to last for 100 days, but because it provoked a public discussion of rebuilding the *Schloss*, it subsequently stayed up for about one year. 'For some, it was an image of something long gone; for others it represented something never seen; for still others it had the potential of something that might be' (Costabile-Heming 2017: 447). A pavilion inside the scaffolding contained a pro-monarchist exhibition about the history, destruction and possible reconstruction of the *Schloss*. This installation was paid for by Hamburg businessman Wilhelm von Boddien, who later spear-headed the *Schloss* reconstruction organization Friends of the Berlin City Palace. Although von Boddien never formally admitted that the intention of the 'Scaffold-Schloss' installation all along was to generate the public discussion that it did, ultimately, 'the façade that wrapped the scaffolding persuaded Berliners of the need for a real reconstruction' (Boym 2001: 193).

The most captivating element of the 'Scaffold-Schloss' installation was the way that the painted façade was reflected in the mirrored glass of the *Palast*, doubling the actual size of the *Schloss* that ever used to be there. Such a structure, whether

scaffolding or real stone, could have easily been kept like that along with the *Palast der Republik*, but that did not happen. The 'Scaffold-Schloss' installation can be easily determined to be the foundation stone for a reconstructed *Berliner Stadtschloss*.

Anticipating and reacting to the criticism of a *Schloss* reconstruction as inauthentic, von Boddien and the Friends of the Berlin City Palace addressed this issue multiple times, particularly in their free English publication *The Berliner Schloss Post* which was periodically issued to provide updates during the reconstruction. The fourteenth edition from March 2020, despite the project being near completion, still contained what can only be termed 'reconstruction justification' in the form of previously published articles.

One such March 2020 *Berliner Schloss Post* recycled article was by architectural historian Winfried Nerdinger entitled 'A copy is no fraud, a facsimile is no forgery, a replica no crime and a reconstruction no lie' from 2015. Under the mantra of 'Architects who reconstruct a lost or ruined building are not deceiving anybody, nor forging anything', the article also goes out of its way to list a multitude of architectural reconstructions throughout history.[19] Another 2015 rerun article worth mentioning in the issue was written by Franco Stella, winner of the 1993/94 architectural competition that prescribed the reconstruction of the north, south and west façades of the *Schloss*. Stella did not mince words, stating:

> To avoid any misunderstandings, let me stress that this will not be a case of manipulating history, of acting as if the palace had not been demolished, as if there had been no World War, no GDR and no Palace of the Republic. Rather it is about the concept and design per se being so in keeping that the building feels totally natural in its overall appearance and on this site. The building must be utterly credible.

After all the discussions, debates and arguments, the fact of the matter is that three façades of the eighteenth-century *Schloss* were copied/reconstructed/replicated to become a twenty-first-century building entitled the Humboldt-Forum. This building houses the Prussian Cultural Heritage Foundation's Ethnological Museum and Museum of Asian Art, the Central and State Library of Berlin and spaces for the Humboldt University of Berlin.

Schloss reconstruction advocate von Boddien cites the reconstruction of Dresden's *Frauenkirche* as a 'reputable and successful reconstruction' similar to his Humboldt-Forum project. However, that particular project, 1994–2005, was a grassroots effort by the people of Dresden, completely funded with private individual and corporate donations, and, except for the dome, utilized original stones that had been set aside and preserved after the war. In contrast, the *Schloss* reconstruction, despite some positive feedback after the 'Scaffold-Schloss' installation,

was not generally agreed upon by members of the public. In addition, it has been mostly funded by the German government and did not utilize any original material, not even the 'Liebknecht balcony' that was saved and incorporated into the GDR's Council of State building.

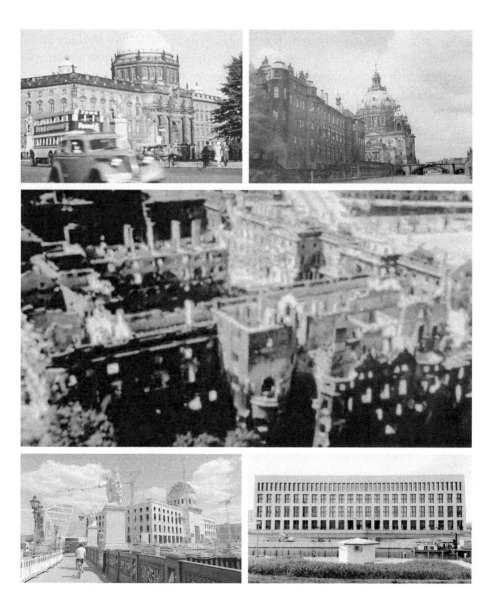

FIGURE 4.3: The *Berliner Stadtschloss* in *Capital of the Reich 1936* (1939), *Under the Bridges* (1944), *My Führer* (2007, with vintage footage from 1945), *Reconstruction of the Berlin City Palace* (2015) and *A Stroll in Berlin* (2020).

What is missing in von Boddien and the other *Schloss* reconstruction proponents' arguments is that just because the Humboldt-Forum is a reconstruction does not automatically make it a Disneyfication. If so, that would be the case with the other reconstructions that they cite such as Reims Cathedral, Warsaw Old Town, the *Frauenkirche* in Dresden and the Campanile in St. Mark's Square, Venice. These examples are not Disneyfication because they do not present themselves as 'real' but as 'replacements'. That is, these reconstructions do not strive to be anything else than newer versions of older structures.

The Humboldt-Forum (i.e. the reconstructed City Palace), on the other hand, is an example of Disneyfication because of the insistence of its proponents on the authenticity of the reconstruction, the fidelity of the materials and the painstaking accurateness of the details, to which many pages in *The Berliner Schloss Post* magazine are also devoted in each issue. Like *Main Street USA* in the various Disneylands around the world, the reconstructed *Stadtschloss* is 'a perverse form of wish fulfilment, a dream of happier days under the benevolent gaze of the palace: Disneyland has its fairy tale castle and Berlin will have its royal dome' (Dolgoy 2017: 318). Moreover, the area in front of the new building was named *Schlossplatz*, a nomenclature that never existed even when the original *Schloss* was standing. In the words of architect Josef Kleihues (1997), 'Reconstructions can make you forget instead of remember.'

This point, that the accuracy of the *Schloss* reconstruction paradoxically qualifies it for Disneyfication, was highlighted in June 2020 when a 21 m Christian cross replica was hoisted onto the reconstructed dome of the Humboldt-Forum. Proponents insist that the entire *Schloss* reconstruction project, including the cross, must be faithful to the original Berlin City Palace, and therefore reject any notion that, in order to more accurately represent the post-colonial multicultural diversity of contemporary Germany, a cross should not be on top of a governmental museum complex in the centre of its capital city. Especially criticized is the original inscription added in the 1840s by King Friedrich Wilhelm IV at the base of the dome, which urges all peoples to submit to Christianity.[20] The irony that a reconstructed imperial palace will hold the very same ethnographic collections that were collected by that empire is also lost on most of the proponents of the *Schloss* reconstruction.[21] The meticulous accuracy of the Humboldt-Forum's replicated facades also qualifies it as a Disneyfication because of the possibility of future visitors not even knowing that it is a reconstruction, a point echoed by both proponents and critics.[22] As pointed out in the film quote at the beginning of this case study, the reconstructed *Schloss* is a deception: a building claiming to be a mere reconstruction that is actually a rigorous replica of the original.

The *Stadtschloss* is known to twenty-first-century Berliners and Germans through paintings, models and postcards, most of which began to heavily

circulate after the 1993 'Scaffold-Schloss' installation. The GDR succeeded in suppressing the urban significance and memory of the *Schloss* through demolition and new construction. The *Schloss* reconstruction proponents' revival is based on an attempt to forget the 70-year stretch between the erasure of the *Schloss* in 1950 and the completion of a replica in 2020. As succinctly summarized by historian Joachim Fest, 'If the destruction of the *Schloss* was supposed to be a symbol of [Socialism's] victory, reconstruction would be a symbol of its failure' (Boym 2001: 184).

Nana Rebhan's documentary *Welcome Goodbye!* (2014) questions the Disneyfication of Berlin as a fashionable destination. When it comes to planning a European city break, the 'poor but sexy'[23] Berlin is a pot of gold. Day and night, tourist attractions keep first-time and returning visitors busy and satisfied. The 'heritage industry' of Berlin (Bairner 2008: 420) feeds into its Disneyfication, which non-German films portraying a touristic Berlin such as *Unknown* (2011), *The Berlin File* (2013), *Meet Me in Montenegro* (2014) and *Berlin, I Love You* (2019) support.

Checkpoint Charlie fulfils sociologist Alan Bryman's 'Disneyization' criteria (1999), with its dark Wall theme, exhibitions, restaurants, hotels, shops, merchandise and even so-called soldiers.[24] The Humboldt-Forum may be on the high art end, however, by replacing an original parliament and culture building with a meticulous replica of an imperial palace that is long gone in order to attract more tourists to Museum Island, it presents a Disneyfied approach. That project was initiated by the state while Checkpoint Charlie is basically ignored by the state. Such Disney-like solutions to significant urban issues damage the urban memory in more than one way. They prevent people from commemorating the past on these authentic sites and also create new memories that are almost completely fake.

NOTES

1. Although Disneyfication is a twentieth-century phenomenon, it is not all that different from the historicization at the core of much nineteenth-century architecture.
2. Typically, a person who legally crossed the border at Checkpoint Charlie was a tourist, a diplomat, a soldier or a spy.
3. There is a Checkpoint Charlie Foundation, the purpose of which is 'to foster German-American relations with special consideration for the role that the U.S. played in Berlin between the years of 1945 and 1994' (http://www.cc-stiftung.de/index.php/language/en, last accessed 26 February 2021).
4. During the Cold War, Berlin had (at first thirteen but eventually) seven checkpoints solely one of which, Checkpoint Charlie, was for foreigners. Its name comes from the English-language military phonetic alphabet: Alpha, Bravo, Charlie, Delta, Echo, etc. After

Checkpoint Alpha and Checkpoint Bravo, Checkpoint Charlie was the third Allied crossing point into West Berlin from the Soviet sector.

5. Indeed, as evidenced in Jehanne Dubrow's 1987 poem 'Returning to West Berlin', Checkpoint Charlie was an exciting threshold between the boring east and the vivid west (2010: 27): Past Checkpoint Charlie and the Wall/each street seems brighter now, more noise and neon/in the shops, a kind of manufactured din. And yet at night we dream of slick concrete/spray paint like lipstick kissing West Berlin, the glossy mouth, the miniskirt, the skin.

6. 'The aria comes from the 1922 revision of Lincke's 1899 operetta Frau Luna, about a trip to the moon in a hot air balloon, where an adventurous party of prominent Berliners meet Mrs Moon and her court. The march was originally from Lincke's 1904 two-act burlesque Berliner Luft' ('Paul Lincke: Biography', https://www.imdb.com/name/nm0511081/bio, last accessed 16 June 2020).

7. An audiovisual recording of the Checkpoint Charlie Closure Ceremony, including this speech, is available at https://www.youtube.com/watch?v=2sSgG9sgcSA (last accessed 16 June 2020).

8. Opened by journalist and activist Dr Rainer Hildebrandt in 1962 shortly after the construction of the Wall as a private 'museum of the international non-violent struggle', the Mauermuseum holds the original sign of Checkpoint Charlie. Though filled with original materials about endeavours to escape East Germany, and many other pieces related to the Wall or Cold War, the exhibitions need a serious clearing-up and new curation.

9. Berlin-based artist Yadegar Asisi's colossal circular panoramic reconstruction of the Wall experienced from a viewing platform on a scaffolding at the level of a friend's Kreuzberg balcony in 1987, and accompanying multimedia representations of the walled city, make up the exhibition. If there is one, the only commemorative experience at Checkpoint Charlie is on this scaffolding.

10. Opened in 2013 in a pop-up single-storey structure with black walls inside and out, this is a supposedly temporary Cold War exhibition by the Berlin Forum for past and present civic organization in partnership with the Berlin government. It has a casual open-air area that feels like a beer garden with souvenir booths, panoramic photographs and pieces of the wall rearranged for photo-shooting. 'Along a temporary wall a timeline exhibit draws clumps of readers, giving the feel of an era when people gathered to read newspapers posted in public' (Bach 2017: 156). Unexpectedly, the exhibition in the box is engaging and well-curated.

11. Some plans to build up and commercialize the area at the time failed for financial reasons.

12. https://www.mauermuseum.de/en/about-us/history (last accessed 17 June 2020).

13. An unnoticeable A4-size printout on one of the windows of the replica admits that it is not 'real'.

14. Referring to the memorial value of Checkpoint Charlie, US Colonel Vern Pike, who witnessed the construction of the Wall when he served in Berlin (1959–63), contacted the mayor of the city to complain about the photography scam with performers dressed as

period soldiers. President of the Berlin Senate Andre Schmidt assured him in writing the elimination of the 'cheap theatrical displays that many consider disparaging and disrespectful' (Harrison 2019: 177). This promise took more than a decade to keep; local actors are banned from posing in front of the fake guardhouse since the thirtieth anniversary of the fall of the Wall in November 2019, but tourists continue to enjoy having their pictures taken at the same spot.

15. Alexandra Hildebrandt was the partner of Rainer Hildebrandt, the founder of the *Mauermuseum*, who passed away in 2004. Her installation was located on the sites of the Black Box and Asisi Panorama today. 'When Hildebrandt described her project as a "counterpart" (her words) to the Memorial to the Murdered Jews of Europe (aka the Holocaust Memorial, then just finishing construction), the 2,711 concrete stelae of the Holocaust Memorial were put in direct comparison with her 1,065 crosses a few city blocks away, both in former no-man's-land' (Bach 2017: 144).

16. Certified 'original' pieces of the Berlin Wall that are sold to tourists in souvenir shops *might be* original pieces of the wall that are chopped from actual 3.6 m precast concrete stelae from the 1980s. As unabashedly documented in a 'the-making-of-chipped-off-Wall-pieces' video, the authors viewed in March 2020 in the popular shop of the Wall Museum: House at Checkpoint Charlie, such stelae were first spray-painted and then chopped now post-reunification, so the graffiti is not original. In addition, those pieces became works on an industrial scale rather than 'hand-pecked' by individual entrepreneurs.

17. For more details about this *Schloss* Debate in English, see Ladd (1998: 47–70), Neill (1997), Wise (1998: 109–20), Boym (2001: 186–94), Ledanff (2003), Ekici (2007), von Buttlar (2007), Carroll La (2010) and Sandler (2016) who provides a comprehensive list of notable texts in German.

18. These quotes are from, respectively, literary critic Andreas Huyssen (1997: 60), architect Bernhard Schneider (1997: 233), journalist Wolgang Kil (1999), architect and critic Bruno Flierl (Ledanff 2003: 44), German scholar Elke Heckner (2002: 324), architectural theorist Werner Sewing (Ledanff 2003: 60), architecture scholar Didem Ekici (2007: 26), artist and historian Khadija Carroll La (2010: 117), Humboldt-Forum curator Friedrich von Bose (2013), artist and cultural researcher Brigitta Kuster et al. (2013), and architecture critic Michael Kimmelman (2008).

19. Reims Cathedral, Ypres Cloth Hall, Warsaw Old Town, St. Michael's Monastery in Kiev, the *Frauenkirche* in Dresden, the old towns of Gdansk, Wroclaw and Poznan, the Temple of Zeus in Olympia, St. Servatius Collegiate Church in Quedlinburg, the Doge's Palace in Venice, Speyer Cathedral, the Schwarzhäupter House in Riga, Lisbon Old Town, San Paolo fuori le Mura in Rome, Colonial Williamsburg (Virginia, USA), the post Second World War reconstructions of Hildesheim, Dresden, Frankfurt and Riga, Goethe's birthplace in Frankfurt-am-Main, Shakespeare's birthplace in Stratford-upon-Avon, Luther's house in Eisleben, Rubens' house in Antwerp, Abraham Lincoln's log cabin in Illinois, the house of Jeanne d'Arc in Orléans, Robert Schumann's house in Zwickau, Henry Thoreau's cabin

on Walden Pond, the Royal Palace of Lithuania in Vilnius, the Saalburg Roman fort and the Campanile on St. Mark's Square in Venice.

20. The old, now new, inscription reads as: 'There is no other salvation, there is no other name given to men, but the name of Jesus, in honour of the Father, that in the name of Jesus all of them that are in heaven and on earth and under the earth should bow down on their knees.'

21. This ironic point has brought about the announcement by the Prussian Cultural Heritage Foundation in June 2021 that their bronzes looted from the Kingdom of Benin in 1897 will be returned.

22. 'Thomas Albrecht, one of the project's local architects, suggested in a promotional DVD produced by [the Friends of the Berlin City Palace] that the reconstructed *Stadtschloss* will eventually be known simply as the *Stadtschloss*, a historical fact, not a reconstruction' (Dolgoy 2017: 318). 'Opponents like the art historian Tilmann Buddensieg have contended that reconstructions produce only simplistic replicas and 'eerie falsifications for tourists who won't look too closely' (Goebel 2003: 1275).

23. Mayor Klaus Wowereit famously stressed these 'attributes' for the city in 2003 (Füller and Michel 2014: 1310).

24. According to Bryman (1999: 29–41), the four aspects of the 'Disneyization' business model that target 'increasing the inclination to consume (goods and services)' are (1) theming: 'drawing on widely recognised cultural sources to create a popular environment', (2) hybrid consumption: 'areas where different kinds of consumption interlinked', (3) merchandising: 'the promotion and sale of goods with copyrighted images and logos' and (4) emotional labour: 'a person altering their outward behaviour to conform to an ideal. In Disneyization, this occurs where a job appears to become more of a performance, with a scripted interaction, dressing up, and the impression of having endless fun' (Hobbs et al. 2015: 127).

The Debt (2010)

5

Cycle of Life:
Mutation

You will see how Francis comes to Berlin.
How he stumbles three times and falls. How he gets up, again and again.
Only to be broken by this city once and for all.
Francis' girlfriend Mieze in *Berlin Alexanderplatz* (2020)

Mutation is the disfigurement of a building or space by removing and/or adding significant pieces over the course of time, thereby altering the memory of the site. In some cases, what was previously represented in mutated structures or places is forgotten. In others, the urban memory is layered and cumulatively remembered. Berlin has mutated so much over the course of the twentieth century that many films set there frequently have a scene where a map, or characters looking at a map, dominates the storyline, usually involving the Berlin Wall.

The district of Kreuzberg is a Berlin example of mutation (via urban gentrification) similar to post-industrial cities of Manchester, Belfast and Detroit. War damage had already made the northern part of Kreuzberg a less desirable neighbourhood in the 1950s, but after the construction of the Wall and stalled urban renewal efforts in the 1960s, the area became even more neglected. Properties became undesirable, vacant, and subsequently squatted and/or controlled by slumlords who rented out individual rooms rather than whole apartments, especially to the new immigrant population who flocked there. Turkish 'guest workers' made up the bulk of these immigrants, and Kreuzberg soon became informally known as Little Istanbul. The Berlin Wall is visible in films made during this time by Turkish directors, but it is certainly not a highlight, reflecting the fact that the Wall was not their issue but just another foreign oddity that they inherited upon immigrating to West Germany.

This attitude of indifference is evident in the 'Treehouse on the Wall' built by Turkish immigrant Osman Kalın that backed directly up to the Wall on

FIGURE 5.1: Cinematic maps tracing Berlin's mutation over the years: *Dr. Mabuse the Gambler* (1922), *M* (1931), *Desperate Journey* (1942), *The Plot to Kill Hitler* (1990 – set in 1944), *Adventure in Berlin* (1952), *The 1,000 Eyes of Dr. Mabuse* (1960), *The Secret Agents/Dirty Game* (1965), *Stories of that Night: The Test* (1967), *Dead Run* (1967), *Coded Message for the Boss* (1979), *Girl in a Boot* (1985) and *Undine* (2020). (All illustrations are film stills captured by the authors.)

Bethaniendamm. Although its triangular plot of land was physically on the western side of the Berlin Wall, East Germany officially owned the parcel. Therefore, West German authorities refrained from stopping Kalın when he began building in 1982, and then continued throughout the years to incorporate running water and electricity.

After reunification, Kreuzberg began a regeneration process, forcing the 1970s newcomers and German squatters to relocate to cheaper peripheral neighbourhoods. Most recently, a process of 'tourism gentrification' (Gotham 2005: 1099) has been taking place whereby visitors frequent the 'off-the-beaten-track' area because it is perceived as authentic, lively and having a certain urban flair (Füller and Michel 2014: 1309), leading to the paradoxical situation whereby the area is no longer authentic. All of these changes since 1945 make Kreuzberg an example of mutation.

The Berlin Wall

It's the Wall – that damn arrogant monument that keeps the German people apart. One city, one culture, cut in half by madmen.

Herr Komanski in *Berlin Tunnel 21* (1981)

The Berlin Wall, 3.6 m tall, was produced in 1.2 m wide sections and made out of L-shaped steel-reinforced concrete varying from 22 cm thick at its base to 12 cm at the top. These technical specifications, however, only describe the final version of the Berlin Wall that existed between 1976 and 1989. This version, arguably the most remembered, was the one seen being ceremoniously danced on, cut through, chipped-away-at and craned away after its fall in the autumn of 1989, but the Wall actually mutated over its 28-year lifetime from lines on a map representing the different municipalities of Berlin to the graffiti-strewn monstrosity that usually comes to mind when the city of Berlin is mentioned.[1]

The genesis of the Berlin Wall can be traced back to the Potsdam Conference in July 1945, during which the Soviet Union, United States, Great Britain and France agreed on the details for the occupation of defeated Germany: each power would control a series of German states, as well as a series of Berlin boroughs. As is well known, because Berlin was inside the Soviet-controlled portion of Germany, the American-, British- and French-controlled boroughs of the city made up an island surrounded by Soviet-occupied territory. These zones were intended to be temporarily occupied until such a time that they could be given back to the German people. That is, the lines on the map that separated the various occupation zones were never meant to be anything but temporary. However, when the Allied-controlled sectors became the Federal Republic of Germany (FRG) in May 1949 and the Soviet-controlled sector became the German Democratic Republic (GDR) in October, these lines all of a sudden became very important and, indeed, the basis of the eventual Berlin Wall.

In May 1952, the border between East and West Germany was sealed. People could still pass, however, between East and West Berlin quite freely, subject to

identity checks. As more and more easterners decided to cross into West Berlin and never return, restrictions and permissions came into effect, allowing only those with a valid excuse to cross (such as workers, students and relatives).[2] In the summer of 1961, it is estimated that over a thousand East Germans were fleeing westwards daily (Harrison 2011: 1). By July 1961, 2.5 million East Germans – approximately one-sixth of the population – had emigrated to West Germany since 1949 (McAdams 1993: 5). The Berlin Wall, code name 'Operation Rose', was built to stop this haemorrhaging of the GDR population, largely composed of professionals and skilled workers. But just how and why the Berlin Wall mutated over the years, including after its disappearance and reappearance as a tourist attraction, requires further explanation.

In the documentary *Berlin under the Allies 1945–1949* (2002), white lines can be seen painted on the ground at Potsdamer Platz in 1948, indicating the exact border between the American and Soviet sectors. However, these lines were merely a formality and, as previously stated, were easily crossed. 'Until that day in August when suddenly they were walled-up and bricked-up people, the city was nonethe-less a whole, and the sector boundaries were crossed in both directions by about half a million people every day' (Wolfrum 2001: 553–54). The first version of a border wall, constructed in the early hours of 13 August 1961, was mostly concer-tina and barbed wire running the 43 km that cut through Berlin. This tentative wire fence is framed in Karl Gass' *Look at this City* (1962), a production of the East German DEFA Studio, which mixes documentary footage with German and Russian classical music when showing the east, and American pop music when showing the west, clearly identifying an ideology of stereotypes.

At strategic points, like the Brandenburg Gate and Potsdamer Platz, cobble-stones were ripped up and concrete uprights were inserted to make a 2 m barbed wire fence. Elsewhere, the border fortification mostly consisted of wire in rolls on the ground, which Hans Konrad Schumann notably jumped over on 15 August 1961 at Bernauer Strasse. The construction of this first version of the Berlin Wall is realistically re-enacted in the opening scene of Richard Michaels' *Berlin Tunnel 21* (1981) using the West Berlin street of Jagowstrasse in Spandau.[3]

Even though the supplies for a more permanent wall had been gathered and were ready, the Soviets did not give East Germany permission to do so at first because they preferred to see the western response to this manoeuvre. When the Allies, particularly the United States, did next to nothing within the first days of the fortifications, permission was granted on 18 August 1961 (Richie 1998: 726) and the GDR began building what is referred to as the Berlin Wall's 'first generation'. This mutation was made from square precast concrete units 1.25 m by 1.25 m, 25 cm thick, set upright and topped with concrete blocks and barbed wire on a Y-frame. The construction of this version was recreated for a

FIGURE 5.2: Early versions of the Berlin Wall in a 1961 vintage image from *Rabbit à la Berlin* (2009), the credits of *The Secret Agents/The Dirty Game* (1965), and the spy thrillers *Funeral in Berlin* (1966) and *A Dandy in Aspic* (1968).

film scene in Gerhard Klein's *Stories of that Night: Big and Small Willy* (1967), when an East German worker picks up the western cigarette packet thrown over the barbed wire and defiantly cements it into the Wall. Roland Suso Richter's *The Tunnel* (2001) also contains a re-creation of this wall version, when Fritzi's fiance, after a failed escape attempt, is brutally left to die at the base of the Wall in a manner similar to Peter Fechter.[4]

At Checkpoint Charlie, two layers of concrete planks were put on top before the barbed wire, for added security. At the Brandenburg Gate and Potsdamer Platz, this first version took a different, hardier form and used only precast concrete planks, approximately 1 m wide by 3 m long by 25 cm high, laid horizontally and cemented together. Actual solid walls were only built in the most urban areas, about 10 km of the total 43 km through Berlin (Schmidt 2011: 63). In some locations, most notably Bernauer Strasse, the border was actually the façade of a building, with the pavement being West Berlin. In this way, escapees could easily jump out of a ground floor (or higher) window and land in the western sector. Because of this, such buildings were ordered to be vacated by 20 September 1961. At Bernauer Strasse alone, eventually around 2000 people were forcefully displaced from their apartments and relocated (Rottman 2008: 32). Afterwards, the windows and doors of those buildings were blocked up. In the 1970s, most of such evacuated buildings were demolished.

At Checkpoint Charlie, a white line was painted on the ground across Frie-drichstrasse to distinguish between the boroughs of Mitte (Soviet) and Kreuzberg (American). This was done by the 20-year-old East German private Hagen Koch, who was a trained surveyor assigned to mark the exact location of the entire Berlin Wall on a series of topographical maps soon after its realization (Taylor 2006: 239). This white line plays a prominent role in the opening scene of Martin Ritt's *The Spy Who Came in from the Cold* (1965) when the main character paces back and forth, millimetres from the line, impatiently waiting for his contact to safely pass through.[5] Another filmic borderline can be seen in Piero Vivarelli's *East Zone, West Zone* (1962) in a scene where police from both sides hold a stand-off on either side of a painted white line while a woman kneels crying in the west with her back to the camera. This line, neatly cutting across streetcar tracks and cobblestones, did not actually represent an authentic border location but was instead staged for the movie, proving the power of cinema in creating images of the city's division, although fake.

In less built-up areas, the first-generation Berlin Wall consisted of multi-layered barbed wire fences held up with concrete posts. Not only were 193 roads blocked but also twelve *S-Bahn* and *U-Bahn* lines (Taylor 2006: 162). In the several cases where a surface train or underground line began in the west, travelled through the east and then emerged in the west again, the eastern stations were simply closed by the GDR, and the trains eerily passed through these 'ghost stations' without stopping.[6]

Films made in East Germany at this time that featured the Berlin Wall, which the GDR labelled as an 'Anti-Fascist Protective Barrier' (*Antifaschistischer Schutzwall*), unsurprisingly attempted to justify its construction. *Look at this City* appropriates Ernst Reuter's notable phrase against the 1948 Berlin Blockade into its title and faithfully repeats the East German party line that the Wall was constructed to protect East Berlin from dangerous West Berlin.[7] Frank Vogel's *And Your Love Too* (1962) and Heinz Thiel's *The Hook to the Chin* (1962) narrate stories of Berliners unsuccessfully attempting to get to their West Berlin jobs on 13 August 1961 (even though the actual day was a Sunday), portraying them as traitors who should stay in the GDR rather than participate in western capitalism. Gerhard Klein's *Sunday Drivers* (1963) depicts several Leipzig families attempting to flee to West Berlin by car, only to be foiled by the new fortifications, portraying the would-be escapers as 'unsympathetic caricatures' (Maulucci 2008: 332). A later contribution, *Stories of that Night* (1967) composed of four short films by different directors, also works to portray the Wall as a defensive element rather than an offensive provocation.[8] Following this release, East German films would not focus on, show or even refer to the Berlin Wall again.

Visually, the first-generation wall was a mess. Cement joints were not cleaned, breeze blocks were not vertically aligned and the barbed wire uprights were not

FIGURE 5.3: Simulated Berlin Walls in *The Tunnel* (2001 – set in 1961), *The Spy Who Came in from the Cold* (1965), *Stories of That Night: Big and Small Willy* (1967), *The Wicked Dreams of Paula Schultz* (1967), *The Man on the Wall* (1982), *Meier* (1986), *Beloved Berlin Wall* (2009 – set in 1989) and *Atomic Blonde* (2017 – set in 1989).

evenly spaced out, all of which can be readily seen in Walter de Hoog's short documentary *The Wall* (1962) produced for the US Information Agency. Since this first Wall was a 'propaganda construct not originally intended to exist for more than a few months' (Schmidt 2011: 57), this look was the product of the slap-dash speed at which it was constructed. Beginning in June 1962, this would all be 'corrected'

with a second-generation Wall that used standard, prefabricated parts spaced equally apart, resulting in a much more consistent and therefore more threatening appearance. Even so, this second version could easily be rammed with a non-military vehicle, something that American General Lucius Clay secretly experimented with against a mock-up wall that he commissioned US combat engineers to create in a secluded forested area of West Berlin (Garthoff 1991: 147).[9]

In the same way that there was never only one version of the Berlin Wall, there was also never only just one wall but two: one on the border with West Berlin and another some distance into East Berlin. The distance between the two walls of this 'deathstrip' varied from as little as 15 m to as much as 150 m. This no-man's land, however, was not empty. Over the years, more and more sophisticated devices and techniques were added to increase the effectiveness of the fortifications, creating a militaristic landscape of ditches, anti-tank obstacles, electric fences, trip-wires, patrol roads, floodlights, dog runs and watchtowers in the middle of the city. One unintended consequence of this empty land was that rabbits could safely breed without predators, especially at Potsdamer Platz, as highlighted in Bartosz Kanopka's docudrama *Rabbit à la Berlin* (2009), which utilizes the trapped-like situation of the animals as a metaphor for all those who lived behind the Iron Curtain.

A third-generation Berlin Wall began to be built in 1965. This mutation, which would stand for over ten years, consisted of upright concrete H-sections spaced 3 m apart, then infilled with precast 15 cm thick concrete panels stacked up to 3 m.[10] These panels had tongue-and-groove ends which locked them together in such a way as to provide more sturdiness than the previous wall versions which were mere blocks cemented together. Further locking these elements together was a 25 cm diameter asbestos pipe topping the construction, which was also effective in preventing a good grip to would-be escapees. This third-generation wall is the one seen in western spy films of the late 1960s such as Werner Klinger's portion of *The Secret Agents* (aka *The Dirty Game*, 1965), Hamilton's *Funeral in Berlin* (1966), Christian-Jaque's *Dead Run* (1967) and Anthony Mann's *A Dandy in Aspic* (1968).

The alluring idea of a wall cutting right through the middle of a city is also enough to create imaginary Berlin Walls in films. In the James Bond spoof *Casino Royale* (1967), a spy school founded by Mata Hari has the Wall going right through the middle of it. In one scene, French, American and British soldiers sit on one side (bathed in blue light) and Soviet, Chinese and Cuban soldiers (bathed in red light) sit on the other, bidding on secret documents being offered by the spy school. Similarly, the athletic main character of George Marshall's *The Wicked Dreams of Paula Schultz* (1968) pole-vaults from east to west over a Berlin Wall that looks nothing like the third-generation version. This imposter wall, again, like the fake white lines of *East Zone, West Zone*, illustrates the power of cinema

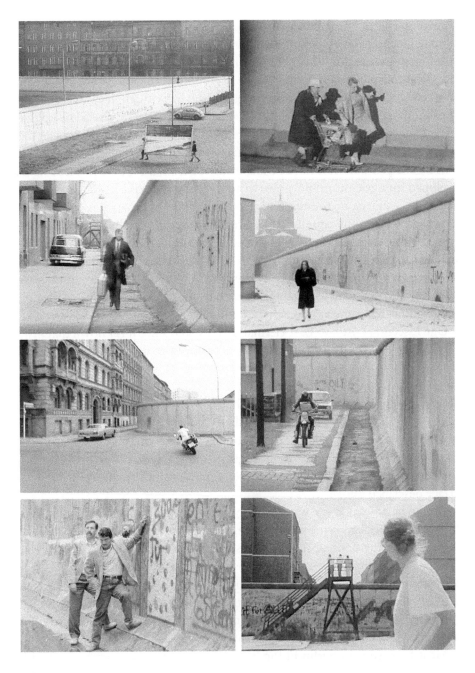

FIGURE 5.4: The final and most famous version of the Berlin Wall in *The All-Around Reduced Personality* (1978), *Ticket of No Return* (1979), *Like World Champions* (1981), *No Mercy, No Future* (1981), *Possession* (1981), *B-Movie: Lust and Sound in West Berlin 1979–1989* (2015), *Octopussy* (1983), *Police* (1988) and *Cycling the Frame* (1988).

in creating images of the Berlin division, even though such images did not reflect the actual technical specifications.

A fourth-generation Berlin Wall, which would end up being its final mutation, is the construction described at the beginning of this case study. Nicknamed 'Border Wall 75' after the year of its design, the individual pieces were officially called Support Wall Element UL 12.41.[11] Beginning in 1976, the GDR upgraded the Wall's fortifications by using these prefabricated panels, with the base of the 'L' mostly, but not always, on the eastern side. Made of high-density steel-reinforced concrete in a plant in Malchin, 200 km north of Berlin, these panels were originally developed for agricultural purposes to allow farmers to quickly construct sturdy enclosures requiring no foundations (Hertle 2007: 94). These same characteristics made these L-sections equally attractive to be used as the Berlin Wall. Furthermore, the fourth-generation Wall offered a smooth and clean face towards West Berlin; an aspect of some significance to the GDR rulers, who, from the 1970s, were becoming more and more interested in the public appearance of their state, which they did not want to see compromised by the obvious brutality of the border fortifications (Klausmeier and Schmidt 2004: 17).

One L-section cost 359 East German Marks, and since it is known that around 45,000 were eventually produced, the final bill came to over 16 million *Ostmarks* just for these panels, roughly the same price as 16 million loaves of bread in the GDR at the time (Rottman 2008: 37). These L-sections were positioned side-by-side with cranes that gripped them through precast holes, allowing for greater precision in their placement than before. They were then welded together at the top via pre-inserted metal bars and topped with a 5 cm thick rounded asbestos pipe, 30 cm in diameter and 4 m in length. Once situated, the gripping holes and joints between the panels would be filled in with mortar, resulting in the smooth surface described above.

Graffiti had always been written on the various mutations of the Wall,[12] but this ultra-smooth surface, on the western side, famously became the perfect canvas onto which slogans, cartoons, abstract designs and works of art were painted, especially after the availability of inexpensive aerosol spray paint cans in the 1980s. World-renowned artists such as Thierry Noir, Richard Hambleton and Keith Haring travelled to Berlin just to make their mark on the Wall.[13] The urban memory of the Berlin Wall became a painted concrete slab, so much so that after its fall chipped-off wall souvenirs with paint sold for higher prices than non-painted chips.

Most films shot in Berlin in the late 1970s and 1980s, from Helke Sanders' serious *The All-Around Reduced Personality* (1977) to the more superficial James Bond instalment *Octopussy* (John Glen, 1983), show this fourth-generation wall, the version that is engrained in the world's memory. Ulrike Ottinger's *Ticket of No Return* (1979) chronicles the travels around Berlin of a woman who is attempting

to drink herself to death, and this final version of the Berlin Wall features promi-
nently throughout the film. Reinhard Hauff's *The Man on the Wall* (1982) portrays
the main character dreaming about leading East Berliners through the Wall to the
West like Moses. Peter Timm's satirical *Meier* (1986) depicts an East German citi-
zen who acquires a West German passport and proceeds to cross back and forth
on almost a daily basis.

Without a doubt, however, Wenders' *Wings of Desire* (1987) most accurately
captures the Wall's strange aura of accepted violence that existed at that time. The
main character angels are not subject to the city's physical division and can easily
walk around in West Berlin, East Berlin and even no-man's land. At one point in the
film, the angels simply walk right through the Wall at the end of *Lohmühlenbrücke*
and into the east, an eerie foreshadowing of events to occur only two years later.[14]

Following the fateful evening of 9 November 1989, the Berlin Wall proceeded to
disappear almost as fast as it went up back in 1961, as documented in Jürgen Böttcher's
The Wall (1991). 'Wall-peckers' chipped away souvenir chunks to be sold to the
many tourists flocking to the city. Entire sections were craned away at major cross-
ing points, like the Brandenburg Gate, Potsdamer Platz and Checkpoint Charlie, in
order to facilitate new foot and vehicular traffic. Before the German reunification on
3 October 1990, the GDR sold whole L-sections of the wall to museums, private indi-
viduals and anyone else who would pay for them.[15] The Federal Republic of Germany
contracted firms (staffed by unemployed East German border guards and soldiers) to
disassemble barriers, clear landmines, reconnect roads and return the restricted zone
to its pre-division state as much as possible (Rottman 2008: 61). The completion of
this endeavour was officially announced to be 30 November 1990 (Bach 2016: 48). It
was at this point that the Berlin Wall morphed from being a border fortification into
being a site of memory.[16] In the words of cultural historian Joachim Schlör (2006: 89):

> Once upon a time there was a wall. It had a certain course, it 'ran' – although it did
> not move – through Berlin. But then, one fine day, it was taken away so thoroughly
> that this former 'course' was not recognizable any more.

Not only had the Wall disappeared but also the no-man's land and its military
installations. Of the 302 watchtowers that existed at the fall of the Wall in 1989,
only three remain today in their original locations, but these are hidden away in
obscure corners.[17] As summarized by urban planner Ute Lehrer (2003: 399), 'The
displacement of watchtowers and wall sections was [...] a symbolic act of historical
annihilation. Berlin's officials consciously sought to rid themselves of all reminders
of the partitioned city – with the exception of a few less disturbing symbolic relics.'

The main remnants of fourth-generation wall sections still located in their
original positions are at the Berlin Wall Memorial on *Bernauer Strasse*, the East

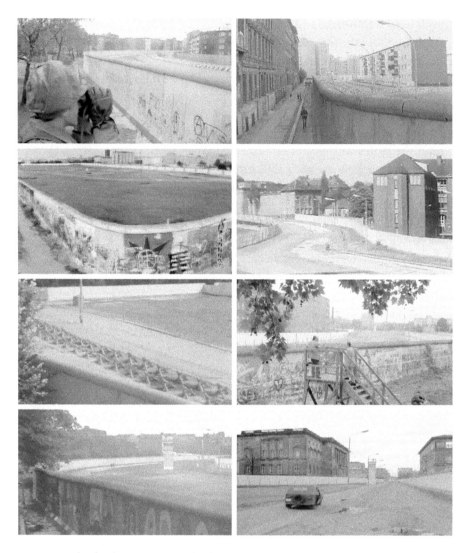

FIGURE 5.5: The deathstrip/no man's land in *Germany, Bitter Homeland* (1979), *The Man on the Wall* (1982), *Learning to Lie* (2003 – set in 1982), *Westler: East of the Wall* (1985), *Girl in a Boot* (1985), *Police* (1988), *Judgement in Berlin* (1988) and *Rabbit à la Berlin* (2009 – vintage photo from the 1980s).

Side Gallery at the foot of the *Oberbaumbrücke* and a section of the Wall that is part of the Topography of Terror. The *Bernauer Strasse* site is the most complete of the three, in terms of having not just the Wall but also some no-man's land and a relocated watchtower, but its preservation has paradoxically rendered the site quite neutral as if the brutality of the 28-year division was turned into a public

FIGURE 5.6: The Berlin Wall at the Brandenburg Gate in 1961, 1971 and 1981, as replicated via the MauAR app.

park. The East Side Gallery, a 1.3 km long original section that was painted by 118 artists from 21 countries in 1990, contains iconic images that capture the euphoria in Berlin immediately after the fall of the Wall, but the fact that they are on the east side of the Wall is misleading in the remembrance of the Wall in divided Berlin.[18] The section of the Wall which is part of the Topography of Terror on Niederkirchnerstrasse is a significant site of memory because it is combined with the basement ruins of the Nazi Gestapo Headquarters to literally remind visitors of the underlying history of the Wall and how the events of 1945 and 1961 were related.

Even more engaging is the MauAR mobile phone app, which indicates the location of the inner and outer Berlin Walls, and therefore the in-between space of no-man's land in real time as visitors walk around the city. The app also allows users to point their phone cameras at a Berlin building near the former Wall and view an augmented reality image of how it may have looked in 1961, 1971 and 1981.[19] In this way, MauAR not only reminds or shows visitors of where the Wall used to be and how that part of the city looked during the division but also the fact that the Berlin Wall mutated over its short lifetime to become the one we now remember.

The Berlin Wall is now perceived as a shared history of East and West Germany. What was once a symbol of the city's division later became a symbol of the country's unification (a shared memory, albeit from different perspectives). Paul Connerton's assertion that 'modernity forgets' (2009: 4) fails to recognize that modernity, in spite of its forces of erasure, does not create a space 'wiped [entirely] clean'. Instead, the remnants and empty space left behind represent a potential. The material remnants at Potsdamer Platz, such as the fragments of the Wall incorporated within the new Ministry for the Environment, are manifold – and this does not begin to count the fragments of imitation or real Wall pieces on display in the most unlikely places in Berlin, be it in Shoe City at Alexanderplatz, the Europa Center or the solid-cocoa slabs of Wall replicas on sale in the upmarket chocolatier Rausch. Yet, as this book has argued throughout, the material remnant is a central element in an encounter with the past that has been a trigger to remembering. The fragment, however, is not self-sufficient; its critical potential can only unfold if the

123

dynamics of urban memory are put in place. Here, the Wall fragments precisely fulfil what Janet Ward (2016: 172) criticizes as the 'petrification of remains'.

Potsdamer Platz

Potsdamerplatz in Berlin [...]
The biggest construction site in Europe. Houses as tall as in New York.
<div align="right">Illegal Ukrainian migrant in Distant Lights (2003)</div>

Of all the places of memory in Berlin's built environment, Potsdamer Platz is perhaps the most difficult to comprehend because throughout the twentieth century, it kept mutating and transforming with each successive Berlin phase. In fact, Potsdamer Platz has changed so radically over the course of that century that it was the centre of cinematic milestones such as *Berlin: Symphony of a Great City*, *Wings of Desire* and *Berlin Babylon* – in totally different appearances. Ruttmann's poetic *Berlin Symphony* (1927), similar to Adolf Trotz's documentary entitled *The City of Millions* (1925), depicts Potsdamer Platz and its surroundings with busy traffic, lively footpaths and a myriad of urban activities. Cinematic representations are backed up by memories of the time, such as from the British diplomat Harold Nicolson (1929: 345):

> There is no city in the world so restless as Berlin. Everything moves. The traffic lights change restlessly from red to gold and then to green. The lighted advertisements flash with the pathetic iteration of coastal lighthouses. The trams swing and jingle.

Potsdamer Platz was a regular fixture in Berlin Street Films *(Strassenfilme)* of the 1920s. In Karl Grune's *The Street* (1923), it is depicted as a mysteriously seductive but dangerous place and in Joe May's *Asphalt* (1929), it provides a hallucinogenic Expressionist experience. Films of the 1930s kept up this image of a lively and dynamic Potsdamer Platz, especially when vice was involved. In Heinrich George and Werner Hochbaum's *Tugboat M17* (1933), the main character strands his wife and child at the bustling Potsdamer Platz while he goes off chasing a woman he had met the previous night. Unaccustomed to city life, they struggle to navigate the many buses, trams, cars and bicyclists – a metaphor for their abandonment.

Largely destroyed by the Second World War Allied bombing as represented in Josef von Baky's *And the Heavens above Us* (1947), Potsdamer Platz was further wiped out during the construction of the Berlin Wall in 1961. The area was featured in *Wings of Desire* (1987) as a wasteland in the heart of the city as

the aged character Homer wanders the area, unable to recognize anything from before the war: 'I cannot find the Potsdamer Platz. Here? This can't be it. Potsdamer Platz, that's where Cafe Josti used to be. [...] This can't be Potsdamer Platz. And no one whom you can ask.' Cultural historian Jonathan Bordo (2008: 91) labels the area a 'locale of memory' and comments that 'in order to remember, in order even to acknowledge, it is also necessary to forget. [...] *Der Himmel über Berlin* remembers without having either to say or show very much' (2008: 108).[20]

Neither this abandoned wasteland nor the Potsdamer Platz that was rebuilt as a business district by the end of the century, as represented in Hubertus Siegert's documentary *Berlin Babylon* (2001), has a connection to the Potsdamer Platz that cinemagoers remember from Ruttmann's notable 'city symphony'. In the twentieth century, Berlin was an incomplete city, both physically and perceptually. It is a city in constant (re)construction, a vast building site. Siegert captures post-reunified Berlin in this context, similar to von Baky's interpretation of post-war Berlin.[21] Contemporary Potsdamer Platz resembles the capitalist cardboard city models in Fritz Lang's science-fiction classic *Metropolis* (1927) released in the same year as

FIGURE 5.7: Potsdamer Platz as a wasteland in *Wings of Desire* (1987), under construction in *Silvester Countdown* (1997) and almost complete in *We Are the Night* (2010).

Ruttmann's *Berlin Symphony*. The multi-storey basements of the shiny building complexes for services, deliveries and parking as 'an invisible other city' (O'Sickey 2001: 68), shown being constructed in *Berlin Babylon* by divers pouring concrete underwater, echo the underground city of the workers in Lang's epic. Ruttmann was Lang's cinematographer, and they were at the time framing a future that is later documented by Siegert. Therefore, it can be argued that Ruttmann marked and shaped Berlin's urban memory at both the beginning and the end of the twentieth century.[22]

Throughout this book, the authors have referred to urban strategies as proactive or reactive 'processes' that initiate some kind of change, difference or newness in the urban fabric as well as urban memory. While this is valid for all twelve strategies,[23] mutation is the process that the authors utilize for cases that have continuously changed (after 1895), where those changes are so radical and extensive that the place is not physically recognizable between its previous and current situation, as in Potsdamer Platz. As an urban pressure point, Potsdamer Platz has had its ups and downs, and additions and removals. It has experienced states of new construction, supplementation and temporary installation in its 'good times', and states of appropriation, demolition and adaptation in its 'bad times'. Major turning points in the twentieth-century history of the area are as follows: the transition from Europe's busiest route that constantly developed and built up since the twentieth century (as seen in *Berlin Symphony*) to a peripheral deathstrip (as seen in *Wings of Desire*), followed by one of the biggest construction sites of the continent (as interrogated in *Berlin Babylon*). It is worth asking: do we forget what mutated places and structures meant prior to their mutation?

Potsdamer Platz has witnessed the best and the worst days of Berlin. The square and its surroundings were demolished and rebuilt throughout the twentieth century. Named in 1831, Potsdamer Platz is not (and never was) a *platz* (city square). In the eighteenth century, it was a city entrance just outside the city walls,[24] a Checkpoint Charlie *per se*, for merchants and visitors to pay the toll to enter Prussian Berlin's formally designed Leipziger Platz (1731–34) through Philipp Gerlach's *Potsdamer Tor*. The significance of Potsdamer Platz as a European transportation hub grew in the nineteenth century when Karl Friedrich Schinkel renewed Gerlach's Baroque gate with two Neoclassical structures straddling the passage (1824), and Potsdamer Railway Station, mainly for the transfer of goods between Berlin and Potsdam in the southwest, was built (1838), as well as the city walls were demolished (1866).

The 'golden era' of Potsdamer Platz was between the wars, made possible by the industrial accomplishments that started in the mid-nineteenth century.[25] In the 1920s, Potsdamer Platz was the centre of business, trade, economy, transportation, technology, social life and entertainment in the city both day and night.[26]

It was the busiest transportation hub in Europe with U-Bahn, S-Bahn, 26 tram lines and five bus routes, besides all the private cars and pedestrians regulated by traffic police and the first traffic light in Europe.[27] Although this was a busy part of Berlin in the 1930s, that is not the time Berliners nostalgically remember Potsdamer Platz. Rather, it is the 1920s, the post-First World War years before the open and optimistic vibe in the area was replaced by the totalitarian direction of the Nazi regime. Brian Ladd writes:

> Berlin of the 1920s offers the set of images by which the world knows Berlin, and which Berlin wants the world to know: vast size, technological prowess, artistic innovation, politicized sexuality, and eroticized politics. At that time Berlin was the third populous city in the world; today it has fewer inhabitants than it did then (over four million then, not even three and a half now).
>
> (2000: 11)

Being a crossroads for the industrialized city of Berlin, Potsdamer Platz was heavily bombed during the Second World War. Most buildings were severely damaged, except a few such as the *Weinhaus Huth* and Erich Mendelsohn's *Columbushaus*.[28] The area was levelled with dynamite and wrecker balls, and generally 'cleaned up' after the war, erasing urban memory by removing history at a massive scale. Potsdamer Platz stayed empty for the following decades because it was divided and turned into the widest no-man's land portion of the Berlin Wall fortifications. In West Berlin, the *platz* was overgrown with weeds and recognizable by two horizontal urban elements: the graffitied Berlin Wall and the elevated railway tracks of the experimental M-Bahn.[29] As a result, the formerly central Potsdamer Platz was pushed to a marginal position in both East and West Berlin between 1945 and 1990: 'More than the Brandenburg Gate nearby, Potsdamerplatz represented to Berliners the consequence of the War's devastation and the Wall's interdiction. [...] With the disappearance of the Wall, the entire expanse of Potsdamer-Leipziger-platz is revealed as a desert-like extension of the Tiergarten' (Hatton 1991: 102).

In contrast, contemporary Potsdamer Platz is a significant German business centre containing new landmarks built in the 1990s and early 2000s, such as Sony's Bahntower (Helmut Jahn), the Kollhoff Tower (Hans Kollhoff)[30] and the Piano-Hochhaus (Renzo Piano), framing the old and the newly directed Potsdamer Strasse.[31] In the 1990s, the area was first a multi-million euro construction site (marketed with concerts, guided tours, fireworks and art installations), then it became an international profit-oriented business/leisure district, a giant sterilized shopping mall, if you like, due to the complete transformation of the area based on the 1991 planning proposal by Munich-based architects Hilmer-Sattler. Ironically, their proposal divided the vast 60-hectare land into four parts, like the

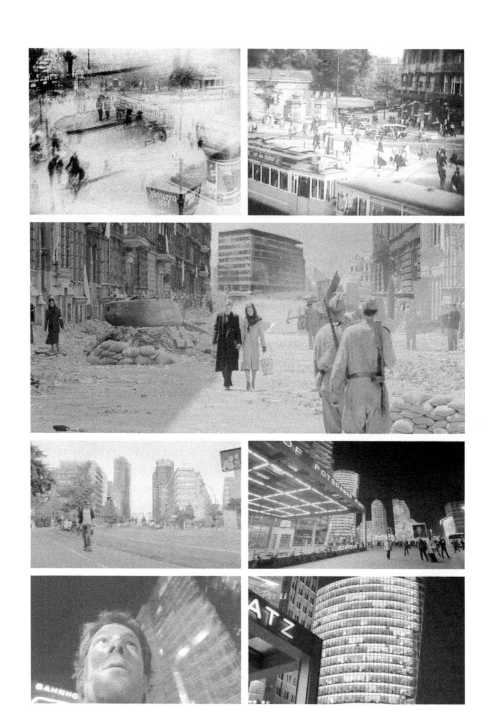

FIGURE 5.8: Potsdamer Platz, old and new, in *Asphalt* (1929), *Tugboat M17* (1933), *A Woman in Berlin* (2008 – set in 1945), *Single by Contract* (2010), *Fucking Berlin* (2016), *Berlin Junction* (2013) and *Distant Lights* (2003).

four-partite divided Berlin after the war. Each of the four parts was developed by a major investor with the help of established architectural practices: Daimler AG (Renzo Piano and Christoph Kohlbecker 1993–98), Sony Center (Helmut Jahn 1996–2000), Park Kollonnaden (Giorgio Grassi 1997–2002) and the Beisheim Center (Hilmer-Sattler and Albrecht 2000–04).[32]

Big names in architecture, or 'starchitects', before turning their attention to the possibilities in China at the turn of the millennium, walked in the footsteps of Wenders' Homer who 'wanders across the empty space of Potsdamer Platz in a state of disorientation' (Ward 2016: 123). They explored design ideas shaping the contemporary fate and atmosphere of the site. British architect David Chipperfield (Parkside Residence 2004), Japanese Arata Isozaki (Berliner Volksbank 1997), Spanish Jose Rafael Moneo (Mercedes Benz Head Office and Grand Hyatt Berlin 1998), Italian Renzo Piano (Debis Tower 1997) and Italian-British Richard Rogers (Daimler Chrysler Offices and Residential Block 1999) were among those architects who were privileged to build right beside Mies van der Rohe (New National Gallery 1968) and Hans Scharoun (Berlin Philharmonie 1963; Berlin National Library 1978) on the *Kulturforum* to the west of Potsdamer Platz.[33] As opposed to the sprawling open space portrayed in Rudolph Thome's *Berlin Chamissoplatz* (1980), this was a new beginning for Berlin with high hopes.[34]

Being the intersection of roads from the west approaching Berlin's city walls and the Potsdam Gate, Potsdamer Platz was historically a place for passing rather than remaining.[35] It was defined by the movement of people and vehicles (with brief stays) and represented the dynamic urban living in Berlin. Being out of official city limits, Potsdamer Platz was not subject to Berlin's planning rules like Leipziger Platz. Therefore, it organically grew as needed. Four streets converged radially at this traffic junction to take travellers into the city through Leipziger Platz.[36] Ebertstrasse followed the city walls and linked to *Brandenburger Tor* and Pariser Platz on the north.[37] In the opposite direction, Stresemannstrasse led to *Anhalter Tor* and Askanischer Platz (near the *Anhalter Bahnhof*) and then to *Hallesches Tor* and the circular Mehringplatz. Branching towards the northwest was Bellevue Strasse, leading to the Bellevue Palace today at the north of the Victory Column in the Tiergarten. Finally, to the southwest extended (Alte) Potsdamer Strasse, the main road to Potsdam 25 km away and the first paved Prussian road.[38]

Potsdamer Platz, rearranged and rebuilt as to Hilmer-Sattler's plan, is still a busy intersection with the east–west Leipziger Strasse and a north–south thoroughfare remaining unchanged, but Bellevue Strasse and Alte Potsdamer Strasse are prevented from directly reaching the intersection by means of slight bends in their courses.[39] The most dramatic layout change in the 1990s was the creation of a new Potsdamer Strasse, a wide boulevard with a generous median (holding the red-carpeted *Boulevard der Stars*) that works as the westward continuation of Leipziger Strasse.

This new street completely ignores the historical layout of the area, cutting through footprints of previous buildings and courtyards like a Baron von Haussmann Paris Boulevard. Its layout knowingly does not follow the pre-ruined condition of Potsdamer Platz. The opportunity was taken to rationalize the previous street arrangement in order to achieve plot sizes suitable for high-rise development.

As one can imagine, post-reunification Potsdamer Platz is not the first or the last Berlin example ignoring historical layouts when building anew. To give an example from West Berlin, the *Hansaviertel* (Hansa Quarter) between the northwestern edge of the Tiergarten and the river Spree was developed in 1957–61 after war damage rendered the area almost a blank slate. The development was carried out 'by invitation only' to established architects of the Modernist movement: Walter Gropius, Le Corbusier,[40] Oscar Niemeyer and Alvar Aalto, as well as local architects such as Egon Eiermann and Franz Joseph Ruf. This neighbourhood of large residential blocks spaced apart from each other is a typical example of Modernist urban planning that ignores previous street patterns. Although the *Hansaviertel* is one of the relatively better Modernist examples, especially in terms of a rather natural incorporation of landscape, Gropius eventually lamented the failure of this urban design: 'I am disappointed that so far the arrangement is more of a chart of modern architecture than an organic setup from a community point of view' (Isaacs [1983] 1991: 287). The large green spaces between the blocks are glamorized in Jan-Ole Gerster's *Lara* (2019) but are generally just that: large green spaces. An equivalent project in East Berlin that ignores historical layouts is Karl-Marx–Allee (originally Stalinallee) that cut through existing neighbourhoods over the course of its 2 km run (1952–60).

Between the end of the Second World War and the early 1990s, Potsdamer Platz stayed as 'a blank, a gap' (Bordo 2008: 100).[41] One wonders how Berliners would react if American architect Daniel Libeskind's highly philosophical and certainly unconventional 1991 competition entry entitled 'Out of Line' was realized instead of Hilmer-Sattler's master plan for redesigning Potsdamer Platz. Libeskind took what he started in his design for the internationally recognized extension to the Jewish Museum in Berlin (competition entry entitled 'Between the Lines', 1989), and used this to surface the fragmented history and porous memory of the city with its interruptions, discontinuities, ups and downs and many wounds; 'his projections of boundary spaces, of sites that fall between or are out of line with established topographies [...] make an effort to connect with [...] the liminal "between-spaces"' (Webber 2008: 59). Alongside graphic models and drawings of the unbuilt proposal, Libeskind on his website describes what Ward (2016: 148) calls the 'allegorical incorporation of the past with the city':[42]

> In the competition, Libeskind chose not to see the desolate space as a tabula rasa, but as a dialectic space for confronting the past and re-imaging the future. [...] Libeskind's

design envisioned a matrix of intersecting lines, [...] a puzzle of memory fragments, nine representing past viewpoints and the tenth a gateway to the future. The lines carry both theoretical significance and have a functional use as a series of mixed-use structures [...] above, on and below the street.

Potsdamer Platz, in the heart of Berlin, is not the same place that it was in 1905, 1935, 1965 or 1995. Its urban and architectural physicality, density and use, as well as its political role, have changed over time. When a site goes through such multiple radical architectural transformations like Potsdamer Platz did in the twentieth century, it is extremely difficult to keep its old memories 'in place'. Replica traffic lights and relocated bits and pieces of damaged buildings do not help but hinder such efforts.[43] In this context, using the historical location of the Potsdam Gate to enter the underground S-Bahn (without replicating the structure) and trying to bring the energy of the post-Second World War nightlife back to the area are more meaningful actions in terms of urban memory. Architecturally, the *tabula rasa* that Potsdamer Platz experienced after the Second World War, supported by the lack of 'damage control' in the 1990s, prevents this chic and consumeristic neighbourhood to be the city centre of Berlin contrary to the consensus view and the writings of experts (Ladd 2000; Webber 2008).[44] In this context, Alexanderplatz, with its relatively natural spatio-temporal development, can be considered the new centre of reunified Berlin.

Referring to Potsdamer Platz in the 1990s, Francis Greene (1997: 225) writes: 'Few urban projects have been attempted on this scale since Baron Haussmann's reconstruction of Paris from 1865 to 1871.' One expects Greene to critique the top-down master plan (devoid of a historical and memorial understanding) of Potsdamer Platz, which was also Haussmann's most criticized oversight on an urban scale. Instead, he supports this *tabula rasa* attitude in the planning of both nineteenth-century Paris and twentieth-century Berlin. At Potsdamer Platz, without scientific but touristic referral to the history of the place: 'Something that normally takes decades or centuries to evolve is being created in only a few years' (Greene 1997: 228). The suggestion here is not to build a replica of the 1920s Potsdamer Platz like Warsaw's recreated city centre following the Second World War. Rather, extensive construction that is rushed (not built-in stages with careful consideration of historical architecture and urbanism) solely makes Potsdamer Platz the poster image for 'the new Berlin for a new century and millennium, as a newly reunited capital for a newly unified country' (Greene 1997: 227) with no architectural, spatial and temporal connections to the rest of the city.

One might argue the significance of Wenders' wasteland was purposefully exaggerated as a marketing strategy in the 1990s. However, the generic 'post-everything' Potsdamer Platz does act as the stitch between the two halves of the city because

its past was erased, leaving it belonging to no historically German ideology and existence.[45] If Berlin has too much history, it seems as if Potsdamer Platz has too little of it. This global privatized mix-use forest of concrete, glass and steel does not even 'feel like' Berlin or resemble any other place in the city.[46] Cinema, including films made on location before the damage was carried out in Potsdamer Platz – for instance, *Violet of Potsdam Square* (J. A. Hübler-Kahla 1936), *Love Thy Neighbour* (Detlev Buck 1998) and *The Legend of Potsdamer Platz* (Manfred Wilhelms 2001) – become a valuable aid in these situations to rediscover the urban memories and former atmosphere of a place. Location films help to remember lost meanings; 'in contemporary Berlin, the "spatial image" operates as a form of resistance' (Ward 2016: 142) defying forgetting. Despite its detached rebirth, 'the Potsdamer Platz as the symbolic place of the excavation, covering over, and rebuilding of a walled and bunkered history, a place next to a death-strip that architect Renzo Piano described as a desert inhabited by an unsettled ghost' (Webber 2008: 42) will live and be remembered in Berlin films, be it fiction or documentary.

Referring to Tokyo, which was significantly destroyed twice in the first half of the twentieth century, Salvator-John Liotta writes: 'The architecture of Japan's capital, as seen through movies, seems to be a realm of mutations in a perpetual state of change. Tokyo shows an incessant flow of construction and destruction' (Liotta 2007: 205). In cities like Tokyo and Berlin that experience some form of natural (earthquake, fire, hurricane, etc.) or human-made (political, economic, societal, etc.) transformation on a regular basis, mutation as a long-term urban strategy seems inevitable. Mutated buildings, complexes and districts may alter several times in their life cycle and the urban memory associated with them may change with each alteration. Depending on the change (depending on which urban strategy is applied each time), memories may be lost, layered or accumulated. These buildings and places, therefore, do not have a fixed memory; their memory is fluid.

NOTES

1. For the most comprehensive accounts of the Wall and its relationship with Berlin, see Silberman (2011), Ward (2011a), Broadbent and Hake (2010) and Major (2010).

2. In 1961, it is estimated that 53,000 East Berliners had jobs in West Berlin and 1100 school children commuted to the West. There were also university students and even spouses who would cross on a daily basis (Baker 1993: 713).

3. While this re-enactment in *Berlin Tunnel 21* is realistic, subsequent scenes in the film show versions of the Berlin Wall and a no-man's land that was not as developed in 1962 (when the film is set), highlighting the power of cinema to manipulate memories.

4. Peter Fechter was an 18-year-old bricklayer's apprentice who was shot and killed by East German border guards while trying to cross over to West Berlin near Checkpoint Charlie on

17 August 1962. He laid at the foot of the Wall for one hour, drowning in his own blood, without help from either side, before dying.

5. Although this scene was shot in a Dublin studio (Liebhart 2007: 260), the set faithfully resembled Checkpoint Charlie, down to this white line.

6. On the S1, these 'ghost stations' were: Potsdamer Platz, Unter den Linden, Oranienburger Strasse, Nordbahnhof and Bornholmer Strasse. On the U6, these were: Stadtmitte, Französische Strasse, Oranienburger Tor, Nordbahnhof (today, Naturkundemuseum) and Stadion der Weltjugend (today, Schwartzkopfstrasse). On the U8, these were: Heinrich-Heine-Strasse, Jannowitzbrücke, Alexanderplatz, Weinmeisterstrasse, Rosenthaler Platz and Bernauer Strasse.

7. Ironically, Ernst Reuter was the Mayor of West Berlin when he said this.

8. The four short films of *Stories of that Night* are: *Phoenix* by Karlheinz Carpentier, which narrates the experiences of 'Battle Group Commander Karl' on 13 August 1961; *The Test* by Ulrich Thein, which recounts the story of 18-year-old Jutta and her opposition to her parents' desire to leave the GDR; *Materna* by Frank Vogel, which chronicles the story of the bricklayer Materna's involvement with building the Wall and his denunciation of pacifism in the face of western fascism; and *The Big and the Small Willy* by Gerhard Klein, in which Small Willy desires to flee to the west but is persuaded by Big Willy to stay.

9. The Soviet's were aware of General Clay's mock-up wall, which was done without his superior's knowledge and cancelled when discovered.

10. Two sizes of these panels were produced, 50 cm and 1 m high, and an appropriate number were stacked to make the 3 m tall wall.

11. The appellation UL 12.41 stands for 'L-shaped Retaining Wall Element, version 12, variation 41'. Other variations of this unit were a thinner UL 12.11, an L-shaped UL 12.42 (without a nib), and a T-shaped QT 1.1 (Rathje 2001: 1289).

12. The first graffiti is claimed to have been 'DDR = KZ' ('GDR = Concentration Camp') as described on the website https://www.berliner-mauer.de (last accessed 20 July 2020) along with a whole range of other trivia about the Berlin Wall.

13. It is Noir's paintings of cartoon people that helps fallen angel Damiel in *Wings of Desire* learn the names of colours, which he is seeing for the first time soon after becoming human.

14. In the same way that some East Berlin films avoided areas where the Wall could be seen, some West German art films set in Berlin during this period – such as Lothar Lambert's *Fucking City* (1981), Michael Brynntrup's *Jesus-The Film* (1986), and Jörg Buttgereit's *Necromancer* (1987) – never show the Wall at all.

15. The website http://demap.the-wall-net.org pinpoints Wall sections in about 240 locations in 40 countries throughout the world, not counting the 185 or so throughout Germany (outside of Berlin). One buyer was reportedly the granddaughter of Winston Churchill, who had initially coined the term Iron Curtain (Wolfrum 2001: 566).

16. Although Berliners, both eastern and western, were more than happy to get rid of the Berlin Wall and tourists are admittedly the target audience of the promotion of Wall remnants,

its absence from the city that made it prominent (and vice versa) renders the Berlin Wall a site of memory.

17. These three towers are on Erna-Berger-Strasse, just south of Leipziger Platz (moved a few metres from its original location), in Schlesischer Busch Park in Treptow, and on Kieler Strasse in northwest Mitte, all of which have been given heritage protection.

18. The East Side Gallery, however, does exemplify the situation that the West invaded, or took over, the East after the fall of the Wall.

19. See https://www.chronik-der-mauer.de/en/182827/the-berlin-wall-app (last accessed 17 July 2020).

20. Mugerauer writes, 'Along with the depression in the midst of the grayness of everyday urban life, Wenders gives us more dramatic events' (2014: 112). The 1980s Berlin films like *Wings of Desire* and *Christiane F.* (1981) portrayed a dystopian, dead-end and depressed city focusing on 'the contemporary hollowness of the historical horizon' (Kreuder 2000: 34) without much prospect or hope for the future, at least from the humans' perspective who are born into a divided city in the Cold War. Wenders' angels revisited the area after the fall of the Wall in *Faraway, So Close!* (1993).

21. Similar to the flashbacks of *Der Himmel über Berlin* to post-Second World War Berlin (therefore superimposing the memory of the city in the 1940s onto Berlin in the 1980s), *Und über Uns der Himmel* goes back to the memories of a thriving Berlin before the war superimposing the city in the 1920s onto Berlin in the 1940s. Jaimey Fisher (2005: 469) mentions von Baky's montaged images of Potsdamer Platz in this context. Referring to the flaneur, Fisher talks about '"panoramic memory" [...] in recalling the war and the bombing' (2005: 462). For both Wenders' storyteller Homer who talks about the good old days and openly says 'this can't be Potsdamer Platz' and von Baky's temporarily-blind former soldier, the panoramic memory of Potsdamer Platz belongs to the golden decade of the city.

22. Karyn Kusama's *Aeon Flux* (2005), filmed in Berlin and set in 2415, arguably marks the beginning of the twenty-first century.

23. And complex cases could have been discussed under two strategies rather than one.

24. The Berlin Customs Wall had replaced Berlin's seventeenth-century fortress walls. Accordingly, the Berlin Wall was not the first urban wall that Potsdamer Platz remembered.

25. Borsig laid the city's industrial foundation by building Germany's first steam locomotive in Berlin in 1841 (https://www.borsig.de/en/company/history, last accessed 29 January 2021). AEG and Siemens strengthened the industrial development of Berlin in the late nineteenth century.

26. Ute Lehrer disagrees: 'Those old enough to remember the Berlin of the 1920s recollect Potsdamer Platz as nothing more than a huge traffic junction' (2003: 396).

27. Potsdamer Platz's significance was mainly based on being a transport hub and locale for entertainment. Compared to the upmarket stores of Leipziger Platz and Leipzigerstrasse, it was the location of downmarket shops.

28. The *Weinhaus Huth* (Conrad Heidenreich and Paul Michel, 1911–12), a wine restaurant and store of the Huth family with rentals above, was saved because of its steel structure chosen for the heavy load of the wine cellar. Its use as social housing in the 1970s and 1980s in the British sector preserved the structure, which still stands on Alte Potsdamer Strasse as part of the so-called Daimler-City. The Daimler contemporary art collection occupies the building. Entertainment centre *Haus Vaterland* (Franz Heinrich Schwechten, 1911–12), on the other hand, partially survived the war but was eventually demolished. Erich Mendelsohn's *Columbushaus* (1932) was also damaged; its upper storeys were never rebuilt and much of what survived was never reglazed. But it did survive the war. It was the 1953 uprising that brought this modernist building to an end. When it acted as the backdrop to the East German uprising, the GDR found demolition as the appropriate strategy to erase Columbus House from urban memory.

29. Operated between 1984 and 1991, the Berlin M-Bahn was an elevated Maglev metro line with three stations (*Kemperplatz*, *Bernburger Strasse* and *Gleisdreieck*) built to fill a gap in the West Berlin public transport network created by the Berlin Wall.

30. This middle tower houses an exhibition about the historical development of Potsdamer Platz and offers aerial views of the area via a platform on the top.

31. Google Maps defines Potsdamer Platz as the 'historic square reborn since [the] fall of [the] Berlin Wall, now a hub of entertainment, restaurants and shops', https://www.google.com/maps/place/Berlin (last accessed 22 June 2020).

32. All four sectors were bound with the 1991 masterplan and planning policies at the time. Guidelines included mixed use, narrow streets, visible entrances, 35 m height limit (except towers at certain locations), consideration of the Berlin block with a courtyard and even masonry street facades.

33. American architect Philip Johnson, who is well known in Berlin for his work around Checkpoint Charlie, was not in the circle of international architects of the Potsdamer Platz redevelopment.

34. On a busy day, 60 cranes hovering above the site would 'welcome' 12,000 workers from 50 countries in three shifts as well as 13,000 trucks.

> After the fall of the Wall, leaders within the government and the business community of Berlin promoted images of a city that presented a bright and promising future. In their shared vision, Berlin was expected to become a major player within the global economy, a world city, a service metropolis, a bridge between East and West, and the old/new capital city of the reunified Germany. [And] architecture was supposed to work as the catalyst for Berlin's quest for a new identity as global city; [...] because Potsdamer Platz had become a non-place in most Berliners' mental maps after the erection of the Wall, the task was to reclaim the space and fill it with new meaning.
> (Lehrer 2003: 384)

35. Schinkel's gate survived the demolition of the customs wall but not the Allied bombings and the construction of the Berlin Wall that followed. Replication of his gatehouses (*Torhäuser*)

135

was considered in the 1990s; however, appropriately, open entrances to the underground train station stand at their exact location.

36. This octagonal square is cut into two on its east–west axis via Leipziger Strasse.

37. Street names may change or stay the same throughout history in Berlin. The street between Potsdam Gate and Anhalt Gate, for instance, was Hirschelstrasse, Königgrätzer Strasse, Stresemannstrasse, Saarlandstrasse and again Stresemannstrasse, respectively. For that reason, current names are used here.

38. Linkstrasse that merged with Potsdamer Strasse a mere 50 m before the intersection and the busy *Potsdamer Bahnhof* with multiple rails parallel to this street were increasing the amount of traffic at this junction. Though they belonged to the Soviet sector, two sites on Potsdamer Platz were left out of East Berlin when the Wall went up: the rectangular site of the Potsdam Train Station and the Lenne-Triangle (*Lenne-dreieck*) between Tiergarten and Leipziger Platz (https://www.berlin.de/mauer/en/history/exchanges-of-territory/lenne-dreieck, last accessed 19 February 2021). For a simulation of the *Potsdamer Bahnhof*, see http://www.youtube.com/watch?v=PItJDRIZTaA (last accessed 12 September 2021).

39. *Alte Potsdamer Strasse* had already been routed this way when Scharoun's library was built (1967–78) and this was not rectified post-reunification.

40. Le Corbusier's most notable Berlin structure, the *Corbusierhaus Berlin* (1956–58), is elsewhere – on the edge of Grunewald Forest near the Olympic Stadium. The large horizontal block of this *Unité d'Habitation* with 530 apartments has a height of 53 m and a 141 m wide façade with vivid balconies.

41. Potsdamerplatz […] wasn't a place, at all. Potsdamerplatz *c.*1987 was a wasteland, a 'zone of exception' extricated from the everyday circulation of life and the 'no-man's land' between East and West Berlin in the partition of the city by the Four Powers after the Second World War (Bordo 2008: 91).

42. Studio Libeskind. *Potsdamerplatz*, https://libeskind.com/work/postdamer-platz (last accessed 12 September 2021).

43. For the busy traffic of Potsdamer Platz in the 1920s, Siemens made the first traffic light in Europe on a tall five-faced structure that stood at the intersection of the five roads between 1924 and 1936. The company made a replica of the traffic light for their 150th anniversary in 1997, which still stands in the Potsdamer Platz but not in its original location.

44. 'Moving through Potsdamer Platz is, in principle, a timetabled experience of consumption' writes Ward (2016: 147). Webber agrees (2008: 14): 'The new Potsdamer Platz is in this sense an engineered centre for the New Berlin – a Sony Center perhaps – that trades on the city as another marketplace for globalised capital in a transnational, telecommunicating, inter-city age.'

45. Ingeborg Major O'Sickey talks about 'a Germany that is post-everything' attitude in this European country: post-Holocaust, post-war, post-Wall, even post-reunification (2001: 65).

46. The city required mix-use for the new Potsdamer Platz and projects had to include twenty per cent apartments (for those who can afford them).

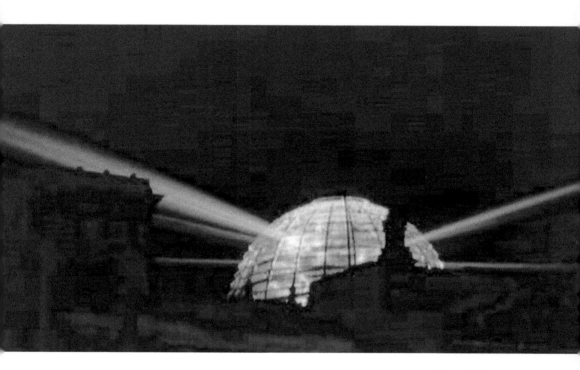

Berlin Babylon (2001)

6

Prosthetic Limbs:
Supplementation

Berlin is now the centre of the world.
 Dr Bettelheim in Weimar Berlin in *Hanussen* (1988)

Supplementation is the addition of new and contemporary-looking elements to a building or space that complement the function of the structure. In order to be supplemental, the new element must not be seen as an extension to an existing building but an integral part of it. Additions and extensions to existing buildings are like the cohabitation of two different organisms, one older and the other newer. Supplementation, on the other hand, is like the symbiosis of two organisms where one lives on or in the other. As architectural preservationist and artist Jorge Otero-Pailos (2015: n.pag.) explains, 'The supplement, by definition, needs to appear secondary to the document, even if without it the document cannot function as such'. Matching the style of the original is not a criterion for being a supplement, but contributing to the interpretation of the original most certainly is.

Up until the twentieth century, many public buildings, especially European Romanesque and Gothic cathedrals, had been supplemented at least once over their lifetime. With the emergence of historic preservation in the nineteenth century, which sought to minimize the complexities of architectural history by usually trying to match the style of existing structures, supplementing existing structures was not preferred. In parallel with the rise of Modernist ideology in the twentieth century, especially after the 1964 Venice Charter that strongly opposed the reconstruction of historic structures, the creation of new, usually free-standing, constructions has been favoured over supplementation. By the twenty-first century, simultaneous to the pressures of sustainable and ecological development, buildings have been supplemented and reused more and more, adding to their already established memory. Two exemplary illustrations of this phenomenon include London's Bankside Power Station conversion into the Tate Modern art gallery (1995–2000)

by Herzog and de Meuron, and Bruno Gaudin and Virginie Bregal's overhaul of the French National Library (2017). In both cases, older structures were updated to fulfil twenty-first-century specifications, however, the Tate Modern changed the use of the building from an industrial facility to a museum, and the library continued to function as a book repository and research centre.

I. M. Pei's glazed entry-hall (2004) for the German Historical Museum, to the rear of the former *Zeughaus*, at first may seem like supplementation, but because it acts as a minor appendage attached to a larger body it is not. A supplementation of sorts occurred in 1964 when the *Stadtschloss* portal containing the balcony from which Karl Liebknecht proclaimed the Free Socialist Republic of Germany, saved from demolition in 1950, was incorporated into the façade of the State Council Building (*Staatsratsgebäude*) of the German Democratic Republic as its main entrance. Contrary to the previous examples where the supplement was a new structure complementing an older structure, this highly decorated eighteenth-century portal stands in stark contrast with the style of the newer structure around it. Supplementation normally helps a historical structure 'catch up with' the contemporary needs of the city and its memory, however, it can also incorporate and reframe a historical supplement that would otherwise be forgotten.

The Reichstag Dome

Do you see the dome? It was designed by Norman Foster.
The reflecting cone directs light to the centre of the building, so it isn't just an architectural element.

Architect Carla in *Off Course* (2015)

Domes on buildings are literally their crowning achievements. When they are monumental, expansive and enclosing, domes are the three-dimensional manifestation of the power vested in whoever they represent – an organized religion, a governmental entity or an economic powerhouse. The Hagia Sophia in Constantinople (*c.*537), Brunelleschi's Duomo in Florence (1436) and Michelangelo's dome for St. Peter's Basilica at the Vatican (completed in 1590) are archetypal examples expressing the religious power of the Christian church. The Ottoman sultans and other Islamic rulers constructed multi-domed buildings to represent imperial and royal power in their public projects such as schools, baths, tombs and caravansaries, in addition to palaces and mosques. Modern democracies and dictatorships have also adopted such dome-symbolism, as evidenced by structures such as the United States Capitol (dome, 1866) and Albert Speer's projected People's Hall for Hitler's Germania plans for Berlin (1938).

In 1999, British architect Norman Foster completed a dome for Berlin's Reichstag building, supplementing the original 1894 building. This was not the first dome on the almost 100-year-old structure, but it has proven to have contributed a considerable amount to the shaping of the Reichstag's and Berlin's interconnected memories. The Reichstag building is a site of remembrance revealing Berlin's urban memory, particularly after its recent renovation to house the Federal Parliament (*Bundestag*) of reunified Germany. Journalist Michael Wise (1998: 121) summarizes this situation as: 'No structure in Germany has a more potent or more turbulent presence than the Reichstag'.

Berlin's Reichstag building was constructed to house the activities of the German Empire's Imperial Parliament.[1] An 1872 architectural competition for the building surprisingly attracted fifteen English architects, of which the renowned Sir George Gilbert Scott,[2] along with his son John, took second prize with a Neo-Gothic proposal (Schulz 2000: 19). First prize was awarded to German architect Ludwig Bohnstedt, but delays in securing the land necessitated a new competition nine years later, which this time was limited to architects 'of the German tongue' (Cullen 2004: 28). The brief for this new competition was straightforward: 'The competing projects should not only be designed to offer the most expedient solution to the pending task but should also embody the idea of a parliamentary building for Germany in a monumental manner' (*Deutscher Bundestag* 2018a: 213).

Out of 188 entries, Frankfurt-based architect Paul Wallot won this second competition. In the words of art historian Peter Chametzky (2001: 251), 'The problem [for Wallot] was to design a building to represent a nation that hardly existed, and to house and represent a democratic body in what was essentially an imperial oligarchy'. The competition brief also called for a national building, but there was no such thing as a German national style. There was a Prussian style, as evidenced by the Classicism seen on nearby Unter den Linden, but this was out of fashion. In addition, Wallot wished to avoid that style in order not to equate Prussia with the German Empire.

The name Reichstag originated from the meeting of territories that assembled under the Holy Roman Empire between 962 and 1806. While attempting to choose a style for his Reichstag building, Wallot could have, therefore, mined the Romanesque or Gothic architectural styles of the Middle Ages to match with this heritage, but instead he preferred a mixture of Neoclassical, Renaissance and Baroque forms, similar to what Gottfried Semper had designed in Dresden, Zürich and Vienna earlier in the century. On top of this mix of architectural styles, literally, Wallot designed a glass and steel dome to crown the building.

Although presenting a monumental face, Wallot's Reichstag building was indeed a rather confused structure. The style choice of sturdy, solid and symmetrical Renaissance forms together with lively, flamboyant and dramatic Baroque

forms made for a confusing presentation, as evidenced by contemporary dispar-
agement of the structure by both conservative and progressive critics (Koepnick
2001a: 307). Although it cannot be seen at one glance, each façade of the building
is different, creating an asymmetry not usually seen in structures attempting to
represent authority and stability. The building's glass and steel dome, modelled
after the 1876 Centennial Hall in Philadelphia (Filler 2007: 226), did not quite
match with its heavy stone base with many ornate and figurative sculptures (Wise
1998: 124). Lastly, although the building was constructed for a democratically
elected parliament, its interior decorative motifs reflected a contradictory imperial
dimension with crowns, sceptres, monograms, heralds, crests and coats of arms
as well as eight bronze statues of Holy Roman Emperors, each about two and a
half metres tall (*Deutscher Bundestag* 2018a: 228).

Wallot was able to explain all of these criticisms. In terms of the style, as
mentioned, he preferred to stay away from the spare Neoclassicism of Prussian
architecture and represent a united German Empire. In terms of the different
façades, each one reflected the various users of the building who entered the build-
ing via different directions.[3] With regard to the aristocratic and monarchical inte-
rior decorations, Wallot was attempting to construct a mythical history for the
parliament stretching back to the Middle Ages (*Deutscher Bundestag* 2018a: 230).

In terms of the dome, Wallot designed it as an expression of the industrial times
in which the building was constructed: the modern art of engineering fused with
the traditional arts of painting, architecture and sculpture (Koepnick 2001a: 306).
Other architects, the public and Wilhelm I, however, did not interpret the dome
in this way. To them, it did not integrate old and new; rather, it was a mismatch.
Keeping in mind that the building housed a democratic body, at least in theory,[4]
Wallot also saw the Reichstag dome as representing the people, making a trio out
of the other domes in the city – the Berlin Cathedral representing the church and
the Berlin City Palace representing the monarchy (Chametzky 2001: 252).[5]

With the dissolution of the monarchy and the establishment of the Weimar
Republic in 1918, in less than half a century, there was hope that the Reichstag
building would fulfil its original duty to house a democratic institution, referred
to as the Weimar National Assembly. This hope was shattered in late 1929 when
a bomb exploded in a light shaft of the Reichstag, shattering windows. A more
famous attack on the building came in 1933, a mere four weeks after Adolf Hitler
was sworn in as chancellor. On the night of 27 February, the plenary chamber
of the Reichstag was burned before the fire department could save it. The Nazi
Party claimed that 24-year-old Dutch communist Marinus van der Lubbe, found
at the scene, was responsible for the fire, although, because the event served their
purposes so well, it is also theorized that they committed the arson.[6] Regard-
less, this fire was the excuse Hitler needed to suspend most civil liberties, citing

the prevention of more Communist violence, and to imprison many Communist sympathizers, including some MPs.

The Nazis would never use the Reichstag building again for assembly purposes, keeping the burned-out middle section as a ruin symbolizing communist barbarism. When the Soviet forces invaded Berlin in April 1945, Stalin ordered that a flag be raised over the Reichstag by 1 May (Richie 1998: 595), not because it represented the Nazi regime but because it represented anti-Communism. Soviet filmmakers Yuli Raizman and Yelizaveta Svilova's documentary *The Fall of Berlin* (1945) follows invading Red Army troops from the Oder River to the streets of Berlin with actual footage of artillery, tanks and foot soldiers shooting their weapons and advancing. When the Soviets reach the suburbs of Berlin, their stated goal is the Reichstag building 30 km away. This one-hour film spends twenty minutes just on this slow advance through the city, which culminates in a celebratory flag-raising on the 'Germania in the Saddle' sculpture on the roof, aiming to create a victorious memory for the Soviets.[7] The Reichstag as the goal of the invading Red Army is dramatized in Max Färberböck's *A Woman in Berlin* (2008) when the main Russian character shows anger and disappointment at being ordered to halt his troops: six decades after the event, the memory of its highlight is the taking of the Reichstag and the famous flag-raising.

In the years immediately following the Second World War, the ruined Reichstag building – like other ruins in Berlin – was a symbol to the international community of the Nazi years, despite the fact that the building reminded Germans of the failed Weimar Republic. The final chase scene of Frantisek Cáp's *Adventure in Berlin* (1952) ends up at the ruined Reichstag, complete with Soviet graffiti and bullet holes. In a last-ditch effort to evade their pursuers, the main characters clamber up onto the roof, where the skeletal ruins of the dome dominate over them. They eventually win their battle while the future fate of the Reichstag remains unknown.

In Irmgard von zur Mühlen's *Berlin under the Allies 1945–1949* (2002), the ruined Reichstag building is framed in the opening scene that sets the tone of the documentary via historical footage: while children play on stranded vehicles and abandoned artillery posts, a large black market develops in the shadow of the ruined building, and vegetable gardens are planted in the neighbouring Tiergarten for much-needed food. Keeping in mind that this documentary was created post-reunification, it seems to be an attempt to come to terms with the past by presenting archival footage as an unbiased spectator rather than the presentation of a recovery and rebirth narrative.[8]

Wallot's glass and steel dome was eventually dismantled in 1954, along with the many cartouches, statues and flourishes of the original building, leaving the Reichstag building reduced to its stone walls. In 1961, German architect Paul Baumgarten won a competition to renovate the building, eventually taking ten

years to insert a new plenary chamber twice as large as the original and opening up the ceremonial west entrance with glass openings. In August of that same year the construction of the Berlin Wall began immediately to the east of the Reichstag. This rendered the building, like the nearby Brandenburg Gate, a good photo-op succinctly representing the conflict of the Cold War. When Baumgarten's renovation was complete in 1971, an exhibition entitled *Questions on German History*, which addressed a narrative of Germany beginning in 1800, opened in the building and ran continually until 1994.

When the Berlin Wall fell in 1989, the Brandenburg Gate was the star of the show. The Reichstag had to wait until 20 June 1991, when the MPs of reunified Germany voted 338 to 320 to not only move the capital back to Berlin from Bonn but also to renovate the Reichstag building to be used by the Federal Parliament. The wrapping of the Reichstag by artists Christo and Jean-Claude in 1995 allowed the public to accept its next phase as the location of the German Parliament (*Bundestag*), although there was some discussion about what the renovated structure should be called: Reichstag, Bundestag in the Reichstag, or simply Bundestag. Even though there was no longer a *Reich* ('empire') nor a Reichstag ('imperial parliament'), the conclusion was simply 'Reichstag'. In the words of a Berlin taxi driver, 'The Reichstag is just the Reichstag, what else?' (Roeck 2001: 155). This acknowledgement of the building's layers of memory became prominent in Norman Foster's renovation and supplementation.

In 1992, the newly reunited Federal Republic of Germany invited 14 non-German architects and 75 German architects to propose projects to renovate the Reichstag building. From these proposals, British architect Norman Foster, Dutch architect Pi de Bruijn and Spanish architect/engineer Santiago Calatrava won a joint first prize and were invited to refine their proposals. Pi de Bruijn kept the Reichstag building as it was and proposed a new separate plenary chamber. Foster proposed an expansive translucent tent-like roof structure supported on thin columns that covered both the building and part of the area to the north. Only Calatrava proposed a new glass dome for the building, which, in the Spaniard's characteristic hi-tech style, was 'capable of opening up like a flower' (Wise 1998: 127).

Foster, de Bruijn and Calatrava were then asked to rework their designs. Although at this stage Foster still did not yet propose a new dome, he won this round – with a glass roof extension within the volume defined by the Reichstag's towers. Certain factions of the *Bundestag* wanted a new steel and glass dome for the building. The most conservative of those wanted an exact replica of the original dome, but this would prove to be outside of their budget. Foster experimented with many variations of shape (semi-circular, ovoid and cylindrical), height (matching the building volume, higher and lower) and of orientation (tapering

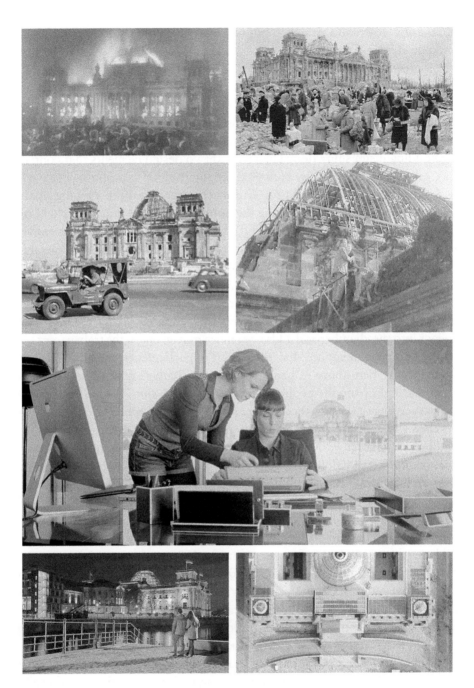

FIGURE 6.1: The Reichstag, with domes in various states, in *Hanussen* (1988 – set in the 1930s), *Taking Sides* (2001 – set in 1945), *Berlin Express* (1948), *Adventure in Berlin* (1952), *Passion* (2012), *Off Course* (2015) and *Look Who's Back* (2015). (All illustrations are film stills captured by the authors.)

up, tapering down and straight), but not material: Foster's dome, like Wallot's, would be glass and steel.[9]

Foster eventually supplemented the Reichstag building with a new dome 23.5 m high and 40 m in diameter. Twenty-four steel ribs arranged in a circle rising up create a semi-circular dome. These ribs are braced in the vertical direction with seventeen steel rings. Covering all of this armature is 3000 m² of clear glass. At night, Foster's dome glows like a beacon. But the architect did not give the Reichstag building just a shiny dome; he inserted two design elements that contribute to its value. The first element is two ramps intertwined in a double helix within the dome. One of the ramps is for visitors to ascend to a top viewing platform and the other to descend. By having the public walk at the inner periphery of his dome – which they can do both day and night free of charge – Foster has enlivened his structure which, without them, would have been a quite static supplement.

The second element that enlivens Foster's dome is a cone, composed of 360 mirrors, that points down into the plenary hall immediately below, which itself has a glass roof. This funnel-like form reflects light down into the large hall and also serves to ventilate it. A shade screen rotates around the dome to prevent direct sunlight into the chamber and adds even more movement to the transparent space. Beyond the crude metaphor that 'the hot air of parliamentary debate is dispersed into the atmosphere above' (Chametzky 2001: 254), there is an additional symbolism in that light from the people above comes down onto the parliamentarians. The glass ceiling of the plenary chamber also hints at the public being able to watch over their chosen representatives, as the character of Julian Assange remarks in Bill Condon's *Fifth Estate* (2003): 'A government destroyed by tyranny re-built under a glass dome so the whole world could look in [...] There's an ideal to aspire to'!

As architectural historian Deborah Ascher Barnstone (2005: 2) points out, the transparency seen in Foster's renovated Reichstag has its roots in the two West German parliament buildings previously constructed in Bonn (Hans Schwippert 1949 and Günther Benisch 1992), under the trope 'He who builds transparently, builds democratically'.[10] Some critics, using the 1920s architectural theories of Paul Scheerbart and Bruno Taut and the 1930s cultural criticism of Sigfried Kracauer, disparage this simplistic equation of clear glass and looking down into the plenary chamber with an idea of 'democratic transparency'. While such an equation of transparent glass = transparent institutional structures = democracy (Jarosinski 2002: 64) is certainly simplistic, what such critics do not take into account is the power of architectural metaphors and how these can function vis-à-vis the urban memory of a city. In the case of the Reichstag building, it is this added transparency metaphor, together with Christo and Jean-Claude's 1995 wrapping and then unwrapping, which helps both remind and avoid any resemblance to Imperial Berlin and Nazi Berlin.

Ironically, a glass and steel dome, which was seen as a weakness of the original building, became part of the success of the millennial Reichstag building. This second time around, both the disjuncture with the building's stone base and the metaphorical allusion to the people and democracy worked. Unlike Wallot, Foster was supplementing an existing building, not building from scratch. And this time, the client was actually a representative governmental body.

In addition to the dome, Foster completely reorganized the interior layout of the Reichstag building, even inserting a new floor level. In reality, all that is left of Wallot's building are its four exterior walls, stripped of most of their sculptural decorations. Having said that, there are some other touches that reinforce the many layers of history in the building. First, and probably most famously, graffiti written by joyous Soviet soldiers can be plainly seen in many areas. Exposing this graffiti to the public is significant because it was a result of a German defeat, not victory, and it is a reminder of two powers – the Soviet Union and Nazi Germany – that both no longer exist. It also reinforces the new Germany's democratic identity. Also exposed to public view are some of Wallot's decorative touches that were not removed in the 1950s. Both graffiti and imperial decorations had been covered over during Baumgarten's 1960s renovation, but when discovered in the 1990s, they were left exposed and available to view. A final element that adds to the complex layers of the building is the preponderance of contemporary art. The works of 33 German and international artists add to the layering effect, representing the time period when Foster's renovation took place.

Interviewed during Carlos Carcas and Norberto López Amado's documentary *How Much Does Your Building Weigh, Mr Foster?* (2010), the architect clearly understands the symbolic nature of his Reichstag renovations:

> Whether it is the Golden Gate or Sydney Harbour, the bridge becomes the symbol of the place [and] transcends the original function. In that sense, I think the way in which the Reichstag, for example, which was very much about creating the democratic forum for a reunified Germany, has become not only the symbol of the city but it has become the symbol of the nation.

Berlin's Reichstag building, supplemented with Norman Foster's dome, no longer represents the German Empire and its powerless parliament. Nor does it represent the failed Weimar Republic or stand as a symbol of Nazi suppression of human rights. All of these thoughts, however, cannot be escaped, as masterfully portrayed by Thomas Schadt in his 2002 film *Berlin Symphony*. This film, itself a reminder of Walther Ruttmann's 1927 *Berlin: Symphony of a Great City*, juxtaposes the current Reichstag dome with still images from its various pasts: the original 1894 building, the building on fire in 1933 and a

gathering on 1 May 1962 protesting the newly built Berlin Wall. Also within this series is a shot of a contemporary rack of Reichstag dome postcards, reminding the viewer of the current status of the building. The supplemented Reichstag building today

> reveals the extent to which historical memories are products of present-day selections and constructions, and in doing so explodes the naturalizing view that inspired the building's initial historicism and monumentalism; [...] it trips up any chauvinistic or revisionist narrative of German history; it envisions a German future neither overshadowed by nor willing to forget the national past.
>
> (Koepnick 2001a: 307)

That is, the Reichstag is just the Reichstag.

Berlin Olympic Stadium

> Impressive, isn't it? Built by Werner in 1936 for The Olympics. [...]
> Certain well-known personalities used to stand right up there.
>
> Pol in *The Quiller Memorandum* (1966)

In *Travellers in the Third Reich*, Julia Boyd writes: 'No one knew better than the Nazis how to manipulate the emotions of vast crowds, and many foreigners – often to their surprise – discovered that they too were not immune' ([2017] 2018: 7–8). Nazi propaganda during the 1930s was a powerful tool in Germany that took the form of rallies, posters, books, photographs, newspapers, public speeches and even comics. If opera was Wagner's *Gesamtkunstwerk*, propaganda film was Hitler's. Similar to the German composer he admired, Hitler would have his Ministry of Propaganda stage and orchestrate an extensive public event, and his Department of Film would record, edit and distribute it.[11] Two Nazi films are perhaps the best examples of such propaganda filmmaking:[12] *Triumph of the Will* and *Olympia*, both directed by Leni Riefenstahl.[13] Due to their artistic and technical innovations, creativity in the use of framing, scale and camera angle, music and sound effects and the art of montage, these were influential films for later documentary filmmakers.

In *Triumph of the Will* (1935), Riefenstahl turned 60 hours of footage into a 105-minute long high-quality Nazi propaganda film. The grand symmetrical and axial decor by architect Albert Speer was populated with giant eagle statues, flags and streamers with swastikas, large fires, fireworks, wreaths and most importantly, hundreds of static or mobile people watching, marching, turning and collectively

giving the Nazi salute.[14] 'In *Triumph of the Will*, the document (the image) not only is the record of reality but is one reason for which reality has been constructed, and must eventually supersede it' (Sontag [1975] 2013: 83). In Hitler's words, the film was 'a totally unique and incomparable glorification of the power and beauty of our Movement' (Sontag [1975] 2013: 82). In the meantime, the Nazis were preparing for an even-bigger international convention to show the world the power of the Third Reich and its leader: The 1936 Olympics.

Various departments of the government that had previously collaborated – architecture, planning, propaganda, film, military and security – as well as sports and international affairs teamed up once again for the organization and documentation of the 'Nazi Olympics'. The most memorable heritage from this unprecedented sports event was Riefenstahl's two-part *Olympia* (1938), *Festival of Nations* and *Festival of Beauty*, commissioned by Hitler. Forty years into the history of cinema and the modern Olympic games, the black-and-white *Olympia* was the first full-length documentary of the Olympic Games and became a precedent for documenting the event.[15] Writer and filmmaker Susan Sontag ([1975] 2013: 87) observes:

> In *Olympia*, one straining, scantily clad figure after another seeks the ecstasy of victory, cheered on by ranks of compatriots in the stands, all under the still gaze of the benign Super-Spectator, Hitler, whose presence in the stadium consecrates this effort.

Riefenstahl had placed cameras almost everywhere for more than two weeks: six on the field in the stadium, several in the stands and automatic ones on balloons and in boats. She also collected professional and amateur footage during the games. Riefenstahl and her team developed advanced techniques and technologies for a new sports documentary aesthetic: panoramic aerial shots from a plane, tracking shots following athletes in motion in water and on land with a mobile camera operator on rails, unconventionally high/low camera angles, slow motion and blurred backgrounds for dramatic effect, details and close-ups of athletes, spectators, shadows and sports equipment, spatial montage with overlapping imagery of, for instance, the stadium and the bell and temporal montage with smash cuts from wide angle to close-up, match cut of a discus thrower sculpture to an actual discus thrower and the list goes on. Riefenstahl's obsession with young healthy bodies, physical beauty and strength is evident in both parts of the film.[16]

Riefenstahl's propaganda film was made possible by the Olympic games held in Berlin in 1936 with the initiative of the Nazi Party. And the immense organization of these major international games was made possible by the Olympic stadium designed and constructed shortly before the Olympics, again with the initiative

of the Nazi Party. The government commissioned Berlin's Olympic Stadium and its supporting buildings to Werner March. The events that brought the architect to that moment began 30 years earlier.

Sports facilities in this area of today's Berlin-Westend began during the time of Wilhelm II, decades before the Nazis, with a 40,000 spectator horse racing track for the Berlin Racing Club (1907–09) designed by Otto March. Close to this racetrack, an 11,500-seat German Stadium (1912–13) for the 1916 Summer Olympics was also commissioned to March who designed it half-buried in the ground. The First World War prevented the implementation of the 1916 games and Berlin had to wait for another twenty years to host the Olympics.[17] In the 1920s, the German University for Athletics started using the structure, accompanied by another university building (1921–22). The complex, German Sportforum, then began to expand. In 1925, Werner March, Otto March's son, won a competition to improve the facilities and build additional buildings, such as a female dormitory. This project had financial setbacks after 1926 and a gymnasium was only

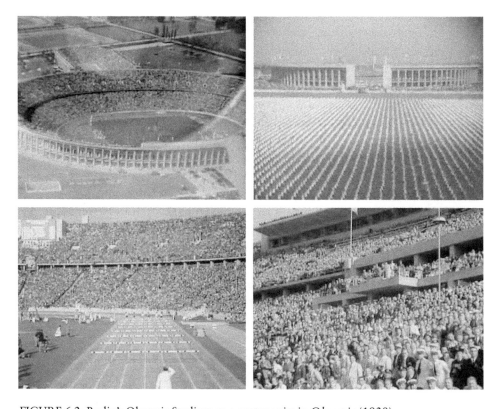

FIGURE 6.2: Berlin's Olympic Stadium as a protagonist in *Olympia* (1938).

half-finished. The project gained a totally new direction in 1930 when the Weimar Republic's Berlin was awarded the 1936 Summer Olympics. Construction started in 1933 to renovate the elder March's stadium, however following Hitler's appointment as chancellor later that year, he visited the existing structure and commissioned Werner March, assisted by his brother Walter March, to design a brand new 100,000 spectator stadium, as well as several other buildings for the Olympics. Both the existing stadium and the racetrack were immediately demolished, along with their memories, and new construction took place between 1934 and 1936, using stone from all around Germany.[18]

The Berlin Olympic Stadium was built as the jewel of a large complex called the Imperial Sports Field (today *Olympiapark Berlin*) with multiple indoor and outdoor sports facilities such as the Olympic Plaza, Swimming Stadium, the House of German Sports with indoor and outdoor pools, Mayfield, a large open sports field for 50,000 people, the Bell Tower and the Dietrich Eckart Amphitheatre. Accessibility was improved with new roads and railways as well as the marathon tunnel under the stadium for athletes and large equipment to enter the field directly (alongside Otto March's existing 20 m wide tunnel). Female athletes stayed in the Friesian House close to the stadium. Also, 20 km away from the sports field, the Olympic Village Elstal was prepared with 140 single-storey timber structures (for eight male athletes each), sports facilities and an assembly hall. March also completed the unfinished gymnasium and constructed a circular 5000-seat dining hall of the nations.

The open-air Dietrich Eckart Amphitheatre for 22,290 spectators was initially used for the 1936 Olympics, but then later for boxing matches, film exhibitions, operas and concerts. A tensile structure canopy was added over the stage in 1982. Curiously, Berliners did not reject this Forest Stage (*Waldbühne*), as it is called today (*Waldbühne*), like they did the stadium, maybe because it was not a three-dimensional enclosed space, or resembled its Greek archetype more than Nazi precedents. In fact, the Modernist look of March's half-sunken oval stadium was altered at the last minute by Hitler's architect Albert Speer to match, as Speer argues, Nazi 'official' stripped-down classicist architecture. This was achieved by cladding March's exposed steel frame with pale limestone to achieve the monumental and classical look Hitler insisted to have before the Olympics: architecture as 'ideology written in stone' (Tietz 2006: 14).[19]

The ceremonies of the 1936 Olympics started in Greece on 20 July with the torch relay between Olympia and Berlin, as framed in Rielenstahl's documentary.[20] Overall, the events between 1 and 16 August went well with negligible protests, some heavy rain and the participation of almost 4000 athletes from about 50 countries competing in almost 130 games. Hitler's Youth did well in the Berlin Olympics and won the most medals overall (89 in total). To Hitler's distaste, however, the star of the games still remembered today was African-American Jesse Owens

who won four track-and-field gold medals breaking world records.[21] Dutch swimmer Hendrika 'Rie' Mastenbroek, never praised as much as Owens, also won four medals, three gold and a silver. The races were covered on live television (via Heimann's *Superikonoskop*) for the first time in history.[22]

What happened to Hitler's stadium after the 1930s? What was/is the stadium's place in the urban memory of Berlin in the 1930s, 1960s, 1990s and even the 2020s? Although the Nazis mostly built governmental buildings, the *Olympic* complex was their largest project (since Germania was never realized). In the 1930s, this urban project and the stadium, in particular, acted as a physical manifestation of the power of the Nazi Party, whereby sports architecture was merged with politics and used for militaristic rituals. During the war, the stadium was used as an underground bunker. Similar to the streets of Berlin in other parts of the city, many underaged and untrained soldiers defended and died at the premises in April 1945. After the war, the British occupying forces based their military headquarters in the area until 1994, as seen in many spy films from the 1950s to 1960s, both western and eastern, and period films depicting events at that time, such as John Schlesinger's *The Innocent* (1993).

The Olympic Stadium quickly reopened in 1946, functioning as a football venue. In the late 1950s, the building was cleaned up and partially renovated. The associated sports facilities, especially the swimming pool, were also reopened and became a summertime fixture in West Berlin. In Will Tremper's *Playgirl* (1966), the main characters enjoy a swim before a quick visit and kiss at the Olympic Stadium, which he introduces to his date as 'Where Jesse Owens ran 10.2', to which she sarcastically (or not?) replies: 'Who was Owens running away from anyway?'

In *The Ghosts of Berlin*, Brian Ladd that states the Nazis 'left their mark all over Berlin; their successors, determined to make their own break with the past, had to decide what to destroy, what to keep, and what to commemorate' (1998: 127). Although the Olympic Stadium was perceived as an embodiment of Nazism and a materialization of shame and guilt on an urban scale, it survived into the 1960s when the city was divided. It was even maintained for the 1974 FIFA World Cup. However, reunified Germany's unsuccessful application in the early 1990s to host the 2000 Summer Olympics opened up these old wounds and a more public critical gaze at the dark side of Germany's past.[23] In Kutluğ Ataman's *Lola and Billy the Kid* (1999), for instance, the Berlin Olympic Stadium first becomes a setting for male homosexual desire, then a centre for neo-Nazi violence, recalling the two phases/stages of the building in the 1930s and 1940s. Why did Berliners have a hard time 'forgiving' this structure more so than other Nazi buildings that survived? Perhaps the stadium was constantly linked in the minds of the people to a glorious moment in time

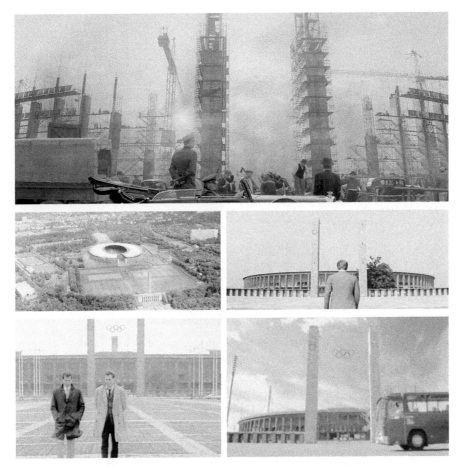

FIGURE 6.3: A visualization of the construction of Berlin's Olympic Stadium in *Race* (2016) and the finished product in *Back to Berlin* (2019), *The Quiller Memorandum* (1966), *Coded Message for the Boss* (1979) and *Lola and Billy the Kid* (1999).

that they actually cherished, the unforgettable 1936 Summer Olympics memorialized in Riefenstahl's *Olympia*.

Between 2000 and 2005, the stadium was completely overhauled to prepare for the 2006 FIFA World Cup. A new roof was added, refreshing the building and finally removing any previous Nazi stigma. With a new seating arrangement, the capacity dropped to a bit less than 75,000. Though heavily supplemented with a large roof, the renovated stadium respected the original design from the outside. The stadium hosted the World Cup exactly 70 years after the Nazi Olympics. The tension building up throughout the first season of *Dogs of Berlin* series (Christian

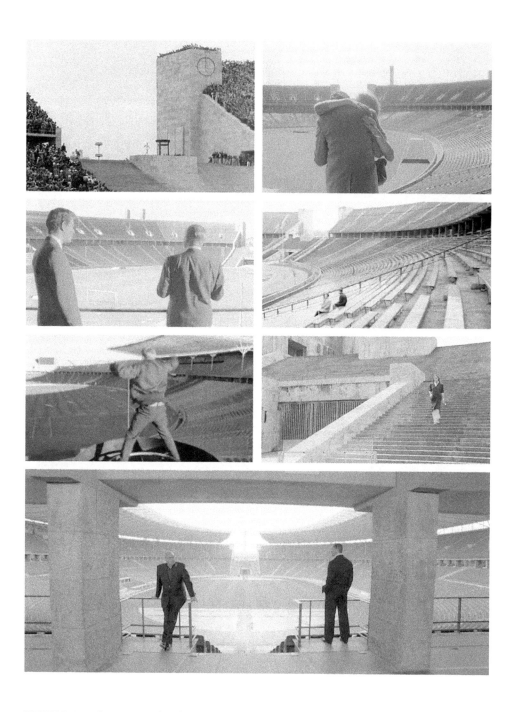

FIGURE 6.4: The interior of Berlin's Olympic Stadium in *Charlie Chan at the Olympics* (1937), *Playgirl* (1966), *The Quiller Memorandum* (1966), *Coded Message for the Boss* (1979), *Lola and Billy the Kid* (1999), Wild Geese II (1985) and *St. George's Day* (2012).

Alvart 2018) towards the final football match in the renewed stadium reveals the current significance of its supplementation for the city.

When built, the Olympic Stadium was not only the venue for Nazi propaganda during the games but also a physical manifestation of that propaganda that remained after the games. In addition to the usual swastika and German eagle motif, the stadium was decorated with a series of sculptures by Karl Albiker depicting Aryan-looking athletes of various sports. Additionally, a pair of sculptures flanking the Mayfield entrance by Josef Wackerle depicted heroic nudes steadfastly holding their horses. Two of Albiker's athletes and both of Wackerle's equestrians are still standing, complemented with explanatory texts that put the artwork in context. As summarized by sports historian Alan Bairner, the Olympic Stadium 'now owes more to the commodification of sport in general and of football in particular than to the wilder fantasies of Aryanism'. He continues: 'a stadium in Berlin, once associated so strongly with a divisive form of politics, can now be regarded as politically neutral' (Bairner 2008: 421, 428).

This may be the case for the Berliners of the reunified Germany, but not all parties. The stadium recently became the focal point of another documentary, *Back to Berlin* (2018). Catherine Lurie's biographical road movie documents a month-long journey of Jewish motor-bikers travelling 5500 km from Tel Aviv to Berlin for the Maccabiah Games, known as the Jewish Olympics, to be held in the Berlin Olympic Stadium in 2015. As well as the torch for the Opening Ceremony of the European Games, they carry with them their troubled past:

> Our riders, like the Nazis' torch relay for the 1936 Olympics, carry their torch from Athens to Berlin but this time take a detour via Auschwitz. As the journey progresses they try to free themselves from the shackles of the past only finding solace on their powerful motorbikes.[24]

In *Berlin Games*, historian Guy Walters (2006: xiii) highlights the 'Nazification' of the 1936 Olympic games and the eternal link between sports and politics:

> Although some argue that a structure so closely associated with the Nazi period should not be used, it would seem churlish (and uneconomical) to abandon so handsome and vast a building. In 1936 it may well have been regarded as an architectural embodiment of the waxing power of the new German Reich, but in 2006, the seventieth anniversary of the Nazis' Olympics, it stands as a symbol that Germany has the ability to come to terms with its past. Why should it not be used? What harm does it do? The shape of the Olympic Stadium does not register as a symbol of evil. [...] The stadium may well not be free from guilt, but like many associated with the Nazi regime, it does not necessarily deserve the death penalty.

While a British historian who, in this context, does not have an issue with reconciling with the past might have a point from an outsider's perspective, usually emotions overpower, even suppress, thoughts when it comes to sites of memory. Rudy Koshar (1998: 179–80) claims:

> [F]or Nazism, although mediaeval townscapes still worked as backdrops to the mobilisation of the nation, it was the Nuremberg parade grounds or the Berlin Olympic stadium that most evocatively engaged the imagination of the *Volk*. Between the hushed tones of worshippers and tourists in the Cologne cathedral and the roars of massed crowds of the Berlin stadium there were, of course, important similarities; both emanated from people who were spectators of and participants in national 'total work of art'.

This voluntary existence and participation of Berliners, Germans and international spectators in the Nazi stadium during the 1936 Olympics, as a significant part of Hitler's well-orchestrated art piece that is forever frozen in time with Riefenstahl's documentary, was the main setback for the collective memory of March's stadium for decades following the defeat of the Nazis.[25] Its supplementation with two pieces of hovering wing-like roof structure, revealed to its visitors once they pass the threshold of doubt and step inside, finally seemed to wash off this unpleasant memory of the early twenty-first century.

The effect of the new dome of the Reichstag is no different; it complements and enhances its older sibling, and the memory layers of the parliament building increase in number, balancing dark ones. Not all supplementation projects have such positive outcomes, but when one does, the supplemented version of the existing building gains a refreshed memory and revised meaning. Supplementation, though permanent, rewrites the history of a building by giving it a second chance, a chance of a new beginning, similar to the cleansing effect of the *Wrapped Reichstag* installation. This does not erase past memories associated with the structure, rather it implies the punishment is over.

NOTES

1. The German Empire's Imperial Parliament was composed of elected representatives from each constituent state, the number corresponding to population.
2. George Gilbert Scott is the grandfather of Sir Giles Gilbert Scott who designed the power station that is the Tate Modern today.
3. The Kaiser, Chancellor and *Bundesrat* members used the east façade as an entrance. Reichstag parliamentarians entered through the south façade and the public were admitted via the north façade. The imposing west façade – the one most exposed because of its location

on a public square and the one most known and framed in film and photography – was largely ceremonial (Chametzky 2001: 251–52).

4. The democratically elected German parliament in actuality did not have democratic authority because the chancellor appointed by the emperor could overrule it.

5. This is why Wallot also provided for an area on the west façade to be engraved with the words 'To the German People' (*Dem Deutschen Volke*). When the final stone of the Reichstag was laid on 5 December 1894, this inscription had not been carried out. The press rumoured that the emperor disapproved of the inscription because it seemed to legitimize the parliament, but the truth is that the Reichstag Works Commission would not allow it because, 'since the German people, through their representative assembly, had approved the allocation of funds for the construction project, [they] could not now dedicate the building to themselves' (Deutscher Bundestag 2018a: 226). The resulting blank area spoke more about the situation than had the inscription been made in the first place. The empty slab under the pediment could be read as a sign of the uncomfortable power relations between the monarchy and the parliament (Martin 2000: 32), a sort of zen 'presence of absence'. The inscription was eventually installed, in bronze letters by architect and designer Peter Behrens, in 1916, as the First World War battle of Verdun was nearing its end (Roeck 2001: 149).

6. The previous weeks had seen bombs exploding in other places in Germany, with the Communists also being blamed.

7. A famous still photograph by Yevgeny Khaldei also captures a Soviet flag-raising on top of the Reichstag building, but on the building's southeast corner tower instead. Although Khaldei's flag-raising scene has been proven to have been re-enacted later, with its battered Reichstag in the foreground and ruined buildings in the background, it has nevertheless proven to be a powerful representation of the defeat of the Third Reich.

8. *Berlin under the Allies 1945–1949* is one of a series of twelve Berlin-related documentary films directed by Irmgard von zur Mühlen and produced by the Chronos-Film Company. The other eleven are listed in the book's filmography.

9. An interesting direct lineage can be traced from Norman Foster (b. 1935) to his teacher Paul Rudolph (1918–97) at Yale University in the 1960s to Walter Gropius (1883–1969), under whom Rudolph studied at Harvard University in the 1940s. Gropius was a leading proponent of modern architecture in Germany, and one of the founders of the Bauhaus (1919–33) as well as the architect of its concrete, glass and steel building in Dessau.

10. Barnstone succinctly deconstructs this trope: 'Based on collective memory and consensus about what events should never be repeated, [...] [i]t offers the false hope that things and events that are visible are controllable.'

11. Though the term propaganda has negative connotations today, that was not the case in the first half of the twentieth century, and many countries, mostly dictatorships, had an organization to advocate their ideology. Soviet Russia, Brazil and North Korea, for instance, had departments similar to the Reich Ministry of Public Enlightenment and Propaganda (*Reichsministerium*

für Volksaufklärung und Propaganda), led by Joseph Goebbels. *A German Life* (2016), a documentary about Goebbels' secretary Brunhilde Pomsel who passed away at the age of 106, portrays an insider's (limited) view to the extent of the propaganda culture in Germany at the time, https://www.a-german-life.com (last accessed 22 May 2020).

12. Nazi propaganda films were not solely documentaries; they were also fictional narrative films such as *Our Flags Lead Us Forward* (Hans Steinhoff, 1933), *The Four Companions* (Carl Frölich, 1938), *The Gas Man* (Carl Frölich, 1941), *The Great Love* (Rolf Hansen, 1942) and *Under the Bridges* (Helmut Käutner, 1944).

13. Director, actor, dancer and photographer Berta Helene Amalie Riefenstahl was an artist with many talents. After pursuing a dance career followed by acting, she sets up her own film production company. Her first work for Hitler was the hour-long *Victory of Faith* (1933) that documented the 1933 Nazi Party Rally in Nuremberg. (Hitler later ordered the destruction of all its copies.) Pleased with the result, Hitler commissioned Riefenstahl to document the sixth and the biggest Nazi Party congress, for which she made *Triumph of the Will*. This 1934 Nuremberg Rally turned into a carefully staged historical event with more than a million German participants. '*Triumph of the Will* represents an already achieved and radical transformation of reality: history became theater' (Sontag [1975] 2013: 83). In Ray Müller's *The Wonderful, Horrible Life of Leni Riefenstahl* (1993) Riefenstahl is interviewed ten years before passing away at the age of 101.

14. Riefenstahl used masses of people as monumental compositional elements of her carefully planned frames and shots, and clearly inspired many filmmakers including Bruce Miller's ceremonial scenes of the authoritarian Gilead regime in *The Handmaid's Tale* series (2017–present) Love and appreciation, even desire, towards Hitler, often shot from below, was clearly displayed and carefully edited. The rigid order of the parades was balanced with the pastoral background of the town with its river, building facades, streets and historic structures. The modern and the rural were meshed up with Riefenstahl's dynamic camerawork in motion.

15. *Olympia* was the principal German entry in 1938 at the Venice Film Festival, where it won the Gold Medal.

16. Riefenstahl used flags, banners, olive wreaths, fire all the way from 'holy' Greece, smoke, darkness, light, shade and shadow, sound and imagery of the crowds, and music to supplement the dramatic effect. Herbert Windt's uplifting classical music favoured high tones for women and low tones for men who dominated the games. (Less than ten percent of the athletes were women, some of whom were filmed in Hollywood production *Charlie Chan at the Olympics* (Bruce Humberstone, 1937) that features no swastikas.) In the stadium, the audience usually heard the German narrator and the cheering of over 100,000 people.

17. This stadium, during the war, was adapted as a military hospital.

18. The Nazi-themed website 'Traces of Evil' lists Franconian limestone, Saxon porphyry, Würtemburg travertine, Anröchte dolomite, Silesian granite and marble, and basalt from the Eifel mountain range as the stones used on the Olympic Stadium, https://www.tracesofevil.com/2008/01/wannsee.html (last accessed 17 October 2020).

19. Upon entering the stadium, one encountered a much larger space than expected, since half of the seats rose upwards while the other half were sunken 12 m into the ground going downwards. This modest and efficient design contradicted with the monumental effect that Hitler was looking for, but enabled a quick exit from the stadium after an event.

20. The Olympic flame was a Dutch invention (1928) but it was the Nazis who introduced the torch run all the way from the ancient Greek city that gave the games its name.

21. Owens won gold medals in the 100 m (equalled the world record of 10.3 seconds), 200 m (world record of 20.7 seconds), the long jump (world record) and, with his team, 4 m × 100 m relay (world record). Stephen Hopkins' *Race* (2016) depicts his life as a runner towards the Berlin Olympics in the Berlin stadium.

22. Following the 1936 Berlin Summer Olympics, the Second World War put the games on hold until the 1948 London Summer Olympics, even though Helsinki had already been chosen to be the next host. Helsinki would eventually host the Summer Olympics in 1952.

23. Sydney was awarded the millennial Olympics in 1993. If the judges voted for Berlin, what would the city have done? Would they have used the stadium built in the 1930s? Would they have built a new stadium and new facilities elsewhere in the city? Both options, to use or not to use, sound problematic in terms of the complicated memory of the stadium.

24. https://rtv2-production-2-6.rottentomatoes.com/m/back_to_berlin (last accessed 23 November 2020).

25. As Alan Bairner (2008: 427) writes,

> In some societies, national stadia and national memorials help to foster collective memory and group identity. In the case of divided, or formerly divided, cities such as Berlin and Belfast, however, these become contested domains. Opposing groups express very different ideas about what should be remembered and how [...]. There is a failure to empathise with the memories of others or, in certain instances, a felt need to block out those memories.

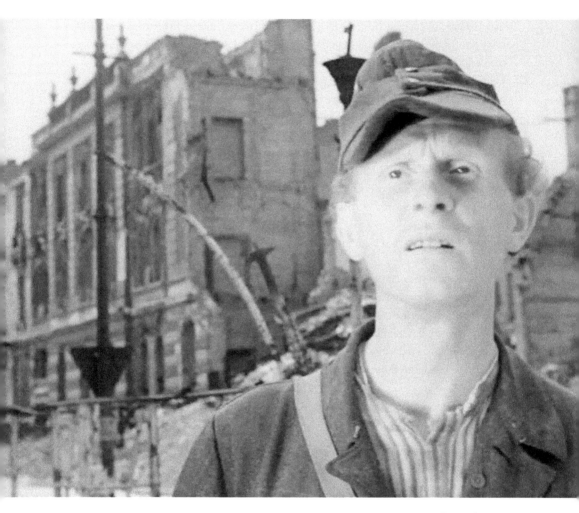

The Berliner (1948)

7

Frozen in Time:
Suspension

It's a great big mess we're trying to clean up here. There's a lot of
rubble. Rubble of all kinds [...] You walk around on it, you're apt
to stumble, or get conked on the head by a loose brick.
Col. Rufus J. Plummer in *A Foreign Affair* (1948)

The urban strategy of suspension preserves damaged structures and spaces in their
ruined state, frozen in time. This does not mean leaving ruins to decay. Instead,
these derelict structures are maintained to not disintegrate further. This is done so
that the visibility and tangibility of the ruined state remind future generations of
that particular time and the reason(s) why the structures became damaged in the
first place. Therefore, among urban strategies, the choice of suspension is argu-
ably the most linked to a structure's layers of memory. Unpacking the seemingly
contradictory relationship between ruins, the past, the present and the future, the
Latin root of ruin, *ruina*, literally means 'collapsed or fallen down', but a second
definition as 'remnants of a decayed structure' has more to do with what is pres-
ent rather than what has disappeared. Memory scholar Silke Arnold-de Simine
(2015: 95) comments:

> [R]uins hold both promise and threat, they speak of death, disaster and destruction
> as much of endurance and rebirth. [In ruins,] time is made visible through space. The
> past is invading the present and the future, always taking us out of the now, casting
> us backwards or forwards in time.

The western attitude towards ruins has not always been the same. In the Renais-
sance, ancient Roman ruins represented a past that was no longer around and were
a reminder of their greatness, 'as documents of the glorious pagan past' (Zucker
1961: 120). Writing in 1341 during his first trip to Rome, the early Renaissance
man-of-letters Petrarch could not conceal his feeling of awe: 'In truth, Rome

161

was greater [than the impressions I had received from books], and greater are its ruins than I imagined. I no longer wonder that the whole world was conquered by this city' (Petrarca 1975: 113). During the Baroque era, ruins began to take on a melancholic characteristic as reminders of the transitoriness of life, with the value being placed on impermanence and decay. Paintings of the era especially employed ruins in this allegorical way. As succinctly summarized by Stead (2003: 59), 'If even the most enduring of human creations, built in stone, were destined for inevitable decay, then the frailty of human flesh was thus revealed to be doubly condemned'.

In the eighteenth and nineteenth centuries, a phenomenon labelled as '*Ruinelust*' (a desire for ruins) emerged and ruins began to fulfil the romantic and picturesque intentions favoured during that time period. French author Victor Hugo ([1838] 1892: 66), recounting his 1838 visit to Heidelberg Castle, exemplified this attitude: 'It is almost impossible to describe this compound of art and reality; it is at once harmonious and discordant. One hardly knows which to admire most, the living or the sculptured foliage'. During this same time period, incomplete and imperfect new structures were created to look like ruins. Eighteenth-century English garden designs were especially well-known for such fake ruins.

It was not until the twentieth century that ruins began to represent devastation and destruction, which is still a reminder of the past, but without any air of superiority over it. In 1911, sociologist and philosopher Georg Simmel ([1911] 1965: 262) formulated this representation as a retrospective revelation of the past, the opposite of a perfect moment that is pregnant with possibilities. Albert Speer ([1969] 1970: 56) gave a name to what he saw as the future ruins of the Third Reich, a 'theory of ruin value':

> [B]uildings of modern construction were poorly suited to form that 'bridge of tradition' to future generations which Hitler was calling for. It was hard to imagine that rusting heaps of rubble could communicate these heroic inspirations which Hitler admired in the monuments of the past. My 'theory' was intended to deal with this dilemma. By using special materials and by applying certain principles of statics, we should be able to build structures which even in a state of decay, after hundreds or (such were our reckonings) thousands of years would more or less resemble Roman models.[1]

Speer and Hitler saw ruins as great monuments of the past, standing grand and proud after all those years. In the words of museum director Christopher Woodward (2010: 30), they were 'attracted to the endurance of the masonry and the survival of an emperor's ambitions', not 'the sight of transience and vulnerability' that a memorial preserving memories would exude.

In the twenty-first century, ruins have come to have value as aids in learning lessons from the past, as urban historian Andreas Schönle (2006: 652) proclaims: 'Somehow we cannot leave ruins alone and let them simply exist in their mute materiality. We need to make them speak and militate for our theories.' This cultural value of ruins is exactly what drives societies to keep them frozen in time. The Coliseum in Rome, Angkor Wat in Cambodia and Tikal in Guatemala are all examples of this, with huge operating budgets to maintain their ruinous state and keep them from further decay. Ruins, even entire villages, are also preserved as memorials to the event that created them.[2]

Following the war, Berlin's ruins were gradually cleaned up and cleared away, as framed in Wolfgang Staudte's *The Murderers Are Among Us* (1946), Gerhard Lamprecht's *Somewhere in Berlin* (1946), Roberto Rossellini's *Germany Year Zero* (1948) and other 'rubble films' of the period.[3] The rubble and ruins in such films represented the extreme depths to which German society had sunk. In these films, ordinary German people strive to survive by any means necessary, and audiences, both victors and losers, are able to experience and sympathize with their fall. After the rubble was eventually cleared, these *Trümmerfilme* served, and continue to serve, to frame and remind of this temporary and transitory state, that is, the presence of the past. Similarly, when the main character in Alfred Hitchcock's *Torn Curtain* (1966) appears to defect to the German Democratic Republic (GDR), all that can be seen out of the windows are ruined buildings of East Berlin, a western propagandist statement visualizing East Germany as undeveloped and in disrepair more than twenty years after the end of the war.

Several of the ruins in Berlin that resulted from the assault on the city in 1945 have been preserved in their ruinous state, kept as reminders of the devastation. The front entry portico of the *Anhalter Bahnhof* (Franz Schwechten, 1880) is one of the most notable. The station became disused in 1952 and by the summer of 1960 almost all of the structure had been demolished. Only the centre portion of the train station's front façade was kept as a sculptural piece representing the war. Its preservation, however, is unique: its exterior side seems to have been renovated, whereas the interior side is deliberately left in a rougher, more ruined state. The station witnessed the deportation of almost 10,000 Jews to Nazi concentration camps, yet this is currently not documented anywhere on the site.[4] In one of the 'Columbo scenes' in *Wings of Desire* (1987), the message is clear: 'Not the station where the trains stop, but the station where the station stops. [...] These ruins, these are remnants from the past.'

Following the fall of the Berlin Wall, the famous border construction was not the only structure to fall into ruins. Buildings and places built by the GDR became abandoned after they were no longer needed, such as the *Haus der Statistik* on Alexanderplatz,[5] or their financing was no longer maintained, such as the

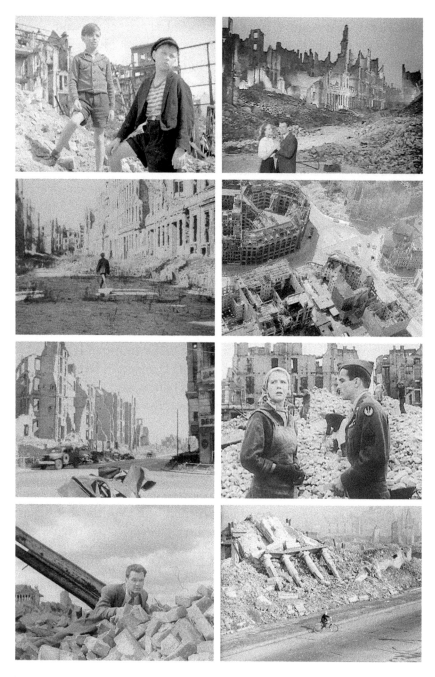

FIGURE 7.1: Cinematic ruins in Berlin *Trümmerfilme*: *Somewhere in Berlin* (1946), *The Murderers are Among Us* (1946), *Germany Year Zero* (1948), *A Foreign Affair* (1948), *Berlin Express* (1948), *The Big Lift* (1950), *Adventure in Berlin* (1952) and *The Man Between* (1953). (All illustrations are film stills captured by the authors.)

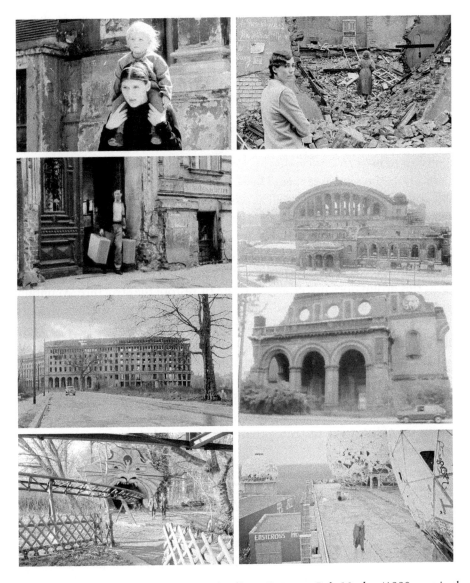

FIGURE 7.2: Other cinematic ruins in Berlin films: *Germany Pale Mother* (1980 – set in the 1940s), *Phoenix* (2014 – set in the 1940s), *The Innocent* (1993 – set in 1955), *Ten Seconds to Hell* (1959), *Man on a String* (1960), *B-Movie: Lust and Sound in West-Berlin 1979–89* (2015), *Meet Me in Montenegro* (2014) and *Manifesto* (2015).

Volkseigener Betrieb Kulturpark Plänterwald (*Spreepark*) amusement complex, and are currently in a ruinous state.[6] This popular GDR fairground in Treptow (1969–89) closed in 2001 and has been used for its abandoned state in many 2010s

films, such as Dennis Gansel's *We are the Night* (2010) with female vampires, Joe Wright's action movie *Hanna* (2011) and Alex Holdridge and Linnea Saasen's romantic comedy *Meet Me in Montenegro* (2014). Structures and places built by the occupying Allied Forces, such as the Teufelsberg Radar Tower, also became abandoned because of the end of the Cold War, and are currently in a ruinous state with their fate unknown.

A final Berlin ruin of note is *Haus Schwarzenberg* on Rosenthaler Strasse 39, a typical nineteenth-century Berlin housing block located in the district of Mitte. In contrast to its surrounding neighbours that were renovated following German reunification, the Schwarzenberg House is in disrepair. Crumbling stucco, peeling paint and rusty ironwork, as well as criss-crossing electrical wires, can be found on its exterior façade, windows and interiors. Since 1995, the building has been occupied by a group of artists and designers who have formed a non-profit organization to run an art gallery, artist studios, arthouse movie theatre and cafe located there. In protest to the gentrification that occurred in their neighbourhood in the 1990s, this group does not clean, renovate or restore the structure. Maintaining their structure in a state of dilapidation and decrepitude, 'the members of the association suggest that the renovation of central Berlin is a form of historical forgetting that effaces the material expression of life in East Germany' (Sandler 2011: 695), because it was under the GDR that many such building stocks were poorly maintained and acquired a patina of grime and soot along the way. Labelled as 'counter-preservation' by architectural historian Daniela Sandler, this type of ruin suspension allows for an experience of an authentic atmosphere and provides for more layers of history in the city, prompting open-ended interpretations, not just a definitive one.

Kaiser Wilhelm Memorial Church

> You live in one city, but it feels like living in two different continents.
>
> Jochen in *Story of a Young Couple* (1952)

Born in the Crown Prince's Palace in Berlin, Friedrich Wilhelm Viktor Albert was the eldest grandson of German Emperor Wilhelm I on his father's side and of British Queen Victoria on his mother's side.[7] Crowned in 1888 when he was about to turn 30, he reigned for another 30 years until Germany's defeat in the First World War. Kaiser Wilhelm II was the last German Emperor and King of Prussia. During his turbulent reign, he supported art, architecture, science, technology, engineering, medicine and the navy.[8] With much respect to his grandfather Wilhelm I, he instructed sculptor Reinhold Begas to create a monument in front

of the *Schloss*, which came to be called the National Kaiser Wilhelm Monument (1897).[9] Wilhelm II also commissioned a Protestant church in memory of his grandfather: the Kaiser Wilhelm Memorial Church.

With new churches such as *Kaiser Wilhelm-Gedächtniskirche* ([1891–95] 1906), the emperor was hoping to control the reforms demanded by workers and socialists at the end of the nineteenth century. The structure was built largely with donations and according to the competition entry (1890) of architect Franz Schwechten who, opposite to the church, also designed the Romanesque House (1897–99) with its Romanesque Café facing the church, ironically favoured by leftist intellectuals.[10] As a designer of churches (including a Lutheran church in Rome) as well as institutional buildings and bridges, Schwechten preferred a revivalist look for imperial buildings, but behind his neo-Baroque or neo-Romanesque facades often stood large-span iron constructions, like *Anhalter Bahnhof*, realized in collaboration with leading engineers. Schwechten's other Berlin buildings included the Prussian Military Academy (1883) close to the Brandenburg Gate and the entertainment venue *Haus Potsdam* (1912) on Potsdamer Platz.[11]

The construction of the Kaiser Wilhelm Memorial Church took place between 1891 and 1895, while its main entrance opened much later in 1906. The delay was particularly caused by Hermann Schaper's extensive mosaic work on the interior, especially the vault. The building did not look like anything around it at the time – a feature that also holds true into the 2020s.[12] Schwechten designed four small towers at the church's corners and a 113 m-tall spire in the middle. The nave could hold more than 2000 churchgoers at a time. Its height, capacity and revivalist design were to show Berliners the imperial power of the Kaiser.

Almost 50 years later, the Kaiser Wilhelm Memorial Church was damaged during a 1943 air raid. Architectural historian Kathleen James-Chakraborty (2018: 56) explains:

> Whether the destruction of much of the building by bombs cleansed it of its original associations [with militant nationalism] and converted the remains into a symbol of wartime destruction and victimhood was the key question surrounding the discussion of its being rebuilt on the same site and, if it were, whether the ruins should be preserved.

The story of the church in the pre-Wall period (1950s) is similar to the story of Wilhelm II's favourite hotel, the Esplanade, in the post-Wall period (1990s). Located on the southern corners of the Tiergarten, they both were heavily damaged in the war but had parts that survived. In the case of the church, most of the entrance hall, altar, spire and baptistry remained. Similar to the Grand Hotel Esplanade 3 km to the east, the imperial church was almost demolished at the hands of a new architect.[13] Its erasure from Ku'damm and Berlin's memory was

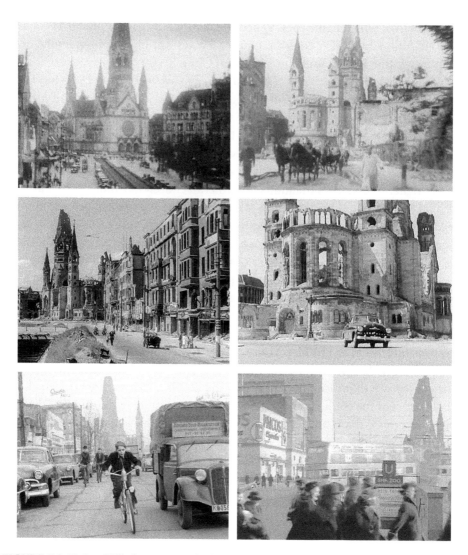

FIGURE 7.3: Kaiser Wilhelm Memorial Church before suspension in *Emil and the Detectives* (1931), *Berlin under the Allies 1945–1949* (2002), *A Foreign Affair* (1948), *Adventure in Berlin* (1952), *The Man Between* (1953) and *Berlin – Schönhauser Corner* (1957).

prevented with the help of grassroots protests. What was rushed in the case of the Sony Centre, though, was handled in a more considered manner by the Kaiser Wilhelm Memorial Church Foundation, established in 1947. Having said that, the foundation wrestled with how to rebuild the church (on its authentic site) for more than ten years, yet did not specify the 'destiny' of the old church in the

ecompetition documents.[14] Egon Eiermann won a two-stage competition for a brand new church to replace the historical one in 1956.[15]

Accordingly, Eiermann's proposal, supported by the foundation and favoured among architects, included the demolition of the imperial building.[16] However, the ruined spire was already an integral part of the city's life, and Berliners strongly objected.[17] As Ward (2016: 121) states, 'urban memory emerges at a moment of threat', which can be considered a rupture in the continuum of urbanism. The demolition ultimatum brought the significance of the ruin to the public eye and this rupture strengthened, if not created, a multi-layered urban memory. As James-Chakraborty (2018: 71) explains:

> The debate over the Memorial Church helped revive the public sphere in West Berlin and the Federal Republic following the censorship of the Third Reich. The very fact that meaning and memory were communicated through images rather than texts – and quite often through a relationship with the surrounding cityscape – provided a welcome elasticity.[18]

As a result of public objections, Eiermann revised his design and retained the old church's tower as is – as a ruin – with its crooked roofline as a symbol of the destruction of the war, but he demolished the rest of the church in order for his modern version to materialize in stark contrast. Restoration specialists repaired the tower's stone walls and reinforced its joints. The vaulted ground floor was reorganized as a memorial hall with an exhibition about the original church. The 'coupling' of the old and the new church performed 'immediately as the symbol of West Berlin' with its 'free market and religions freedom', writes James-Chakraborty, and 'the Memorial Church served for the next three decades as the most prominent architectural emblem of the supposedly capitalist – but in fact heavily subsidized – western half of the city' during the Cold War (2018: 33–36). Barbara Miller Lane (1991: 137), however, does not see this 'collage' as a balanced architectural symbiosis:

> Initially the juxtaposition was supposed to indicate to the public the triumph of modernity over the remnants of an undesirable past. But the church has now come to represent the persistence of the old, its survival in the face of the depredations of the present. This reversal of meaning took place rather quickly.

The existence of the past in the present changed the meaning and memory of Eiermann's futuristic design. Using blue stained glass embedded in large precast concrete grids on its facades, the architect designed a four-partite steel-structured geometric complex with a distinctive look even today. His structure consists of an octagonal

church (holding half the capacity of Schwechten's church) with a foyer and a hexagonal tower with a rectangular chapel for about 100 people (1957–63). This new structure is located at the base of the memorial church as shown under construction in Wilder's *One, Two, Three* (1961), and in its final form in Rainer Werner Fassbinder's *The Third Generation* (1979) as well as Glen's *Octopussy* (1983). Fassbinder, in particular, flattened the dysfunctional church between the layers of the modern city and the modern church in the opening credits of his film, suppressing and minimizing the memory layer of the original church within contemporary Berlin.

Whereas the tower has single walls, the new church has a 2.15 m apart double wall system, similar to the Berlin Wall. This void was intended for noise control since the building is located in the middle of two busy roads, *Kurfürstendamm* and *Budapester Strasse*. This gap also housed a lighting system that simulates a daytime effect, even during nighttime. The exposed steel structure of Eiermann's building gives form to the architecture of the new church around this in-between space. With a total of more than 20,000 stained glass inlays designed by French artist Gabriel Loire, the interior is unique and impressively atmospheric day and night. Influenced by the architecture of 'the space age', Eiermann's church and tower are alien to the context of their environment due to their overall geometric form and honeycomb-shaped illuminated facades holding grids of seven by eight rectangular glass pieces and five by five square pieces, respectively.

Breitscheidplatz, at the east end of 3.5 km-long *Kurfürstendamm* where the church stood in its 'broken' state, was highly populated after the war.[19] Therefore this ruin close to the busy Zoo Station, which was once surrounded by war debris, is framed by medium- and high-rise buildings today.[20] *Wings of Desire* and *Germany, Bitter Homeland* depict this site of memory by mainly focusing on the suspended ruin, not the new memorial church, as one of the landmarks of West Berlin. Along with the shoulder of Victoria on top of the Victory Column in Tiergarten, the church's damaged spire, now 71 m rather than 113 m, was the favourite spot of Wenders' angels to watch over Berlin.[21] Wenders, besides Fassbinder, is one of the few German directors who include the temporary-but-permanent guest workers into his cinematic narrative. Voluntary migrants' stories and lived spaces in divided Berlin were instead mostly portrayed by directors from their homeland, as in the case of the previously-mentioned *Germany, Bitter Homeland*.[22] Exhausted following the long bus/train trip all the way from his village in Turkey and after spending the night sleeping on the street, Mahmut wakes up to the loud sound of church bells and an overwhelming appearance of the original Kaiser Wilhelm Church in worm's eye view as the camera pans vertically from the bottom up. Unknowingly, he took refuge at the gate of the new church.[23] As a Muslim foreigner, this is his first encounter with a Christian urban landscape and soundscape in a big, modern, crowded city with busy traffic.

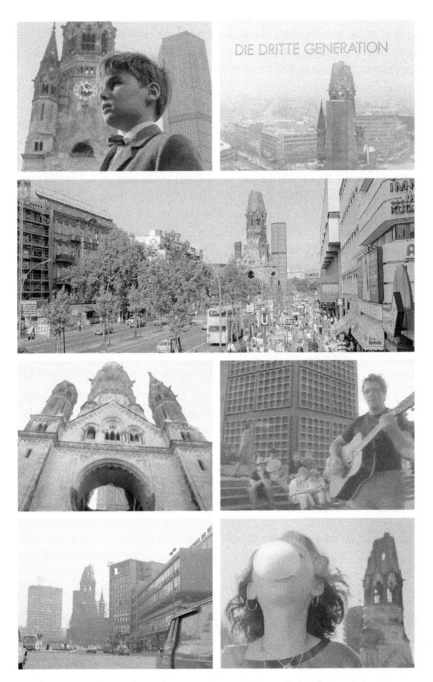

FIGURE 7.4: Kaiser Wilhelm Memorial Church after suspension in *Emil and the Detectives* (1964), *The Third Generation* (1979), *Octopussy* (1983), *Germany, Bitter Homeland* (1979), *B-Movie: Lust and Sound in West-Berlin 1979–89* (2015), *What Have I Done to Deserve This?* (1984) and *Tiger Milk* (2017).

As early as the construction of its foundation, the original Kaiser Wilhelm church was a memorial building, not commemorating Wilhelm II who commissioned it, as most people might believe, but his idolized grandfather Kaiser Wilhelm I. However, its commemoration covers much more than a long-gone king. Together with its tower and new neighbour, the ruined church helps visitors, even passers-by, interact with the complex multi-layered urbanism and memory of a city. In that sense, the suspension of the ruin of the original church should be interpreted as temporal as well as spatial. By advocating the preservation of the original church in its post-Second World War status, time was frozen in the zero-hour at the exact location of the ruin. The city 'moved on' and kept changing around it, but contemporary time is always sucked into a temporal black hole and goes back to the zero-hour at Breitscheidplatz. As one of the 'churches in which memory was integrated into modern architecture' (James-Chakraborty 2018: 39), the Kaiser Wilhelm Memorial Church is arguably one of the best examples of the urban suspension of a ruin that perpetuates the memory of the Second World War, even 75 years later because:

> [T]he incompleteness of the Memorial Church's steeple provided an acceptable way of expressing the destruction and suffering that had indeed taken place. Memory here certainly encompassed the very recent past. [...] The resulting strategies, which seemed at the time to be piecemeal compromises, provided a key precedent for the postmodern fascination with palimpsests and for the commemorative strategies of absence as well as presence that have accompanied the memorial boom of the last thirty years.
>
> (James-Chakraborty 2018: 72)

Topography of terror

Judge Fromm: Who is your commanding officer?
Inspector Zott: Inspector Escherich, Police headquarters, Prinz-Albrecht-Strasse.
Judge Fromm: I know the address.

Alone in Berlin (2016)

On 5 May 1985, exactly 40 years after the defeat of Nazi Germany, a group of volunteers organized by the grassroots Active Museum against Fascism and for Resistance in Berlin (*Aktives Museum gegen Faschismus und Widerstand in Berlin*) began to dig into the piles of rubble, debris and weeds at an empty site south of the Berlin Wall on Niederkirchner Strasse. This was no authorized archaeological endeavour. Entitled 'Let's Dig!', the action was described by the Active Museum as a 'commemorative operation on the site' (Moshenska 2010: 42). There were

no professional archaeologists present and the dig was neither endorsed by the West Berlin Senate nor the Federal Republic of Germany.

Rather, it was the culmination of years of discussions about what to do with the area which, between 1933 and 1945, was the home to the many security institutions of the Nazi regime, most notably the Secret Police or Gestapo (*Geheime Staats Polizei*). Nobody digging that day knew exactly what was going to be found. For years, the area had been nicknamed the 'Gestapo Terrain' (*Gestapo Gelände*), but just like with the ruins of Hitler's New Reich Chancellery, nobody knew precisely what lay below the surface. This unknown information was partly because the war had ended 40 years before, but also because the area had largely been left alone, ignored and forgotten for decades.

Before the 1950s, Niederkirchner Strasse was called Prinz-Albrecht-Strasse, named after the prince whose 1830s mansion, the *Prinz-Albrecht-Palais*, was located at Wilhelmstrasse 102. North of that mansion was the Hotel Prinz-Albrecht (1902). And west of the hotel, at Prinz-Albrecht-Strasse 8, was the School of Industrial Arts and Crafts (*Kunstgewerbeschule*, 1905). Beginning

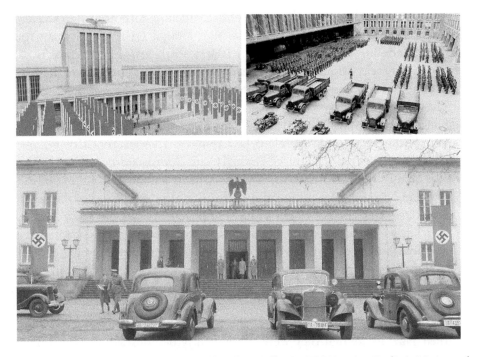

FIGURE 7.5: An SS Headquarters simulated in *Valkyrie* (2008) using Berlin's *Messe* and Tempelhof Airport and the Gestapo Headquarters on Niederkirchner Strasse simulated in *Alone in Berlin* (2016).

in 1933, the school served as the headquarters for the Gestapo. In 1934, the *Prinz-Albrecht-Palais* began to act as the headquarters for the State Security Service (*Sicherheitsdienst des Reichsführers – Schutzstaffel*, or SD).

Also in 1934, Heinrich Himmler moved into the Hotel Prinz-Albrecht and took it over as a headquarters for his paramilitary *Schutzstaffel* (Protection Squad, or SS). From within this tight concentration of three buildings, the Nazi leadership planned and carried out their well-organized programme of persecution and terror. It was within these buildings that decisions to arrest, interrogate, deport and/or imprison people were made, as well as from where the official paperwork to carry out these orders were produced. Some of the actual arresting, interrogating and imprisoning occurred on the site.

While there is no film explicitly depicting any of these buildings, many films hint at them. Peter Godfrey's *Hotel Berlin* (1945), filmed at the Warner Brothers studios in Burbank, California, alludes to the Hotel Prinz-Albrecht in the way that it acts as a meeting point for those with similar interests, whether that be loyal to the Nazi regime or not. Brian Singer's *Valkyrie* (2008) utilizes a number of surviving Nazi buildings to stand-in for various headquarters and administration buildings, most notably Berlin's Exhibition Hall (*Messe*, Richard Ermisch, 1937) as the exterior of the SS Headquarters and Tempelhof Airport as the interior. In Vincent Pérez's *Alone in Berlin* (2016), the Nazi-looking GDR Free German Youth College (Hermann Henselmann 1951), 10 km northeast of Berlin, was used as the Prinz-Albrecht-Strasse Gestapo headquarters, which contradicts the reality that the actual building on Niederkirchner Strasse was in the *Art Nouveau* style.

The Gestapo Terrain was heavily damaged in the Second World War. However, 'the buildings here were not destroyed in 1945. Damaged, yes, but still structurally sound, the Nazi headquarters could easily have been restored. They were not' (Irwin-Zarecka 1995: 20). The Museum of Industrial Arts and Crafts (*Kunstgewerbemuseum* 1877–81) was apparently damaged worse than the others, but it was not demolished (Till 2005: 76). Instead, a rigorous renovation took place during the late 1970s and the structure is currently an art museum known as the Martin Gropius Building, named after one of its architects. This situation highlights the inherent selectivity in preservation when what is demolished or retained is based on ideological preferences rather than architectural merit or memorial/urban significance.

The mansion, school and hotel that were appropriated by the Nazis were obviously not specifically built for their terror uses but were instead adapted for their malicious deeds.[24] Regardless of this point, they were considered so tainted by their Nazi usage that they were subsequently demolished: the mansion (SD Headquarters) in 1949, the school (Gestapo Headquarters) in 1953 and the hotel (SS Headquarters) in 1958/59. The newly formed GDR changed the name of Prinz-Albrecht-Strasse to Niederkirchnerstrasse in 1951.[25]

In the early 1950s, West German city planners proposed a modern heliport for the site. In 1957, an urban renewal competition entitled 'Capital Berlin' was held in which most of the 149 entries proposed large-scale highway infrastructure running right through the site, typical of the post-war urban design strategies at that time. With the arrival of the Berlin Wall on the south side of Niederkirchnerstrasse in 1961, the area became even more marginalized, just one of the many empty sites adjacent to the Wall. By the 1970s, the area not only contained rubble from the demolished security buildings, but also from its Kreuzberg neighbours, resulting in characteristic large mounds of debris with overgrown weeds, right in the middle of the city. This landscape perfectly suited its two users at that time: a construction materials recycling company that mined the rubble piles for inventory and a driving track, or *Autodrom*, for those learning to drive.

By 1980, a group of architects, historians and city planners called the International Exhibition of Construction and Design in Berlin (*Internationale Bauausstellung*, or IBA) 'rediscovered' the dark history of the site and began to call for some sort of recognition of its past. On the fiftieth anniversary of the Nazi rise to power in 1983, the West Berlin Senate sponsored an architectural competition to design a memorial to the victims of fascism. The winning design, by landscape architect Jürgen Wenzel and artist Nikolaus Lang, proposed to cover the site with a regular grid of chestnut trees and cast-iron plaques embossed with original Nazi documents, the kind that were produced on site by Nazi office workers, labelled the 'desktop perpertrators' (Till 2005: 111). The plaques would have been arranged in such a way that the floor plans of the demolished buildings would also be visible.

Concerned that any authentic artefacts from the Nazi years might get buried under Wenzel and Lang's metal plates, the Active Museum staged their 'Let's Dig!' action, excavating 'not for money, academic interest, fun or to comply with planning regulations. They excavated as an act of remembrance' (Baker and Korff 1992: 243). Although they did not find much that day, their strategy worked. The following year, an official excavation was carried out by city authorities who found detention cells in the basement of the former Gestapo building, as well as a basement cafeteria for SS soldiers. Following these findings, it was decided to establish an interpretation centre on the site instead of a memorial. In this way, the narrative of the site was shifted to include both the victims and the perpetrators, which paralleled the course of official West German attitude towards the Nazi years from the silences of the 1950s, to the questioning of the 1960s and 1970s, to a form of acknowledgement in the 1980s (Till 2005: 86–90).

The interpretation centre was to be named the 'Topography of Terror' and became part of West Berlin's many activities in 1987 celebrating the 750th anniversary of the founding of Berlin. A makeshift wooden roof was constructed on top of the Gestapo cells to protect them from weathering and explanatory panels

were installed. A single-storey wood-and-glass pavilion was built over the basement cafeteria, housing an exhibition about the rise and fall of National Socialism. These were only meant to be temporary, but they proved to be so popular that the exhibitions remained standing. In 1992, the Topography of Terror officially became a non-profit foundation. In the meantime, the events of 1989–90 opened up Niederkirchnerstrasse, and an original stretch of the Berlin Wall just above the Gestapo cells was saved.

After winning a 1992 competition, Swiss architect Peter Zumthor started constructing a more permanent interpretation centre, which halted in 1999 due to budgetary concerns. The German Federal Government scrapped this project and held another competition in 2004, recognizing the fact that this site was of national importance. Architect Ursula Wilms and landscape architect Heinz Hallmann won this competition and their design was implemented during 2007–10. Together with its surrounding gravel landscaping, this large but modest documentation centre, which includes a permanent exhibition, library and seminar rooms, is deliberately understated and does not compete with the Nazi ruins. While Wilms and Hallman's design has been criticized for its bland neutrality, this disconnection works to the advantage of the visitor's experience: 'the aloof and abstract quality of the building and landscape design require a stronger effort of reflection and imagination, of recalling historical connections in the mind's eye instead of receiving them on one's retina' (Sandler 2016: 186). Michael Moore's *Where to Invade Next?* (2015), a documentary of world governments' social policies, eloquently frames this new design through a chipped-away hole in the Berlin Wall remnant there, perhaps as a metaphor for the frank discussion of Germany's history that he promotes in his film.

The simple wood roof protecting the Gestapo cells was replaced with a high-tech steel-and-glass construction, and the mounds of debris with overgrown weeds were removed to give way to sleek granite paving and gravel. A fifteen-station self-guided outdoor tour of the site with permanent placards in German and English provides information about the Nazi institutions that were located there as well as particulars about the Berlin Wall. An audio guide is available that provides more in-depth information. After opening the new documentation centre and landscaping by Wilms and Hallman, the Topography of Terror drew an exceptional two million visitors between 2010 and 2012 (James-Chakraborty 2018: 143).

While some may mourn the loss of the 'edginess' of the original 1985–87 project that these new aspects represent (Dawson 2010) and others yearn for the 'rough, unstable, open-ended, and provisional' nature of the initial grassroots endeavour (Sandler 2016: 186), the Topography of Terror is still a physical manifestation of what could be called a 'remembrance of forgetting' (Irwin-Zarecka 1995: 17), or the retrieval of suppressed memories. The ruins of the Gestapo cells and the SS cafeteria are suspended in time, more or less kept as they were found. They are authentic architectural remnants that, without much explanation, speak powerfully about what

happened there. They represent a shift in the remembering process away from photographs and texts towards concrete physical remains. Their half-buried ruined state reminds the visitor that the area was forgotten about until such a time that Germany could begin to deal with its role in the terror. In the words of Hell and Schönle (2010: 6), 'The ruin is a ruin precisely because it seems to have lost its function or meaning in the present, while retaining a suggestive, unstable semantic potential'. The ruins at the Topography of Terror are not there to be viewed as symbolic of a long lost time. Nor do they represent the great devastation that occurred because of the Nazi regime. They simply exist, speaking to the visitor silently.

In comparison to the nearby Memorial to the Murdered Jews of Europe (1997–2005), the Topography of Terror has a 'strong grounding in a specific physical setting' (James-Chakraborty 2018: 140), which validates the area as an 'authentic site'. The site proves Jordan's statement: 'It is rare that the traces of previous ways of treating the landscape are fully erased' (2005: 39). In comparison to Hitler's bunker, which was demolished again and again as its remnants popped up over the decades, the Topography of Terror confronts the residue of Nazi rule and attempts to mediate between it and the present as well as the future.[26] 'Through this site, the possibilities of a more democratic and humanitarian future are imagined' (Till 2005: 21). Adding to the

FIGURE 7.6: *Niederkirchner Strasse* and the Topography of Terror in *Three* (2010), *Victoria: One City, One Night, One Take* (2015) and *Where to Invade Next?* (2015).

experience at the Topography of Terror is the 200 m Berlin Wall remnant, hovering menacingly over the Gestapo cells, as well as a grove of locust trees in the southeast corner of the site where the *Autodrom* driving track can still be seen. They are all just what they are, frozen in time, accurately matching the Active Museum's 1987 capital-lettered manifesto that 'THE WOUND MUST STAY OPEN' (Moshenska 2010: 42).

In Berlin, the urban strategy of suspension is usually applied to structures ruined in the Second World War in order to keep them at or close to the state they were in at the 'Zero Hour' in May 1945, which can be considered as a massive disruption and turmoil in the history and urban memory of the city, from a proud nation to a defeated, occupied and divided one; from a prosperous city looking forward to a city in rubble looking back, regretting its past. Stephen Green (2014: 200) writes:

> It seemed all too obvious at the time that *Stunde Null* was the end of all that had been. It was not obvious at all that it might be the beginning of something new. The devastation was so widespread, the trauma so shocking, the challenge of restoring a functioning society so mountainous: it would have been easy to despair.

Why do communities hold on to ruins of buildings that are long gone? If it is for the commemorative value of a tangible monumental construct, what is the best way to keep a memory alive without worshipping structures more than they deserve? These questions stand alone beyond a romantic or Romantic longing for the past. The social character of human species benefits from storytelling to give meaning to the lives of the self, other individuals and the collective. Concrete structures reinforce these stories, if not prove evidence to them, making narratives visible and believable. Filmmakers, too, benefit from this persuasive quality of architecture. Damien, the angel of Berlin, is convincing because he is framed in the city's sky perched on the dramatically suspended ruin of the Kaiser Wilhelm Church, as well as Victory's colossal wing. Architecture makes a difference in memory-making both in film and in life.

NOTES

1. In addition, a footnote from Speer's autobiography explains

> To this end we planned to avoid, as far as possible, all such elements of modern construction as steel girders and reinforced concrete, which are subject to weathering. Despite their height, the walls were intended to withstand the impact of the wind even if the roofs and ceilings were so neglected that they no longer braced the walls. The static factors were calculated with this in mind.
>
> ([1969] 1970: 528)

2. For example, the entire village of Oradour-sur-Glane, France, is kept in a ruinous state in memory of the massacre of its entire population by Nazi soldiers in June 1944. England contains many similar examples, such as Temple Church in Bristol, which is kept as a bombed-out shell in memory of the Nazi aerial bombing campaigns conducted on England during the Second World War.

3. When German cities were in ruins, the domination of *Trümmerfilm* in German cinema in the 1940s was understandable. As the rubble lifted, *the Heimatfilm* genre appeared in West Germany in the 1950s (until the internationally recognized New German Cinema with figures like Fassbinder, Wenders, von Trotta and Helma Sanders-Brahms came along in the 1960s). These homeland films, for instance, *The Spring before the Gates* (Hans Wolff 1952), usually set in the countryside, had a nostalgic view towards the good old days when life was simpler. 'West German audiences flocked to cinemas to watch escapist, brightly coloured images of Germany as a rural idyll' (Cooke 2006: 81).

4. The *Anhalter Bahnhof*'s role in these deportations will be a highlight of the *Exilmuseum* proposed to be constructed immediately behind the station's ruined entrance portico. Architect Dorte Mandrup won a 2020 competition, which is expected to be built by 2025, https://stiftung-exilmuseum.berlin/en/wettbewerb (last accessed 26 August 2021).

5. The GDR Central Administration for Statistics (1968–70) was kept after the reunification and used until 2008. A grassroots initiative saved the building from demolition in 2015 but its facades are being 'renovated' in a totally different style. This will minimize the memories of former East Berliners that are associated with this once governmental building.

6. See https://qz.com/248117/the-bizarre-history-and-fiery-end-of-berlins-iconic-abandoned-amusement-park (last accessed 19 February 2021).

7. Son of Frederick III and Princess Royal Victoria, Wilhelm II was trained in law, politics, the military and foreign affairs. He proposed improvements in educational, residential and social systems. In the second half of his reign, he followed a more aggressive foreign policy alienating France, his mother's homeland Britain, Russia and even Japan. His ambitious and impulsive political decisions eventually led Germany into a world war and the end of the empire and his kingdom. The *Kaiser* lost his power to the military during the war, which resulted in a mutiny in his beloved navy and the German Revolution towards the Weimar Republic under the ruling of the Social Democratic Party (SPD). Kaiser Wilhelm survived the 1918 pandemic known as the Spanish flu but not the consequences of the war. He died in exile in Nazi-occupied Netherlands in 1941.

8. The emperor saw the future of Germany on the water. He sketched design proposals for ships; he politically and financially promoted the construction of a large German navy. In this way, he was hoping to make his country a world power.

9. The GDR demolished the *Kaiser Wilhelm-Nationaldenkmal* in 1950. A new structure entitled the Monument to Freedom and Unity is currently being built on its base on the water in front of the new *Schloss*/Humboldt Forum.

10. The *Romanisches Haus*, destroyed in 1943, architecturally complimented the church.

11. The academy and the *Haus Vaterland*, as it was named later, were demolished in 1976.
12. This is also the case for Egon Eiermann's new Modernist church directly beside the Kaiser Wilhelm Memorial Church.
13. This was not the first attempt to erase the imperial church from urban memory

> By the end of the 1920s there were already calls to demolish the building, ostensibly because it was an obstacle to the speed of automobile traffic, but almost certainly as well because the café and cabaret culture that flourished along the Kurfürstendamm.
> (James-Chakraborty 2018: 55)

14. It should be noted that destructive Modernist urbanism was not specific to Berlin or Germany but was the norm worldwide for several decades following the war; its duration depended on the country. The urge was to look ahead, start over, clear and rebuild. As Ladd explains: 'Sentimental attachment to the ruins only came years later, when there were far fewer of them. In the late 1950s, when the West Berlin authorities proposed to remove the ruins of the Kaiser Wilhelm Memorial Church at the head of Kurfürstendamm, they were simply continuing the work they had begun a decade before' (1998: 177).
15. The initial plan in 1947 was to restore the church in a rather simplified way. This proposal was from Werner March, the architect of the Olympic Stadium.
16. Many thought the building lacked architectural merit and remembered its nationalist/imperial connotations. However, the binary opposition of religious West Germany versus secular East Germany was a fact; West Berliners objected to its destruction partly because of the meaning of the original/old church and partly because it reminded them of the pain caused by the war and the peace that came after.
17. According to a poll sponsored by local newspaper *Tageszeitung*, more than 45,000 West Berliners voted for retaining a tower. Less than a thousand people objected (James-Chakraborty 2018: 57).
18. This democratic debate culture continued in West Berlin in relation to the Holocaust Memorial.
19. Ku'damm was already developing before the war as part of the independent city of Charlottenburg and became the high street, the commercial centre of West Berlin after the Second World War. Following the reunification it had to compete with other commercialised streets and squares.
20. The area around the Zoo is well-liked by tourist families with little children in contemporary Berlin.
21. Since the angel Damiel's appearance in *Wings of Desire* on the roof of Kaiser Wilhelm Memorial Church, it feels like an angel is watching over Berlin.
22. Serif Gören mainly located this film in Siemensstadt (where Turks worked) and in Kreuzberg (where they lived). In the taxi on her way from Tegel Airport to Kreuzberg, Güldane refers to Kreuzberg as *memleket mahallesi*, literally: homeland neighbourhood or more loosely, Turkishtown or Little Istanbul.

23. The vertical pan through Mahmut's eye is actually not possible because the large canopy over the entrance of the church where he sits would get in the way. Gören cleverly moved his camera just outside of the covered space for this shot.

24. On the north side of Prinz-Albrecht-Strasse, the Reich Aviation Ministry (Ernst Sagebiel, 1936) was purposefully built to be a Nazi structure, was renovated after the Second World War and ironically serves as the Ministry of Finance for the reunited Germany.

25. This was done in honour of Käthe Niederkirchner, a communist fighter who died at the Ravensbrück Concentration Camp.

26. Since the *Führerbunker* area was controlled by the GDR 1949–89, it is difficult to know whether the same sort of grassroots project would have materialized there. East German individuals diving down into the ruins of the bunker have been documented, but they were carrying out an illegal and voyeuristic endeavour and were not trying to influence the future of the site.

Back to Berlin (2019)

8

On the Move:
Relocation

You can never really get out of Berlin.
 Lena Brandt in *The Good German* (2006)

Relocation is the moving of entire buildings/structures or pieces of buildings – either exteriors or interiors – from one place in the city to another. This could be to reuse them in their new location, or for the sole purpose of display. With this strategy, there is either an attempt to continue and benefit from associated memories in the new location or an attempt to purge the building or interior from its previous memories, depending on the motives of the movers.

Fragments of buildings, rather than entire structures, are understandably the most common candidates for relocation. In Berlin, as part of measures to turn Alexanderplatz into a modern traffic and business hub, the Royal Colonnades (*Königskolonnaden*) were relocated in 1910 to adorn the new Kleistpark in Schöneberg. 'The Prussian superior Court of Justice, whose stately neo-Baroque building adjacent to Kleistpark was completed in 1913, may have borne a vague stylistic resemblance to the colonnades, but it has remained a curious juxtaposition ever since', writes historian Marc Schalenberg (2009: 55). An architectural fragment in Berlin that the GDR relocated was the cast-iron front door of Schinkel's *Bauakademie* (1832–36), which was demolished in 1970 to make way for the GDR Ministry of Foreign Affairs. This door can still be seen today at the Schinkelklause restaurant nearby.

An entire building in Berlin that was moved was the eighteenth-century *Ermerlerhaus*, a mansion purchased in 1824 by wealthy tobacco merchant Wilhlem Ermerler who held weekly gatherings of intellectuals in his salon. Owned by the city of Berlin since 1914, the building suffered severe damage in the Second World War but was largely reconstructed in the 1950s. In 1967, it was dismantled and moved 300 m from *Breiten Strasse* to *Märkisches Ufer* in

order to make way for GDR governmental buildings. Even so, 'the *Ermelerhaus* kept its name, façade, staircase and some of its internal layout, but it was reduced in its overall size and has served as an inn and hotel since' (Schalenberg 2009: 60).

Businesses in Berlin, mostly cafes and bars, have also moved around throughout the years, bringing their (brand) name to their new location. Hotel Stadt Rom (1755) became the Hotel de Rome in 2006, 100 m southeast of the original location. Cafe Kranzler was founded in 1834 on Unter den Linden and relocated in 1951 to the Kurfürstendamm, almost like fleeing to the west. Cafe Josty, founded in 1812 on Schlossplatz, moved to Potsdamer Platz in 1880 to become a well-liked venue in the first decades of the twentieth century, especially by Expressionist artists, to then nostalgically reappear in 2001 at the Sony Center, 200 m away.

Grand Hotel Esplanade

While it was under international surveillance as the largest urban construction site in Europe, Potsdamer Platz witnessed an extensive relocation project. This was not about the moving of a group of sculptures or a business, but the moving of the remains of an entire building. The complete Emperor's Hall (*Kaisersaal*) and Breakfast Room (*Frühstücksraum*) of the Grand Hotel Esplanade (1908) were relocated and integrated into the design of the Sony Center on Potsdamer Platz in March 1996.[1] The 11 m high 17.5 m by 13.5 m *Kaisersaal* was moved in one piece about 75 m, while the Breakfast Room was cut up into multiple pieces and reassembled as part of a new Café Josty. In his original design, Helmut Jahn incorporated no part of the historical hotel into a visible part of his shiny new Sony Center, neither in Potsdamer Platz nor on the new Potsdamer Strasse. The new swallowed the old, assimilating history into its translucent design in ways that fitted its millennial architecture.[2] At the beginning of the relocation process, Knut Teske wrote in *Die Welt*:

> Although the new old 'Kaisersaal' is the historical heart of the 1.5 billion mark Sony Center at Potsdamer Platz, it will be surrounded by the ultra-modern facility. Star architect Helmut Jahn did not really want to risk (or invest in?) an externally visible symbiosis between preserving old age and shaping the future. But what matters most is the interior. The whole splendor of the neo-baroque interior unfolded again. Among eight layers of paint that have since been scraped off, a portrait of 'KW two' even came to light.

> (1996: n.pag.)

The bombed and heavily ruined Hotel Esplanade was a significant venue in Berlin's social life in the early twentieth century. With its grandeur revivalist architecture by Otto Rehnig, its Winter Garden and Palm Court, two glass-covered atriums, and a 1600 m² garden in its generous central courtyard designed by landscape architect Willi Wendt, the hotel was a well-liked gathering place for the elite in the 1910s, for celebrities in the 1920s and for monarchists throughout the Weimar period, because of which the National Socialists decided to demolish the palatial building in 1941, a decision never carried out. In fact, the lack of Nazi buildings and presence in Potsdamer Platz at the time contributed to sustaining the vivid social life in the area. Bob Fosse's *Cabaret* (1972), the film adaptation of a successful Broadway musical based on a novel by Christopher Isherwood starring Liza Minelli, portrays Berlin's lighthearted nightlife in the early 1930s that occurred in places similar to the Hotel Esplanade, montaged over ascending Nazi power and influence.[3] After the bombing of the Second World War, the remains of the hotel, in West Berlin, were used as a restaurant in the 1950s as well as for dance gatherings and fashion shows. The division of Potsdamer Platz by the Wall in 1961 pushed the Esplanade to the periphery of the city. A small hotel business used the remains of the building until 1981.[4] There were plans to adapt the remains of the Esplanade into a centre consisting of an academy, museum and library dedicated to film. Dutch Architect Herman Hertzberger was the winner of a 1986 competition for this project, but then the Wall fell.[5] The new Senate listed the ruined Hotel Esplanade as a historical monument in 1990 under the German Landmark Preservation Law.

Jahn's initial plan for the Esplanade was to keep only the main façade on Bellevuestrasse and demolish the rest of the building – a fact not mentioned in a plaque in the Sony Center honouring the hotel.[6] Such a plan would have erased the memory associated with the historic hotel after surviving two world wars and five regimes. The Esplanade's historical monument status, the State of Berlin's insistence on its preservation (during the selling of the land to Sony in 1992) and Berliners' protests eventually forced the architect and his client to reconsider. Being a skilled designer, Jahn did not follow one way of modification and integration, however, relocation was the main urban strategy that he utilized. The hotel's Breakfast Room was relocated by chopping it into pieces and repositioning it. The highly decorated *Kaisersaal* was relocated by uprooting and displacing the whole building. These displacements minimized any interruption of Jahn's design and enabled the creation of the brand new Potsdamer Strasse since the hotel ruin extended five metres into the footpath of the new street. The main hotel entrance, now 'at the back' was cleaned up, made presentable and integrated into Jahn's housing block design. The overwhelmingly unconventional preservation of the

Esplanade, not carried out according to monument preservation guidelines, cost Sony 50 million Deutsche Marks.

The manipulation of history began when engineers moved the entire 1800-tonne Emperor's Hall on a U-shaped track in the northwest direction towards the Tiergarten. Using high-precision computer-controlled air cushion displacement, the remnant was relocated between 1–21 March 1996.[7] First, all openings were bricked up and additional interior walls were built for structural stability. The Emperor's Hall was raised up using a computerized hydraulic pump lifting system and a reinforced concrete frame was placed under it. Moving along rails laid for the relocation, the structure progressed a total of 75 m in three stages and then anchored into new foundation piles at its final destination.[8]

A decade before its relocation, the hotel's Breakfast Room featured prominently in cinematic clubbing scenes as 'an aesthetic experience of historical material' (Kreuder 2000: 36) in Wenders' *Wings of Desire*, serving, for instance, as a venue for a Nick Cave concert. 'The scene in the Hotel Esplanade is [...] a way of encountering the city as the repository of past time' says Ward (2016: 125), adding, 'The Hotel Esplanade is a paradigmatic location for *Wings of Desire*, an interstitial space and time on the ultimate margin of West Berlin, the ruins of Potsdamer Platz where the concept-city has not yet imposed the post-war regime of synchronic time' (2016: 125).[9] The hotel superimposes multiple spaces and times into one place, revealing the layered nature of memory in the city. This feature is even more prominent in an earlier Berlin film, Margarethe von Trotta's political *The German Sisters* (1981). To foreground her filmic intentions, von Trotta goes back and forth between the childhood, adolescence and adulthood of activist/journalist Juliane and activist/terrorist Marianne, framing a dance scene in the Esplanade in their teen years to reveal a particular character trait of the sisters.

FIGURE 8.1: Remnants of the Hotel Esplanade surrounded by new construction in *Berlin Babylon* (2001) and the final product in *Passion* (2012). (All illustrations are film stills captured by the authors.)

Known from the memorable trapeze artist's monologue scene in *Wings of Desire*, this distinctive space was broken into approximately 500 pieces, dismantled, packed in special containers and stored in Gotha, Thuringia. During the construction of the Sony Center, these pieces were relocated back to Berlin and two (not four) original walls, ceiling and floor were reassembled to fit the design of the Café Josty (2001), a tourist restaurant in the centre's atrium.[10] The irregular joints between the pieces are cleverly left visible, reminiscent of large versions of Berlin Wall pieces commonly seen in souvenir shops. Two of the original walls were never moved and the entire room was enclosed with Sony's glass and steel architecture. These curtain walls enable visitors of the Sony Center to have a peek into the historical room from behind the shiny glass.[11]

The two walls of the Esplanade's Breakfast Room that were not relocated are similarly displayed behind glass. Jahn matched his showcase design with the high-tech glass-wall aesthetic of the rest of the centre, rather than with the decorated room. These detached walls now appear like an expensive antique on display for sale in a shop window, adding to the staging of the spaces of the Hotel Esplanade in the Sony Center, this time in two dimensions. When visitors stand in the semi-open atrium and look at these walls through Jahn's glass case, they are physically standing on the authentic site of the historical room: another ghost for Brian Ladd. Through the openings of these walls, visitors can also peek into the Palm Court and partially survived Silver Hall, but these rooms are not open to the public.

Though not relocated, it is worth mentioning another commercialized fragment of the Hotel Esplanade, its historical entrance, to exemplify the variety of so-called preservation methods Jahn utilized to manipulate the urban memory of Potsdamer Platz. The Sony Center's housing block on Bellevuestrasse, named 'Esplanade Residences', is entered via a lobby that incorporates into its design the remains of the five-storey main block of the historical hotel that was not relocated.

> The remaining façade of the former grand hotel – the historic entrance – is being restored at great cost. It will be protected by glass frontage and then be spanned by an apartment complex, the result being a highly expensive bridging construction,

wrote theatrical scholar Friedemann Kreuder during the construction (2000: 23). Regarding this fragment, Ward comments, 'The museal urban gaze is instrumentalized here to create a sense of narrative coherence, of a past seamlessly incorporated into the present. These objects are not obstacles to movement, to the circulatory rhythms of the city' (2016: 146). Like the amputated walls of the Breakfast Room on display, this large sandstone ruin behind a glass façade adds (financial) value to the luxurious residences above, but at the same time becomes the ghost of a past

fading away. Kreuder sums up the tension between the Sony and the Esplanade as follows (2000: 38):

> The ruins of the Esplanade, which have been encapsulated by the Sony Center's scaffolding, [...] deliciously arranged behind greenish glass, bears hardly any witness to the violent act to which it owes its present condition. Hence, by architectural means, Jahn's Sony Center contributes to the current trend of objectivizing German history. Problematic historical materials are covered up, built over, arranged appealingly, levelled, made to disappear.

A historically listed hotel favoured by the last emperor is allowed to stand within the premises of the Sony Center only after its bits and pieces are shuffled in rather unfortunate ways to fit a Chicago-based German-American architect's contemporary vision. In his detailed study of the Hotel Esplanade, Kreuder (2000: 23), who had not yet visited the finished Sony Center, wrote: 'They will bring the layers of the past into the very interior appointment of the new building. [...] Jahn's conception of an architectural museum marks a fundamental turning point in how German historical memory is represented and preserved.' While Jahn turned the ruin of a historical building into puzzle pieces and transplanted them into diverse parts of his modern design, these visually contrasting pieces were treated like antiques in a display case, or rich interior decorations. In a commercial urban setting, they either disappeared or turned into spectacles of touristification. Every time a careful visitor discovers relocated pieces of the Esplanade that are squeezed between *Bellevuestrasse* and the Sony Center's large atrium, they must mentally reconstruct the objectified hotel piece by piece, since Jahn's architecture does not do that for them.

Victory Column

Caroline: What's that statue for? George: Victory.
Caroline: Whose victory? George: Anybody's.

A Dandy in Aspic (1968)

On 20 April 1939, prior to a five-hour military parade in honour of his fiftieth birthday, Adolf Hitler was driven down Unter den Linden, through the Brandenburg Gate and onto the newly widened east–west Charlottenburg Carriageway[12] through the Tiergarten.[13] Halfway down this axis was Berlin's Victory Column (*Siegessäule*), which had been supplemented, reoriented and relocated into the middle of a new roundabout, the Great Star, by Hitler's

architect Albert Speer. The relocation of the massive column was carried out in order to appropriate it as a Nazi monument and also to move it out of the way of the north–south axis of Hitler's grand *Germania* project for Berlin, a large replica model of which can be seen in Oliver Hirschbiegel's *Downfall* (2004) and other films portraying the final days of Hitler. Satisfied with the results of Speer's efforts, Hitler circled back to the Brandenburg Gate and took his position to watch his birthday parade.

Johann Heinrich Strack designed Berlin's Victory Column in 1864 to commemorate the Prussian victory over the Danish. By the time the column was inaugurated in 1873, there were two more victories to celebrate: over Austria in 1866 and France in 1870–71. Strack's original column design had already been divided up into three separate drums increasing in height towards the top, so the three drums conveniently then symbolized each of these three victories.

These column drums are 6.7 m in diameter and contain a stairway that leads to a viewing platform at the top, just below an 8.3 m high-gilded statue of the Roman goddess of victory.

This winged goddess wears a helmet with German eagles and, like her quadriga counterpart atop the Brandenburg Gate not too far away, holds a laurel wreath in one hand and a staff with an Iron Cross in the other. The column itself sits on a circular base composed of 16 red granite columns in the Tuscan order. The inner wall behind these columns is decorated with a glass mosaic depicting the history of the German Empire from the Wars of Liberation (1813–14) to the proclamation of the empire (1871).[14] This circular base sits on an 18.8 m^2 base of polished red granite 7.2 m high. Each side of this base contains massive 2 m by 12 m bronze bas reliefs depicting scenes from the victories that the column commemorates as well as one scene portraying a victorious entry of German troops into Berlin in 1871.[15] When completed in 1873, the total height of the square base, round base, column and statue was approximately 80 m.

The original location of the Victory Column was on the *Königsplatz*, the public square that eventually became the western forecourt of the Reichstag. The victory statue on top of the column faced south, looking down Victory Avenue (*Siegesallee*), a north–south thoroughfare that intersected with the east–west Charlottenburg Carriageway, plainly seen in August Blom's *Atlantis* (1913), Adolf Trotz's *The City of Millions* (1925), and other silent films of that era. Between 1895 and 1901, Kaiser Wilhelm II commissioned 32 statues from sculptor Reinhold Begas for this avenue that depicted his Hohenzollern ancestors from the twelfth-century Albert the Bear to his grandfather Wilhelm I.

Together with the Brandenburg Gate, TV Tower and Berlin Wall, the Victory Column is one of Berlin's most iconic urban structures today, often seen in contemporary promotional material, logos and abstract skylines of the city. Because of its

FIGURE 8.2: The Victory Column in its original location in *Atlantis* (1913) and *The City of Millions* (1925).

location in the middle of a roundabout, its representation in cinema has largely been from the perspective of a moving vehicle – whether bus, taxi or car. What is largely forgotten, however, is that the monument was not just designed to be a celebration of the beginning of the German Empire but also to be an act of disdain to the defeated armies of Denmark, Austria and France. Not only did the three sections of the column represent each of the three victories, their grey sandstone flutes were also decorated with canons taken from each enemy during each conflict, 60 in total, which were gilded when installed onto the column. Additionally, the massive bronze bas reliefs on the square base do not just commemorate important Prussian victories but also depict the conquered as no match for the German military.[16]

This was a point not lost on Hitler who proceeded in 1938 to amplify this message. First, he ordered Speer to add a fourth segment to the column. This new segment was added to the bottom and each segment's canons were moved down by one, resulting in the top segment – not coincidentally the longest – representing the impending victory envisioned for Hitler's war that he would start in September 1939. Speer ([1969] 1970: 139) recalled in his autobiography:

> Hitler regarded [the Victory Column] as a monument of German history. In fact, he was going to make the column more impressive by adding a tambour to increase its height. [...] In discussing the matter, he made fun of the thrift practiced by the State of Prussia even at the height of its triumph, pinching pennies by saving on the height of its column.[17]

Next, Hitler ordered the Victory Column to be moved away from the Reichstag (admittedly an awkward location for an imperial monument) and instructed

that the victory statue, in its new location, face west – towards France. This was just one of many actions he carried out in his life-long mission to avenge what was called the 'stab in the back' of the Treaty of Versailles, the agreement that disfavorably ended the First World War for the German Empire.[18] Lastly, Hitler instructed Speer to relocate three other imperial monuments from *Königsplatz* to just north of the new Victory Column location,[19] as well as relocate the 32 Hohenzollern sculptures from the north-south Victory Avenue onto the new east–west axis. All of these relocations were Hitler's way of emphasizing the Prussian lineage of his 'Third Reich'.

The French were acutely aware of the symbolism of Berlin's Victory Column, especially the bronze bas reliefs.[20] Following the Battle of Berlin, before any formal control of sectors was established, the French, on their own accord, removed three of the Victory Column's reliefs and sent them to Paris.[21] In 1984, after multiple requests for their return since the 1950s, Paris mayor Jacques Chirac returned two of the reliefs. In 1987, French President François Mitterrand returned the third, making the monument's base whole again.

The return of these reliefs, more than 40 years after their theft, could have only happened because Berlin's Victory Column was no longer a symbol of either the German Empire or Nazi Germany. By the 1980s, Europe had been at peace for several generations and there was even serious talk of a new political entity called the European Union. The Victory Column had ceased to be offensive, despite its gilded spoila and bronze victory reliefs. It was open for sight-seeing, and given its 75 m view over the city, it was (and still is) a popular tourist attraction. Although the monument is in the middle of a rather busy roundabout, it is easily accessible via four gatehouses, designed by Speer, with corresponding underground tunnels for safe passage.

Part of this change in the meaning of Berlin's Victory Column can perhaps be attributed to the way in which it was depicted in *Wings of Desire*, where the angels sit on Victoria's shoulder. Gazing down upon the city and philosophizing about life in Berlin, the angels in Wenders' film seem to transform the Victory sculpture into an angel herself. If asked, a tourist (or even a Berliner?) would probably identify the sculpture as an angel, not an expression of military victory.[22] This sculpture-as-angel motif also appears in Roman Kuhn's *be.Angeled* (2001), which narrates eight different stories over two days during the Love Parade – the city's techno-music and substance-fueled erotic mass street party that took place annually in Berlin between 1989 and 2010 (and was scheduled to return in 2022).

Perhaps more attracted to the column's phallic nature than its history as a tool of military humiliation, Love Parade participants, starting in 1996, culminated their daytime raving at the Victory Column, after which they spent their nights clubbing in Berlin's many underground techno venues. Cultural critic Svetlana Boym (2001: 179)

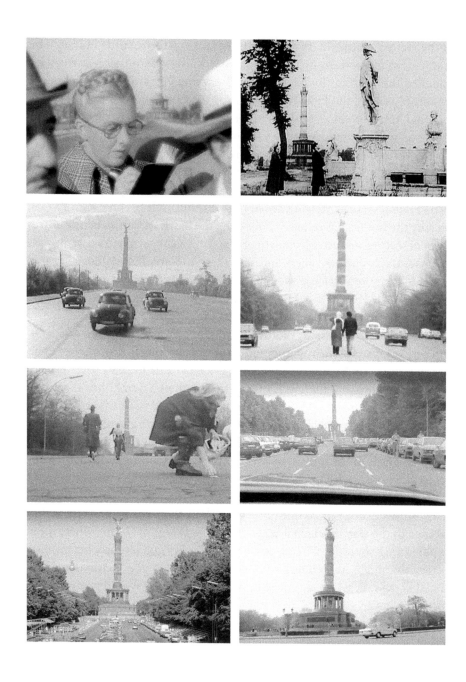

FIGURE 8.3: Post-relocation cinematic representations of Berlin's Victory Column in *A Foreign Affair* (1948), *The Big Lift* (1950), *Adventure in Berlin* (1952), *Germany, Bitter Homeland* (1979), *Ticket of No Return* (1979), *Judgement in Berlin* (1988), *Police* (1988) and *Berlin I Love You* (2019).

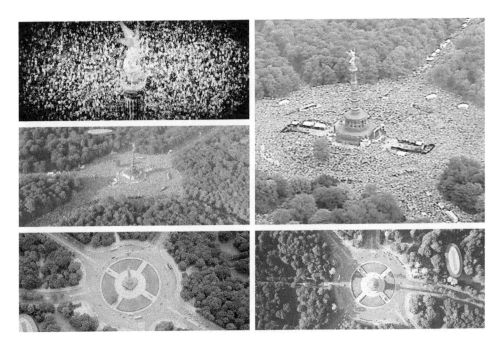

FIGURE 8.4: The Victory Column as the phallic focal point of the Love Parade in *We Are the Night* (2010), *Chasing Liberty* (2004) and *Sound of Berlin* (2018); and as establishing shots for *Captain America: Civil War* (2016) and *Charlie's Angels* (2019).

points out that this usage of the Victory Column, as well as the Brandenburg Gate, allowed ravers and non-ravers alike to 'stray distractedly from the painful debates about the past and the future [of reunited Germany] and simply hang out at the contested sites'. The Victory Column is also a symbol of the gay community in Berlin. It is the namesake of the city's monthly queer magazine, *Siegessäule*, and is used as a phallic symbol of desire for homosexual Berliners in Kutluğ Ataman's *Lola and Billy the Kid* (1999) (Hamm-Ehsani 2008: 375).[23] The urban strategy of relocation, in this instance, seems to have allowed for forgetting the original meaning of the column rather than remembering its negative connotation.

The relocation, supplementation and reorientation of Berlin's Victory Column by Hitler made it into a Nazi monument, which was readily apparent to the victors of the Second World War, each of whom was eager to fly their flag on top of it. Over the years, however, it seems that all of this was forgotten as other, 'more Nazi', buildings and monuments were de-Nazified by demolition, reappropriation and/or the removal of swastikas. Indeed, while the Allies did not remove the *Königsplatz* monuments that Hitler relocated to the new roundabout, they did remove the Hohenzollern sculptures from the Charlottenburger Chaussee, tore up Wilhelm

II's Victory Avenue, and planted it over with grass and trees to match the rest of the vast Tiergarten urban park, forever erasing the street from the memory of the city, presumably because it recalled Germany's militaristic past, but not before films such as Robert Stemmle's *The Berliner* (1948) and George Seaton's *The Big Lift* (1950) were able to incorporate the Hohenzollern sculptures into their stories, both mocking the name 'Victory Avenue'. The main character of *The Berliner*, a former German soldier trying to build a new life after the war, can be seen sarcastically saluting the Victory Avenue statues. In *The Big Lift*, an American soldier, after being told by his German girlfriend that the place was called '*Siegesallee* – it means Victory Avenue', replies, 'They don't look so *Sieges* any more, do they?'

Berlin's Victory Column, equally a reminder of Germany's militaristic past, is today an easily accessible tourist attraction that allows breathtaking views over the Tiergarten and the city of Berlin; never mind the fact that it is decorated with stolen gilded canons and battle scenes. It is currently an active icon and memorable landmark of Berlin. This may change in the future; Berlin is a city of becoming, but for now, the Victory Column is remembered as 'that place where we climbed 285 stairs', 'that place where we got sprayed with champagne by topless ravers' or, on a more everyday level, 'that pillar that I drive around five days a week to get to work'.

The most touristic and historically significant relocated structure in Berlin is arguably not the Victory Column but the Pergamon Altar (second-century BCE), excavated in the nineteenth century (Carl Humann, 1878–86) and brought to Germany piece-by-piece from the ancient Greek acropolis of Pergamon, near contemporary Bergama in Turkey.[24] The first Pergamon Museum in Berlin, which housed the massive reassembled altar and other relocated examples of Greek and Roman architecture, was built in 1897–99 by Fritz Wolff and opened in 1901. This structure was shortly considered unfit for its purpose, unbuilt in 1909 and rebuilt according to Alfred Messel's design on the Museum Island in 1930. In her near-future science fiction romance *I'm your Man* (2021), Maria Schrader uses the museum as scientist Alma's workplace where she finds AI Tom in the middle of the night as he admires the Market Gate of Miletus (from around 100 CE brought to Berlin from 200 km south of Pergamon) and they end up hiding from the museum guard behind the Roman gate's Ionic columns.

What does it mean to have colossal structures such as this altar, the remains of Hotel Esplanade or the Victory Column moved metres or kilometres away from their original sites? Each case of the implementation of this unusual urban strategy is unique[25] and what would happen if the relocation did not take place changes from case to case. Some may have been demolished and perished, and some would stay on their authentic sites as a ruin in decline or a building well maintained. Each action – relocation, demolition, preservation, etc. – would impact on the urban memory associated with the structure differently because its memory would be

distinct on alternative sites. (Unlike most design disciplines, architectural design is contextual; buildings are bound to their site, to their natural and built environment.) It would have been quite an adventure to imagine this duality of memory (maybe in a fiction film) and the impact of having *all* displaced (misplaced?) structures in their original location, given the fact that Berlin, unusually, has a large number of relocated monuments and buildings.

The needs of cities alter over the course of time, and relocation may be the solution to adjust to contemporary urban needs. As an urban strategy, relocation deals with changes and moves in space, aiding the preservation of urban memory in an unusual way. A great deal may be lost on the move, but some breadcrumbs can still be traced.

NOTES

1. The 80 m² Red Hall (*Rote Salon*) of the Hotel Esplanade was known as the Emperor's Hall because it was a favourite room of Wilhelm II, the last ruler of the German Empire. Along with the Breakfast Room, Silver Hall, Palm Court and main entrance, it surprisingly survived the heavy bombing of Potsdamer Platz on 3 February 1945 whereas the rest of the large building did not.

2. On review here is not Jahn's motive since his task is to design a commercial centre for his client, not to preserve Potsdamer Platz, the Esplanade and the urban memory of the city; that is the job of the city authorities.

3. There was a competition in the early twentieth century between the Esplanade, owned by a Hamburg-based hotel company Deutsche Hotel Aktien-Gesellschaft, and also privately owned luxurious Hotel Adlon (Carl Gause and Robert Leibnitz, 1907) opened a year before facing the Brandenburg Gate. In *Cabaret*, based in 1931 Berlin, the cabaret singer/dancer of Kit Kat Klub (whose shows in the film were shot in studio) goes to the respectable Adlon to meet her father who is a US ambassador. Unlike the Esplanade, which cost 23 million Deutsche Marks to build, Adlon is still in its original location, but the building was rebuilt (Rainer Michael Klotz, 1995–97) following the German reunification since a fire caused by Russian soldiers in the hotel's wine cellar (1945) left only the rear service wing standing in East Berlin. The popular hotel was supplemented with new wings in 2003–04.

4. On the *Luetzowufer* in West Berlin, another Grant Hotel Esplanade (Jürgen Sawade, 1988) opened a few years later.

5. Otto Redlin, the *hausmeister* of Hotel Esplanade, is 'showing the audience around' in footage from 1987, https://www.youtube.com/watch?v=OmjzmBE2IrE (last accessed 19 February 2021).

6. This explanatory plaque refers to the remains of the Esplanade in the Sony Center as an 'architecture museum', which is misleading on several layers. The rooms are not publicly accessible, they are not curated, they can be booked commercially (imagine having a party

at the Pergamon Altar), there is a guided tour specific to Sony but not the Esplanade, and the list goes on.

7. The use of air cushions minimizes friction. An animated real-time footage of the relocation process (filmed from the *Weinhaus Huth*) can be seen at https://www.youtube.com/watch?v=f6mnl-yIfBE (last accessed 13 September 2021).

8. The Kaisersaal moved first 7.3 m to the south, then 42.15 m to west and finally 25 m to north.

9. Ward (2016: 126) also states

> the Esplanade is a spatial image combining past and present in which the city's repository can be reactivated and put on display for the 'live gaze' of the cinematic spectator. [*Wings of Desire*] engages with [...] the potential of the monument whose meaning and intention is not foregrounded.

10. Sybille Frank (2019) states

> [t]he new cafe with the old name Josty, integrated into translocated parts of the former hotel Esplanade, which itself has been integrated into the built glass structures of the new Sony Center, is the most vivid example of the shuffling of heritage sceneries, locations, narratives and time layers at New Potsdamer Platz on the one hand, and of the capitalisation of tamed historic trophies on the other.

11. The combination of the old and new in the Breakfast Room gives one the feeling of astronaut Dave Bowman's part Louis XVI and part high-tech room at the end of Stanley Kubrick's *2001: A Space Odyssey* (1968).

12. *Charlottenburger Chaussee*, today's 17 June Street.

13. As early as 1902, the Tiergarten was framed in a short film entitled *Kaiser Wilhelm in the Tier Garten*.

14. German artist Anton von Werner designed the mosaic and Venetian artist Antonio Salviati executed it.

15. The four bas reliefs and their artists are: 'Assault on the Düppeler Schanzen' (Danish War) by Alexander Calandrelli, 'Battle of Königgrätz' (Austrian War) by Moritz Schulz, 'Battle of Sedan and Entry into Paris' (French War) by Karl Keil and 'Entry of Troops into Berlin' by Albert Wolff.

16. The German Empire's Sedan Day Holiday, commemorating their victory at the Battle of Sedan on 2 September 1870, took place every year at the foot of the Victory Column.

17. Tambour is the architectural term for a column drum.

18. Hitler's other action to avenge the Treaty of Versailles was stealing the Compiègne train wagon inside which the treaty was signed in 1918 and bringing it to Berlin for display

between 1940 and 1944, not to mention the rearmament of Germany and the occupation of lands otherwise forbidden in the treaty.

19. These monuments were to Otto von Bismarck (first Chancellor of the German Empire), Helmuth von Moltke the Elder (a Prussian Field Marshal) and Albrecht Graf von Roon (a Prussian soldier and statesman).

20. The relief entitled 'Battle of Sedan', for example, not only illustrates a victorious German army but also depicts German soldiers marching under Paris's *Arc de Triomphe* – itself a victory monument – in 1870, a humiliating scene for the French that was repeated in 1940 by Nazi troops.

21. The French left the 'Battle of Königgrätz' on the monument. Sometime in the 1950s, it was taken to Berlin's *Spandauer Zitadelle* by West German authorities for safe-keeping.

22. This understanding is frequently compounded by the fact that Victoria has wings, which is because the sculpture is a direct descendent of the Ancient Greek *Nike* that also has wings.

23. German scholar Karin Hamm-Ehsani writes

> the monument's image of national power is deconstructed and appears in queered perspective by association with the sexual activities between men visiting the park by night. The film thus challenges the conventional notion of (heterosexual) phallic authority implied in the monument's symbolism.
>
> (2008: 375)

24. The Pergamon Altar section of Pergamon Museum is under reconstruction until the mid 2020s. Until then, visitors can enjoy one of Yadegar Asisi's panoramic representations (of not just the altar but the whole city of Pergamon), https://www.asisi.de/en/panorama/pergamon (last accessed 13 September 2021).

25. In his 2021 novel *Land of Lost Gods* (*Kayıp Tanrılar Ülkesi*), Ahmet Ümit sets his Berlin-based detective story on the relocation of the Pergamon Altar and the complicated story of a Turkish family that relocated from Bergama to Berlin.

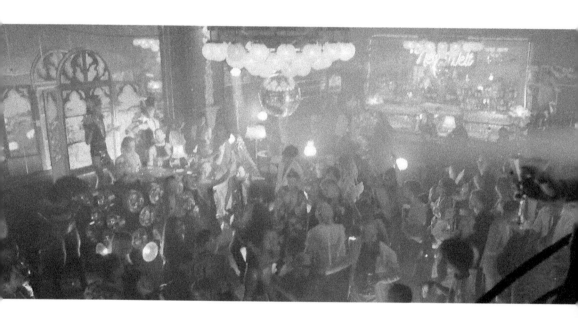

Berlin Alexanderplatz (2020)

9

Survival Instinct:
Adaptation

Our past has been locked in time, arbitrated by time, defined by time.
If we change that, what have we got left?
 Ryan in *Time Cop: The Berlin Decision* (2003)

The urban strategy of adaptation is the reuse of structures that were originally designed for another purpose. In *Building Adaptation*, building surveyor James Douglas defines adaptation as 'any work to a building over and above maintenance to change its capacity, function or performance' as well as 'work accommodating a change in the use or size or performance of a building' (2006: 583). Also known as 'adaptive reuse', the urban strategy of adaptation may or may not involve the design and creation of new forms to accommodate the new function(s). Due to the continual usage of older buildings, their adaptation results in a layering of meaning and memory. The older building acts as a representation of the past, even if that past is long gone and just a memory.

There is a complex mechanism of political, social and economic factors that renders a building either redundant or no longer necessary. Adaptation of these buildings can occur for a variety of reasons – from a simple lack of resources to build new buildings to a desire to be eco-friendly by reusing existing buildings. As interior architect Fred Scott (2008: 17) notes:

> In the city, uses and occupations migrate from quarter to quarter in quantum shifts; the one-time brothel becomes software offices, the soap factory becomes artists' studios. Change of use causes a massive change in the rituals of occupation. Buildings change as the city changes.

A notable Berlin building that has been adapted more than once both legally and illegally was a shopping arcade, *Friedrichstrassenpassage*, constructed in 1907–08 in the Berlin Jewish district of *Scheunenviertel*. First, an AEG showroom in 1928

and then a Nazi prison in 1941, small German Democratic Republic (GDR) businesses took over the ruined concrete building in 1948. In 1990, artists claimed the structure, dubbing it the *Künstlerhaus Tacheles* ('Straight Talking' Artists House) and adapted it into an art centre with exhibition galleries, bars, studios and workshops for the artists, with vivid murals and modern sculptures inside and out. Closed in 2012, the building was a haven of alternative art practices, experimental social constructs and activist art. Other examples of Berlin building adaptation include the conversion of the disused Neukölln Pump Station by Nils Wenk and Jan Wiese in 2008 into a private residence for artists Michael Elmgreen and Ingar Dragset. Additionally, in 2017, Wilk-Salinas Architects transformed a defunct bus depot into the Arena Berlin, which now hosts trade fairs, exhibitions, conventions, street-food markets and similar activities.

Berlin techno clubs

Berlin is not a city. Berlin is a rhythm, in an endless loop.

Sonia in *Fucking Berlin* (2016)

The relationship between urban strategies, architecture and memory (or urban strategies and urban memory) cannot be discussed without considering the role of power in the process. Most of the time, stakeholders of power are political authorities such as public servants and municipal planning departments, professional authorities such as architects and planners, and financial authorities such as developers and private investors. Although rare, users may also participate in the shaping of the city and its memory. Citizens who have initiated change, especially in the Kreuzberg district of walled-in Berlin in the late 1970s and 1980s, have been not only the residents and tenants but also squatters who illegally occupied neighbourhood structures. Some of those activists were protesting the post-war renewal plans of the 1950s and 1960s that favoured demolition, clearance and new construction.[1] Others squatted to draw attention to the shortage of affordable housing, replacement of old pre-war buildings, the relocation of the urban poor and or rapid gentrification. A civilian adaptation movement, as the authors of this book call it, began.

One of their first acts was multiple rehab-squatting (*Instandbesezten*)[2] that started with occupying two buildings in Kreuzberg in 1979 by the Citizens' Initiative SO 36. Unauthorized dwellers moved into derelict buildings and began to informally renovate them. Block 103 at *Manteuffelstrasse* 39–42, first squatted in 1981, gained a central role in the movement, especially with its craftwork collaborative that supported the renewal and maintenance of occupied buildings

by providing new and recycled materials, fixtures, tools, workshops and know-how. This gave agency and control to Berliners to reshape and adapt their urban environment. Rehab-squatting influenced urban and housing development policies from 1978 onwards via the *IBA-Altbau* that consisted of low-cost renovations of existing buildings to keep rents low and tenants in place, at least for the time being.[3] For the voices of the residents in Kreuzberg to be heard, the *IBA* also experimented with participatory design practices and democratic consensus-building, 'attempting to reconcile the demands of buildings' owners, legal tenants, squatters and activists, district council and city government officials, planning authorities, and architects' (Pugh 2015: 197).[4] Eventually, organized squatting maintained the urban fabric of most of the area and saved numerous buildings. At its core, this was a social, political, economic and architectural movement of urban adaptation initiated for the people by the people (Pugh 2015).

FIGURE 9.1: Squatted apartment buildings in *The Attempt at Living* (1983), *Führer Ex* (2002 – set in the 1980s) and *What to Do in Case of Fire* (2001). (All illustrations are film stills captured by the authors.)

The squatting situation on the socialist side of the Wall was somewhat different. Since the state could not supply housing to everyone that fulfilled basic domestic needs, especially in large cities, in the 1970s and 1980s East Berliners squatted vacant apartments, referred to as illegal living (*Schwarzwohnen*). Although the GDR Ministry for Building and Construction continuously erected Soviet-style mass-produced housing blocks in urban areas and on the city's fringes, the shortage of adequate housing was massive after the air raids Berlin went through in the 1940s. As seen in the rubble films of this decade, two-thirds of homes were destroyed and were hardly in any condition to be repaired (in both Berlins). Migration to cities was making the situation worse. In the early 1970s, an East German could be on the official waiting list of 600,000 people for 6–8 years. Such housing insecurity was a serious issue between the East German state and its citizens because housing had been a constitutional right in this socialist country since 1949.

The housing shortage was one of the main topics of the established culture of official complaints in the GDR. Capped at the level of the 1930s, rents were low but apartments without basic infrastructure and not meeting modern health and safety standards led people to look for alternative places to live illegally. The eviction of squatters was not the norm. Unauthorized occupation was generally tolerated because it eased the shortage by 'provid[ing] an informal mechanism for alleviating a crisis in housing that administrators were ultimately unable to address' (Vasudevan 2014: 150).

The Ministry for State Security (*Ministerium für Staatsicherheit*) or 'The Stasi' (GDR secret police) seemed more concerned about the punk subculture and emerging activism than urban squatting.[5] Illegal living was not a communal act or a political movement like in West Berlin. Rather, people were only being practical and deploying a tactic to secure housing. As good citizens, squatters even paid rent and utility bills. Just like in the West, they tried to repair and maintain squatted buildings with materials, tools and training provided in community centres or organized among themselves. This does not mean that *Schwarzwohnen* did not become the venue for the emergence of political resistance, especially in the district of *Prenzlauer Berg*. Political or apolitical in nature, the adaptation of hundreds of temporary informal squats gave East Berliners a voice in the redevelopment of their city during the Cold War (Vasudevan 2019: 152).

Post-reunification, squatting in the former east took on a new form. In the 1990s, it was not undertaken solely for a space to live. For dissimilar reasons, the new-found ecstasy of freedom dominated the suppressed youth of the east and the walled-in youth of the west.[6] Inclusion, tolerance, self-expression, individuality and joy filled the air and brought young Berliners together to party in squatted vacant buildings and underground venues, especially in former East Berlin. The Love Parade, initiated by Matthias Roeingh ('Dr Motte') and Danielle de Picciotto, started with 150 people in 1989 on the streets of former West Berlin (*Kurfürstendamm*), and male-only

202

SNAX parties in 1992 on the top floor of a reinforced concrete Nazi bunker in East Berlin. The annual parade exploded quickly. In 1996, thousands partied in the Tiergarten around the Victory Column, turning the authorities' attention to the economic potential of both the parade and techno music.

> A crowd of 750,000 mobbed the area, shutting down the city center and the Berlin transit system. Outrageously dressed youths danced through the Tiergarten, drinking and drugging, creating general havoc, and evoking delight – or concern – among observers and local residents.
>
> (Perry 2019: 565)[7]

The police shut down the gay SNAX parties at the Friedrichstrasse Station bunker in 1995, but the parties then moved multiple times until squatting a railway warehouse close to the Spree river in 1998 and naming their newly adapted club Ostgut.[8] Spontaneous one-off underground happenings of the late 1980s and early 1990s were very much linked to the chosen sites that were usually ruined, derelict and neglected spaces and places. What started as temporary installations within unused or unusable venues under a bridge, in a car park or an empty basement with minimal sound and light systems turned into a serious adaptation of (usually industrial) buildings. By the end of the millennium, this spontaneous subculture associated with techno music had its own squatted and adapted buildings. These industrial spaces, factories, warehouses, bunkers and power plants, which became redundant in the post-industrial city, were inspired and shaped by the industrial beat of Berlin techno.[9]

Influenced by 1970s Düsseldorf experimental electronic music, techno was born in Detroit in the second half of the 1980s as a version of electronic dance music, EDM, but it grew up in Berlin around the same time with improvised parties, gay parades and marginal clubs such as Bar25, Der Bunker, E-Werk, KitKat, Tresor and Watergate, just to name a few.[10] Since the fall of the Wall, Berlin has had a growing techno music scene that resonates with the urban nightlife at the beginning of the twentieth century. As musician and producer Mark Reeder says in *SubBerlin – Underground United* (2008), 'The [techno] sound was radical and unlimited, and excessive just like the Fall of the Wall'.[11] Though begun as a subculture, underground clubbing has added a new experiential layer to the city which is already rich with tourist attractions. Documentary films such as Christian Lim's *Sound of Berlin* (2018) about DJs in Berlin and Amelie Ravalec's *Paris/Berlin: 20 Years of Underground Techno* (2012) frame the city's nightlife and its clubs that 'serve' people from around the world day and night.[12] A homage to Ruttmann's 1920s *Berlin Symphony*, Johanne Schaff's *Symphony of Now* (2018) documents Berliners' nightlife in the twenty-first century. Gabriela Tscherniak's fiction film

Berlin Nights (2005) portrays the nightlife in the city at the dawn of the new millennium, whereas Qurbani's *Berlin Alexanderplatz* (2020) takes the audience to contemporary Berlin at night with a nightmarish narrative.[13]

Berlin's unparalleled nightlife had been exceptionally busy throughout the twentieth century from cabaret, jazz and swing to punk, rap and techno. As the German subtitle to Will Tremper's *Playgirl* (1966) declares, 'Berlin is worth a sin'. The city has had (at least) two layers,[14] one emerged during the day and one at night.[15] German historian Joe Perry sees these layers as 'a series of binaries – between alternative and mainstream, cool and straight, authentic and commercial,

FIGURE 9.2: Some cinematic nightlife of Berlin in *Dr. Mabuse the Gambler* (1922), *Berlin: Symphony of a Great City* (1927), *The Blue Angel* (1930), *Tugboat M17* (1933), *A Great Love* (1944), *A Foreign Affair* (1948), *Adventure in Berlin* (1952), *Playgirl* (1966), *Christiane F.* (1981), *Wings of Desire* (1987), *Coming Out* (1989) and *Mute* (2018 – set in 2035).

night and day' (2019: 562). Going back to what is perceived as the golden 1920s in his book *Berlin Cabaret*, Peter Jelavich admired freedom, creativity and play in the cabaret theatre of the Weimar Republic (1993: 6). Techno subculture brought back the urban memory of these values that was on hold, or at least stripped of joy, during most decades of the twentieth century.[16] The beat of this music matches the beat of the city. One can watch *Berlin: Symphony of a Great City* (1927) listening to a Techno playlist. In her review of Jelavick's book, Barbara Miller Lane writes (1996: 138):

> The 'real' Berlin cabaret was not strip shows, not vaudeville, not theater – rather it was a unique form of entertainment. It was defined by the intimacy of the small night-club or theater setting; it included music and dancing and satirical lyrics – sometimes broadly political and sometimes not.

Although techno music does not usually include lyrics, this 'picture' resonates with techno club subculture and the alternative lifestyle it suggests a hundred years later.

Evolved after Detroit, techno music has always had an energetic machine sound, a never-ending industrial beat.[17] This matched with both the anti-militaristic, leftist, activist and inclusive social dynamics of Berlin and its vacant industrial buildings adapted for partying and clubbing. The underground clubs usually kept the industrial look of the abandoned and neglected spaces, with minimal alterations during the adaptation of large spaces, leaving rough concrete structures empty other than graffiti, murals, coloured light and projections – courtesy of the strong visual arts scene in Berlin after the fall of the Wall. Working with DJs inspired by the dark side of the city, VJs produced 'visual-music' as *Pfadfinderei*, a group of visual artists, called it (Bianchi 2006). This brought architecture and music even closer; the rhythm of the music gave life to the ever-changing visuals and the visuals projected onto the weathered walls gave a new life to the derelict buildings. DJ Clé comments, 'We played (music) in clubs that were not owned by anyone, in districts no one was responsible for, in buildings that did not exist according to the land register; we lived at a time when normal people slept' (Schofield and Rellensmann 2015: 116).

The functionality, safety and security of the club were significant for freedom, creativity and play but more important were its aura and mood shaped through tangible and intangible qualities of the space such as light/darkness, colour, smell, temperature, humidity, oxygen level, materiality, texture, proportions and most of all sound, music and the vibrations created by deep bass pulsations. Bouncers at the door act like they are guarding a castle and there is a high possibility of rejection at the door after queuing for several hours. When the main characters skip the normally impenetrable queue outside of a techno club in *Unknown* (2011),

FIGURE 9.3: Techno Clubs in *Tattoo* (2002), *We are the Night* (2010), *Meet Me in Montenegro* (2014), *Berlin Calling* (2008), *Berlin, I Love You* (2019), *Victoria: One City, One Night, One Take* (2015) and *Unknown* (2011).

because they happen to know the bouncer, they escape from their pursuers who assume that there is no way they can be inside. This strict door policy is followed by a strict no-photography policy. These are important because expressing oneself via fetish clothing, partial or full nudity or outside-the-box sex rituals is expected. In Berlin's techno clubs, anything goes. Earth-shattering infinite beats, sexual fetish

parties and inclusive all-weekend parties are common and if let in, rule-breakers kill the vibe and the techno's non-judgemental hedonistic attitude. Therefore, the queue is as important as inside.[18]

Techno clubs, not controlled at the beginning, were pushed to the periphery of Mitte: the area along the Spree river between Kreuzberg and Friedrichshain, and also Prenzlauer Berg.[19] With every urban move, the clubs' symbiotic relationship with the architecture they occupied grew and strengthened. This was no different for Berghain, a venue considered as the most established electronic music club in Berlin, and arguably in the world, for more than a decade.[20] Michael Teufele and Norbert Thorman's Berghain club evolved from parties celebrating the fall of the Wall, their SNAX parties and the Ostgut club that they ran in an illegally adapted railway warehouse that used to repair cranes. Ostgut (1998) was not a club exclusive to men and the gay community anymore. Panorama Bar with softer techno and house opened on the top floor and hardcore gay activity moved down to the dark rooms of laboratory. Besides marginal SNAX, they held parties for all techno lovers regardless of their sex and sexuality. When they were evicted in 2003, the industrial GDR building they preserved for years was demolished and erased from memory in 2004. That is the downside of the nomadic existence of techno clubs. Ironically, on the site of Ostgut now stands the Mercedes-Benz Arena (2006–08), a generic commercial 17,000-seat sports and concert venue built for 165 million euros. Their website lists the number of their toilet brushes (308) and the amount of their rubbish per event (120 litres) but 'forgets' to mention the memory of the site with a prominent techno club in an adapted GDR building. The commercial value of the site facing another GDR inheritance, the open-air East Side Gallery, exceeds its (underground) heritage value.

Ostgut continued having the soul of squatting and SNAX.[21] Berghain, on the other hand, though still perceived as an underground gay club, is a tax-paying business,[22] one that is now officially considered 'high culture' like the Berlin Philharmonie and State Opera.[23] Teufele and Thorman turned their illegal activities into a successful professional establishment. Interior architecture firm Studio Karhard carefully adapted the interior of a thermal power plant (1954)[24] not too far from Ostgut's site into a techno club with a state-of-the-art Funktion-One sound system.[25] Their high-tech design utilizes concrete, steel and art[26] and is minimalist and respectful to the industrial appearance and atmosphere of the original building. The temple-like cubic structure sits on the site of the former Wriezen train station with its original three-partite façade with tall formal pilasters, narrow windows and a plinth. The Berghain dance floor for hardcore electronic music inhabits the 18 m high turbine hall, accompanied by a relatively airy Panorama Bar upstairs and *Kantine am Berghain*

for concerts and events. About Berghain's adaptation, Thomas Rogers (2014: n.pag.) says:

> The club melded Ostgut's underground vibe with a more professional service experience – drinks are shuttled to and from the bar via hidden hallways, and the building was retrofitted so clubbers couldn't easily injure themselves [...] The building is so large and maze-like, you can discover new stairways and rooms even after spending a few days in the club.

As guests wander around, they may come across unisex toilets,[27] an ice bar, sofas for napping and dark rooms with chained sweaty bodies in cages. 'Located on a barren block, in a former power station, the culture of the club and the people who regularly frequent it have become the zeitgeist of the city' (Dundon 2018). Berlin now promotes itself as the capital of clubbing and nightlife, a creative city that never sleeps, a *Partymetropole* to attract young Europeans. As Thomas Rogers (2014: n.pag.) questions:

> Over the past decade, Berlin has transformed into Europe's unofficial party capital, and Berghain has developed a reputation as the Mecca of clubbing. [The club] has gone from being a local phenomenon, infamous for its sex parties and drugs, to one of the city's most high-profile tourist attractions. Now the venue stands at the intersection of the bigger trends facing the city, namely gentrification, a rise in low-fare tourism and a flood of international hype, and faces an awkward question: What does it mean for a club to be underground when the entire world wants to dance there?

Emerged from fetish gay clubbing, Berghain remains a safe place for the wider LGBTQIA+ community. From underground club subculture to high culture, the internationally known 'Temple of Techno' is the poster venue of Berlin's club scene but still no photography is allowed. Artist Felix Scheinberger's book *Hedo Berlin* displays his illustrations of Berghain clubbers as well as other Berlin clubbers, which John Schofield and Luise Rellensmann (2015) refer to as a 'heritage community'. Scheinberger's marginal characters help to visualize the environment inside Berghain for those who could not pass its 'cool' East German guard Sven Marquardt, one of the three protagonists of David Dietl's *Berlin Bouncer* (2019), to join the 1500 people non-stop clubbing from Saturday night to Monday morning.[28] The strict entrance policy is for safety (not to bother anyone), respect (to the culture of the club) and enjoyment (appreciation of techno as *the* urban music).

Berlin films of the new century usually include a scene in a techno club. In *Meet Me in Montenegro* (2014), Lina says, 'We should just go to a club, and dance all night, and forget about everything else' to Anderson. It can be argued that the

grassroots adaptation of industrial buildings into clubs was/is a productive use of land as part of the reconstruction of the city. It gives Berliners the agency to shape the built environment and manipulate urban memory. In the meantime, clubs are regularly pushed to the periphery, as private interest overpowers public good. There could be more discussion around how the energy of the club scene can be captured within the city. The techno beat spilled onto the streets of Berlin in the 1990s and 2000s, and the Love Parade currently being planned for the summer of 2022 might be an urban step.

Clubbing appeared as a non-stop ecstasy-driven celebration of the fall of the Berlin Wall and it might be the only heritage from the 1990s that was not eastern or western. For westerners, the new freedom meant opening up to new territories, and for easterners, meant freedom of the individual from the collective. The dance floor of secret techno clubs in Berlin in this decade became a democratic and egalitarian centrifuge for mixing young East and West Berliners with artificially separated pasts. For their parents, the stitching of the broken city and its communities might be as unnatural as the division itself, but for the Berlin youth – the ambience, drugs, music and dance helped – it was a no-brainer. In that sense, techno and its architecture had a significant influence on the healing of these stitches and on the rewriting of the urban memory of the city after reunification. 'Techno requires the creation or sourcing of specific spaces to suit the sound, as well as the drugs associated with it' (Schofield and Rellensmann 2015: 120). By squatting and adapting industrial buildings of the past for partying, Berlin clubbers on the one hand generated this new subculture and ingredients for an urban memory, and on the other retained those buildings and the urban memory of a past time alive. They formed, in Richard Florida's words (2002), a 'creative class'. Was this escapism from all the memory work occurring because of the disruptures coming from reunification? Perhaps, but young Berliners who escaped using an adaptation of the built environment most likely did not really care that it was.

Berlin bunkers

> Those who build bunkers throw bombs.
> Graffiti on the Anhalter Bahnhof Bunker in *Wings of Desire* (1987)

The Anhalt Train Station was the largest railway station in Germany and continental Europe at the time of its completion in 1880. Air raids during the Second World War rendered the train station useless and most of it was demolished in 1960. However, a part of the *Anhalter Bahnhof* did survive both the war and the main station's demolition: its air-raid bunker.

This was one of many bunkers built by the architects of the Nazi Regime in Berlin and other cities during the war. After the first British air raids on Berlin in 1940, Hitler ordered a robust programme of underground bunkers and shelters, as well as requiring all governmental buildings, both new and old, to have one. His *Führerbunker* under the New Reich Chancellery is perhaps the most well-known Nazi bunker, but there were many others. For civilians, Albert Speer hoped to have 1000 underground air-raid shelters built within three months, but by 1941 only 120 had been constructed. He then focused instead on above-ground facilities, particularly near train stations. By 1943, there were over 400 bunkers in Berlin, providing for about five per cent of the population (Donath 2006: 11).

The *Anhalter Bahnhof* bunker was originally constructed as an air-raid shelter for the use of employees and passengers of the railway station. Connected via a tunnel to the station, this five-floor concrete structure could accommodate 3500 people sleeping and 12,000 standing. In 1945, it was hit by a 500 kg bomb that left a 1.5 m crater on its roof. When the station was demolished, its bunker was spared, presumably because it was too difficult and expensive to destroy.

During the divided-Berlin years, the *Anhalter Bahnhof* bunker, in West Berlin, was used to store emergency food supplies in case another Soviet/East German blockade was attempted like in 1947. It also became one of many curious suspended ruins of Berlin, like the Esplanade Hotel on Potsdamer Platz. In 2007, the bunker was adapted into the 'Berlin Chamber of Horrors' (*Das Berliner Gruselkabinett*), which converted the building into a freak show, complete with skeletons, executioners, spiders, cockroaches and vampires. Despite the authenticity of the war-era *Anhalter Bahnhof* bunker, other authentic 'dark tourism' (Lennon and Foley 2000: 3) sites in Berlin like the Topography of Terror or escape tunnels at *Bernauer Strasse* proved more attractive, and in 2016 the bunker owners decided to adapt the building again and change the content of their entertainment. At this time, two separate exhibitions – 'The Berlin Story' and 'Hitler – How Could it Happen?' – both curated by historian Wieland Giebel, were installed in the Nazi structure.

As might be expected, the air-raid shelters and bunkers built by Speer were very robust, with walls and roofs up to 4 m thick. Many others, besides the *Anhalter Bahnhof* bunker, survived the war and have been adapted to new, non-military uses. A five-storey concrete bunker for the German National Railways (*Reichsbahn*) was constructed in 1942 behind the Friedrichstrasse train station. This structure, designed with a neoclassical base and cornice by Karl Bonatz, could hold up to 3000 people. Immediately after the war, it was adapted as a prisoner facility and then as a textile warehouse. During the GDR years, the bunker served as fruit storage, earning the nickname 'banana bunker'. Following German reunification, the structure became a venue for the previously mentioned underground SNAX parties. In 2003, Karen and Christian Boros purchased the structure. Architects Jens Casper and

FIGURE 9.4: An anonymous bunker in *Spy for Germany* (1956 – set in 1944), the *Führerbunker* in *Downfall* (2004 – set in 1945), the *Zoo Flakturm* in *The Big Lift* (1950) and the *Pallassstrasse* bunker in *Wings of Desire* (1987).

Petra Petersson designed a 450 m² glass penthouse for the new owners, who then converted the bottom floors of the bunker into a museum exhibiting their personal art collection, the *Boros Sammlung*. This bunker is perhaps the most adapted Nazi structure in the city carrying the memory of multiple pasts.

A bunker on *Pallasstrasse* in Schöneberg that also functioned as a telephone exchange was left intact following the Second World War. A social housing project designed by architects Jürgen Sawade, Dieter Frowein, Dietmar Grötzebach and Günter Plessow was constructed around it in 1977. One of the apartment buildings in the complex physically bridges over the bunker. This four-storey structure is open once a year for tours, during which it is explained how forced labour housed in a nearby school was used to construct the bunker. Wim Wenders used this bunker as a film set in *Wings of Desire* (i.e. in his film, the building was a film set). The bunker, in its semi-damaged state, with visible bullet holes on the façade and pieces of floor missing, provided a fitting authentic backdrop to Wenders' fictional Nazi-era film being produced, a further adaptation.

Another bunker, known as The Cone (*Der Kegel*), is an 18 m high conical structure in Friedrichshain that was constructed for maintenance workers of the *Reichsbahn*. This is one of about 200 such structures around Germany that engineers Winkel & Company built. A periscope installed at the top of the structure allowed those inside to spot fires during air raids and also check if it was safe to come out (Morgan 2015: 37). By not having a more vulnerable horizontal surface, the cone shape was deemed safer than flat roofs. This particular bunker could hold up to 400 people. After the Second World War, East Berliners adapted the structure to safely store flammable materials. Since 2015, the bunker has been covered with a multitude of climbing holds and used as a challenging concrete obstacle by recreational climbers.[29]

Also constructed in Berlin in the early 1940s were three massive anti-aircraft towers, known as *Flakturm,* in Humboldthain, Friedrichshain and near Zoo Station.[30] Designed by Friedrich Tamms, these were massive 70 m² concrete towers, 40 m tall, with octagonal anti-aircraft gun positions at the corners. During air raids, the citizens of Berlin were allowed to shelter inside the lower parts of the towers, sometimes holding upwards of 30,000 people each. The anti-aircraft bunker at Friedrichshain not only protected people but also valuable items like artwork: 450 paintings from Berlin's *Gemäldegalerie* and *Nationalgalerie* were found inside after the Second World War.[31]

Following the Second World War, the British destroyed the Zoo Flakturm with great difficulty, but the Friedrichshain and Humboldthain towers largely survived. Both towers were partially demolished in 1948 and filled with rubble and planted with greenery in 1951, giving the impression of natural mountain forms today. The north side of the Humboldthain Flakturm, along with two octagonal gun positions, is still exposed and can be climbed via a steep set of stairs, providing a raised viewing platform over the city. It could be said that these bunkers have been adapted into a form of landscape architecture, providing both picturesque silhouettes and touristic site-seeing.

Philosopher Paul Virilio ([1976] 1994: 46) argues, 'The bunker has become a myth, present and absent at the same time: present as an object of disgust [...] absent insofar as the essence of the new fortress is elsewhere, underfoot, invisible from here on in'. That is, a military bunker left over after a conflict, more so than civilian ruins, 'remain enduring testimonies to historical trauma' (Morgan 2015: 26). Studies have shown that one of the defining elements of the Second World War for German civilians was their experiences in air-raid bunkers and shelters (Steneck 2011: 65). Three generations later, the surviving bunkers are reminders, as wittily stated by the *Anhalter* bunker's graffiti, of a past time when those who built the bunkers were also throwing bombs. The adaptive reuse of these bunkers in Berlin has taken different forms, from historical exhibition to art museum to

leisure destination, yet these adaptations do not all address the bunker and its representation of Nazi Germany equally.

Der Kegel cleverly allows people to climb all over it and attempt to conquer its summit, but despite the strong metaphors of wrestling, tackling and conquering, the memory of the air-raid shelter and the war from which it arose is not addressed. This is also the case with the Humboldthain *Flakturm*, which was literally attempted to be buried (i.e. forgotten), although there is an explanatory plaque on the exposed northern face. The Boros Collection successfully preserves the exterior of the Friedrichstrasse bunker, providing a hint to passers-by that something unusual had been happening inside at one time, but the interior is neither preserved in a bunker state nor is the issue of why a bunker is located in central Berlin is addressed.

The exhibitions in the Anhalt Station bunker, as well as the prismatic building itself, are certainly beneficial for remembering the past. *The Berlin Story*, which takes up two of the building's five floors, explains a full 800 years of Berlin's history, with a particular emphasis on the twentieth century. Room-size installations, original artefacts and mock-ups, plus an audio-guide in ten languages, provide a variety of audio–visual material to convey the history of Berlin. The *Hitler – How Could It Happen?* exhibition is even more comprehensive, covering every conceivable topic, both chronologically and thematically, in 38 different sections.[32] This exhibition does not dance around any difficult topics, and some of the images are quite graphic, which is appropriate given the gruesome story being told. This exhibition culminates in a scale model of Hitler's *Führerbunker*, as well as a full-scale replica of the bunker's study where he took his own life.

Perhaps the most assertive of all the bunker adaptations presented here within the urban landscape is the *Pallasstrasse* example. Neither demolished nor ignored when the housing project was built around it, the bunker literally cannot be missed. Passers-by can neither overlook nor disregard it, especially the way that the newer construction bridges over. In May 2002, a 'place of remembrance' was inaugurated at this bunker, which, together with its annual tour, directly addresses the war and the forced labour used to build it. Offering such tours more often would improve on this already thought-provoking site of remembrance. Cultural theorist John Beck (2011: 98) states:

> The disturbing and relentless oscillation between life and death, ruin and rubble, nature and culture, exposure and concealment, image and object, [and] art and atrocity that vibrates deep in the rebars of the [*Pallasstrasse*] bunker's reinforced concrete is the tremor of modernity's ambivalence [that] no amount of cultural recuperation can, or should contain.

While this statement may seem hopeless, the authors instead interpret it as a call to acknowledge, pay attention to and appreciate Berlin's bunkers as a vital part of remembering the city.

Each adaptation process – intended to be a temporary adaptation (as in most techno clubs) or a permanent adaptation (as in most bunkers) – leaves its mark on a building similar to the rings of an oak tree. They show how the structure grew (or aged and weathered) in time, layer by layer. Because these are interruptions in the lifecycle of the building, they enhance old memories while creating new ones. It can be argued that adapted buildings, more than other structures, bring urban memory close to their occupants and users because they carry many traces and scars that reveal the burden and joy of the past into the future:

> The idea of alteration is to offer an alternative to preservation or demolition, a more general strategy to keep buildings extant beyond their time, that is to be inhabited, occupied. [...] It becomes like an act of transition or translation, from the past into the present, with logically also a consideration for the future of the host building.
>
> (Scott 2008: 11)

Adaptation prepares existing buildings for the near future by transforming them as to the needs of the city and urban living. This strategy changes the function of a structure so that it can be reused. Then, it physically alters whatever needs to be adapted for the new purpose and its inhabitants into the building. In this way, although the meaning of the building is altered, its urban memory is kept intact – with additions and revisions. Compared to demolition, the urban strategy of adaptation is a sustainable solution in terms of urban memory.

NOTES

1. The CIAM-driven 1963 and 1972 Urban Renewal Programmes (*Stadterneuerungsprogramm*), for instance, implemented massive demolition projects followed by the construction of high-rise housing blocks in Berlin. Modernism made its biggest mistakes on the city-scale.
2. *Instand(be)sezten* is a word play of *instandsetzen* (restore) and *besetzen* (occupy).
3. In the 1980s, the *IBA-Altbau* (International Building Exhibition-Old Building) defended the preservation of old buildings while the *IBA-Neubau* advocated for new infill projects on vacant sites to 'complete' an existing block as opposed to a 'clear and rebuild' approach. As usual, architects had the role of mediator between various stakeholders, however this time they had less design-related more social responsibilities to preserve the urban fabric.

4. In general, the Turkish community and other immigrant populations were not a part of this process.
5. The Stasi was well-known for its intense surveillance tactics and watched the punks as if they were a serious threat to the East German state.
6. Because living in West Berlin allowed men to avoid conscription, the city had a young and left-leaning demographic compared to the rest of the country.
7. The parade did not last long after its rights being 'sold' to McFit Fitness Studios in 2001. The company shut down the event in 2010 after a tragic accident causing 21 deaths.
8. First to Milchhof in *Anklamer Strasse* and then to a building in *Revaler Strasse* in Friedrichshain.
9. Salon Zur Wilden Renate occupied an old apartment building, for instance, and turned this into an advantage as they adapted it into a maze of interconnected spaces on three levels.
10. In 2012, Britta Mischer and Nana Yuriko produced a 95-minute documentary *Bar 25* about the club. Dimitri Hegemann, a founder of Tresor who has been around 'back in the day' when techno was new in Berlin, dreams of a techno museum, or the 'Living Archive of Elektronika' as he calls it in the Kraftwerk, a former GDR power plant (https://theculturetrip.com/europe/germany/articles/this-just-in-location-of-berlins-new-techno-museum-revealed, last accessed 5 June 2020). Tresor, the longest running techno club, moved into one of its buildings in 2007, which appeared in Jaume Collet-Serra's *Unknown* (2011), and managed to keep its original vibe (1991–2005) in the large vault in the basement of a warehouse on *Leipziger Strasse* 126–28 in its new space: 'The new incarnation of an old techno institution, Tresor Club is set in an abandoned power plant spanning 22,000 m² on *Köpenicker Strasse* in Berlin's Mitte neighbourhood – a labyrinth of concrete passages merging into basement vaults and industrial halls. Inside, there are three separate but connected floors: Globus and +4Bar for house and experimental electronic music, and, of course, the famed vault [*Tresor*] which, reached through a 30 m long tunnel, carries the Tresor sound uncompromisingly' (Walkthrough to the First Location of Tresor Berlin, https://www.onlytechno.net/walkthrough-to-the-first-location-of-tresor-berlin, last accessed 5 June 2020).
11. Reeder is a dominant character in a more recent tribute to the rich culture and music scene of 1980s West Berlin: *B-Movie: Lust and Sound in West-Berlin 1979–89* (Jörg A. Hoppe, Heiko Lange and Klaus Maeck, 2015).
12. Urban legend is, throw a stone in Berlin and it hits a DJ.
13. There are many other films to mention including Maren Sextro and Holger Wick's *We Call It Techno!* (2008) and Romi Agel and Holger Wick's *We Are Modeselektor* (2013) as well as fiction like Hannes Stohr's *Berlin Calling* (2008).
14. Radical Living, a 'hip' Berlin website for 'strangers', splits the city into two on its home page: 'Berlin by Day' and 'Berlin by Night' (https://www.radical-living.net, last accessed 5 June 2020).

15. As argued in 'Underground Heritage: Berlin Techno and the Changing City',

> throughout the twentieth century Berlin has maintained a significant club scene, with venues in abundance, from 'Club Dada' (driven underground to avoid censorship), to cabaret, jazz and swing, punk (including in East Berlin), and most recently techno, a genre that has now prevailed for 30 years and shows no sign of fading.
> (Schofield and Rellensmann 2015: 115)

One that survived Berlin's harsh turning points for decades is the Claerchen's Ballroom in the east.

16. The Nazis did not only strip down their architecture but many other layers of German culture.

17. Techno was loud, repetitive, machine-made, and driven by fast tempos of 110- to 140-plus beats per minute. Its booming bass lines vibrated through listeners' bodies. For fans, listening and dancing to techno could evoke a sensuous, potentially semispiritual trance state, brought on by sensory overload (Perry 2019: 565).

18. As two independent layers of subculture in Berlin, rap (by mainly Germany-born youth of immigrant families) and techno seem to coexist separately. A venue where one would go for a rap battle, as seen in *Dogs of Berlin*, would have nothing to do with the people queuing for clubbing, as seen in *Unknown*.

19. Friedrichshain and Prenzlauer Berg can be seen in various scenes in the *Sense8* TV series (Michael Straczynski, Lana and Lilly Wachowski, 2015–18). The nightlife of Berlin is extremely vibrant and varied, especially when it comes to techno music. (Filming locations are available at https://moviemaps.org/movies/wm, last accessed 6 June 2020.) In Mitte, techno clubs used to occupy mainly the western half of *Leipziger Strasse* that was a no-man's land in 1990.

20. The successor of Ostgut, Berghain is named after two districts, which at *Am Wriezener Bahnhof 1* the club stands between Kreuzberg's mountain (*berg*) in the west and Friedrichshain's grove (*hain*) in the east. The internet is filled with mysterious stories around the iconic club, for instance: https://www.youtube.com/watch?v=6nGYKSqzW54, https://dashinsky.com/berghain-statistics, and https://theculturetrip.com/europe/germany/articles/10-types-of-people-youre-bound-to-bump-into-in-berghain (last accessed 19 August 2021).

21. SNAX moved away from expressing oneself through fetish (1990s) towards nudity (2010s) of not just any homosexual man but strong attractive men in small amounts of leather and rubber; 'the fetish-to-flesh ratio tipped heavily in favour of the latter (harnessed hunks), much to the chagrin of purists who now choose to abstain, hitting the Schöneberg bars' (https://berlin.gaycities.com/bars/303881-snax-club-at-berghain, last accessed 5 June 2020).

22. In addition to Berghain, the club owners have a record label called 'Ostgut Ton' (2005) and an online shop: https://www.berghain.berlin/en/shop (last accessed 5 June 2020).

23. As 'an icon of the industrial party revolution' Berghain gained cultural recognition and was awarded cultural venue status in 2016 (https://theculturetrip.com/europe/germany/articles/this-is-the-worlds-most-exclusive-art-exhibition-in-berlins-most-select-club, last accessed 6 June 2020).
24. The power plant belonged to Vallenfall and was abandoned in the late 1980s.
25. Thomas Karsten and Alexandra Erhard founded Karhard in Berlin in 2003 (https://www.karhard.de/architektur/barclub/berghain, last accessed 5 June 2020).
26. Art on the wall includes a large Piotr Nathan installation and two large Wolfgang Tillmans photographs.
27. Mirrors are not permitted to minimize bad trips.
28. Unlike most cities, Berlin clubs do not have a closing time; the morning event/party is called 'after hour'.
29. See https://www.derkegel.de (last accessed 19 August 2021).
30. *Flak* is an abbreviation of the German for anti-aircraft gun, *FLugzeug Abwehr Kanone*. In Hamburg, two more Flak towers were constructed, as well as three in Vienna.
31. Eight Rubens, four van Dycks, three Caravaggios and an altar piece from Fra Bartolomeo and Andrea del Sarto (Richie 1998: 611).
32. Introduction, The German Empire, Hitler's Youth (three sections), First World War, Revolution, Hitler becomes Nazi, Hitler's Rise (two sections), Seizure of Power (two sections), Alignment of Society, Nazification, Pogrom Night, Preparation for War, National Socialist Regime (three sections), Foreign Policy, Second World War (six sections), Height of Power (two sections), Ghettoes and Pogroms, Extermination Camps, Front and Home Front (two sections), Retreat and Downfall (two sections), Hitler in Führer Headquarters, Battle of Berlin (two sections) and Führerbunker Documentation.

Off Course (2015)

10

Altered States:
Appropriation

I came to Berlin for a rebirth.
Katarina in *Berlin, I Love You* (2019)

In the art world, appropriation is the use of imagery for a purpose other than it was first produced, like when Andy Warhol appropriated commercial imagery to conflate the line between 'high art' and 'low art'.[1] Architecture historians Amanda Reeser Lawrence and Ana Miljački (2018: 1) define architectural appropriation as 'to borrow, to reclaim, to rethink. Although the source material may be different for architects than for artists, the conceptual operation is the same'. Appropriation, different from 'adaptive reuse', is a process whereby the meaning of a building or space changes without physically altering its architecture. What used to represent one ideology now represents another. As a result, the associative memory of the place adjusts to new needs over time. Whereas adaptation is the physical reuse of a structure, the urban strategy of appropriation is the psychological reuse of a structure – the changing of its meaning.[2]

In the 1960s, the Glienicke Bridge (1907) connecting Berlin with Potsdam became appropriated as a symbol of the Cold War. Following the construction of the Wall, the bridge straddled the boundary between West Berlin and East Germany over the Havel River. It was not an official crossing point like Checkpoints Alpha, Bravo or Charlie. Instead, the bridge came to be used, or appropriated rather, for prisoner exchanges between the Allies and the Soviet Union. The most notable exchange took place in 1962 when the United States traded Soviet spy Rudolf Abel for American pilot Gary Powers, whose spy plane was shot down over the Soviet Union in 1960, dramatized in Steven Spielberg's *Bridge of Spies* (2015). Under normal circumstances, bridges connect two sides of the natural or built environment. The Glienicke Bridge, however, with a 'soft border' in the middle, was appropriated to act as such a connector of the two sides of the Cold War. Hamilton's *Funeral in Berlin* (1966) shows the bridge as a neutral location for a

coffin to be transported to West Berlin. Because access could not be granted to use the actual Glienicke Bridge, Hamilton filmed the scene at the Swinmünder Bridge.[3] Post-reunification, the 'Bridge of Spies' was de-appropriated to its original use (and meaning) as a link between two German cities.

Because the historic centre of Berlin was in the east, various areas of West Berlin were appropriated from being minor to major parts of the city after the construction of the Wall. Since the 1880s, the *Kurfürstendamm*, affectionately known as Ku'damm, had always been a shopping street and a new centre in the western part of Berlin.[4] During the Weimar years, it was the location of fashionable cafes, nightclubs and shops. After the city's division, this boulevard became the leading commercial street of West Berlin and one of its central arteries. Originally constructed in the eighteenth century as a bridle path to the suburb of Grunewald and enlarged into a boulevard with electric trolleys in the nineteenth century, the Ku'damm was appropriated in the 1960s to become the main showcase of capitalist principles in the Cold War against the socialist development taking place in the other Berlin. Luxury boutique shops and car showrooms located themselves on the *Kurfürstendamm* to highlight the purchasing power of the westerners. In *Wings of Desire* (1987), Wenders' angels chat about window shoppers while sitting in a BMW convertible in a showroom at Kurfürstendamm 31. The Europa Centre, a shopping mall and skyscraper whose construction was heavily subsidized by the West German government in the 1960s, terminates the eastern end of the *Kurfürstendamm*. Its location solidified the appropriation of the area as the centre of West Berlin. The junkie children of Zoo Station[5] in Uli Edel's tragic *Christiane F.* (1981) have fun running through the Europa's corridors and yelling down to policemen from atop the modern Mercedes Benz tower.[6]

FIGURE 10.1: The Swinmünder Bridge as Glienicke Bridge in *Funeral in Berlin* (1966). (All illustrations are film stills captured by the authors.)

Another Berlin example of architectural appropriation is Tempelhof Airport (1935–39) designed by Ernst Sagebiel as a showcase for Nazi airpower. After the Second World War, the United States military used it as a base for operations. This came in particularly handy during the 1948–49 Berlin Airlift when Britain, France and the United States circumvented a Soviet blockade of West Berlin by flying in up to 4500 tonnes of supplies a day into Tempelhof. Because of that effort, the airport subsequently became a symbol of freedom and defiance towards the Soviets. In 1962, to help de-Nazify Tempelhof's entrance hall, a suspended ceiling was inserted which lowered the hall's height to a less grandiose level. Still, the monumental proportions and enormous windswept plazas give away its Third Reich roots and have been used as background Nazi architecture in many period films, such as Brian Singer's *Valkyrie* (2008). Though not as Berlin, the airport was also filmed in Francis Lawrence's *The Hunger Games: Mockingjay – Part 1* (2014) to represent the architecture of a dictatorship.[7]

Following the reunification of Germany, other Nazi and East German buildings were appropriated to serve the new republic. The Nazi Aviation Ministry (Ernst Sagebiel, 1935–36), which itself had been appropriated as the 'House of Ministries' by the German Democratic Republic (GDR) in 1949, was re-appropriated in 1990 to serve as headquarters for the *Treuhand* and has served as the German Federal Ministry of Finance since 1999.[8] The Wilhelmstrasse wing of the Nazi Ministry of Popular Enlightenment and Propaganda (Karl Reichle, 1934–38) has a similar history: becoming the East German 'National Council of the National Front' in 1949 and then the German Federal Ministry for Work and Social Affairs in 1999. In partnership with financial considerations, it would seem that appropriation, which is directly linked to the memory of the city, has been a common urban strategy in twentieth-century Berlin, possibly saving the likes of the Nazi Tempelhof Airport and the GDR TV Tower.

Berlin TV Tower

Strange sensation, isn't it?
> Britta, looking out of the TV Tower, in *Learning to Lie* (2003)

Alexanderplatz in Berlin's Mitte district has been changing according to political motives and historical circumstances since the beginning of the twentieth century. Represented as a lively growing square with multiple layers of transportation in the Skladanowsky Brothers' *Alexanderplatz* as early as 1896 and Phil Jutzi's *Berlin Alexanderplatz: The Story of Franz Biberkopf* (1931),[9] following partly realized urban strategies,[10] Alexanderplatz became the symbol of the technological and

political power of East Germany during the division of the city as displayed in *The Legend of Paul and Paula* (1973). Since then it has been adapted into a well-liked, highly touristic part of reunified Berlin, still more working class than similar places in the west, with a dark side as depicted in Burhan Qurbani's *noir* fiction *Berlin Alexanderplatz* (2020).[11]

Unlike Potsdamer Platz and neighbouring Leipziger Platz, Alexanderplatz did not turn into a *tabula rasa*[12] after the Second World War, as seen in Wolfgang Becker's *Good Bye Lenin!* (2003). Alexanderplatz Train Station (1882), a major crossroads for Berlin's S-Bahn, U-Bahn and regional trains, as well as trams, buses, bicycles and pedestrians, was well-maintained following the war. With the addition of the 'World Time Clock' (*Weltzeituhr*, Erich John, 1969),[13] 'Fountain of International Friendship' (*Brunnen der Völkerfreundschaft*, Walter Womacka, 1968–70), 37-storey Hotel Stadt Berlin (1967–70, today Park Inn by Radisson), as well as other construction projects in the following two decades, the square became an urban hub for East Germany, as seen in Wieland Speck's *Westler: East of the Wall* (1985), where the day-tripping westerners of the title hang out after seeing the sights.

Within this busy picture of Alexanderplatz, an iconic broadcasting station was constructed just beside the train station. The East German government built the Berlin TV Tower (*Berliner Fernsehturm*, 1965–69) 'to demonstrate the strength and efficiency of the socialist system' and as a symbol of technological progress.[14] The steel sphere towards the top of the tower is a reminder of Soviets' Sputnik 1 (1957), the first-ever artificial satellite successfully launched. This 1960s fascination with space travel is also evident in other aspects of the design such as the rocket-like tower, the wing-like folded cantilevers of the base and several decorative touches inside.

The planning of the Berlin TV Tower started as early as the 1950s, after the popularization on both sides of the border following the opening of the 216 m Stuttgart TV Tower (1956), the world's first concrete communications tower. This structure contained an open-air platform with remarkable views over West Germany. The central site of the Berlin TV Tower on *Panoramastrasse* was chosen in the 1960s, and its sandy soil was good for the deep foundation of the structure. Like the Stuttgart example, the first choice for the site of the Berlin tower in the woods of *Müggelberge* in the southeast of Berlin was abandoned because it was within the flight path of GDR's Schönefeld Airport.[15] More importantly, the tall structure would be easily visible in the city, on both sides of the Wall. In fact, it was intended 'not to look too small from a distance and not too big from close up'.[16] Its erection was quite an embarrassment for West Germany, especially when the Allied countries tried to prevent its construction by contacting the Soviets. The tower was within the flight path of planes travelling to American-controlled Tempelhof Airport. Equally embarrassing, the

FIGURE 10.2: Pre-Second World War Alexanderplatz in *Berlin Alexanderplatz* (1931).

Federal Republic of Germany had attempted and failed to build a TV Tower in West Berlin in the 1960s.

The brightest and the best GDR architects and planners, such as Edmund Collein, Hermann Henselmann, Hanns Hopp, Josef Kaiser, Gerhard Kosel and Hans Schmidt, were responsible for the redevelopment of the area. City planning in the 1960s and 1970s often resulted in the demolition of countless historical buildings in the western world, some with great merit, some with less. Similarly, several mediaeval buildings in the area between Alexanderplatz and the river Spree were sacrificed to open up the land needed for such a large project as well as the landscaping at its base. During the construction of the tower in the second half of the 1960s, the 'old' buildings in the area gradually disappeared, while the Gothic St. Mary's Church (*Marienkirche*), just beside the tower, was spared from demolition.[17] However, it is not the *Fernsehturm* but the church that is alien to its contemporary local context.

On its east side, the TV Tower faced Alexanderplatz Train Station. Landscape architect Hubert Matthes and architect Dieter Bankert designed this side of the site (1969–73). On its west side, an axial and symmetrical landscape design by Anton Stamatov and Helmut Viegas (1984–86) links the structure to the river.[18] The picture would be complete when the Palace of the Republic was built on the other side of the river in 1976 to effectively frame and praise the TV Tower. For the district around the tower, mixed-use buildings were constructed with the efforts of an architect and theorist Hans Schmidt of CIAM, a friend of Italian architect Aldo Rossi, who shared his ideas about socialist urbanism. Not to follow the mistakes of the past, a mix of residential, commercial, leisure and workplaces full of light and air, as well as parks, were planned for the area.[19]

Although chief GDR architect Hermann Henselmann, with the help of Jorg Streitparth, drafted the initial design of a 'Signal Tower' to broadcast GDR TV programmes as part of his 1959 *Forum of the Nation* planning proposal, the architectural design of the Berlin TV Tower was a team effort that matched the socialist ideology of the superiority of the collective to the individual.[20] Fritz Dieter and Günter Franke from the state Industrial Project Planning Office revised the preliminary design and drafted the construction drawings and specifications with structural engineer Werner Ahrend. The 368 m tall tower, ahead of its time in terms of construction, is still the tallest structure in Germany and the fourth tallest freestanding structure in Europe.[21]

An innovative construction method of climbing formwork was used to build the 30.8 tonnes concrete tower that shows the influence of both the Bauhaus and Soviet Constructivism, rather than socialist realism.[22] The inner steel scaffold was put up in five stages and the concrete shaft around it followed each stage. These five parts with portholes are detectable from the outside. The shaft's diameter diminishes from 16 m to 9 m as the tower ascends. The steel *sputnik* ball is a single-shell structure 32 m in diameter and was a challenge to construct for the engineers because it was located 200 m above the ground. After being assembled on the ground, a steel frame was lifted piece by piece using cranes. Each piece of this frame was attached to the top section of the concrete shaft until they completed a circle. Following that, the builders suspended the sphere from the tower shaft with 140 steel segments on supporting tie rods.

The best architects, engineers and builders in the GDR constructed the tower using the best materials available in East Germany as well as imported materials and systems such as West German steel and Belgian glass for the sphere. The air-conditioning plant and lifts were Swedish mechanical systems operated by an American IBM computer, which was high-technology at the time. The tower performs well under strong winds; its oscillation at the top is 60 cm, and only 15 cm at the restaurant level with a frequency of 7–10 seconds. The opening of

the building on 7 October 1969 marked the twentieth anniversary of the GDR, merely five years after the selection of the project site and the beginning of the design process. At the time, nobody knew this would mark the middle of the lifetime of the GDR.

Horst Bauer's initial design (1964) for the base of the tower, a two-storey circular volume, was not the best connection of the futuristic monolith to the ground and did not go forward. The dynamic horizontal base that the tower sits on today was designed later (1967) by Walter Herzog in collaboration with Manfred Prasser, Heinz Aust and structural engineer Rolf Heider, and was built after the completion of the tower to house an open exhibition gallery as well as restaurants and cafes. Engineer Ulrich Müther, a concrete wizard, provided the construction company for this base. The expressionist folded concrete roofs of the symmetrical pavilion may have been inspired by Pier Luigi Nervi's contemporaneous decorative roofs made of structural concrete. The slender abstract tower contrasted this expressive mass with triangular cantilevering canopies floating in the air, hexagons, parallelograms and diagonals, floating platforms for people-watching and large open stairs on the ground level that encourage public use. In its own way, Herzog's design respected its mediaeval neighbour and changed the immediate context of the enclosed tower indefinitely.

East Berliners were quite proud of their technologically advanced TV Tower. The government made sure that their socialist ideology was materialized through this symbol, linking their glorification of science with 'media for the masses'. The enclosed observation deck with Bar 203 and the revolving Telecafe (today's Sphere Restaurant) at 207 m, which had a feeling of floating in the air, were favoured destinations.[23] To accompany the 360° uninterrupted panoramic view of the divided city (and beyond), a ring of information with annotated aerial photographs and text about what the visitor could see was introduced on the platform in front of the inclined panorama windows with no starting point or an end, just like the city they frame. This printed information has been turned into a *Fernsehturm* App for visitors to digitally learn about the development of the city.[24]

During the division years, the Berlin TV Tower was a feature of both East German and West German films, mostly because it is difficult to film a scene on the streets of Berlin without having the tower appear somewhere in the background.[25] Wolf and Kohlhaase's *Solo Sunny* (1980) lets the audience know that the action is moving out of East Berlin by depicting Sunny's van heading out of town on a motorway, leaving the tower behind. The day-tripping westerners of *Westler: East of the Wall*, who have already been seen in this book visiting the Palace of the Republic, hang out with their eastern friend and eat ice cream at the base of the tower.

Mostly technical (rather than architectural) renovations of the tower took place twice in 1995–96 (when its antenna was extended) and in 2011–12.

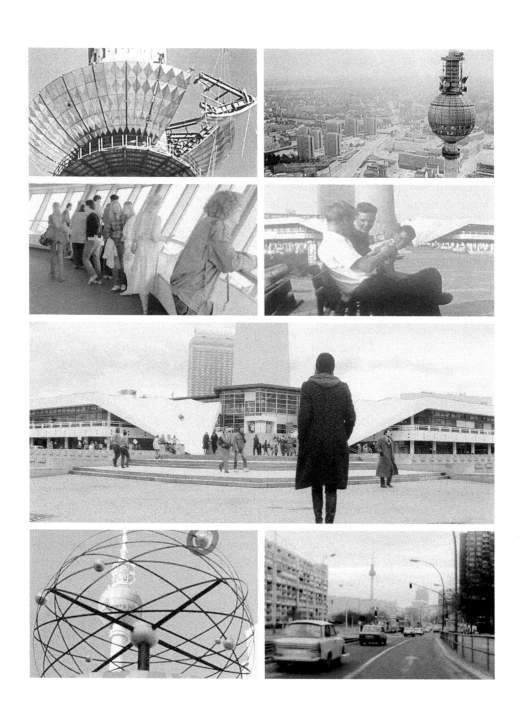

FIGURE 10.3: The TV Tower as the symbol of the GDR in *Heroes Like Us* (1999 – set in the 1980s), *Führer Ex* (2002 – set in the 1980s), *Atomic Blonde* (2017 – set in 1989), *Learning to Lie* (2003 – set in 1982), *Westler: East of the Wall* (1985), *Berlin Blues* (2003 – set in 1989) and *The Architects* (1990).

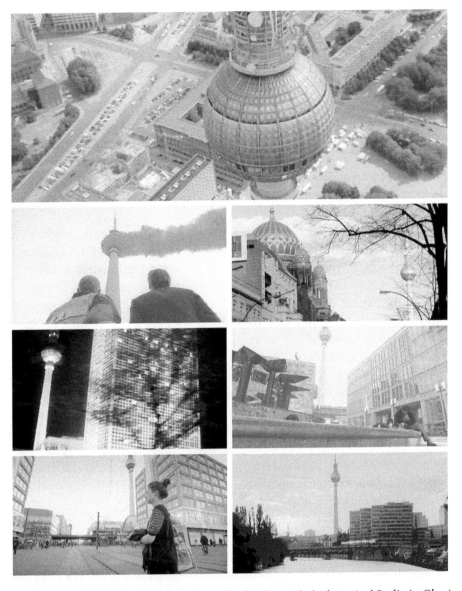

FIGURE 10.4: The TV Tower is appropriated to be the symbol of reunited Berlin in *Chasing Liberty* (2004), *Raging Inferno* (2007), *Cherry Blossoms* (2008), *Coffee in Berlin* (2012), *Berlin Junction* (2013), *Fucking Berlin* (2016) and *Citizenfour* (2014).

Post-reunification, the GDR structure has been appropriated to represent the unification of the east and west in contemporary Germany. An exhibition entitled *50 Years of the Berlin TV Tower: Between Everyday Life and World Politics* was organized by the *Initiative Offene Mitte Berlin* in collaboration with the State Monument Office

Berlin to celebrate the fiftieth anniversary of the building in October 2019. Every day of the week, thousands of tourists pay €24.50 to take one of the fast glass-roofed lifts to the circular viewing platform within the sphere[26] at the height of 203 m. (The alternative to the 40-second ride is taking the steel staircase with 986 steps.) More than 1.5 million people annually visit the now *Deutsche-Telekom*-owned structure.

This iconic tower is framed in many post-reunification films, such as Uli M. Schuppel's *Planet Alex* (2001) as a landmark for Alexanderplatz and David Dietl's *Berlin Bouncer* (2019) as a landmark for the entire city. In *Meet Me in Montenegro* (2014), directors Alex Holdridge and Linnea Saasen are almost obsessed with the TV Tower, constantly framing this 'third protagonist' as establishing shots or lurking in the background. Indeed, the TV Tower almost seems to be a default establishing shot when filming in contemporary Berlin.

This tower is erased from the cityscape of Berlin, along with many other iconic post-Second World War buildings in the TV series *Babylon Berlin* (Handloegten, Tykwer and von Borries, 2017–present), since the story is based in Berlin during the great depression of the 1930s. Framing the striking view of the city from the tower, Veit Helmer's *The Window Cleaner* (1993) gives its audience the opportunity for a closer look, this time from inside out. An unusual interpretation of the structure can be found in a 44-minute documentary entitled *Fernsehturm* by British film artist Tacita Dean (2001).[27]

Besides German productions, Hollywood films such as *The Atomic Blonde* (David Leitch, 2017) and *The Bourne Supremacy* (Paul Greengrass, 2004) portray the TV Tower as the symbol of contemporary Berlin for international audiences to easily identify the city, as with the Space Needle in Seattle and the Eiffel Tower in Paris. In Florian Gottschick's *Fucking Berlin* (2016), the TV Tower presides over a clean and vibrant Alexanderplatz as the main character travels between her home and brothel. Here, the square hardly has a 'GDR look', it rather belongs to the twenty-first century and modern Berlin.

If one were to choose an engineering masterpiece from each major political regime in Berlin in the twentieth century, they might select Peter Behrens' 1909 AEG Turbine Factory for the German Empire (1871–1918), Walter Gropius' 1926 Bauhaus Building for the Weimar Republic (1918–33), Ernst Sagebiel's 1937 movable cantilever roof of Tempelhof Airport for Nazi Germany (1933–45) and finally the 1969 Berlin TV Tower for the divided Germanies (1945–90). (Norman Foster's 1999 glass Reichstag dome may follow for reunified Germany.) Accordingly, the meaning of the *Berliner Fernsehturm* was beyond its structural mastery. The tower was a symbol of socialist Germany and a reminder of its productive times that were full of optimism and potential for the future.[28]

It should be recalled that this was the post-war period. East German socialism and West German capitalism came right after Hitler's national socialism that few

Germans in either the East or West preferred to remember. They needed to turn their faces to the future, build the now-divided nation from the ground up and move forward. They needed new or altered icons, symbols and landmarks to hold onto in this process, especially in the ruined Berlin. In the west, the Kaiser Wilhelm Memorial Church was chosen and in the east, the Berlin TV Tower. Historian Yuval Noah Harari writes, 'In the twentieth century, the dystopian Nazi vision did not fall apart spontaneously. It was defeated by the equally grand visions of socialism and liberalism' ([2015] 2017: 439). The *Fernsehturm*, with its new design principles and structural and technical superiority, as well as stylistic and functional dissimilarity to Nazi architecture, provided East Berliners with that new anchor.

Despite the fact that neither their euphoria of hope nor the power of the GDR lasted long, Berlin's TV Tower continues to hold a similar meaning post-reunification. Although technologically modernized in time, its design and use have not significantly changed over the decades and yet its memory and meaning were almost instantly appropriated in the 1990s. As its surroundings rapidly change, the *Fernsehturm*, a member of the World Federation of Great Towers, keeps existing like a grand old plane tree. Once a physically dense area that was carefully emptied out and re-planned under GDR rule, the ever-busy Alexanderplatz and the larger context of the TV Tower get denser as time goes by in the twenty-first century.

Neue Wache

Commissioner Kras: Come on, a building is not born!
Mr Mistelweg: Yes, they are Commissioner. The first stone laid to build it is the time of its birth.

The 1,000 Eyes of Dr. Mabuse (1960)

Can a single room in a city evoke so many burdened meanings and contribute to the urban memory of a city in various ways depending on its political agenda? Commenting on the evolution of Berlin's *Neue Wache* (New Guardhouse) from a national war memorial, to a sacred space for Nazi heroes, to an anti-fascist site of memory and, currently, to a post-reunification memorial to the dead of 'the two World Wars and the two dictatorships', Till (1999: 275) notes that 'public sites of memory like the Neue Wache gain their meanings through the interplay of historical narratives, official cultural politics, local interests, media representations, expected interest group representations and cultural productions'.

The *Neue Wache* is a small Neoclassical stone structure designed in 1816 by Karl Friedrich Schinkel, the newly appointed director of the Prussian Royal

Building Commission.[29] King Friedrich Wilhelm III of Prussia commissioned the building primarily to house guards for his Royal Palace across the street.[30] The building was also a celebration of the Prussian victory over the French in 1814, attempting to erase the memory of their defeat eight years earlier.[31]

During the 1812–14 Wars of Liberation to defeat Napoleon, the Prussian military had evolved from its eighteenth-century manifestation as a tool of the aristocracy to a more modern expression. Because of this, the commission of the Neue Wache, while simultaneously celebrating Prussian military might, has been interpreted as an attempt by the king to publicize this new image (Miller 1997: 232). Schinkel reflected this change by combining classical Roman and Greek architectural forms into one building. The resulting hybrid is a modest 21 m² volume with small towers at the corners, representing a Roman *castrum*, and Greek temple porticoes added to the front and back.[32] The *castrum* signified the Prussian military and the porticoes were meant to represent the increasing prominence of the civic sphere in Prussian life (Forner 2002: 518). Further multiplying the military representation of the Neue Wache, a goddess of victory leading German warriors into battle is depicted on the front portico[33] and statues of General Gerhard von Scharhorst and Field Marshal Friedrich von Bülow were located next to the building in 1822.

Adding to this military/civic symbolism is the location of the Neue Wache on Unter den Linden, the grand thoroughfare through central Berlin that was first developed in 1647 by Friedrich William the Great Elector of Prussia.[34] The Brandenburg Gate was constructed in 1791 at the western end of Unter den Linden. At the eastern end of the street, adjacent to the Neue Wache, was the Prussian *Zeughaus* (Armory) completed in 1730. Immediately to the west of the Neue Wache was the University of Berlin (later, Humboldt University), opened in 1809. Across the street from the university was the already established Friedrich Forum, with an ensemble of the State Opera (1742), St. Hedwig's Cathedral (1773) and Royal Library (1780). All of this is to say that the monumental and civic structures on Unter den Linden were just as important for the location of the Neue Wache as the fact that it was across from the Royal Palace.[35]

By the time the German Empire was declared in 1871, Unter den Linden had become a *Via Triumphalis* (Victory Boulevard) and was the main location of military parades, especially victory celebrations. The Neue Wache played an integral role in this pomp as a state ceremonial site from which decrees were proclaimed, military orders were announced and celebrations were held (Pickford 2005: 140). It is this connection with the German armed forces which made the Neue Wache an unofficial 'monument to the "Wars of Liberation" from French occupation [...] that were subsequently glorified as a struggle of national unity' (Forner 2002: 516).

Accordingly, the Neue Wache became a signifier of national memorialization, not a place where guards were housed. Captured on film by the first filmmakers early in the twentieth century, the building, and Unter den Linden, subsequently adapted to upcoming changes and challenges in years to come.

After the dissolution of the German Empire following the First World War, it was the Weimar Republic's turn to commemorate the war dead in a physical form. Proposals to build a national war memorial appeared as early as 1924 but did not materialize until 1931. This was because not everyone could agree on where it should be: veterans groups preferred a calm countryside setting rather than a chaotic metropolitan one. They also preferred a natural construction like a 'heroes' grove of trees' rather than a classically designed architectonic monument. Eventually, an exhibition inside the *Neue Wache* by the German War Graves Commission (*Volksbund deutsche Kriegsgräberfürsorge*) in 1929 showing war cemeteries outside of Germany propelled the suggestion by Prussian Minister-President Otto Braun that the Neue Wache itself be renovated as a war memorial. The Weimar Parliament, without consulting the public, invited six architects to 'redesign the interior in organic relations with the exterior', 'produce a memorial that would convey a 'simple' and solemn 'impression' and 'use simple architectural means' (Forner 2002: 526).[36]

The two main contenders for the winning proposal were Mies van der Rohe and Heinrich Tessenow. Both architects filled-in the open courtyard of the Neue Wache, but their schemes were diametrically opposed. Tessenow's light-filled interior and altar-like marble block were quasi-religious, emphasizing the soldiers' sacrifice over all else, whereas Mies's dark interior and low block of polished black granite engraved with a German eagle and the words *DEN TOTEN* ('TO THE DEAD') created a secular atmosphere.

The jury awarded the project to Tessenow, who also proposed to install a giant gold and silver oak wreath (a symbol of death and mourning) on top of a 2 m high marble block, as well as two slender candelabra and natural wreaths hung on the side walls, and inscribe the war years in the rim of the Neue Wache's skylight. The exterior of the Neue Wache was generally left untouched by Schinkel's design, except for the addition of an Iron Cross above the central door. With sunlight pouring through a circular skylight, Tessenow's design, completed in 1931, made it look like either God or the war dead were looking down from above. Commenting on the project, Siegfried Kracauer wrote the following in the *Frankfurter Zeitung*:

A memorial site for the fallen in World War: if we want to be honest, it should not be much more than an empty room. And precisely this is the propriety of Tessenow's design: that he only wants to give what we possess that is not much, indeed

it is very little, but in consideration of our present economic and intellectual life it is precisely enough.

<div align="right">(Pickford 2005: 142)</div>

At the inauguration of the memorial, President Otto Braun spoke about the 'soldiers who had sacrificed their blood in a way never before imagined in world history, and in a way, as we hope and as we will try to ensure, that the course of history will never call for again' (Marcuse 1997: 1), which reinforced the memorial's new name: 'Memorial for Those Killed in the Great War' (*Gedächtnisstätte für die Gefallenen des Weltkrieges*). In this way, the Weimar Republic appropriated Schinkel's building into a site of memory.

When the Nazi Party came into power only two years later, they kept the Neue Wache as a war memorial but changed the message to suit their purposes. In the place of sacrifice, they stressed honour, as seen in the changing of its name from memorial (*Gedächtnisstätte*) to cenotaph (*Ehrenmal*, literally 'honour memorial'). Two gigantic oak wreaths were hung on the exterior of the Neue Wache and a large oak cross was placed inside behind Tessenow's marble block, making the scene more overtly religious than before, almost 'legitimizing Hitler's fiction that the Nazi state was chosen by God as the successor of the Holy Roman Empire' (Till 1999: 258).

The guards in front of the memorial were changed from regular police officers to high-stepping military sentries, 'transforming the gesture of remembering the dead into a spectacle of the [Nazi] state's enduring power as the protector of memory' (Grenzer 2002: 100). The changing of the guard on Sundays, Tuesdays and Fridays was a popular event, as was the wreath-laying by Hitler on Heroes Remembrance Day (Pickford 2005: 142–43). While still acknowledging the fallen soldiers of the First World War, the Nazis, therefore, changed the depiction of them from victims of mindless slaughter into honourable martyrs who died for a good national cause. With each appropriation, the memorial kept swinging between the military and the civic, the religious and the secular.

During the Second World War, the Neue Wache's southeastern corner collapsed, the roof caved in and Tessenow's black marble block had been semi-melted by a large fire. Tessenow recommended that the memorial, in the Soviet sector, be kept that way as a reminder of the dangers of over-militarization. The building was kept as a ruin and transformed into a museum of Soviet–German friendship, recalling the joint Russian–Prussian forces who defeated Napoleon that Schinkel's original building commemorated. In 1951, the military statues were removed, and inscriptions honouring Stalin in German and Russian were added to their pedestals.

Like all Prussian architectural remnants, the GDR was not interested in the Neue Wache and considered demolishing it, just as they had done to the *Berliner*

Stadtschloss and other Berlin imperial structures. Despite this, in the early 1950s, the building was renovated back to its original state. In 1957, architect Heinz Mehlan removed the Nazi-installed cross and the dates 1914–18 from the skylight to make the memorial match a more general commemorative purpose, as evidenced by its 1960 renaming into the 'Memorial to the Victims of Fascism and Militarism' (*Mahnmal für die Opfer des Faschismus und Militarismus*). Tessenow's deformed marble block was kept as a stark symbol of the effects of war.

For the twentieth anniversary of the GDR in 1969, architect Lothar Kinasnitza refined the memorial further. According to a GDR souvenir booklet, 'it became ever more clear that the interior design of the memorial did not correspond to the understanding of socialist society' (Pickford 2005: 146). Tessenow's marble block was replaced with an eternal flame, the GDR hammer-and-compass crest was installed on the rear wall and the text 'To the Victims of Fascism and Militarism' was highlighted. Urns containing the remains of an unknown Nazi resistance fighter and unknown German soldier killed in East Prussia were buried under the eternal flame, evoking the themes of resistance and victimhood. The resistance fighter was buried in soil from Nazi concentration camps and the soldier was buried in soil from eastern battlefields.[37]

The exterior of the building was the focus of GDR military parades and the weekly changing of the goose-stepping guards strangely echoed the Nazi version. The Neue Wache, therefore, was turned into a cemetery and a 'secular altar of anti-fascism' by the GDR (Till 1999: 262).[38] By the 1980s, the building and its guards became a sightseeing destination for day-tripping westerners, as seen in a secretly filmed scene in Wieland Speck's *Westler: East of the Wall* (1985). It can be argued that films including this meaning-loaded site do not usually refer to or care about anything other than the building's touristic reputation and external appearance. These films' lack of reference to the Neue Wache's various histories and memories hints at a way of forgetting.

Upon the reunification of Germany, a renewed call for a national war memorial developed and, since the Neue Wache had been serving that purpose for 175 years, it should come as no surprise that it was chosen. In January 1993, Chancellor Helmut Kohl announced that a 'Central Memorial of the Federal Republic of Germany for the Victims of War and Tyranny' (*Zentrale Gedenkstätte der Bundesrepublik Deutschland für die Opfer des Krieges und der Gewaltherrschaft*), mirroring the wording used in a West German 1960s war memorial in Bonn,[39] would open in November of that same year inside the building. Again, as in other times past, there were no public consultations on this matter, no hearings, no competition and no jury of experts. It was another top-down decision made to speed the process along.

The exterior of the Neue Wache remained true to Schinkel's design, with its severe Neoclassicism, but the interior, again, became the focus of renovations. Tessenow's

design was replicated – this time without the black marble monolith. Instead, an enlarged reproduction of a sculpture by socialist artist Käthe Kollwitz was installed. The sculpture, entitled 'Mother with her Dead Son' was created in 1937/38 in memory of her son Peter who had died in the First World War. The original size of the sculpture, on view in the Kollwitz Museum in Cologne, was 38 cm. Harald Haacke enlarged it to just over life-size at 1.5 m, replacing Tessenow's monolith.

Just how the government was able to obtain permission for the reproduction, as well as permission to enlarge it, is unclear. What is clear is the attempt to shift the commemoration of the German war dead away from an idea of masculine martyrdom. Kollwitz's son actually died in her arms (Marcuse 1997: 8), so the original sculpture was no mere re-enactment but a genuine impression of grief. The use of the replica sculpture has been criticized since it resembles a Christian *pietá*, especially because Kollwitz herself apparently described it that way. However, the dead son here is not being supported by the grieving mother: instead, he is situated between her legs, curled up almost in a fetal position, somewhat returning to infancy. A more valid criticism would be that this sculpture, originally made to chronicle a private moment between mother and son, was crudely transformed into a national memorial.

The provenance of the original sculpture, as an anti-war artwork with its roots in the Weimar years, as well as the reinstatement of Tessenow's 1931 design, helped to relate the Germany of the 1990s back to the Germany of the 1920s, which was the last time that democracy freely existed throughout the entire country. In fact, in reaction to the suggestion that the sculpture-replica blurred the boundaries between victims and perpetrators, a bronze plaque containing a celebrated 1985 speech by then Federal President Richard von Weizsäcker was mounted to the right of the Neue Wache entrance, and translated into eight languages.[40] This particular speech was the first public occasion when a German official specifically addressed all war victims and clearly acknowledged the differences between the social groups that suffered during the Second World War (Till 1999: 273). Lastly, acknowledging that this memorial did not precisely address the Holocaust, it was at this time that an official decision was made to create what would later be called 'The Memorial for the Murdered Jews of Europe' on another site.

Every appropriation of the Neue Wache has evoked different aspects of German victimhood and national honour, attempting to shape Berlin's urban memory. Even though a German nation-state did not exist when Schinkel first designed the building in 1816, he attempted to represent a unity between the Prussian military, the Prussian monarchy and the Prussian people. The German Empire appropriated the building gradually as a military and ceremonial site as Prussian victories accumulated, unofficially beginning its life as a war memorial. The Weimar Republic commemorated those German soldiers who sacrificed their lives in the First World

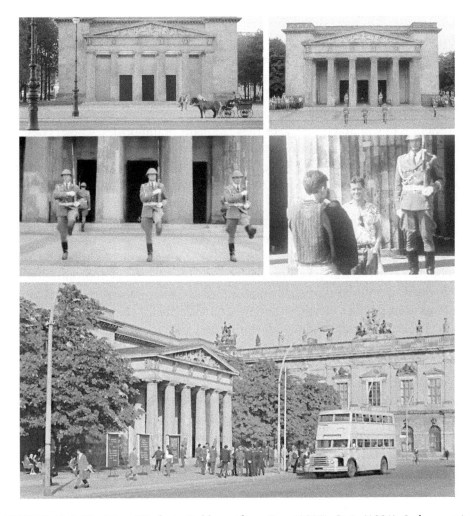

FIGURE 10.5: The *Neue Wache* in *Rabbit without Ears* (2007), *Stein* (1991), *Judgement in Berlin* (1988), *Westler: East of the Wall* (1985) and *Torn Curtain* (1966).

War but stayed away from any mention of German aggression. The Nazis manipulated the commemoration into bestowing an implicitly religious honour to the German war dead. Although the GDR did not see itself as an heir to the Nazis, it continued the theme of honour at the Neue Wache and expanded those being commemorated to include resistance fighters and concentration camp inmates, again avoiding the topic of German aggression, as well as any acknowledgement for causing the Second World War. Additionally, like most buildings constructed by the GDR, their Neue Wache also served to legitimize the existence of the East

German state, as portrayed in the opening sequence of Leo Penn's *Judgement in Berlin* (1988), where soldiers goose-stepping in front of the building represent the GDR, albeit in a western-biased manner.

Lastly, the post-reunification appropriation of the Neue Wache successfully downplays the original military function of the building, harkens back to the time of the Weimar Republic and attempts over-arching inclusivity by commemorating 'all' victims of war and tyranny, be they Germans or minorities, soldiers or civilians, men or women, making it just another tourist site in the city, often portrayed in romantic comedies such as Til Schweiger's *Rabbit without Ears* (2007) and the latest instalment in the 'Cities of Love' series, *Berlin I Love You* (2019). Jordan (2005: 39) describes this situation as 'the terrain of past political eras combines with new efforts to shape landscapes of memory to create a multiple and even conflicting narrative of different elements of the past'.

The intention of appropriation is to redirect or reframe the meaning of a building by changing the way it is (historically) perceived. Through appropriation, the authorities suppress an existing memory associated with a structure and promote a new one using school education, the news and social media. As in some other urban strategies, such as preservation, adaptation and relocation, when appropriated, a building gains a new life or a 'second chance'. Appropriation is arguably the most affordable urban strategy chosen to implement since it does not require much substantial physical change. However, its timing is crucial and needs to be right, otherwise the act of appropriation may not affect urban memory. Such psychological changes are usually the result of a pivotal turning point in history. Maybe not overnight, but in time the associated memory of a landmark or monument, as in the case of the TV Tower and Neue Wache, can be altered and its perceived meaning can shift for Berliners, sometimes naturally, sometimes forced. This provides a continuation in history while appropriating the urban role of the building as to new political or societal needs. What is urban memory for anyway, if not the present and the future?

NOTES

1. The fields of literature, music and film also have their own versions of appropriation, from quotation to sampling to montage.
2. Squatting, the urban intervention of taking control of disused spaces, may seem like appropriation because physical property is literally appropriated, but since squatters do not intend to change the meaning of squatted buildings (except to challenge the notion of private property), the authors have classified squatting under the strategy of adaptation.
3. This was also the case in *Berlin Tunnel 21*, where characters Georg and Greta attempt to flee East Germany via the Glienicke Bridge in 1961, but because the film was shot in 1981, access could not be granted.

4. A literal English translation for *Kurfürstendamm* is 'Elector's Causeway'.

5. Located one block north of the Kurfürstendamm, *Bahnhof Zoo* similarly had its fate appropriated post-Wall. It too was not a major element of the urban life of Berlin until after the division, when the main pre-war central station, *Anhalter Bahnhof*, was not rebuilt and kept partially as a ruin. Acting as a city-centre, the triangle between the Ku'damm, Europa Center and Zoo Station features in many West German films of the 1970s and 1980s. The hapless Turkish character who is ditched by his arranged bride upon arrival at Zoo Station in Şerif Gören's *Germany, Bitter Homeland* (1979) spends a day in that triangle, sleeping on the street, until he meets a Turkish speaker who can help him. In Frank Ripploh's *Taxi to the Toilet* (1980), the protagonist spends his time cruising this triangle in his car until he finds a partner. Post-reunification, the Ku'damm did not lose its urban significance and is often included in contemporary Berlin films.

6. A more contemporary film portraying a children's perspective of Berlin is Edward Berger's *Jack* (2014) in which the eponymous 10-year-old main character and his little brother must make their own way through the city, day and night.

7. The addition of fascist-looking banners onto Karl Schinkel's *Konzerthaus am Gendarmenmarkt* in James McTeigue's *V for Vendetta* (2005) also worked in this way, although the location was meant to be London. Similarly, many Berlin films that are not shot there, such as Alfred E. Green's *Appointment in Berlin* (1943), James P. Hogan's *The Strange Death of Adolf Hitler* (1943), John Farron's *The Hitler Gang* (1944), Werner Klinger's *Spy for Germany* (1956) and Stephen Boyum's *Timecop: The Berlin Decision* (2003), appropriate monumental stone buildings to represent Nazi architecture.

8. *Treuhand* was the governmental agency that privatized East Germany's state-owned companies.

9. Jutzi represents Alexanderplatz as a crossroads with busy traffic of people and vehicles, and a vibrant place to be. Unlike other early or late films that are shot in the area, his *Berlin Alexanderplatz* continuously cuts to construction work and workers. The film portrays Alexanderplatz of the early 1930s as a place of becoming, of growth and development.

10. An urban design competition for Alexanderplatz took place in 1929, in which Modernist architect Mies van der Rohe participated. Rather than building the winning project of Hans and Wassili Luckhardt brothers, however, Peter Behrens, who won the second prize, was commissioned. Two office buildings, *Alexanderhaus* and *Berolinahaus*, were constructed right away along with intense infrastructure work (1929–32), but the rest of the project was abandoned. Interestingly, Behren's geometric volumes architecturally define the frame of the Skladanowskys' fixed camera (*Bioskop*) from 1896.

11. Similar to Wenders' Potsdamer Platz in West Berlin shown as a twentieth-century cosmopolitan city with guest workers and different nationalities, Qurbani's Alexanderplatz is portrayed as a twenty-first-century cosmopolitan city with refugees and different nationalities. *My Dream of the Dream of Franz Biberkopf,* adapted from Alfred Döblin's 1929 book, in Rainer Werner Fassbinder's TV series *Berlin Alexanderplatz* (1980) is also worth mentioning, although the square in East Berlin at the time of filming is nowhere to be seen

in this poetic piece. Different forms of visualizing Alexanderplatz give a glimpse of different meanings regardless of their use of location shots or not.

12. The area turned into contemporary Alexanderplatz with few physical and atmospheric adjustments as shown in Thomas Schadt's *Berlin Symphony* (2002).

13. This 16-tonne cylindrical 'turret clock' is a temporal map of the Earth that simultaneously shows the time at all 24 time zones of the world on a metal drum balanced on a single column. A metal sculpture of the solar system above the modern urban installation adds to the global vision of the GDR during the space age. The 10 m-tall World Clock in Alexanderplatz is an appealing meeting point for Berliners, individuals and protestors alike.

14. The official website of the TV Tower, https://tv-turm.de (last accessed on 12 May 2020).

15. Another abandoned site option was a public park, the *Volkspark Friedrichshain*, which was not financially feasible.

16. Gabi Dolff-Bonekämper und Stephanie Herold, 'Der Berliner Fernsehturm' (2015), http://www.hermann-henselmann-stiftung.de/wp-content/uploads/Dolff-Bonekaemper_Herold-Der_Berliner_Fernsehturm_2015-08-30_final.pdf (last accessed 13 May 2020).

17. The late thirteenth/early fourteenth-century *Marienkirche*, with a calm whitewashed Gothic interior, is one of the oldest churches in Berlin and still actively used. Originally Roman Catholic, the red brick building was appropriated as a Lutheran Protestant church in 1539 and survived the Second World War with minor damage.

18. This large area, between Karl-Liebknecht-Strasse and Rathausstrasse, was a historical collage with the medieval St. Mary's church, a relocated nineteenth-century Neptune Fountain (Reinhold Begas, 1891) dedicated to the god of sea and four Prussian rivers, a late nineteenth-century Martin Luther monument (Paul Otto and Robert Toberentz 1895) and symmetrical contemporary water cascades (Walter Herzog 1972). Similar to Central Park in Manhattan, the area is surrounded and framed by a set of mixed-use buildings as well as the Red City Hall (*Rotes Rathaus,* well represented in *Babylon Berlin* TV series, 2017–20, though montaged with Berlin's *Rathaus Schöneberg*) from the 1860s. This landscaping was renovated in 2009 by Levin and Monsigny for contemporary needs such as bicycle racks and playgrounds.

19. The surroundings of St. Mary's Church had changed from mixed-use to offices in the imperial period (1871–1918).

20. Henselmann contributed to the architectural and planning projects around *Alexanderplatz* and *Karl-Marx-Allee*, including the *Haus des Lehrers* and the twin dual towers at Frankfurter Tor and Strausberger Platz, in the 1950s and 1960s. His *Forum of the Nation* vision for the new city centre of East Berlin was considerably more futuristic and utopian than today's *Alexanderplatz*.

21. 'Everyone is supposed to remember that Berlin's *Fernsehturm* (TV Tower) is 365 m high and the tallest building in Berlin. As urban legend has it, the tower's height was a deliberate decision taken by Walter Ulbricht, the leader of the SED, so that every child would be able to remember it, just like the days of the year. In fact the tower's summit today is 368 m' after the renovation of the antenna in 1995 (https://www.berlin.de/en/

attractions-and-sights/3560707-3104052-berlin-tv-tower.en.html, last accessed 12 May 2020). The red and white antenna transmits more than 60 analog and digital TV and radio signals.

22. The Bauhaus was claimed by both West and East Germany. It could be argued that there was a battle between progressive modernist architecture (without looking like the western examples) and more conservative monumental revivalism (without looking like Nazi buildings) in the GDR. The latter were sometimes inspired by the socialist realism that Stalin favoured.

23. The restaurant had an outer ring populated with tables that revolved to make a full turn in an hour. (Since the renovations in the 1990s, the turn takes half an hour.)

24. The 'Alex Tower' does keep up with new technologies. There is also a virtual tour of the building available on the tower's official website (https://tv-turm.de/en/virtual-tour, last accessed 27 January 2022).

25. Because it can be seen from anywhere and is in most of the photographs taken on the streets of Berlin, a hashtag, #thattoweragain, is dedicated to the TV Tower on Instagram.

26. The sphere was turned into a football in silver and magenta colours in 2006 for the World Cup Football Championships.

27. Positioning her camera in the non-revolving elevator lobby, Dean solely framed the slow-moving tables and diners of the revolving restaurant, revealing a different view than can be seen out the windows and sharing a less common experience of the structure. *Tacita Dean Looking to See* (Katy Homan 2018), a documentary about Dean's work, is available at https://www.youtube.com/watch?v=pEEUhkQZ8QU (last accessed 20 August 2020). The TV Tower appears at around 17:00.

28. Berliners might have included the two glazed courtyards of the Wertheim Department Store (Alfred Messel, 1896–1906) on Leipziger Platz on this list. However, the building was bombed in 1943, and by 1956 when its site was cleared, it was no longer a physical part of urban memory.

29. Schinkel typically gets the design credit for the Neue Wache, but he loosely based his design on an 1806 proposal by civil-servant architect Salomo Sachs, which was never carried out due to Napoleon defeating Prussia in 1806.

30. This Royal Palace, at 3 Unter den Linden, is not to be confused with the Berlin City Palace (*Berliner Schloss*), further east across the Spree River, which, although existing beforehand, only began to be used on a permanent basis in 1840. The Royal Palace then became known as the Former Royal Palace.

31. Napoleon victoriously marched into Berlin in 1806 and the city was occupied by French forces until 1813 following the Battle of Leipzig. Because of this, the military disrespected the king until Napoleon's 1814 defeat.

32. A *castrum* is a Roman fortress with look-out towers and interior courtyard.

33. As described by Schinkel (1819: n.pag., translation by the authors)

in the middle, Victoria decides in favor of the heroes fighting on the right, on the left is shown: The Final Efforts, Exhortation to Fight, [and the] Flight, Robbery and

Pain of the Family Awaiting their Fate; on the right one can see the overwhelming emotion and mourning for a fallen hero.

34. *Unter den Linden* translates as 'Under the Limewood Trees', not 'Under the Lime Trees' (which implies a citrus fruit producing tree). The street received this name because it began life as a bridle path lined with such trees.

35. Schinkel was also commissioned by King William III to design buildings near Unter den Linden throughout his career: the Royal Theatre on *Gendarmenmarkt* (1821), the Royal Museum (known today as the *Altes Museum*, 1824), the Friedrich-Werderitsch Church (1830) on the parallel street south of Unter den Linden, the Customs Building (*Packhof*, 1832) behind the *Altes Museum* and the Building Academy (*Bauakademie*, 1836) adjacent to his Friedrich-Werderitsch Church.

36. The invited architects were Peter Behrens, professor of architecture at the Vienna Academy; Erich Blunck, editor of the *Deutsche Bauzeitung* (German Construction Newspaper); Hans Grube, Government Construction Councillor; Modernist architect Ludwig Mies van der Rohe; Expressionist architect Hans Poelzig and *Deutscher Werkbund* architect Heinrich Tessenow, both of whom were professors at the Berlin Technical College. Grube's and Blunck's entries were seen by the jury as too crowded. They also did not approve of Poelzig's proposed grave mound, nor Behren's suggested sarcophagus.

37. The installation of an eternal flame, socialist crest and battlefield remains parallels the 1967 memorial to an unknown soldier in the Kremlin Wall, Moscow (Pickford 2005: 146).

38. Till (1999: 262) also relates that the East German government suggested that newlywed brides lay their wedding bouquets at the memorial's eternal flame, thereby both paying tribute to the commemorated victims and implicitly gaining their blessing.

39. In West Germany, there was no comparable war memorial to the Neue Wache at this time. In 1964, a small bronze plaque was erected in the *Hofgarten*, the large park in front of the University of Bonn, 'to the victims of war and tyranny'. This was moved to a more appropriate location, a war cemetery to the north of Bonn, in 1969.

40. The full English text of von Weizsäcker's speech is

> We honour the memory of the peoples who suffered through war. We remember their citizens who were persecuted and who lost their lives. We remember those killed in action in the world wars. We remember the innocent who lost their lives as a result of the war in their homeland, in captivity and through expulsion. We remember the millions of Jews who were murdered. We remember the Sinti and Roma who were murdered. We remember all those who were killed because of their origin, homosexuality, sickness or infirmity. We remember all of the murdered whose right to life was denied. We remember the people who had to die because

of their religious or political convictions. We remember all those who were victims of tyranny and met their death, though innocent. We remember the women and men who sacrificed their lives in resistance to despotic rule. We honour all who preferred to die rather than act against their conscience. We honour the memory of the women and men who were persecuted and murdered because they resisted totalitarian dictatorship after 1945.

Also installed was a bronze plaque summarizing the history of the building.

Tiger Milk (2017)

11

My Precious!:
Preservation

Four criteria or categories are determined which apply to individual houses.
First: preservation at all costs. Second: modernisation practical.
Third: modernisation problematic. Fourth: preservation not justifiable.
Architect Martin in *Berlin Chamissoplatz* (1980)

'We are living in an incredibly exciting and slightly absurd movement, namely that preservation is taking over us', remarks Rem Koolhaas (2004: 2). While the 'starchitect' may be exaggerating the situation, the preservation of buildings deemed to be historically significant is certainly a practice that is more prevalent than has been in the past. The historic preservation of buildings is a discipline that is regulated in most countries by local, regional or national governments who define standards as to what and how the work should be carried out.[1] In Germany, the Association of State Monument Conservators (*Vereinigung der Landesdenkmalpfleger*) defines preservation as an act 'directed against processes of decay that reduce the material fabric of a monument' (2011: 41). According to the Council of Europe, 'Germany has about one million archaeological sites, settlements, churches, dwellings, castles and palaces, parks and gardens, industrial and administrative buildings which are listed as monuments'.[2] In Germany, not the federal government but individual states are responsible for the preservation of their own monuments. In Berlin, this is regulated by the 1995 Historic Preservation Law (*Denkmalschutzgesetz*).

The first modern monument protection law in Germany was passed in the Grand Duchy of Hesse in 1902 with the Law Concerning Monument Protection (*Gesetz, den Denkmalschutz betreffend*). The Athens Charter for the Restoration of Historic Monuments of 1931 was a seven-point manifesto proposed by European scholars that advocated guidelines and standards for preservation organizations, review boards, legislative bodies and technical associations. This was supplemented in 1964

with the Venice Charter for the Conservation of Historic Monuments, which defined historic structures as 'common heritage' and created the International Council on Monuments and Sites to advocate for their preservation.

In an introduction to the 1903 Austrian architectural preservation law, art historian Alois Riegl described how the monuments of that time were only appreciated for what he termed their 'age-value'. This was merely the quality of those structures to evoke the concept of the passing of time – their 'outstanding or extraordinary significance' laid not in the memory of any specific person, time or event, but merely as 'indispensable catalysts which trigger in the beholder a sense of the life cycle, of the emergence of the particular from the general and its gradual but inevitable dissolution back into the general' (Riegl [1903] 1982: 24). According to architectural preservationist Carolyn Ahmer (2020: 152), Riegl was reacting to the restoration of monuments back to their 'original state' that had become prevalent in the late nineteenth century.

In contrast, the urban strategy of preservation is the general upkeep of buildings and spaces historically valuable to a society so that they do not appear to age at all. It is a constant maintenance that repairs anything that would give the buildings or spaces 'age-value'. Although physical alterations may take place as buildings are regularly maintained, the goal of such preservation is to appear as if nothing has ever changed, thereby continuing the memory that is associated with that place. In the words of art historian and conservation theorist Paul Philippot ([1972] 1996: 268), 'The word preservation – in the broadest sense, being equivalent in some cultures to conservation or restoration – can be considered as expressing the modern way of maintaining living contact with cultural works of the past'. Although the goal of preservation is primarily to 'keep things as they are', the process can sometimes result in extensive changes in order to get to that state. That is, to preserve is to remember, but to preserve is also to forget (the traces of time).

Structures that get this treatment are often monumental buildings of great importance to a society: religious buildings such as cathedrals and mosques, government facilities such as assembly halls and palaces, and cultural establishments such as museums and theatres. The maintenance of such structures over the years – keeping them looking new and unaffected by weather and other hazards – provides a certain stability that the society values. This process does not only work on an individual building level but can also be in effect on an overall urban scale when, for example, historic cities attempt to regulate the *status quo* of the built environment by restricting development or at least requiring new development to 'fit in' with the old.[3]

It is easier to throw things out than to bring things in [...] But we kept everything. 35,000 pieces of metal and stone were cleaned, modified, and brought back, which is not something you would do with a building from 1968,

said David Chipperfield in the opening ceremony of Mies van der Rohe's *Neue Nationalgalerie* in Berlin (Merin 2021).[4] Following the completion of the British architect's long-lasting renovation (2014–21), the New National Gallery does look new and its memory refreshed. As the home for modern art, Mies' modernist building continues to be a significant component of the urban memory of *Kulturforum*.

The Brandenburg Gate

> I've decided that the Brandenburg Gate could wait.
> W.H. Auden, just before entering a club, in *Christopher and His Kind* (2011)

In the same way that the Eiffel Tower is a symbol of Paris and Big Ben of London, the Brandenburg Gate is a symbol of Berlin.[5] Its image is on the German 10-, 20- and 50-cent euro coins as well as many Berlin U-Bahn seat textiles and window designs. The official website of Berlin, https://www.berlin.de, utilizes an abstracted Brandenburg Gate in its logo, and the gate's image or silhouette can be found on postcards, t-shirts, umbrellas, fridge magnets and other myriads of products that are sold as souvenirs, which aid tourists in remembering their Berlin.[6]

In the early twentieth century, the Brandenburg Gate as an architectural symbol of Berlin was also cinematically the case, as seen by the flaneur of August Blom's *Atlantis* (1913) travelling by taxi through the gate to his hotel and the aerial view of the gate and Pariser Platz to introduce the audience to Berlin as the character Konsul Langen luxuriously flies from Paris to Berlin in Joe May's *Asphalt* (1929).

The Brandenburg Gate, so named because it leads west to Brandenburg an der Havel, is one of eighteen such structures that were created for a 1730s customs wall around Berlin. Architect Carl Gotthard Langhans, first director of the Prussian Royal Building Commission, designed the current gate, which was built in 1788–91. Loosely based on the *Propylaea* at the entrance of the Athens Acropolis, the Brandenburg Gate is a simple sandstone structure with six columns on each side, making five 'doors'. The gate measures about 20 m high, 63 m wide and 11 m deep.[7] To mimic the marble of ancient Greece, the yellow sandstone was originally plastered and covered with white lime wash, which has long since disappeared (Schneider 1998: 14).

This emulation of ancient Greece, instead of the emulation of ancient Rome, can be seen not only in Germany but also elsewhere on the continent at this time. Because it was seen as the oldest example of European architecture, it was therefore considered more authentic. Matching the *Propylaea*, Langhans utlised the Doric order, considered the most sturdy-looking of ancient Greek orders, as well as spacing out the middle columns to make the central door wider than the side

doors. Langhans deviated from the *Propylaea* by reducing the depth of his struc-
ture, and incorporating bases and 'cabled' fluting to his columns. He also designed
his columns to be narrower and higher than traditional Doric proportions. One
final deviation was, instead of a triangular gable, a massive parapet was placed
above the columns, with a stair-like construction holding a quadriga sculpture
(a chariot pulled by four horses) by Johann Gottfried Schadow. All of these devia-
tions combine to make the Brandenburg Gate look more like a Roman triumphal
arch than a Greek temple, which would prove to be a factor in its success and later
popularity (Demandt 2004: 29).

The gate was commissioned by King Frederick William II of Prussia, who meant it
to be a 'Gate of Peace'. This theme can be seen in the decoration of the eastern para-
pet relief, entitled 'The Train of the Goddess of Peace', which depicts her arriving on
a quadriga with olive branches, and the figures that follow her – Joy, Abundance,
Architecture, Sculpture, Painting, Music, and Poetry – 'show the blessings of peace,
abundance and a happy blossoming of the arts' (Seibt 2001: 72). Despite being dedi-
cated to peace, images of victory and war dominate the Brandenburg Gate, such as
reliefs of the mythological battle of the Lapiths and the Centaurs, Hercules in various
victorious skirmishes, and the Roman god and goddess of war Mars and Minerva.
On the eastern parapet relief, the goddess of victory, together with State Wisdom,
hands Hercules, who is violently chasing away Discord and Envy, a victory trophy.[8]
The representations of war and victory on the Brandenburg Gate – the main entrance
into Berlin that leads directly to the City Palace – could suggest that peace in Prussia
was due to its successful military conquests that were supported by the monarchy
and the customs taxes generated by the gate.[9] These extensive decorations, for what
is simply an entrance way into the city, were made to shape the urban memory of
Berlin as the Prussian capital from which many military victories were won.

In 1793, the Brandenburg Gate's most prominent representation of victory
and its most recognizable feature, Schadow's quadriga sculpture, was installed on
the top. This is a massive copper artwork, almost 6 m in height, that dominates
the gate.[10] Victoria, the Roman goddess of victory, rides a chariot pulled by four
horses, each almost 4 m tall.[11] She originally held a pole with the victory symbols
of an oak wreath and an eagle. In 1814, upon the return of the stolen quadriga
from Paris, Karl Friedrich Schinkel renewed her pole with a Prussian eagle and an
iron cross war decoration inside an oak wreath.[12] It was at this time that the gate
was appropriately renamed 'Gate of Victory'.

The people of Berlin were 'very impressed by this classicistic gate in its balanced
and elegant dimensions' (Demandt 2004: 29). After the destruction of the customs
tax wall in the vicinity of the gate in 1865, the Brandenburg Gate continued its life
as a purely symbolic structure, which is exactly how it functioned in the late nine-
teenth century when Prussian troops returned to Berlin from their many victories,

marching down Unter den Linden and then into the city centre. The gate now fulfilled its appearance as a triumphal arch.

Since Victoria and the quadriga are oriented to the east, it appeared as if she, too, were returning from a victorious battle with the soldiers. This eastern orientation of the sculpture is also significant because it faces towards the people who are being ruled by the monarchy, not towards those who are arriving, which normally be the case with city gates (Demandt 2004: 29). By the time of the founding of the German Empire in 1871, the Brandenburg Gate was an integral piece of Berlin's symbolic built environment.

In the twentieth century, victorious German soldiers returned from China in 1901 after the Boxer Rebellion marched through the gate, as did the troops from German Southwest Africa in 1904 after the Herero Uprising. However, when defeated German troops processed through the gate in December 1918, this symbolism did not work and the Weimar Republic that followed tried to reappropriate the structure by using it as the location of their annual 11 August 'Constitution Day' celebrations. Less than a month after the defeated troops were processed, the gate and other strategic locations in Berlin were taken over by the Spartacists who were promoting a socialist alternative to the new republic. The gunfights that ensued, although brief, damaged the quadriga and gate with bullet holes and minor abrasions. The gate suffered similar damage during the *Kapp-Lüttwitz Putsch* of March 1920.

The gate then turned into a piece of funerary architecture as the Weimar Republic mourned the loss of Foreign Minister Walter Rathenau (1922), President Friedrich Ebert (1925) and Chancellor Gustav Stresemann (1929) by routing their state funeral processions through it. Recognizing the importance of erasing any memory of their being challenged, the Weimar Republic cleaned up the Brandenburg Gate over the winter of 1926/27, using 35 wagon loads of sandstone on the gate itself and a significant amount of bronze for a new quadriga support structure (Demandt 2004: 41).

The Nazis returned the victory function to the Brandenburg Gate on their first night of power, 30 January 1933, with a torch-lit procession of paramilitary units (SS, SA and 'Steel Helmet' [*Stahlhelm*] veterans) marching through the gate to the Reich Chancellery on *Wilhelmstrasse*. When the gate was used as a backdrop for celebrations like the opening of the 1936 Olympic Games, Mussolini's state visit (1937), and Hitler's fiftieth birthday, the Nazis reversed this traditional eastward marching direction and finished up their processions at the relocated Victory Column (Pohlsander 2008: 180). For triumphal marches, like when German troops returned from France in July 1940, the traditional eastward direction was maintained. Because the Neoclassical gate was useful to them, the Nazi Party made sure to maintain and preserve it in good condition.

The street-to-street fighting of the Battle of Berlin in April 1945 damaged many structures in the city, but the image of the scarred Brandenburg Gate, with its fragmented quadriga, became a symbol of that struggle. The gate was still standing, but many of the columns were fractured, and the parapet had many large craters. The metopes and other reliefs were riddled with bullet holes. Victoria and her chariot were gone, two horses were left, one of which was leaning against the other. The only structure next to the gate was a partially destroyed French Embassy. The Brandenburg Gate used to be 'the symbol for the connection between the Prussian monarchy and the German nation, [but] in the end it was only a symbol for the defeat of German weapons' (Seibt 2001: 81). There was talk of replacing the quadriga with a new artwork, as a sign of rebirth. Many ideas for a new sculpture were proposed – a workers group, a mother and child, a peace dove – but 'protests against this total break with the past and against the forms of new ideology' never allowed any of these to go forward (Demandt 2004: 43).

The Brandenburg Gate, although partially in ruins, continued to be a location of historic events. Ernst Reuter delivered a speech against the Soviet blockade of the city in 1948 in front of it, imploring 'You peoples of the world! Look at this city!' and during the 1953 East German uprising, the Soviet flag was taken down by a crowd and burned, only to be replaced that evening. In 1958, a joint effort by the city governments of West Berlin and East Berlin (in whose territory the gate was located) renovated the gate and renamed it a 'Memorial to Striving for Unity' (*Mahnmal für das Streben nach Einheit*). East Berlin restored the estimated 10,000 bullet holes in the sandstone and West Berlin constructed a new Victoria and quadriga sculpture from plaster moulds that had been made before the war (Demandt 2004: 44). To the great consternation of some West Germans, Victoria's staff with the iron cross and Prussian eagle was removed by the East Germans after receiving the new sculpture.

During the shooting of Billy Wilder's *One, Two, Three* (1961), the Berlin Wall was erected. The Brandenburg Gate, with a barbed-wire barrier in front, features in the film's opening sequence, which was written to use the Wall to its advantage. As the main character explains: 'On Sunday, August 13th, 1961, [...] the East German Communists sealed off the border between East and West Berlin. I only mention this to show the kind of people we're dealing with – *real shifty*.' The Brandenburg Gate in this film, and in reality, became the backdrop to the division of the city. Wilder, who was a Berliner with Polish Jewish parents (1926–33) before immigrating to America, constructed a full-scale replica of the gate at the Bavarian Film Studios in Munich one month before the appearance of the Wall, not because of any border tension but because the East Berlin authorities would not give him permission to film a car chase scene there, further proving that Berlin equals the Brandenburg Gate.

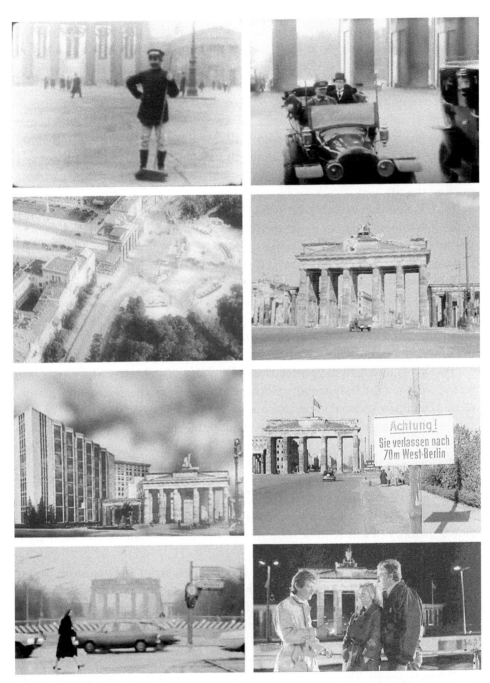

FIGURE 11.1: The twentieth-century history of the Brandenburg Gate in *Where Is Coletti?* (1913), *Atlantis* (1913), *Asphalt* (1929), *Berlin Express* (1948), *The Berliner* (1948, depicting 2048), *Adventure in Berlin* (1952), *No Mercy, No Future* (1981) and *The Holcroft Covenant* (1985). (All illustrations are film stills captured by the authors.)

After the physical separation of East and West Berlin, the Brandenburg Gate, alone in an empty field with the Berlin Wall immediately to its west, suddenly became one of the symbols of the division and the Cold War. The symbolism of a locked gate was powerful. Like in other locations in Berlin, a viewing platform was erected immediately next to the Wall on the western side, which soon became a tourist destination. In Cynthia Beatt's *Cycling the Frame* (1988), a bicycle journey that follows the path of the Berlin Wall through urban, suburban and almost rural conditions begins and ends at the Brandenburg Gate, indicating not only the importance of the monument to Berlin but also its symbolic nature as a landmark of the city.

John F. Kennedy's celebrated 1963 '*Ich bin ein Berliner*' speech of assurance to West Berliners was not given in front of the Brandenburg Gate. During his visit to the city, however, the five passages of the gate were blocked off with red curtains by the German Democratic Republic (GDR) in order to restrict the view in both directions. In the early 1980s, Richard von Weizsäcker, mayor of West Berlin, made the powerful statement that 'As long as the Brandenburg Gate is closed, the German question is open'. This was echoed in Ronald Reagan's noteable 1987 'Mr. Gorbachev, tear down this Wall!' speech, which did take place at the Brandenburg Gate.

Two years and 150 days after Reagan's plea to Gorbachev, the Berlin Wall was opened and the Brandenburg Gate, once again, was a backdrop for a historic scene of German national importance as joyful revellers stood in front of the Wall, sprayed champagne and celebrated the memorable moment. The Berlin Wall officially opened at the Brandenburg Gate on 22 December 1989, just in time for new year celebrations to take place there. During that night, partiers climbed up the gate from all sides, damaging the stonework and mangling the replicated quadriga. Across the parapet, someone had spray-painted the slogan *Vive L'Anarchie* (Demandt 2004: 50). These images travelled around the world and are now a global memory of this reunification moment of the German people, with architecture as a backdrop.

Once again, the Brandenburg Gate underwent a renovation to clean up this mess and make itself presentable for the reunified Germany that was to come. The Federal Republic of Germany (FRG), newly enlarged with the former East German states, funded this refurbishment. The West German industrial conglomerate Mannesmann financed the complete renovation of Victoria and her quadriga, including a new replica of Schinkel's iron cross and Prussian eagle that the GDR had removed. These projects were all completed in time for the bicentennial celebration of the gate on 6 August 1991. It is at this point when the preserved Brandenburg Gate, despite the renewal of its 200-year-old Prussian insignia, became a symbol of reunited Germany.

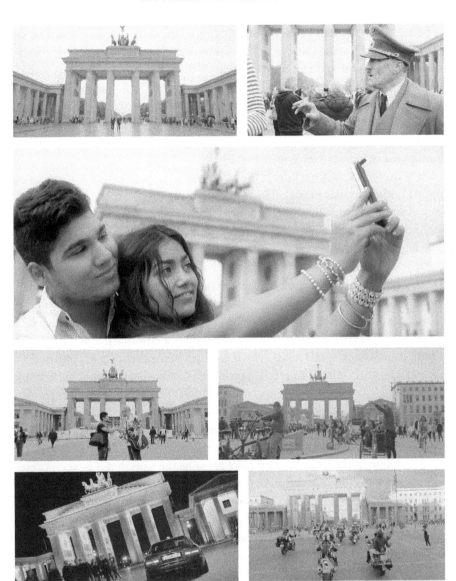

FIGURE 11.2: The twenty-first-century representation of the Brandenburg Gate in *St. George's Day* (2012), *Look Who's Back* (2015), *One Fine Day* (2016), *Berlin Drifters* (2017), *Berlin Syndrome* (2017), *Berlin, I Love You* (2019) and *Back to Berlin* (2019).

The gate then began to take on more of a national function than before, continuing to be the place where important dignitaries were taken when visiting Berlin, but also as a location for national protests, even though the Reichstag, seemingly a more appropriate place to take one's national grievances, is a mere 250 m away.

251

The pedestrianization of Pariser Platz made sure that tourists would not be hit by cars when trying to take their selfies, although that is still a danger on the western side of the gate, where the path of the Wall is traced in cobblestones. Artist Hans Hoheisel emphasized this national reading during his 1997 'Gate of the Germans' installation: at one point, an image of the Auschwitz concentration camp gates with the well-remembered phrase *Arbeit Macht Frei* ('Work Sets You Free') can be seen projected onto the Brandenburg Gate, overlaying the structure with a topic of national discussion: Germany's Nazi past.

The gate serves as a backdrop for new year parties, football victory celebrations and other similar events. The Olympic torch passed through it in 1936 on its way to the Olympic Stadium and more recently has been used as the finishing line for the Berlin Marathon. Another cleaning occurred between 2000 and 2002 by the Monument Protection Foundation Berlin (*Stiftung Denkmalschutz Berlin*), who state on their website that it was a correction of 'improperly carried out postwar repairs'.[13] While this four million euro project was not funded by a private company (although *Deutsche Telekom* did pay to advertise on the scaffolding), it is telling that the government of Germany did not finance the preservation of this monument that represents the nation. The gate is a landmark and meeting point for both tourists and locals alike, which is why a re-awakened and confused Adolf Hitler, attempting to locate Speer's New Reich Chancellery, makes his way to the gate in David Wnendt's *Look Who's Back* (2015) and the cruising character Ryota of Kôichi Imaizumi's *Berlin Drifters* (2017) sets to meet his dates there.

The maintenance and renovation continued: perhaps due to the U5 underground extension, heavy traffic and loud concerts in the area, 30 cm cracks were repaired in 2008.[14] As long as the Brandenburg Gate remains the icon that it is, such preservation projects will continue and films set in Berlin will have to frame the obligatory gate shot just like Riefenstahl's *Olympia* showing marathon runners in front of the Brandenburg Gate decorated with Olympic rings and swastika banners in 1936. Spider-Man's alter ego Peter Parker films himself at the gate in Jon Watts' *Spider-Man: Homecoming* (2017) and the young Romanian cousins take a selfie at the gate in Philip Scheffner and Colorado Velcu's *One Fine Day* (2016). As far as filmmakers are concerned, the gate will never disappear. Robert A. Stemmle's *The Berliner* (1948) depicts the gate in 2048, with Bauhaus-looking buildings to the north and Duncan Jones' *Mute* (2018) depicts it in 2035 with a hulking deconstructivist building overshadowing it.

The Brandenburg Gate has been called Germany's 'Gate of Fate' (Pohlsander 2008: 177). What began life as a simple customs checkpoint in eighteenth-century Prussia quickly became appropriated in the nineteenth century as a symbol of greater Germany. Following theft, damage, substantial destruction, isolation and renewal in the twentieth and twenty-first centuries, the Brandenburg Gate

has been restored, repaired, rebuilt, renovated and, in parts, replicated, to both preserve the structure as a symbol of Berlin and as a constant part of Berlin's ever-changing urban memory. That is, it has been preserved in its original state despite everything that has happened to it as well as the city around it.

Berlin State Opera

If I did agree to be outside the Opera tonight, how do I know that you would stop Kestner from coming?

Susanne in *The Man Between* (1953)

In the twentieth century, there were three opera houses in Berlin, the *Deutsche Staatsoper Berlin* at *Bismarckstrasse 35*, *Komische Oper Berlin* at *Behrenstrasse 55* and the *Staatsoper Unter den Linden* at Unter den Linden 7, all of which are still in use today.[15] Despite diverse branding and specialized programmes complementing one another, ranging from classical/traditional to avant-garde, these three operas have competed with each other as one would expect. Since 2004 they have been under a single administrative roof, the Berlin Opera Foundation (*Stiftung Oper in Berlin*), which owns and maintains all their buildings.[16] It should be noted that the twentieth-century Berlin music scene was, and still is, rich with many more theatre buildings and concert halls including the *Admiralspalast*, a variety venue that also included ice skating, *Ackerstadtpalast* for performing arts, *Berliner Philharmoniker*[17] for the city's internationally recognized philharmonic orchestra, *Friedrichstadt-Palast* which now presents big production musicals, *Konzerthaus Berlin* for orchestral performances, Frank Gehry's oval *Pierre Boulez Saal* for chamber music, *Titania Palast* cinema opened in 1928, and the list goes on. Berlin supports upwards of 10 professional orchestras, 50 theatres and 120 museums, while annually hosting the world's largest film festival, the Berlinale, every February and a major theatre festival, the *Theatertreffen*, every May, all of which can be seen as the continuation of the vivid nightlife and music culture in Berlin before the Second World War – a cultural result of political decision to fund such 'high culture' activities, on both sides of the Wall. Post-reunification, this variety has been carried to another level (without governmental subsidies) with the (immigrant youth) rap and techno subculture clubbing scene that is in high demand in the city.

The *Deutsche Staatsoper Berlin*, designed by Fritz Bornemann in Charlottenburg, was the largest opera of the twentieth century in the area. Accessed by an opera-themed U-Bahn station, the venue contains 1865 seats. Opening its doors in 1961 with Mozart's *Don Giovanni* (1787), it was the only opera building

in the walled-in Berlin. Following the democratic approach of its pioneer on the same site from the early 1900s that was severely destroyed in the Second World War, this modern building (inside and out) provided an uninterrupted view of the stage from every seat.

The smallest opera house in Berlin, with 1270 seats, the *Komische Oper* was never intended for classical opera; instead, it was designed to be a musical theatre venue.[18] In the golden twenties following the First World War, this neo-Baroque building was favoured for its operettas and revues. Designed in 1892 by Ferdinand Fellner and Hermann Helmer on the site of a theatre long gone, it was initially called *Theater unter den Linden*. The venue was renovated and renamed *Metropol Theater* in 1898. Its elaborate auditorium had tables behind the stalls, boxes on the sides and two circular balconies. In the 1930s, Jewish stage artists started leaving the city after the Nazi Ministry for Education and Propaganda took over the building and began a programme

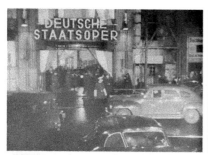

FIGURE 11.3: Berlin's Deutsche Staatsoper in *The Berliner* (1948) and the Staatsoper Unter den Linden in *Run Lola Run* (1998) and *I'm Your Man* (2021).

themed 'Strength through Joy' (*Kraft*).[19] As expected from its central location, the building was destroyed in 1944–45 when Berlin was heavily bombed. After its renovation, the theatre reopened in 1947 with a calm modern exterior (and its current name), performing Johann Strauss's *Die Fledermaus* (1874).[20] It was 'a unique establishment, where opera and operetta were performed, always in German, with intense theatricality. The *Komische Oper* became a staging ground and laboratory for unconventional production values, and so it remains today' (Chaikin 2010: 4).

Not far from the *Komische Oper* stands the city's oldest opera: *Staatsoper Unter den Linden*. Georg Wenzeslaus von Knobelsdorff designed this building, known in English as the Berlin State Opera (1741–43), as the first detached and largest opera house in Europe. Theatre buildings were normally located within a palace complex, but this freestanding 'enchanted castle', as envisioned by the king, on the main boulevard of the city became the continent's first independent theatre building. The Royal Court Opera (*Königliche Hofoper*) performed Carl Heinrich Graun's *Cleopatra and Caesar*, which was commissioned by Frederick II specifically for the opening of the building in 1742. That is, the eager and/or impatient king opened the building ten months before its practical completion.

In the eighteenth century, the *Staatsoper* was one of the most prominent buildings on Unter den Linden, among the Crown Prince's Palace (1663–69), the Princesses' Palace (1773) and the Armory (today's German Historical Museum, 1695–1730). The Crown Prince's Palace was designed as the home of a cabinet secretary. Later, it was turned into a residence for the ruling Hohenzollern House of Prussia. The Princesses' Palace, next to the opera building, was specifically built for the daughters of the much loved Queen Luise and Friedrich Wilhelm III, and served later as the Opera Cafe.

Located on Unter den Linden on a prestigious urban site close to the Museum Island, the Berlin State Opera was first envisioned by Frederick II and his architect Knobelsdorff as part of a greater plan: *Friedrichsforum* (or *Forum Fridericianum* in Latin, a term not used during the time of the king) centred around *Opernplatz* (today's *Bebelplatz*). King Frederick was actively interested in architecture and urbanism; he enjoyed researching as well as discussing and sketching his ideas. He even had the vision of turning Berlin's military image around for a European metropolis with innovative civic buildings. Like any massive-scaled urban move, the forum was only partially built over the years because of a lack of finances and shift of political interest. The grand royal palace was substituted with a palace for the king's brother, Prince Henry (today, Humboldt University, 1748–65). However, Friedrich's first building, the *Staatsoper*, used mainly for operas and masked balls, and its successors,

St. Hedwig's Catholic Cathedral (1747–73) and the Royal Library (1775–80) as well as the palace are still preserved today.

The preservation of Friedrich the Great's opera building should not be taken literally. Not much in the contemporary opera house actually dates from the eighteenth century, apart from the notable portico on Unter den Linden and some reliefs on the rear pediment. Rather, the memory of the building has been preserved over and over again for almost three centuries through multiple reconstructions and renovations. The goal of each alteration was the technical and functional modernization of the building while maintaining its original urban (outward) appearance. Knobelsdorff's building completely burned down after a military ballet in 1843.[21] All that remained was its outer shell. A replica was built to the exact same external form by Carl Ferdinand Langhans and named the Royal Opera House. Its new interior was different from Knobelsdorff's cheerful Rococo design, changing to a rather serious Neoclassical style. This version opened with the premiere of Giacomo Meyerbeer's *A Camp in Silesia* (1844). Since then, the building and its surroundings have experienced many historical and political transformations.[22]

After the end of the German Empire in 1918, the building received its current name, *Staatsoper Unter den Linden*. Several renovations took place in the 1920s, 1950s and 1980s, again preserving the original external façade design. The building was listed as a historical monument rather late, in 1979. During the 1926–28 Weimar renovation, the stage at its rear was demolished[23] and renewed with the addition of a rotating stage, trap room and wings, tested for the first time with Wolfgang Amadeus Mozart's *The Magic Flute* (1791). In this way, the slim rectangular plan of the original building changed to the combination of this rectangle and an overlapping square.

The most prominent *Staatsoper* renovation occurred in 1955. In the Second World War, the building was destroyed twice; first in 1941 and then in 1945.[24] A 1942 renovation, on Hitler's orders, was to reassure Berliners of an immediate and efficient response to hostilities. The source of inspiration was Frederician Rococo coupled with the propaganda of the Third Reich. Both in 1942 and 1955, the building reopened with the same Wagner opera. In the 1950s, Richard Paulick, an assistant to Bauhaus architect Walter Gropius, almost completely rebuilt the opera. His preservation method was both considerate and creative. Paulick followed Knobelsdorff's original lead and removed the changes that did not match the eighteenth-century design, which had been inspired by Italian Renaissance architect Andrea Palladio. Paulick and his GDR team decorated the Apollo Hall, for instance, with ornaments inspired by the hall's original design, but moved the main entrance from the first floor to the ground level, after changing the main façade staircases. He also rearranged the audience circulation, modified

the flytower and reduced the balconies to three in the theatre hall in order to improve visibility.

Between 1945 and 1955, operas were performed in the Admiral's Palace on Friedrichstrasse.[25] Following its renovations in 1952–55, the building served as the State Opera of East Germany until 1990. It reopened with Richard Wagner's 4.5-hour *Mastersingers of Nuremberg* (1868), which was a controversial choice because Wagner, with his *Gesamtkunstwerk* view of art and anti-Semitic politics, was a role model for Hitler, as detailed in his *Mein Kampf* (1925).[26]

The building was again renovated in 1986, and in 2009 architect Hans Gunter Merz began a final renovation which was jointly financed by the German government and the city of Berlin. The *Staatsoper* was modernized by more than 90 contractors costing about 400 million euros to renew aspects such as acoustic treatments and air-conditioning, restore the building's listed façade windows, fixtures, furnishings and 1950s colour schemes, as well as comply with current health and safety requirements of building regulations such as structural integrity, fire protection and accessibility. Waterproofing was provided under the building to deal with Berlin's legendary high groundwater level and on top of the building with an up to 3 cm thick steel sheet with a 7 km weld joint usually applied in the shipbuilding industry.

Architectural renovations at this time included a 115 m underground tunnel dug to assemble, move and store stage decor, to provide access to mechanical and electrical facilities, and to make a link with a new rehearsal centre.[27] To lengthen its reverberation time from 1.1 to 1.6 seconds, the 1356-seat hall was enlarged by raising its ceiling by 5 m, creating a modern reverberation gallery behind a permeable porcelain net inspired by the existing diamond-shaped lattice. Though this affected the profile and height of the roof, the appearance of the building at street level was kept unchanged, following the traditions of previous preservation projects. The Berlin State Opera reopened one last time in October 2017 on its two hundred and seventy-fifth anniversary with Engelbert Humperdinck's *Hansel and Gretel* (1893).

The opera is engraved in the urban memory of Berlin with its symmetrical temple-like front elevation that has a pedimented portico supported by six monumental Corinthian columns in the middle, grand staircases on two sides to take the audience to the upper level (and 'to see and to be seen' even before entering) and sculptures/statues incorporated into the façade design. The use of a portico on a civic building has been implemented in the design of other opera houses following this Berlin example. The *Staatsoper*'s official website states:

From Knobelsdorff to Paulick, many architects have constantly changed the opera house and adapted it to meet new challenges and functions. And that is still happening

today. [...] Berliners will still recognise their opera house as a familiar venue with the accustomed ambiance. [...] It takes into account the historic appearance but also sensitively articulates where something new has been created.

<div align="right">(Berlin State Opera 2022: n.pag.)</div>

Therefore, the effort of the architects who dealt with the building since the eighteenth century has been to keep the memory of the original venue intact while balancing this with the modernization of its facilities for current use. Berlin has witnessed the *Staatsoper* suffer a great deal of loss, particularly in the twentieth century, and its preservation via rebuilding each time, again and again, has strengthened its meaning in the urban memory of the city. With each renovation, the first freestanding opera house of all time reinforced its position on the physical and mental map of Berlin.

As can be seen in Skladanowsky Brothers' *Unter den Linden* (1896),[28] the *Staatsoper* has been well maintained throughout the history of cinema. It is questionable how much of the original building(s) from the eighteenth and nineteenth centuries are still in the State Opera that can be seen today since the building has been continually restored, renovated and improved to satisfy new (technical and safety) needs and requirements. It is almost impossible to preserve and continue using such a functional building without altering it or at least incorporating new building technologies. However, the key here is the intention of keeping the architectural and spatial design as it was.

Bebelplatz with surrounding Royal Library, Humboldt University and the State Opera makes a cameo appearance in Tom Tykwer's *Run Lola Run* (1998), as Lola exits her father's bank after just robbing it. The police, having set up a firing line in the square, scream 'Hey girl! Get away from there!', not realizing that she is the criminal whom they actually seek. An opera house provides a respectable venue to carry out the non-respectable act of kidnapping in Farhan Akhtar's Bollywood action-thriller *Don – The King Is Back* (2011). The exterior used for this purpose, however, is interestingly none of the actual opera buildings in Berlin but the *Konzerthaus* on Gendarmenmarkt, minutes away from the original building. Carol Reed also incorporates a tense Berlin opera scene into *The Man Between* (1953), whereby the main character and her eponymous protector get shuffled into a police car after the performance, but again the action does not take place at the *Staatsoper Unter den Linden*.

The long-established *Staatsoper* has been fortunate to undergo preservation throughout the centuries rather than perishing forever. As Fred Scott states (2008: 11):

[B]uildings chosen for preservation are memorials to failed collective architectural endeavour; the reason for preserving such paradigms is to retain examples of how

architects attempted to devise a built form fitting to the emergent convictions of particular times and places, which is the purpose of pure architecture. The atmosphere of all preserved buildings is unavoidably instilled with the qualities of *fetish*.

It is more difficult to 'sense' the collective urban memory in a new city with a relatively short history than it is in a more established city. That is, however diverse a new city's architecture might be spatially, it will not be vastly diverse temporally. One way of creating or triggering urban memory is to rely on what Riegl ([1903] 1982) referred to as the 'age-value' of buildings. As older buildings are preserved, looked after and inhabited, they and their neighbourhoods give life and meaning to the new dynamics of a city through the continuation of urban memory – like the elderly representing continuity in a family. Their stories and memories define human societies, as stories and histories told through preserved buildings define cities.

Acknowledging highly individualistic liberal humanism as the 'religion' of the western world, historian and philosopher Yuval Noah Harari sees society as the dominant aspect of twentieth-century human history. In *Homo Deus*, he writes: 'the twentieth century was the age of the masses. Twentieth century armies needed millions of healthy soldiers, and economies needed millions of healthy workers. [...] But the age of the masses may be over' ([2015] 2017: 406–07). This approach coincides with a shift in focus in memory studies towards collective memory, a memory shared by the masses, in the twentieth century. Preservation can be considered as an affordable way of keeping the memories of the masses up to date. Through preservation and maintenance, historical monuments may be utilized to serve the needs of the current state. In this way, a building that once represented the power of the Empire or socialist Germany can be turned into a symbol of the reunified state almost as if that past did not happen or is misremembered.

NOTES

1. In the United States, for instance, the Secretary of the Interior sets these standards and has defined preservation as 'the act or process of applying measures necessary to sustain the existing form, integrity, and materials of an historic property', as well as: 'Work, including preliminary measures to protect and stabilise the property, generally focuses upon the ongoing maintenance and repair of historic materials and features rather than extensive replacement and new construction' (Weeks and Grimmer 1995: 17).
2. https://www.coe.int/en/web/herein-system/germany (last accessed 31 January 2021). For a complete and detailed discussion of German preservationist discourse from the nineteenth century to the 1970s, see Koshar (1998).

3. In 2012, the Greater London Authority began enacting legislation and enforcing regulations on new construction in order to maintain thirteen selected 'view corridors' that they felt should be preserved, mostly with regards to views of St. Paul's Cathedral from various locations in London. In order to receive planning permission, any proposed development within the view corridors must adhere to height and set-back guidelines so that a clear view is maintained and preserved.

4. David Chipperfield Architects have also preserved, and supplemented, the *Neues Museum* (1993–2009) and built James Simon Gallery (1999–2018) in Berlin's Museum Island.

5. The TV Tower and Reichstag building are also used as symbols of Berlin, but the Brandenburg Gate is by far the most prevalent.

6. The French word 'souvenir' can in fact be translated into English as 'single memory'. That is, it is a singular portable object that can recall memories for the person carrying/displaying/owning it.

7. The height to the top of the Quadriga sculpture is 26 m.

8. In addition to all of these decorations, paintings on the passages' ceilings, which no longer exist, depicted 'trophies' such as the Martial Trophy for heroism, Hercules' Club for bravery, Minerva's Shield for scientific knowledge, Mercury's Staff for unity and an eagle for strength.

9. The Lapiths and Centaur theme is usually understood as a parable for a civilization that triumphs over barbarism (Seibt 2001: 73). The Hercules reliefs could be understood as a parallel to the deeds of Frederick the Great (Ulferts 1991: 109). The Mars and Minerva sculptures represent diligence and vigilance (Demandt 2004: 31). And lastly, the seven arrows bound into one is a clear reference to the seven Dutch provinces that were united in the 'Dutch Crisis' of 1787 by William V, Prince of Orange, who could not have done it without the help of Prussian forces (Cullen and Kieling 1999: 9).

10. The sculpture was originally supposed to have been gilded, but this was not done due to financial reasons – it had already cost 20,640 thalers in 1795 (Demandt 2004: 35), the equivalent of approximately $325,000 in 2020.

11. Despite the fact that ancient Greek models were used for the architecture and other artworks on the gate, Schadow's sculpture is always referred to as Victoria, not Nike.

12. Schinkel designed the famous German iron cross war decoration in 1813 based on a sketch by King William III. It was a new medal to be given for bravery in battle, regardless of rank, further reflecting the reformation of the military's image.

13. https://www.bürger-für-denkmale.de/projekte-der-stiftung.html (last accessed 20 November 2020).

14. https://www.theguardian.com/world/2008/dec/08/germany-brandenburg-gate (last accessed 20 May 2020).

15. There was also the *Neuköllner Oper*, a small private theatre on Karl-Marx-Strasse (seating 220) that has performed provocative productions since 1972.

16. https://www.oper-in-berlin.de (last accessed 9 September 2021).

17. The leading music venue of the twentieth century in the city was and still is Berlin Philharmonie mainly for two reasons: the orchestra led by conductor Herbert von Karajan (from

1956 till his death in 1989, before working at the Staatsoper, 1939–45) was one of the best in the world, and they performed in world's one of the best concert halls for classical music. Hans Scharoun's iconic building (1960–63) in the *Kulturforum* is easily recognizable with its organic forms and yellow cladding and established with its dynamic multi-layered foyers and auditorium that put music at its heart. 'Scharoun's own imagery of a "valley at the base of which can be found the orchestra, surrounded by ascending vineyards" of the audience blocks has retained its poetic character', as Gerhard Zohlen wrote in a programme booklet citing the architect himself (20 October 2013, https://www.berliner-philharmoniker.de/en/philharmonie/architecture, last accessed 9 September 2021) and as can be experienced via a virtual tour of the building here: https://www.berliner-philharmoniker.de/en/philharmonie/virtual-tour (last accessed 28 January 2022).

18. *Komische Oper* can be translated as 'comic/odd/eccentric opera' referring to their less rigid repertoire compared to traditional opera houses. The choice is loosely related to French opera comique as well as the *Komische Oper* on Friedrichstrasse near Weidendammer Bridge that was destroyed. There is a tendency in Berlin to name a theatre after a former one that is destroyed, which at times leads to confusion in 'the age of hashtags'.

19. Nazism spread through all aspects of both the political regime and the cultural network including opera, film, olympic games, education and, as discussed in this book, architecture.

20. Strauss's 'bat' operetta has been filmed many times, starting in 1923 by Max Mack. Geza von Bolvary's well-liked loosely adapted comedy version is worth noting as it was shot in 1944 during the Nazi regime in the war and edited and released by the GDR's DEFA in 1946.

21. The 1742 building would be one of the oldest monuments of Berlin if not burned down. The ballet was Hermann Schmidt's *The Swiss Soldier* (1835).

22. The *Staatsoper*'s architectural history by Frank Schmitz, accompanied with historical photographs, is available at https://artsandculture.google.com/exhibit/staatsoper-unter-den-linden---architectural-history-deutsche-staatsoper-berlin/cgKyN9SR7aTlLg?hl=en (last accessed 9 September 2021).

23. The flytower built in 1910 was kept during this process.

24. This is the deadly air raid on 3 February 1945 that also hit Alexanderplatz on the other side of the river. Therefore the renovated opera stood intact only for 26 months. Three bombs, and the fire they caused, heavily damaged the theatre hall but left the front portico and Apollo Hall more or less intact.

25. First post-war DEFA films including Wolfgang Staudte's *The Murderers Are Among Us* (1946) are exhibited in the *Admiralspalast*.

26. Wagner, Strauss and Verdi operas were often included in opera programmes during the Nazi years.

27. The previous storage building (*Magazin* since the mid 1950s) was turned into a rehearsal centre for the orchestra, choir and the ballet.

28. The magician brothers' work is well documented in Wim Wenders' *A Trick of the Light* (*Die Gebruder Skladanowsky*, 1995) made in tribute to the centennial of cinema.

Alone in Berlin (2016)

12

Once upon a Time: Memorialization

Jason Bourne: I know who I am. I remember everything.
Nicky Parsons: Remembering everything doesn't mean you know
everything.

Jason Bourne (2016)

Along with demolition, memorialization is one of the most frequently employed urban strategies used for the shaping of urban memory, not only in Berlin but also worldwide. This chapter discusses the conscious creation of architectural forms for the sole purpose of remembering the past – memorials. A memorial is a physical entity 'preserving the memory of a person or thing; often applied to an object' (Oxford 1978: M-330). Unlike the other strategies discussed throughout this book, the process of memorialization is a deliberate effort to create a new construction that adds to the contemporary memory of the city by referring back to its past. Historian Pierre Nora (1989: 8) explains the difference between history and memory, while delineating his widely referred term 'sites of memory' (*lieux de mémoire*):

> Memory is life, borne by living societies founded in its name. It remains in permanent evolution, open to the dialectics of remembering and forgetting [...]. History, on the other hand, is the reconstruction, always problematic and incomplete, of what is no longer. Memory is a perpetually actual phenomenon, a bond tying us to the eternal present; history is a representation of the past.

By extension, memorialization, the act of memorial-making, is not simply a representation of the past, but the process of being 'perpetually actual', the process, as Nora states, of 'tying us to the eternal present'. If memory is a process, a memorial can be said to be a product of that process at a certain present. As explained by sociologist Elke Grenzer (2002: 94), 'the appearance of the past in the present is

a socially constructed phenomenon that dramatizes commemoration as an imaginary terrain for capturing the past from the distance of the present'.

The urban strategy of memorialization is not about monuments, which are similar to, but different from memorials. While both memorials and monuments are a way of scrutinizing and possibly politicizing the past, there is a subtle difference. As elaborated by anthropologist Michael Rowlands (2001: 131–32), a memorial reminds society to recall its memories and 'moves people to remember as much as possible', whereas a monument seems to move people to forget as much as possible.[1] A monument is a 'storage medium of elapsed memory' (Autenreith and von Boekel 2019: 157). It presents itself as resolute and determined, as eternal and unchanging. Monuments could be said to be constantly forgetting in order to remember, persistently suppressing unresolved memories, whereas memorials could be said to never forget in order to remember, repeatedly raising unresolved memories, or reopening old wounds.

Memorials have been created in those societies that have wished to remember the past. They recall both events and people, and the most common type is a sign that marks the location of physical remains – a gravesite. Some tombs and mausolea can be quite elaborate, and memorials found in the urban environment are usually larger and more complex than a simple gravestone. Such constructions can take the form of plaques, sculptures, statues, street furniture and even entire buildings.[2]

Memorials are not only constructed for particular individuals but can also be purposely linked with other identities such as ethnicity, gender, profession, political beliefs and nationality. Memorials are also created to commemorate traumatic historical events such as battles, assassinations, mass murder, industrial accidents and natural disasters. Whatever the size, complexity, identity or dedication of a memorial, its purpose remains the same: to attempt to keep a memory alive throughout the coming generations after its installation. Memorials are apparatuses of making, remaking and preserving memory through physical artefacts of the built environment. They literally concretize, in built form, the intangible concept of memory.

Memorials are reminders. They are also fluid. Thus, memorials tell spatio-temporal and political stories. Since memories belong to a past time but are experienced in the present, the spatial quality of a memorial is always accompanied by a temporal attribute. Memorials (re)shape the past from the perspective of the time they are built and with a specific vision or agenda for the future. Therefore, memorials are rarely inclusive: most are commissioned by nation-states and they usually represent the beliefs of specific groups in the society. Could there be a memorial for the Holocaust that is appreciated by all Jews, Germans and neo-Nazis?

In the 1980s, parallel with the rise of the post-modern attitude that the past must not be innocently revisited (Eco 1984: 65), a type of memorial

called 'counter-monument' (*Gegen-Denkmal*) arose in Germany and around the world. As defined by the founding Director of the Institute for Holocaust, Genocide, and Memory Studies at UMass Amherst, James E. Young (1993: 28), a counter-monument is 'against the traditionally didactic function of monuments, against their tendency to displace the past they would have us contemplate – and finally, against the authoritarian propensity in all art that reduces viewers to passive spectators'. Young presents several German artworks as counter-monuments,[3] while the Vietnam Veterans' Memorial in Washington, DC (Maya Lin 1982) pre-dates these and provides a more spatial experience.[4]

Berlin is no different from any other world city in terms of the appearance of memorials within its landscape.[5] One of the first colossal Berlin memorials was architect Karl Friedrich Schinkel's Prussian National Memorial for the Liberation Wars (*Preussisches Nationaldenkmal für die Befreiungskriege*, 1818–21). Commissioned by King Frederick William III, this cast-iron Gothic spire structure decorated with statues is dedicated to military and civilian Prussians who lost their lives in the 1813–14 War of the Sixth Coalition.[6] Atop its spire is an Iron Cross, which, because the memorial is on a hill, subsequently gave the name to the surrounding area, *Kreuzberg* (literally, 'cross-mountain'). Typical of memorials at this time, the war is not mourned for its loss of life but celebrated for its dissolution of Napoleon's tyranny.

In 1915, a memorial to the dead in the ongoing war was installed in the *Königsplatz*, fronting the Reichstag, which took the form of a 12 m wooden statue of general Paul von Hindenburg. This was part of a German tradition of 'nail figures' into which people would bang nails to show their solidarity. As one of the largest nail figures ever produced, this statue required a three-storey scaffolding around it to allow access for nailing. Historian Susanne Brandt (2004: 62) explains, 'Civilians as well as soldiers bought nails – sometimes of silver or gold – which were used to cover the wood with a literal and symbolic metal surface'. The temporary structure created a participatory memory-making experience, one in which the public felt that they were contributing to the war effort.

Memorials concerned with issues that arose between 1933 and 1989 make up the bulk of remembrance structures in contemporary Berlin. As early as 10 May 1933, a mere four months after Hitler became Chancellor of Germany, a book-burning ceremony was held in *Platz am Opernhaus* (*Bebelplatz* since 1947), next to the State Opera. As simulated in *Christopher and his Kind* (Geoffrey Sax 2011) and many other period films set in 1930s Berlin, the German Student Association organized and carried out this event, the first of many to come, in which it is estimated that 20,000 books were lost. In 1995, artist Micha Ullmann installed a memorial to the 1933 book burning entitled 'Sunken Library' (*Versunkene Bibliothek*). Set into the ground, this memorial is an empty room with equally

empty bookshelves visible through a glass ceiling that is at street level. An eerily prescient quote from Heinrich Heine can be found nearby on a metal plate: 'That was but a prelude; where they burn books, they will ultimately burn people as well'. Young (1999: 6), discussing the memorial's impact, states 'the shelves are still empty, unreplenished, and it is the absence of both people and books that is marked here in yet one more empty memorial pocket'. The power of Ullmann's memorial in reminding visitors of the book burning is derived from absence, not presence. The inaccessibility of the underground room feels like it is in the past, buried away, yet we can still see the void it left.

In 1991, the Schöneberg Borough of Berlin opened a competition for a memorial to commemorate the absent Jewish population in their Bavarian Quarter.[7] Artists Renata Stih and Frieder Schnock's winning proposal 'Places of Remembrance',[8] installed in 1993, consists of eighty 50 cm by 70 cm signs attached to light poles, particularly around Bayerischer Platz. On one side of each sign is a one-sentence summary of an anti-Semitic Nazi law, written in the present tense, with its date of validity.[9] On the opposite side of the sign is an image corresponding to that law.[10] These simplistically rendered colourful images, almost akin to a commercial advertisement, are the power of the memorial: in their graphic imagery, Stih and Schnock's signs appear as if they could exist in today's world (or at least the 1990s), but their content is clearly in the past.[11] These signs act as an urban

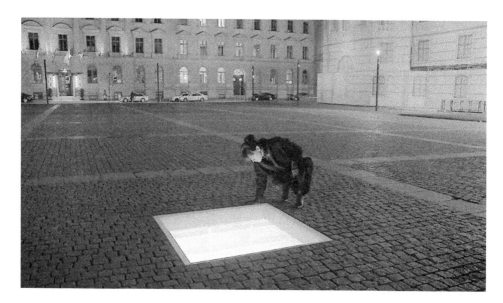

FIGURE 12.1: Experiencing Micha Ullmann's 'Sunken Library' in *A House in Berlin* (2014). (All illustrations are film stills captured by the authors.)

memorial because they are reminders to passers-by about a time in history in that very location when a certain population was not only treated differently but with contempt and disrespect.[12]

Architectural historian Kathleen James-Chakraborty (2018: 54) comments, 'Few societies have taken memorial culture as seriously as [...] the Federal Republic since the reunification of Germany in 1990.' This is particularly true with regard to the Berlin Wall. Memorials related to the Wall appeared almost as soon as it was constructed. The first was the 'Memorial for the Victims of the Wall' (*Denkmal für die Opfer der Mauer* 1961), erected on 17 June Street between the Victory Column and Brandenburg Gate. Others soon followed in West Berlin, especially to commemorate individuals who lost their lives attempting to flee the German Democratic Republic (GDR), including White Crosses (*Weisse Kreuze*, 1971) by Berlin Citizens' Association at the point where the GDR border switched from the south to the north bank of the Spree River.

There are three original sections of the Berlin Wall in their original locations: Bernauer Strasse, Niederkirchnerstrasse and the East Side Gallery. In 2004, it was estimated that there were 100 places in Berlin where the construction, victims or fall of the Wall were commemorated via plaques, signs, kiosks and crosses (Flierl 2006: 16). Throughout Berlin, the famous 1.2 m wide pre-fabricated wall pieces can be found. While these serve as reminders of the division, their incorrect placement can be deceiving. Other memorials, however, mark the exact former location of the Berlin Wall. Since 1996, a double-row of cobblestones with periodic bronze plaques inscribed *Berliner Mauer 1961–1989* has traced its former path for 5.7 km through the city centre. Installed by the Berlin Senate, this ghostly footprint reveals the sometimes strange placement and randomness of the Wall's location, emphasizing its unnatural urban existence. These stones are part of the Berlin Wall History Mile (*Geschichtsmeile Berliner Mauer*), which is a permanent exhibition consisting of 32 pylons that tell the stories of the division of Berlin, the construction and destruction of the Wall as well as its victims. These subtle but tangible urban additions serve the memory-making process in Berlin.[13]

While these are successful in reminding visitors about the former location of the Berlin Wall, they do not (and cannot) relay the brutality and absurdity of a national border fortification that ran right through the middle of the city, in addition to the individual situation(s) of the people on both sides. A commercial installation by artist Yadegar Asisi, entitled 'Berlin Panorama', comes close. Located in the former no-man's land at Checkpoint Charlie since 2017, Asisi's installation is a 15 m high and 90 m long hyper-realistic mural mounted on the inner surface of a drum. It is a snapshot of the Kreuzberg corner of *Sebastienstrasse* and *Luckauer Strasse* sometime in the 1980s. Complete with squatted tenements hanging ragged protest banners, an empty plot with a petting zoo, GDR watch towers with guards and the Wall making a strange

90-degree turn,[14] this mural can be viewed from ground level or from the scaffolding that puts the visitor at about 5 m high.[15] From this scaffolding, the mural envelopes the visitor. Like an analogue version of a virtual reality model, the scene depicts both the eastern and western sides and what it was like when the Wall was still standing: on one side a grubby, rough-around-the edges Kreuzberg, and on the other side an empty no-man's land with grey, seemingly lifeless buildings beyond.[16] When not packed with tourists, 'Berlin Panorama' gives the visitor a moment, away from crowded city streets, to remember or imagine the sense of living in divided Berlin.

The filmic version of such a realistic immersion is shown in the lobby of Asisi's Berlin Panorama: a documentary made from 50 hours of footage privately filmed in and around the Wall between 1960 and 1990. Entitled *Up to the Border: The Private View of the Wall* (2012), directors Claus Oppermann and Gerald Grote edited bits and pieces of 250 amateur films that they collected from Germany, Austria and the United States. The documentary looks at Berlin and the condition of living there during the division, with a personal eye from the past. For example, one scene shows two women casually chatting on either side of a 1 m high Berlin Wall sometime in 1961, while another is similar to Asisi's depiction of the GDR guards monitoring the situation with binoculars from their towers. The film, therefore, represents individual memories of the Wall period collectively and critically, but at the same time on an intimate scale.

Artist Juan Garaizabal's *Memoria Urbana Berlin* (2008) is an illuminated steel frame marking the three-dimensional outline of the Bohemian Church (*Böhmische-Bethlehem Kirche*, 1735) near *Zimmerstrasse*. Like the lost church, it almost disappears in daylight and reappears at night. The original church, the former centre of the Czech community in Berlin, was severely bombed in 1943 and demolished after the building of the Wall. Originally meant to be a temporary installation, Garaizabal's project turned into a permanent memorial as the artist conducted extensive research to find historical images and architectural drawings ensuring the outline was exact. Since the church was built for religious refugees, Garaizabal conceived of his project 'as a symbol of tolerance and a memorial tribute to immigration' (Arandelovic 2019: 51). Though not every passerby pays attention to the history of this memorial, its appealing nighttime lighting at a central location and clear message (that it outlines a lost building) make it a part of urban memory.

Berlin's newest memorial entitled Monument to Freedom and Unity (*Freiheits- und Einheitsdenkmal*) broke ground in May 2020.[17] Located immediately west of the Humboldt-Forum (the reconstructed *Stadtschloss*), this memorial aims to commemorate the peaceful revolution of 1989 that brought about the dissolution of East and West Germany, and the German reunification. Designed by choreographer Sasha Waltz and scenographer Johannes Milla, the memorial is a gigantic seesaw that is capable of gently being rocked when several hundred people visit it. Oversized letters spell out the well-known slogan from the 1989 protests, 'We are

the people. We are one people'. The underside of the seesaw is adorned with gilded photographs from the fall of the Wall. The metaphors are quite clear: first it takes an entire society, or a number of individuals working together, to 'make things move'. Second, the events of 1989 are in the past but provide a base that can be viewed when needed – for today and the future.

Memorial to the Murdered Jews of Europe

If you acknowledge your dark side, and make amends for it, you can free yourself to be a better people and do well by others.

Michael Moore in *Where to Invade Next?* (2015)

The Jewish Museum Berlin (competition 1989, completion 2001), which extended the Berlin Museum,[18] is Daniel Libeskind's contribution to the memorialization of the Holocaust in Berlin.[19] As part of this project, the Polish-American architect designed a Garden of Exile, accessed through his zig-zag building, as a memorial for the Jews who were forced to leave Berlin. The 'garden', visible from the street, is square in plan and contains 49 tilted concrete columns, on a dense seven by seven grid, with olive bushes wildly sticking out of their tops.[20] This semi-enclosed exterior space, experienced on a sloped ground, produces an uncanny feeling for visitors as they encounter the narrow voids between the square pillars, digesting what the museum has to offer via its collections and thought-provoking architecture.[21]

A very similar design idea was implemented in the Memorial to the Murdered Jews of Europe (*Denkmal für die ermordeten Juden Europas*) by another Jewish-American architect, Peter Eisenman and American artist Richard Serra, who won a 1997 competition for the project. Also known as the Holocaust Memorial (*Holocaust-Mahnmal*), it is a vast urban installation on *Cora-Berliner-Strasse*, minutes away from Potsdamer Platz, the Reichstag and the *Spreebogen* government district. The biggest difference between these two design proposals is the level of abstraction in their projects. While both designs are highly conceptual and abstract, Eisenman and Serra's solution is stripped down to the basic design principles of form, material, light and experience so that it has the potential to commemorate whatever one sees in it.[22] Eisenman believes the memorial 'has posited a different modernist idea of abstraction, a different kind of autonomy, and a different idea of ground' (Eisenman and Brillembourg 2011: 68–69).

The idea for a Holocaust memorial in Berlin began as a grassroots initiative in West Berlin at the end of the 1980s and gained political support with the launch of two competitions. Television journalist Lea Rosh began a discussion for a Holocaust Memorial in 1988 following her work on a documentary about

the murder of Jews during the Holocaust and a trip to Israel. Rosh and historian Eberhard Jaeckel published a call-for-proposals in 1989 for a memorial via the citizens' initiative *Perspektive Berlin*. A working group called the Association for the Promotion of a Memorial to the Murdered Jews of Europe (*Förderkreis zur Errichtung eines Denkmals für die Ermordeten Juden Europas*) was formed to raise public interest, funds and political support.[23] In 1992, the new Federal Government and Chancellor Helmut Kohl agreed to build a memorial on a site to the north-west of the demolished New Reich Chancellery.[24] The Berlin Senate Department for Building and Housing organized an open competition in 1995, with guidelines defined mainly by the Memorial Association and received 528 entries.[25] The jury of 15, mainly from former West Germany, recommended two winners.[26] However, Chancellor Helmut Kohl, who showed firsthand interest in the project, and many other politicians, opposed both proposals based on personal preference.

In 1997, the Berlin Senate of Cultural Affairs organized a second, invitation-only, competition that included the designers of the top nine proposals from the first competition, as well as new international artists/architects. The five-member Finding Commission proposed two new winners out of the nineteen entries: the projects of Peter Eisenman/Richard Serra (New York) and architect Gesine Weinmiller (Berlin).[27] In addition, the jurors nominated the work of artist Jochen Gerz (Paris) and architect Daniel Libeskind (New York). 'The four had a simplicity and an aesthetic rigour lacking in most submissions to the original competition' (Wise 1998: 153). Following a heated public debate about the widely displayed nominations, the Eisenman/Serra project was favoured in 1998. At this stage, American sculptor Richard Serra left the project, after which Eisenman revised their initial design according to Kohl's recommendations.[28] Although this project had to be revised one more time, the newly-elected Bundestag approved the construction of a memorial in 1999[29] and decided to build Eisenman's second design supplemented with an information centre.[30] In 2000, the Memorial to the Murdered Jews of Europe Foundation (*Stiftung Denkmal für die ermordeten Juden Europas*) was established to work with Eisenman and Berlin-based exhibition designer Dagmar von Wilcken for the below-ground Information Centre. In 2002, an information platform on the vacant site displayed the finally approved project with drawings and tall banners, accompanied by an art exhibition, a concert, public talks and publications. Commemorations and several protests also took place in the contested space of the memorial site.[31]

Following budget approval,[32] design completion and the preparation of construction drawings and contracts, the erection of the memorial began in April 2003 and lasted for twenty months. Only one more major incident interrupted the project: subcontractor Degussa, which was to provide a paint-resistant coating for concrete surfaces,[33] had apparently previously supplied the Zyklon B gas used

by the Nazis in their concentration camps. Following parliamentary discussions, a continuation with this firm was decided, despite the fact that a cheaper Swiss alternative was available. The last slabs were assembled by the end of 2004, and the memorial officially opened in May 2005, exactly six decades after Year Zero. During its first six months, the 'Field of Stelae' welcomed about 350,000 visitors (*Stiftung Denkmal für die Ermordeten Juden Europas*,[34] 2020). It should be noted that this brief summary of the design process of this memorial, from initial idea to completion of the construction, is only the tip of the iceberg. When one goes into the details of conflicting ideas and countless obstacles that went on for years, the actualization of this colossal project feels like a miracle.[35]

Berliners, Germans, artists, experts and politicians had been openly discussing the representation and remembrance of the Holocaust (not just towards Jews, but also all affected groups including homosexuals, Roma, Sinti and people with disabilities)[37] in detail via public events, competitions and the media since 1998.[38] Aleida Assmann (2015: 209) calls this type of remembrance, when it happens on a transnational scale, 'dialogical remembrance'. Michael Wise (1998: 154) writes 'if a memorial's purpose is to be an antidote to forgetting, a means of ensuring continuous engagement with the Holocaust and its moral imperatives, perhaps the debate itself [within Germany] was far more effective than any physical monument'. Opening old wounds can be painful but healthy, and there were many different voices. That may be the main reason why

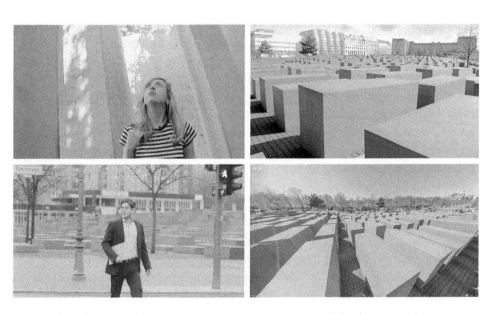

FIGURE 12.2: The Jewish Museum's Garden of Exile in *Berlin Calling* (2015), and the Memorial to the Murdered Jews of Europe in *Where to Invade Next?* (2015), *Berlin, I Love You* (2019), and as interactively experienced via www.YouVisit.com.[36]

Eisenman's abstract proposal has 'worked'. The architect agreed to multiple major modifications in his design, but he repeatedly refused to compromise its abstract nature. Calling his project, which is devoid of Jewish (and German) symbolism, the 'Field of Otherness', Eisenman states that he was interested in: 'what was it like to be other in space and time?' Like a child separated from her mother in a concentration camp feeling alone and lost. 'I wanted that feeling of being lost in space to inhabit the memorial. And you can feel dislocated from being' (2020).[39] The memorial does not teach visitors about the attempted genocide perpetrated by the Nazis; however, it does help them feel some of the negative sentiments that victims might have felt.

Eisenman's memorial is a new construction; it does not appropriate a Jewish or Nazi structure, or supplement a ruin. Neither it is on an authentic site. The memorial is contextual because its relationship with its immediate surroundings is carefully planned. Yet, the structure is also alien to its context because of its form and purpose. It is not a typical monument like a sculpture or an object to look at from certain angles, but a sculpturesque spatial installation – a counter-monument in Young's terms. About Eisenman's design, Till (2005: 168) writes: 'Individuals are asked to interpret a field that moves and changes in relation to the human body, rather than be told how to mourn for the past through a centrally placed sculptural form atop a pedestal.' Unlike other Berlin memorials, for instance, the *Neue Wache*, the Holocaust Memorial does not dictate or help visitors with how to interact with a difficult past, enabling society to create their own memories.

One block south of the Brandenburg Gate, Eisenman's Memorial to the Murdered Jews of Europe purposely creates an uneasy and disorienting landscape composed of 2711 dark-grey concrete pillars of varying heights and ground levels.[40] Part of the uneasiness results from the ability to easily get lost within the 19,073 m² memorial amongst countless slabs identical in width and depth. In addition, with their resemblance to tombs, one could argue that visitors are wandering around an abstraction of a cemetery, where the silence of the monoliths speaks loudly.[41] Its abstractness makes the memorial open to personal interpretation. In that sense, the memorial is democratic and international; it does not choose to be for a specific group, be it Germans, Jews or tourists. The memorial is indeed a German civil initiative for all Germans rather than Jews.[42] For that reason, the architect attempted to create a space that does not evoke guilt or shame. Eisenman explains:

> Anti-memory is different from sentimental or nostalgic memory, since it neither demands nor seeks a past [...]. But it is not mere forgetting either, because it uses the act of forgetting, the reduction of the former pattern, to arrive at its own structure or order. [Anti-memory] involves the making of a place that derives its order from the obscuring of its own recollected past.
>
> (Hornstein 2011: 51)

Eisenman's design creates a disorder with a paradoxically consistent grid of uneven columns unequal at the top and bottom, and sometimes at a slight angle (of 0.5°–2°). The 54 by 87 grid, which is amorphous at its edges, gives way to straight, narrow and long alleys with an ever-changing ground that purposefully promotes instability and insecurity, but also playfulness. Life in the city (the every day) happens at the end of each alleyway, but inside the depths of the stelae such 'every-day-ness' feel miles away.[43] The west ends of the alleys near the Tiergarten are lined up with two rows of trees.[44] Visitors can easily lose their orientation as they randomly turn right and left within the labyrinth. Alien to their context, the stelae are 2.38 m by 95 cm in plan, with varying heights from 0.2 to 4.7 m and are only 95 cm apart from each other. There is floor lighting at night, and the memorial is open 24 hours a day, seven days a week. It is a public space as well as a memorial, open to everyone. There is no entrance fee, and there is also no official entrance or exit, no signage or any plaques.[45]

Walking within this dense forest of columns, as the hustle and bustle of the city disappears, is akin to meditation. There is nothing to do other than proceed towards an internal journey on the wavy surface, hearing only one's inner voice, which is encouraged by the voicelessness of the faceless concrete slabs.[46] 'It is not about the pillars, it is about the field of this movement and the walking in it and feeling it' says Eisenman (2020).[47] The stelae stand between two undulating surfaces: the ground and the invisible horizontal surface connecting the tops of the monoliths. Stating that 'the ground erupts into figure', Hornstein (2011: 47) explains:

> [T]he ground is active, is itself a figure, and contributes to the dialectic relationship-ever-present- between the figure-as-ground and the ground-as-figure. [It] is never passive or mute but rather a vibrant and visible force engaged unequivocally in the work as part of it.

Eisenman favoured a single material for the stelae and maximized their non-representational character by choosing an almost immaterial material with a colourless, mat and smooth finish, carefully sanded.[48] Like natural landscapes, this human-made landscape of ghostly concrete looks and feels different in sunlight, rain and snow. About the abstract character of the memorial's concrete,[49] Eisenman notes:

> In the Holocaust Memorial in Berlin, the attempt was to use a non-iconic material. We didn't want stone, especially Jerusalem stone, which would evoke a place and time and have representational qualities. A concrete was chosen that was made to look like metal, the surface becoming close to being *not* concrete. The edges of the

corners were not beveled; there were absolute knife-edge corners to dematerialize the material and thus to create a sense of estrangement from the real and the everyday.
(Eisenman and Brillembourg 2011: 72–73, original emphasis)

In the absence of colour, texture, form, light, shade and shadow – as well as changes in them as time goes by – start to become noticeable. Trapped in this labyrinth of textureless geometric forms on a sloping ground, visitors often lose their companions – family and friends – after a while, akin to the experience of Jews in the 1930s, the only difference being that they, in most cases, did not see their loved ones again. Eisenman's artificial forest is not directly about the Holocaust, but the idea or image of it. Therefore, it does not try to educate the visitor but attempts to give them a feeling and remembrance of separation, loss, isolation, instability and alienation through tectonic experience and kinetic, tactile and auditory stimulation. This poetic participation can energize the imagination, promote reflection and self-search, even transformation, via a critical gaze, and enable embodied engagement and performance.[50]

'Its location, physical openness, newness and abstractness, besides its sheer size, make it a fascinating location for the staging, and performance of memory work' (Dekel 2013: 6). For architectural theorist K. Michael Hays (2017), 'the project constructs [...] critical memory, a kind of memory that is reflective, is contemplative' and Eisenman's use of abstraction is 'a response to the need for critical memory, or [...] a way of producing critical memory'.[51] Referring to Nietsche, Simon Ward (2016: 81–82) discusses 'critical memory value' stating 'the encounter with "place" generates a critical, unresolved understanding of the past'. Although Ward argues that the Information Centre, not the memorial itself, has a critical memory value (2016: 193), by questioning self-reactions to the 'artificial forest' above ground, visitors do actually critically reflect on their experience with a memorial that is linked to the Holocaust. That is, they make sense of the Holocaust on their own by creating their own meaning. This is not a passive learning and memory-making process, it is also not an interactive process, like opening drawers and pushing buttons in a museum. It is a participatory process: the visitor is challenged to experience the space and create a meaning hidden to others. Abstraction forces the visitor towards interpretation. 'The time of the monument', Eisenman says, 'is disjoined from the time of experience. In this context, there is no nostalgia, no memory of the past, only the living memory of the individual experience'.[52]

The multiplicity, or the lack, of an official entrance on the one hand gives visitors a freedom of experience. On the other hand, this lack pulls visitors into an uncanny world, catching them off guard as they lose their horizontal frame of reference while moving on the sloped ground. The fact that the memorial has no beginning or end, no central space or courtyard, and no planned directionality dramatically increases this uncanny feeling. Visitors who are able to find the staircase or lift hidden between the

stelae on the southeast end of the site can access the underground centre. As a later addition to the purely conceptual design, the centre complements the memorial by contrasting it. The coffered concrete ceiling of the 800 m² space, which mirrors the undulating ground above, includes horizontal versions of the monoliths as voids. The exhibition is composed of large horizontal screens that are buried in the ground flush with the floor, also resembling the proportions of the stelae. Similarly, prismatic benches, exits and embedded wall lights resemble the slabs above ground. Memorialization occurs almost on an unconscious level via spatial experience and individual reflection above ground, while it occurs via learning through image and text in the centre under the ground.[53] Both are quiet spaces.

Webber (2008: 14) refers to the site as 'an open space of remembrance'.[54] There is a group of visitors, though, that engages with the memorial solely on a physical level. For them, the experience of this unusual urban space becomes an enjoyable, even playful activity, maybe on a school trip or touristic break on the way to another museum or attraction. Unlike many who see recreational use as a desecration of the memorial, Eisenman encourages play and fun with his design and his words. Against his preference, two security guards patrol the site, which is clearly designed as a tourist attraction as well as a memorial.[55]

This project would probably not have been built if Eisenman was not an architect. Designers, unlike artists, are accustomed to applying multiple modifications to their initial proposals. There is just too much at stake and too many stakeholders in the manufacturing and construction industries. Eisenman is aware that his proposal co-designed with Richard Serra was severely changed, especially the discarded third version. However, like most architects who prefer built work over unbuilt projects, he proceeded anyway with the sole purpose of realizing the memorial. Having said that, architects generally do their best not to compromise their major design principles. If their list has twenty items for instance, in order of priority, they make sure that the top five (or so, depending on the design and designer) come to fruition in a built version of the project. In that context, after all the changes that occurred, Eisenman successfully kept his memorial's severe abstractness free of text and signage, its timeless, decentralized and maze-like atmosphere as well as its inclusive, inviting and open character, along with other qualities that make it a busy public space as well as a thought-provoking memorial.

Stumbling Blocks

Berlin is a strange, large city.
There are many reasons why a girl like you should simply vanish from the streets.
<div align="right">The gangster Halendar in The Man Between (1953)</div>

Walking through the streets of Berlin, especially in residential areas, pedestrians are quite likely to stumble across 10 cm by 10 cm brass plaques mounted onto cobblestones set flush into the pavement. Embossed into these plaques, usually beginning with the phrase *HIER WOHNTE* ('HERE LIVED'), would be the name, birth year and subsequent fate of a documented victim of Nazi oppression.[56] These fates range from 'escaped' to 'murdered'. Other fates include 'flight into death' (a euphemism for suicide) and 'fate unknown'. If a victim survived a concentration camp imprisonment, the term 'liberated', not survived, is used.[57]

These plaques, usually of the same size as the cobblestones surrounding them, are the work of artist Günter Demnig, whose father was a member of the notorious Nazi Condor Legion responsible for the bombing of civilians at Guernica during the Spanish Civil War (Apel 2014: 182). Demnig has named his project *Stolpersteine*, or 'Stumbling Blocks'. As of 2021, more than 75,000 Stumbling Blocks have been installed in 26 countries. Most of the individuals commemorated are Jewish victims of the Holocaust, but not all; several other groups persecuted by the Nazis are also represented in Demnig's blocks.[58]

Since the early 1970s, Demnig had been creating art in the public sphere. In the 1990s, he became interested in the fates of the Sinti and Roma populations of Cologne, whom the Nazis had also persecuted in addition to Germany's Jewish population. Demnig created several installations that involved tracing the path on which they were marched to the train station and eventually deported. In 1992, the Cologne city government commissioned the artist to make a more permanent piece to memorialize that event. He created a small 10 cm by 10 cm brass plaque entitled 'Himmler's Order' (*Himmler Befehl*) that was engraved with the 1942 Nazi law condemning Sinti and Roma to concentration camps and installed this on the pavement outside of Cologne City Hall. This artwork contained all the characteristics of the later *Stolpersteine*, including size, material, engraving, subject matter, public installation, except one: it was not dedicated to one particular individual.

This aspect would appear four years later in 1996 when Demnig participated in an exhibition entitled 'Artists Investigate Auschwitz' (*Künstler forschen nach Auschwitz*), which challenged artists to confront 'the impossibility of giving artistic shape to the inconceivable dimensions of the Holocaust' (Grimstad 2019: 109). Using the Kreuzberg District Museum's 1991 research on 'Jews in Kreuzberg', Demnig's contribution consisted of installing about 50 *Stolpersteine* into the pavement (without the local authority's permission) in front of the last-known residences of Jewish deportees who used to live on *Oranienstrasse*. These last two characteristics – dedicated to individuals and located in front of their former homes – make these plaques the first *Stolpersteine*.

Earlier in the decade, artist Christian Boltanski created a similar artwork to Demnig's *Stolpersteine*. Entitled 'Missing House' (1990), the piece utilized the

empty central portion of a residential building at *Grosse Hamburger Strasse* 15/16 that had been bombed in 1943 and then never rebuilt.[59] On both of the exposed walls of the remaining side wings, Boltanski installed plaques, 120 cm by 60 cm, documenting the tenants of each of the missing flats. The plaques were located at the corresponding level and position of each flat, giving the installation a uniquely spatial structure. The total number of flats was twelve, yet 24 plaques in total were installed. This is because Boltanski documented two sets of tenants: the original Jewish families and their German replacements who moved in after they were deported, but before the destruction of the building.

In 2000, the momentum to create more Stumbling Blocks began after a South-African descendant of Jewish refugees, Steven Robins, visited Berlin and saw Demnig's 1996 *Stolpersteine*. Robins then contacted the artist to create a pair for his aunt and uncle Siefried and Edith Robiniski (Richarz 2006: 330). Demnig obliged, installed them at *Naunynstrasse* 46, and then more and more requests began to arrive. By 2006, 1300 *Stolpersteine* had been installed in Berlin. By 2017, 7000 *Stolpersteine* of the approximately 63,000 installed throughout Europe were in Berlin (Heyden 2020: 332).[60] The first Stumbling Blocks to be installed outside of Germany appeared in Vienna in 1997. The plaques, always inscribed in the local language, became widespread in Europe, starting in the Netherlands and Hungary after 2007.

The tremendous interest in the Demnig's plaques can be explained in several ways. Firstly, they 'localize collective memory' (Gould and Silverman 2013: 793). By placing his stones within the everyday realm of the streetscape, Demnig is shaping memory in a decentralized way. As opposed to other memorials in which visits are mostly pre-arranged and exist only in one location, Demnig's *Stolpersteine* can be found all throughout Berlin and in various other European cities. There are no signs announcing their locations and no definitive maps indicating where to find them, although there are websites and mobile phone apps that are dedicated to doing so.[61] Whether seen once while passing by as a tourist or seen every day while leaving home, Demnig's *Stolpersteine* bring Germany's Nazi past into the present. They are a form of 'active commemoration' that engages the public in the memorial process (Heyden 2020: 335). In doing so, they are true memorials that work 'not to forget' in the daily routine of the city.

A second reason for the public's great interest is the personal connection that some people, especially descendants like Steven Robins, have with the small stones. *Stolpersteine* can be initiated by anyone, although an attempt to locate descendants is strongly recommended. People who live in a victim's former apartment building and individuals who identify with the particular reason for victimization (ethnicity, sexual orientation, political affiliation, etc.) have also been known to commission

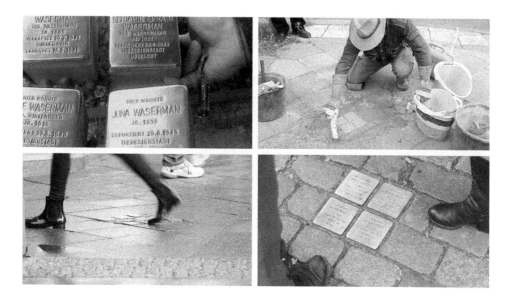

FIGURE 12.3: Stolpersteine in *Berlin Calling* (2015), *Where to Invade Next?* (2015) and *Berlin, I Love You* (2019).

Stolpersteine. School classes are welcome to initiate *Stolpersteine* because, in addition to paying a small fee for materials and labour, the process involves carrying out the research to document the exact location for the plaque, birth and death dates and the eventual fate of the individual.[62] During this process, many more details usually emerge about a person's life and it has been observed that many people who initiate *Stolpersteine* and subsequently carry out the research refer to the individual as 'my/our victim' (Apel 2014: 186), again revealing the personal dimension to the project. The actual installation of a *Stolperstein* has become a special event that is taken seriously by locals. In addition, an entire network of organizations and clubs has emerged whose sole purpose is to maintain the blocks, periodically cleaning and shining them, sometimes in the manner of a celebratory festival. In this way, Demnig's project ingeniously ties together the contingents of memory producers, memory consumers and memory maintainers (Heyden 2020: 334). On the other hand, some critics have equated the purchasing of a *Stolperstein* to buying off one's guilt, like the sale of indulgences by the Catholic Church (Apel 2014: 191).

A final reason for the great interest in Demnig's project is that the individual plaques 'successfully appeal to the contemporary association of authentic memory with an avoidance of ritual' (Harjes 2005: 149). That is, keeping in mind that these blocks are Demnig's artworks, not an institutional programme to commemorate

these victims, their popularity is also explained by the way that they are a link with the past that is not a pre-written script from a textbook or government-sponsored memorial. 'They claim to offer a more open, more democratic path to collective memory in which the citizens themselves develop a conception of national identity and historical responsibility from the bottom up' (Harjes 2005: 144). In fact, Demnig's Stumbling Blocks say so little that, like an abstract work of art, they can be interpreted according to the audience. A German might wonder about their ancestors and how much complicity, even passive, they possibly had in the deportations. An immigrant might be reminded of the struggles they experienced to end up in their new home. A tourist might realize that the city they are visiting might have been a much different place before the Second World War.

Michael Moore's 2015 documentary *Where to Invade Next?* praises the *Stolpersteine* for their role in not allowing us to forget about the people who were taken away and killed. In Josef Rusnak's 'Transitions' segment of the film *Berlin, I Love You* (2019), an Israeli tourist locates the former Berlin address of her 95-year-old grandmother who survived the Second World War, and in front of the apartment building literally stumbles upon the *Stolpersteine* of those from her family who did not survive. When asked by her German acquaintance 'How in the world can you come here, to this city, with all these bad memories?', the tourist matter-of-factly replies 'I don't have these bad memories', cleverly revealing that the Stumbling Blocks represent different things to different people who are yet equal generations distant from those tragic events.

'The *Stolpersteine* form a part of a memorial landscape which can be described as a mental-material pattern or structure, connecting spaces, objects and memories' (Volmert 2017: 10), but not everyone has so heartedly embraced Demnig's project. As opposed to the first illegal installations back in the 1990s, Demnig will not install a plaque without permission from the local authority, which is another responsibility of the initiator.[63] Sometimes negotiations are required with apartment building dwellers who fear that the plaques will attract Neo-Nazi violence or lessen the value of their property (Heyden 2020: 335). Some *Stolpersteine* have been stolen by extremists of all kinds who see them as a threat to their beliefs, and Demnig has replaced many of these over the years (Richarz 2006: 335). The most formal rejection of Demnig's project has come from the city government of Munich, 'thereby adhering to a position taken by Charlotte Knobloch, the former president of the Central Council of Jews in Germany, who finds it unacceptable that people step on the names of the dead' (Apel 2014: 183).[64] Indeed, because Demnig's *Stolpersteine* are permanent markers with individual names, birth years and death years, they do resemble gravestones, especially more so because the individuals being commemorated most likely do not have an actual gravestone of their own anywhere else in the world.

Demnig's motto for his *Stolpersteine* project can be found on his website: 'One stone. One name. One person', reinforcing the individuality of each of the plaques.[65] Although the lettering on each stone is created with industrially produced letter forms, it is Demnig himself who hits the hammer to make an impression on the brass. The spacing between letters and the straightness of the words is obviously done by hand because sometimes the letters are crooked, sometimes the spacing is uneven. It is a question if Demnig does this on purpose or not, especially after his comment that 'Every stone has to be made by hand so that the individual returns' in Dörte Franke's documentary *Stolperstein* (2008).

Now that so many *Stolpersteine* have been laid, the question of saturation and over-exposure can readily be raised:

> We must ask ourselves how many stumbling stones may a given urban space contain without risking memorial inflation, burdening its users with the cognitive effort of remembrance. Are there limits to the numbers of them that may be placed per square kilometre in urban space?
>
> (Carrier 2016: 66)

Or rather, should there be such limits? Demnig cannot possibly produce an individual stone for every single victim of Nazi persecution, at least not in his lifetime. Since 2005, artist Michael Friedrichs has been helping Demnig in making the many *Stolpersteine* produced each year (Cook and van Riemsdijk 2014: 140). This then begs another question: after Demnig is no longer able to create and install *Stolpersteine*, will this project continue in the form of a non-profit organization or stop altogether? Whatever the final destiny of Demnig's project, it has succeeded in creating a decentralized memorial that not only reminds passers-by of the past but also enlarges the definition of authentic site from places like the *Führerbunker* or Gestapo Headquarters (Topography of Terror) from which the perpetrators functioned: it reminds us that the Nazi terror did not stop at the ministry buildings but seeped into everyday life, even into the homes and private lives of people.

Philosopher Henry W. Pickford (2005: 169) succinctly summarizes the relationship between Berlin's present-day built environment and its past when he says, 'Each time a[n unexploded] bomb is located, construction sites are blocked off, traffic is rerouted, whole apartment buildings are cleared, and the vintage ordnance is defused [...]. The past continues to send its own material memorials to posterity'.[66] There are around 4000 Turkish döner kebab shops in Berlin, which is more than in populous Istanbul (Khalil 2017), and the number of memorials in the city exceeds this amount. Six hundred new memorials have been added to Berlin's existing repertoire of sites, monuments, museums, cemeteries, statues and plaques since the reunification (Grenzer 2002: 94). The last three decades can be considered as the era of memorials

in Germany, especially in its reinstated capital. For the last century since Maurice Halbwachs, memory scholars have been emphasizing the connection between memory and the built environment, and Berlin's embracing of existing and new memorials is a result of this close relationship. Intangible memories gain embodiment and representation in the physical presence of memorials. Urban memory can *dwell* in a memorial.[67]

NOTES

1. Discussing the topic of war memorials, the full citation from Rowlands (2001: 132) is: 'we have two radically different visual modes of forgetting at work: one that promotes ambivalence and moves people to remember as much as possible of what suffering meant to the victims, and another that effectively transforms suffering into something else – a form of collective validation that transcends personal trauma.'

2. Shanken (2002) identifies these as 'living memorials': Memorial libraries, schools, stadiums, bridges, airports, etc.

3. Young refers to the work of Jochen and Esther Gerz (the disappearing *Monument against Fascism*, Hamburg 1986–91), Alfred Hrdlicka (*Hamburg Firestorm* 1985), Norbert Radermacher (*Neukölln Light Projection*, Berlin 1994) and Horst Hoheisel (*Inverted Aschrott Fountain*, Kassel 1985).

4. This memorial consists of two walls making a V-shape sloping downward towards the middle, while the tops of the walls remain constant, making it seem to dig into the ground. The polished black granite cladding of the walls are engraved with the names of approximately 58,000 US casualties of the Vietnam War (1963–73). Referring to this memorial, art critic Arthur Danto (1985: 152) comments 'memorials ritualize remembrance and mark the reality of ends' whereas 'monuments commemorate the memorable and embody the myths of beginnings'. Visitors' ritualized remembrance includes searching for the names of loved ones, taking rubbings and leaving remembrance trinkets. The extreme shininess of the wall functions to reflect the image of the visitor back upon themselves, creating a simultaneous reading of the past and present.

5. For a historical survey of post-war memorialization practices in East and West Berlin, see Jordan (2005).

6. Johann Heinrich Strack supplemented Schinkel's memorial with an octagonal stone base in 1878.

7. A 1933 census counted 16,261 'Germans of Jewish faith' who lived in this residential district, mostly in the Bavarian Quarter (Till 2005: 156).

8. The full title of this project was 'Places of Remembrance in the Bavarian Quarter – Exclusion, Discrimination, Expulsion, Deportation and Murder of Berlin Jews in the Years 1933 to 1945' (Koss 2004: 116).

9. In the 1930s and 1940s, the Nazis would enact a series of laws specifically aimed at Germany's Jewish population, at first only restricting such activities such as the usage of

certain park benches, but later prohibiting Jews from practicing specific occupations. These laws gradually curbed the Jewish population's rights until eventually forcefully removing them from society and ultimately killing them *en masse*. Sample laws range from 'Jews are excluded from choral societies. 16.8.1933' to the restrictive 'Jews in Berlin are only allowed to buy food in the afternoons from 4 to 5 pm. 4.7.1940' to the downright prohibitory 'Jews are no longer allowed to buy newspapers and magazines. 17.2.1942'. Conversely, in order to look good while hosting the 1936 Olympics in Berlin, a law was passed that read 'In order to avoid a bad impression on visitors from abroad, signs with extreme content should be removed; signs like "Jews are not wanted here" are sufficient. 29.1.1936.'

10. Such as musical notes for a choral society exclusion, a loaf of bread for a shopping hour restriction and an 'Extrablatt' masthead for a newspaper/magazine ban.

11. This is why the present tense was used. Renata Stih explains

> If we had said that 'Jews were not allowed to buy milk', everybody would say, 'Yes, that was terrible back then'. But when we said, 'Jews are not allowed' – it created a scandal. People did not look at the date [on the signs] but said, 'This is incredible. How can someone post this?'

> (Till 2005: 158)

12. Stih and Schnock's 'Bus Stop!' proposal for the Holocaust Memorial Competition was equally creative in the way it attempted to decentralize the project site and utilize 'the everyday'.

13. Related to this is the Berlin Wall Trail (*Berliner Mauerweg*), which is a 165 km hiking and biking trail in fourteen stages. Built in 2002–06 by the Berlin Senate Department for Urban Development, this trail follows the entire course of the GDR's border fortifications around West Berlin with informative plaques and stations to explain the situation during the division. Lastly, commemorating the rabbits who used to peacefully live in the no-man's land along *Chausseestrasse* (as narrated in Bartek Konopka's *Rabbit à la Berlin* 2009), artist Karla Sachse installed 120 brass plaques in the shape of rabbits in the road surface in 1999. Entitled 'Rabbit's Field' (*Kaninchenfeld*), this memorial is possibly driven over by many commuters each day who may not know nor remember that the rabbits ever lived there.

14. This street corner with a right-angled Wall, second possibly only to Checkpoint Charlie, was exemplary of the randomness and irrationality of the Berlin Wall. It featured in many 1980s films, such as Andrzej Żuławski's *Possession* (1981), Reinhard Hauff's *The Man on the Wall* (1982) and Manfred Stelzer's *Unlicensed Driver* (1983).

15. This scaffolding is reminiscent, but not exactly like, the wooden viewing platforms built in West Berlin to peek over the Wall, one of which is depicted in Asisi's mural.

16. Soundbites from famous speeches such as Walter Ulbricht's 'Nobody intends to build a wall' and John F. Kennedy's 'Ich bin ein Berliner', although informative and historically

correct, detract from the illusion of Asisi's Berlin Panorama, but this is balanced by the periodic simulation of nighttime that makes the installation more evocative.

17. *Mahnmal* (literally, reminding time) is the typical translation of 'memorial' into German. The word *Denkmal* can also be translated as 'memorial' because it is derived from *denken* (to think), and therefore can be literally translated as 'thinking time' or 'time to think'.

18. The original building on the site was the former Supreme Court (*Collegienhaus* 1735) damaged in the Second World War. Architect Günter Hönow's replica (1963–69) replaced the ruin with the Berlin Museum dedicated to the history of the city.

19. The Jewish Museum is one of Libeskind's first built work. Since then, he has designed multiple military or Jewish museums in Europe and elsewhere.

20. The voids inside the columns are filled with soil from Berlin, except the one in the middle that has soil from Jerusalem. This feature of the garden makes the design more representational and less abstract formally, while its direct link to the Jewish context of the museum makes the design more representational and less abstract conceptually.

21. The official website of the museum states

> [t]he slanting ground of the Garden of Exile gives visitors a dizzying feeling of unsteadiness and disorientation. The only vegetation is located high out of reach. Libeskind wanted this spatial experience to recall the lack of orientation and instability felt by the émigrés forced out of Germany.
> (https://www.jmberlin.de/en/libeskind-building, last accessed 24 January 2022)

22. This approach can also be observed in Eisenman's highly conceptual early work of numbered houses (his 'cardboard architecture').

23. It was important to include all victims from Europe since the majority of murdered Jews were from other countries, especially Poland and the Soviet Union.

> The act of building a memorial that includes every Jewish victim in every European nation [...] centralized Berlin's role as the adjudicator of this memory just as Germany was reestablishing itself as a key participant in the formation of the EU.
> (Grenzer 2002: 104)

This clarifies the state's interest in this 'mega-memorial', and what makes it a political artwork.

24. The eighteenth-century imperial gardens in the city centre that had become part of the chancellery were within the no-man's land of the recently demolished Berlin Wall. This was a compromise to the use of an authentic Nazi site for the memorial, for instance the site of the former Gestapo Headquarters (now Topography of Terror) or Hitler's chancellary.

25. It has been argued that some descriptions in the competition guidelines were too literal, such as the mention of the Star of David that gave formal clues to the participants and the encouragement to use the whole site, which may have influenced the competitors in a negative way (Till 2005: 175–79).

26. Simon Ungers with Christiana Moss and Christopher Alt (Cologne/New York), and Christine Jackob-Marks with Hella Rolfes, Hans Scheib and Reinhard Stangl (Berlin).

27. The only person of Jewish heritage (and foreigner) on the Finding Commission was American scholar James Young, who was an expert on Holocaust memorials. Referring to Young, Till writes:

> Memory, he argued, shouldn't just be preserved – it had to be created. He proposed that if Germans only preserve historic sites of National Socialism, then the process of remembering in the present is defined by the historic Nazi plan and structure only. A centrally located memorial at a symbolic site, in contrast, might offer a contemporary interpretation of the violent legacy of the German nation.
>
> (2005: 166)

In a way, this approach to memory-making justifies the variety of urban strategies that have been implemented in Berlin.

28. Serra, who was an invited international participant of both competitions, did not agree to compromise the design principles he and Eisenman set at the beginning, such as the heights and number of stelae (https://www.nytimes.com/1998/06/04/arts/serra-quits-berlin-s-holocaust-memorial-project.html, last accessed 23 July 2020). Finalist Jochen Gerz also withdrew from the competition.

29. The parliament first voted whether to build or not to build a memorial at all, which means that, if rejected, there would be no Holocaust memorial in Berlin.

30. Holocaust scholar Peter Carrier (2005: 124) refers to the criticism about the supplementation of Eisenmam's spatial installation with an information centre as 'a lack of public trust in the "silent message" of art alone'.

31. By the Bundestag and the Jewish Community.

32. This was the first time ever in German history that a grassroots organization, the Memorial Association, financially contributed to a project funded by both the Federal Republic and the City of Berlin.

33. The authorities were worried about Neo-Nazi vandalism. In fact, Swastikas and anti-Semitic slogans were drawn on the stelae multiple times shortly after its opening.

34. In this detailed chronological history, the foundation curiously fails to mention a Nazi bunker found on the site. In 1997, construction workers discovered a 300 m² three-room structure 2 m underground as part of the residence that belonged to Hitler's propaganda minister Joseph Goebbels and was demolished in the war. Although the Information Centre of the memorial is also underground, the bunker was not incorporated into the memorial

in one way or the other; it stayed buried underground (https://www.chicagotribune.com/news/ct-xpm-1998-01-26-9801270081-story.html, last accessed 10 September 2021).

35. This structure is not Eisenman's first project in Berlin. He previously designed Block 5, an IBA social housing project beside the Berlin Wall, which includes the Wall Museum: Haus am Checkpoint Charlie (1985–86).

36. GoogleMaps StreetView has allowed us to see other places from the comfort of our internet-connected devices, but there is still a certain detachment to that experience that cannot be replaced by visiting the actual location. Through the use of recorded moving imagery, https://www.YouVisit.com gets closer to 'the real thing', but is still a screen-based experience separate from one's body. A recently developing trend, in both Berlin and elsewhere, is the availability of virtual reality offerings which literally surround the visitor and simulate experiences that no longer exist. TimeRide Berlin and the MauAR app have already been mentioned, and currently there is the chance to be a prisoner in the Stasi-Investigation Centre Berlin-Hohenschönhausen or visit artist Max Liebermann's home and studio destroyed in the Second World War (https://www.visitberlin.de/en/blog/11-tips-virtual-reality-experiences-berlin, last accessed 14 September 2021).

37. There are three official memorials to commemorate Nazi victim groups in Berlin, built after Eisenman's memorial: The Memorial to the Homosexuals Persecuted under the National Socialist Regime by artists Michael Elmgreen and Ingar Dragset (2008), the Memorial to the Sinti and Roma Victims of National Socialism by artist Dani Karavan (2012) and the Memorial to the Victims of the Nazi Euthanasia Murders by architect Ursula Wilms, artist Nikolaus Koliusis and landscape architect Heinz W. Hallmann (2014). 27 January, the liberation of Auschwitz, has officially been the Day of Remembrance of the Victims of National Socialism in Germany since 1996; again, half a century late. In 2005, the United Nations declared 27 January as the International Day of Commemoration in Memory of the Victims of the Holocaust.

38. This was mostly owned by the former West Germany for various reasons but why did the memorial and its debate come so late? Ladd calls it an 'anti-national monument' because the memorial is an official acknowledgement of Germany's six-million Jewish 'victims who died at the hands of the fatherland'; it is an architectural admittance of a genocide (2000: 15, 17). Differently, dealing with the Nazi past was never a priority for East Germany because the Third Reich was seen as a predecessor to the capitalists and was then defeated – end of story.

39. *Peter Eisenman Interview: Field of Otherness* (2020) (https://www.youtube.com/watch?v=Uggl6a1FLng, last accessed 23 July 2020).

40. Differentiating between 'architectural and sculptural site-specific projects', Eisenman states his vast urban installation belongs to the latter (Eisenman and Brillembourg 2011: 68).

41. It is a question of whether Stanley Kubrick's silent monolith in *2001: A Space Odyssey* (1968) was an inspiration for Eisenman's stelae.

42. Referring to the (second) competition, Carrier (2005: 118) states that the problem was 'based on the demand that a single monument should embody the whole nation's memory

of the genoside against the Jews during the Second World War, and on the consistent demand for consensus'.

43. This infinite space is similar to the prison with no walls in George Lucas' first film *THX 1138* (1971). In this film, the inhabitant feels trapped rather than liberated in this endless space.

44. These pine, lime and antler trees are another later addition to the project, with which Serra disagreed.

45. The site is wheel-chair accessible, which is one of the reasons why the number of pillars, which was more than 4000 in the original design, dropped to around 2700 in the final project.

46. In its first years in the 2000s, this new way of commemoration by participation *in* the memorial and making sense of it in person without being told what to do took some getting used to (Dekel 2013: 20).

47. https://www.youtube.com/watch?v=Uggl6a1FLng (last accessed 23 July 2020).

48. After tapping the stelae in front of and then behind him in a documentary by German-American architectural filmmaker Michael Blackwood entitled *Peter Eisenman: Building Germany's Holocaust Memorial* (2005), Eisenman talks about the tactile quality of his design, which is there to be experienced by feeling rather than seeing. The hour-long documentary also reveals the feelings and impressions of politicians, academics and Berliners to the memorial, in order to compile collective reactions to this site of memory.

49. The abstract nature of the installation is open to many interpretations. The gradual change of the slope and the rigid form could resemble the slow change of Germans' attitude towards the Jews between the world wars, from dislike to persecution. The almost-identical upright grey slabs may also remind visitors of the horrific photographs from concentration camps of malnutritioned prisoners with grey ragged clothing and hair cut short, looking almost identical.

50. Rachel Mumma (2015) describes her experience

> As you wander further into the memorial, the stelae begin growing taller, and the ground slopes downwards until the memorial consumes its visitors. Walking through concrete alleyways creates a feeling of being trapped, with only the choice to keep moving forward or go back.

51. https://www.youtube.com/watch?v=bMhhTyJBRpo (last accessed 28 July 2020).

52. https://eisenmanarchitects.com (last accessed 29 July 2020). Elsewhere, Eisenman opens up this approach further:

> Remembering the Holocaust can only have a living form in which the past remains active in the present. In this context, the monument tries to develop a new idea of memory that differs markedly from nostalgia. We suggest that the time of the monument, its duration, differs from the time of human experience and understanding. [...] The time of the experience of the individual does not grant further

understanding, because understanding is not possible. The time of the monument, its duration from its upper to its lower end, is separate from the time of its experience. In this context, there is no nostalgia, no memory of the past, only the vivid memory of individual experience. Today we can only understand the past through its manifestation in the present.
(https://www.stiftung-denkmal.de/memorials/memorial-to-the-murdered-jews-of-europe/?lang=en, last accessed 29 July 2020)

53. The information includes a Holocaust timeline from 1933 to 1941, and thousands of names of known Jewish victims in the *Room of Names*. The diversity of Jewish lives before the Holocaust is represented in the *Room of Families*, whereas the *Room of Dimensions* is about the mass of the killing. The *Room of Sites* displays where the killing took place in Europe, as well as continental memorial sites to visit. This central Berlin site was envisioned as a stepping stone to other memorials in the country and the continent, and this room aims to fulfil this need. Roughly, only one in every ten visitors to the memorial takes the time to go down to the Information Centre (Dekel 2013: 8).

54. He writes

[t]he field of stelae that makes up Eisenman's memorial for the murdered Jews of Europe is indicative of the project for an open city: a conversion of the empty space inherited from the violence and division of the twentieth century into another kind of open space; a conspicuous space of unbuilt prime real estate, an expensive graveyard in the purview of Potsdamer Platz that cannot be reclaimed by venture capitalism; and an open space of remembrance which, however, encloses the visitor and provokes uncanny psychosomatic memories of the city's past. Its exposure prompts a recall of agoraphobia (fears of the open) and the enclosure within a recall of claustrophobia (fears of hiding and imprisonment). It [initiates] psychically fraught spatial memory that haunts the combination of open and closed spaces.
(Webber 2008: 14–15)

55. This was not the case in the early 2010s when the authors observed many visitors climbing, sitting and jumping on the monoliths.

56. Exceptions might be made if a street no longer exists or if there is a reason for placing a *Stolperstein* in front of a place of employment for example. In such cases it might bear the heading HERE STUDIED, HERE TAUGHT, HERE WORKED or HERE PRACTISED (http://www.stolpersteine.eu/en/steps/#c325, last accessed 14 August 2020).

57. In German-speaking countries, the inscriptions are in German: *ERMORDET, FLUCHT, BEFREIT, FLUCHT IN DEN TOD* and *SCHICKSAL UNBEKANNT*. Intermediary fates include *DEPORTIERT* (deported), *ENTRECHTET* (disenfranchised), *GEDEMÜTIGT* (humiliated), *INTERNIERT* (interned) and *VERHAFTET* (arrested). *ÜBERLEBT* is the

German used for survived. *ZURÜCKGEKEHRT* (returned) is used if a person eventually came back to their country of origin. Each country uses its own native language(s) for their Stumbling Blocks.

58. Other groups persecuted by the Nazis and memorialized in Demnig's *Stolpersteine* include Sinti and Roma, homosexuals, the mentally disabled, Jehovah's Witnesses and Freemasons.

59. Boltanski was one of thirteen artists invited by the city of Berlin to create artworks in the city for a project called 'The Finitude of Freedom' (*Die Endlichkeit der Freiheit*). The artists were asked 'to describe the reality of East and West both in terms of unity and difference' (Solomon-Godeau 1998: 5). Instead, Boltanski focused on Berlin's Second World War past, pre-division. His artwork is one of two that eventually became permanent installations.

60. Other cities in Germany with large numbers of Demnig's plaques include Hamburg (5000) and Cologne (2500).

61. https://www.stolpersteine-berlin.de/en/finding-stolpersteine and https://map.stolpersteine. app/en, for example (both last accessed 11 December 2020).

62. Demnig started off conducting the background research himself but soon realized that the commissioners of the *Stolpersteine* should be responsible for the research instead.

63. The Kreuzberg District Government has retrospectively given permission for Demnig's first 1996 installations on *Oranienstrasse* to remain.

64. This ban in Munich only applies to city property, like streets, pavements and parks. Nothing can be done if someone wants to install a *Stolperstein* on private property, which Demnig has done twice in Munich (Richarz 2006: 331).

65. See http://www.stolpersteine.eu/en/home (last accessed 17 August 2020).

66. The late explosion of such a home-made bomb initiates the narrative in *What to Do In Case of Fire?* (Gregor Schnitzler 2001).

67. The authors of this book propose an immaterial Wall Memorial for Berlin: The trace of the dual layers of the 1980s Berlin Wall on the ground, or on buildings if no longer empty, with a permanent layer of blue light beaming towards the sky at night – one sweep of light for each wall defining the deathstrip. A somewhat similar temporary installation was put in place in Berlin for the twenty-fifth anniversary of the fall of the Wall. The 15 km long 'Light Border' (*Lichtgrenze*) by Marc and Christopher Bauder consisted of 8000 free-standing, biodegradable and illuminated balloons that occupied inner Berlin for three days and were released on 9 November 2014 (https://www.domusweb.it/en/art/2014/11/12/ lichtgrenze_lightwall.html, last accessed 19 February 2021).

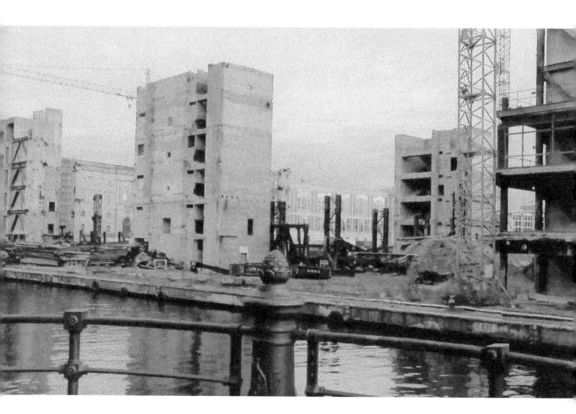

One Night in Berlin (2011)

Conclusions:

Berlin: Remember When ...

By the way: not forgetting means not letting go.
Ralph in *Solo Sunny* (1980)

If 'London is basically a nineteenth-century city' as author J.G. Ballard claims (Coverley 2006: 117), Berlin is fundamentally a twentieth-century city. 'Berlin is a microcosm of twentieth century European history; a city that still bears many of the signs and scars of its experiences and upheavals' (Mastin 2007: 29). The authors conducted fieldwork in Berlin for this 'book of change' in 2013, 2019 and 2020, which was two decades after Wilson practised architecture in the recently reunified capital city. On each visit, Berlin slightly morphed and continued becoming. Just before the COVID-19 pandemic, Kacmaz Erk held a residency at the ZK/U Centre for Art and Urbanism and, with Dublin-based filmmaker Paddy Cahill, organized an urban filmmaking workshop entitled *Framing Berlin's Urban Memory* to experiment on the relationship between the city and its memory via film-making. The workshop films were exhibited online at the ZK/U Digital Openhaus in May 2020.[1] Francois Penz, Richard Koeck, Laura Rascaroli and other esteemed reviewers commended and commented on the films.[2] In this workshop, participant Çağdaş Ozan Karabay, for instance, overlapped contemporary Berlin imagery in *A Stroll in Berlin* with the words of Otto-man author Ahmet Mithat, who visited the city in 1889 and wrote *Three Days in Berlin*. These workshop films contributed to the urban memory of Berlin at a pivotal moment in its history. Film scholar Laura Rascaroli commented:

[*A Stroll in Berlin*] choreographs image and sound to reveal the urban palimpsest. The distant past and the present moment collapse, so that we look at Berlin with eyes that are all at once historical and current. It's a syncretic temporality through which

291

we can appreciate both our proximity to and distance from the 1880s traveller, and his response to the city. And see two Berlins at once.

Two decades after the reunification of East and West Germany, historian Susan Buck-Morss (2010: 228) noted that 'the images of dazed and drinking Germans on top of the Berlin Wall gave the world a rush of freedom, but also provided little vision of the content of what was to come'. And how correct she was: that night was only just the beginning of what followed whereby Germany began to resolve for itself not only its division into two Germanies after the Second World War but also its Nazi past before that. While many intellectual and artistic fields participated in this process, the most visible and transforming were the changes that occurred in the built environment. As summarized by German scholar Andrew Webber, 'Since the Wende, the 'turn' of unification, the city has substantially rebuilt, reorganised, and re-imagined itself' (2008: 14). Berlin may not be the number one construction site of Europe anymore but it continues to transform through various urban strategies.

This process is not a novelty for Berlin, which had been undergoing similar changes almost constantly since becoming the capital city of the German Empire in the late nineteenth century. Having been scarred and healed multiple times since then, the city of Berlin is an open wound that has been surgically worked on throughout the past 125 years. Ever since the Skladanowskys made their first films in the city in 1895, Berlin has been disrupted, 'moved on' and had multiple unsettled pasts that it becomes confusing which past to remember; 'because these many layers of history have the potential to imbue Berlin's topography with meaning, every project must make choices about which history it preserves, protects, highlights and privileges' (Costabile-Heming 2017: 448).

This research has explored the process of memory-making that lies behind the erection, demolition or alteration of buildings, spaces and urban environments in Berlin and has concluded that mindful memory-works have been those that do not ignore the many physical (and psychological) layers and remnants in the city but acknowledge, embrace and even celebrate them. As Michael Wise notes (1998: 145):

> Memory, of course, has been at the heart of Germany's capital dilemma. The vexing issue of commemoration versus forgetting has been played out in both the city's new architectural projects and decisions about whether and how to preserve its older buildings.

This study has also shown that a strong link exists between space, time and memory. The perception of space is temporal, and it changes, just like space itself, over time. In the words of urban planner Michael Hebbert (2005: 592), 'Human memory is spatial. The shaping of space is an instrument for the shaping

of memory'. This perception is one of the generators of memory, and 'nowhere has discussion about the relationship between space and memory been more intense than in Berlin' (Bairner 2008: 419). Accordingly, the book has not taken a political or economic approach to what has occurred to/in Berlin over time, but an architectural filtering of its changes through the lens of urban memory. In doing so, it has brought together architecture, urban development, history and film locations, as the urban strategies practised in the city actively and repeatedly deconstructed and reconstructed the urban memory of Berlin. The way Guy Hamilton and Ryoo Seung-wan framed a version of Berlin with the exact same camera angle almost half a century apart (in a British and South Korean film, respectively) is a demonstration

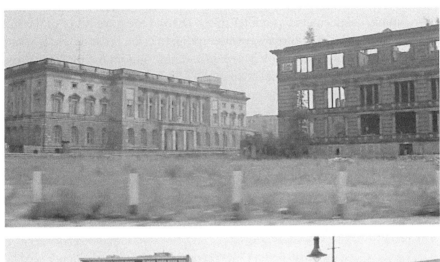
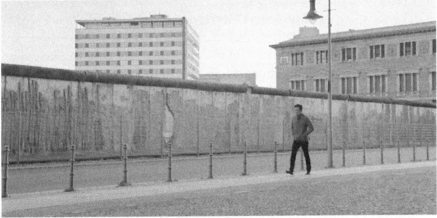

FIGURE C.1: The same places in *Filmstadt Berlin* appear and reappear over the years: The Martin Gropius Bau in *Funeral in Berlin* (1966) and *The Berlin File* (2013). (All illustrations are film stills captured by the authors.)

of the role of cinema as an audio-visual urban archive. This also demonstrates that Berlin and its memories constantly transform – in a state of becoming.

When reading any text about Berlin, attention needs to be paid to *at what particular time* that specific text was written, because how much of the city's history and memory the author is familiar with at the time of writing matters. Berlin is an ever-changing city, not just because of the German division but also the repercussions of two world wars, the Third Reich, Weimar Republic and the end of its imperial period. While Berlin is Germany's political capital, it is also its arts and media centre, with a thriving 'creative class' (Florida 2002), and a booming tourism industry. Rather than being reminiscent of one single film, each urban strategy in Berlin is like one thematic episode of a documentary series. The aim of this book was to frame these episodes so that binge-watching would not be so overwhelming, using cinema as a filter to see beyond the physicality of the many changes. In this way, the authors were attempting to bring order to what, at times, could seem like an uncontrollable wave of (tangible and intangible) transformations from an architectural perspective in the 2020s.

Berlin lessons

So, what have I learned after all this time?
After all the sleepless nights, lying to friends, lovers, myself?
Playing this crooked game in this crooked town filled with backstabbers and four-faced liars? I'll tell you what I've learned. One thing and one thing only: I fucking love Berlin!

MI6 Berlin Chief David Percival in *Atomic Blonde* (2017)

Thinking of the twelve urban strategies and twenty-four case studies explored in this book raises many questions. How can the erasure of urban memory be prevented? Can a city grow without demolishing its ruins and buildings? How to decide what to keep while clearing large areas of rubble? How to integrate new construction into a historical city? Can the *tabula rasa* approach be abandoned? Does new construction have the responsibility to consider the urban history and memory of its site and surroundings? How can memorial-making be inclusive for different groups in society? Are there any ground rules not to cross the line to Disneyfication when branding a city for international tourism? How to integrate new construction into a traumatic city? How to benefit from supplementation to keep an existing structure and engineer a fair transition from a sensitive memory? Tempelhof Airport's monumentality was deliberately hindered by the Allies who installed a very low suspended ceiling in the 15 m high entrance hall, drastically

changing the proportions of this dramatic space – to make it 'less Nazi'. Instead, is it possible for a Nazi building to be supplemented, without being appropriated, meaning, by keeping its Naziness?

When is suspension beneficial to urban memory? Can adaptation be given more room in urbanism as cities evolve? Why is it important for urban memory? And is an adaptation not more sustainable, maybe not always economically but environmentally? How to benefit from temporary installations and (permanent) urban artwork more – to maintain, repair or build urban memory? Why is

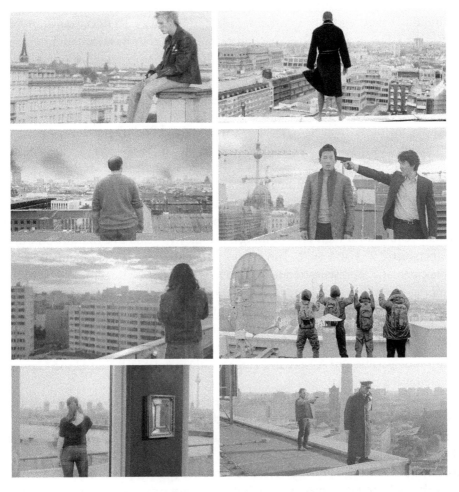

FIGURE C.2: The roofscapes of Berlin as protagonists in *Führer Ex* (2002), *Why Men Don't Listen and Women Can't Read Maps* (2007), *Rammbock: Berlin Undead* (2010), *The Berlin File* (2013), *Berlin Syndrome* (2017), *Who Am I* (2014), *Sara Stein: Shalom Berlin, Shalom Tel Aviv* (2015) and *Look Who's Back* (2015).

preservation harder than new construction, and what can be done about that? How does appropriation influence old and new urban memories? The filmic representation of a city cements its image into our memories until another representation or memory comes along; accordingly, what is the role of film in all this? These are fundamental but complicated questions. While it is not the intention of the authors to dictate what should and should not be done when the urban memory of a city is at stake during its development, there are some lessons that can be learned from the prolific example of Berlin.

Attempts to erase urban memory through demolition, in order to privilege one memory over other memories, usually causes more harm than good. This is valid for buildings that represent a particular ideology, such as the *Palast der Republik* and other GDR-era structures, as well as buildings that have suffered damage, neglect or other deterioration, such as the *Berliner Stadtschloss*. It would seem that dynamiting the *Schloss* in 1950 created such a loss that its replication was highly sought by certain groups 50 years later. Only time will tell if such a similar desire will bubble up from society 50 years after the demolition of the *Palast*. Had they investigated such demolitions that scarred Berlin's memory, American federal and state authorities would not have decided to destroy Pruitt-Igoe (Minoru Yamasaki, 1951–55) which became a symbol of the failure of Modernist urbanism. Pruitt-Igoe development in St. Louis, Missouri had provided social housing to mostly Black lower-income residents in the 1950s and 1960s but turned into a locale of inhumane living conditions due to poor management and lack of maintenance required for high-rise buildings. It took five years to dynamite 33 buildings between 1972 and 1976, leaving no physical evidence to remember, except for its cinematic representation in *Koyaanisqatsi* (Godfrey Reggio, 1982) and the memories of residents recorded in *The Pruitt–Igoe Myth* (Chad Freidrichs, 2011). This icon of the so-called 'death of Modernism' (as coined by architectural critic Charles Jencks) is lost for good while it could have been turned into a destination for architectural education and/or tourism, similar to the V&A Museum's preservation of a section of Alison and Peter Smithson's 1972 Robin Hood Gardens social housing project.

Similarly, the sweeping away of rubble following tragic events such as war, accidents and other misfortunes, while understandable from a health and safety point of view, usually results in a similar outcome: later generations are unaware of the physicality of that destruction, even if they are able to access documentation. That is, although photographs and films contribute to the urban memory of a city through their documentary capability, in most cases they are no replacement for actual, three-dimensional, tangible objects that can be experienced in time and space. The absence of any 'real' Berlin Wall experience following its collapse is perhaps the best Berlin example of the value of authentic physical objects. This

is not to say that the authors argue that destroyed cities should remain in ruins; however, there are ways of keeping urban memories intact as discussed throughout this book. Following the tragic port explosion in Beirut in August 2020, which wiped out nearly 40 per cent of this contested city that has already been through plenty of suffering in its civil war (1975–90), experts might consider lessons learned from Berlin in their process of the preservation of urban memory during the reconstruction of the ruined waterfront of this 5000-year-old Mediterranean city.

Another lesson to be learned from this analysis of urban strategies in Berlin concerns the building or rebuilding of an urban area without considering what was there before – both the natural and built environment. In such *tabula rasa* cases, like Potsdamer Platz or the *Spreebogen*, a similar situation following demolition (for economic, political or ideological reasons) can occur in which the previous forms are unknown to later generations, and therefore not an integral part of contemporary urbanism. In this respect, temporary installations were helpful to alleviate any such gaps, but in the end, they were only ephemeral constructions, not permanent memory-makers. Looking at the positive contribution of temporary installations in Berlin, more significance could be given to such constructs globally, be it street festivals and bazaars, flea markets, circuses, amusement parks, urban art installations, world expositions, even food trucks and coffee kiosks. These public installations are either temporal because they appear weekly, monthly or annually, or they create a rupture in the urban dwellers' routine enabling them to connect to their city and its memory in a new way. In that context, not-as-positive temporary constructions for refugees, survivors of disasters or pandemic patients also contribute to the memory of a city.

The urban strategy of appropriation shows that architecture and the built environment are sometimes able to represent ideas and concepts quite external to their actual forms. An awareness of this dynamic relationship helps in understanding why certain buildings and public spaces contribute extensively to the memory-making process, while others do not. With such awareness, memory activists and other agents can begin to empathize with the people whose memories are being affected, something lost on the various appropriations of the *Neue Wache* over the years and the more recent appropriation of the TV Tower on Alexanderplatz. This awareness may explain the animated debate around Istanbul's Hagia Sophia (Isidore of Miletus and Anthemius of Tralles, 532–37) that turned back into a mosque in July 2020. Originally built as an eastern Roman (Byzantine) Orthodox Church (as the third one on the same site), this landmark building was converted into a mosque after Ottoman Sultan Mehmet II conquered Constantinople in 1453. Though the change required the removal or covering of Christian features and the addition of new Islamic elements like its minarets, the world's largest cathedral until the early sixteenth century was simply appropriated from the Church of Hagia Sophia to *Ayasofya Camii* without

losing its spatial qualities defined by its magnificent pendentive dome. The secular Republic of Turkey turned this structure into a museum in 1935, which was abandoned in 2020 by the current Turkish government despite its 1985 UNESCO World Heritage declaration. International discussions around the appropriation of the sacred structure (that has not been destroyed, supplemented or adapted) only strengthens the Berlin cases that show certain structures contribute heavily to the memory-making process even at a global scale.

The urban strategy of preservation works well to solidify memories by ensuring that the protected structure does not change over time. In the case of architecture and the built environment, this involves high levels of disciplined maintenance routines on a regular and ongoing basis, as has been done to the Brandenburg Gate and Berlin State Opera. However, it is important preservationists understand that the memory of the particular object they maintain is just one of a multitude of memories that make up a city's overall urban memory, and not the one and only. Like preservation, the urban strategy of supplementation also works well to solidify memories, however, unlike preservation's single-memory-mindedness, supplementation typically exposes and highlights a multitude of memory layers, as seen in the renovations to the Reichstag and Berlin Olympic Stadium. In 2011, David Closes renovated the heavily ruined church of the Convent de Sant Francesc (Franciscan priests, 1721–29) in Santpedor, Spain, for instance, preserving what he could, and supplemented the remains with contemporary building elements such as a new entrance and vaulted roof. In this way, the Catalan architect captured the two layers of memory that the new cultural building currently holds.

The urban strategy of adaptation is perhaps the most grassroots or bottom-up example of them all. Frequently fulfilling a need that a top-down approach is either unable or unwilling to accomplish, adaptation turns the unwanted and undesirable aspects of the built environment (such as abandoned apartment buildings, unoccupied industrial complexes or disused products of war), into functional, useful and thriving structures (squatter housing, techno clubs or bunker museums). A danger of memory loss occurs if, however, over time these organizations become institutionalized and morph their spontaneous and improvisational character into something more planned and calculated. In Amsterdam, a historical city with a well-established squatting movement since the 1960s, 'church conversion' into high-end residential buildings is a business because there are many spaces of worship no longer in religious use, accompanied by a shortage of living space. Finding new uses for empty buildings prevents them from decaying or being demolished, ensuring community symbols that provide social orientation remain. However, memories associated with these sacred spaces are also affected as their generous interiors with pitched roofs and tall windows are divided up into apartments for the private use of the upper class.

Tourism contributes to memory-making by saving objects, buildings and landscapes that would have otherwise disappeared if they had not been turned into tourist attractions. Without the various GDR museums, for example, how would future generations even begin to understand what life was like in East Germany between 1949 and 1989? Oral histories, memoires, period novels and films only go so far in contemporising such everyday experiences. While it is true that the fundamental character of tourist attractions changes from 'authentic' to somewhat 'invented', at least the process keeps some sort of memory alive, however questionable. These made-up memories are basically for national and international tourists rather than the local community. A danger lies in Disneyfication, though, when the 'invented' becomes downright 'falsified', as seen at Checkpoint Charlie and the Humboldt Forum (replicated *Schloss*), where the memories presented are not only fake but also attempt to replace previous memories that have disappeared. Disneyfication marketing often creates stories that are not always the ones historians agree with. While it might be hard to encounter locals at certain parts of highly touristic cities like Venice, Dubai and Bangkok, there are better preserved authentic cities like Prague and Kyoto that attract the attention of international tourism. Such places contribute to the economy of their country while keeping multiple layers of urban memory alive for the locals and visitors alike.

The urban strategy of mutation, if not carried out in a sensitive manner, inherently attempts to change memories with each mutation. Similar to the urban strategy of new construction, mutation is rarely concerned with the past and therefore frequently constructs layer upon layer without revealing these layers to the public. This was not only seen in the constant mutation of the Berlin Wall during its lifetime but also in its disappearance soon after it was no longer needed. It goes without saying that the mutations of Potsdamer Platz over the years, including its latest incarnation, were each trying to 'out-memorize' its previous one. Adjacent to Hagia Sophia in Istanbul stands Topkapi Palace (1459) at the intersection of the Bosphorus, Golden Horn and Marmara Sea, built and transformed over more than five centuries. Commissioned by Mehmet the Conqueror, the Ottoman sultan's 700,000 m² 'live/work space' sits on and around the remains of the hilly Greek and Byzantine acropolis, making use of old city walls on the waterfront. Mehmet II himself designed the initial site plan, and his best builders worked on its construction. Suleyman the Magnificent significantly expanded the palace (1520–60) that mostly consists of two-storey buildings around courtyards and large gardens. New buildings and supplementations were incorporated into the colossal but humble complex over the centuries by architects such as Mimar Sinan, Acem Ali and Davud Aga, and major renovations took place due to damage caused by earthquakes in 1509 and 1574 and a Harem fire in 1665. Neglected buildings disappeared in time, including the fifth courtyard and the structures by the water that fell prey to technology:

nineteenth-century railway construction. A museum since 1924 and UNESCO World Heritage Site since 1985, the 560-year-old contemporary *Topkapi Sarayi* is a product of these multiple urban mutations. As the architecture of the palace mutated in conjunction with political, economic and technological changes, its meaning and memory constantly morphed, building new layers upon old memories.

Similar to preservation, the urban strategy of relocation is able to maintain memories by simply moving buildings and urban structures to new locations. However, the older memories attached to such moved items are not always automatically retained in the new location. In fact, this is rarely the case, especially when the motivation to move the items came from a desire to 'refresh' or 'start anew', which was the case for the Victory Column, but not so for the remnants of the Esplanade Hotel. Similarly, the Historic Asolo Theatre (Antonio Locatelli, 1798) now in Sarasota, Florida, was relocated there from Asolo near Venice. The entire building was dismantled in 1930 and its pieces were put into storage. The John and Mable Ringling Museum of Art purchased the pieces in 1949 and reassembled them in Florida in 1958. Although the building now has a new meaning and memory, this is vaguely linked to the memory that the theatre had while it was standing on its Italian site in the nineteenth century.

The urban strategy of the suspension of ruins is the most visible example of the multi-layered nature of urban memory. Frozen in time, the layers are not a temporary but permanent installations that allow for a reflection on the past and its validity for the future (with a perspective of the present). However, just like with previous urban strategies, the danger with suspension might be judging one type of ruin from a particular time period as the one and only to preserve. That is, value judgements about what layers to show and what layers to hide can creep into the process. At the Kaiser Wilhelm Memorial Church, for example, only a certain section of the damaged structure was retained in order to allow enough space for the church's modern addition. At the Topography of Terror, this was not the case, although its latest addition has some people longing for the previous ad hoc nature of the complex's beginnings in memory activism. An unusual suspension process took its course in Albania from 1990 onwards. Through his 'bunkerization' programme (1967–86), Socialist leader Enver Hoxha commissioned almost 175,000 defensive bunkers that spread all over the country from urban towards rural areas. Citizens were required to clean and maintain their local bunker and conduct drills in these 3 meter-wide concrete domes that were fitted out with gun slits. Though not in military use for the last 30 years, most Albanian bunkers still sit at odd locations like pop-up wild mushrooms, as a daily reminder of the iron curtain period in the Balkans.

By its very nature, the urban strategy of memorialization attempts to keep memories alive through its three-dimensionality. The sole purpose of memorials, as opposed to monuments, is to commemorate people, events and actions from

the past, thereby keeping them in the present and a part of people's memories. In general, the more personal the touch, as seen in Gunter Demnig's *Stolpersteine*, the more effective the commemoration. However, the impersonality of abstraction, as seen in Eisenman's *Memorial to the Murdered Jews of Europe*, can also work since it opens itself up to a variety of interpretations. Architectural practice Gómez Platero also follows an abstract approach for their *World Memorial to the Pandemic* (2020) proposed to commemorate those who have succumbed to COVID-19. To be sited in Uruguay on an urban waterfront with access by a long pedestrian walkway, the award-winning proposal is a large circular platform with a central open void, capable of holding around 300 socially distanced people. The internally inclined disc has no railings or balusters to evoke unease and introspection. It attempts 'activating the senses and re-creating bridges between the experience of the place and individual memory'.[3] As of the writing of this book, many temporary COVID-19 pandemic memorials have been organized using installations of banners, national flags, trees, flowers and origami cranes,[4] so, if actually constructed, Gómez Platero's project will be the first large-scale memorial to the coronavirus pandemic that transformed everyday life around the world in 2020 onwards creating a global memory rupture.

It should be noted that the over-memorialization of the built environment, or the existence of too many memorials, may be a danger, as the public then do not value their special nature and begin to take them for granted, a question raised about the future of the *Stolpersteine*. Similarly, murals on the gable walls of numerous terrace houses in both the Nationalist/Republican/Catholic and Unionist/Loyalist/Protestant communities are spread widely in Belfast. These murals as well as the 'peace walls' are scattered around the city to divide more than to commemorate. For a certain fee, drivers take tourists for a tour of the Troubles (1968–98) by driving them in their nostalgic black cabs from mural to mural. This significant urban feature defines many neighbourhoods, therefore though their purpose is to commemorate the past (remembering the dead and the Troubles), they contribute to urban living today (by marking a territory) and tomorrow (by 'educating' the youth via propaganda). The UK's exit from the European Union in 2021, known as Brexit, has complicated the Northern Ireland situation, stirring up old wounds and memories.

The global context

Mandy: Is this typical Berlin?
Nico: Nothing is typical Berlin.

Berlin, I Love You (2019)

As the above-mentioned international examples reveal, an understanding of urban strategies and the consequences of urban renewal for the sake of urban memory is globally beneficial. This alternative way of seeing cities may improve the way cities are altered in practice and transform in time. The situations discussed in this book are unique to Berlin, while the ideas put forth are global. As Ladd explains, 'the attempts to understand Berlin's history and identity deserve international attention. The concentration of troubling memories, physical destruction, and renewal has made Berliners, however reluctantly, international leaders in exploring the links between urban form, historical preservation, and national identity' (1998: 4).

Thus, the analyses found in this volume are applicable to other (cinematic) cities that have undergone urban transformation in their history like New York, London, Paris or Sydney, and cities that are currently undergoing urban transformation like Istanbul, Hong Kong, Detroit or Mumbai. Some cities, such as Belfast, Sarajevo, Beirut or Nicosia/Lefkoşe, have been divided or contained contested spaces like Berlin at some point in their history. The green line in Beirut (1975–90) was very similar to the Berlin Wall, and Nicosia in Cyprus is still a divided city between the Greek and Turkish territories. The Polish wanted their capital city the way it was, to erase the memory of the war, so post-Second World War Warsaw was built as a replica of pre-war Warsaw, but the authorities could have used any number of urban strategies. Belfast, if there ever comes a time that its peace walls are no longer required, may choose to implement some of the urban strategies already practised after the fall of the Berlin Wall. Some of Belfast's walls with graffiti/murals have already turned into attractions of dark tourism, as stated above, but the city might benefit more from urban strategies such as temporary installation, appropriation, adaptation or relocation.

Fast-growing cities like Dubai or Shenzhen could also learn from the urban strategies that have shaped Berlin's urban memory. Since they are rarely created out of thin air like Brasilia or Canberra, such rapidly developing cities with multiple densely populated 'urban villages' may be able to mature and expand without completely erasing their more humble beginnings – a fate that befell many of the vast metropolises of the previous century. Urban strategies such as preservation, adaptation, mutation and relocation would be particularly helpful in those cases.

Finally, cities and regions in conflict could also benefit from the research presented in this book. After the Syrian War, the reconstruction of Damascus and Aleppo could be inspired from Berlin precedents, especially the suspension of ruins, adaptation and preservation to keep the memory of these historical cities – at least partially – alive. Development in the Gaza Strip and West Bank in Palestine/Israel could likewise gain insight from the urban strategies of supplementation, relocation and even Disneyfication. Buildings and locations that remind society of the conflict could become museums, memorials or places keeping or generating urban memories.

FIGURE C.3: The past montaged over the present in *Berlin Now & Then: the Reichshauptstadt of Adolf Hitler* (2018).

As this flexible megastructure of urban strategies is considered and tailored in relation to urban memory for other cities, it may be broadened with new strategies, such as 'replication' (the so-called historically accurate replica of the damaged and destroyed parts of the Notre Dame Cathedral in Paris after the 2019 fire), 'gentrification' (Diamond Island, Phnom Penh, Cambodia), 'beautification' (giant façade posters by BlowUP Media[5]), 'excavation' (the uncovering of Albert Speer's Nazi Academy in Teufelsberg) or even 'determination' (the never-ending construction of Antoni Gaudi's *Sagrada Familia* in Barcelona). It is also possible to expand the variety of strategies in the scope of Berlin itself. For instance, West Berliners started to strip their pre-Second World War housing of their stucco ornamentation after the Second World War not only to modernize their homes but also to forget the immediate past. That could be considered as the urban strategy of 'subtraction'. The temporary info-boxes that enabled viewing Berlin's large construction sites from a high ground in the 1990s were installed and became part of the urban strategy of 'touristification' – turning the act of construction into a touristic performance in open air.

Karl Scheffler's words from 1910 summarizes Berlin's constant process of transformation: 'Berlin is a city condemned forever to becoming and never being' (Schofield and Rellensmann 2015: 117).[6] There has been a constant dilemma in Germany since the end of the nineteenth century between the conservation of history and the architecture that represents it, and the (capitalist) desire and need to progress, move forward and move on. In Berlin, and in many other global cities,

history and stories are updated and revised almost every decade by reframing the architectural and urban formations of the past.

> In Berlin,
> To demolish or to preserve?
> To build or to rebuild?
> To relocate or to suspend?
> To forget or to remember?
> That is the question.

To be continued ...

NOTES

1. https://www.zku-berlin.org/timeline/gul-kacmaz-erk-berlin-2020-urban-filmmaking-workshop (last accessed 30 June 2021).
2. Three short films were made in the workshop in March 2020. The weeklong exercise started face-to-face and finished from a distance when the pandemic reached Berlin. Reviewers watched and commented on the films online (https://vimeo.com/groups/641251, last accessed 30 August 2021).
3. https://www.gomezplatero.com/en/proyecto/memorial-pandemic (last accessed 8 September 2020).
4. https://www.usnews.com/news/health-news/articles/2021-07-31/us-memorials-to-victims-of-covid-19-pandemic-taking-shape (last accessed 14 September 2021).
5. BlowUP Media can produce a 'deceptively life-like copy' of the original façade of a derelict historical building for their customers (http://www.blowup-media.co.uk/build-a-brand-advertising/sitedevelopment/heritage-protection, last accessed 1 October 2021).
6. Scheffler concludes *Berlin – A City Fate* (*Berlin – ein Stadtschicksal*, 1910) stating: 'As with a joke of self-irony, this hard-determined city individual helps himself beyond the hidden tragedy of his existence [...] through the tragedy of a fate that condemns [...] Berlin: to be everlasting and never to be.' The situation that he defined more than a century ago as: 'Berlin is a city that never is, but is always in the process of becoming', is still the city's reality.

Filmography

Berlin films, 1895–2022

The following films have been shot on location in Berlin, either partially or fully, or are set in Berlin but shot somewhere else, usually in a studio or even another city. This filmography mainly lists full-length fiction films, both cinematic releases and made-for-television movies. Only those documentaries, television shows and short films that are highly relevant to the book's case studies and/or urban strategies have been listed.[1]

1 Berlin-Harlem, Lothar Lambert (dir.) (1974), West Germany: Lothar Lambert Filmproduktion.

1 Punk 36, Albrecht Metzger (dir.) (1980), West Germany: Westdeutscher Rundfunk.

1st of May: All Belongs to You [*1. Mai – Helden bei der Arbeit*], Jan-Christoph Glaser, Carsten Ludwig, Sven Taddicken and Jakob Ziemnicki (dirs.) (2008), Germany: Jetfilm/Frisbeefilms.

II-A in Berlin [aka *Drei Bayern an der Spree*, aka *Drei Bayern in Berlin*], Hans Albin (dir.) (1956), West Germany: Ariston Film.

4:00 pm – Kanzler Pastry Shop [*16:00 Uhr – Konditorei Kanzler*], Eberhard Weissbarth (dir.) (1987), West Germany: Film- und Fernsehproduktion Eberhard Weissbarth.

6:15 pm at Ostkreuz [*18.15 Uhr ab Ostkreuz*], Jörn Hartmann (dir.) (2006), Germany: Heinz und Horst Filmproduktion.

The 7th Year – Views on the State of the Union [*Das 7. Jahr – Ansichten zur Lage der Nation*], Pepe Danquart ('Straßenfeger, Der'), Egon Günther ('Warum bist Du eigentlich nicht abgehauen?'), Leander Haussmann ('WohnHaft Sonnenallee'), Volker Koepp ('Märkisches Wasser, märkischer Schnaps'), Helke Misselwitz ('Oskar, Karli und der Mann mit der Zigarre'), Katharina Thalbach ('Der Türsteher von Clärchen's Ballhaus') and Lothar Warneke ('Zerrbilder – Harald Kretzschmar') (dirs.) (1997), Germany: Ostdeutscher Rundfunk Brandenburg.

8 Seconds [*8 Sekunden – Ein Augenblick Unendlichkeit*], Ömer Faruk Sorak (dir.) (2015), Germany: BKM Film.

24 Hours at the Silesian Gate [*24 Stunden Schlesisches Tor*], Anna de Paoli and Eva Lia Reinegger (dirs.) (2007), Germany: Deutsche Film- und Fernsehakademie Berlin (DFFB).

24 Hours Berlin [*24h Berlin – Ein Tag im Leben*], Volker Heise et al. (dir.) (2009), Germany: Zero One Film.

36m² of Fabric [*36m² Stoff*], Neco Çelik (dir.) (1997), Germany: Çelik Productions.

99 Euro-Films, Sebastian Beer, Miriam Dehne, Matthias Glasner, Esther Gronenborn, Rolf Peter Kahl, Michael Klier, Nicolette Krebitz, Peter Lohmeyer, Daniel Petersen, Frieder Schlaich, Mark Schlichter and Martin Walz (dirs.) (2001), Germany: Oldenburg International Filmfestival.

100 Things [*100 Dinge*], Florian David Fitz (dir.) (2018), Germany: Erfttal Film/Pantaleon Films.

196 bpm, Romuald Karmakar (dir.) (2003), Germany: Pantera Film.

The 1,000 Eyes of Dr. Mabuse [*Die 1,000 Augen von Dr. Mabuse*], Fritz Lang (dir.) (1960), West Germany: Central Cinema Company Film.

1000 Miles from Tashkent [*1000 Meilen von Taschkent*], Katarina Wyss (dir.) (2009), Germany: Deutsche Film- und Fernsehakademie Berlin.

1914, The Last Days before the Burning of the World [*1914, die letzten Tage vor dem Weltbrand*], Richard Oswalt (dir.) (1931), Germany: Richard-Oswalt-Produktion.

80,000 Shots, Manfred Walther (dir.) (2002), Germany: Diesel & Dünger Film.

Ace of Aces [*L'as des as*], Gérard Oury (dir.) (1982), France/West Germany: Cerito Films/Gaumont International/Rialto Film/Bavaria Film.

The Actress [*Die Schauspielerin*], Siegfried Kühn (dir.) (1988), East Germany: DEFA.

Adolf and Marlene [*Adolph und Marlene*], Ulli Lommel (dir.) (1974), West Germany: Albatross.

Adventure in Berlin (aka *International Counterfeiters*) [*Die Spur führt nach Berlin*], Frantisek Cáp (as Franz Cap) (dir.) (1952), West Germany: Central Cinema Company Film.

After Effect, Stephan Geene (dir.) (2007), Germany: bbooksz av production.

After the Fall [*Nach dem Fall*], Eric Black and Frauke Sandig (dirs.) (2000), Germany: Umbrella Films.

Age and Beauty [*Alter und Schönheit*], Michael Klier (dir.) (2009), Germany: ARTE/X-Filme Creative Pool.

Agnes and His Brothers [*Agnes und seine Brüder*], Oskar Roehler (dir.) (2004), Germany: X-Filme Creative Pool.

AIDS: Love in Danger [*Gefahr für die Liebe – Aids*], Hans Noever (dir.) (1985), West Germany: Central Cinema Company Film.

The Airship [*Das Luftschiff*], Rainer Simon (dir.) (1983), East Germany: DEFA.

Aimee & Jaguar, Max Färberböck (dir.) (1999), Germany: Senator Film Produktion.

The Airlift (aka *Berlin Airlift*) [*Die Luftbrücke – Nur der Himmel war frei*], Dror Zahavi (dir.) (2005), Germany: teamWorx Television & Film.

Alarm at the Circus [*Alarm im Zirkus*], Gerhard Klein (dir.) (1954), East Germany: DEFA.

alaska.de, Esther Gronenborn (dir.) (2000), Germany: Bioskop Film.

The Albanian [*Der Albaner*], Johannes Naber (dir.) (2010), Germany: Neue Schönhauser Filmproduktion.

Alexanderplatz, Unter den Linden, Schönholz Station, and *The Fire Brigade Turnout* [*Alarm der Feuerwehr*], Max Skladanowsky and Emil Skladanowsky (dirs.) (1895–96), Germany.

Aliens [*Außerirdische*], Florian Gärtner (dir.) (1993), Germany: Zweites Deutsches Fernsehen.

Alki Alki, Axel Ranisch (dir.) (2015), Germany: Sehr gute Filme.

The All-Around Reduced Personality – ReduPers [*Die Allseitig reduzierte Persönlichkeit*], Helke Sander (dir.) (1978), West Germany: Basis-Film-Verleih.

All Lies [*Alles Lüge*], Heiko Schier (dir.) (1992), Germany: Delta Film.

Allow Me, Undertaker! [*Gestatten, Bestatter!*], Lothar Lambert (dir.) (1986), West Germany: Horizont-Filmproduktion.

All My Girls [*Alle mein Mädchen*], Iris Gusner (dir.) (1980), East Germany: DEFA.

Alma Mater, Rolf Hädrich (dir.) (1969), West Germany: Norddeutscher Rundfunk.

Alone in Berlin, Vincent Perez (dir.) (2016), Germany: X-Filme Creative Pool.

Always Ready [*Immer bereit*], Kurt Maetzig (dir.) (1950), East Germany: DEFA-Studio für Dokumentarfilme.

American Traitor: The Trial of Axis Sally, Michael Polish (dir.) (2021), USA: Pimienta.

Ana Bekhair, Jibril Awad and Sofoklis Adamidis (dirs.) (1979), Germany: Deutsche Film- und Fernsehakademie Berlin.

Anatomy 2 [*Anatomie 2*], Stefan Ruzowitzky (dir.) (2003), Germany: Deutsche Columbia TriStar Filmproduktion.

Andi is Back [*Der Andi ist wieder da*], Friederike Jehn (dir.) (2015), Germany: Südwestrundfunk.

Andreas Schlüter, Herbert Maisch (dir.) (1942), Germany: Terra-Filmkunst.

And the Heavens above Us [*... und über uns der Himmel*], Josef von Báky (dir.) (1947), Germany: Objektiv Film.

And Your Love Too [*... und deine Liebe auch*], Frank Vogel (dir.) (1962), East Germany: DEFA.

Angel Basin [*Engelbecken*], Gamma Bak and Steffen Reck (dirs.) (2014), Germany: Gamma Bak Filmproduktion.

Angel Express, Rolf Peter Kohl (dir.) (1998), Germany: Erdbeermund Filmproduktion.

Angels of Iron [*Engel aus Eisen*], Thomas Brasch (dir.) (1981), West Germany: Independent Film Heinz Angermeyer.

Angst [*Der alte Affe Angst*], Oskar Roehler (dir.) (2003), Germany: Neue Bioskop Film.

Anita: Dances of Vice [*Anita: Tänze des Lasters*], Rosa von Praunheim (dir.) (1987), Germany: Exportfilm Bischoff & Co.

Antibodies [*Antikörper*], Christian Alvart (dir.) (2005), Germany: MedienKontor Movie.

Anton the Magician [*Anton der Zauberer*], Günter Reisch (dir.) (1978), East Germany: DEFA.

Anywhere Else [*Anderswo*], Ester Armani (dir.) (2014), Germany/Israel: Dirk Manthey Film.

The Apple (aka *Star Rock*), Menahem Golan (dir.) (1980), West Germany: NF Geria II Film.

Appointment in Berlin, Alfred E. Green (dir.) (1943), USA: Columbia Pictures.

Apprehension [*Die Beunruhigung*], Lothar Warneke (dir.) (1981), East Germany: DEFA.

April Has 30 Days [*Ein April hat 30 Tage*], Gunther Scholz (dir.) (1979), East Germany: DEFA.

The Architects [*Die Architekten*], Peter Kahane (dir.) (1990), East Germany: DEFA.

Around an Investigation [*Voruntersuchung*, aka *Autour d'une enquête*], Henri Chomette and Robert Siodmak (dirs.) (1931), Germany: UFA.

Around the World in 80 Days, Frank Coraci (dir.) (2004), USA/Germany/Ireland/UK: Walt Disney Pictures/Studio Babelsberg/Walden Media/Spanknyce Films.

The Art of Being a Man [*Die Kunst, ein Mann zu sein*], Matthias Drawe (dir.) (1989), West Germany: Muavin-Film.

Asphalt, Joe May (dir.) (1929), Germany: UFA.

Asphalt Night [*Asphaltnacht*], Peter Fratzscher (dir.) (1980), West Germany: Tura-Film.

Assignment Berlin, Tony Randel (dir.) (1998), USA/Germany: Hallmark Entertainment/Filmproduktion Janus.

Asternplatz 10 at 6:00am [*Asternplatz 10 Uhr 6*], Karl-Heinz Bieber (dir.) (1969), West Germany: CCC Television.

Atlantis, August Blom (dir.) (1913), Denmark: Nordisk Film.

Atomic Blonde, David Leitch (dir.) (2017), Germany: 87Eleven.

Atomised [*Elementarteilchen*], Oskar Roehler (dir.) (2006), Germany: Medienfonds GFP.

The Attempt at Living (aka *Trying to Stay Alive*) [*Der Versuch zu leben*], Johann Feindt (dir.) (1983), West Germany: Deutschen Film- und Fernsehakademie Berlin.

The Awakening of the Woman [*Das Erwachen des Weibes*], Fred Sauer (dir.) (1927), Germany: Domo-Strauss-Film.

B-Movie: Lust and Sound in West-Berlin 1979–89, Jörg A. Hoppe, Heiko Lange and Klaus Maeck (dirs.) (2015), Germany: DEF Media.

Baader, Christopher Roth (dir.) (2002), Germany: 72 Film.

The Baader Meinhof Complex [*Der Baader Meinhof Komplex*], Uli Edel (dir.) (2008), Germany: Constantin Film.

Baby, Uwe Friessner (dir.) (1984), West Germany: Basis-Film Verleih.

Babylon Berlin, Henk Handloegten, Tom Tykwer and Achim von Borries (dirs.) (2017–present), Germany: X-Filme Creative Pool.

Backhouse Bliss [*Glück im Hinterhaus*], Herrmann Zschoche (dir.) (1980), East Germany: DEFA.

Backstairs [*Hintertreppe*], Leopold Jessner (dir.) (1921), Germany: Gloria-Film.

Back to Berlin, Catherine Lurie (aka Catherine Lurie-Alt) (dir.) (2019), United Kingdom: Cat-Mac.

Back to Square One [*Alles auf Anfang*], Reinhard Münster (dir.) (1994), Germany: Metropolis Filmproduktion.

Bags of Time [*Alle Zeit der Welt*], Matl Findel (dir.) (1997), Germany: Schramm Film Koerner & Weber.

Bailing Out (aka *Cascading Backwards*) [*Kaskade rückwärts*], Iris Gusner (dir.) (1984), East Germany: DEFA.

Ballad of Berlin [*Berliner Ballade*, aka *Berlin 1990*], Chris Marker (dir.) (1995), France: FR2.

Banal Days [*Banale Tage*], Peter Welz (dir.) (1992), Germany: DEFA.

Banana Paul [*Bananen Paul*], Richard Claus (dir.) (1982), West Germany: C&H Film.

Bank Vault 713 [*Banktresor 713*], Werner Klingler (dir.) (1957), West Germany: Berolina.

Barbara, Christian Petzold (dir.) (2012), Germany: Schramm Film Koerner & Weber.

Bar 25, Britta Mischer and Nana Yuriko (dirs.) (2012), Germany: 25Films.

Battle of Berlin [*Schlacht um Berlin*], Franz Baake and Jost von Morr (dirs.) (1973), West Germany: Bengt von zur Mühlen.

Be.Angeled, Roman Kuhn (dir.) (2001), Germany: Lounge Entertainment.

Because Women Are Weak [*Denn das Weib ist schwach*], Wolfgang Glück (dir.) (1961), West Germany: Cine International.

Bedbugs [*Fikkefuchs*], Jan Henrik Stahlberg (dir.) (2017), Germany: Poison/Story House Productions.

Bedways, Rolf Peter Kahl (dir.) (2010), Germany: Independent Partners.

The Beginning [*Der Beginn*], Peter Lilienthal (dir.) (1967), West Germany: Süddeutscher Rundfunk.

The Beggar Countess of Kurfürstendamm [*Die Bettelgräfin vom Kurfürstendamm*], Richard Eichberg (dir.) (1921), Germany: Eichberg-Film.

Behind Locked Doors [*Hinter verschlossenen Türen*], Anka Schmid (dir.) (1991), Deutsche Film- und Fernsehakademie Berlin.

Being Mean Is also a Sign of Emotion [*Böse zu sein ist auch ein Beweis von Gefühl*], Cynthia Beatt (dir.) (1983), Germany: Heartbeat Pictures.

Bella Donna [*Bella Donna – Kann denn Liebe Sünde sein?*], Peter Keglevic (dir.) (1983), West Germany: Sender Freies Berlin.

Bella Vita, Thomas Berger (dir.) (2010), Germany: Hager Moss Film.

The Beloved [*Die Geliebte*], Gerhard Lamprecht (dir.) (1939), Germany: UFA.

Beloved Berlin Wall [*Liebe Mauer*], Peter Timm (dir.) (2009), Germany: Relevant Film.

Beloved Comrade [*Geliebte Genossin*, aka *Ninotschka und Peer*], Joachim Mock (dir.) (1965), West Germany: ARD.

Be My Star [*Mein Stern*], Valeska Grisebach (dir.) (2001), Germany: Filmakademie Wien.

Benno Makes Stories [*Benno macht Geschichten*], Helmut Krätzig (dir.) (1982), East Germany: Fernsehen der DDR.

The Benthin Family [*Familie Benthin*], Slatan Dudow, Kurt Maetzig and Richard Groschopp (uncredited) (dirs.) (1950), East Germany: DEAF.

Berlin, 10:46, Torsten C. Fischer and Jean-Philippe Toussaint (dirs.) (1994), Germany: Ö-Film.

Berlin '36, Kaspar Heidelbach (dir.) (2011), USA: ARD Degeto Films.

Berlin 4 Lovers, Leonie Loretta Scholl (dir.) (2019), Germany: Radar Berlin.

BeRLiN [*Berurin*], Gô Rijû (dir.) (1995), Japan: KSS Films.

Berlin – A City Awakes [*Berlin – Eine Stadt erwacht*], Mate Spörl (dir.) (2004), Germany: Spiegel TV.

Berlin – A City Looking for a Murderer [*Berlin – Eine Stadt sucht den Mörder*, aka *Taxi in den Tod*], Urs Egger (dir.) (2003), Germany: Stream Films.

Berlin around the Corner [*Berlin um die Ecke*], Gerhard Klein (dir.) (1965), East Germany: DEFA.

Berlin Affair, David Lowell Rich (dir.) (1970), USA: Universal Television.

The Berlin Affair [*Leidenschaften*], Liliana Cavani (dir.) (1985), USA: Cannon Productions.

Berlin Alexanderplatz: The Story of Franz Biberkopf [*Berlin-Alexanderplatz: Die Geschichte Franz Biberkopfs*], Phil Jutzi (dir.) (1931), Germany: Allianz Tonfilm.

Berlin Alexanderplatz, Episode 14: My Dream of the Dream of Franz Biberkopf [*Berlin Alexanderplatz 14 – Mein Traum vom Traum des Franz Biberkopf von Alfred Döblin: Ein Epilog*, aka *Mein Traum vom Traum des Franz Biberkopf: Vom Tode eines Kindes und der Geburt eines Brauchbaren*], Rainer Werner Fassbinder (dir.) (1980), Germany: Bavaria Atelier.

Berlin Alexanderplatz, Burhan Qurbani (dir.) (2020), Germany: ARTE.

The Berlin Antigone [*Berliner Antigone*], Rainer Wolffhardt (dir.) (1968), West Germany: UFA.

Berlin: A Square, a Murder and a Famous Communist [*Berlin Ecke Volksbühne*], Britta Wauer (dir.) (2005), Germany: Britska Film.

Berlin, Berlin: Lolle on the Run [*Berlin, Berlin: Der Kinofilm*], Franziska Meyer Price (dir.) (2020), Germany: ARD Degeto Film.

Berlin Babylon, Hubertus Siegert (dir.) (2001), Germany: Philip-Gröning-Filmproduktion.

Berlin Blockade [*Berliner Blockade*], Rudolf Jugert (dir.) (1968), West Germany: Zweites Deutsches Fernsehen.

Berlín Blues, Ricardo Franco (dir.) (1988), Spain: Emiliano Piedra.

Berlin Blues [*Herr Lehmann*], Leander Haussmann (dir.) (2003), Germany: Boje Buck Produktion.

The Berlin Bride, Michael Bartlett (dir.) (2019), USA/Germany: Cloudcover Films.

Berlin Bouncer, David Dietl (dir.) (2019), Germany: Flare Film.

Berlin by the Sea [*Berlin am Meer*], Wolfgang Eissler (dir.) (2008), Germany: Alinfilmproduktion.

Berlin Calling, Hannes Stöhr (dir.) (2008), Germany: Sabotage Films GmbH.

Berlin Calling, Nigel Dick (dir.) (2015), USA/Czech Republic/France/Germany: Dick Films.

Berlin Capital of the Reich 1936 [*Berlin Reichshauptstadt 1936*], Franz Fielder (dir.) (1939), Germany: Unknown.

Berlin Chamissoplatz, Rudolph Thome (dir.) (1980), W. Germany: Anthea Film.

Berlin Diary [*Berliner Tagebuch*], Rosemarie Blank (dir.) (2012), Germany: Casafilm/Doc.Eye Film Amsterdam.

Berlin Drifters, Kôichi Imaizumi (dir.) (2017), Japan/Germany: habakari-cinema+records/Jürgen Brüning Filmproduktion.

Berlin during the Imperial Era – The Glory and Shadow of an Epoch [*Berlin zur Kaiserzeit – Glanz und Schatten einer Epoche*], Irmgard von zur Mühlen (dir.) (1986), West Germany: Chronos-Film.

Berlin, Here I Am [*Berlin, hier bin ich*], Gerard Hujer (dir.) (1982), East Germany: Fernsehen der DDR.

The Berliner (aka *Ballad of Berlin*) [*Berliner Ballade*], Robert A. Stemmle (dir.) (1948), Germany: Comedia-Film.

Berliners on Sunday [*Berliner am Sonntag (Wild Clique)*], Hannelore Conradsen and Dieter Köster (dirs.) (1983), West Germany: Hannelore Conradsen-Köster-Film.

Berlin Express, Jacques Tourneur (dir.) (1948), USA: RKO Radio Pictures.

Berlin Falling, Ken Duken (dir.) (2017), Germany: Grant Hotel Pictures.

The Berlin File (aka *In Berlin*) [*Bereullin*], Seung-wan Ryoo (dir.) (2013), South Korea: Filmmaker R&K.

Berlin for Heroes [*Berlin für Helden*], Klaus Lemke (dir.) (2012), Germany: Klaus Lemke Filmproduktion.

Berlin, I Love You, Dianna Agron, Peter Chelsom, et al. (dirs.) (2019), Germany: Bily Media Berlin.

Berlin in Berlin, Sinan Çetin (dir.) (1993), Turkey: Plato Film Production.

Berlin is in Germany, Hannes Stöhr (dir.) (2001), Germany: DFFB.

Berlin-Jerusalem [*Berlin-Yerushalaim*], Amos Gitai (dir.) (1989), USA: Agav Films.

Berlinized [*Berlinized – Sexy an Eis*], Lucian Busse (dir.) (2012), Germany: Lucian Busse – Alien TV.

Berlin Izza Bitch!, Klaus Lemke (dir.) (2021), Germany: Klaus Lemke Filmproduktion.

Berlin Junction, Xavier Agudo (dir.) (2013), Germany: Ex Film Collective.

Berlin Mitte, Peter Beauvais (dir.) (1980), West Germany: Sender Freies Berlin.

Berlin Neck Pillow [*Berliner Bettwurst*], Rosa von Praunheim (dir.) (1975), West Germany: Rosa von Praunheim Filmproduktion.

Berlin-Neukölln, Bernhard Sallmann (dir.) (2002), Germany: Hanfgarn & Ufer Film und TV Produktion.

Berlin Nights, Gabriela Tscherniak (dir.) (2005), Germany: Cohen Sisters Entertainment and Jollygood Films.

Berlin Now, Wolfgang Büld and Sissy Kelling (dirs.) (1985), West Germany: Stein Film.

Berlin Now & Then: The Reichshauptstadt of Adolf Hitler, Jeroen Ruiter (dir.) (2019), Netherlands: Ruiter Productions.

Berlin Open Bracket East Close Bracket [*Berlin Klammer auf Ost Klammer zu*], Fritz Illing and Werner Klett (dirs.) (1966), West Germany: Illing-Klett Filmproduktion.

Berlin Playground [*Hans im Glück*], Claudia Lehman (dir.) (2009), Germany: Lehmann & Minneker Filmproduktion.

Berlin – Prenzlauer Berg [*Berlin-Prenzlauer Berg: Begegnungen zwischen dem 1. Mai und dem 1. Juli 1990*], Petra Tschörtner (dir.) (1991), Germany: DEFA.

Berlin Report [*Baereurlin Ripoteu*], Kwang-su Park (dir.) (1991), South Korea: Mokad Korea.

A Berlin Romance [*Eine Berlin Romanze*], Gerhard Klein (dir.) (1956), East Germany: DEFA.

Berlin Round Dance [*Berliner Reigen*], Dieter Berner (dir.) (2007), Germany: Hochschule für Film und Fernsehen 'Konrad Wolf'.

Berlin: Ruins 1945 – Metropolis 2000 [*Berlin: Ruine 1945 – Metropole 2000*], Irmgard von zur Mühlen (dir.) (1999), Germany: Chronos-Film.

Berlin – Schönhauser Corner [*Berlin – Ecke Schönhauser*], Gerhard Klein (dir.) (1957), East Germany: DEFA.

Berlin's Sharpest Line [*Berlins schärfster Strich*], Dietmar Buchmann and Hilde Heim (dirs.) (1987), West Germany: Sender Freies Berlin.

Berlin – Sketches from a Big City [*Berlin – Skizzen aus einer großen Stadt*], Gunther Hahn (dir.) (1971), West Germany: Sender Freies Berlin.

BerlinSong, Uli M. Schüppel (dir.) (2007), Germany: De.Flex-Film.

Berlin Stories [*Stadt als Beute*], Miriam Dehne, Esther Gronenborn and Irene von Alberti (dirs.) (2005), Germany: Filmgalerie 451.

Berlin Syndrome, Cate Shortland (dir.) (2017), Australia: Aquarius Films.

Berlin: Symphony of a Great City [*Berlin: Die Sinfonie der Grossstadt*], Walther Ruttmann (dir.) (1927), Germany: Deutsche Vereins-Film.

Berlin Symphony, [*Berlin: Sinfonie einer Grossstadt*] Thomas Schadt (dir.) (2002), Germany: Odyssee-Film.

Berlin Telegram, Leila Albayaty (dir.) (2012), Belgium/Germany: Stempel/Zero Fiction Film.

Berlin Tunnel 21, Richard Michaels (dir.) (1981), USA: Cypress Point Productions.

Berlin under the Allies 1945–1949 [*Berlin unter den Alliierten 1945–1949*], Irmgard von zur Mühlen (dir.) (2002), Germany: Chronos-Film.

Berlin under the Swastika [*Berlin unterm Hakenkreuz*], Irmgard von zur Mühlen (dir.) (1987), West Germany: Chronos-Film.

Berlin W [aka *Der Weg, der ins Verderben führt*], Manfred Noa (dir.) (1920), Germany: Eiko Film.

The Berlin Wall: Escape to Freedom, Michael Hoff (dir.) (2006), Germany: Michael Hoff Productions.

Berlin with Interruptions [Berlin mit Unterbrechungen], Rudolf Laepple (dir.) (1976), West Germany: Westdeutscher Rundfunk.

Berlin – Your Film Face [*Berlin – Dein Filmgesicht*], Hans Borgelt (dir.) (1979), West Germany: Känguruh-Film.

Bernauer Strasse 1-50 (or When Our Front Door Was Nailed Shut) [*Bernauer Straße 1-50 oder Als uns die Haustür zugenagelt wurde*], Hans-Dieter Grabe (dir.) (1981), West Germany: Zweites Deutsches Fernsehen.

Best Friends [*Beste Freunde*, aka *bestefreunde*], Jonas Grosch and Carlos Vai (dirs.) (2014), Germany: Achtfeld.

Beware of Dog, Nadia Bedzhanova (dir.) (2020), Germany/Russia/USA: Lilit Abgarian Productions.

Bewildered Youth [*Anders als Du und ich (§ 175)*], Veit Harlan (dir.) (1957), West Germany: Arca-Filmproduktion.

Beyond Fear [*Jenseits der Angst*], Thorsten Näter (dir.) (2019), Germany: JoJo Film und Fernsehproduktion.

Beyond Silence [*Jenseits der Stille*], Caroline Link (dir.) (1996), USA: ARTE.

Beyond the Wall [*Jenseits der Mauer*], Friedemann Fromm (dir.) (2009), Germany: Mitteldeutscher Rundfunk.

The Bicycle [*Das Fahrrad*], Evelyn Schmidt (dir.) (1982), East Germany: DEFA.

Big City Kids [*Großstadtkinder – Zwischen Spree und Panke*], Arthur Haase (dir.) (1929), Germany: Haase-Filmproduktion.

Big City Secret [*Grossstadt Geheimnis*, aka *Bankraub am Wittenbergplatz*], Leo de Lafourge (dir.) (1952), West Germany: Ideal-Film.

Big City Small [*Grossstadtklein*], Tobias Wiemann (dir.) (2013), Germany: Mr. Brown Entertainment.

The Big Eden, Peter Dörfler (dir.) (2011), Germany: Rohfilm.

The Big Flutter [*Die große Flatter*], Marianne Lüdcke (dir.) (1979), West Germany: Regina Ziegler Filmproduktion.

The Big Game [*Das große Spiel*], Robert A. Stemmle (dir.) (1942), Germany: Bavaria-Filmkunst.

Big Girls Don't Cry [*Große Mädchen weinen nicht*], Maria von Heland (dir.) (2002), Germany: Deutsche Columbia TriStar Filmproduktion.

Big Lies! [*Große Lügen!*], Jany Tempel (dir.) (2007), Germany: Schiwago Film.

The Big Lift, George Seaton (dir.) (1950), USA: 20th Century Fox.

B.i.N. – Berlin in November [*B.i.N. – Berlin in November*], Victor Schefé (dir.) (2011), Germany: RadioVictorFilm.

The Black Forest [*La Forêt Noire*], Béatrice Jalbert (dir.) (1986), West Germany: Les Films de la Passion.

Blackout [*380.000 Volt – Der große Stromausfall*], Sebastian Vigg (dir.) (2010), Germany: Constantin Film.

Bleached Happiness [*Das blondierte Glück*], Svenne Köster (dir.) (2008), Germany: Kneese-beck-Film.

Blinker, Uwe Brandner (dir.) (1969), West Germany: Literarisches Colloquium Berlin.

Bliss [*Glück*], Doris Dörrie (dir.) (2012), Germany: Constantin Film.

Bliss Street [*Blissestraße*], Paul Donovan (dir.) (2011), Germany: Alexander Sextus.

A Blonde Dream [*Ein blonder Traum*], Paul Martin (dir.) (1932), Germany; UFA.

Blonde to the Bone [*Blond bis aufs Blut*], Lothar Lambert (dir.) (1997), Germany: LoLa Produktion.

Blonde Venus, Josef von Sternberg (dir.) (1932), USA: Paramount Pictures.

Blondie's Number One (aka *Blondie's Bye Bye Love*), Robert van Ackeren (dir.) (1971), West Germany: Cine-Circus.

The Blue Angel [*Der Blaue Engel*], Josef von Sternberg (dir.) (1930), Germany: UFA.

The Blue from the Sky [*Das Blaue vom Himmel*], Viktor Janson (dir.) (1932), Germany, Aafa-Film.

The Blue from the Sky [*Das Blaue vom Himmel*], Wolfgang Schlief (dir.) (1964), Germany, CCC Television.

The Blue of the Sky (aka *Promising the Moon*) [*Das Blaue vom Himmel*], Hans Steinbichler (dir.) (2011), Germany: die Film.

The Blue One [*Der Blaue*], Lienhard Wawrzyn (dir.) (1994), Germany: Bayerischer Rundfunk.

Bomber under Berlin [*Götterdämmerung – Morgen stirbt Berlin*], Joe Coppoletta (dir.) (1999), Germany/USA: Engram Pictures/Novamedia/ProSieben.

Bombs on Berlin – Life between Fear and Hope [*Bomben Auf Berlin – Leben zwischen Furcht und Hoffnung*], Irmgard von zur Mühlen (dir.) (1983), West Germany: Chronos-Film.

Bonhoeffer: Agent of Grace, Eric Till (dir.) (2000), Canada/Germany/UA: Neue Filmproduktion Teleart.

A Bonus for Irene [*Eine Prämie für Irene*], Helke Sander (dir.) (1971), West Germany: Frie-drich Kramer.

Bon Voyage [*Glückliche Reise*], Alfred Abel (dir.) (1933), Germany: Victor Klein-Film.

Boomerang (aka *Cry Double Cross*) [*Bumerang*], Alfred Weidemann (dir.) (1960), West Germany: Roxy Film.

Bornholm Street [*Bornholmer Straße*], Christian Schwochow (dir.) (2014), Germany: ARD Degeto Film.

Born in '45 [*Jahrgang 45*], Jürgen Böttcher (dir.) (1966/1990), East Germany: DEFA.

Bosom Friends [*Freundinnen*], Heiko Schier (dir.) (1994), Germany: Von Vietinghoff Film-produktion.

The Bought Dream [*Der gekaufte Traum*], Helga Reidemeister and Eduard Gernart (dir.) (1977), West Germany: Deutsche Film- und Fernsehakademie Berlin.

The Bourne Supremacy, Paul Greengrass (dir.) (2004), USA/Germany: Universal Pictures.

Boxhagener Platz, Matti Geschonneck (dir.) (2010), Germany: Claussen Wöbke Putz Film-produktion.

The Bread of Those Early Years [*Das Brot der Frühen Jahre*], Herbert Vesely (dir.) (1962), West Germany: Modern Art Film.

Breakaway, Henry Cass (dir.) (1956), UK: Cipa.

Breaking Horizons [*Am Himmel der Tag*], Pola Beck (dir.) (2012), Germany: Alinfilmproduktion.

The Break-In [*Der Bruch*], Frank Beyer (dir.) (1988), East Germany: DEFA.

The Breakthrough [*Durchbruch Lok 234*], Frank Wisbar (dir.) (1963), West Germany: Profil-Film.

The Break Up Man [*Schlussmacher*], Matthias Schweighöfer and Torsten Künstler (dir.) (2013), Germany: Amalia Film.

Bridge of Spies, Steven Spielberg (dir.) (2015), USA: Dreamworks.

Bronstein's Children [*Bronsteins Kinder*], Jerzy Kawalerowicz (dir.) (1991), Germany/Poland: Novafilm Fernsehproduktion.

Brother and Sister [*Die Geschwister*], Jan Krüger (dir.) (2016), Germany: Schramm Film Koerner & Weber.

Brothers and Sisters [*Geschwister – Kardeşler*] Thomas Arslan (dir.) (1997), Germany: Trans-Film.

Brüno (aka *Brüno: Delicious Journeys through America for the Purpose of Making Hetero-sexual Males Visibly Uncomfortable in the Presence of a Gay Foreigner in a Mesh T-Shirt*), Larry Charles (dir.) (2009), Universal Pictures.

Bruno the Black – One Day a Hunter Blew His Horn [*Bruno der Schwarze – Es blies ein Jäger wohl in sein Horn*], Lutz Eisholz (dir.) (1970), West Germany: Deutsche Film- und Fernsehakademie Berlin.

The Bubi Scholz Story [*Die Bubi-Scholz-Story*], Roland Suso Richter (dir.) (1998), Germany: Bayerischer Rundfunk.

The Buchholz Family [*Familie Buchholz*], Carl Froelich (dir.) (1944), Germany: UFA.

Buildings in the New Germany [*Bauten im neuen Deutschland*], Curt A. Engel (dir.) (1939), Germany: Boehner-Film.

The Buildings of Adolf Hitler [*Die Bauten Adolf Hitlers*] Walter Hege (dir.) (1938), Germany: Deutsche Film Gesellschaft.

The Bunker, George Schaefer (dir.) (1981), France-USA: Société Française de Production.

Burnout [*Abgebrannt*], Verena S. Freytag (dir.) (2011), Germany: Jost Hering Filmproduktion.

Bus No. 2 [*Autobus Nr. 2*], Max Mack (dir.) (1929), Germany: Terra-Filmkunst.

But Dad! [*Aber Vati!*], Klaus Gendries (dir.) ([1974] 1979), East Germany: DEFA.

Cabaret, Bob Fosse (dir.) (1972), USA: Allied Artists Pictures.

Café Nagler, Mor Kaplansky (dir.) (2016), Germany/Israel: ARTE/Atzmor Productions.

Candidates for Marriage [*Heiratskandidaten*], Klaus Emmerich (dir.) (1975), West Germany: Sender Freies Berlin.

Captain America: Civil War (aka *The First Avenger: Civil War*), Anthony Russo and Joe Russo (dirs.) (2016), USA: Marvel Studios.

The Captain from Köpenick [*Der Hauptmann von Köpenick*], Siegfried Dessauer (dir.) (1926), Germany: Alhambra-Film.

The Captain from Köpenick [*Der Hauptmann von Köpenick*], Richard Oswald (dir.) (1931), Germany: Roto Film.

The Captain from Köpenick [*Der Hauptmann von Köpenick*], Helmut Käutner (dir.) (1956), Germany: Real-Film.

The Captain from Köpenick [*Der Hauptmann von Köpenick*], Frank Beyer (dir.) (1997), Hanover Film.

The Caretaker and his Palace – a Berlin Fate [*Der Hausmeister und sein Palast – ein Berliner Schicksal*], Arpad Bondy and Margit Knapp Cazzola (dirs.) (1991), Germany: Arpad Bondy Filmproduktion.

The Case of Dr. Wagner [*Der Fall Dr. Wagner*], Harald Mannl (dir.) (1954), East Germany: DEFA.

Casino Royale, Val Guest, Ken Hughes, John Huston, Joseph McGrath, Robert Parrish and Richard Talmadge (dirs.) (1967), USA: Famous Artists Productions.

Casual Acquaintances [*Flüchtige Bekanntschaften*], Marianne Lüdcke (dir.) (1982), West Germany: Ziegler Film.

The Cavaliers of Kurfürstendamm [*Kavaliere vom Kurfürstendamm*], Romano Mengon (dir.) (1932), Germany: Mengon-Film.

Cemil, Johannes N. Schäfer (dir.) (1985), West Germany: Jo Schäfer Productions.

Censored: Kuhle Wampe [*Ein Feigenblatt für Kuhle Wampe oder Wem gehört die Welt?*], Werner Hecht and Christa Mühl (dirs.) (1975), East Germany: DEFA.

Central Airport THF [*Zentralflughafen THF*], Karim Aïnouz (dir.) (2018), Germany: Lupa Film.

Charlie & Louise [*Das doppelte Lottchen*], Joseph Vilsmaier (dir.) (1931), Germany: Filmproduktion Peter Zenk.

Charlie Chan at the Olympics, H. Bruce Humberstone (dir.) (1937), USA: 20th Century Fox.

Charlie's Angels, Elizabeth Banks (dir.) (2019), USA: Columbia Pictures.

Charlotte Is a Little Crazy [*Charlott etwas verrückt*], Adolf Edgar Licho (dir.) (1928), Germany: Phoebus-Film AG.

Chasing Liberty, Andy Cadiff (dir.) (2004), USA/UK: Alcon Entertainment/Trademark Films.

Chasing Paper Birds (aka *Coke, Champagne & Cigarettes*), Mariana Jukica (dir.) (2021), Germany: Beleza Film.

Cherry Blossoms [*Kirschblüten – Hanami*], Doris Dörrie (dir.) (2008), Germany: Olga Film.

Children Are Not Cattle [*Kinder sind keine Rinder*], Helke Sander (dir.) (1970), West Germany: Deutsche Film- und Fernsehakademie Berlin.

The Children of the Confetti Machine [*Die Kinder der Konfettimaschine*], Rainer Grams (dir.) (1987), West Germany: Jürgen Brüning Filmproduktion.

The Children from Number 67 [*Die Kinder aus No. 67*], Usch Barthelmess-Weller and Werner Meyer (dirs.) (1980), West Germany: Renée Gundelach Filmproduktion.

Children of No Importance [*Die Unehelichen*], Gerhard Lamprecht (dir.) (1926), Germany: Gerhard Lamprecht Filmproduktion.

Chilled [*Kaltgestellt*], Bernhard Sinkel (dir.) (1980), West Germany: ABS Filmproduktion.

Chill Out, Andreas Struck (dir.) (2000), Germany: Jost Hering Filmproduktion.

Chinese Boxes, Christopher Petit (dir.) (1984), UK/West Germany: AAA Classics.

Christiane F – We Children of Zoo Station [*Christian F – Wir Kinder vom Bahnhof Zoo*], Uli Edel (dir.) (1981), West Germany: Solaris Film.

Christopher and His Kind, Geoffrey Sax (dir.) (2011), UK: Mammoth Screen.

Chronicle of the Rain [*Chronik des Regens*], Michael Freerix (dir.) (1992), Germany: Deutsche Film- und Fernsehakademie Berlin.

Chutzpah – Humans Need Klops! [*Chuzpe – Klops braucht der Mensch!*], Isabel Kleefeld (dir.) (2015), Germany/Austria: ARD Degeto Film/Tivoli Produktion.

*Citizenfour*s, Laura Poitras (dir.) (2014), USA/Germany: Praxis Films.

The City as Prey [*Die Stadt als Beute*], Andreas Wilcke (dir.) (2016), Germany: Wilckefilms.

City of Lost Souls [*Stadt der verlorenen Seelen*], Rosa von Praunheim (dir.) (1983), West Germany: Rosa von Praunheim Filmproduktion.

The City of Millions [*Die Stadt der Millionen*] Adolf Trotz (dir.) (1925), Germany: UFA.

The City Pirates [*Die Stadtpiraten*], Rolf Silber (dir.) (1986), West Germany: Sender Freies Berlin.

Cityscapes and the Berlin Stadtbahn [*Berliner Stadtbahnbilder*], Alfred Behrens (dir.) (1982), West Germany: Basis Film.

Class Enemy [*Klassen Feind*], Peter Stein (dir.) (1983), West Germany: Ziegler Film.

Claire Berolina, Klaus Gendries (dir.) (1987), East Germany: DEFA.

Clarissa, Gerhard Lamprecht (dir.) (1941), Germany: Aco-Film.

Class Life [*Klassenleben*], Hubertus Siegert (dir.) (2005), Germany: ARTE.

The Cleaning Women Island [*Die Putzfraueninsel*], Peter Timm (dir.) (1996), Germany: Avista Film.

Close, Marcus Lenz (dir.) (2004), Germany: Deutsche Film- und Fernsehakademie Berlin.

Close to the Limit [*Hart an der Grenze*], Wolfgang Tumler (dir.) (1985), West Germany: Sender Freies Berlin.

Cloud 9 (aka *Cloud Nine*) [*Wolke 9*, aka *Wolke Neun*], Andreas Dresen (dir.) (2008), Germany: Peter Rommel Productions.

Cloves in Aspic [*Nelken in Aspik*], Günter Reisch (dir.) (1976), East Germany: VEB DEFA-Studio für Spielfilme.

Cocoon [*Kokon*], Leonie Krippendorff (dir.) (2020), Germany: Jost Hering Filmproduktion.

Coded Message for the Boss (aka *Code for the Boss: Sortie No. 5*) [*Chiffriert an Chef – Ausfall Nr. 5*], Helmut Dziuba (dir.) (1979), East Germany: DEFA.

A Coffee in Berlin [*Oh Boy*], Jan-Ole Gerster (dir.) (2012), Germany: Schiwago Film.

Columbus 64, Ulrich Thein (dir.) (1966), East Germany: Deutscher Fernsehfunk.

Come and Play [*Komm und Spiel*], Daria Belova (dir.) (2013), Germany: Deutsche Film-und Fernsehakademie Berlin.

Comedian Harmonists, Eberhard Fechner (dir.) (1976), Germany: Norddeutscher Rundfunk.

Comedian Harmonists, Joseph Vilsmaier (dir.) (1997), Germany: Bavaria Film.

A Completely Normal Flatshare [*Eine ganz normale WG*], Georg Schönharting (dir.) (2014), Germany: Das Kleine Fernsehspiel/Zimmer 209.

The Coming Days [*Die kommenden Tage*], Lars Kraume (dir.) (2010), Germany: Badlands Film.

Coming In, Thomas Bahmann (dir.) (1997), Germany: Südwestfunk.

Coming In, Marco Kreuzpaintner (dir.) (2014), Germany: Summerstorm Entertainment.

Coming Out, Heiner Carow (dir.) (1989), East Germany: DEFA.

The Components of Love [*Die Einzelteile der Liebe*], Miriam Bliese (dir.) (2019), Germany: Deutsche Film- und Fernsehakademie Berlin.

Comrade Couture, [*Ein traum in Erdbeerfolie*], Marco Wilms (dir.) (2009), Germany: LOOKSfilm.

Concrete and Money [*Beton und Devisen*], Lew Hohmann (dir.) (1994), Germany: DEFA-Studio für Dokumentarfilm.

Confessions of a Dangerous Mind, George Clooney (dir.) (2002), USA: Miramax.

Conrad: The Factory-Made Boy [*Konrad oder Das Kind aus der Konservenbüchse*, aka *Konrad aus der Konservenbüchse*], Claudia Schröder (dir.) (1983), West Germany: Ottokar Runze Filmproduktion.

Conspiracy, Frank Pierson (dir.) (2001), USA/UK: HBO Films.

Contaminated Palace (aka *Old Burden Palace*) [*Altlastpalast*], Irina Enders (dir.) (2006), Germany: MonstaMovies Filmproduktion.

Cop in Drag [*Delitto al Blue Gay*], Bruno Corbucci (dir.) (1984), Italy/West Germany: Globe/Medusa.

Coq au Vin [*Kokowääh*], Til Schweiger and Torsten Künstler (dirs.) (2011), Germany: Barefoot Films.

Coq au Vin 2 [*Kokowääh 2*], Til Schweiger and Torsten Künstler (dirs.) (2013), Germany: Barefoot Films.

Cosima's Lexicon [*Cosimas Lexicon*], Peter Jahane (dir.) (1992), Germany: Rialto Film.

Countdown, Ulrike Ottinger (dir.) (1990), Germany: Ulrike Oettinger Filmproduktion.

Counterfeiters [*Falschmünzer*], Hermann Pfeiffer (dir.) (1940), Germany: Terra-Filmkunst.

The Countess from Chamissoplatz: A Story from Today's Berlin [*Die Gräfin vom Chamissoplatz: Eine Geschichte aus dem heutigen Berlin*], Sigi Rothemund (dir.) (1980), West Germany: Neue Filmproduktion.

Crash – Man Looking for a Man [*Crash – Man sucht Mann*], Rüdiger Tuchel (dir.) (1984), West Germany: Tuchel & Co. Filmproduktion.

Crash Point: Berlin [*Crashpoint – 90 Minuten bis zum Absturz*], Thomas Jauch (dir.) (2009), Germany: Hager Moss Film.

Crazy Love [*Amour Fou*], Jessica Hausner (dir.) (2014), Austria: Coop99 Filmproduktion.

A Crazy Night [*Eine tolle Nacht*], Richard Oswalt (dir.) (1927), Germany: Richard-Oswalt-Produktion.

Crime Scene Berlin [*Tatort Berlin*], Joachim Kunert (dir.) (1958), East Germany: DEFA.

Crook's Honor [*Ganovenehre: Ein Film aus der Berliner Unterwelt*], Richard Oswalt (dir.) (1933), Germany: Rio-Film.

Crook's Honor (aka *A Scoundrel's Honor*) [*Ganovenehre*], Wolfgang Staudte (dir.) (1933), West Germany: Inter West Film.

The Cuckoo [*Die Kuckucks*], Hans Deppe (dir.) (1949), East Germany: DEFA.

Cyanide [*Cyankali*], Hans Tintner (dir.) (1930), Germany: Atlantis Film.

Cycling the Frame, Cynthia Beatt (dir.) (1988), USA: Icarus Films.

Dana Lech, Frank Guido Blasberg (dir.) (1992), West Germany: Deutsche Film- und Fernsehakademie Berlin.

The Dancing Hussar [*Der Tanzhusar*], Fred Sauer (dir.) (1931), Germany: Hegewald Film.

A Dandy in Aspic, Anthony Mann (dir.) (1968), USA: Columbia British Productions.

Dangerous Crossing [*Gleisdreieck*], Robert A. Stemmle (dir.) (1937), Germany: Fabrikation Deutscher Filme.

Dark Lipstick Makes You More Serious [*Dunkler Lippenstift macht seriöser*], Katrin Rothe (dir.) (2003), Germany: Unique Film- und Fernsehproduktion.

Dark Shadows of Fear [*Dunkle Schatten der Angst*], Konstantin Schmidt (dir.) (1992), Germany: Arte G.E.I.E.

The Dark Side [*Die dunkle Seite*], Peter Keglevic (dir.) (2008), Germany: Network Movie Film- und Fernsehproduktion.

Darkroom [*Tödliche Tropfen*], Rosa von Praunheim (dir.) (2019), Germany: Rosa von Praunheim Filmproduktion.

Dating Lanzelot, Oliver Rihs (dir.) (2011), Germany: Port au Prince Film & Kultur Produktion.

Daughters [*Töchter*, aka *Anonym*], Maria Speth (dir.) (2014), Germany: Madonnen Film.

David, Peter Lilienthal (dir.) (1979), West Germany: Von Vietinghoff Filmproduktion.

The Day It Rained [*Am Tag, als der Regen kam*, aka *Die schwarzen Panther*], Gerd Oswald (dir.) (1959), West Germany: Alfa Film.

Daylight Saving Time Begins at the Last Tone [*Beim letzten Ton des Zeitzeichens beginnt die Sommerzeit*], Wolfgang Ramsbott (dir.) (1985), West Germany: Literarisches Colloquium Berlin.

The Days Between [*In den Tag hinein*], Maria Speth (dir.) (2000), Germany: Hochschule für Film und Fernsehen 'Konrad Wolf'.

Day Thieves (aka *Hangin' Around*) [*Tagediebe*], Marcel Gisler (dir.) (1985), West Germany: Marcel Gisler Filmproduktion.

Deadly Decision [*Canaris*, aka *L'affaire de l'amiral Canaris*], Alfred Weidenmann (dir.) (1954), West Germany: UFA.

Dead Run [*Geheimnisse in goldenen Nylons*], Christian-Jaque (dir.) (1967), France/Italy/West Germany: Central Cinema Company Film.

The Dead Stay Young [*Die Toten bleiben jung*], Hans-Joachim Kunert (dir.) (1968), East Germany: DEFA.

Dealer, Thomas Arslan (dir.) (1999), Germany: Trans-Film.

Dear Fatherland, Be at Peace [*Lieb Vaterland, magst ruhig sein*], Roland Klick (dir.) (1976), West Germany: Cotta Film.

Dear Thomas [*Lieber Thomas*], Andreas Kleinert (dir.) (2021), Germany: Zeitsprung Pictures.

Deathline [*Der kalte Finger*], Ralf Huettner (dir.) (1996), Germany: Neue Deutsche Filmgesellschaft.

A Deathtrip in Berlin, Mario Schollenberger (dir.) (2016), Germany: Schollenberger Film.

The Debt (aka *The Rachel Singer Affair*), John Madden (dir.) (2010), USA/UK: Miramax.

Declaration of Love for Berlin [*Liebeserklärung an Berlin*], Uwe Belz (dir.) (1977), East Germany: DEFA.

Demolition of the Berlin City Palace [*Sprengung des Berliner Stadtschloss*], Helmut Gerstmann, Ewald Krause and Rudolph Schemmel (dirs.) (1950), East Germany: DEFA-Studio für Dokumentarfilme.

Demons [*Demoni*], Lamberto Bava (dir.) (1985), Italy: DACFILM Rome.

Der Tunnel, Roland Suso Richter (dir.) (2001), Germany: teamWorx.

Desert of Love [*Die Liebeswüste*], Lothar Lambert (dir.) (1987), West Germany: Lothar Lambert Filmproduktion.

Desire Will Set You Free, Yony Leyser (dir.) (2015), Germany: Amard Bird Films/Desire Productions.

Despair [*Eine Reise ins Licht*], Rainer Werner Fassbinder (dir.) (1978), West Germany: Bavaria Atelier.

Desperate Journey (aka *Forced Landing*), Raoul Walsh (dir.) (1942), USA: Warner Brothers.

Destination Freedom [*Westflug – Entführung aus Liebe*], Thomas Jauch (dir.) (2010), Germany: Monaco Film.

Destinies of Women [*Frauenschicksale*], Slatan Dudow (dir.) (1952), Germany: DEFA.

Destiny [*Der Müde Tod*], Fritz Lang (dir.) (1921), Germany: Decla-Bioscop.

The Detours of Beautiful Karl [*Die Umwege des schönen Karl*], Carl Froelich (dir.) (1937), Germany: Tonfilmstudio Carl Froelich.

The Devil of Kreuzberg [*Ein Schöner Film*], Alexander Bakshaev (dir.) (2015), Germany: Yellow Bag Films.

The Devil's General [*Des Teufels General*], Helmut Käutner (dir.) (1955), West Germany: Real-Film.

The Devious Path [*Abwege*], Georg Wilhelm Pabst (dir.) (1928), Germany: Deutsche-Universal Film.

Diary of a Lost Girl [*Tagebuch einer Verloren*], Richard Oswald (dir.) (1918), Germany: Richard Oswald Produktion.

Diary of a Lost Girl [*Tagebuch einer Verloren*], Georg Wilhelm Pabst (dir.) (1929), Germany: Pabst-Film.

Different from the Others (*Paragraph 175*) [*Anders als die Andern* (§ *175*)], Richard Oswald (dir.) (1919), Germany: Richard-Oswald-Produktion.

Dirty Daughters [*Dirty Daughters – Die Hure und der Hurensohn*], Dagmar Beiersdorf (dir.) (1982), West Germany: Dagmar Beiersdorf Filmproduktion.

Displaced, Sharon Ryba-Kahn (dir.) (2021), Germany: Tondowski Films.

The Distance Between You and Me and Her [*Die Entfernung zwischen dir und mir und ihr*], Michael Kann (dir.) (1988), East Germany: DEFA.

Distant Lights [*Lichter*], Hans-Christian Schmid (dir.) (2003), Germany: ARTE.

Divided Heaven [*Der geteilte Himmel*], Konrad Wolf (dir.) (1964), East Germany: DEFA.

The Divine Jetta [*Die göttliche Jette*], Erich Waschneck (dir.) (1937), Germany: Fanal-Film-produktion.

Dr. Ketel [*Dr. Ketel – Der Schatten von Neukölln*], Linus da Paoli (dir.) (2011), Germany: Deutsche Film- und Fernsehakademie Berlin.

Dr. M., Claude Chabrol (dir.) (1990), Germany: NEF Filmproduktion & Vertrieb.

Dr. Mabuse, the Gambler [*Dr. Mabuse, der Spieler*], Fritz Lang (dir.) (1922), Germany: Uco-Film.

The Dogs Are to Blame [*Die Hunde sind schuld*], Andreas Prochaska (dir.) (2001), Germany: die film.

Dogs of Berlin, Christian Alvart (dir.) (2018), Germany: Syrreal Entertainment.

Domino [aka *Das wahre Leben*], Thomas Brasch (dir.) (1982), West Germany: Argos Films.

Don 2 The Chase Continues (aka *Don – The King Is Back*), Farhan Akhtar (dir.) (2011), India/Germany: Excel Entertainment/Film Base Berlin.

Don't Forget My Traudel [*Vergesst mir meine Traudel nicht*], Kurt Maetzig (dir.) (1957), East Germany.

Don't Forget to Go Home [*Feiern*], Maja Classen (dir.) (2006), Germany: Hochschule für Film und Fernsehen 'Konrad Wolf'.

Dorado – One Way, Reinhard Münster (dir.) (1984), West Germany: Futura Film.

Dorian Gray in the Mirror of the Tabloids [*Dorian Gray im Spiegel der Boulevardpresse*], Ulrike Ottinger (dir.) (1984), West Germany: Ulrike Ottinger Filmproduktion.

Downfall [*Der Untergang*], Oliver Hirschbiegel (dir.) (2004), Germany: Constantin Film.

Downhill City, Hannu Salonen (dir.) (1999), Germany/Finland: Luna-Film/Talent House Oy.

Do You Know Urban? [*Kennen Sie Urban?*], Ingrid Reschke (dir.) (1971), East Germany: DEFA.

Dragan Wende – West Berlin (aka *Dragan Wende or How the Trabant Invaded West-Berlin and Ruined My Uncle's Kingdom*), Lena Müller and Dragan von Petrovic (dirs.) (2012), Germany/Serbia: Von Müller Film.

Drama in Blond, Lothar Lambert (dir.) (1984), West Germany: Lothar Lambert Filmproduktion.

Drawing a Line [*Striche Ziehen*], Gerd Kroske (dir.) (2015), Germany: Mitteldeutscher Rundfunk.

The Dreamed Path [*Der traumhafte Weg*], Angela Schanelec (dir.) (2016), Germany: Film-galerie 451.

Dreamfactory [*Traumfabrik*], Martin Schreier (dir.) (2019), Germany: Traumfabrik Babelsberg.

Dreamgirls [*Traumfrauen*], Anita Decker (dir.) (2015), Germany: Hellinger/Doll Filmproduktion.

The Dream of Lieschen Mueller [*Der Traum von Lieschen Müller*, aka *Happy-End in siebten Himmel*], Helmut Käutner (dir.) (1961), West Germany: Divina-Film.

Dreams Are Like Wild Tigers [*Träume sind wie wilde Tiger*], Lars Montag (dir.) (2021), Germany: Kinderkanal.

The Dream Ship [*Das Traumschiff*], Herbert Ballmann (dir.) (1956), East Germany: DEFA.

Drifter, Sebastian Heidinger (dir.) (2007), Germany: Boekamp and Freunde.

The Drifters [*Eine flexible Frau*], Tatjana Turanskyj (dir.) (2010), Germany: Turanskyj & Ahlrichs.

A Drunken Life [*Ein rauschendes Leben*], Hannelore Conradsen and Dieter Köster (dirs.) (1983), West Germany: Hannelore Conradsen-Köster-Film.

Dschungel Berlin 1986, Knut Hoffmeister (dir.) (1986), West Germany: Knut Hoffmeister Filmproduktion.

Dunckel (aka *Freddy Dunckel*), Lars Kraume (dir.) (1998), Germany: Deutsche Film- und Fernsehakademie Berlin.

The Dust of Time [*Trilogia II: I skoni tou hronou*], Theodoros Angelopoulos (dir.) (2008), Greece/Germany: Theodoros Angelopoulos Films.

Dust on Our Hearts [*Staub auf unseren Herzen*], Hanna Doose (dir.) (2012), Germany: Deutsche Film- und Fernsehakademie Berlin.

Dutschke, Stefan Krohmer (dir.) (2009), Germany: teamWorx.

East Zone, West Zone [*Oggi a Berlino*], Piero Vivarelli (dir.) (1962), Italy: Cinematografica Cervi.

E.C.G. Expositus (*The Broadcast and Artistic Media*) [*E.K.G. Expositus* (*die öffentlichen und die künstlerischen Medien*)], Michael Brynntrup (dir.) (2004), Germany: MBC Filmproduktion.

Edith Schröder – A German Housewife [*Edith Schröder – eine deutsche Hausfrau*], Ogar Grafe, Calli Wolf and Ades Zabel (dirs.) (1981), Germany: Teufelsberg-Produktion.

The Edukators [*Die fetten Jahre sind vorbei*], Hans Weingartner (dir.) (2004), Germany: Y3 Film.

Eight Miles High [*Das wilde Leben*], Achim Bornhak (dir.) (2007), Germany: Babelsberg Film.

Einstein's Baby [*Einsteins Baby*], Rudolf Steiner and Detlef (Ted) Tetzke (dirs.) (1995), Germany: Rudolf Steiner Film.

The Einstein of Sex [*Der Einstein des Sex*], Rosa von Praunheim (dir.) (1999), West Germany: ARTE.

Elected [*Die Gewählten: Vier Jahre im Bundestag*], Nancy Brandt (dir.) (2014), Germany: if... Productions.

Electric Girl, Ziska Riemann (dir.) (2019), Germany: NiKo Film.

The Elegant Bunch [*Elegantes Pack*], Jaap Speyer (dir.) (1925), Germany: Domo-Film.

Emil and the Detectives [*Emil und die Detektive*], Gerhard Lamprecht (dir.) (1931), Germany: UFA.

Emil and the Detectives [*Emil und die Detektive*], Robert A. Stemmle (dir.) (1954), West Germany: Berolina.

Emil and the Detectives, Peter Tewksbury (dir.) (1964), USA: Walt Disney Productions.

Emil and the Detectives, Franziska Buch (dir.) (2001), USA: Constantin Film.

Emil the Comedian [*Komödianten-Emil*], Joachim Hasler (dir.) (1980), East Germany: DEFA.

The Empty Center [*Die leere Mitte*], Hito Steyerl (dir.) (1998), Germany: Hochschule für Fernsehen und Film München.

The End of Domination [*Das Ende der Beherrschung*], Gabi Kubach (dir.) (1977), West Germany: Gabi Kubach Filmproduktion.

The Endless Night [*Die endlose Nacht*] Will Tremper (dir.) (1963), West Germany: Will Tremper Filmproduktion.

The End of the Rainbow [*Das Ende des Regenbogens*], Uwe Friesser (dir.) (1979), West Germany: Basis-Film-Verleih.

Equality [*Égalité*], Kida Khodr Ramadan (dir.) (2021), Germany: Kida Films.

Equilibrium, Kurt Wimmer (dir.) (2002), USA: Dimension Films.

Erebos, Nico Ligouris (dir.) (1988), West Germany: Von Vietinghoff Filmproduktion.

Escape from East Berlin (aka *Tunnel 28*), Robert Siodmak (dir.) (1962), West Germany: Walter Wood Productions.

The Eskimo Baby [*Das Eskimobaby*], Walter Schmidthässler (dir.) (1916), Germany: Neutral-Film.

EuroTrip, Jeff Schaffer (dir.) (2004), USA: Dreamworks.

An Evening in SE 36, A Concert with Einstürzende Neubauten [*Ein Abend im SO 36, Ein Konzert mit Einstürzende Neubauten*], Albrecht Metzger (dir.) (1982), West Germany: Westdeutscher Rundfunk.

Everyday Life [*Alltag*], Neco Çelik (dir.) (2002), Germany: teamWorx.

Everyone Dies Alone [*Jeder stirbt für sich allein*], Falk Harnack (dir.) (1962), West Germany: Sender Freies Berlin.

Everyone Dies Alone [*Jeder stirbt für sich allein*], Hans-Joachim Kasprzik (dir.) (1970), East Germany: DEFA.

Everyone Dies Alone [*Jeder stirbt für sich allein*], Alfred Vohrer (dir.) (1976), West Germany: Lisa-Film.

Everyone Has Their Own Story [*Jeder hat seine Geschichte*], Heiner Carow (dir.) (1965), East Germany: DEFA.

Ex, George Markakis (dir.) (2020), Germany: Authorwave.

Experience Berlin: 100 Years of the Cosmopolitan City [*Erlebnis Berlin – 100 Jahre Weltstadt*], Irmgard von zur Mühlen (dir.) (1997), Germany: Chronos-Film.

Exploitation, Edwin Brienen (dir.) (2012), Germany: Ultra Vista Produktion.

Ex and Hopp [*Ex und hopp*], Lothar Lambert and Wolfram Zobus (dirs.) (1972), West Germany: Lothar Lambert Filmproduktion.

Fabian, Wolf Gremm (dir.) (1980), West Germany: Regina Ziegler Filmproduktion.

Fabian: Going to the Dogs [*Fabian oder Der Gang vor die Hunde*], Dominik Graf (dir.) (2021), Germany: Lupa Film.

A Fairy for Dessert [*Eine Tunte zum Dessert*], Dagmar Beiersdorf (dir.) (1992), Germany: Wolfgang Krenz Filmproduktion.

Faith [*Shahada*], Burhan Qurbani (dir.) (2010), Germany: Bittersüss Pictures.

The Fall of Berlin [*Padenie Berlina – ПАДЕНИЕ БЕРЛИНА*], Mikheil Chiaureli (dir.) (1950), USSR: Mosfilm.

Fall of Berlin – 1945 (aka *Battle of Berlin – 1945*) [*Bitva za Berlin – 1945*], Yuli Raizman and Yelizaveta Svilova (dirs.) (1945), USSR: Tsentralnaya Studiya Dokumentalnikh Filmov (TsSDF).

Faraway Land Pa-Isch [*Fernes Land Pa-Isch*], Rainer Simon (dir.) (1994), Germany: Studio Babelsberg.

Faraway So Close [*In Weiter Ferne, So Nah!*], Wim Wenders (dir.) (1993), Germany: Road Movies.

Farewell [*Abschied*, aka *So sind die Menschen*], Robert Siodmak (dir.) (1930), Germany: UFA.

Farewell in Berlin [*Abschied in Berlin*], Antonio Skármeta (dir.) (1985), West Germany: Prole Filme.

Far from Berlin [*Loin de Berlin*], Keith McNally (dir.) (1992), France: ARP Sélection.

Far from Home [*In der Fremde*, aka *Das Ghorbat*], Sohrab Shahid Saless (dir.) (1975), West Germany: Provobis Film.

Farssmann or Walk Up the Blind Alley [*Farßmann oder Zu Fuß in die Sackgasse*], Roland Oehme (dir.) (1991), Germany: DEFA.

The Fate of Hitler's Capital [*Der Todeskampf der Reichshauptstadt*], Irmgard von zur Mühlen (dir.) (1995), Germany: Chronos Film.

Fatherland, Christopher Menaul (dir.) (1994), USA/Czech Republic: HBO Pictures/Eis Film.

Fear [*Angst – Die schwache Stunde einer Frau*], Hans Steinhoff (dir.) (1928), Germany: Orplid-Film.

Female2 Seeks HappyEnd [*Frau2 sucht HappyEnd*], Edward Berger (dir.) (2001), Germany: Box! Film- und Fernsehproduktions.

The Fiancée [*Der Verlobte*], Günter Reisch and Günther Rücker (dirs.) (1980), East Germany: DEFA.

The Fifth Estate, Bill Condon (dir.) (2013), USA/Belgium: Dreamworks/Reliance.

Film Location Berlin [*DrehOrt Berlin*], Helga Reidemeister (dir.) (1987), West Germany: Journal Filmproduktion.

Film Without a Name [*Film ohne Titel*], Rudolf Jugert (dir.) (1947), Germany: Bavaria Film.

The Final Battle [*Die letzte Schlacht*], Hans-Christoph Blumenberg (dir.) (2005), Germany: ZDF.

The Final Farewell [*Abschiedstournee*], Alexander Pfander (dir.) (2012), Germany: Pfanderfilm.

The Final Solution: The Wannsee Conference (aka *Hitler's Final Solution: The Wannsee Conference*) [*Die Wannseekonferenz*], Heinz Schirk (dir.) (1984), West Germany: Bayerischer Rundfunk.

Final Stop Silesia – A Trip on Line 1 of the Berlin Underground [*Endstation Schlesien – Eine Reise mit der Berliner U-Bahn Linie 1*], Peter Adler and Hans-Jörg Reinek (dirs.) (1987), West Germany: Carsten Krüger Film- und Fernsehproduktion.

A Fine Day [*Der schöne Tag*], Thomas Arslan (dir.) (2001), Germany: Filmboard Berlin-Brandenburg.

Fire in the Opera House [*Brand in der Oper*], Carl Froelich (dir.) (1930), Germany: Carl-Froelich Film.

The Fireman [*Der Mann im Feuer*], Erich Waschneck (dir.) (1926), Germany: UFA.

The First Row – Pictures of the Berlin Resistance [*Die erste Reihe – Bilder aus dem Berliner Widerstand*], Peter Vogel (dir.) (1987), East Germany: DEFA.

Fist in the Pocket [*Die Faust in der Tasche*], Max Willutzki (dir.) (1978), West Germany: Basis Film.

Five Beers and One Coffee [*Fünf Bier und ein Kaffee*], Rudolf Steiner (dir.) (1989), West Germany: Consul Film.

Five Fingers, Joseph L. Mankiewicz (dir.) (1952), USA: Twentieth Century Fox.

A Five Star Life [*Viaggio sola*], Maria Sole Tognazzi (dir.) (2013), Italy: Bianca Film.

Fleur Lafontaine, Horst Seemann (dir.) (1978), East Germany: DEFA.

The Flight [*Die Flucht*], Roland Gräf (dir.) (1977), East Germany: DEFA.

Flight to Berlin, Christopher Petit (dir.) (1984), Sweden/UK: British Film Institute.

Flight through the Night [*Flug durch die Nacht*], Ilona Baltrusch (dir.) (1980), West Germany: Deutsche Film- und Fernsehakademie Berlin.

Flightplan, Robert Schwentke (dir.) (2005), USA: Touchstone Pictures.

Florentine Street 73 [*Florentiner 73*], Klaus Gendries (dir.) (1972), East Germany: DEFA.

The Flower Woman of Potsdamer Platz [*Die Blumenfrau vom Potsdamer Platz*], Jaap Speyer (dir.) (1925), Germany: Domo-Film.

Fly, Katja von Garnier (dir.) (2021), Germany: SevenPictures Film.

Flying Rats [*Fliegende Ratten*], David Jazay (dir.) (2006), Germany: Inselfilm Produktion.

Forbidden, Anthony Page (dir.) (1984), West Germany/UK: Mark Forstater Productions/Clasart Film- und Fernsehproduktion.

A Foreign Affair, Billy Wilder (dir.) (1948), USA: Paramount.

For Eyes Only [*Streng geheim*], János Veiczi (dir.) (1963), East Germany: DEFA.

For Once I'd Like to Have No Troubles [*Einmal möcht' ich keine Sorgen haben*], Max Nosseck (dir.) (1932), Germany: Biograph-Film.

For What, Then? [*Für wat denn?*], Dagmar Döring and Klaus Langenkamp (dirs.) (1983), Germany: Döring/Langenkamp Filmproduktion.

Four Against the Bank [*Vier gegen die Bank*], Wolfgang Petersen (dir.) (2016), Germany: Hellinger/Doll Filmproduktion.

The Four Companions [*Die vier Gesellen*], Carl Frölich (dir.) (1938), Germany: Tonfilmen.

The Fourth State (aka *In the Year of the Snake*) [*Die vierte Macht*, aka *Im Jahr der Schlange*], Dennis Gansel (dir.) (2012), Germany: SevenPictures Film/UFA Fiction.

Franziska! [aka *Auf Wiedersehn, Franziska!*], Wolfgang Liebeneiner (dir.) (1957), Germany: Central Cinema Company Film.

Fraulein [*Fräulein*], Henry Koster (dir.) (1958), USA: Twentieth Century Fox.

Freak Orlando, Ulrike Ottinger (dir.) (1981), West Germany: Ulrike Ottinger Filmproduktion.

Freddy and the Melody of the Night [*Freddy und die Melodie der Nacht*], Wolfgang Schleif (dir.) (1960), West Germany: Melodie Film.

A Friend of Mine [*Ein Freund von mir*], Sebastian Schipper (dir.) (2006), Germany: Film 1.

From the Diary of a Sex Bully [*Aus dem Tagebuch eines Sex-Moppels*], Lothar Lambert (dir.) (2004), Germany: Lothar Lambert Filmproduktion.

From Today Your Name Is Sarah [*Ab heute heisst du Sarah*], Peter Behle (dir.) (1989), West Germany: Grips-Theater.

Front City [*Frontstadt*], Klaus Tuschen (dir.) (1983), West Germany: Tupro-Welt-Klang-Cine.

Fuck Hamlet, Cheol-Mean Whang (dir.) (1996), Germany: Deutsche Film- und Fernsehakademie Berlin.

Fucking Berlin, Florian Gottschick (dir.) (2016), Germany: Arenico Productions.

Fucking City, Lothar Lambert (dir.) (1982), West Germany: Lothar Lambert Filmproduktion.

Führer Ex, Winfried Bonegal (dir.) (2002), Germany: Next Film.

Funeral in Berlin, Guy Hamilton (dir.) (1966), UK: Jovera Pictures.

Futuro Beach [*Praia do Futuro*], Karim Aïnouz (dir.) (2014), Brazil/Germany: Coração da Selva/Hank Levine Film.

The Gas Man, [*Der Gasmann*], Carl Frölich (dir.) (1941), Germany: Tonfilmstudio Carl Frölich.

Gentleman, Oskar Roehler (dir.) (1995), Germany: Appartement Zero/Berlin Film.

Gentlemen in White Vests (aka *The Vacuum Cleaner Gang*) [*Die Herren mit der weißen Weste*], Wolfgang Staudte (dir.) (1970), Germany: Rialto Film.

German Angst, Jörg Buttgereit (*Final Girl*), Michal Kosakowski (*Make a Wish*), Andreas Marschall (*Alraune*) (dirs.) (2015), Germany: Kosakowski Films.

German Dreams, Lienhard Wawrzyn (dir.) (1985), West Germany: Westdeutscher Rundfunk.

German Police: Many Cultures – One Troop [*Deutsche Polizisten: Viele Kulturen – Eine Truppe*], Aysun Bademsoy (dir.) (2004), Germany: Harun Farocki Filmproduktion.

Germans [*Deutschländer*], Irina Hoppe (dir.) (1994), West Germany: Deutsche Film- und Fernsehakademie Berlin.

The German State Opera [*Die Deutsche Staatsoper*], Peter Ulbrich (dir.) (1956), East Germany: DEFA.

Germany 09: 13 Short Films about the State of the Nation [*Deutschland 09: 13 kurze Filme zur Lage der Nation*], Fatih Akın, Wolfgang Becker, Sylke Enders, Dominik Graf, Martin Gressmann, Christopher Hochhäusler, Romuald Karmakar, Nicolette Krebitz, Dani Levy, Angela Schanelec, Hans Steinbichler, Isabelle Stever, Tom Tykwer and Hans Weingartner (dirs.) (2009), Germany: Herbstfilm Produktion.

Germany, Bitter Homeland [*Almanya Aci Vatan*], Serif Gören (dir.) (1979), Turkey: Gulsah Film.

Germany Awakens – A Document of the Rebirth of Germany [*Deutschland erwacht – Ein Dokument von der Wiedergeburt Deutschlands*], Anonymous (dir.) (1933), Germany: Deutsche Film Gesellschaft.

Germany Greets Kennedy – Four Days of History [*Deutschland grüßt Kennedy – Vier geschicht- liche Tage*], Manfred Purzer (dir.) (1963), West Germany: Deutsche Wochenschau.

Germany Pale Mother [*Deutschland bleiche Mutter*], Helma Sanders-Brahms (dir.) (1980), West Germany: Helma Sanders-Brahms Filmproduktion.

Germany Year Zero [*Germania Anno Zero*], Roberto Rossellini (dir.) (1948), Italy: Tevere Film.

Ghosts [*Gespenster*], Christian Petzold (dir.) (2005), Germany: Schramm Film Koerner & Weber.

The Gift Horse [*Hilde*, aka *Hildegard Knef Biopic*], Kai Wessel (dir.) (2009), Germany: Egoli Tossell Pictures.

Gigant Berlin, Leo de Lafourge (dir.) (1964), West Germany: Lafourge Filmproduktion.

Girl in a Boot (aka *A Berlin Love Story*) [*Einmal Ku'damm und zurück*], Herbert Ballmann (dir.) (1985), West Germany: Cinecom Pictures.

The Girl in the Lift [*Das Mädchen aus dem Fahrstuhl*], Hermann Zschoche (dir.) (1991), East Germany: DEFA.

The Girl from Ackerstrasse – 1 [*Das Mädchen aus der Ackerstraße – Ein Drama aus der Grossstadt*], Reinhold Schünzel (dir.) (1920), Germany: Cserépy-Film.

The Girl from Ackerstrasse – 2 [*Das Mädchen aus der Ackerstraße – 2. Teil*], Werner Funck (dir.) (1920), Germany: Funck-Film.

The Girl from Ackerstrasse – 3 [*Wie das Mädchen aus der Ackerstraße die Heimat fand*], Martin Harwig (dir.) (1921), Germany: Basta-Film.

A Girl from the Chorus [*Ein Mädel vom Ballett*], Karel Lamac (dir.) (1937), Germany: UFA.

A Girl of 16 ½ [*Ein Mädchen von 16 ½*], Carl Balhaus (dir.) (1958), East Germany: DEFA.

Girls in Gingham [*Die Buntkarierten*], Kurt Maetzig (dir.) (1949), East Germany: DEFA.

The Glamorous World of the Adlon Hotel [*In der glanzvollen Welt des Hotel Adlon*], Percy Adlon (dir.) (1996), Germany: ARTE.

The Glass Tower [*Der gläserne Turm*], Harald Braun (dir.) (1957), West Germany: Bavaria Film.

Gleimtunnel – Here and Over There [*Am Gleimtunnel – Hier und drüben*], Torsten Löhn (dir.) (2010), Germany: Belle Journée Productions Genève.

Go for Zucker [*Alles auf Zucker!*] Dani Levy (dir.) (2004), Germany: X-Filme Creative Pool.

Golden October [*Der goldene Oktober*], *Knut Hoffmeister* (dir.) (1985), West Germany: Knut Hoffmeister Filmproduktion.

A Goldfish among Sharks [*Ein Goldfisch unter Haien*], Marc-Andreas Bochert (dir.) (2004), Germany: UFA.

Gold: You Can Do More Than You Think [*Gold – Du kannst mehr als du denkst*], Michael Hammon (dir.) (2013), Germany: Parapictures Film Production.

Gölge – The Shade [*Gölge – Schatten*, aka *Zukunft der Liebe*], Sofokolis Adamidis and Sema Poyraz (dirs.) (1980), West Germany: Deutsche Film- und Fernsehakademie Berlin.

Gomez: Heads or Tails [*Gomez – Kopf oder Zahl*], Edward Berger (dir.) (1998), Germany/ Switzerland: Valerian Film/Medias Res Filmproduktion.

Goodbye Berlin [*Tschick*], Fatih Akın (dir.) (2016), Germany: Lago Film.

Good Bye Lenin! Wolfgang Becker (dir.) (2003), Germany: X-Filme Creative Pool.

The Good German, Steven Soderbergh (dir.) (2006), USA: Warner Brothers.

Good Land [*Ein gutes Land*], Horatius Haeberle (dir.) (1982), West Germany: Interart Productions Film.

Good Vibrations, Bad Situations [*Gut drauf, schlecht dran*], Lothar Lambert (dir.) (1993), Germany: Lothar Lambert Filmproduktion.

Gorilla Bathes at Noon, Dusan Makavejev (dir.) (1993), Yugoslavia/Germany: Alert Film/Ekstaza/Von Vietinghoff Filmproduktion.

Go with Le Flo, Michael Glover (dir.) (2013), Germany: Bright Blue Gorilla.

Grand Hotel, Edmond Goulding (dir.) (1932), USA: Metro-Goldwyn-Mayer.

The Great Dictator, Charles Chaplin (dir.) (1940), USA: Charles Chaplin Productions.

The Great Hall [*Der Große Saal*], Hans-Jürgen Hohman (dir.) (1977), East Germany: DEFA.

The Great Love [*Die Große Liebe*], Rolf Hansen (dir.) (1942), Germany: UFA.

Guarantee for One Year [*Bürgschaft für ein Jahr*], Herrmann Zschoche (dir.) (1981), East Germany: DEFA.

Gunpowder Milkshake, Navot Papushado (dir.) (2021), France/Germany/USA: StudioCanal/Studio Babelsberg/The Picture Company.

The Hairdresser [*Die Friseuse*], Doris Dörrie (dir.) (2010), Germany: Collina.

Half the Rent [*Halb Miete*], Marc Ottiker (dir.) (2002), Germany: Filmstiftung Nordrhein-Westfalen.

A Handful of Notes [*Eine Handvoll Noten*], Otto Schneidereit and Helmut Spiess (dirs.) (1961), East Germany: DEFA.

Hanna, Joe Wright (dir.) (2011), USA: Focus Features.

Hans Westmar, Franz Wenzler (dir.) (1933), Germany: Volksdeutsche Film.

Hanussen, O.W. Fischer and Georg Marischka (dirs.) (1955), West Germany: Royal Film.

Hanussen, István Szabó (dir.) (1988), Hungary/West Germany: Hungarofilm/Central Cinema Company.

Happy as One [*Komm näher*], Vanessa Jopp (dir.) (2006), Germany: K5 Film.

A Happy Family Life [*Familienglück*], Ingo Kratisch and Marianne Lüdcke (dirs.) (1975), West Germany: Regina Ziegler Filmproduktion.

The Happy Sundays of the Plinsch Couple [*Die glücklichen Sonntage der Eheleute Plinsch*], Christa Pohland and Eva Häussler (dirs.) (1966), West Germany: Hansjürgen Pohland Film-produktion.

Happy Weekend, Ed Herzog (dir.) (1996), Germany: Senator Film Produktion.

Hard Days in Berlin, Heiner Hänsel (dir.) (2020), Germany: Hänsel Filmproduktion.

Hard Jobs [*Harte Jobs*], Hannelore Conradsen and Dieter Köster (dirs.) (1993), West Germany: Hannelore Conradsen-Köster-Film.

Hauptstadt Berlin: New Principles of Town Planning 1958–1959, John McHale (dir.) (1959), UK: The Independent Group.

Heading for Berlin [*Kierunek Berlin*], Jerzy Passendorfer (dir.) (1969), Poland: Zespól Filmowy Studio.

Heart Sucking [*Herzlutschen*], Joost Renders (dir.) (2004), Germany: Hey Ho, Let's Go Films.

Heaven Is Never Booked Up, [*Der Himmel ist nie ausverkauft*], Alfred Weidemann (dir.) (1957), West Germany: Capitol Film.

Heavy Girls [*Dicke Mädchen*], Axel Ranisch (dir.) (2012), Germany: Sehr Gute Filme.

Heidi M., Michael Klier (dir.) (2001), Germany: X-Filme Creative.

Heimat 3: A Chronicle of Endings and Beginnings [*Heimat 3: Chronik einer Zeitenwende*], Edgar Reitz (dir.) (2004), Germany: Reitz Film Productions.

Heinrich, Helma Sanders-Brahms (dir.) (1977), West Germany: Ziegler-Film.

Heinrich Zille, Rainer Wolffhardt (dir.) (1977), West Germany: Novafilm Fernsehproduktion.

Hell of a Reporter [*Der Teufelsreporter*], Ernst Laemmle (dir.) (1929), Germany: Deutsche Universal-Film.

The Hello Sisters [*Die Hallo-Sisters*], Ottokar Runze (dir.) (1990), Germany: Ottokar Runze Filmproduktion.

Helsinki-Naples All Night Long, Mika Kaurismäki (dir.) (1987), Finland: Condor Films.

Hereditary Problems? [*Erblich Belastet?*], Harry Piel (dir.) (1913), Germany: Eiko Film.

Here's Berlin [*Allo Berlin? Ici Paris!*, aka *Hallo Hallo! Hier spricht Berlin!*], Julien Duvivier (dir.) (1932), France/Germany: Films Sonores Tobis/RKO.

Her First Experience [*Ihr erstes Erlebnis*], Josef von Baky (dir.) (1939), Germany: UFA.

Her Most Beautiful Day [*Ihr schönster Tag*], Paul Verhoeven (dir.) (1962), West Germany: Melodie Film.

Heroes Like Us [*Helden wie Wir*], Sebastian Peterson (dir.) (1999), Germany: Senator Film.

The Heroes of the Neighborhood [*Die Helden aus der Nachbarschaft*], Jovan Arsenic (dir.) (2008), Germany: Helden Film.

Heroin, Horst E. Brandt and Heinz Thiel (dirs.) (1968), East Germany: DEFA.

Her Third [*Der Dritte*], Egon Günther (dir.) (1972), East Germany: DEFA.

Hey You! [*He Du!*], Rolf Römer (dir.) (1970), East Germany: DEFA.

The Hiding Place [*Das Versteck*], Frank Beyer (dir.) (1977), East Germany: DEFA.

The High Life [*Das kunstseidene Mädchen*], Julien Duvivier (dir.) (1960), West Germany/France: Kurt Ulrich Filmproduktion/Capitole Films.

Hilde (aka *The Gift Horse*), Kai Wessel (dir.) (2009), Germany: Egoli Tossell Pictures.

His Great Victory (aka *His Big Victory*) [*Sein großer Sieg*], Franz Barrenstein (dir.) (1952), East Germany: DEFA.

The History of Berlin [*Die Geschichte Berlins*], Irmgard von zur Mühlen (dir.) (1991), Germany: Chronos-Film.

Hitler (aka *The Women of Nazi Germany*), Stuart Heisler (dir.) (1962), USA: United Artists.

Hitler: Beast of Berlin (aka *Goose Steps*, aka *Hell's Devils*), Sam Newfield (dir.) (1939), USA: Producers Pictures Corporation.

Hitler's Children, Edward Dmytryk, dir. (Irving Reis, resigned dir.) (1943), USA: RKO Pictures.

The Hitler Gang, John Farron (dir.) (1944), USA: Paramount Pictures.

Hitler: The Last Ten Days, Ennio De Concini (dir.) (1973), UK: Westfilm.

The Holcroft Covenant, John Frankenheimer (dir.) (1985), UK: Edie & Ely Landau.

Home and Away [*Heimat und Fremde*], Joe May (dir.) (1913), Germany: Projektions-AG Union.

Home for the Weekend [*Was bleibt*], Hans-Christian Schmid (dir.) (2012), Germany: 23/5 Filmproduktion.

Homesick for You [*Heimweh nach dir*], Robert A. Stemmle (dir.) (1952), West Germany: Melodie Film.

The Hook to the Chin (aka *Knock-Out*) [*Der Kinnhaken*], Heinz Thiel (dir.) (1962), East Germany: DEFA.

Hopnick, Detlev Buck (dir.) (1990), West Germany: Deutsche Film- und Fernsehakademie Berlin.

Hostess, Rolf Römer (dir.) (1976), East GErmany: DEFA.

Hot Dog, Torsten Künstler (dir.) (2018), Germany: Barefoot Films.

Hotel Adlon, Josef von Baky (dir.) (1955), Germany: Central Cinema Company Film.

Hotel Berlin, Peter Godfrey (dir.) (1945), USA: Warner Brothers.

Hotel Deutschland, Stefan Paul (dir.) (1992), Germany: Arsenal Film.

Hotel Deutschland 2, Stefan Paul (dir.) (2011), Germany: Stefan Paul Filmproduktion.

Hot Goods in Berlin [*Heiße Ware in Berlin*], Peter Hagen (dir.) (1984), East Germany: DEFA.

Hotte in Paradise [*Hotte im Paradies*], Dominik Graf (dir.) (2002), Germany: Bayerischer Rundfunk.

The House [*Das Haus*], Rainer Wolffhardt (dir.) (1965), West Germany: Zweites Deutsches Fernsehen.

A House in Berlin [*Ein Haus in Berlin*], Cynthia Beatt (dir.) (2014), Germany: Heartbeat Pictures.

House of Shame: Chantal All Night Long, Johanna Jackie Baier (dir.) (2011), Germany: BITone! Professionals.

How Much Does Your Building Weigh, Mr Foster? Carlos Carcas and Norberto López Amado (dirs.) (2010), USA: First Run Features.

How the Berlin Worker Lives [*Zeitprobleme: wie der Berliner Arbeiter wohnt*], Slatan Dudow (dir.) (1930), Germany: Filmkartell Weltfilm.

Hunted until Dawn [*Gejagt bis zum Morgen*], Joachim Hasler (dir.) (1957), East Germany: DEFA.

The Hunt for the Boot [*Die Jagd nach dem Stiefel*], Konrad Petzold (dir.) (1962), East Germany: DEFA.

Hunting for You [*Jagd auf Dich*, aka *Filmdarsteller aus dem Kinopublikum*], Ernst Angel (dir.) (1929), Germany: Erdeka Film.

Hussars in Berlin [*Husaren in Berlin*], Erwin Stranka (dir.) (1971), East Germany: DEFA.

I Am a Camera, Henry Cornelius (dir.) (1955), UK: Romulus Films/Remus Films.

I Am a Citizen of the GDR [*Ich bin ein Bürger der DDR*], Erika Runge (dir.) (1973), East Germany: Runge Filmproduktion.

I Am, Thank God, at the Movies! [*Ich bin, Gott sei Dank, beim Film!*], Lothar Lambert (dir.) (2003), Germany: 3Sat.

I Am the Ex [*Die Ex bin ich*], Katrin Rothe (dir.) (2009), Germany: Das Kleine Fernsehspiel (ZDF).

I by Day, You by Night [*Ich bei Tag und du bei Nacht*], Ludwig Berger (dir.) (1932), Germany: UFA.

Icarus [*Ikarus*], Heiner Carow (dir.) (1975), East Germany: DEFA.

I Don't Want to Be a Man [*Ich möchte kein Mann sein*], Ernst Lubitsch (dir.) (1918), Germany: Projektions-AG Union.

I Feel Like Disco [*Ich fühl mich Disco*], Axel Ranisch (dir.) (2013), Germany: Kordes & Kordes Film.

If Not Us, Who? [*Wer wenn nicht wir*], Andres Veiel (dir.) (2011), Germany: ARD Degeto Film.

I Love You – April! April! [*Ich liebe dich – April! April!*], Iris Gusner (dir.) (1988), East Germany: DEFA.

I'm an Antistar [*Ich bin ein Antistar – Das skandalöse Leben der Evelyn Künneke*], Rosa von Praunheim (dir.) (1976), Germany: Westdeutscher Rundfunk.

The Implementer [*Der Umsetzer*], Brigitte Toni Lerch (as Antonia Lerch) and Benno Trautmann (dirs.) (1976), Germany: Lerch – Trautmann Produktions.

I'm Your Man, Maria Schrader (dir.) (2021), Germany: Letterbox Filmproduktion.

In Berlin, Michael Ballhaus and Ciro Cappellari (dirs.) (2009), Germany: ARTE.

Inge, April and May [*Inge, April und Mai*], Gabriele Denecke and Wolfgang Kohlhaase (dirs.) (1993), Germany: Filmpool Fiction.

In Hate-Love Lola [*In Haßliebe Lola*], Lothar Lambert (dir.) (1995), Germany: FMT.

In My Room, Ulrich Köhler (dir.) (2018), Germany: Pandora Filmproduktion.

The Innocent, John Schlesinger (dir.) (1993), USA: Miramax.

In One Breath [*In einem Atem*], Dietmar Hochmuth (dir.) (1988), East Germany: DEFA.

The Intermediaries [*Die Vermittler*], Astrid Schult (dir.) (2011), Germany: Cube Films.

The International, Tom Tykwer (dir.) (2009), USA: Columbia Pictures.

Interview with Berlin [*Interview mit Berlin – 10 Jahre Deutsche Demokratische Republik 1949–1959*], Max Jaap (dir.) (1959), East Germany: DEFA-Studio für Wochenschau und Dokumentarfilme.

In the Deep Valley of the Treated [*Im tiefen Tal der Therapierten*], Lothar Lambert (dir.) (2008), Germany: Sange-Film.

In the Desert [*In der Wüste*], Rafael Fuster-Pardo (dir.) (1987), West Germany: Deutsche Film- und Fernsehakademie Berlin.

In the Shadows [*Im Schatten*], Thomas Arslan (dir.) (2010), Germany: Schramm Film.

In This Very Moment [*Milchwald*], Christoph Hochhäusler (dir.) (2003), Germany: Cine Image.

Introduction [*Inteurodeoksyeon*], Hong Sang-soo (dir.) (2021), South Korea: Jeonwonsa Film.

Investigating the Murder Case of Ms. XY, Rouzbeh Rashidi (dir.) (2014), Germany/Ireland: Experimental Film Society.

Invincible, Werner Herzog (dir.) (2001), Germany: Werner Herzog Filmproduktion.

The Invincibles [*Die Unbesiegbaren*], Arthur Pohl (dir.) (1953), East Germany: DEFA.

The Invisible Dr. Mabuse [*Die unsichtbaren Krallen des Dr. Mabuse*], Harald Reinl (dir.) (1962), West Germany: Central Cinema Company Film.

The Invisible Frame, Cynthia Beatt (dir.) (2009), USA: Icarus Films.

An Invisible Man Walks the City [*Ein Unsichtbarer geht durch die Stadt*], Harry Piel (dir.) (1933), Germany: Ariel-Film.

The Invisibles [*Die Unsichtbaren*], Claus Räfle (dir.) (2017), Germany: Look! Filmproduktion.

I Phone You, Dan Tang (dir.) (2011), Germany/China: Reverse Angle Production/Ray Production.

The Iron Gustav [*Der eiserne Gustav*], Georg Hurdalek (dir.) (1958), West Germany: Berolina.

The Iron Gustav [*Der eiserne Gustav*], Wolfgang Staudte (dir.) (1979), West Germany: Südwestfunk.

Irregular Train Service [*Zugverkehr Unregelmässig*], Erich Freund (dir.) (1951), East Germany: DEFA.

I See This Land from Afar [*Aus der Ferne sehe ich dieses Land*], Christian Ziewer (dir.) (1978), West Germany: Basis Film.

Island of Swans [*Insel der Schwäne*], Herrmann Zschoche (dir.) (1983), East Germany: DEFA.

Isn't Life Wonderful? David Wark Griffith (dir.) (1924), USA: D.W. Griffith Productions.

I Stayed in Berlin All Summer [*Ich bin den Sommer über in Berlin geblieben*], Angela Schanelec (dir.) (1994), Germany: Deutsche Film- und Fernsehakademie Berlin.

Isy Way Out [*Alles Isy*], Mark Monheim (dir.) (2018), Germany: Drive Filmproduktion.

It [(*Er, Sie und*) *Es*, aka *Zwei Zimmer, Küche, Bad*], Ulrich Schamoni (dir.) (1966), West Germany: Horst Manfred Adloff Produktion.

It Happened on July 20th (aka *Jackboot Mutiny*) [*Es geschah am 20. Juli*, aka *Aufstand gegen Adolf Hitler!*, aka *Drei Schritte zum Schicksal*, aka *Die Stunde der Versuchung*], Georg Wilhelm Pabst (dir.) (1955), West Germany: Arca-Filmproduktion.

It Happened in August – The Construction of the Berlin Wall [*Es geschah im August – Der Bau der Berliner Mauer*], Hans-Hermann Hertle and Ullrich Kasten (dirs.) (2001), Germany: Sender Freies Berlin.

It Only Happened Once (aka *Just Once for All Times*) [*Das gab's nur einmal*], Géza von Bolváry (dir.) (1958), West Germany: Kurt Ulrich Film.

It Stops Here (aka *Stop the Whole Thing!*) [*Das Ganze halt!*], Dieter Mendelsohn (dir.) (1961), East Germany: DEFA.

Ivan's Childhood [*Ivanovo detstvo*], Andrei Tarkovsky (dir.) (1962), USSR: Mosfilm.

The Ivory Tower [*Der Elfenbeinturm*], Matthias Drawe (dir.) (1993), Germany: Muavin-Film.

I Was at Home, But ... [*Ich war zuhause, aber*], Angela Schanelec (dir.) (2019), Germany: Nachmittagfilm.

I Will Kill You, Wolf [*Ich werde dich töten, Wolf*], Wolfgang Petersen (dir.) (1971), West Germany: Deutsche Film- und Fernsehakademie Berlin.

Jack, Edward Berger (dir.) (2014), Germany: Port au Prince Film & Kultur Produktion.

Jana and Jan [*Jana und Jan*], Helmut Dziuba (dir.) (1992), Germany: DEFA.

Jargo, Maria Solrun (dir.) (2004), Germany: X-Filme Creative Pool.

Jason Bourne, Paul Greengrass (dir.) (2016), USA; Universal Pictures.

Jeans, Nicolette Krebitz (dir.) (2001), Germany: Exercise 4.

The Jesse Owens Story, Richard Irving (dir.) (1984), USA: Harve Bennett Productions.

John Wick: Chapter 4, Chad Stahelski (dir.) (2022), USA: Lionsgate.

The Journey [*Die Reise*], Markus Imhoof (dir.) (1986), West Germany: DRS/Filmaalpha.

Journeys from Berlin/1971, Yvonne Rainer (dir.) (1980), USA/West Germany: Beard's Fund Inc.

The Joys of the Old Women of Neukölln [*Die Freuden der alten Frauen von Neukölln*], Josefa Wittenborg (dir.) (1984), West Germany: Wittenborg Filmproduktion.

Judgement in Berlin, Leo Penn (dir.) (1988), USA: Sheen/Greenblatt Productions.

Julia, Fred Zinnemann (dir.) (1977), USA: Twentieth Century Fox.

Julia, J. Jackie Baier (dir.) (2013), Germany: Gamma Bak Filmproduktion.

Julia Next Door [*Die Julia von nebenan*], Rainer Bär (dir.) (1977), East Germany: Fernsehen der DDR.

Julietta – It Is not What You Think [*Julietta – Es ist nichts wie du denkst*], Christoph Stark (dir.) (2001), Germany: teamWorx.

Just Flowers on the Roof [*Einfach Blumen aufs Dach*], Roland Oehme (dir.) (1979), East Germany: DEFA.

Just Married, Rudolph Thome (dir.) (1998), Germany: ARD Degeto Film.

Kaddish for a Friend [*Kaddisch für einen Freund*], Leo Khasin (dir.) (2012), Germany: SiMa Film.

Kai Out of the Box [*Kai aus der Kiste*], Günter Meyer (dir.) (1989), East Germany: DEFA.

The Kaiser, Beast of Berlin, Rupert Julian (dir.) (1918), USA: Universal Studios.

Kamikaze 1989, Wolf Gremm (dir.) (1982), West Germany: Regina Ziegler Filmproduktion.

Kaminsky's Night [*Kaminskys Nacht*], Michael Lähn (dir.) (1985), West Germany: Panorama Film.

Kaptn Oskar, Tom Lass (dir.) (2013), Germany: Joroni Film.

Killing Is My Business, Honey [*Mord ist mein Geschäft, Liebling*], Sebastian Niemann (dir.) (2009), Germany: Rat Pack Filmproduktion.

Killing Mom, Carl Andersen (dir.) (1994), Germany: Carl Andersen Filmproduktion.

King Kong's Fist [*King Kongs Faust*], Heiner Stadler (dir.) (1985), West Germany: Gotham Film and Media Institute.

The King of Kreuzberg [*Der König von Kreuzberg*], Matthias Drawe (dir.) (1991), Germany: Muavin Film.

King of the Fairies [*Erlkönig*], Georg Ladanyi (dir.) (1982), West Germany: Ladanyi Filmproduktion.

King of the Fairies [*Erlkönig*], Urs Egger (dir.) (2007), Germany: Colonia Media Filmproduktions.

Kismet – Roll the Dice for Your Life [*Kismet – Würfel Dein Leben*], Lars Kraume (dir.) (2002), Germany: jetzt:film.

Kiss me, Chancellor! [*Küß mich, Kanzler!*], Ulrich Stark (dir.) (2002), Germany: Maran Film.

Kiss My Blood, David Jazay (dir.) (1998), Germany: Hochschule für Fernsehen und Film München.

Klappe Cowboy! Ulf Behrens and Timo Jacobs (dirs.) (2012), Germany: Profitfilms.

Kleinhoff Hotel, Carlo Lizzani (dir.) (1977), Italy: Roxi Films.

KLK Calling PTZ: The Red Orchestra [*KLK an PTX – Die Rote Kapelle*], Horst E. Brandt (dir.) (1971), East Germany: DEFA.

Knut and His Friends [*Knut und seine Freunde*], Michael G. Johnson (dir.) (2008), Germany: DOKFilm Fernsehproduktion.

Kreuzberg, Carl Bessai (dir.) (2017), Canada: Eggplant Picture & Sound.

Kreuzberg "Ahoy" [*Kreuzberg "Ahoi"*], Steven Adamczewski and Christian Sievers (dirs.) (1980), West Germany: Pankipei Film.

Kreuzberg Love Nights [*Kreuzberger Liebesnächte*], Claus Tinney (dir.) (1980), West Germany: Central Cinema Company.

Kroko, Sylke Enders (dir.) (2003), Germany: Luna-Film.

Kuhle Wampe, or Who Owns the World? [*Kuhle Wampe, oder: Wem gehört die Welt?*], Slatan Dudow (dir.) (1932), Germany: Prometheus-Film-Verleih und Vertriebs.

Kurfürstendamm, Richard Oswalt (dir.) (1920), Germany: Richard-Oswalt-Produktion.

Kuttel, Siegfried Menzel (dir.) (1961), East Germany: DEFA.

La Deutsche Vita, Alessandro Cassigoli and Tania Masi (dirs.) (2013), Germany: Kloos & Co. Medien.

La Deutsche Vita, Nicolas Clasen (dir.) (2017), Germany: Nicolas Clasen Produktion.

Laputa, Helma Sanders-Brahms (dir.) (1986), West Germany: Von Vietinghoff Filmproduktion.

Lara, Jan-Ole Gerster (dir.) (2019), Germany: ARTE.

Large Tram Ring with an Outer Loop [*Großer Straßenbahnring mit Aussenschleife*], Eugen York (dir.) (1966), West Germany: Südwestfunk.

The Last Film [*Der letzte Film*], Ades Zabel (dir.) (1986), Germany: Teufelsberg Produktion.

The Last Horse-Cab in Berlin: Old Hearts, A New Time [*Die letzte Droschke von Berlin: Alte Herzen, Neue Zeit*], Carl Boese (dir.) (1926), Germany: Rex-Film.

The Last Laugh [*Der Letzte Mann*], F. W. Murnau (dir.) (1924), Germany: UFA.

The Last One Turns Off the Lights! [*Der Letzte macht das Licht aus!*, aka *19 gehen Einer bleibt!*], Clemens Schönborn (dir.) (2007), Germany: Das Kleine Fernsehspiel.

The Last Ten Days, (aka *Ten Days to Die*, aka *The Last Act*) [*Der letzte Akt*] Georg Wilhelm Pabst (dir.) (1955), West Germany/Austria: Cosmopol-Film.

The Last Train [*Der letzte Zug*], Joseph Vilsmaier and Dana Vávrová (dirs.) (2006), Germany: Central Cinema Company Film.

Learning to Lie [*Liegen lernen*], Henk Handloegten (dir.) (2003), Germany: X-Filme Creative Pool.

The Legend of Paul and Paula, the [*Die Legende von Paul und Paula*], Heiner Carow (dir.) (1973), East Germany: DEFA.

The Legend of Potsdamer Platz [*Die Legende vom Potsdamer Platz*], Manfred Wilhelms (dir.) (2001), Germany: Lassoband Filmproduktion.

The Legend of Rita [*Die Stille nach dem Schuss*], Volker Schlöndorff (dir.) (2000), Germany: ARTE.

Liberation: The Last Assault [*Osvobozhdenie: Posledniy shturm*], Yuriy Ozerov (dir.) (1971), USSR: Mosfilm.

Lída Baarová (aka *The Devil's Mistress*), Filip Renc (dir.) (2016), Czech Republic: NOGUP Agency.

The Lies of the Victors [*Die Lügen der Sieger*], Christoph Hochhäusler (dir.) (2014), Germany: Heimatfilm.

The Lieutenant of Schwann-Kreitz [*Der Leutnant vom Schwann-Kreitz*], Rudi Kurz (dir.) (1974), East Germany: DEFA.

The Life and Death of Colonel Blimp, Michael Powell and Emeric Pressburger (dirs.) (1943), UK: The Archers/Independent Pictures.

Life Begins [*Das Leben beginnt*], Heiner Carow (dir.) (1960), East Germany: DEFA.

Life Can Be So Beautiful [*Das Leben kann so schön sein*, aka *Eine Frau fürs Leben*], Rolf Hansen (dir.) (1938), West Germany: Tonfilmstudio Carl Froelich.

Life for Two [*Leben zu zweit*], Herrmann Zschoche (dir.) (1968), East Germany: DEFA.

Life Is All You Get [*Das Leben ist eine Baustelle*], Wolfgang Becker (dir.) (1997), Germany: X-Filme Creative Pool.

Life Is Too Long [*Das Leben ist zu lang*], Dani Levy (dir.) (2010), Germany: X-Filme Creative Pool.

The Life of Adolf Hitler [*Das Leben von Adolf Hitler*], Paul Rotha (dir.) (1961), West Germany: Real-Film.

Life Sucks! Rudolf Steiner (dir.) (2008), Germany: RS Film.

Light It Up, the Fire Brigade Is Coming [*Zünd an, es kommt die Feuerwehr*, aka *Die Feuerwehr von Siebenlehn*], Rainer Simon (dir.) (1978), East Germany: DEFA.

Light Muse [*Leichte Muse*], Arthur Maria Rabenalt (dir.) (1941), Germany: Terra-Filmkunst.

Like World Champions [*Wie die Weltmeiste*r], Klaus Lemke (dir.) (1981), West Germany: Albatros Filmproduktion.

Lili Marleen, Rainer Werner Fassbinder (dir.) (1981), West Germany: Bayerischer Rundfunk.

Line 1 [*Linie 1*], Reinhard Hauff (dir.) (1998), West Germany: Bioskop Film.

Lisa! Mario Schollenberger (dir.) (2018), Germany: Schollenberger Film.

Lissy, Konrad Wolf (dir.) (1957), East Germany: DEFA.

Little Angel [*Engelchen*], Helke Misselwitz (dir.) (1996), Germany: Thomas Wilkening Filmgesellschaft.

Little Lights [*Kleine Lichter*], David Wnedt (dir.) (2008), Germany: ARTE and Hochschule für Film und Fernsehen 'Konrad Wolf'.

Little Man – Really Big! [*Kleiner Mann – ganz groß!*], Robert A. Stemmle (dir.) (1938), Germany: UFA.

Little Paris, Miriam Dehne (dir.) (2008), Germany: Cineplus Media Service.

The Little Punk [*Der kleene Punker*], Michael Schaack (dir.) (1992), Germany: TFC Trickompany Filmproduktion.

The Lives of Others [*Das Leben der Anderen*], Florian Henckel von Donnersmarck (dir.) (2006), Germany: Wiedemann and Berg.

The Living Room Fountain [*Der Zimmerspringbrunnen*], Peter Timm (dir.) (2001), Germany: Senator Film.

The Loan Shark of Berlin [*Der Wucherer von Berlin*], Emil Justitz (dir.) (1922), Germany: Justitz & Co.

Lola and Billy the Kid [*Lola + Bilidikid*], Kutlug Ataman (dir.) (1999), Germany.

A Lonely City [*Eine einsame Stadt*], Nicola Graef (dir.) (2020), Germany: Lona.media Filmproduktion.

Longing [*Sehnsucht*], Valeska Grisebach (dir.) (2006), Germany: Peter Rommel Productions.

The Long Lament [*Der lange Jammer*], Max Willutzki (dir.) (1975), West Germany: Basis Film.

Long Live Love [*Es lebe die Liebe*], Erich Engel (dir.) (1943), Germany: Bavaria Filmkunst.

The Lookalike [*Der Doppelgänger*], Werner W. Wallroth (dir.) (1985), East Germany: DEFA.

Look at This City [*Schaut auf diese Stadt*], Karl Gass (dir.) (1962), East Germany: DEFA.

Looking for His Murderer [*Der Mann, der seinen Mörder sucht*], Robert Siodmak (dir.) (1931), Germany: UFA.

Look Who's Back [*Er ist wieder da*], David Wnendt (dir.) (2015), Germany: Constantin Film.

A Lord of Alexander Square [*Ein Lord am Alexanderplatz*], Günter Reisch (dir.) (1967), East Germany: DEFA.

Lose Your Head, Stefan Westerwelle and Patrick Schuckmann (dirs.) (2013), Germany: Mutter-Film Produktions.

Lot's Wife [*Lots Weib*], Egon Günther (dir.) (1965), East Germany: DEFA.

Love and the Co-Pilot [*Die Liebe und der Co-Pilot*], Richard Groschopp (dir.) (1961), East Germany: DEFA.

Love and Victor [*Die Liebe und Viktor*], Patrick Banush (dir.) (2009), Germany: Klein Bukarest Film.

Love at First Sight [*Liebe auf den ersten Blick*], Rudolph Thome (dir.) (1991), Germany: Moana-Film.

Love Between the Walls [*Im Niemandsland*], Florian Aigner (dir.) (2019), Germany: Flare Film.

Love in Thoughts [*... was nützt die Liebe in Gedanken?*], Achim von Borries (dir.) (2004), Germany: X-Filme Creative Pool.

Love Fiction [*Leo-beu-pik-syeon*], Jeon Kye-soo (dir.) (2012), South Korea: Samgeori Pictures.

Love Life, Live Loving [*Liebe das Leben, lebe das Lieben*], Lutz Eisholz (dir.) (1977), West Germany: Lutz Eisholz Filmproduktion.

A Love Like No Other [*Eine Liebe wie anderes auch*], Martin Ripkens and Hans Stempel (dirs.) (1983), West Germany: Janus Film.

Love Me! [*Hab mich lieb!*], Sylke Enders (dir.) (2004), Germany: Alfredfilms Krueger & Wiesner.

Love's Confusion [*Verwirrung der Liebe*], Slatan Dudow (dir.) (1959), East Germany: DEFA.

Love, Peace & Beatbox, Volker Meyer-Dabich (dir.) (2008), Germany: Karl Handke Filmproduktion.

A Low Life Mythology, Lior Shamriz (dir.) (2012), Germany/Israel/US: Spekulativ.

Luck 1 [*Glück 1*], Lih Janowitz (dir.) (1992), Germany: Deutsche Film- und Fernsehakademie Berlin.

Lucky Hans [*Hans im Glück*], Wolfgang Peterson (dir.) (1976), West Germany: Sender Freies Berlin.

Lucy, Henner Winckler (dir.) (2006), Germany: Schramm Film Koerner & Weber.

M – A City Seeks a Murderer [*M – Eine Stadt sucht einen Mörder*], Fritz Lang (dir.) (1931), Germany: UFA.

Make Love to Me [*Hab mich lieb*] Harald Braun (dir.) (1942), Germany: UFA.

The Man Between (aka *Berlin Story*), Carol Reed (dir.) (1953), UK: London Film Productions.

The Man from U.N.C.L.E., Guy Richie (dir.) (2015), USA, UK: Warner Bros.

Mania: The Story of a Cigarette Girl [*Mania: Die Geschichte einer Zigarettenarbeiterin*], Eugen Illés (dir.) (1918), Germany: Projektions-AG Union.

Manifesto, Julian Rosefeldt (dir.) (2015), Germany: Bayerischer Rundfunk.

The Man in Pajamas [*Der Mann im Pyjama*], Christian Rateuke and Hartmann Schmige (dirs.) (1981), West Germany: Rialto Film.

Man of Straw (aka *The Kaiser's Lackey*) [*Der Untertan*], Wolfgang Staudte (dir.) (1951), East Germany: DEFA.

Man on a String [aka *Ten Years a Counterspy*], André de Toth (dir.) (1960), USA: RD-DR Productions.

The Man on the Wall [*Der Mann auf der Mauer*], Reinhard Hauff (dir.) (1982), West Germany: Bioskop Film.

The Man Who Ate the World [*Der Mann der die Welt ass*], Johannes Suhm and Lena Lessing (dirs.) (2020), Germany: Barrierifilm.

The Man Who Came after Grandmother [*Der Mann, der nach der Oma kam*], Roland Oehme (dir.) (1972), East Germany: DEFA.

Marianne & Juliane (aka *The German Sisters*) [*Die bleierne Zeit*], Margarethe von Trotta (dir.) (1981), USA: Bioskop Film.

Marriage in the Shadows [*Ehe im Schatten*], Kurt Maetzig (dir.) (1947), Germany: DEFA.

A Marriage in W. Berlin [*Eine Ehe in Berlin W.*], Eugen Illés (dir.) (1917), Germany: Neutral-Film.

The Marriage of Maria Braun [*Die Ehe der Maria Braun*], Rainer Werner Fassbinder (dir.) (1979), West Germany: Albatros Filmproduktion.

Marseille, Angela Schanelec (dir.) (2004), Germany: Schramm Film Koerner & Weber.

Mathilde Möhring [*Mein Herz gehört Dir*, aka *Erlebnis einer großen Liebe*, aka *Ich glaube an Dich*], Rolf Hansen (dir.) ([1945] 1950), Germany/West Germany: Berlin-Film/DEFA.

Me Boss, You Sneakers! [*Ich Chef, Du Turnschuh*], Hussi Kutlucan (dir.) (1998), Germany: Malita Film.

Meet Me in Montenegro, Alex Holdridge and Linnea Saasen (dirs.) (2014), USA: Viking Productions.

Meier, Peter Timm (dir.) (1986), Germany: ARTHAUS.

Mein Kampf [*Den blodiga tiden*], Erwin Leiser (dir.) (1960), Sweden/West Germany: Minerva Film.

Melek Leaves [*Die Kümmeltürkin geht*], Jeanine Meerapfel (dir.) (1985), West Germany: Journal-Film Klaus Volkerborn.

Melodies of Spring [*Märzmelodie*], Martin Walz (dir.) (2008), Germany: SevenPictures Film and X-Filme Creative Pool.

Melody of a Great City [*Grossstadt Melodie*], Wolfgang Liebeneiner (dir.) (1943), Germany: Berlin-Film.

Memories of a Summer in Berlin [*Erinnerung an einen Sommer in Berlin*], Rolf Hädrich (dir.) (1972), West Germany: Norddeutscher Rundfunk.

Memory of Berlin, John Burgan (dir.) (1998), Germany: oe-Film/ZDF.

Men in the City [*Männerherzen*], Simon Verhoeven (dir.) (2009), Germany: Wiedemann & Berg Filmproduktion.

Men in the City 2 [*Männerherzen... und die ganz ganz grosse Liebe*], Simon Verhoeven (dir.) (2011), Germany: Wiedemann & Berg Filmproduktion.

A Men's Thing [*Männersache*], Gernot Roll and Mario Barth (dirs.) (2009), Germany: Constantin Film.

Mephisto, István Szabó (dir.) (1981), West Germany/Hungary: Mafilm/Objektív Film.

Metin, Thomas Draeger (dir.) (1979), West Germany: Cikon Filmproduktion.

Metropolis, Fritz Lang (dir.) (1927), Germany: UFA.

Meyer from Berlin [*Meyer aus Berlin*], Ernst Lubitsch (dir.) (1919), Germany: Projektions-AG Union.

Midnight Revue [*Revue um Mitternacht*], Gottfried Kolditz (dir.) (1962), East Germany: DEFA.

The Miracle of Berlin [*Das Wunder von Berlin*], Roland Suso Richter (dir.) (2008), Germany: teamWorx.

Mr. Sanders Lives Dangerously [*Herr Sanders lebt gefährlich*], Robert A. Stemmle (dir.) (1944), Germany: Tobis Filmkunst.

Miss Berlin [*Fräulein Berlin*], Lothar Lambert (dir.) (1983), West Germany: Lothar Lambert Filmproduktion.

Miss Butterfly [*Fräulein Schmetterling*], Kurt Barthel (dir.) ([1965] 2005), East Germany: DEFA.

Mission: Impossible III, J. J. Abrams (dir.) (2006), USA: Paramount Pictures.

The Mistake [*Verfehlung*], Heiner Carow (dir.) (1988), East Germany: DEFA.

Mommy Is Coming, Cheryl Dunye (dir.) (2012), Germany: Jürgen Brüning Filmproduktion.

Monologue for a Taxi Driver [*Monolog für einen Taxifahrer*], Günter Stahnke (dir.) (1962), East Germany: DEFA.

The Most Beautiful One [*Die Schönste*], Ernst Rechenmacher (as Ernesto Remani) (dir.) (1957), East Germany: DEFA.

The Most Beautiful Woman [*Die Allerschönste*], Georg Leopold (dir.) (1965), East Germany: Fernsehen der DDR.

The Most Sophisticated Woman in Berlin [*Die raffinierteste Frau Berlins*], Franz Osten (dir.) (1927), Germany: Peter Ostermayr Produktion.

A Most Wanted Man, Anton Corbijn (dir.) (2014), USA: Lionsgate.

Mother Krause's Journey to Happiness [*Mutter Krausens Fahrt ins Glück*], Phil Jutzi (dir.) (1929), Germany: Prometheus-Film-Verleih und Vertriebs.

A Mouth Full of Bandages [*Frontalwatte*], Jakob Lass (dir.) (2011), Germany: Hochschule für Film und Fernsehen 'Konrad Wolf'.

Move [*3 Zimmer/Küche/Bad*], Dietrich Brüggemann (dir.) (2012), Germany: TeamWorx.

Murder Case Zernik [*Leichensache Zernik*], Helmut Nitzsche (dir.) (1972), East Germany: DEFA.

Murder Commission Berlin One [*Mordkommission Berlin Eins*] Marvin Kren (dir.) (2015), Germany/Czech Republic: Sat.1/W&B Television.

A Murder at Lake Lietzen [*Ein Mord am Lietzensee*], Lutz Büscher (dir.) (1978), West Germany: TV-Union.

The Murdered City [*Die gemordete Stadt: Abgesang auf Putte und Straße, Platz und Baum*], Manfred Durniok (dir.) (1965), West Germany: Manfred Durniok Produktion.

The Murderers Are Among Us [*Die Mörder sind Unter Uns*], Wolfgang Staudte (dir.) (1946), East Germany: DEFA.

Mute [aka *Moon II*], Duncan Jones (dir.) (2018), USA: Liberty Films.

My Bed Is Not for Sleeping [*Negresco***** – *Eine tödliche Affäre*], Klaus Lemke (dir.) (1968), West Germany: FIOR Film.

My Führer – The Really Truest Truth about Adolf Hitler [*Mein Führer – Die wirklich wahrste Wahrheit über Adolf Hitler*], Dani Levy (dir.) (2007), Germany: ARTE.

My Husband, The Economic Miracle [*Mein Mann, das Wirtschaftswunder*], Ulrich Erfurth (dir.) (1961), West Germany: Deutsche Film Hansa.

My Sister's Good Fortune [*Das Glück meiner Schwester*], Angela Schanelec (dir.) (1996), Germany: Luna-Film.

My Son [*Mein Sohn*], Lena Stahl (dir.) (2021), Germany: Akzente Film- und Fernsehproduktion.

My Words, My Lies – My Love [*Lila Lila*], Alain Gsponer (dir.) (2009), Germany: Millbrook Pictures.

Naked [*Nackt*], Doris Dörrie (dir.) (2002), Germany, Constantin Film.

Naked in the Night [*Madeleine Tel. 13 62 11*], Kurt Meisel (dir.) (1958), West Germany: Arca-Filmproduktion.

The Naked Man in the Stadium [*Der nackte Mann auf dem Sportplatz*], Konrad Wolf (dir.) (1974), East Germany: DEFA.

Neckties for the Olympics [*Krawatten für Olympia*], Stefan Lukschy and Hartmann Schmige (dirs.) (1976), West Germany: Deutsche Film- und Fernsehakademie Berlin.

Netto, Robert Thalheim (dir.) (2005), Germany: 2004 Filmproduktion.

Neukölln Unlimited (aka *Berlin City Limits*, aka *Life's a Battle*), (2010), Agostino Imondi and Dietmar Ratsch (dirs.) Germany: INDI Film.

New Year's Eve [*Sylvester – Tragödie einer Nacht*], Lupu Pick (dir.) (1924), Germany: Rex-Film.

New Year's Eve on Alexanderplatz [*Silvesternacht am Alexanderplatz*], Richard Schneider-Edenkoben (dir.) (1939), Germany: Majestic-Film.

The Nightmare [*Der Nachtmahr*], Akiz (dir.) (2015), Germany: OOO-Films.

The Nightmare Woman [*Die Alptraumfrau*], Lothar Lambert (dir.) (1981), West Germany: Lothar Lambert Filmproduktion.

Nightmare in Suburbia [*Der Teufel von Rudow*], Ulrich Meczulat (dir.) (2004), Germany: Magicland Pictures.

Night Out, Stratos Tzitzis (dir.) (2018), Germany: GiGi Pictures.

Night over Berlin [*Nacht über Berlin*], Friedemann Fromm (dir.) (2013), Germany: ARD Degeto Film.

Night People, Nunnally Johnson (dir.) (1954), USA: Twentieth Century Fox.

Nights, Gambled Away [*Verspielte Nächte*], Angeliki Antoniou (dir.) (1997), Germany/Greece: Filmboard Berlin-Brandenburg.

Night Shapes (aka *Nightshapes*) [*Nachtgestalten*], Andreas Dresen (dir.) (1999), Germany: ARTE.

Nightsongs [*Die Nacht singt ihre Lieder*], Romuald Karmakar (dir.) (2004), Germany: Babelsberg Film.

Night Train to Munich (aka *Night Train*, aka *In Disguise*), Carol Reed (dir.) (1940), UK: Twentieth Century Fox.

Ninja Assassin, James McTeigue (dir.) (2009), USA/Germany: Warner Brothers/Legendary Entertainment/Dark Castle Entertainment/Silver Pictures.

No Big Thing [*Kein Großes Ding*], Klaus Lemke (dir.) (2013), Germany: Klaus Lemke Filmproduktion.

The Nobility of Görli [*Der Adel vom Görli*], Volker Meyer-Dabisch (dir.) (2011), Germany: Karl Handke Filmproduktion.

No Country (aka *Without a Country*) [*Kein Land*], Karsten Wichniarz (dir.) (1981), West Germany: Deutsche Film- und Fernsehakademie Berlin.

No Evidence of Murder [*Für Mord kein Beweis*, aka *Der Mann, der über den Hügel*], Konrad Petzold (dir.) (1978), East Germany: DEFA.

Noise in the Front Building [*Krach im Vorderhaus*], Paul Heidemann (dir.) (1941), Germany: Tobis-Film.

No Mercy, No Future [*Die Berührte*], Helma Sanders-Brahms (dir.) (1981), West Germany: Helma Sanders Filmproduktion.

Non Stop Trouble with Spies [*Der Schnüffler*], Ottokar Runze (dir.) (1983), West Germany: UFA.

No Place for Love [*Kein Platz für Liebe*], Hans Deppe (dir.) (1947), Germany: DEFA.

No Place to Go [*Die Unberührbare*], Oskar Roehler (dir.) (2000), Germany: Distant Dreams Filmproduktion.

Now and Everything [*Jetzt und alles*], Dieter Meier (dir.) (1981), West Germany: Luna-Film.

No Wave – Underground '80: Berlin – New York, Christoph Dreher (dir.) (2009), Germany: Kloos & Co. Medien.

No Way Back [*Weg ohne Umkehr*], Victor Vicas (dir.) (1953), West Germany: Occident Film-produktion.

Octopussy, John Glen (dir.) (1983), UK/USA: Eon Productions/United Artists.

Off Course [*Perdiendo el Norte*], Nacho G. Velilla (dir.) (2015), Spain: Producciones Aparte.

Offroad, Elmar Fischer (dir.) (2012), Germany: Claussen Wöbke Putz Filmproduktion.

Old Berlin [*Alt Berlin – Wie es einmal war*], Franz Fielder (dir.) ([1934] 1950), Germany: Sonne-Film.

The Old People of the Kreuzberg Neighbourhood [*Die alten Leute vom Kreuzberger Kiez*], Monika Hoffmann (dir.) (1981), West Germany: Journal-Film Klaus Volkenborn.

The Old Song [*Das Alte Lied*], Fritz Peter Buch (dir.) (1945), Germany: Berlin-Film.

Olé Henry [*Olle Henry*], Ulrich Weiss (dir.) (1983), East Germany: DEFA.

Olga, Jayme Monjardim (dir.) (2004), Brazil: Europa Filmes.

Olympia Part One: Festival of Nations [*Olympia 1. Teil – Fest der Völker*], Leni Riefenstahl (dir.) (1938), Germany: Olympia Film GmbH.

Olympia Part Two: Festival of Beauty [*Olympia 2. Teil – Fest der Schönheit*], Leni Riefenstahl (dir.) (1938), Germany: Olympia Film GmbH.

The Olympic Summer [*Der olympische Sommer*], Gordian Maugg (dir.) (1993), Germany: Film Under Fernsehproduktionen.

One Crazy Night, London Hilton (dir.) (2006), USA: Hilton Entertainment Group.

One Day in Europe, Hannes Stöhr (dir.) (2015), Germany/Spain: Moneypenny Filmproduktion/Filmanova.

One Fine Day [*And-Ek Ghes*], Philip Scheffner and Colorado Velcu (dirs.) (2016), Germany: Pong.

One from the Fairground [*Einer vom Rummel*], Lothar Grossmann (dir.) (1983), East Germany: DEFA.

One Hour Stay [*Eine Stunde Aufenthalt*], Hubert Hoelzke (dir.) (1975), East Germany: Fernsehen der DDR.

One Night in Berlin [*Danach*], Kivmars Bowling (dir.) (2011), Germany: Dog Animal Films.

One of Us [*Einer von uns*], Helmut Spiess (dir.) (1960), East Germany: DEFA.

One or the Other (aka *One or the Other of Us*) [*Einer von uns beiden*], Wolfgang Petersen (dir.) (1974), West Germany: Divina-Film.

The Ones on the Street [*Die von der Straße*], Micky Kwella (dir.) (1980), West Germany: Deutsche Film- und Fernsehakademie Berlin.

One, Two, Three, Billy Wilder (dir.) (1961), USA: Bavaria Film.

One, Two Three: Corona [*Eins, Zwei, Drei: Corona*], Hans Müller (dir.) (1948), Germany: DEFA.

Only One Day in Berlin [*Nur Ein Tag in Berlin*], Malte Wirtz (dir.) (2018), Germany: Unfiltered Artists.

On the Island [*Auf der Insel*], Wolfram Zobus (dir.) (1977), West Germany: Literarisches Colloquium Berlin.

On the Reservation [*Im Reservat*], Peter Beauvais (dir.) (1973), West Germany: Zweites Deutsches Fernsehen.

Operation Valkyrie [*Operation Walküre*], Franz-Peter Wirth (dir.) (1971), West Germany: Bavaria Atelier/Westdeutscher Rundfunk.

The Orange Gate [*Oranisches Tor*], Lilly Grote (dir.) (1986), West Germany: Ulrike Herdin GbR.

Ostkreuz, Michael Klier (dir.) (1991), Germany: Michael Klier Film.

Our Bad Children (aka *Our Naughty Children*) [*Unsere bösen Kinder*], Karl-Heinz Lotz (dir.) (1992), Germany: DEFA.

Our Daily Bread [*Unser täglich Brot*], Slatan Dudow (dir.) (1949), East Germany: DEFA.

Our Flags Lead Us Forward [*Hitlerjunge Quex*], Hans Steinhoff (dir.) (1933), Germany: UFA.

Output [*Die Knacker – Der Film, der zum Coup wurde*], Michael Fengler (dir.) (1974), West Germany: Filmverlag der Autoren/ZDF.

The Outsider [*Berlinger: Ein Deutsches Abenteuer*], Alf Brustellin and Bernhard Sinkel (dirs.) (1975), West Germany: ABS Filmproduktion.

The Package, Andrew Davis (dir.) (1989), USA: Orion Pictures.

Palace [*Palast*], Tacita Dean (dir.) (2004), Germany: Tacita Dean Productions.

A Palace and Its Republic [*Ein Palast und seine Republic*], Julia M. Novak and Thomas Beutelschmidt (dirs.) (2004), Germany: ARTE.

Palace of the Republic: House of the People [*Palast der Republik: Haus des Volkes*], Horst Winter (dir.) (1976), East Germany: DEFA.

Pandora's Box [*Die Büchse der Pandora*], Georg Wilhelm Pabst (dir.) (1929), Germany: Nero-Film AG.

Parents [*Eltern*], Robert Thalheim (dir.) (2013), Germany: Kundschafter Filmproduktion.

Paris/Berlin: 20 Years of Underground Techno, Amélie Ravalec (dir.) (2012), France: Les Films du Garage.

Pariser Platz – Berlin (aka *The Berlin Project*) [*90 Minuten – Das Berlin Projekt*], Ivo Trajkov (dir.) (2011), Germany: Basis Berlin Filmproduktion.

Paroled [*Entlassen auf Bewährung*], Richard Groschopp (dir.) (1965), East Germany: DEFA.

The Party – Nature Morte, Cynthia Beatt (dir.) (1991), Germany: Alert Film.

The Party Photographer [*Der Partyphotograph*], Hans D. Bove (dir.) (1968), West Germany: Top-Film.

Paso Doble [aka *Ein Paar tanzt aus der Reihe*], Lothar Lambert (dir.) (1984), West Germany: Horizont Filmproduktion.

The Passerby [*La passante du Sans Souci*], Jacques Rouffio (dir.) (1982), France: Éléphant Production.

Passing Summer [*Mein langsames Leben*], Angela Schanelec (dir.) (2001), Germany: Schramm Film.

Passion, Brian de Palma (dir.) (2012), USA: SBS Productions.

The Patriotic Woman [*Die Patriotin*], Alexander Kluge (dir.) (1979), West Germany: Kairos-Film.

The Peanut Man [*Der Erdnussmann*], Harmut Jahn and Dietmar Klein (dirs.) (1992), Germany: Hartmut Jahn Filmproduktion.

The Pearl of the Caribbean [*Die Perle der Karibik*], Manfred Stelzer (dir.) (1981), West Germany: Deutsche Film- und Fernsehakademie Berlin.

The Pentecost Outing [*Der Pfingstausflug*], Michael Günther (dir.) (1978), West Germany: Ottokar Runze Filmproduktion.

People on Sunday [*Menschen am Sonntag*], Robert Siodmak and Edgar G. Ulmer (dirs.) (1929), Germany: Film Studio.

People's Police 1985 [*Volkspolizei 1985*], Thomas Heise (dir.) (1985), East Germany: Staatliche Filmdokumentation.

Persistence [*Ausdauer*], Daniel Eisenberg (dir.) (1997), Germany: Daniel Eisenberg Films.

The Phantom – The Hunt for Dagobert [*Das Phantom – Die Jagd nach Dagobert*], Roland Suso Richter (dir.) (1994), Germany: TV-Erstsendung.

Phantom Pain [*Phantomschmerz*], Matthias Emke (dir.) (2009), Germany: Barefoot Films.

The Philosopher [*Der Philosoph*], Rudolf Thome (dir.) (1989), West Germany: Moana-Film.

Phoenix, Christian Petzold (dir.) (2014), Germany: Schramm Film Koerner & Weber.

Photo: Ostkreuz [*Foto: Ostkreuz*], Maik Reichert (dir.) (2015), Germany: nachtaktivfilm.

Pierre Lunaire [aka *Pierrot Lunaire: Butch Dandy*], Bruce La Bruce (dir.) (2014), Germany: Die Lamb.

Pigeons on the Roof [*Die Relativitätstheorie der Liebe*], Otto Alexander Jahrreiss (dir.) (2011), Germany: UFA.

Pigs Will Fly, Eoin Moore (dir.) (2002), Germany: Workshop Leppin Moore Hoerner/ZDF.

The Pimp [*Der Lude*], Horst E. Brandt (dir.) (1984), East Germany: DEFA.

A Place in Berlin [*Konzert im Freien*], Jürgen Böttcher (dir.) (2001), Germany: Ö-Filmproduktion.

Places in Cities [*Plätze in Städten*], Angela Schanelec (dir.) (1998), Germany: Schramm Film.

Planet Alex, Uli M. Schüppel (dir.) (2001), Germany: De.Flex-Filmproduktion.

Playgirl (aka *That Woman*) [*Playgirl – Berlin ist eine Sünde wert*], Will Tremper (dir.) (1966), West Germany: Will Tremper Filmproduktion.

Plea for Berlin [*Plädoyer für Berlin*], Irmgard von zur Mühlen (dir.) (1982), West Germany: Chronos-Film.

The Plot to Assassinate Hitler [*Der 20. Juli*], Falk Harnack (dir.) (1955), West Germany: Central Cinema Company Film.

The Plot to Kill Hitler, Lawrence Schiller (dir.) (1990), USA: Warner Brothers.

Plus-minus Null, Eoin Moore (dir.) (1998), Germany: Deutsche Film- und Fernsehakademie Berlin.

Police [*Polizei*], Serif Gören (dir.) (1988), West Germany: Penta Films.

Police Raid [*Razzia*], Werner Klingler (dir.) (1947), East Germany: DEFA.

Pool of Princesses [*Prinzessinnenbad*], Bettina Blümner (dir.) (2007), Germany: ARTE.

Poor Jenny [*Die arme Jenny*], Urban Gad (dir.) (1912), Germany: Deutsche Bioscop.

Possession (aka *The Night the Screaming Stops*), Andrzej Żuławski (dir.) (1981), France/West Germany: Gaumont/Oliane Productions.

Posthumous, Lulu Wang (dir.) (2014), USA/Germany: Flying Box Productions.

The Power of Men Is the Patience of Women [*Die Macht der Männer ist die Geduld der Frauen*], Cristina Perincioli (dir.) (1978), Germany: Sphinx-Film.

The Private Secretary Gets Married (aka *The Ugly Girl*) [*Das hässliche Mädchen*], Henry Koster (dir.) (1933), Germany: Avanti-Tonfilm.

A Prize of Gold [*Kenntwort: Berlin-Tempelhof*], Marc Robson (dir.) (1955), USA: Warwick Film Productions.

Professor Mamlock, Konrad Wolf (dir.) (1961), Germany: DEFA.

The Promise [*Das Versprechen*], Margarethe von Trotta (dir.) (1994), Germany/France: Bioskop Film/Canal+.

Punk Berlin 1982 [*Tod den Hippies!! Es lebe der Punk!*], Oskar Roehler (dir.) (2015), Germany: X-Filme Creative Pool.

The Pusher [*Der Drücker*], Uwe Frießner (dir.) (1986), West Germany: FFG Film- und Fernseh-GmbH.

Quiet as a Mouse [*Muxmäuschenstill*], Marcus Mittermeier (dir.) (2004), Germany: Schiwago Film.

The Quiller Memorandum, Michael Anderson (dir.) (1966), USA: The Rank Organisation.

Rabbit à la Berlin [*Królik po Berlińsku*, aka *Mauerhase*], Bartek Konopka (dir.) (2009), Germany/Poland: MS Films.

The Rabbit Is Me [*Das Kaninchen bin ich*], Kurt Maetzig (dir.) (1965), East Germany: DEFA.

Rabbit without Ears, [*Keinohrhasen*], Til Schweiger (dir.) (2007), Germany: SevenPictures Films.

Rabbit without Ears 2, [*Zweiohrküken*], Til Schweiger and Torsten Künstler (dirs.) (2009), Germany: Barefoot Films.

Race, Stephen Hopkins (dir.) (2016), Canada/Germany/France: Forecast Pictures.

Racing Fever [*Rennfieber*], Richard Oswald (dir.) (1918), Germany: Richard-Oswald-Produktion.

Raging Inferno [*Das Inferno – Flammen über Berlin*], Rainer Matsutani (dir.) (2007), Germany: Lithuanian Film Studio.

Raging Roland [*Der rasende Roland*], Edgar Kaufmann (dir.) (1977), East Germany: Deutscher Fernsehfunk.

Rammbock: Berlin Undead (aka *Siege of the Dead*), Marvin Kren (dir.) (2010), Germany: ZDF.

The Raspberry Reich (aka *The Revolution Is My Boyfriend*), Bruce LaBruce (dir.) (2004), Germany: Jürgen Brüning Filmproduktion.

The Rat [*Die Ratte*], Harry Piel and Joe May (dirs.) (1918), Denmark: May-Film.

The Rats [*Die Ratten*], Robert Siodmak (dir.) (1955), West Germany: Central Cinema Company.

The Reader, Stephen Daldry (dir.) (2008), Germany/USA: Studio Babelsberg/Mirage Enterprises.

The Rechlin Family [*Familie Rechlin*], Vera Loebner (dir.) (1982), East Germany: DEFA.

The Red Flag [*Die rote Fahne*], Gerd Conradt (dir.) (1968), West Germany: Deutsche Film- und Fernsehakademie Berlin.

The Red Stocking [*Der rote Strumpf*], Wolfgang Tumler (dir.) (1981), West Germany: Aspekt Telefilm-Produktion.

Refuge [*Zuflucht*], Carl Frölich (dir.) (1928), Germany: Carl Frölich Film.

The Reichs Orchestra – The Berlin Philharmonic and National Socialism [*Das Reichsorchester – Die Berliner Philharmoniker und der Nationalsozialismus*], Enrique Sánchez Lansch (dir.) (2007), Germany: Cine Impuls.

Rendezvous Aimée [*Treffpunkt Aimée*], Horst Reinecke (dir.) (1956), East Germany: DEFA.

Rent Boys [*Die Jungs vom Bahnhof Zoo*], Rosa von Praunheim (dir.) (2011), Germany: Norddeutscher Rundfunk.

Request Concert [*Wunschkonzert*], Eduard von Borsody (dir.) (1940), Germany: UFA.

Resident Evil, Paul W. S. Anderson (dir.) (2002), UK/Germany: New Legacy/Constantin Film.

Return to Go! [*Zurück auf Los!*], Pierre Sanoussi-Bliss (dir.) (2000), Germany: Ö-Filmproduktion Löprich & Schlösser.

The Rhinestone (aka *Rhinestones*) [*Der Strass*], Andreas Höntsch (dir.) (1990), East Germany/West Germany: DEFA.

A Ride through Berlin [*Eine Fahrt durch Berlin*], Oskar Messter (dir.) (1910), Germany: Messters Projektion GmbH.

Ripley's Game, Liliana Cavani (dir.) (2002), UK/Italy/USA: Baby Films/Cattleya/Mr. Mudd.

Rising High [*Betonrausch*, aka *Betongold*], Cüneyt Kaya (dir.) (2020), Germany: UFA Fiction.

Romance in a Minor Key [*Romanze in Moll*], Helmut Käutner (dir.) (1943), Germany: Tobis Filmkunst.

Romeo and Juliet in Berlin [*Romeo und Julia in Berlin*], Hanns Korngiebel (dir.) (1957), West Germany: Nord- und Westdeutscher Rundfunkverband.

A Roof over Your Head [*Dach überm Kopf*], Ulrich Thein (dir.) (1980), East Germany: DEFA.

Rosa Luxemburg, Margarethe von Trotta (dir.) (1986), West Germany/Czechoslovakia: Bioskop Film/Pro-ject Filmproduktion.

Rosenstrasse, Margarethe von Trotta (dir.) (2003), Germany/Netherlands: Studio Hamburg Letterbox Filmproduktion.

Rosi and the Big City [*Rosi und die große Stadt*], Gloria Behrens (dir.) (1981), West Germany: Tura-Film- und Fernsehproduktion.

Rotation, Wolfgang Staudte (dir.) (1949), East Germany: DEFA.

Royal Children (aka *Star-Crossed Lovers*, aka *And Your Love Too*) [*Königskinder*], Frank Beyer (dir.) (1962), East Germany: DEFA.

The Rubble Women of Berlin [*Die Trümmerfrauen von Berlin*], Hans-Dieter Grabe (dir.) (1968), West Germany: Zweites Deutsches Fernsehen.

Run Lola Run [*Lola Rennt*], Tom Tykwer (dir.) (1998), Germany: X-Filme Creative Pool.

Russian Disco [*Russendisko*], Oliver Ziegenbalg (dir.) (2012), Germany: Black Forest Films.

Salmonberries, Percy Adlon (dir.) (1991), Germany: Pelemele FIlm.

Salon Kitty, Tinto Brass (dir.) (1976), Italy/France/West Germany: Coralta Cinematografica.

Sara Stein: Shalom Berlin, Shalom Tel Aviv, Matthias Tiefenbacher (dir.) (2015), Germany: TV 60 Filmproduktion.

Schönefeld Boulevard, Sylke Enders (dir.) (2014), Germany: Credofilm.

The Schlemiel [*Der Schlemihl*], Max Nosseck (dir.) (1931), Germany: Mikrophon Film.

The Secret Agents (aka *The Dirty Game*), Werner Klingler, Carlo Lizzani, Christian-Jaque (aka Christian Maudet), Terence Young (dirs.) (1965), France/Italy/West Germany/USA: Eichberg-Film/Euro International Film.

The Secrets of Berlin [*Die Geheimnisse von Berlin*], Max Mack and Arthur Teuber (dirs.) (1921), Germany: Esha-Film.

Seeds of Doubt [*Folgeschäden*], Samir Nasr (dir.) (2004), Germany: Maran Film.

The Sensuous Three [*Harlis*], Robert Ackeren (dir.) (1972), West Germany: Interwest Film.

See, This Is Berlin! [*Sehn'se, det is Berlin!*] Hannelore Conradsen and Dieter Köster (dirs.) (2008), Germany: MaRock–Film.

The Separation [*Die Trennung*], Tom Toelle (dir.) (1967), West Germany: Chamier-Film.

The Serpent's Egg, Ingmar Bergman (dir.) (1977), USA: Dino De Laurentiis Co.

Seven Journeys [*In jenen Tagen*], Helmut Käutner (dir.) (1947), Germany: Camera-Filmproduktion.

The Seventh Target [*La 7ème cible*], Claude Pinoteau (dir.) (1984), France: Gaumont International.

Several Times Daily [*Mehrmals täglich*, aka *Darf ich Sie zur Mutter machen?*], Ralf Gregan (dir.) (1969), West Germany: Industrie & Dokumentar Film.

The Shadow Hour [*Schattenstunde*], Benjamin Martins (dir.) (2021), Germany: Herbsthunde Filme.

Shapes of Light [*Lichtgestalten*], Christian Moris Müller (dir.) (2015), Germany: Christian Moris Müller Filmproduktion.

Sheriff Teddy, Heiner Carow (dir.) (1957), East Germany: DEFA.

Shining Through, David Seltzer (dir.) (1992), USA/UK: Twentieth Century Fox/Sandollar Productions.

Shoe Palace Pinkus [*Schuhpalast Pinkus*], Ernst Lubitsch (dir.) (1916), Germany: Projektions-AG Union.

Shortcut to Istanbul [*So schnell es geht nach Istanbul*], Andreas Dresen (dir.) (1990), East Germany: Hochschule für Film und Fernsehen "Konrad Wolf").

A Shot at Longing – His Struggle [*Ein Schuss Sehnsucht – Sein Kampf*], Lothar Lambert and Wolfram Zobus (dirs.) (1973), West Germany: Lothar Lambert Filmproduktion.

Shot on Command [*Auf Befehl erschossen: Die Brüder Sass, einst Berlins große Ganoven*], Rainer Wolffhardt (dir.) (1972), West Germany: UFA.

The Sickness of Youth [*Krankheit der Jugend*], Dieter Berner (dir.) (2010), Germany: HFF Potsdam-Babelsberg.

Silvester Countdown (aka *In with the New*), Oskar Roehler (dir.) (1997), Germany: Erdbeermund Filmproduktion.

Simple Luck [*Das einfache Glück*], Edzard Onneken (dir.) (1990), West Germany: B.A. Produktion.

Single by Contract [*Groupies bleiben nicht zum Frühstück*], Marc Rothemund (dir.) (2010), Germany: SamFilm Produktion.

Sister Anne, Don't You See Anything Coming? [*Soeur Anne ne vois-tu rien venir?*], Danièle Dubroux (dir.) (1982), France: Six Girls Production.

The Sixth Sense [*Der sexte Sinn*], Dagmar Beiersdorf and Lothar Lambert (dirs.) (1984), West Germany: Horizont-Filmproduktion.

The Sleeping of Reason (aka *Reason Asleep*) [*Der Schalf der Vernunft*], Ula Stöckl (dir.) (1984), West Germany: Common Film Produktion.

Slums of Berlin [*Die Verrufenen*, aka *Der Fünfte Stand*], Gerhard Lamprecht (dir.) (1925), Germany: National-Film.

The Soldier, James Glickenhaus (dir.) (1982), USA: James Glickenhaus.

Solo Sunny, Konrad Wolf and Wolfgang Kohlhaase (dirs.) (1980), East Germany: DEFA.

Something to Do with the Wall, Ross McElwee and Marilyn Levine (dirs.) ([1989] 1991), USA: First Run Features.

Something to Remind Me [*Toter Mann*], Christian Petzold (dir.) (2001), Germany: TeamWorx.

Somewhere in Berlin [*Irgendwo in Berlin*], Gerhard Lamprecht (dir.) (1946), East Germany: DEFA.

Sound of Berlin Documentary: The Journey through the Capital of Electronic Music, Christian Lim (dir.) (2018), Germany: Embassy One.

Sources of Life [*Quellen des Lebens*], Oskar Roehler (dir.) (2013), Germany: X-Filme Creative Pool.

Special Features: None [*Besondere Kennzeichen: keine*, aka *Eine Frau um Mitte 30*], Hans-Joachim Kunert (dir.) (1956), East Germany: DEFA.

Speed Racer, The Wachowskis (dirs.) (2008), USA/Germany: Warner Brothers/Village Roadshow Pictures/Silver Pictures.

Speer & Hitler: The Devil's Architect [*Speer und er*], Heinrich Breloer (dir.) (2005), Germany: Bavaria Media.

Spider-Man: Far from Home, Jon Watts (dir.) (2019), USA: Columbia Pictures/Marvel Studios.

Spider-Man: Homecoming, Jon Watts (dir.) (2017), USA: Columbia Pictures/Marvel Studios.

The Spider's Web [*Das Spinnennetz*], Bernhard Wicki (dir.) (1989), West Germany: Beta Film.

Spies [*Spione*], Fritz Lang (dir.) (1928), Germany: UFA.

Spirit Berlin, Kordula Hildebrandt (dir.) (2014), Germany: Hildebrandt Film.

The Spree – Symphony of a River [*Die Spree – Sinfonie eines Flusses*], Gerd Conradt (dir.) (2007), Germany: Basis-Film.

Spring in Berlin [*Frühling in Berlin*], Arthur Maria Rabenalt (dir.) (1957), Germany: Berolina.

Spy for Germany [*Spion für Deutschland*], Werner Klinger (dir.) (1956), West Germany: Berolina.

Spy Game, Tony Scott (dir.) (2001), USA: Universal Pictures.

The Spy Who Came in from the Cold, Martin Ritt (dir.) (1965), UK: Salem Films Limited.

The Stars Shine [*Es leuchten die Sterne*], Hans Z. Zerlett (dir.) (1938), Germany: Tobis-Filmkunst.

Status Yo! Till Hastreiter (dir.) (2004), Germany: Discofilm/gute filme.

Stay Crazy – Stay in Love [*Verrückt bleiben – verliebt bleiben*], Elfi Mikesch (dir.) (1997), Germany: Mediopolis Film- und Fernsehproduktion.

Stein, Egon Günther (dir.) (1991), East Germany: DEFA.

St. George's Day (aka *Berlin Job*), Frank Harper (dir.) (2012), UK: Double D Productions.

The Stone River [*Der steinerne Fluss*], Thorsten Näter (dir.) (1983), West Germany: Regina Ziegler Filmproduktion.

Stopped on Track [*Halt auf freier Strecke*], Andreas Dresen (dir.) (2011), Germany: Peter Rommel Productions.

Stories of That Night: Big Willy and Small Willy [*Geschichten jener Nacht: Der Große und der Kleine Willi*], Gerhard Klein (dir.) (1967), East Germany: DEFA.

Stories of That Night: Materna [*Geschichten jener Nacht: Materna*], Frank Vogel (dir.) (1967), East Germany: DEFA.

Stories of That Night: Phoenix [*Geschichten jener Nacht: Phönix*], Karlheinz Carpentier (dir.) (1967), East Germany: DEFA.

Stories of That Night: The Test [*Geschichten jener Nacht: Die Prüfung*], Ulrich Thein (dir.) (1967), East Germany: DEFA.

Story of a Young Couple [*Roman einer Jungen Ehe*], Kurt Maetzig (dir.) (1952), East Germany: DEFA.

Straight, Nicolas Flessa (dir.) (2007), Germany: Käferfilm Produktion.

The Strange Death of Adolf Hitler, James P. Hogan (dir.) (1943), USA: Universal Pictures.

The Strange Little Cat [*Das merkwürdige Kätzchen*], Ramon Zürcher (dir.) (2013), Germany: Deutsche Film- und Fernsehakademie Berlin.

The Street [*Die Straße*], Karl Grune (dir.) (1923), Germany: UFA.

Street Acquaintances [*Straßenbekanntschaft*], Peter Pewas (dir.) (1948), Germany: DEFA.

Strictly Propaganda [*Kinder, Kader, Kommandeure*], Wolfgang Kissel (dir.) (1992), Germany: DEFA.

Strike Back [*Kalt wie Eis*], Carl Schenkel (dir.) (1981), West Germany: Lisa-Film.

Stroszek, Werner Herzog (dir.) (1977), West Germany: Werner Herzog Filmproduktion.

Stumbling Block [*Stolperstein*], Dörte Franke (dir.) (2008), Germany: ARTE.

SubBerlin – Underground United, Tilmann Künzel (dir.) (2008), Germany: Filmlounge Production.

The Subjective Factor [*Der subjektive Faktor*], Helke Sander (dir.) (1981), West Germany: Helke Sander Filmproduktion.

Suck My Dick, Oskar Roehler (dir.) (2001), Germany: Helkon Media.

Summer in Berlin [*Sommer vorm Balkon*], Andreas Dresen (dir.) (2005), Germany: Peter Rommel Productions and X-Filme Creative Pool.

Summer in the City, Wim Wenders (dir.) (1971), West Germany: Hochschule für Fernsehen und Film München/Wim Wenders Stiftung/atlas Film.

Summer Palace [*Yi He Yuan*], Ye Lou (dir.) (2006), China/France: Norman Rosemont Productions.

Summer Window [*Fenster zum Sommer*], Hendrik Handloegten (dir.) (2011), Germany: Zentropa Entertainments Berlin.

Sun Alley [*Sonnenallee*], Leander Haussmann (dir.) (1999), Germany: Delphi Filmverleih.

Sunday Drivers [*Sonntagsfahrer*], Gerhard Klein (dir.) (1962), East Germany: DEFA.

Sunrise (aka *Sunrise: A Song of Two Humans*), F. W. Murnau (dir.) (1927), USA: Fox Film Corporation, 1927.

Superbrain (aka *The Tunnel Gangsters of Berlin*) [*Die Tunnelgangster von Berlin*], Menahem Golan (dir.) (1996), Germany: 21st Century Film Corporation.

Survival in Berlin-Neukölln [*Überleben in Neukölln*], Rosa von Praunheim and Markus Tiarks (dirs.) (2017), Germany: Rosa von Praunheim Filmproduktion.

Suspiria, Luca Guadagnino (dir.) (2018), Italy/USA: Frenesy Film Company.

Symphony of a World City [*Symphonie einer Weltstadt*, aka *Berlin wie es war*], Leo de Laforgue (dir.) ([1939] 1950), Germany/West Germany: Leo de Laforgue Filmproduktion.

Symphony of Now, Johannes Schaff (dir.) (2018), Germany: Pappel Studios.

Taking Sides [*Der Fall Furtwängler*], István Szabó (dir.) (2001), France/UK/Germany: Paladin Production/Maecenas Film- und Fernseh/Studio Babelsberg.

Talking with Germans [*Deutschland – Endstation Ost*], Frans Buyens (dir.) (1964), East Germany: DEFA.

Tattoo, Robert Schwentke (dir.) (2002), Germany: Lounge Entertainment.

Taxi to the John [*Taxi zum Klo*], Frank Ripploh (dir.) (1980), West Germany: Exportfilm Bischoff & Co.

Teenage Wolfpack [*Die Halbstarken*], Georg Tressler (dir.) (1956), West Germany: Interwest See.

Ten Seconds to Hell, Robert Aldrich (dir.) (1959), UK/USA: Hammer Films.

The Testament of Dr Mabuse (aka *The Crimes of Dr. Mabuse*) [*Das Testament des Dr Mabuse*], Fritz Lang (dir.) (1933), Germany: Nero-Film AG.

Text for You [*SMS für Dich*], Karoline Herfurth (dir.) (2016), Germany: Hellinger/Doll Filmproduktion.

Thalia under Rubble – Berlin Theater of the Post-war Period 1945–1951 [*Thalia unter Trümmern – Das Berliner Theater der Nachkriegszeit 1945–1951*], Irmgard von zur Mühlen (dir.) (1982), West Germany: Chronos-Film.

Thank You, I'm Fine [*Danke, es geht mir gut*, aka *Eine reizende Familie* (*A Lovely Family*)], Erich Waschneck (dir.) (1948), Germany: DEFA.

That Guy Loves Me, Am I Supposed to Believe That? [*Der Kerl liebt mich – und das soll ich glauben?*], Marran Gosov (dir.) (1969), West Germany: Rialto Film.

That Was Zille's Milieu [*Det war Zille sein Milljöh*], Irmgard von zur Mühlen (dir.) (1980), West Germany: Chronos-Film.

There Is Something Contagious about Freedom [*Die Freiheit hat etwas Ansteckendes*], Klaus-Günter Otto and Volker Schutsch (dirs.) (1982), West Germany: Otto-Schutsch Filmproduktion.

They Used to Be Stars [*Sie waren mal Stars*], Malte Wirtz (dir.) (2020), Germany: Unfiltered Artists.

The Third Generation [*Die Dritte Generation*], Rainer Werner Fassbinder (dir.) (1979), West Germany: Filmverlag der Autoren.

This Ain't California, Marten Persiel (dir.) (2012), Germany: Neue Heimat Filmproduktion.

This Crazy Heart [*Dieses bescheuerte Herz*], Marc Rothemund (dir.) (2017), Germany: Constantin Film.

This Is Berlin Not New York, Ethan H. Minsker (dir.) (2008), Germany: Minsker and Lee Production.

Those Who Show Off Get More from Life [*Wer angibt, hat mehr vom Leben*], Hannelore Conradsen and Dieter Köster (dirs.) (1999), West Germany: Hannelore Conradsen-Köster-Film.

Three [*Drei*], Tom Tykwer (dir.) (2010), Germany: X-Filme Creative Pool.

Three Against Troy [*Drei gegen Troja*], Hussi Kutlucan (dir.) (2005), Germany: Condor Films.

Three Days to All Souls' Day [*Drei Tage bis Allerseelen*], Herbert Ballmann (dir.) (1970), West Germany: Chamier-Film.

Three Dragons from the Grill [*Drei Drachen vom Grill*], Thomas Goerke, Robert Schneider and Ades Zabel (dirs.) (1992), Germany: Teufelsberg Filmproduktion.

Three from the Filling Station (aka *Three Good friends*) [*Die Drei von der Tankstelle*], Wilhelm Thiele (dir.) (1930), Germany: UFA.

Three Loves [*Die Frau, nach der man sich sehnt*], Kurt Bernhardt (dir.) (1929), Germany: Terra-Filmkunst.

Three Wars – Part 3: In Berlin [*Drei Kriege – 3. Teil: In Berlin*], Norbert Büchner (dir.) (1965), East Germany: Deutscher Fernsehfunk.

Through the Brandenburg Gate (aka *The Brandenburg Arch*) [*Durchs Brandenburger Tor. So lang' noch untern Linden ...*]. Max Knaake (dir.) (1929), Germany: Deutsche Universal-Film.

Ticket of No Return (aka *Portrait of a Woman Drinker*) [*Bildnis einer Trinkerin*], Ulrike Ottinger (dir.) (1979), West Germany: Autorenfilm-Produktionsgemeinschaft.

Tiergarten, Lothar Lambert (dir.) (1979), West Germany: Lothar Lambert Filmproduktion.

Tiger Milk [*Tigermilch*], Ute Wieland (dir.) (2017), Germany: Akzente Film.

Timecop: The Berlin Decision, Stephen Boyum (dir.) (2003), USA: Universal Studios.

Time Is Up [*Open Wound: The Über-Movie*], Jürgen Weber (dir.) (2018), China/Germany: Lumax.

Time of Stillness [*Zeit der Stille*], Thorsten Näter (dir.) (1986), West Germany: Thorsten Näter Filmproduktion.

Tobby, Hansjurgen Pohland (dir.) (1961), West Germany: Modern Art Film.

To Be or Not to Be, Ernst Lubitsch (dir.) (1942), USA: Romaine Film Corporation.

Tonight and Tomorrow Morning [*Heute abend und morgen früh*], Dietmar Hochmuth (dir.) (1980), East Germany: DEFA.

Top Hat [*Chapeau Claque*], Ulrich Schamoni (dir.) (1974), West Germany: Bärenfilm.

Top Secret Trial of the Third Reich [*Geheime Reichssache*], Jochen Bauer (dir.) (1979), West Germany: Chronos-Film.

The Torchbearer [*Der Fackelträger*], Johannes Knittel (dir.) (1957), East Germany: DEFA.

Torn Curtain, Alfred Hitchcock (dir.) (1966), USA: Alfred J. Hitchcock Productions.

To the German People – Wrapped Reichstag 1971–1995 [*Dem Deutschen Volke – Verhüllter Reichstag 1971–1995*], Wolfram and Jorg Daniel Hissen (dirs.) (1996), Germany: Universum Film.

Tough Enough [*Knallhart*], Detlev Buck (dir.) (2006), Germany: Boje Buck Produktion.

Tough Love [*Härte*], Rosa von Praunheim (dir.) (2015), West Germany: Rosa von Praunheim Filmproduktion.

The Tragedy of Silence [*Ich kann nicht länger schweigen*], Jochen Wiedermann (dir.) (1962), West Germany: Hans Oppenheimer Film.

The Tragic Life of Gloria S. [*Das traurige Leben der Gloria S.*, aka *Second Life*], Christine Gross and Ute Schall (dirs.) (2011), Germany: ACHTFILM.

Train Station Pickups [*Die Schulmädchen vom Treffpunkt Zoo*], Walter Boos (dir.) (1979), West Germany: Geiselgasteig Film.

A Trick of the Light [*Die Gebruder Skladanowsky*], Wim Wenders (dir.) (1995), Germany: Bayerischer Rundfunk.

Trouble Backstairs [*Krach im Hinterhaus*], Veit Harlan (dir.) (1935), Germany: A.B.C. Film.

Trust Me (aka *Friends*) [*Freunde*], Martin Eigler (dir.) (2000), Germany: Moneypenny Filmproduktion.

Tugboat M17 [*Schleppzug M17*], Heinrich George and Werner Hochbaum (dirs.) (1933), Germany: Orbis-Film.

The Tunnel, Piers Anderton and Reuven Frank (dirs.) (1962), USA: NBC.

TV Tower [*Fernsehturm*], Tacita Dean (dir.) (2001), Germany: Tacita Dean Productions.

Twilight (aka *Dusk – East Berlin Bohemia in the 1950s*) [*Dämmerung – Ostberliner Bohème der 50er Jahre*], Peter Voigt (dir.) (1992), Germany: Brandenburger Filmbetrieb & Dokfilm GmbH (Potsdam).

The Twitcher [*Der Zappler*], Wolfram Deutschmann (dir.) (1983), West Germany: C&H Film.

Two in a Million [*Zwei unter Millionen*], Wieland Liebske and Victor Vicas (dirs.) (1961), West Germany: UFA.

Two in One Big City [*Zwei in Einer Großen Stadt*], Volker von Collande (dir.) (1942), Germany: Tobis Filmkunst.

Two Valentianos [*Duo Valentianos*], Gertrud Pinkus (dir.) (1987), West Germany: Elefant Film.

Two Worlds [*Endstation Liebe*], Georg Tressler (dir.) (1958), West Germany: Inter West Film.

Under the Bridges [*Unter den Brückern*], Helmut Käutner (dir.) (1944), Germany: UFA.

Under the Pavement Lies the Strand (aka *Under the Beach's Cobblestones*) [*Unter dem Pflaster ist der Strand*], Helma Sanders-Brahms (dir.) (1975), West Germany: Helma Sanders-Brahms Filmproduktion.

Under the Radar [*Unterm Radar*], Elmar Fischer (dir.) (2015), Germany: Enigma Film.

Undine, Christian Petzold (dir.) (2020), Germany/France: Schramm Film.

Unfinished Business, Ken Scott (dir.) (2015), USA: New Regency Productions.

Unknown, Jaume Collet-Serra (dir.) (2011), USA: Dark Castle Entertainment.

Unlicensed Driver [*Schwarzfahrer*], Manfred Stelzer (dir.) (1983), West Germany: Tura-Film- und Fernsehproduktion.

Until We Meet Again, Franziska! [*Auf Wiedersehn, Franziska!*], Helmut Käutner (dir.) (1941), Germany: Terra-Filmkunst.

Up and Down [*Oben-Unten*], Joseph Orr (dir.) (1994), Germany: Loeprich & Schloesser Filmproduktion.

Up to the Border – The Private View of the Wall [*Bis an DIE GRENZE – Der private Blick auf die Mauer*], Claus Oppermann and Gerald Grote (dirs.) (2012), Germany: EinfallsReich Filmproduktion.

Urban Guerillas, Neco Çelik (dir.) (2004), Germany: 36pictures.

Valerie, Birgit Möller (dir.) (2006), Germany: Credofilm.

The Valiant Truant (aka *The Brave Truant*) [*Der tapfere Schulschwänzer*], Winfried Junge (dir.) (1967), East Germany: DEFA.

Valkyrie, Bryan Singer (dir.) (2008), USA: MGM.

Variety (aka *Jealousy*, aka *Vaudeville*) [*Varieté*], Ewald André Dupont (dir.) (1925), Germany: UFA.

The Venus Trap [*Die Venusfalle*], Robert van Ackeren (dir.) (1988), West Germany: M+P Film.

Victor and Victoria [*Viktor und Viktoria*], Reinhold Schünzel (dir.) (1933), Germany: UFA.

Victoria: One City, One Night, One Take, Sebastian Schipper (dir.) (2015), Germany: Monkey-Boy/Deutschfilm.

The Violet of Potsdam Square [*Das Veilchen vom Potsdamer Platz*], J. A. Hübler-Kahla (dir.) (1936), Germany: Lothar-Stark Film.

A Virus Knows No Morals [*Ein Virus kennt keine Moral*], Rosa von Praunheim (dir.) (1986), West Germany: Rosa von Praunheim Filmproduktion.

The Visitor [*Cibrâil*], Tor Iben (dir.) (2011), Germany: Feel Bad Movies.

The Visitor [*Die Besucher*], Constanze Knoche (dir.) (2012), Germany: Silvia Loinjak Filmproduktion.

Wacky: Describing the Criminal Career of a Crash-Kid [*Abgefahren: schildert den kriminellen Werdegang eines Crash-Kids*], Uwe Friessner (dir.) (1995), Germany: ZDF.

Waiting for Angelina [*Warten auf Angelina*], Hans-Christoph Blumenberg (dir.) (2008), Germany: Feuerland Filmproduktion.

The Wall [*Die Mauer*], Matthias Walden (dir.) (1961), West Germany: Sender Freies Berlin.

The Wall, Walter de Hoog (dir.) (1962), USA: US Information Agency.

The Wall [*Die Mauer*], Jürgen Böttcher (dir.) (1990), East Germany: DEFA.

The Wall [*Die Mauer*], Joachim Tschirner, Lew Hohmann and Klaus Salge (dirs.) (1991), Germany: Gerlinde Böhm Filmproduktion.

The Wall – Berlin '61 [*Die Mauer – Berlin '61*], Hartmut Schoen (dir.) (2006), Germany: Westdeutscher Rundfunk.

Walkman Blues [*Der Verweigerer*], Alfred Behrens (dir.) (1985), West Germany: Basis Films.

The Wandering Jew [*L'ebreo errante*], Goffredo Alessandrini (dir.) (1948), Italy: Cinematografica Distributori Indipendenti.

We Are Modeselektor, Romi Agel and Holger Wick (dirs.) (2013), Germany: Monkeytown Records.

We Are the Night, Dennis Gansel (dir.) (2010), Germany: Celluloid Dreams.

We Call It Techno! Maren Sextro and Holger Wick (dirs.) (2008), Germany: Sense Music & Media.

Wedding Night in the Rain [*Hochzeitsnacht im Regen*], Horst Seemann (dir.) (1967), East Germany: DEFA.

Welcome Goodbye! Nana Rebhan (dir.) (2014), Germany: Alfaville.

Westler: East of the Wall, Wieland Speck (dir.) (1985), West Germany: Searcher Film.

Wetlands [*Feuchtgebiete*], David Wnendt (dir.) (2013), Germany: Rommel Film.

We Want to Build Flowers and Fairy Tales [*Wir wollen Blumen und Märchen bauen*], Thomas Hartwig and Jean-François Le Moign (dirs.) (1970), West Germany: Sender Freies Berlin.

We Were in Berlin [*Wir waren in Berlin*], Ursula Demitter, Joachim Hadaschik, Alfons Machalz, Heinz Müller, Kurz Plickat, Heinz Sobiczewski and Horst Winter (dirs.) (1973), East Germany: DEFA.

What Have I Done to Deserve This? [*¿Qué he hecho yo para merecer esto?*], Pedro Almadovar (dir.) (1984), Spain: Kaktus Producciones Cinematográficas.

What Might Have Been [*Was gewesen wäre*], Florian Koerner von Gustorf (dir.) (2019), Germany: Flare-Film.

What Shall Become of You [*Was soll bloss aus dir werden*], Horst Flick (dir.) (1984), West Germany: Film- und Fernsehgesellschaft.

What to Do in Case of Fire [*Was tun, wenn's brennt?*], Gregor Schnitzler (dir.) (2001), Germany: Claussen & Wöbke Filmproduktion.

What to Do, Little Man? [*Kleiner Mann was tun?*], Uschi Madeisky and Klaus Werner (dirs.) (1982), West Germany: Colorama.

When Hitler Stole Pink Rabbit [*Als Hitler das rosa Kaninchen stahl*], Caroline Link (dir.) (2019), Germany/Switzerland/Italy: Sommerhaus Filmproduktion.

When Unku Was Ede's Friend [*Als Unku Edes Freundin war*], Helmut Dziuba (dir.) (1981), East Germany: DEFA.

When We Leave [*Die Fremde*], Feo Aladag (dir.) (2010), Germany: Independent Artists Filmproduktion.

Where Is Coletti? [*Wo ist Coletti?*] Max Mack (dir.) (1913), Germany: Vitascope.

Where Is Fred? [*Wo ist Fred?*], Anno Saul (dir.) (2006), Germany: Bioskop Film.

Where Others Keep Silent [*Wo andere schweigen*], Ralf Kirsten (dir.) (1984), East Germany: DEFA.

Where to Invade Next? Michael Moore (dir.) (2015), USA: Dog Eat Dog Films/IMG FIlms.

Whiskey with Vodka (aka *Whisky & Vodka*) [*Whisky mit Wodka*], Andreas Dresen (dir.) (2009), Germany: ARTE.

Whisper and Shout [*flüstern & SCHREIEN*], Dieter Schumann (dir.) (1989), East Germany: DEFA.

The White Dwarfs [*Die weißen Zwerge*], Dirk Schäfer (dir.) (1989), West Germany: Tara-Film.

White Trash [*Kanakerbraut*], Uwe Schrader (dir.) (1983), Germany: Deutsche Film- und Fernsehakademie Berlin.

Who Am I [*Who Am I – Kein System ist sicher*], Baran bo Odar (dir.) (2014), Germany: SevenPictures/Deutsche Columbia Pictures/Wiedemann & Berg Filmproduktion.

Who's Afraid of the Bogeyman? [*Wer fürchtet sich vorm schwarzen Mann?*], Helke Misselwitz (dir.) (1989), East Germany: DEFA.

Why Men Don't Listen and Women Can't Read Maps [*Warum Männer nicht zuhören und Frauen schlecht einparken*], Leander Haußmann (dir.) (2007), Germany: Constantin Film.

The Wicked Dreams of Paula Schultz, George Marshall (dir.) (1968), USA: Edward Small Productions.

Wild Geese II, Peter R. Hunt (dir.) (1985), UK: Frontier Films.

The Window Cleaner [*Der Fensterputzer*], Veit Heimer (dir.) (1993), Germany: Veit Heimer Filmproduktion.

Wings of Desire [*Der Himmel uber Berlin*], Wim Wenders (dir.) (1987), West Germany: Road Movies.

The Wolf's Bride [*Die Wolfsbraut*], Dagmar Beiersdorf (dir.) (1984), West Germany: Norddeutscher Rundfunk.

The Wollands [*Die Wollands*], Ingo Kratisch, Marianne Lüdcke and Johannes Mayer (dirs.) (1972), West Germany: Deutsche Film- und Fernsehakademie Berlin.

The Woman across the Street [*Die Frau von gegenüber*, aka *Die Frau gegenüber*], Döndü Kılıç (dir.) (2005), Germany: Deutsche Film- und Fernsehakademie Berlin.

The Woman across the Way [*Die Frau gegenüber*], Hans Noever (dir.) (1978), West Germany: Bayerischer Rundfunk.

Woman Driving, Man Sleeping [*Frau fährt, Mann schläft – Zeitreisen: Die Gegenwart*], Rudolph Thome (dir.) (2004), Germany: Moana-Film.

A Woman for Three Days [*Eine Frau für drei Tage*], Fritz Kirchhoff (dir.) (1944), Germany: UFA.

A Woman in Berlin [*Anonyma – Eine Frau in Berlin*], Max Färberböck (dir.) (2008), Germany/Poland: ZDF/Constantin Film.

A Woman in Flames [*Die flambierte Frau*], Robert van Ackeren (dir.) (1983), West Germany: Dieter Geissler Filmproduktion.

Woman in Love [*Rubbeldiekatz*], Detlev Buck (dir.) (2011), Germany: Film1/UPI/Boje Buck Productions.

Women in Bondage (aka *Hitler's Women*), Steve Sekely (dir.) (1943), USA: Monogram Pictures.

Word Made of Stone [*Das Wort aus Stein*], Kurt Rupli (dir.) (1939), Germany: UFA.

World Stage Berlin – The Twenties [*Weltbühne Berlin – Die zwanziger Jahre*], Irmgard von zur Mühlen (dir.) (1986), Germany: Chronos-Film.

The World without a Mask [*Die Welt ohne Maske*], Harry Piel (dir.) (1934), Germany: Ariel Film.

Wrong Steps from Two [*Faux pas de deux*], Lothar Lambert (dir.) (1976), West Germany: Lothar Lambert Filmproduktion.

Yes, I Do! [*Evet, ich will!*], Sinan Akkuş (dir.) (2008), Germany: ARTE/Luna-Film.

You and Me Berlin [*Du und icke Berlin*], Eberhard Schäfer (dir.) (1977), East Germany: DEFA.

You Are Not Alone [*Du bist nicht allein*], Bernd Böhlich (dir.) (2007), Germany: Rundfunk Berlin-Brandenburg.

You Elvis, Me Monroe [*Du Elvis, ich Monroe*], Lothat Lambert (dir.) (1989), West Germany: Lothar Lambert Filmproduktion.

You Love Me Too (aka *The Same to You*) [*Du Mich Auch*], Helmut Berger, Anja Franke and Dany Levy (dirs.) (1986), West Germany: DRS.

You Need to Change Your Life [*Du musst dein Ändern Leben*], Benjamin Riehm (dir.) (2015), Germany: Riehm Filmproduktion.

The Young Lions, Edward Dmytryk (dir.) (1958), USA: Twentieth Century Fox.

Young People in the City [*Junge Leute in der Stadt*], Karl-Heinz Lotz (dir.) (1985), East Germany: DEFA.

Yung, Henning Gronkowski (dir.) (2018), Germany: Deutschfilm.

Zettl [*Zettl – Unschlagbar Charakterlos*, aka *Berlin Mitte – Die Nullnummer*], Helmut Dietl (dir.) (2012), Germany: Diana-Film.

Zille and Me [*Zille und ick*], Werner W. Wallroth (dir.) (1983), East Germany: DEFA.

Zischke, Martin Theo Krieger (dir.) (1986), West Germany: Backhaus + Krieger Filmproduktion.

Zoe, Maren-Kea Freese (dir.) (1998), Germany: Ciak Filmproduktion.

NOTE

1. The following sources aided the compiling of this filmography: Berlin-Film-Catalogue, http://www.berlin-film-catalogue.com/die-liste.html (last accessed 30 August 2021), DEFA Film Library: East German Cinema & Beyond, ecommerce.umass.edu/defa (last accessed 30 August 2021), Leclercq (2003), Maulucci (2008), Ingram (2010), Postlethwaite (2015) and SHOT IN BERLIN – Berliner Filme und deren Drehorte, http://www.shotinberlin.de (last accessed 30 August 2021).

Bibliography

Abel, Marco (2008), 'Intensifying life: The cinema of the "Berlin School"', *Cineaste*, 33:4, http://www.cineaste.com/articles/the-berlin-school.htm, last accessed 8 January 2021.

Adam, Peter (1992), *The Arts of the Third Reich*, London: Thames & Hudson.

Adler, Thomas P. (1974), 'Pinter's night: A stroll down memory lane', *Modern Drama*, 17:4, pp. 461–65.

Ahmer, Carolyn (2020), 'Riegl's "Modern Cult of Monuments" as a theory underpinning practical conservation and restoration work', *Journal of Architectural Conservation*, 26:2, pp. 150–65.

Akcan, Esra (2010), 'Apology and triumph: Memory transference, erasure, and a rereading of the Berlin Jewish Museum', *New German Critique*, 110, 37:2, Summer, pp. 153–79.

Akcan, Esra (2018), *Open Architecture: Migration, Citizenship and the Urban Renewal of Berlin-Kreuzberg by IBA 1984–87*, Berlin: De Gruyter.

Allais, Lucas (2018), *Designs of Destruction: The Making of Monuments in the Twentieth Century*, Chicago: University of Chicago Press.

AlSayyad, Nezar (2006), *Cinematic Urbanism: A History of the Modern from Reel to Real*, London: Routledge.

Ammon, Sabine, Froschauer, Eva Maria, Gill, Julia, Petrow, Constanze A. and the *Netzwerk Architekturwissentschaft* (Architectural Science Network) (eds) (2014), *z.B. Humboldt-Box: Zwanzig architekturwissenschaftliche Essays über ein Berliner Provisorium (For Example, Humboldt-Box: Twenty Architectural Scientific Essays on a Provisional Arrangement in Berlin)*, Bielefeld: Transcript Verlag.

Ampelmann (2022), 'Saving the Ampelmännchen', https://www.ampelmann.de/en/a-brand-with-a-history/saving-the-ampelmaennchen, last accessed 29 January 2022.

Anderson, Benedict (2019), *Buried City, Unearthing Teufelsberg, Berlin and Its Geography of Forgetting*, London and New York: Routledge.

Andrews, Edmund L. (1998), 'Serra quits Berlin's Holocaust memorial project', *The New York Times*, 4 June, http://www.nytimes.com/1998/06/04/arts/serra-quits-berlin-s-holocaust-memorial-project.html, last accessed 23 July 2020.

Apel, Linde (2014), 'Stumbling blocks in Germany', *Rethinking History*, 18:2, pp. 181–94.

Arandelovic, Biljana (2014), 'Berlin Mitte: Alexanderplatz and Friedrichstrasse – urban historical images', *Spatium International Review*, 31, pp. 51–56.

Arandelovic, Biljana (2019), *Public Art and Urban Memorials in Berlin*, Cham: Springer.

Arandelovic, Biljana and Bogunovich, Dushko (2014), 'City profile: Berlin', *Cities*, 37, pp. 1–26.

Arbeitsgemeinschaft Wettbewerb Spreebogen (Spreebogen Competition Working Group) (1993), *Internationaler Städtebaulicher Ideenwettbewerb Spreebogen: Protokoll des Preisgerichts (Spreebogen International Competition for Urban Design Ideas: Minutes of the Jury Deliberations)*, Berlin: Bundeshauptstadt Berlin.

Arnold, Dietmar (2005), *Neue Reichskanzlei und 'Führerbunker': Legenden und Wirklichkeit (New Reichs Chancellery and 'Fuhrer Bunker': Legends and Reality)*, Berlin: Christoph Links Press.

Arnold, Dietmar and Arnold, Ingmar (1997), *Dunkle Welten: Bunker, Tunnel und Gewölbe unter Berlin (Dark Worlds: Bunkers, Tunnels and Vaults under Berlin)*, Berlin: Links Verlag.

Arnold, Dietmar and Kellerhoff, Sven Felix (2008), *Die Fluchttunnel von Berlin (The Escape Tunnels of Berlin)*, Berlin: Propyläen.

Arnold-de Simine, Silke (2015), 'The ruin as memorial – The memorial as ruin', *Performance Research*, 20:3, pp. 94–102.

Assmann, Aleida (2006), *Der lange Schatten der Vergangenheit: Erinnerungskultur und Geschichtspolitik (The Long Shadow of the Past: Cultures of Memory and the Politics of History)*, Munich: C.H. Beck.

Assmann, Aleida (2008), 'Transformations between history and memory', *Social Research*, 75:1, Spring, pp. 49–72.

Assmann, Aleida (2015), 'Dialogic memory', in P. Mendes-Flohr (ed.), *Dialogue as a Transdisciplinary Concept: Martin Buber's Philosophy of Dialogue and Its Contemporary Reception*, Berlin: De Gruyter, pp. 119–214.

Assmann, Aleida (2016), *Shadows of Trauma: Memory and the Politics of Postwar Identity*, New York: Fordham University Press.

Assmann, Jan (1995), 'Collective memory and cultural identity', *New German Critique*, 65: Spring-Summer, pp. 125–33.

Atkinson, Joshua (2016), 'Hiding hedonism in plain sight: Acoustic participatory camouflage at the DDR Museum in Berlin', *Javnost: The Public*, 23:3, pp. 237–54.

Autenreith, Sabrina N. and von Boekel, Diewertje (2019), '*Zerstörungswut* – The deliberate destruction of monumentality in ancient and modern times', in F. Buccellati, S. Hageneuer, S. van der Heyden and F. Levenson (eds), *Size Matters: Understanding Monumentality across Ancient Civilizations*, Bielefeld: Transcript Verlag, pp. 157–70.

Bach, Jonathan (2013), 'Memory landscapes and the labor of the negative in Berlin', *International Journal of Politics, Culture, and Society*, 26:1, pp. 31–40.

Bach, Jonathan (2016), 'The Berlin Wall after the Berlin Wall: Site into sight', *Memory Studies*, 9:1, pp. 48–62.

Bach, Jonathan (2017), *What Remains: Everyday Encounters with the Socialist Past in Germany*, New York: Columbia University Press.

Bairner, Alan (2008), 'The cultural politics of remembrance: Sport, place and memory in Belfast and Berlin', *International Journal of Cultural Policy*, 14:4, pp. 417–30.

Baker, Frederick (1993), 'The Berlin Wall: Production, preservation and consumption of a 20th-century monument', *Antiquity*, 67:257, pp. 709–33.

Baker, Frederick and Korff, Gottfried (1992), 'National, Heimat and active museums: An outline of the development of german museums into the 1990s', in S. Pearce (ed.), *Museums and Europe 1992*, London: Athlone, pp. 116–33.

Bakshi, Anita (2017), *Topographies of Memories: A New Poetics of Commemoration*, New York: Palgrave Macmillan.

Balfour, Alan (ed.) (1995), *World Cities: Berlin*, London: AD Academy Editions.

Barber, Stephen (2002), *Projected Cities: Cinema and Urban Space*, London: Reaktion Books.

Barber, Stephen (2010), *The Walls of Berlin: Urban Surfaces, Art, Film*, Washington, DC: Solar Books.

Barnstone, Deborah Ascher (2005), *The Transparent State: Architecture and Politics in Post-war Germany*, London: Routledge.

Barnstone, Deborah Ascher (2016), 'Between the Walls: The Berlin no-man's land reconsidered', *Journal of Urban Design*, 21:3, pp. 287–301.

Bartlett, Fredric ([1932] 1961), *Remembering: A Study in Experimental and Social Psychology*, Cambridge: Cambridge University Press.

Bartmanski, Dominik and Fuller, Martin (2018), 'Reconstructing Berlin: Materiality and meaning in the symbolic politics of urban space', *City*, 22:2, pp. 202–19.

Bastea, Eleni (ed.) (2004), *Memory and Architecture*, Albuquerque: University of New Mexico.

Bauer, Karin and Hosek, Jennifer Ruth (eds) (2018), *Cultural Topographies of the New Berlin*, New York: Berghan Books.

Beck, John (2011), 'Concrete ambivalence: Inside the bunker complex', *Cultural Politics*, 7:1, pp. 79–102.

Bélanger, Anouk (2002), 'Urban space and collective memory: Analysing the various dimensions of the production of memory', *Canadian Journal of Urban Research*, 11:1, Summer, pp. 69–92.

Bennett, Luke (2011), 'The Bunker: Metaphor, materiality and management', *Culture and Organization*, 17:2, pp. 155–73.

Bennett, Luke (2019), 'Grubbing out the Führerbunker: Ruination, demolition and Berlin's difficult subterranean heritage', *Geographics Polonica*, 92:1, pp. 71–82.

Berger, John (1972), *Ways of Seeing*, London: Penguin Classics.

Berger, John (1991), *About Looking*, New York: Vintage International.

Berlin Official Website (2020), 'Berlin in Brief: History', https://www.berlin.de/berlin-im-ueberblick/en/history, last accessed 27 March 2020.

Berlin Partner (2019), 'A journey through time: 25 years of capital city marketing', *Berlin to Go: Business News to Take Away*, pp. 10–15.

Berlin State Opera (*Staatsoper Unter den Linden*) (2022), '"The Sound of Opera History" and "History"', http://www.staatsoper-berlin.de/en/staatsoper/unter-den-linden, last accessed 29 January 2022.

Berlin Wall Foundation (Stiftung Berliner Mauer) (2014), 'Risking freedom: Helping East Germans escape, 1961–1989', http://www.risking-freedom.de, last accessed 27 April 2020.

Berlin Wall Foundation (Stiftung Berliner Mauer) (2015a), 'Berlin Wall Memorial Area A: The Berlin Wall and the Death Strip', http://www.berliner-mauer-gedenkstaette.de/en/uploads/flyer/a-en-final.pdf, last accessed 28 April 2020.

Berlin Wall Foundation (Stiftung Berliner Mauer) (2015b), 'Berlin Wall Memorial Area B: The Destruction of the City', http://www.berliner-mauer-gedenkstaette.de/en/uploads/flyer/b-en-final.pdf, last accessed 28 April 2020.

Berlin Wall Foundation (Stiftung Berliner Mauer) (2015c), 'Berlin Wall Memorial Area C: The Building of the Wall', http://www.berliner-mauer-gedenkstaette.de/en/uploads/flyer/c-en-final.pdf, last accessed 28 April 2020.

Berlin Wall Foundation (Stiftung Berliner Mauer) (2015d), 'Berlin Wall Memorial Area D: Everyday Life at the Wall', http://www.berliner-mauer-gedenkstaette.de/en/uploads/flyer/d-en-final.pdf, last accessed 28 April 2020.

Bevan, Robert (2006), *The Destruction of Memory: Architecture at War*, London: Reaktion Books.

Bilsel, Can (2017), 'Architecture and the social frameworks of memory: A postscript to Maurice Halbwachs' "Collective Memory"', *International Journal of Architecture and Planning*, 5:1, pp. 1–9.

Blake, Linnie (2008), *The Wounds of Nations: Horror Cinema, Historical Trauma and National Identity*, Manchester: Manchester University Press.

Bodnar, John (1991), *Remaking America: Public Memory, Commemoration, and Patriotism in the Twentieth Century*, Princeton: Princeton University Press.

Bollag, Burton (1999), 'In Berlin, a historian of architecture weighs history and hope', *Chronicle of Higher Education*, 45:47, p. B2.

Bordo, Jonathan (2008), 'The Homer of Potsdamerplatz – Walter Benjamin in Wim Wenders's *Sky over Berlin/Wings of Desire*: A critical topography', *Images*, 2:1, pp. 86–109.

Boyd, Julia ([2017] 2018), *Travellers in the Third Reich: The Rise of Fascism through the Eyes of Everyday People*, London: Elliott and Thompson.

Boyer, Christine M. (1996), *The City of Collective Memory: Its Historical Imagery and Architectural Entertainments*, Cambridge and London: The MIT Press.

Boym, Svetlana (2001), *The Future of Nostalgia*, New York: Basic Books.

Brandt, Susan (2004), '*Nagelfiguren*: Nailing patriotism in Germany 1914–1918', in N.J. Saunders (ed.), *Matters of Conflict: Material Culture, Memory and the First World War*, London: Routledge, pp. 62–71.

Breymayer, Ursula and Bemd, Ulrich (2006), 'Commemorating heroes', in R. Rother (ed.), *Historic Site: The Olympic Grounds 1909–1936–2006*, Berlin: Jovis, pp. 22–37.

Broadbent, Philip and Hake, Sabina (eds) (2010), *Berlin Divided City, 1945–1989*, New York and Oxford: Berghahn Books.

Brock, Angela (2008), 'Exhibition review: DDR museum Berlin', *German History*, 26:1, pp. 109–11.

Brunk, Katja, Giesler, Markus and Hartmann, Benjamin J. (2018), 'Creating a consumable past: How memory making shapes marketization', *Journal of Consumer Research*, 44, pp. 1325–42.

Bryman, Alan (1999), 'The Disneyization of society', *The Sociological Review*, 47:1, pp. 25–47.

Buck-Morss, Susan (2000), *Dreamworld and Catastrophe: The Passing of Mass Utopia in East and West*, Cambridge: The MIT Press.

Bull, Synne and Paasche, Marit (eds) (2011), *Urban Images: Unruly Desires in Film and Architecture*, Berlin and New York: Sternberg Press.

Bullock, Nicholas and Read, James (1985), *The Movement for Housing Reform in Germany and France, 1840–1914*, Cambridge: Cambridge University Press.

Butter, Andreas and Hartung, Ulrich (2004), *Ostmoderne: Architektur in Berlin 1945–65 (East Modernism: Architecture in Berlin 1945–65)*, Berlin: Jovis Verlag.

Bündnis für den Palast (Alliance for the Palace) (2005), '*12 gute Gründe gegen einen Abriss: Neue Fakten für den Palast der Republik*' ('12 good reasons against demolition: New facts for the Palace of the Republic') (pamphlet), Berlin.

Byles, Jeff (2005), *Rubble: Unearthing the History of Demolition*, New York: Three Rivers Press.

Cairns, Graham (2013), 'Sigfried Giedion, Rem Koolhaas and the fragmentary architecture of the city: Run Lola run', in G. Cairns (ed.), *The Architecture of the Screen: Essays in Cinematographic Space*, Bristol and Chicago: Intellect Books.

Carrier, Peter (2005), *Holocaust Monuments and National Memory Cultures in France and Germany since 1989*, Oxford and New York: Berghahn.

Carrier, Peter (2016), 'Stumbling stones (*Stolpersteine*): The moral authenticity of micromonuments', *Trialog*, 118/119:3&4, pp. 64–68.

Carroll La, Khadija (2010), 'The very mark of repression: The demolition theatre of the Palast der Republik and the New Schloss Berlin', *Architectural Design: Special Issue – Post-Traumatic Urbanism*, 80:5, pp. 116–23.

Carter, Erica, Donald, James and Squires, Judith (eds) (1993), *Space and Place: Theories of Identity and Location*, London: Lawrence and Wishart.

Centre for Contemporary History Potsdam (*Zentrum für Zeithistorische Forschung Potsdam*) (2021), Chronicle of the Berlin Wall (*Chronik der Mauer*), http://www.chronik-der-mauer. de/en, last accessed 20 October 2021.

Chaichian, Mohammed (2014), *Empires and Walls: Globalization, Migration, and Colonial Domination*, Leiden: Brill.

Chaikin, Paul Martin (2010), 'Circling opera in Berlin', Ph.D. thesis, Ann Arbor: Brown University.

Chametzky, Peter (2001), 'Rebuilding the nation: Norman Foster's Reichstag Renovation and Daniel Libeskind's Jewish Museum Berlin', *Centropa*, 1:3, pp. 245–64.

Chapman, Michael (2017), 'Against the wall: Ideology and form in Mies van der Rohe's monument to Rosa Luxemburg and Karl Liebknecht', *Rethinking Marxism*, 29:1, pp. 199–213.

Chicago Tribune (1998), 'Goebbels Bunker Found near Holocaust Memorial', 26 January, http:// www.chicagotribune.com/news/ct-xpm-1998-01-26-9801270081-story.html, last accessed 23 July 2020.

Choi, Rebecca M. (2009), 'Reconstructing urban life', *Places*, 21:1, pp. 18–20.

Clarke, David (2006), *German Cinema since Unification*, London: Continuum.

Clarke, David B. (ed.) (1997), *The Cinematic City*, London and New York: Routledge.

Clarke, David and Wölfel, Ute (eds) (2011), *Remembering the German Democratic Republic: Divided Memory in a United Germany*, Basingstoke: Palgrave Macmillan.

Cochrane, Allan (2006), 'Making up meanings in a capital city: Power, memory and monuments in Berlin', *European Urban and Regional Studies*, 13:1, pp. 5–24.

Cochrane, Allan and Jonas, Andrew (1999), 'Reimagining Berlin: World capital, national capital or ordinary place?', *European Urban and Regional Studies*, 6:2, pp. 145–64.

Colomb, Claire (2007), 'Requiem for a lost *Palast*. "Revanchist Urban Planning" and "Burdened Landscapes" of the German Democratic Republic in the new Berlin', *Planning Perspectives*, 22:3, pp. 283–323.

Colomb, Claire (2012), *Staging the New Berlin: Place Marketing and the Politics of Urban Reinvention Post-1989*, London: Routledge.

Connerton, Paul (1989), *How Societies Remember*, Cambridge: Cambridge University Press.

Connerton, Paul (2009), *How Modernity Forgets*. Cambridge: Cambridge University Press.

Cook, Matthew and van Riemsdijk, Micheline (2014), 'Agents of memorialization: Gunter Demnig's *Stolpersteine* and the individual (re-)creation of a holocaust landscape in Berlin', *Journal of Historical Geography*, 43, pp. 138–47.

Cooke, Paul (2006), 'The continually suffering nation? Cinematic representations of German victimhood', in B. Niven (ed.), *Germans as Victims: Remembering the Past in Contemporary Germany*, New York: Palgrave, pp. 76–92.

Copley, Clare (2019), '"Stones do not speak for themselves": Disentangling Berlin's Palimpsest', *FASCISM*, 8:2, pp. 219–49.

Costabile-Heming, Carol Anne (2011), 'Berlin's history in context: The Foreign Ministry and the *Spreebogen* complex in the context of the architectural debates', in K. Gerstenberger and J. Evans Braziel (eds), *After the Berlin Wall: Germany and Beyond*, New York: Palgrave, pp. 231–47.

Costabile-Heming, Carol Anne (2017), 'The reconstructed city palace and Humboldt Forum in Berlin: Restoring architectural identity or distorting the memory of historic spaces?', *Journal of Contemporary European Studies*, 25:4, pp. 441–54.

Costabile-Heming, Carol Anne, Halverson, Rachel J. and Foell, Kristie A. (eds) (2004), *Berlin – The Symphony Continues: Orchestrating Architectural, Social, and Artistic Change in Germany's New Capital*, Berlin: Walter de Gruyter.

Coverley, Merlin (2006), *Psychogeography*, Herts: Pocket Essentials.

Cullen, Michael S. (2004), *The Reichstag: German Parliament between Monarchy and Federalism*, Berlin: be.bra Verlag.

Cullen, Michael S. and Kieling, Uwe (1999), *Das Brandenburger Tor: Ein deutsches Symbol (The Brandenburg Gate: A German Symbol)*, Berlin: Edition.

Cupers, Kenny and Miessen, Markus (eds) (2018), *Spaces of Uncertainty: Berlin Revisited* (trans. J. O'Donnell), Basel: Birkhäuser.

Curtis, William J.R. (2000), 'A conversation with Tadao Ando', *El Croquis*, 45, pp. 12–21, https://www.amazon.co.uk/Tadao-Ando-1983-2000-El-Croquis/dp/8488386141.

Czaplicka, John (1995), 'History, aesthetics and contemporary commemorative practice in Berlin', *New German Critique*, 65, Spring–Summer, pp. 155–87.

Dal Co, Francesco (1984), 'The stones of the void', *Oppositions*, 26, pp. 99–116.

Danto, Arthur (1985), 'The Vietnam veterans' memorial', *The Nation*, 241:5, pp. 152–55.

Dark Tourism (2022), 'Anhalter Train Station Ruins and Bunker', http://www.dark-tourism. com/index.php/germany/15-countries/individual-chapters/230-anhalter-train-station-ruins-and-bunker, last accessed 29 January 2022.

Dawson, Layla (2010), 'Berlin, Germany – Topography of terror has washed away too much dirt in presenting Nazi history', *The Architectural Review*, 227, 1361.

de Brosses, Charles (1760), *Du Culte des Dieux Fétiches (Cult of the Fetish Gods)*, Ghent: Ghent University.

de Certeau, Michel (1984), *The Practice of Everyday Life* (trans. S. Rendall), Berkeley and Los Angeles: University of California Press.

de Leeuw, Marc (1999), 'Berlin 2000: Fragments of totality – Total fragmentation', *Parallax*, 5:3, pp. 58–68.

de Valck, Marijke and Hagener, Malte (eds) (2005), *Cinephilia: Movies, Love and Memory*, Amsterdam: Amsterdam University Press.

Dekel, Irit (2013), *Mediation at the Holocaust Memorial in Berlin*, Hampshire: Palgrave Macmillan.

Dellenbaugh-Losse, Mary (2020), *Inventing Berlin: Architecture, Politics and Cultural Memory in the New/Old German Capital Post-1989*, Cham: Springer.

Demandt, Barbara (2004), 'Metamorphosen eines Tores: Handreichungen zur Erklärung des Brandenburger Tores' ('The metamorphosis of a gate: Handouts to explain the Brandenburg Gate'), *Pegasus-Onlinezeitschrift (Pegasus Online Magazine)*, IV/1, pp. 26–53.

Descombes, Vincent (2000), 'The philosophy of collective representations', *History of the Human Sciences*, 23:1, pp. 37–49.

DeSilvey, Caitlin and Edensor, Tim (2012), 'Reckoning with ruins', *Progress in Human Geography*, 37:4, pp. 465–85.

Desrochers, Brigitte (2000), 'Ruins revisited: Modernist conceptions of heritage', *The Journal of Architecture*, 5:1, pp. 35–46.

Deutsche Welle (German Wave) (2020), 'Cross causes controversy atop reconstructed Berlin palace', 29 May, https://www.dw.com/en/cross-causes-controversy-atop-reconstructed-berlin-palace/a-53614166, last accessed 23 June 2020.

Deutscher Bundestag (Parliament of the Federal Republic of Germany) (1984), *Questions on German History: Ideas, Forces, Decisions from 1800 to the Present*, Bonn: Deutscher Bundestag.

Deutscher Bundestag (Parliament of the Federal Republic of Germany) (2018a), *The German Bundestag in the Reichstag Building*, Berlin: Deutscher Bundestag.

Deutscher Bundestag (Parliament of the Federal Republic of Germany) (2018b), *A Walk around Parliament and Its Buildings*, Berlin: Deutscher Bundestag.

Deutscher Bundestag (Parliament of the Federal Republic of Germany) (2018c), *From the Reichstag to the Bundestag: Dates. Pictures. Documents*, Berlin: Deutscher Bundestag.

Diefendorf, Jeffry M. (1993), *In the Wake of War: The Reconstruction of German Cities after World War II*, New York: Oxford University Press.

Diller, Elizabeth and Scofidio, Ricardo (eds) ([1994] 1996), *Back to the Front: Tourisms of War*, Princeton: Princeton Architectural Press.

Dillon, Brian (2011), *Ruins*, London: Whitechapel Art Gallery.

Dion, Emanuel (1991), 'Symmetry: A social symbol and two monuments', *Leonardo*, 24:5, pp. 511–17.

Dolff-Bonekämper, Gabi (2002), 'The Berlin Wall: An archaeological site in progress', in C.M. Beck, W. Gray Johnson and J. Schofield (eds), *Material Culture: The Archaeology of Twentieth-Century Conflict*, London: Routledge, pp. 236–48.

Dolff-Bonekämper, Gabi and Herold, Stephanie (2015), 'Der Berliner Fernsehturm: Ansichten und Aussichten' ('The Berlin TV tower: Views and prospects'), *Hermann Henselmann Stiftung* (Hermann Henselmann Foundation), https://www.hermann-henselmann-stiftung.de/wp-content/uploads/Dolff-Bonekaemper_Herold-Der_Berliner_Fernsehturm_2015-08-30_final.pdf), last accessed 18 May 2020.

Dolgoy, Rebecca Clare (2017), 'Berlin's Stadtschloss-Humboldtforum and the disappearing glass: The museum as diorama', *European Journal of Cultural and Political Sociology*, 4:3, pp. 306–35.

Domarus, Max (1962), *Hitler: Reden und Proklamationen, 1932–1945. Band 1: Triumph (Hitler: Speeches and Proclamations, 1932–1945. Volume 1: Triumph)*, Neustadt a.d. Aisch: Schmidt.

Donald, James (2020), 'Urban cinema and photography: On cities and "Cityness"', in Z. Krajina and D. Stevenson (eds), *The Routledge Companion to Urban Media and Communication*, London and New York: Routledge.

Donath, Matthias (2006), *Architecture in Berlin 1933–1945: A Guide through Nazi Berlin*, Berlin: Lukas.

Douglas, James (2006), *Building Adaptation*, Chennai: Elsevier.

Drechsel, Benjamin (2010), 'The Berlin Wall from a visual perspective: Comments on the construction of a political media icon', *Visual Communication*, 9:1, pp. 3–24.

Dubrow, Jehanne (2010), 'Returning to West Berlin, 1987', *Prairie Schooner*, 84:4, Winter, p. 27.

Dundon, Alice (2018), 'The 10 Types of People You'll Bump Into in Berghain', 12 July, https://theculturetrip.com/europe/germany/articles/10-types-of-people-youre-bound-to-bump-into-in-berghain, last accessed 6 June 2020.

Duong, Sindy (2007), 'Zwischennutzung im Palast der Republik: Ein Kreativfeld ohne Ideologische Interessen?' ('Temporary use in the Palace of the Republic: A creative field

without ideological interests?'), in A. Schug (ed.), *Palast der Republik: Politischer Diskurs und Private Erinnerung (Palace of the Republic: Political Discourse and Private Memory)*, Berlin: Berliner Wissenschafts Verlag.

Eco, Umberto (1984), *Postscript to The Name of the Rose* (trans. W. Weaver), San Diego: Harcourt Brace Jovanovich.

Eco, Umberto (1986), 'Architecture and memory' (trans. W. Weaver), *VIA, The Journal of the Graduate School of Fine Arts, University of Pennsylvania*, 8, pp. 88–94.

Eisenman, Peter (2013), interviewed by I. Ansari, *The Architectural Review*, 26 April, https://www.architectural-review.com/essays/interview-peter-eisenman, last accessed 4 October 2022.

Eisenman, Peter (2020), interviewed by M.C. Wagner, *Louisiana Museum of Modern Art: Louisiana Channel*, January, https://www.youtube.com/watch?v=Uggl6a1FLng, last accessed 23 July 2020.

Eisenman, Peter and Brillembourg, Carlos (2011), 'Peter Eisenman', *Bomb*, 117, Fall, pp. 66–73.

Ekici, Didem (2007), 'The surfaces of memory in Berlin: Rebuilding the Schloss', *Journal of Architectural Education*, 61:2, pp. 25–34.

Ekman, Mattias (2009), 'The memories of space', *ADGD Conference*, Nottingham Trent University, Nottingham, 17–18 September.

Elsaesser, Thomas (ed.) (1996), *A Second Life: German Cinema's First Decades*, Amsterdam: Amsterdam University Press.

Elsaesser, Thomas (2005), *European Cinema: Face to Face with Hollywood*, Amsterdam: Amsterdam University Press.

Elsaesser, Thomas (2013), *German Cinema: Terror and Trauma: Cultural Memory since 1945*, London and New York: Routledge.

Encke, Nadja (2007), 'The memory expert: Aleida Assmann – A researcher of literature and culture', *Goethe Institut*, http://www.goethe.de/ins/gb/lp/prj/mtg/men/tie/kul/en2873780.htm, last accessed 18 August 2020.

Erll, Astrid (2011), *Memory in Culture*, Basingstoke: Palgrave Macmillan.

Feinstein, Joshua (2002), *The Triumph of the Ordinary: Depictions of Daily Life in the East German Cinema, 1949–1989*, Chapel Hill: University of North Carolina Press.

Fentress, James W. and Wickham, Chris (1992), *Social Memory*, Oxford: Blackwell Publishers.

Fest, Joachim (2005), *Inside Hitler's Bunker: The Last Days of the Third Reich*, London: Pan.

F-IBA (2020), 'Projektportraits' (Project Portraits), http://f-iba.de/category/projektportraits, last accessed 22 July 2020.

Filipcevic Cordes, Vojislava (2020), *New York in Cinematic Imagination*, London: Routledge.

Filler, Martin (2007), *Makers of Modern Architecture*, New York: New York Review of Books.

Firebrace, William (1993), 'Jasmine way', *AA Files*, 25, Summer, pp. 63–66.

Fisher, Jaimey (2005), 'Wandering in/to the rubble-Film: filmic flânerie and the exploded panorama after 1945', *The German Quarterly*, 78:4, Fall, pp. 461–80.

Fitch, James Marston (1990), *Historic Preservation: Curatorial Management of the Built World*, Charlottesville: University of Virginia Press.

363

Flierl, Thomas (ed.) (2006), *Gesamtkonzept zur Erinnerung an die Berliner Mauer: Dokumentation, Information und Gedenken (Overall concept for the memory of the Berlin Wall: documentation, information and commemoration)*, Berlin: Senate Department for Science, Research and Culture, https://www.berlin.de/mauer/_assets/dokumente/asv2006616_1.pdf, last accessed 25 August 2020.

Florida, Richard (2002), *The Rise of the Creative Class*, New York: Basic Books.

Forner, Sean A (2002), 'War commemoration and the republic in crisis: Weimar Germany and the Neue Wache', *Central European History*, 35:4, pp. 513–45.

Forty, Adrian and Küchler, Susan (eds) (1999), *The Art of Forgetting*, Oxford: Berg.

Foucault, Michel ([1969] 1972), *The Archaeology of Knowledge*, London: Routledge.

Foundation Memorial to the Murdered Jews of Europe (*Stiftung Denkmal für die Ermordeten Juden Europas*) (2022), 'History of the Memorial', https://www.stiftung-denkmal.de/en/memorials/memorial-to-the-murdered-jews-of-europe, last accessed 30 January 2022.

Francisco, Ronald A. and Merritt Richard L. (1986), *Berlin between Two Worlds*, Boulder: Westview Press.

François, Etienne and Schulze, Hagen (eds) (2001), *Deutsche Erinnerungsorte (German Sites of Memory)*, Munich: Beck.

Frank, Sybille (2019), 'Entrepreneurial heritage-making in post-wall Berlin: The case of New Potsdamer Platz', in M. Ristic and S. Frank (eds), *Urban Heritage in Divided Cities: Contested Pasts*, New York: Routledge.

Friedrich, Thomas (2012), *Hitler's Berlin: Abused City*, New Haven: Yale University Press.

Friends of the Berlin Palace Association (Förderverein Berliner Schloss) (2017), *The Berliner Schloss Post*, 14th Edition, February, Berlin: Förderverein Berliner Schloss e.V., https://issuu.com/berliner-schloss/docs/schloss-post_02-2017, last accessed 29 January 2022.

Fritzsche, Peter (2004), 'History as trash: Reading Berlin 2000', *Studies in 20th & 21st Literature*, 28:1, pp. 76–95.

Frowein-Ziroff, Vera (1982), *Die Kaiser Wilhelm-Gedächtniskirche: Entstehung und Bedeutung (The Kaiser Wilhelm Memorial Church: Origin and Importance)*, Beiheft 9 (Supplement 9), Berlin: Die Bauwerke und Kunstdenkmäler von Berlin (The buildings and Art Monuments of Berlin).

Fryd, Vivien Green (2020), 'Walking with *The Murderers Are Among Us*: Henry Ries's Post-WWII Berlin Rubble photographs', *Arts*, 9:3, pp. 75–99.

Fuchs, Anne, Cosgrove, Mary and Grote, Georg (eds) (2006), *German Memory Contests: The Quest for Identity in Literature, Film and Discourse Since 1990*, Rochester: Camden House.

Fuchs, Anne, James-Chakraborty, Kathleen and Shortt, Linda (eds) (2011), *Debating German Cultural Identity Since 1989*, Rochester: Camden House.

Füller, Henning and Michel, Boris (2014), '"Stop Being a Tourist!" New dynamics of urban tourism in Berlin-Kreuzberg', *International Journal of Urban and Regional Research*, 38: 4, February, pp. 1304–18.

Gardner, Geraldine (2002), '*Friede, Freude, Eierkuchen*: The love parade and the politics of culture in the "new" Berlin', *American Association of Geographers Convention*, Los Angeles, 19–23 March.

Garthoff, Raymond L. (1991), 'Berlin 1961: The record corrected', *Foreign Policy*, 84, Autumn, pp. 142–56.

Gedi, Noa and Elam, Yigal (1996), 'Collective memory – What is it?', *History and Memory*, 8:1, Spring–Summer, pp. 30–50.

Gelbman, Alon and Timothy, Dallen J. (2010), 'From hostile boundaries to tourist attractions', *Current Issues in Tourism*, 13:3, pp. 239–59.

Gerstenberger, Katharina and Jana, Evans Braziel, eds. (2011), *After the Berlin Wall: Germany and Beyond*, New York: Palgrave Macmillan.

Gillis, John R. (ed.) (1994), *Commemorations: The Politics of National Identity*, Princeton: Princeton University Press.

Gittus, E.J. (2002), 'Berlin as a conduit for the creation of German national identity at the end of the twentieth century', *Space and Policy*, 6:1, pp. 91–115.

Gleber, Anke (1999), *The Art of Taking a Walk: Flanerie, Literature and Film in Weimar Culture*, Princeton: Princeton University Press.

Goebel, Rolf J. (2003), 'Berlin's architectural citations: Reconstruction, simulation, and the problem of historical authenticity', *PMLA*, 118:5, pp. 1268–89.

Goldberger, Paul (1995), 'Christo's wrapped Reichstag: Symbol for the New Germany', *New York Times*, 23, C3.

Goldberger, Paul (2009), 'Architecture and memory', in *Why Architecture Matters*, New Haven: Yale University Press, pp. 139–70.

Golden, Elizabeth (2014), 'Following the Berlin Wall', in P. Barron and M. Mariani (eds.), *Terrain Vague: Interstices at the Edge of the Pale*, London: Routledge, pp. 465–71.

Goodsell, Charles T. (1988), *The Social Meaning of Civic Space: Studying Political Authority through Architecture*, Lawrence: University Press of Kansas.

Gordillo, Gaston R. (2014), *Rubble: the Afterlife of Destruction*, Durham: Duke University Press.

Gotham, Kevin Fox (2005), 'Tourism gentrification: The case of New Orleans' Vieux Carre (French Quarter)', *Urban Studies*, 42:7, pp. 1099–121.

Gould, Mary Rachel and Silverman, Rachel E. (2013), 'Stumbling upon history: Collective memory and the urban landscape', *GeoJournal*, 78, pp. 791–801.

Göbel, Hanna Katharina (2005), *The Re-Use of Urban Ruins: Atmospheric Inquiries of the City*, London: Routledge.

Grass, Günter (1990), *2 States – 1 Nation? A Case against German Reunification*, London: Secker and Warburg.

Green, Stephen (2014), 'Remnants, renewal, redemption, reconciliation', in *Reluctant Meister: How Germany's Past Is Shaping Its European Future*, London: Haus Publishing, pp. 200–33.

Greene, Francis J. (1997), 'Environments of change: Building the New Berlin for the New Millennium', *Symploke*, 5:1–2, pp. 222–31.

Grenzer, Elke (2002), 'The topographies of memory in Berlin: The Neue Wache and the memorial for the murdered Jews of Europe', *Canadian Journal of Urban Research*, 11:1, Summer, pp. 93–110.

Grewe, Cordula and Neumann, Dietrich (eds) (2005), *From Manhattan to Mainhattan: Architecture and Style as Transatlantic Dialogue, 1920–1970*, Washington, DC: German Historical Institute, https://www.ghi-dc.org/fileadmin/publications/Bulletin_Supplement/Supplement_2/supp2.pdf, last accessed 29 January 2022.

Griffin, Roger (2018), 'Building the visible immortality of the nation: The centrality of "Rooted Modernism" to the Third Reich's Architectural New Order', *FASCISM*, 7, pp. 9–44.

Grimes, William (2009), 'Jeanne-Claude, Christo's Collaborator on Environmental Canvas, is Dead at 74', *New York Times*, 19 November, https://www.nytimes.com/2009/11/20/arts/design/20jeanne-claude.html, last accessed 11 May 2020.

Grimstad, Kirsten (2019), 'Still struggling with German History: W.G. Sebald, Gunter Demnig and activist memory workers in Berlin Today', *Holocaust Studies*, 25:1–2, pp. 101–17.

Hake, Sabine ([2002] 2008), *German National Cinema*, London: Routledge.

Hake, Sabine (2008), *Topographies of Class: Modern Architecture and Mass Society in Weimar Berlin*, Ann Arbor: University of Michigan Press.

Halbwachs, Maurice ([1925] 1992), *On Collective Memory*, Chicago: University of Chicago Press.

Halbwachs, Maurice (1941), *La Topographie légendaire des Évangiles en Terre Sainte: Étude de mémoire collective (The Legendary Topography of the Gospels in the Holy Land: A Study on Collective Memory)*, Paris: Presses Universitaires de France.

Halbwachs, Maurice ([1950] 1980), 'Space and collective memory', *The Collective Memory*, New York: Harper and Row.

Hales, Barbara, Petrescu, Mihaela and Weinstein, Valerie (eds) (2016), *Continuity and Crisis in German Cinema, 1928–1936*, Rochester: Camden House.

Hamm-Ehsani, Karin (2008), 'Intersections: Issues of national, ethnic, and sexual identity in Kutlug Ataman's Berlin Film Lola und Bilidikid', *Seminar: A Journal of Germanic Studies*, 44:3, pp. 366–81.

Handa, Rumiko (2021), *Presenting Difficult Pasts through Architecture: Converting National Socialist Sites [in]to Documentation Centers*, London: Routledge.

Harari, Yuval Noah ([2015] 2017), *Homo Deus: A Brief History of Tomorrow*, London: Vintage.

Harjes, Kirsten (2005), 'Stumbling stones: Holocaust memorials, national identity and democratic inclusion in Berlin', *German Politics and Society*, 74:23, pp. 138–51.

Harrison, Hope M. (2011), 'The Berlin Wall and its resurrection as a site of memory', *German Politics and Society*, 29:2, pp. 78–106.

Harrison, Hope M. (2019), *After the Berlin Wall: Memory and the Making of the New Germany, 1989 to the Present*, Cambridge: Cambridge University Press.

Hartmann, Rudi (2020), 'Virtualities in the new tourism landscape: The case of the Anne Frank house virtual tour and the visualizations of the Berlin Wall in the Cold War context', in M. Gravari-Barbas, N. Graburn and J.F. Staszak (eds), *Tourism Fictions, Simulacra and Virtualities*, New York: Routledge, pp. 211–23.

Hartung, Ulrich (2001), '*Zwischen Bauhaus und Barock: Zur Ästhetik des Palastes der Republik*' ('Between Bauhaus and Baroque: On the aesthetics of the Palace of the Republic'), *E-Journal für Kunst- und Bildgeschichte (E-Journal for Art and Painting History)*, 1, 1–11, https://edoc.hu-berlin.de/bitstream/handle/18452/7613/hartung.pdf, last accessed 17 April 2020.

Harvey, David C. (2008), 'The history of heritage', in B. Graham and P. Howard (eds), *The Ashgate Research Companion to Heritage and Identity*, Oxon: Ashgate, pp. 19–36.

Haspel, Jörg, Martin, Dieter Josef, Wenz, Joachim and Drewes, Joachim (2008), *Denkmalschutzrecht in Berlin: Gesetz zum Schutz von Denkmalen in Berlin (Monument Protection Law in Berlin: For the Protection of Monuments in Berlin)*, Berlin: Kulturbuch-Verlag.

Hatton, Brian (1991), 'Letter from Berlin', *AA Files* 21, pp. 102–03.

Haus der Geschichte Foundation (House of History Foundation) (2020a), 'Collection Concept', https://www.hdg.de/en/museum-in-der-kulturbrauerei/collections, last accessed 10 June 2020.

Haus der Geschichte Foundation (House of History Foundation) (2020b) 'TRÄNENPALAST: Site of German Division', https://www.hdg.de/en/traenenpalast/permanent-exhibition, last accessed 10 June 2020.

Häussermann, Hartmut (1999), 'Economic and political power in the new Berlin: A response to Peter Marcuse', *International Journal of Urban and Regional Research*, 23:1, pp. 180–84.

Hayden, Dolores (1995), *The Power of Place: Urban Landscapes as Public History*, Cambridge: The MIT Press.

Hebbert, Michael (2005), 'The street as locus of collective memory', *Environment and Planning D: Society and Space*, 23:4, pp. 581–96.

Heckner, Elke (2002), 'Berlin remake: Building memory and the politics of capital identity', *The Germanic Review: Literature, Culture, Theory*, 77:4, pp. 304–25.

Hell, Julia and Schönle, Andreas (eds) (2010), *Ruins of Modernity*, Durham: Duke University Press.

Hell, Julia and van Moltke, Johannes (2005), 'Unification effects: Imaginary landscapes of Berlin', *The Germanic Review*, 80:1, pp. 74–95.

Helmer, Stephen D. (1985), *Hitler's Berlin: The Speer Plans for Reshaping the Central City*, Ann Arbor: UMI Press.

Hertle, Hans-Hermann (2007), *Die Berliner Mauer: Monument des Kalten Krieges (The Berlin Wall: Monument of the Cold War)*, Berlin: Ch. Links Verlag.

Heyden, Ryan W (2020), 'Humanizing remembrance, reproducing contention: The *Stolpersteine* project', *German Studies Review*, 43:2, pp. 331–52.

Hobbs, Michael, Tomley, Sarah, Todd, Megan and Weeks, Marcus (2015), *The Sociology Book*, London: Dorling Kindersley.

Hochman, Elaine S. (1989), *Architects of Fortune: Mies van der Rohe and the Third Reich*, New York: Weidenfeld and Nicolson.

Hodgin, Nick (2011), *Screening the East: Heimat, Memory and Nostalgia in German Film Since 1989*, New York: Berghahn Books.

Hodgin, Nick and Pearce, Caroline (eds) (2011), *The GDR Remembered: Representations of the East German State Since 1989*, Rochester: Camden House.

Hoffmann-Axthelm, Dieter (1994), 'Kritische Rekonstruktion: Kritik der Praxis' ('Critical Reconstruction: A Critique of Praxis'), in A. Burg (ed.), Neue Berlinische Architektur: Eine Debatte (New Berlin Architecture: A Debate), Berlin: Birkhäuser, pp. 102–22.

Hohensee, Naraelle (2010), 'Reinventing traditionalism: The influence of critical reconstruction on the shape of Berlin's Friedrichstadt', Intersections, 11:1, pp. 55–99.

Hornstein, Shelley (2011), Losing Site: Architecture, Memory and Place, Farnham: Ashgate.

Hugo, Victor ([1838] 1892), The Rhine, vol. 2, Boston: Estes and Lauriat.

Huxtable, Ada Louise (1997), The Unreal America: Architecture and Illusion, New York: The New Press.

Huyssen, Andreas (1997), 'The voids of Berlin', Critical Inquiry, 24:1, Autumn, pp. 57–81.

Huyssen, Andreas (2003), Present Pasts: Urban Palimpsest and the Politics of Memory, Stanford: Stanford University Press.

Ingram, Susan (ed.) (2012), World Film Locations: Berlin, Bristol and Chicago: Intellect Books.

Ingram, Susan (2014), 'Berlin: A spectacularly gendered cinematic landscape of dystopian devastation', Space and Culture, 17:4, pp. 366–78.

Irwin-Zarecka, Iwona (1994), Frames of Remembrance: The Dynamics of Collective Memory, New Brunswick: Transaction Publishers.

Irwin-Zarecka, Iwona (1995), '"Topography of Terror" in Berlin: Is remembrance of forgetting possible?', Journal of Arts Management, Law and Society, 25:1, pp. 17–26.

Isaacs, Reginald ([1983] 1991), Walter Gropius: An Illustrated Biography of the Creator of the Bauhaus, London: Bulfinch Press.

James, Kathleen (1997), Erich Mendelsohn and the Architecture of German Modernism, Berkeley: University of California.

James-Chakraborty, Kathleen (2018), Modernism as Memory: Building Identity in the Federal Republic of Germany, Minneapolis: University of Minnesota Press.

Jarosinski, Eric (2002), 'Architectural symbolism and the rhetoric of transparency: A Berlin ghost story', Journal of Urban History, 29:1, pp. 62–77.

Jarosinski, Eric (2004), 'Building on a metaphor: Democracy, transparency and the Berlin Reichstag', in C.A. Constabile-Heming, R.J. Halverson and K.A. Foell (eds), Berlin – The Symphony Continues: Orchestrating Architectural, Social, and Artistic Change in Germany's New Capital, Berlin: Walter de Gruyter, pp. 59–76.

Jelavich, Peter (1993), Berlin Cabaret, Cambridge: Harvard University Press.

Jesinghausen, Martin (2000), 'The Sky over Berlin as transcendental space: Wenders, Döblin and the angel of history', Spaces in European Cinema, Exeter: Intellect Publishing, pp. 77–92.

Jesinghausen, Martin (2003), 'Berlin: A coreless city', in E. Mazierska and L. Rascaroli (eds), From Moscow to Madrid: Postmodern Cities, European Cinema, London: I.B. Tauris, pp. 115–36.

Jewish Museum Berlin (Jüdisches Museum Berlin) (2020), 'The Libeskind Building: Architecture retells German-Jewish history', https://www.jmberlin.de/en/libeskind-building, last accessed 23 July 2020.

Jones, Sara (2015), '(Extra) ordinary life: The rhetoric of representing the socialist everyday after unification', *German Politics and Society*, 33:1&2, pp. 119–34.

Jordan, Jennifer A. (2005), 'A matter of time: Examining collective memory in historical perspective in postwar Berlin', *Journal of Historical Sociology*, 18:1&2, pp. 37–71.

Jordan, Jennifer A. (2006), *Structures of Memory: Understanding Urban Change in Berlin and Beyond*, Stanford: Stanford University Press.

Kaçmaz Erk, Gül (2004), 'Architecture as symbol: Space in Wim Wenders' cinema', *Cloud Cuckoo Land: International Journal of Architectural Theory*, 9:1, https://www.cloud-cuckoo.net/openarchive/wolke/eng/Subjects/041/Kacmaz-Erk/kacmaz_erk.htm, last accessed 30 January 2022.

Kaçmaz Erk, Gül (2009), *Architecture in Cinema: A Relation of Cinema Based on Space*, Cologne: Lambert.

Kaçmaz Erk, Gül and Wilson, Christopher S. (2018), 'Framed memories of Berlin: Film, architecture and remembrance', *Journal of Architecture and Culture*, 6:2, pp. 243–63.

Kahn, Louis (1961), 'Kahn', *Perspecta*, 7, pp. 9–28.

Kansteiner, Wulf (2002), 'Finding meaning in memory: A methodological critique of collective memory studies', *History and Theory*, 41:2, pp. 179–97.

Kapczynski, Jennifer M. (2007), 'Negotiating nostalgia: The GDR past in Berlin is in Germany and Good Bye, Lenin!', *The Germanic Review: Literature, Culture, Theory*, 82:1, pp. 78–100.

Kellerhof, Sven Felix (2007), *The Führer Bunker: Hitler's Last Refuge*, Berlin: Berlin Story Press.

Kenny, Michael G. (1999), 'A place for memory', *Comparative Studies in Society and History*, 41:3, pp. 420–37.

Khalil, Shireen (2017), 'Germany's favorite fast food', 9 February, https://www.bbc.com/travel/story/20170203-germanys-favourite-fast-food, last accessed 18 August 2020.

Kil, Wolgang (1999), '*Die Unendliche Debatte: HAUPTSTADTWERDUNG – Zum Streit um die Berliner Mitte*' ('The Never-Ending Debate: BECOMING A CAPITAL CITY: On the Dispute over the Centre of Berlin'), *Der Freitag, Die Wochenzeitung (Friday, The Weekly Newspaper)*, 23 July.

Kil, Wolgang (2006), '*Chronik eines Angekündigten Todes*' ('Chronicle of an announced death'), in A. Deuflhard, S. Krempl-Klieeisen, P. Oswalt and M. Lilienthal (eds), *Volkspalast: Zwischen Aktivismus und Kunst (People's Palace: Between Activism and Art)*, Berlin: Theater der Zeit.

Kilbourn, Russell J.A. (2010), *Cinema, Memory, Modernity: The Representation of Memory from the Art of Film to Transnational Cinema*, New York and London: Routledge.

Kimmelman, Michael (2008), 'Rebuilding a palace may become a grand blunder', *New York Times*, 31 December, https://www.nytimes.com/2009/01/01/arts/01iht-01abroad.19025085.html, last assessed 13 December 2022.

Klausmeier, Axel and Schmidt, Leo (2004), *Wall Remnants – Wall Traces*, Berlin: Westkreuz-Verlag.

Kleihues, Josef Paul (1990), 'New building areas, buildings and projects', *Internationale Bauausstellung Berlin: 1987 Project Report*, Berlin: IBA, pp. 6–9.

Kleihues, Josef Paul (1993), 'From the destruction to the critical reconstruction of the city: Urban design in Berlin after 1945', in J.P. Kleihues and C. Ratheburger (eds),

Berlin-New York: Like and Unlike. Essays on Architecture and Art from 1870 to the Present, New York: Rizzoli, pp. 395–410.

Kleihues, Josef Paul (1997), 'Der Ort, an dem das Schloss stand' ('The place where the castle stood'), in M. Zimmermann (ed.), *Der Berliner Schlossplatz, Visionen zur Gestaltung der Berliner Mitte (The Berlin Castle Square, Visions for the Design of Central Berlin)*, Berlin: Argon, pp. 11–13.

Klein, Kerwin Lee (2000), 'On the emergence of *Memory* in historical discourse', *Representations*, 69, Winter, pp. 127–50.

Knischewski, Gerd and Spittler, Ulla (2006), 'Remembering the Berlin Wall: The Wall Memorial Ensemble on Bernauer Strasse', *German Life and Letters*, 59:2, pp. 280–93.

Koeck, Richard (2013), *CinelScapes: Cinematic Spaces in Architecture and Cities*, New York and London: Routledge.

Koeck, Richard and Roberts, Les (eds) (2010), *The City and the Moving Image: Urban Projections*, New York: Palgrave MacMillan.

Koepnick, Lutz (2001a), 'Redeeming history? Foster's dome and the political aesthetic of the Berlin Republic', *German Studies Review*, 24:2, pp. 303–23.

Koepnick, Lutz (2001b), 'Forget Berlin', *The German Quarterly*, 74:4, Autumn, pp. 343–54.

Komische Oper Berlin (2020), 'History', https://www.komische-oper-berlin.de/en/discover/history, last accessed 18 May 2020.

Koolhaas, Rem (2004), 'Preservation is overtaking us', *Future Anterior: Journal of Historic Preservation, History, Theory, and Criticism*, 1:2, Fall, xiv, pp. 1–3.

Koshar, Rudy (1998), *Germany's Transient Pasts: Preservation and National Memory in the Twentieth Century*, Chapel Hill and London: University of North Carolina Press.

Koshar, Rudy (2000), *From Monuments to Traces: Artifacts of German Memory, 1870–1990*, Berkeley: University of Chicago Press.

Koss, Juliet (2004), 'Coming to terms with the present', *Grey Room*, 16, Summer, pp. 116–31.

Kostof, Spiro (1982), 'His majesty the pick: The aesthetics of demolition', *Design Quarterly*, 118/119, pp. 32–41.

Kracauer, Siegfried (1932), 'Die Wiederholung: Auf der Durchreise in München' ('The repetition: passing through Munich'), *Frankfurter Allgemeine Zeitung*, 25, pp. 394–95.

Kracauer, Siegfried (1947), *From Caligari to Hitler: A Psychological History of the German Film*, Princeton and Oxford: Princeton University Press.

Kramer, Jane (1996), *The Politics of Memory: Looking for Germany in the New Germany*, New York: Random House.

Kreuder, Friedemann (2000), 'Hotel Esplanade: The cultural history of a Berlin location', *PAJ: A Journal of Performance and Art*, 22:2, pp. 22–38.

Krüger, Rolf-Herbert (1989), *Das Ephraim-Palais in Berlin: Ein Beitrag zur preußischen Kulturgeschichte (The Ephraim Palace in Berlin: A Contribution to Prussian Cultural History)*, Berlin: Verlag für Bauwesen.

370

Kuster, Brigitta, Schmidt, Dierk and Sarreiter, Regina (2013), 'Fait accompli? In search of actions for postcolonial injunctions', *Darkmatter Journal Afterlives*, 11, https://www. darkmatter101.org/site/2013/11/18/fait-accompli-in-search-of-actions-for-postcolonial-injunctions-an-introduction, last accessed 22 June 2020.

Kutz, Jens Peter (2014), 'Spreepark: Berlin's Sleeping Beauty', 14 July, https://failedarchitecture. com/spreepark, last accessed 30 March 2021.

Ladd, Brian (1990), *Urban Planning and Civic Order in Germany, 1860–1914*, Cambridge: Harvard University Press.

Ladd, Brian (1998), *The Ghosts of Berlin: Confronting German History in the Urban Landscape*, Chicago and London: University of Chicago Press.

Ladd, Brian (2000), 'Center and periphery in the New Berlin: Architecture, public art, and the search for identity', *PAJ: A Journal of Performance and Art*, 22:2, pp. 7–21.

Ladd, Brian (2004), *The Companion Guide to Berlin*, Woodbridge: Companion Guides.

Lamster, Mark (ed.) (2000), *Architecture and Film*, New York: Princeton Architectural Press.

Landesdenkmalamt Berlin (State Monument Office Berlin) (2020), '*Liste, Karte, Datenbank – Denkmaldatenbank: Palais Ephraim*' ('*List, Map, Database – Monument Database: Ephraim Palace*'), https://www.stadtentwicklung.berlin.de/denkmal/liste_karte_datenbank/de/ denkmaldatenbank/daobj.php?obj_dok_nr=09011270, last accessed 16 July 2020.

Lane, Barbara Miller (1985), *Architecture and Politics in Germany 1918–1945*, Cambridge: Harvard University Press.

Lane, Barbara Miller (1991), 'National Romanticism in Modern German Architecture', *Studies in the History of Art*, 29, Symposium Papers XIII: Nationalism in the Visual Arts, pp. 110–47.

Lane, Barbara Miller (1996), 'Book review: Berlin Cabaret by Peter Jelavich', *Central European History*, 29:1, pp. 138–40.

Lange, Bastian, Kalandides, Ares, Stöber, Birgit and Mieg, H.A. (2008), 'Berlin's creative industries: Governing creativity?', *Industry and Innovation*, 15:5, pp. 531–48.

Lawrence, Amanda Reeser and Miljački, Ana (eds) (2018), *Terms of Appropriation: Modern Architecture and Global Exchange*, London: Routledge.

Leclercq, Emmanuel (2003), '*Berlin au Cinéma: La Ville Miroir de L'Histoire*' ('Berlin at the movies: The mirror city of history'), *Revue Les Temps Modernes*, 625:4, pp. 241–57.

Ledanff, Susanne (2003), 'The Palace of the Republic versus the Stadtschloss', *German Politics and Society*, 21:4, Winter, pp. 30–73.

Lehmann-Haupt, Hellmut (1954), *Art under a Dictatorship*, Oxford: Oxford University Press.

Lehrer, Ute (2003), 'The spectacularization of the building process: Berlin, Potsdamer Platz', *Genre*, 36:3&4, Fall/Winter, pp. 383–404.

Lehrer, Ute (2004), 'Reality or image? Place selling at Potsdamer Platz, Berlin', in R. Paloscia and INURA (eds), *The Contested Metropolis: Six Cities at the Beginning of the 21st Century*, Berlin: Birkhauser, pp. 45–52.

Lennon, John and Foley, Malcolm (2000), *Dark Tourism: The Attraction of Death and Disaster*, London: Continuum Books.

Leuenberger, Christine (2016), 'Mapping divided cities and their walls: Berlin and Jerusalem', *Geoforum Perspective*, 15:27, pp. 86–103.

Levine, Neil (1996), *The Architecture of Frank Lloyd Wright*, Princeton: Princeton University Press.

Libeskind, Daniel (2009), 'Global building sites – Between past and future', in U. Staiger, H. Steiner and A. Webber (eds), *Memory Culture and the Contemporary City*, London: Palgrave Macmillan, pp. 69–81.

Liebhart, Karin (2007), '*Authentischer Ort, 'DDR-Disneyland' oder 'Pendant zum Holocaust-denkmal'? Checkpoint Charlie und das Berliner Mauermuseum*' ('Authentic Place, 'GDR Disneyland' or 'Counterpart to the Holocaust Memorial'? Checkpoint Charlie and the Berlin Wall Museum'), in R. Jaworski and P. Stachel (eds), *Die Besetzung des öffentlichen Raumes. Politische Plätze, Denkmäler und Strassennamen im europäischen Vergleich (The Occupation of Public Space. Political Places, Monuments and Street Names in a European Comparison)*, Berlin: Frank and Timme, pp. 259–76.

Liggett, Helen (1995), 'City sights/sites of memories and dreams', in H. Liggett and D. Perry (eds), *Spatial Practices: Critical Exploration in Social/Spatial Theory*, Thousand Oaks: Sage Publications, pp. 243–72.

Light, Duncan (2000), 'Gazing on communism: Heritage tourism and post-communist identities in Germany, Hungary and Romania', *Tourism Geographies*, 2:2, pp. 157–76.

Liotta, Salvator-John A. (2007), 'A critical study on Tokyo: Relations between cinema, architecture, and memory. A cinematic cartography', *Journal of Asian Architecture and Building Engineering*, 6:2, pp. 205–12.

Loeb, Carolyn and Andreas, Luescher,(eds.), (2015), *The Design of Frontier Spaces*, London: Routledge.

Long, J.J. (2012), 'Photography/topography: Viewing Berlin, 1880/2000', *New German Critique*, 116, Summer, pp. 25–45.

Lovell, Sophie (2017), 'Becoming Berlin', *The Architectural Review*, 1446, pp. 76–83.

Luescher, Andreas (2002), 'Refashioning no-man's-land', *Cities*, 19:3, pp. 155–60.

Lynch, Kevin (1960), *The Image of the City*, Cambridge: The MIT Press.

Macdonald, Sharon (2013), *Memorylands: Heritage and Identity in Europe Today*, London: Routledge.

MacGregor, Iain (2019), *Checkpoint Charlie: The Cold War, the Berlin Wall and the Most Dangerous Place on Earth*, London: Constable.

Maier, Helmut (1984), *Berlin: Anhalter Bahnhof (Berlin: Anhalt Train Station)*, Berlin: Ästhetik und Kommunikation.

Maier, Wilhelm (1997), 'Construction logistics for Potsdamer Platz', *Structural Engineering International*, 7:4, pp. 233–35.

Major, Patrick (2010), *Behind the Berlin Wall: East Germany and the Frontiers of Power*, Oxford: Oxford University Press.

Marcus, Alan and Neumann, Dietrich (eds) (2007), *Visualizing the City*, Oxfordshire: Routledge.

Marcuse, Peter (1997), 'The National Memorial to the victims of war and tyranny: From conflict to consensus', *Annual German Studies Association Conference*, Washington, DC, 25 September, http://marcuse.faculty.history.ucsb.edu/present/neuewach.htm, last accessed 12 May 2020.

Marcuse, Peter (1998), 'Reflections on Berlin: The meaning of construction and the construction of meaning', *International Journal of Urban and Regional Research*, 22:2, pp. 331–38.

Margalit, Avishay (2002), *The Ethics of Memory*, Cambridge: Harvard University Press.

Martin, Timothy (2000), 'Signs of tragedy past and future: Reading the Berlin Reichstag', *Architectural Design*, 70:5, pp. 30–35.

Mastin, Steven (2007), 'What can Berlin tell us about Germany in the twentieth century?', *Teaching History*, 126, p. 29.

Maulucci, Thomas W. Jr. (2008), 'Cold War Berlin in the movies', in P.C. Rollins and J.O'Connor (eds), *Why We Fought: America's Wars in Film and History*, Lexington: University Press of Kentucky, pp. 317–48.

Mazierska, Ewa and Rascaroli, Laura (2003), 'Berlin, A coreless city', in *From Moscow to Madrid: Postmodern Cities, European Cinema*, London and New York: I.B. Tauris, pp. 115–36.

McAdams, A. James (1993), *Germany Divided: From the Wall to Reunification*, Princeton: Princeton University Press.

McStotts, Jennifer Cohoon (2006), 'The second fall of the Berlin Wall: Examining the Hildebrandt Memorial at Checkpoint Charlie', *Future Anterior: Journal of Historic Preservation, History, Theory, and Criticism*, 3:1, Summer, pp. 36–47.

Mennel, Barbara (2004), 'Masochism, marginality, and the metropolis: Kutlug Ataman's *Lola and Billy the Kid*', *Studies in 20th & 21st Century Literature*, 28:1, Winter, pp. 286–315.

Mennel, Barbara (2008), *Cities and Cinema*, London: Routledge.

Merin, Gili (2021), '"Most of the people thought it was ugly – Like a petrol station": David Chipperfield on the Neue Nationalgalerie's Renovation', *ArchDaily*, 24 August, https://www.archdaily.com/967248/most-of-the-people-thought-it-was-ugly-like-a-petrol-station-david-chipperfield-on-the-neue-nationalgaleries-renovation, last accessed 29 January 2022.

Mertins, Detlef (2001), 'Architectures of becoming: Mies van der Rohe and the Avant-Garde', in T. Riley and B. Bergdoll (eds), *Architectures of Becoming: Mies in Berlin*, New York: Museum of Modern Art, pp. 106–33.

Middleton, David and Edwards, Derek (eds) (1990), *Collective Remembering*, London: Sage.

Miller, Wallis (1997), 'Schinkel and the politics of German Memory: The life of the Neue Wache in Berlin', in S.D. Denham, I. Kacandes and J. Petropoulos (eds), *A User's Guide to German Cultural Studies*, Ann Arbor: University of Michigan Press, pp. 227–56.

Misselwitz, Philipp and Oswalt, Philipp (2004), 'Palast der Republik: Architects as agents', in *Verb Connection: Architecture Boogazine*, Barcelona: Actar, http://www.urbancatalyst.net/downloads/2004_UC_pdr.pdf, last accessed 15 December 2022.

Misztal, Barbara A. (2003), *Theories of Social Remembering*, Maidenhead: Open University Press.

Mitchell, Greg (2016), *The Tunnels: Escapes under the Berlin Wall and the Historic Films the JFK White House Tried to Kill*, New York: Broadway Books.

Mittig, Hans-Ernst (2001), '*Antikbezüge nationalsozialistischer Propaganda-architektur und – skulptur*' ('Antique references to national socialist propaganda architecture and sculpture'), in B. Näf (ed.), *Antike und Altertumswissenschaft in der Zeit von Faschismus und Nationalsozialismus (Ancient and Classical Studies in the Time of Fascism and National Socialism)*, Mandelbachtal: Edition Cicero, pp. 242–65.

Mittig, Hans-Ernst (2005), '*Marmor der Reichskanzlei*' ('Marble from the Reich Chancellery'), in D. Bingen and H.M. Hinz (eds), *Die Schleifung / Zerstörung und Wiederaufbau historischer Bauten in Deutschland und Polen (The Grinding / Destruction and Reconstruction of Historical Buildings in Germany and Poland)*, Wiesbaden: Harrassowitz Publishers, pp. 174–87.

Molnar, Virag (2013), *Building the State: Architecture, Politics and State Formation in Post-War Central Europe*, New York: Routledge.

Moore, Lisa M. (2009), '(Re) Covering the past, remembering the trauma: The politics of commemoration at sites of atrocity', *Journal of Public and International Affairs*, 20, Spring, pp. 47–64.

Morgan, Diane (2015), 'Bunker conversion and the overcoming of siege mentality', *Textual Practice*, 4:6, pp. 25–41.

Moshenska, Gabriel (2010), 'Working with memory in the archaeology of modern conflict', *Cambridge Archaeological Journal*, 20:1, pp. 33–48.

Mugerauer, Robert (2014), 'When the given is gone: From the Black Forest to Berlin and back via Wim Wenders' *Der Himmel Über Berlin*', in *Responding to Loss: Heideggerian Reflections on Literature, Architecture, and Film*, New York: Fordham University Press, pp. 109–40.

Mumford, Lewis ([1937] 1971), 'The death of the monument', in J.L. Martin, B. Nicholson and N. Gabo (eds), *Circle: International Survey of Constructive Art*, New York: Praeger, pp. 262–69.

Mumford, Lewis (1938), *The Culture of Cities*, New York: Harcourt, Brace and Company.

Mumma, Rachel (2015), 'A reaction to the memorial to the murdered Jews of Europe', https://www.northeastern.edu/universityscholars/a-reaction-to-the-memorialto-the-murdered-jews-of-europe, last accessed 22 July 2020.

Murray, George J.A. (2008), 'City building and the rhetoric of "Readability": Architectural Debates in the New Berlin', *City and Community*, 7:1, pp. 3–21.

NARA: United States National Archives and Records Administration (2013), *A City Divided: Life and Death in the Shadow of the Wall*, College Park: NARA.

Neill, William J.V. (1997), 'Memory, collective identity and urban design: The future of Berlin's Palast der Republik', *Journal of Urban Design*, 2:2, pp. 179–92.

Neill, William J.V. (2004), *Urban Planning and Cultural Identity*, London: Routledge.

Nelis, Jan (2008), 'Modernist neo-classicism and antiquity in the political religion of Nazism: Adolf Hitler as *Poietes* of the Third Reich', *Totalitarian Movements and Political Religions*, 9:4, pp. 475–90.

Nicolson, Harold (1929), 'The charm of Berlin', *Der Querschnitt*, 9:5, pp. 345–46.

Nishen (ed.) (1996), *Info Box: der Katalog*, Berlin: Nishen.

Niven, Bill (ed.) (2006), *Germans as Victims: Remembering the Past in Contemporary Germany*, Basingstoke: Palgrave Macmillan.

Noga-Banai, Galit (2015), 'Places of remembrance: A Via Dolorosa in Berlin's Bavarian quarter', in R. Bartal and H. Vorholt (eds), *Between Jerusalem and Europe: Essays in Honour of Bianca Kühnel*, Leiden: Brill, pp. 173–94.

Nolan, Mary (2001), 'The politics of memory in the Berlin Republic', *Radical History Review*, 81, Fall, pp. 113–32.

Nolan, Mary (2005), 'Air wars, memory wars', *Central European History*, 38:1, pp. 7–40.

Nora, Pierre (1989), 'Between history and memory: *Les Lieux de Mémoire*', *Représentations*, 26, pp. 7–24.

Nora, Pierre (ed.) (1996), *Realms of Memory: Rethinking the French Past*, New York: Columbia University Press.

Novikov, Alexey and Vitaliev, Vitali (2009), 'Technology of escapes', *Engineering and Technology*, 4:19, pp. 22–24.

Novy, Johannes (2017), '"Destination" Berlin revisited. From (new) tourism towards a Pentagon of mobility and place consumption', *Tourism Geographies*, 20:3, pp. 418–42.

Nye, Sean (2009), 'Love parade, please not again: A Berlin cultural history', *ECHO: A Music-Centered Journal*, 9:1, http://www.echo.ucla.edu/Volume9-Issue1/nye/nye1.html, last accessed 27 July 2020.

O'Donnell, James P. (1979), *The Berlin Bunker*, London: J.M. Dent and Sons.

Oettler, Anika (2021), 'The Berlin memorial to the homosexuals persecuted under the national socialist regime: Ambivalent responses to homosexual visibility', *Memory Studies*, 14:2, pp. 333–47.

Olick, Jeffrey K. (1999), 'Collective memory: The two cultures', *Sociological Theory*, 17:3, pp. 333–48.

Olick, Jeffrey K. (2007), *The Politics of Regret: On Collective Memory and Historical Responsibility*, New York and London: Routledge.

Olick, Jeffrey K. and Robbins, Joyce (1998), 'Social memory studies: From "Collective Memory" to the historical sociology of mnemonic practices', *Annual Review of Sociology*, 24, pp. 105–40.

O'Sickey, Ingeborg Majer (2001), 'Cinematic ciphers: Potsdamer Platz, Berlin', *German Politics and Society*, 19:4, pp. 64–84.

Ören, Aras (1995), *Berlin Savignyplatz*, Berlin: Elefanten Press.

Osborne, Dora (2014), '*Mal d'archive*: On the growth of Günter Demnig's *Stolperstein*-Project', *Paragraph*, 37:3, pp. 372–86.

Ostrovsky, Max (2007), *Y = Arctg X: The Hyperbola of the World Order*, Lanham: University Press of America.

Otero-Pailos, Jorge (2015), 'Monumentaries: Toward a theory of the Apergon', *e-flux journal*, p. 66.

Oxford English Dictionary (1978), 'Memorial', Oxford: Oxford University Press.

Öztürk, Mehmet (ed.) (2008), *Sinematografik Kentler: Mekanlar, Hatiralar, Arzular (Cinematographic Cities: Spaces, Memories, Desires)*, Istanbul: Agora.

Paeslack, Miriam (2013), 'High-speed ruins: Rubble photography in Berlin, 1871–1914', *Future Anterior*, 10:2, Winter, pp. 32–47.

Pallasmaa, Juhani (1996), *The Eyes of the Skin: Architecture and the Senses*, London: Academy Press.

Pallasmaa, Juhani (2007), *The Architecture of Image: Existential Space in Cinema*, Helsinki: Rakennustieto Publishing.

Palutzki, Joachim (2000), *Architektur der DDR (Architecture of the GDR)*, Berlin: Dietrich Reimer.

Paterson, Tony (2004), 'Berliners angered by "Disneyland" recreation of the iron curtain divide', *Independent*, 13 October, https://www.independent.co.uk/news/world/europe/berliners-angered-by-disneyland-recreation-of-the-iron-curtain-divide-5351017.html, last accessed 18 June 2020.

Penz, François and Lu, Andong (eds) (2011), *Urban Cinematics: Understanding Urban Phenomena through the Moving Image*, Bristol: Intellect.

Perez, Gilberto (1998), *The Material Ghost: Films and Their Medium*, Baltimore: Johns Hopkins.

Perez de Arce, Rodrigo (1978), 'Urban transformations and the architecture of additions', *Architectural Design*, 48:4, p. 12.

Perry, Joe (2019), 'Love Parade 1996: Techno playworlds and the neoliberalization of post-Wall Berlin', *German Studies Review*, 42:3, pp. 561–79.

Petrarca, Francesco (1975), *Rerum Familiarium Libri I-VIII* (trans. A.S. Bernardo), Albany: State University of New York Press.

Pfadfinderei (2006), interviewed by S. Bianchi, *Digimag*, 16 July–August, http://digicult.it/digimag/issue-016/pfadfinderei-first-class-digital-shit, last accessed 4 June 2020.

Philippot, Paul ([1972] 1996), 'Historic preservation: Philosophy, criteria, guidelines, I', in N. Price, M.K. Talley and A. Melucco Vaccaro (eds), *Historical and Philosophical Issues in the Conservation of Cultural Heritage*, Los Angeles: Getty Conservation Institute, pp. 268–75.

Philpott, Matthew (2012), 'Cultural-political palimpsests: The Reich Aviation Ministry and the multiple temporalities of dictatorship', *New German Critique*, 117:39, pp. 207–30.

Philpott, Matthew (2016), *Relics of the Reich: The Buildings the Nazis Left Behind*, Barnsley: Pen and Sword Books.

Pickford, Henry W. (2005), 'Conflict and commemoration: Two Berlin memorials', *MODERNISM/modernity*, 12:1, pp. 133–73.

Pike, David L. (2010), 'Wall and tunnel: The spatial metaphorics of Cold War Berlin', *New German Critique*, 110:37, pp. 73–94.

Pinkert, Anke (2008), *Film and Memory in East Germany*, Bloomington: Indiana University Press.

Pohlsander, Hans A. (2008), *National Monuments and Nationalism in 19th Century Germany*, Berlin: Peter Lang.

Postlethwaite, Luke V. (2015), 'Beyond the Baustelle: Redefining Berlin's contemporary cinematic brand as that of a global media city', Ph.D. thesis, Leeds: University of Leeds.

Prager, Brad (2010), 'Passing time since the *Wende*: Recent German film on unification', *German Politics and Society*, 28:1, pp. 95–110.

Proust, Marcel (2006), *Remembrance of Things Past*, (trans. Ingrid Wassenaar and C. K. Scott-Moncrieff), Ware: Wordsworth Editions.

Pugh, Emily (2014), *Architecture, Politics, and Identity in Divided Berlin*, Pittsburgh: University of Pittsburgh Press.

Pugh, Emily (2015), '"You Are Now Entering Occupied Berlin": Architects and rehab-squatters in West Berlin', *Centropa*, 15:2, pp. 189–202.

Radley, Alan (1990), 'Artefacts, memory and a sense of the past', in D. Middleton and D. Edwards (eds), *Collective Remembering*, London: Sage, pp. 46–59.

Radstone, Susannah and Schwarz, Bill (eds) (2010), *Memory: Histories, Theories, Debates*, New York: Fordham University Press.

Rathje, Wolfgang (2001), *'Mauer-Marketing' unter Erich Honecker: Schwierigkeiten der DDR bei der technischen Modernisierung, der volkswirtschaftlichen Kalkulation und der politischen Akzeptanz der Berliner 'Staatsgrenze' von 1971–1990 ('Wall Marketing' under Erich Honecker: Difficulties of the GDR in the Technical Modernization, Economic Calculation and Political Acceptance of the Berlin 'State Border' from 1971–1990)*, Kiel: R. Gründer.

Rechtien, Renate and Tate, Dennis (eds) (2011), *Twenty Years on: Competing Memories of the GDR in Postunification German Culture*, Rochester: Camden House.

Rentschler, Eric (2010), 'The place of rubble in the *Trümmerfilm*', *New German Critique*, 110, 37:2, Summer, pp. 9–30.

Reulecke, Jürgen (1989), 'Das Berlinbild: was ist Imagination, was Wirklichkeit? Einige abschliessende Überlegungen' ('The Berlin picture: What is imagination, what is reality?'), in G. Brunn and J. Reulecke (eds), *Blicke auf die Deutsche Metropole (Views of the German Metropolis)*, Essen: Reimar Hobbing, pp. 251–63.

Reynolds, Christopher (2002), 'Out with the old', *Los Angeles Times*, 29 December. https://www.latimes.com/archives/la-xpm-2002-dec-29-ca-reynolds29-story.html, last accessed 15 December 2022.

Richarz, Monika (2006), 'Stumbling stones: Marks of holocaust memory on German streets', in L.B. Strauss and M. Brenner (eds), *Mediating Modernity: Challenges and Trends in the Jewish Encounter with the Modern World*, Detroit: Wayne State University Press, pp. 325–38.

Richie, Alexandra (1998), *Faust's Metropolis: A History of Berlin*, New York: Carroll and Graf.

Richter, Dagmar (1996), 'Spazieren in Berlin', *Assemblage*, 29 (April), pp. 72–85.

Ricoeur, Paul (2004), *Memory, History, Forgetting*, Chicago and London: University of Chicago Press.

Riding, Alan (1999), 'THE NEW BERLIN – Building on the rubble of history; A capital reinstated and remodeled', *New York Times*. April 11, 1999, Section 2, Page 1. https://www.nytimes.com/1999/04/11/arts/new-berlin-building-rubble-history-capital-reinstated-remodeled.html, last accessed 15 December 2022.

Riegl, Alois ([1903] 1982), 'The modern cult of monuments: Its character and its origin', (trans. K. Forster and D. Ghirardo), *Oppositions*, 25, pp. 20–51.

Roeck, Berndt (2001), 'Der Reichstag' ('The Reichstag'), in E. François and H. Schulze (eds), *Deutsche Erinnerungsorte (German Sites of Memory)*, vol. 1, Munich: Beck, pp. 138–55.

Rogers, Thomas (2014), 'Berghain: The secretive, sex-fueled world of techno's coolest club', 6 Febraury, https://www.rollingstone.com/culture/culture-news/berghain-the-secretive-sex-fueled-world-of-technos-coolest-club-111396, last accessed 31 May 2020.

Rogier, Francesca (1996), 'From the opening of the wall to the wrapping of the Reichstag', *Assemblage*, 29, April, pp. 40–71.

Roselt, Jens (2012), 'Change through rapprochement: Spatial practices in contemporary performances', in E. Fischer-Lichte and B. Wihstutz (eds), *Performance and the Politics of Space: Theatre and Topology*, London: Taylor and Francis, pp. 265–75.

Rosenfeld, Gavriel D. (1997), 'The architects' debate: Architectural discourse and the memory of Nazism in the Federal Republic of Germany, 1977–1997', *History and Memory*, 9:1–2, Fall, pp. 189–225.

Rosenfeld, Gavriel D. (2000), *Munich and Memory: Architecture, Monuments, and the Legacy of the Third Reich*, Berkeley, Los Angeles and London: University of Chicago Press.

Rossell, Deac (1998), 'Beyond Messter: Aspects of early cinema in Berlin', *Film History*, 10:1, pp. 52–69.

Rossi, Aldo ([1966] 1982), *The Architecture of the City* (trans. D. Ghirardo and J. Ockman), Cambridge: The MIT Press.

Rottman, Gordon L. (2008), *The Berlin Wall and the Intra-German Border 1961–89*, Oxford: Osprey.

Rowlands, Michael (2001), 'Remembering to forget: Sublimation as sacrifice in war memorials', in A. Forty and S. Küchler (eds), *The Art of Forgetting*, Oxford: Berg Publishers, pp. 129–45.

Ruskin, John (1885), *The Seven Lamps of Architecture*, New York: Dover.

Saarinen, Hannes (2008), 'Symbolic places in Berlin before and after the fall of the Wall', in J. Aunesluoma and P. Kettunen (eds), *The Cold War and the Politics of History*, Helsinki: Edita Publishing, pp. 81–105.

Sadowski, Piotr (2017), *The Semiotics of Light and Shadows: Modern Visual Arts and Weimar Cinema*, London: Bloomsbury.

Sandler, Daniela (2011), 'Counterpreservation: Decrepitude and memory in post-unification Berlin', *Third Text*, 6, pp. 687–97.

Sandler, Daniela (2016), *Counterpreservation: Architectural Decay in Berlin Since 1989*, Ithaca: Cornell University Press.

Saunders, Anna (2009), 'Remembering the Cold War division: Wall remnants and border monuments in Berlin', *Journal of Contemporary European Studies*, 17:1, pp. 9–19.

Sälter, Gerhard (2010), 'Die Mauersegmente, aus denen die Mauer errichtet wurde' ('The Wall Segments from which The Wall was Built'), *Stiftung Berliner Mauer (Berlin Wall*

Foundation), *Gedenkstätte Berliner Mauer (Berlin Wall Memorial)*, https://www.berliner-mauer-gedenkstaette.de/de/uploads/berliner_mauer_dokumente/mauersegmente.pdf, last accessed 29 July 2020.

Schalenberg, Marc (2009), 'City of displacement: On the unsteadiness of Berlin sites and sights', *WEIMARPOLIS, Multi-disciplinary Journal of Urban Theory and Practice*, 1:2, pp. 53–64.

Scharf, Inga (2007), 'Staging the border: National identity and the critical geopolitics of West German film', in M. Power and A. Crampton (eds), *Cinema and Popular Geo-Politics*, New York: Routledge, pp. 182–202.

Scharf, Inga (2008), *Nation and Identity in the New German Cinema: Homelessness at Home*, New York: Routledge.

Schäche, Wolfgang (1995), 'From Berlin to Germania', in D. Ades, T. Benton, D. Elliott and I. Boyd Whyte (eds), *Art and Power: Europe under the Dictators, 1930–45*, London: Southbank Centre, pp. 582–86.

Schinkel, Karl Friedrich and Berger, Ferdinand (1819), *Sammlung architectonischer Entwürfe von Schinkel enthaltend theils Werke welche ausgeführt sind, theils Gegenstände deren Ausführung beabsichtigt wurde (Collection of Architectural Drafts by Schinkel Containing Partly Works Which have been Executed, Partly Objects Whose Execution was Intended)*, Berlin: Ludwig Willem Wittich.

Schlör, Joachim (2006), '"It has to go away, but at the same time it has to be kept": The Berlin Wall and the making of an icon', *Urban History*, 33:1, pp. 85–105.

Schmaling, Sebastian (2005), 'Masked nostalgia, chic regression: The "Critical" reconstruction of Berlin', *Harvard Design Magazine, Special Issue – Regeneration: Design as Dialogue, Building as Transformation*, 23, Fall/Winter, pp. 24–30.

Schmidt, Leo (2011), 'The architecture and message of the "Wall", 1961–1989', *German Politics and Society*, 29:2, Summer, pp. 57–77.

Schneider, Bernhard (1997), 'Berlin's centre: What shall there be?', *The Journal of Architecture*, 2:3, Autumn, pp. 225–33.

Schneider, Bernhard (1998), 'Invented history: Pariser Platz and the Brandenburg Gate', *AA Files*, 37, pp. 12–16.

Schofield, John and Rellensmann, Luise (2015), 'Underground heritage: Berlin techno and the changing city', *Heritage and Society*, 8:2, November, pp. 111–38.

Schönle, Andreas (2006), 'Ruins and history: Observations on Russian approaches to destruction and decay', *Slavic Review*, 65:4, Winter, pp. 649–69.

Schultes, Axel (1995), 'Berlin – The belated capital', *AA Files*, 29, pp. 61–70.

Schultes, Axel (1997), 'The New Chancellory [sic]', *Journal of Architecture*, 2:3, Autumn, pp. 269–82.

Schulz, Bernhard (2000), *The Reichstag: The Parliament Building by Norman Foster*, New York: Prestel.

Schwartz, Barry (1982), 'The social context of commemoration: A study in collective memory', *Social Forces*, 61:2, pp. 374–402.

Scobie, Alex (1990), *Hitler's State Architecture: The Impact of Classical Antiquity*, University Park: Pennsylvania State University.

Scott, Fred (2008), *On Altering Architecture*, New York: Routledge.

Sebald, Winfried Georg ([1999] 2004), *On the Natural History of Destruction*, New York: The Modern Library.

Seibt, Gustav (2001), 'Das Brandenburger Tor' ('The Brandenburg Gate'), in E. François and H. Schulze (eds), *Deutsche Erinnerungsorte (German Sites of Memory)*, 1, Munich: Beck, pp. 67–85.

Sert, Josep Lluís, Léger, Fernand and Giedion, Siegfried ([1943] 1984), 'Nine points on monumentality', *Harvard Architecture Review*, IV, pp. 62–63.

Shandley, Robert R. (2001), *Rubble Films: German Cinema in Shadow of the Third Reich*, Philadelphia: Temple University Press.

Shanken, Andrew M. (2002), 'Planning memory: Living memorials in the United States during World War II', *The Art Bulletin*, 84:1, pp. 130–47.

Shanken, Andrew M. (2004), 'Research on memorials and monuments', *Anales del Instituto de Investigaciones Estéticas*, 84, pp. 163–72.

Sharpley, Richard and Stone, Philip R. (eds) (2009), *The Darker Side of Travel: The Theory and Practice of Dark Tourism*, Bristol, Buffalo and Toronto: Channel View Publications.

Sharr, Adam (2010), 'The sedimentation of memory', *The Journal of Architecture*, 15:4, pp. 499–515.

Sheridan, Dougal (2007), 'The space of subculture in the city: Getting specific about Berlin's indeterminate territories', *Field: A Free Journal for Architecture*, 1:1, pp. 97–119.

Shiel, Mark and Fitzmaurice, Tony (eds) (2001), *Cinema and the City: Film and Urban Societies in a Global Context*, Oxford and Malden: Blackwell.

Shiel, Mark and Fitzmaurice, Tony (eds) (2003), *Screening the City*, London: Verso.

Shonfield, Katerine (2000), *Walls Have Feelings: Architecture, Film and the City*, London and New York: Routledge.

Silberman, Marc (ed.) (2011), *The German Wall: Fallout in Europe*, New York: Palgrave Macmillan.

Simmel, Georg ([1911] 1965), 'The ruin', in K.H. Wolff (ed.), *Essays on Sociology, Philosophy and Aesthetics*, New York: Harper and Row.

Soja, Edward (2003), 'Writing the city spatially', *City: Analysis of Urban Change, Theory, Action*, 7:3, pp. 269–80.

Solomon-Goddeau, Abigail (1998), 'Mourning or Melancholia: Christian Boltanski's *Missing House*', *Oxford Art Journal*, 21:2, pp. 1–20.

Sonne, Wolfgang (2004), 'Specific intentions – General realities: On the relation between urban forms and political aspirations in Berlin during the twentieth century', *Planning Perspectives*, 19:3, pp. 283–310.

Sontag, Susan ([1975] 2013), 'Fascinating fascism', *Under the Sign of Saturn*, New York: Farar, Straus and Giroux, pp. 73–108.

Specht, Jan (2014), *Architectural Tourism: Building for Urban Travel Destinations*, Wiesbaden: Springer Gabler.

Speer, Albert ([1969] 1970), *Inside the Third Reich: Memoirs by Albert Speer* (trans. R. Winston and C. Winston), New York: Macmillan.

Stadtmuseum Berlin (Berlin City Museum), 'Berlin 1945 | 2015', https://www.stadtmuseum.de/objekte-und-geschichten/berlin-1945-2015, last accessed 20 May 2020.

Staiger, Uta (2009), 'Cities, citizenship, contested cultures: Berlin's Palace of the Republic and the politics of the public sphere', *Cultural Geographies*, 16:3, pp. 309–27.

Stangl, Paul (2008), 'The vernacular and the monumental: Memory and landscape in post-war Berlin', *GeoJournal*, 73, pp. 245–53.

Stead, Naomi (2003), 'The value of ruins: Allegories of destruction in Benjamin and Speer', *Form/Work: An Interdisciplinary Journal of the Built Environment*, 6, pp. 51–64.

Steneck, Nicholas J. (2011), 'Hitler's legacy in concrete and steel: Memory and civil defence bunkers in West Germany, 1950–65', in H. Schmitz and A. Seidel-Arpacı (eds), *Narratives of Trauma: Discourses of German Wartime Suffering in National and International Perspective*, Amsterdam: Rodopi, pp. 59–73.

Stevens, Quentin (2015), 'Memorial planning in Berlin, London and New York', *Landscape Review*, 15:2, pp. 59–70.

Stevens, Quentin, Franck, Karen A. and Fazakerley, Ruth (2012) 'Counter-monuments: The anti-monumental and the dialogic', *The Journal of Architecture*, 17:6, pp. 951–72.

Stimmann, Hans (1994), 'Kritische Rekonstruktion und steinerne Architektur für die Friedrichstadt' ('Critical reconstruction and stone architecture for Friedrichstadt'), in A. Burg (ed.), *Neue Berlinische Architektur: Eine Debatte (New Berlin Architecture: A Debate)*, Berlin: Birkhäuser, pp. 123–33.

Strom, Elizabeth (2001), *Building the New Berlin: The Politics of Urban Development in Germany's Capital City*, Lanham and Oxford: Lexington.

Stubblefield, Thomas (2011), 'Do disappearing monuments simply disappear?', *Future Anterior*, 8:2, Winter, pp. 1–11.

Studio Daniel Libeskind (2022), 'Studio profile', http://www2.citycenter.com/press_pdf/Studio%20Daniel%20Libeskind%20-%20Studio%20Profile.pdf, last accessed 30 January 2022.

Taylor, Frederick (2006), *The Berlin Wall: A World Divided 1961–1989*, New York: Harper Collins.

Taylor, Robert R. (1974), *The Word in Stone: The Role of Architecture in the National Socialist Ideology*, Berkeley: University of California Press.

Teske, Knut (1996), '*Der Salon des Kaisers ist Reisefertig*' ('The Emperor's Hall Is Ready to Travel'), *Die Welt (The World)*, 2 March, https://www.welt.de/print-welt/article653418/Der-Salon-des-Kaisers-ist-reisefertig.html, last accessed 1 July 2020.

Thomas, Maureen and Penz, Francois (2003), *Architecture and Illusion: From Motion Pictures to Navigable Interactive Environments*, Bristol and Portland: Intellect.

Thrift, Nigel (1996), *Spatial Formations*, London: Sage.

Tietz, Jurgen (2006), 'Sport and remembrance: The Berlin olympic site', in R. Rother (ed.), *Historic Site: The Olympic Grounds 1909–1936–2006*, Berlin: Jovis, pp. 10–20.

Till, Karen (1999), 'Staging the past: Landscape designs, cultural identity and *Erinnerungspolitik* at Berlin's Neue Wache', *Ecumene*, 6:3, pp. 251–83.

Till, Karen (2005), *The New Berlin: Memory, Politics, Place*, Minneapolis and London: University of Minnesota Press.

Tölle, Alexander (2010), 'Urban identity policies in Berlin: From critical reconstruction to reconstructing the wall', *Cities*, 27, pp. 348–57.

Turner, Lauren (2015), 'Bomber command maps reveal extent of German destruction', 8 October, https://www.bbc.com/news/uk-34467543, last accessed 22 April 2020.

Ulferts, Gert-Dieter (1991), 'Friede nach Siegreichem Krieg / Das Bildprogramm – Skulpturen und Malereien' ('Peace after the Victorious War / The Picture Program – Sculptures and Paintings'), in R. Bothe (ed.), *Das Brandenburger Tor 1791–1991: Eine Monographie (The Brandenburg Gate 1791–1991: A Monograph)*, Berlin: Verlag Willmuth Arenhövel, pp. 93–132.

Urban, Florian (2007), 'Designing the past in East Berlin before and after the German Reunification', *Progress in Planning*, 68, pp. 1–55.

Urban, Florian (2009), *Neo-historical East Berlin: Architecture and Urban Design in the German Democratic Republic, 1970–1990*, Surrey and Burlington: Ashgate.

USIS: United States Information Service (1963), *Freedom or Death*, Washington, DC: US Department of State.

van der Hoorn, Melanie (2009), *Indispensable Eyesores: An Anthropology of Undesired Buildings*, Oxford: Berghahn Books.

van Dijck, Jose A. (2008), 'Mediated memories: A snapshot of remembered experience', in J. Kooijman, P. Pisters and W. Strauven (eds), *Mind the Screen: Media Concepts According to Thomas Elsaesser*, Amsterdam: Amsterdam University Press, pp. 71–81.

van Lessen, Christian (1998), *'Der "Frühstückssaal" Entsteht im Original – auf Zwei Orte Verteilt'* ('The Original "Breakfast Room" is Spread over Two Locations'), *Der Tagesspiegel (The Daily Mirror)*, 26 November, https://www.tagesspiegel.de/berlin/der-fruehstuecks-saal-entsteht-im-original-auf-zwei-orte-verteilt/66372.html, last accessed 3 July 2020.

Vasudevan, Alex (2014), 'Autonomous urbanism and the right to the city: The spatial politics of squatting in Berlin, 1968–2012', in B. van der Steen, A. Katzeff and L. van Hoogenhuijze (eds), *The City Is Ours: Squatting and Autonomous Movements in Europe from the 1970s to the Present*, Oakland: MP Press, pp. 131–52.

Virilio, Paul ([1976] 1994) *Bunker Archaeology* (trans. G. Collins), New York: Princeton Architectural Press.

Vereinigung der Landesdenkmalpfleger in der Bundesrepublik Deutschland ('Association of State Monument Conservators in the Federal Republic of Germany') (2011), *'Leitbild Denkmalpflege – Zur Standortbestimmung der Denkmalpflege heute'* ('Monument Preservation Mission Statement – To Determine the Current Position of Monument Preservation', but published as 'Conservation in Germany – The Principles of Conservation in Today's World'),

Petersberg: Imhof Verlag, http://www.denkmalpflege-forum.de/Download/Leibild_Denk-malpflege_Imhof_Verlag.pdf, last accessed 22 January 2021.

Verheyen, Dirk (2008), *United City, Divided Memories? Cold War Legacies in Contemporary Berlin*, Lanham: Lexington Books.

Vogt, Guntram (2001), *Die Stadt im Kino: Deutsche Spielfilme 1900-2000 (City in Cinema: German Feature Films 1900–2000)*, Marburg: Schüren.

Volmert, Miriam (2017), 'Landscape, boundaries, and the limits of representation: The *Stolpersteine* as a commemorative space', *Scandinavian Jewish Studies*, 28:1, pp. 4–21.

von Bose, Friedrich (2013), 'The making of Berlin's Humboldt-Forum: Negotiating history and the cultural politics of place', *Darkmatter Journal Afterlives*, 11, https://www.academia.edu/24270002/The_Making_of_Berlin_s_Humboldt_Forum_Negotiating_History_and_the_Cultural_Politics_of_Place_in_Chinese, last accessed 17 June 2022.

von Buttlar, Adrian (2007), 'Berlin's castle versus palace: A proper past for Germany's future?' *Future Anterior*, 4:1, pp. 13–29.

Wagner, Brigitta A. (2015), *Berlin Replayed: Cinema and Urban Nostalgia in the Postwall Era*, Minneapolis: University of Minnesota Press.

Walters, Guy (2006), *Berlin Games: How Hitler Stole the Olympic Dream*, London: John Murray.

Warburg, Aby (1999), *The Renewal of Pagan Antiquity: Contributions to the Cultural History of the European Renaissance*, Los Angeles: Getty Research Institute for the History of Art and the Humanities.

Ward, Janet (2001), *Weimar Surfaces: Urban Visual Culture in 1920s Germany*, Berkeley, Los Angeles and London: University of California Press.

Ward, Janet (2011a), *Post Wall Berlin: Borders, Space and Identity*, Basingstoke: Palgrave Macmillan.

Ward, Janet (2011b), 'Re-capitalizing Berlin', in M. Silberman (ed.), *The German Wall: Fallout in Europe*, New York: Palgrave Macmillan, pp. 79–97.

Ward, Janet (2016), *Sites of Holocaust Memory*, London: Bloomsbury.

Ward, Simon (2016), *Urban Memory and Visual Culture in Berlin: Framing the Asynchronous City, 1957–2012*, Amsterdam: Amsterdam University Press.

Webber, Andrew (2008), *Berlin in the Twentieth Century: A Cultural Topography*, Cambridge: Cambridge University Press.

Weeks, Kay and Grimmer, Anne (1995), *The Secretary of the Interior's Standards for the Treatment of Historic Properties with Guidelines for Preserving, Rehabilitating, Restoring and Reconstructing Historic Buildings*, Washington, DC: US Department of the Interior.

Weihsmann, Helmut (1988), *Gebaute Illusionen: Architektur im Film (Built Illusions: Architecture in Film)*, Vienna: Promedia.

Weihsmann, Helmut (1990), '*Das Wort aus Stein – eine Welt aus Schein: Architektur im Medium des NS-Propagandafilms*' ('The word made from stone – A world made from appearance:

Architecture in the medium of Nazi propaganda films'), in M. Gimes, J. Huber and A. Messerli (eds), *Kinos Reden (Cinemas Talk)*, Basel: Stroemfeld/Roter Stern, pp. 137–50.

Weihsmann, Helmut (1998), *Bauen unterm Hakenkreuz: Architektur des Untergangs (Building under the Swastika: Architecture of Doom)*, Vienna: Promedia.

Weiss-Sussex, Godela (2011), 'Berlin: Myth and memorialization', in K. Pizzi and G. Weiss-Sussex (eds), *The Cultural Identities of European Cities*, Berlin: Peter Land, pp. 145–64.

Welzbacher, Chrisitan (2006), *Die Staatsarchitektur der Weimarer Republik (State Architecture of the Weimar Republic)*, Berlin: Lukas Verlag.

Wenders, Wim (1988), interviewed by C. Fusco, *Cineaste*, 16:4, pp. 14–17.

Wenders, Wim (1991), *The Logic of Images: Essays and Conversations*, London: Faber and Faber.

Wertsch, James V. (2002), *Voices of Collective Remembering*, Cambridge: Cambridge University Press.

White, Paul and Gutting, Daniel (1998), 'Berlin: Social convergences and contrasts in the reunited city', *Geography*, 83:3, July, pp. 214–26.

Whiting, Sarah, Diller, Elizabeth and Scofidio, Ricardo (1995), 'Tactical histories: Diller + Scofidio's "Back to the Front: Tourisms of War"', *Assemblage*, 28, pp. 71–85.

Whitney, Craig R. (1993), 'A Berlin palace stirs in its grave: A *Trompe L'oeil* façade recalls the glory days', *New York Times*, 12 July, https://www.nytimes.com/1993/07/12/arts/a-berlin-palace-stirs-in-its-grave.html, last accessed 30 January 2022.

Whybrow, Nicolas (2005), *Street Scenes: Brecht, Benjamin and Berlin*, Bristol: Intellect Books.

Whyte, Iain Boyd (1998), 'Reflections on a polished floor: Ben Willikens and the *Reichskanzlei* of Albert Speer', *Harvard Design Magazine*, 6, Fall, pp. 1–8.

Whyte, Iain Boyd and Frisby, David (eds) (2012), *Metropolis Berlin: 1880–1940*, Oakland: University of California Press.

Wilkinson, Tom (2020), 'Typology: Nightclub', *The Architectural Review*, 1470, April, https://www.architectural-review.com/essays/typology/typology-nightclub, last accessed 30 January 2022.

Wilson, Christopher S. (2000), 'Times Square', *St. James Encyclopaedia of Popular Culture*, Detroit: St. James Press, pp. 659–61.

Wilson, Christopher S. (2013), *Beyond Anitkabir: The Funerary Architecture of Atatürk*, London: Ashgate Press.

Winter, Jay (2001), 'Film and the matrix of memory', *The American Historical Review*, 106:3, June, pp. 857–64.

Wise, Michael (1998), *Capital Dilemma: Germany's Search for a New Architecture of Democracy*, New York: Princeton Architectural Press.

Wolfgram, Mark (2007), 'Gendered border crossings: The films of division in divided Germany', *symplokē*, 15:1&2, pp. 152–69.

Wolfgram, Mark (2011), *Getting History Right: East and West German Collective Memories of the Holocaust and War*, Lewisburg: Bucknell University Press.

Wolfrum, Edgar (2001), '*Die Mauer*' ('The Wall'), in E. François and H. Schulze (eds), *Deutsche Erinnerungsorte (German Sites of Memory)*, vol. 1, Munich: Beck, pp. 552–68.

Wolters, Rudolpf and Wolff, Heinrich (eds) ([1940] 2005), *Die Neue Reichskanzlei: Über den Bau der Neuen Reichskanzlei von Adolf Hitler (The New Reich Chancellery: On the construction of Adolf Hitler's New Reich Chancellery)*, Berlin: Unglaublichkeiten Verlag.

Wong, Lilliane (2017), *Adaptive Reuse: Extending the Lives of Buildings*, Basel: Birhäuser.

Woodward, Christopher (2010), *In Ruins: A Journey through History, Art, and Literature*, New York: Knopf Doubleday.

Young, James E. (1992), 'The counter-monument: Memory against itself in Germany today', *Critical Inquiry*, 18:2, Winter, pp. 267–96.

Young, James E. (1993), *The Texture of Memory: Holocaust Memorials and Meaning*, New Haven: Yale University Press.

Young, James E. (ed.) (1994), *The Art of Memory: Holocaust Memorials in History*, Munich: Prestel.

Young, James E. (1999), 'Memory and counter-memory', *Harvard Design Magazine*, 9, Fall, pp. 1–10.

Young, James E. (2003), 'Germany's Holocaust memorial problem and mine', *Religion and Public Life*, 33, pp. 55–70.

Zalampas, Sherree Owens (1990), *Adolf Hitler: A Psychological Interpretation of His Views on Architecture, Art and Music*, Bowling Green: Bowling Green State University Popular Press.

Zehfuss, Maja (2007), *Wounds of Memory: The Politics of War in Germany*, Cambridge: Cambridge University Press.

Zeman, Zbyněk Anthony Bohuslav (1964), *Nazi Propaganda*, Oxford: Oxford University Press.

Zerubavel, Evitar (1996), 'Social memories: Steps to a sociology of the past', *Qualitative Sociology*, 19:3, Fall, pp. 283–99.

Zucker, Paul (1961), 'Ruins – An aesthetic hybrid', *Journal of Aesthetics and Art Criticism*, 20:2, Winter, pp. 119–30.

Zwoch, Felix (ed.) (1993), *Hauptstadt Berlin: Parlamentsviertel im Spreebogen (Capital Berlin: Parliament District at the Spreebogen)*, Berlin: Bauwelt.

Index

Note: page numbers in italics refer to figures.